Meaning in the Visual Arts: Views from the Outside

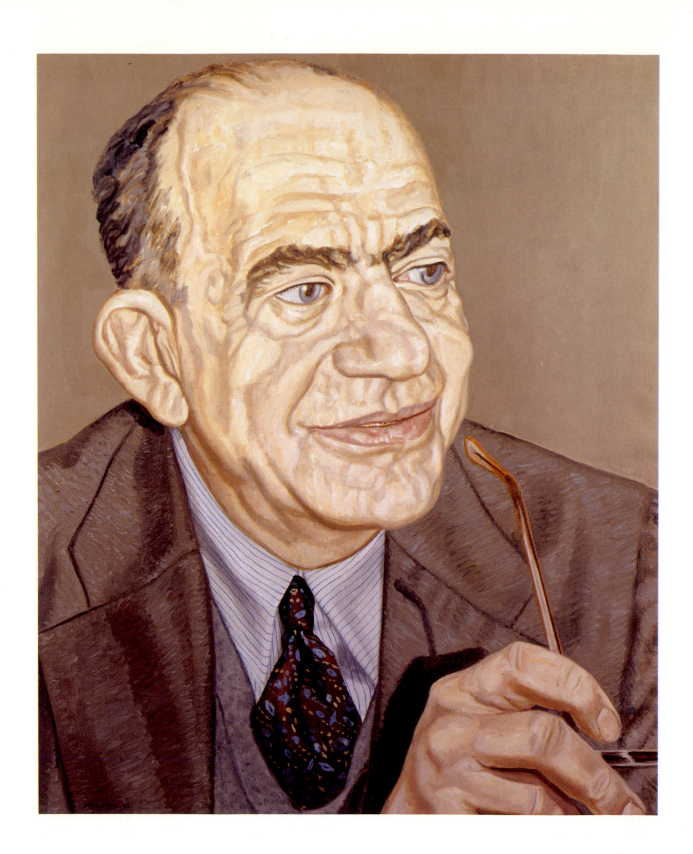

Meaning in the Visual Arts: Views from the Outside

A Centennial Commemoration of Erwin Panofsky (1892–1968)

EDITED BY
IRVING LAVIN

Institute for Advanced Study · Princeton · 1995

Copyright © 1995 by the Institute for Advanced Study
Published by the Institute for Advanced Study, Olden
Lane, Princeton, New Jersey, 08540

Library of Congress Cataloging-in-Publication Data

Meaning in the visual arts : views from the outside : a
centennial commemoration of Erwin Panofsky (1892–
1968) / edited by Irving Lavin.
 p. cm.
Proceedings of a symposium held at the Institute for
Advanced Study, Oct. 1–3, 1993.
ISBN 0-691-00630-X (cl : acid-free paper)
1. Visual perception—Congresses. 2. Art—Psychology
—Congresses. 3. Panofsky, Erwin, 1892–1968—
Criticism and interpretation—Congresses. I. Panofsky,
Erwin, 1892–1968. II. Lavin, Irving, 1927– .
N7430.5.M38 1995
700'.1—dc20 95-10534

Support for the publication of this book has been
provided by the Arcana Foundation, Inc., The Gladys
Krieble Delmas Foundation, and Emily Rose and
James H. Marrow

This book has been composed in Futura by The
Composing Room of Michigan, Inc.

Books published by the Institute for Advanced Study are
printed on acid-free paper and meet the guidelines for
permanence and durability of the Committee on
Production Guidelines for Book Longevity of the Council
on Library Resources

Printed in the United States of America by Princeton
Academic Press, Princeton, New Jersey, 08540

1 3 5 7 9 10 8 6 4 2

Frontispiece: Philip Pearlstein, *Portrait of Erwin Panofsky*,
1993, oil on canvas, 86 × 71 cm. Institute for Advanced
Study, Princeton

Copyedited by Timothy Wardell
Designed by Laury A. Egan

Contents

Preface

The papers published in this volume are the permanent record of a symposium held at the Institute for Advanced Study October 1–4, 1993, to commemorate the centennial of the birth of Erwin Panofsky (1892). The chronological discrepancy may reflect indirectly a certain time warp that is perhaps endemic to this institution; but the delay is a direct result of the fact that the building in which we gathered, Wolfensohn Hall, was under construction during 1992, and we thought it convenient as well as appropriate to wait until this splendid new facility was completed.

By a perverse kind of logic one might think of our symposium as a happy outcome of one of those unlikely historical events that Panofsky liked to call "accidents on the highways of tradition": I refer to the coincidental advent of the Nazi terror in Germany, and the foundation of the Institute for Advanced Study at Princeton. The collision of those two diametrically opposed forces made it possible for some of the most creative minds of the twentieth century to work out their lives and develop their full potential under ideal conditions. Having been dismissed as a Jew from his professorship at the University of Hamburg, Panofsky, already famous in the scholarly world, immigrated to America in 1933; in 1935 he received one of the first permanent appointments in the nascent School of Historical Studies at the Institute. When he died in 1968 he left not only a great legacy of classic publications on an amazing variety of subjects, but also what might well be regarded as a new field of the humanities masquerading under an old name. No longer the narrow province of an elite band of specialists, of only anecdotal interest to "serious" scholars in other fields, art history had become fair game for anyone with the imagination to perceive the depth and breadth of the contribution of visual artists to the content of human culture. By now, few serious historians or social scientists neglect to consider visual culture in one form or another. I believe this profound change is due in good measure to the enormous influence of Panofsky, and in particular to his own method of explicating works of art by reference to other contexts, such as philosophy, literature, theology, and science. In this way, he showed that works of art are in turn relevant to those fields, as well.[1]

In recent years there has been a veritable flood of interest in Panofsky, and the literature on his ideas and scholarship is growing by leaps and bounds (I am not aware that anyone has yet undertaken a full-scale biography, but that will surely not be long in coming). Even so, the importance of his work as a stimulus in other fields has been surprisingly neglected. I therefore thought it might be interesting and appropriate to commemorate Panofsky's centennial by exploring some of the vast extraterritorial domain he helped discover. Hence the dual theme of the symposium: Meaning in the Visual Arts (this was his own phrase for his principle mission in life and the title of one of his most influential books, a volume of essays in which he sought to define how the visual arts convey meaning—intellectual sense, not just aesthetic pleasure—as no one had before);[2] and Views from the Outside.

The papers, in great majority by representatives from disciplines other than art history, illustrate how thinkers whose primary goal is to elucidate non-visual subjects perceive the relevance of the visual arts to their purpose. The point was not to eulogize Panofsky, but rather to address the problem of visual signification that he posed as an art historian, from the different perspectives of other disciplines for which his work was a stimulus; one paper in each section considers

Panofsky's own work in that light. Many important subjects have been reluctantly omitted—I am particularly pained by the absence of philosophy. On the other hand, special concessions have been made to two of Panofsky's own special interests: the History section has been devoted to the Renaissance, Panofsky's trademark subject, and Film has been included because Panofsky's seminal work in that field—a single, brief essay —is relatively unknown to non-specialists. The composition of each section was worked out in close consultation with the chairpersons, deliberately keeping the number of professional art historians to a necessary minimum: David Summers, who writes about Panofsky's own concept of meaning in the visual arts, is really half a philosopher, anyway; Martin Kemp was the only historian we could think of who could cover the range of Panofsky's interests in the history of science. (In an unpublished lecture titled "What is Baroque?," which I revived for the occasion, Panofsky spoke for himself.[3]) Three other distinguished art historians in turn give us their views of our proceedings as commentators-at-large: Horst Bredekamp, Willibald Sauerlaender, and Craig Smyth. I count our fourth commentator, Carl Schorske, as at least an honorary art historian, with a special interest in cultural history.[4]

I first broached the idea for a commemoration of Erwin Panofsky with the faculty of the School of Historical Studies, who demonstrated their collegiality with their official *nihil obstat* and personal encouragement. The Director of the Institute, Phillip Griffiths, responded to my proposal immediately and enthusiastically, allowing his staff to expend enormous amounts of time and energy to bring it to fruition. The Associate Director, Rachel Gray, and the Public Relations Assistant, Ann Humes, have borne with perfect grace a double burden: that of preparing and pursuing every detail, from fund-raising to dinner menus; and that of dealing through it all with a cantankerous, demanding and aging art historian/organizer who is forever grateful to them. I feel personally indebted to the participants in the

symposium; I have badgered them aplenty, but I hope and trust that, all having been said and done, they feel their efforts have been worthwhile. Elizabeth Powers has been most kind in representing Princeton University Press, and Timothy Wardell has been most able and patient in editing the texts and shepherding the work into print.

The symposium and publication were made possible financially by generous grants from The Arcana Foundation, Inc., The Gladys Krieble Delmas Foundation, and Emily Rose and James H. Marrow.

A Note on the Frontispiece

The splendid portrait of Panofsky that serves as the frontispiece of this volume was commissioned from Philip Pearlstein in 1993 and is now installed in the Institute's library of the Schools of Historical Studies and Social Science. Although not yet very old, the portrait already has an interesting history, because it resulted from another of those Panofskian accidents, this time involving a collision of at least a half-dozen vehicles of history. First, in 1964 one of the Institute's Trustees, Harold Lindner, gave a modest sum for art for our library, in memory of Senator Robert Lehman. Evidently long forgotten, the existence of the fund was very kindly brought to my attention some years ago by our librarian, Elliott Shore, but it proved devilishly difficult—the second coincidence—to hit upon an appropriate and really first rate work for the amount available. The difficulty was in fact providential because—the third coincidence—the money was still there when Panofsky's centennial approached and the idea, which seems inevitable in retrospect, dawned on me that it would be singularly appropriate if we could obtain for the centennial of one of the leading art historians our time, a portrait by one of the leading artists of our time. That artist, Philip Pearlstein, was also inevitable and providential. Pearlstein had already done a double portrait of

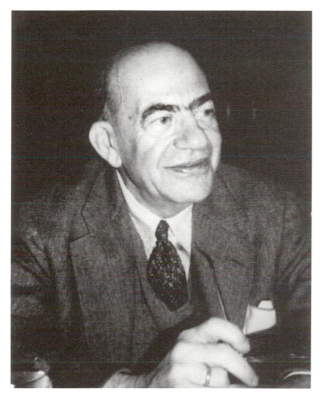

Figure 1. Snapshot of Erwin Panofsky

two leading American art historians, Linda Nochlin and Richard Pommer, and a portrait of Panofsky by him would stand in the grand tradition of Max Liebermann's portrayal of Wilhelm von Bode, and Oskar Kokoschka's painting of Hans and Erika Tietze. A fourth coincidence, probably not altogether unrelated to the third, was that Philip and I have known each other for more than forty years, ever since we were graduate students together at the Institute of Fine Arts in New York, where we both heard—and this is the fifth coincidence—the lectures of none other than Erwin Panofsky, who taught there regularly. I telephoned Philip and made him an offer which, under those circumstances, he could hardly refuse. What came as an astonishing surprise, however, was that instead of producing a modest little sketch or drawing, which is all I expected

at the agreed price, Pearlstein made a grand and labor-intensive painting.

Pearlstein's unusual artistic generosity was matched by an equally unusual scholarly generosity. Besides his own memories of Panofsky, he based the portrait on several snapshots I sent him, some of which were kindly lent by Gerda Panofsky (fig. 1).[5] Well-trained art historian that he is, when he finished the picture Pearlstein sent me the following documentary letter describing his working procedure, along with several slides:

May 1, 1993

Dear Irving,

Enclosed is the original slide, my painting and the studio set-up crudely improvised —I suspended a piece of transparent vellum from an old canvas-stretcher frame that is leaning against an unused easel, onto which I projected, from the rear, the original slide which then became my "model." (fig. 2) I tried to paint as if from a still-life. Projecting the slide this way allowed me to keep on the usual studio lights I work with. You can see that I re-positioned the hand holding the eye glasses, to compress the composition, and as I told you, I painted the details of the hand from my own hand as a model—there simply wasn't enough detail in the photo— and my hand is just as pudgy as Panofsky's! Thanks for the opportunity to do this.

Yours,
Philip

The artist's use of the word compression is a dead giveaway, for by this device he transformed the snapshot into a modern, Philip Pearlstein version of those powerfully analytical and evocative portraits by Early Netherlandish painters like Jan van Eyck. In fact, with its close-up view, body and arms hidden below the frame leaving visible only the hand with fingers holding a personal symbol (eyeglasses for the scholar), the portrait of Panofsky is reminiscent of the so-called *Man with a Pink* in Berlin (fig. 3). The next-to-last coin-

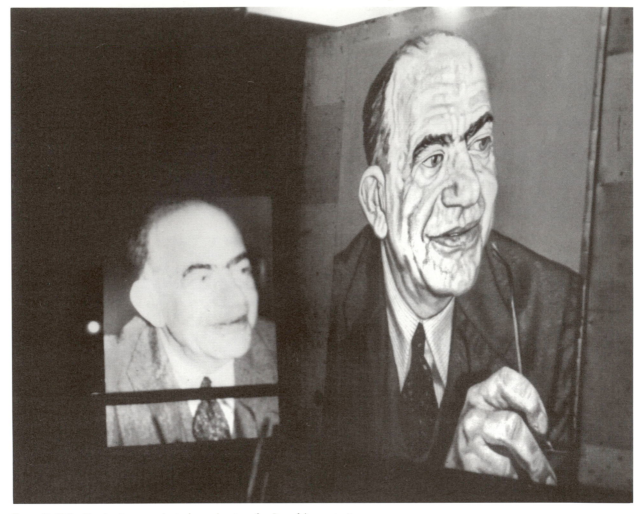

Figure 2. Philip Pearlstein, snapshot of easel set-up for Panofsky portrait

cidence is that the lectures Panofsky gave in New York in the early 1950s were none other than the manuscript of what later became one of his most important books, entitled *Early Netherlandish Painting*, and the *Man With the Pink* was one of the well-known works he discussed. The final co-incidence is that Pearlstein actually bears an un-canny personal resemblance to Panofsky, both physically (not only the pudgy hands) and in his personal warmth and good humor; hence Pearl-

stein's portrait of Panofsky may also be viewed as an appropriately whimsical indulgence in that fateful tendency of artists described in the Re-naissance by the famous aphorism, "every painter paints himself" (ogni dipintore dipinge se), which Leonardo considered the painter's "worst defect."[6]

IRVING LAVIN
The Institute for Advanced Study
Princeton, January 1994

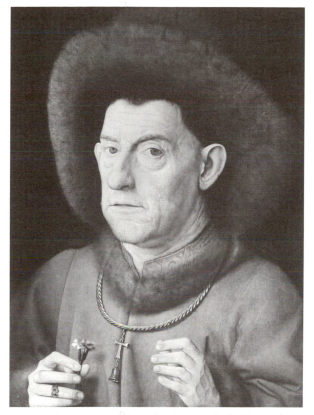

Figure 3. Sometimes attributed to Jan van Eyck, *Man with a Pink*. Staatliche Gemäldegalerie, Berlin

Notes

1. The interest of the historical disciplines in art has a long and complex history, which has been traced by F. Haskell, *History and its Images. Art and the Interpretation of the Past*, New Haven and London, 1993. Equally significant has been the cooptation in literary studies, especially over the past half-century, of art-historical concepts, notably: Baroque (F. J. Warnke, *Versions of Baroque. European Literature in the Seventeenth Century*, New Haven and London, 1972) and Mannerism (J. V. Mirollo, *Mannerism and Renaissance Poetry. Concept, Mode, Inner Design*, New Haven and London, 1984); the visual categories of Heinrich Wölfflin and Alois Riegl (a seminal transferral was that of E. Auerbach; *Mimesis. Dargestellte Wirklichkeit in der abendländische Literatur*, Bern, 1946, and see, especially in relation to Panofsky, M. A. Holly, *Panofsky and the Foundations of Art History*, Ithaca and London, 1984, 36–68, 69–96); the space-time synthesis of Wilhelm Worringer (J. Frank, *The Idea of Spatial Form*, New Brunswick, 1991); and the structuralism of Guido Kaschnitz-Weinberg (S. Nodelman, "Structural Analysis in Art and Anthropology," *Yale French Studies*, XXXVI–XXXVII, 1966, 89–103). Aside from the use of art objects simply as historical illustrations, however, these relationships were mainly concerned with matters of style, whereas Panofsky showed how works of art are articulate expressions of significant ideas.

2. *Meaning in the Visual Arts. Papers in and on Art History* (Garden City, N.Y., 1955). Panofsky's concept of the work, including its title, may have been indebted to T. M. Greene, who edited a lecture series by various authors delivered in 1937–38, in which Panofsky's essay on the discipline of Art History, mentioned below on pages 7–8, was first published: *The Meaning of the Humanities. Five Essays by Ralph Barton Perry, Augustus Charles Krey, Erwin Panofsky, Robert Lowry Calhoun, Gilbert Chinard*, ed. T. M. Greene (Princeton-London, 1940).

3. Soon to be published in E. Panofsky, *Three Essays on Style*, ed. I. Lavin (Cambridge, MA, 1995).

4. As it appears here, the session on Science is unfortunately unbalanced by the absence of two papers that were delivered at the symposium but were not forthcoming for publication: "Styles of Reasoning: From the History of Art to the Epistemology of Science" by Arnold Davidson, and "Constructing Modernism: the Cultural Location of Logical Positivism" by Peter Galison.

5. I have been informed by Panofsky's son, Wolfgang, that the snapshot was taken by the latter's son, Edward, then aged 15, in Kennebunkport, Maine, in July 1962.

6. M. Kemp, "'Ogni dipintore dipinge se': A Neoplatonic Echo in Leonardo's Art Theory?," in C. H. Clough, ed., *Cultural Aspects of the Italian Renaissance. Essays in Honour of Paul Oskar Kristeller* (Manchester, 1976), 311–33; F. Zollner, "'Ogni pittore dipinge se.' Leonardo da Vinci and 'Automimesis,'" in M. Winner, ed., *Der Künstler über sich in seinem Werk. Internationales Symposium der Biblioteca Hertziana. Rom 1989* (Weinheim, 1992), 137–60.

Meaning in the Visual Arts: Views from the Outside

Panofsky's History of Art

IRVING LAVIN

Upon consideration, it is really quite remarkable that art history should be the one branch of cultural history represented at the Institute for Advanced Study. After all, the visual arts had since antiquity been low man (or low woman, since the arts are always represented as women) on the totem pole of human creativity, far behind literature, music, and history, for example. Painting, sculpture, and the like were classed as mechanical, rather than liberal arts, since they were considered the products of manual, rather than intellectual labor.

To appreciate how an art historian came to be a charter member of the Institute faculty one must know something of the nature of Panofsky's singular achievement.[1] A fundamental common denominator underlies all his vast outpouring of articles and books on an immense variety of subjects, from his astonishing dissertation on Albrecht Dürer's theoretical studies of human proportions (published in 1914 when Panofsky was 22, it brought him instant notoriety as a kind of child prodigy) to his last major work, published posthumously in 1969, a volume on Titian which he produced only at the urging of friends because, as he said, he felt inadequate to write about his favorite artist.[2] The study of Dürer's proportion theory revolutionized our understanding of the position in European history of Germany's great national painter, who had previously been treated as the epitome, the very incarnation of the pure, mystical German national spirit. Panofsky showed, to the dismay of many, that Dürer was in fact the principal channel through which the classical tradition of rational humanism, reborn in Italy in the Renaissance, was transmitted to Germany, transforming its cul-

ture forever (figs. 1, 2). At the end of his career Panofsky revolutionized our understanding of Italy's most beloved painter of the Renaissance by showing, again to the dismay of many, that Titian was not just the painter's painter *par excellence*, the pure colorist, the virtuoso of the brush, the unrestrained sensualist of form and light. On the contrary, Titian was also a great thinker who suffused his brilliant displays of chiaroscuro with layers and layers of wide learning and profound meaning, like the many layers of oil glazes that lend to his canvases their luminosity and depth. Ironically, and most appropriately, one of the prime instances of this transformed understanding of Titian—and how one understands Titian is how one understands the nature of painting itself, indeed of visual expression generally—was his analysis of one of Titian's seminal works, commonly known by the rather common title of *Sacred and Profane Love* (fig. 3). Panofsky showed that the picture, which includes two females, one scrumptiously dressed, the other divinely nude, in fact belonged in a long tradition of intellectual allegories; it can only have been providential, I might add, that the same tradition ultimately produced the Institute for Advanced Study's own official seal contrasting an adorned figure of Beauty with a naked figure of Truth (fig. 4).

Thus, Panofsky did not come to the Institute merely through the coincidence that, owing to Hitler, one of the world's leading art historians happened to be available at the moment when what was to become one of the world's leading institutions of higher learning was being established. He deserved his place at the Institute because of the *way* he did art history. He was the

Figure 1. Albrecht Dürer, Vitruvian man, drawing. British Museum, London

Figure 2. Leonardo da Vinci, Vitruvian man, drawing. Galleria dell'Accademia, Venice

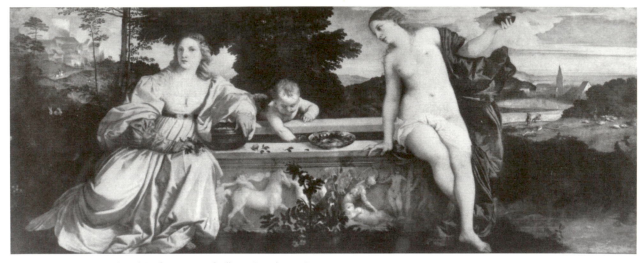

Figure 3. Titian, *Sacred and Profane Love*. Galleria Borghese, Rome

first to hear clearly, take seriously, and apply systematically to all art, what artists since the Renaissance—Leonardo, Raphael, Dürer, Michelangelo, Titian, and the rest—were saying, sometimes desperately: that art is also a function of the brain, that man can speak his mind with his hands. Whereas his predecessors were concerned mainly with the classification of artists, styles, and periods, or with the social, religious, and political contexts in which art was produced, or with the psychological and formal principles that determine its various forms, Panofsky was concerned first, last, and foremost with meaning. The artist had something special to say and found special ways to say it. (Panofsky wrote a miraculous essay on precisely this subject with respect to what would now be called "filmic" technique.[3]) It was this insistence on, and search for, meaning—especially meaning in places where no one suspected there was any—that led Panofsky to understand art, as no previous historian had, as an intellectual endeavor on a par with the traditional liberal arts like literature and music; and in so doing he made art history into something it had never been before, a humanistic discipline. It was this elevating, intellectual approach—not to mention, of course, the bril-

liance, perspicuity, and charm with which he pursued it—that put Panofsky justly in the company of Einstein, Gödel, and those other miracle workers who performed their tricks in the citadel of higher intellect and imagination that this strange new institution was intended to provide. And that is how art history at the Institute was born.

I conclude by quoting three brief paragraphs from the famous "little" volume of essays Panofsky published in 1955 under the title, the significance of which I hope my remarks so far have helped to make clear, *Meaning in the Visual Arts*.[4] The passages give at least a soupçon of the quality of Panofsky's intelligence, humanity, and wit, and not incidentally, his uncanny command of the English language, which he learned to speak and write fluently only after he moved here at age 41. But mainly, I intend the readings to provide some idea of the past, present, and future of art history as Panofsky saw it.

The first two passages come from the essay "Three Decades of Art History in the United States. Impressions of a Transplanted European." Near the beginning, Panofsky speaks of his transferral from Hamburg to New York and the Institute:

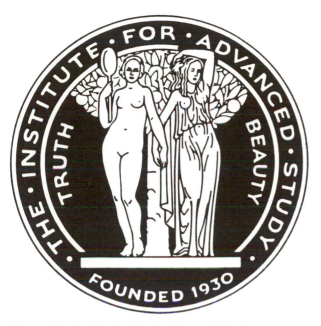

Figure 4. Seal of the Institute for Advanced Study

And when the Nazis ousted all Jewish officials in the spring of 1933, I happened to be in New York while my family were still at home. I fondly remember the receipt of a long cable in German, informing me of my dismissal but sealed with a strip of green paper which bore the inscription: "Cordial Easter Greetings, Western Union."

These greetings proved to be a good omen. I returned to Hamburg only in order to wind up my private affairs and to attend to the Ph.D. examinations of a few loyal students (which, curiously enough, was possible in the initial stages of the Nazi regime); and thanks to the selfless efforts of my American friends and colleagues, unforgettable and unforgotten, we could establish ourselves at Princeton as early as 1934. For one year I held concurrent lectureships at New York and Princeton universities, and in 1935 I was invited to join the newly constituted humanistic faculty of the Institute for Advanced

Study, which owes its reputation to the fact that its members do their research work openly and their teaching surreptitiously, whereas the opposite is true of so many other institutions of learning.[5]

In the second passage Panofsky describes the difference between European and American scholarship, and what the latter meant to him as an immigrant intellectual:

But what made the greatest impression on the stranger when first becoming aware of what was happening in America was this: where the European art historians were conditioned to think in terms of national and regional boundaries, no such limitations existed for the Americans.

The European scholars either unconsciously yielded to, or consciously struggled against, deep-rooted emotions which were traditionally attached to such questions as whether the cubiform capital was invented in Germany, France, or Italy, whether Roger van der Weyden was a Fleming or a Walloon, or whether the first rib-vaults were built in Milan, Morienval, Caën, or Durham; and the discussion of such questions tended to be confined to areas and periods on which attention had been focused for generations or at least decades. Seen from the other side of the Atlantic, the whole of Europe from Spain to the Eastern Mediterranean merged into one panorama the planes of which appeared at proper intervals and in equally sharp focus.

And as the American art historians were able to see the past in a perspective picture undistorted by national and regional bias, so were they able to see the present in a perspective picture undistorted by personal or institutional *parti pris*.[6]

In the third passage, which comes from an essay called "The History of Art as a Humanistic Discipline," first written for a lecture series in 1937–38, Panofsky is discussing what he says

the ancients called the *vita contemplativa* as opposed to the *vita activa,* and the relations between them:

> The man who takes a paper dollar in exchange for twenty-five apples commits an act of faith, and subjects himself to a theoretical doctrine, as did the mediaeval man who paid for indulgence. The man who is run over by an automobile is run over by mathematics, physics and chemistry. For he who leads the contemplative life cannot help influencing the active, just as he cannot prevent the active life from influencing his thought. Philosophical and psychological theories, historical doctrines and all sorts of speculations and discoveries, have changed, and keep changing, the lives of countless millions. Even he who merely transmits knowledge or learning participates, in his modest way, in the process of shaping reality—of which fact the enemies of humanism are perhaps more keenly aware than its friends.* It is impossible to conceive of our world in terms of action alone. Only in God is there a "Coincidence of Act and Thought" as the scholastics put it. Our reality can only be understood as an interpretation of these two.[7]

After the word "friends" at the end of the fourth to last sentence of this passage Panofsky added a footnote that must have had deep personal and intellectual meaning for him; in it he cites a letter-to-the-editor published in a popular British magazine of current affairs, not long after he had been expelled to America:

> *In a letter to the *New Statesman and Nation,* XIII, 1937, June 19, a Mr. Pat Sloan defends the dismissal of professors and teachers in Soviet Russia by stating that "a professor who advocates an antiquated pre-scientific philosophy as against a scientific one may be as powerful a reactionary force as a soldier in an army of intervention." And it turns

out that by "advocating" he means also the mere transmission of what he calls "pre-scientific" philosophy, for he continues as follows: "How many minds in Britain today are being kept from ever establishing contact with Marxism by the simple process of loading them to capacity with the works of Plato and other philosophers? These works play not a neutral, but an anti-Marxist role in such circumstances, and Marxists recognize this fact." Needless to say, the works of "Plato and other philosophers" also play an anti-Fascist role "in such circumstances," and Fascists, too, "recognize this fact."

With the change of disquietingly few words the same letter might have been written by some of those who denigrate "the canon" today.

Notes

This essay was first printed in the pamphlet *From the Past to the Future through the Present. Conversations with Historians at the Institute for Advanced Study* (Princeton, 1992), 21–25; portions were incorporated in my paper "Iconography as a Humanistic Discipline ("Iconography at the Crossroads")," in B. Cassidy, ed., *Iconography at the Crossroads* (Princeton, 1992), 33–42.

1. Panofsky describes the circumstances of his appointment at the beginning of the essay on art history in the United States, mentioned below.
2. *Die theoretische Kunstlehre Albrecht Dürers (Dürers Aesthetik)* (Berlin, 1914); *Problems in Titian, Mostly Iconographic* (New York, 1969).
3. "Style and Medium in the Motion Pictures," first published in 1936 and often reprinted, most recently in E. Panofsky, *Three Essays on Style,* ed. I. Lavin (Cambridge, MA, 1995). Reprinting the essay in 1947, the editors of *Critique. A Review of Contemporary Art* referred to it as "one of the most significant introductions to the aesthetics of the motion picture yet to be written." A critical discussion of the text, by Thomas Y. Levin, will be found below.
4. *Meaning in the Visual Arts. Papers in and on Art History* (Garden City, N. Y., 1955). The first sentence of the preface begins, "The essays collected in this little volume."
5. *Meaning,* 321–22.
6. *Meaning,* 328.
7. *Meaning,* 23.

Meaning in the Visual Arts as a Humanistic Discipline

DAVID SUMMERS

In this paper I am going to be mostly concerned with a lecture Erwin Panofsky read to the Kantgesellschaft in Kiel in May 1931, that is, at about the time he was persuaded by Richard Offner and Millard Meiss to teach part of the year in New York and about four years before he came to the Institute for Advanced Study. The lecture, published in 1932, is entitled "Zum Problem der Beschreibung und Inhaltsdeutung von Werken der bildenden Kunst," or, as it might be translated, "On the Problem of Description and Meaning in the Visual Arts."[1] Panofsky later referred to the text as his "methodological article" and it figured centrally in his best-known publications. It was the basis for the introduction to *Studies in Iconology*, the Mary Flexner Lectures at Bryn Mawr College, first published in 1939. Panofsky described this second version as a synthesis of the original lecture with an article he had co-authored with Fritz Saxl in 1933.[2] This introduction was revised again as the first chapter of *Meaning in the Visual Arts*, published in 1955. This time it was entitled "Iconography and Iconology: An Introduction to the Study of Renaissance Art"[3] and was preceded by a second introductory essay entitled "The History of Art as a Humanistic Discipline," first published by Princeton University Press in 1940.[4] This chain of introductory essays begun by Panofsky's lecture of 1931—the last links of which are very familiar to students of art history—provides the theme and title for my remarks.

Panofsky came to this country from the collapsing social, political, and intellectual world of Weimar Germany, where by the age of 35 he had consolidated a brilliant academic career in a professorship at the new university of Hamburg. This career was shattered in 1933 when the Nazis purged German universities of Jewish faculty. After he came to the United States, and began to write his lovely English, Panofsky had harsh words for the intellectual tradition he had left behind, and, with characteristic graciousness, praised the anti-theoretical—or non-theoretical—traditions of American scholarship.[5] But if the so-called "American Panofsky" adjusted the presentation of his ideas to new circumstances, these ideas did not abruptly change. On the contrary, in "The History of Art as a Humanistic Discipline," written as one of the Spencer Trask Lectures at Princeton in 1937–38, and published in a book entitled *The Meaning of the Humanities*, Panofsky underscored and extended his earlier arguments. Here Panofsky—like other authors in the volume—defended the free critical inquiry of humanistic study against its modern totalitarian foes and oppressors at both ends of the political spectrum, especially against what he called the "satanocracy" of fascism.[6] But it was in his lecture of 1931, in another world, before the cataclysm of world war, that Panofsky summarized his earlier theoretical and historical writing and located his work—and therefore located the history of art—in relation to broader intellectual cur-

rents, to Wilhelm Dilthey's "critique of historical reason," to Edmund Husserl's phenomenology, to the emerging existentialist ontology of Martin Heidegger, and to various strands of Neo-Kantianism, especially that of Ernst Cassirer. It was also in this lecture that Panofsky first cleared the conceptual space for what came to be called "iconology," a term he himself used reluctantly, and, for reasons that will become clear, refused to define in any but the most general terms. By examining this first project I believe we will be able to gain a better understanding of what Panofsky might have meant by "iconology" and what he might have meant when he called the history of art a "humanistic discipline."

I am going to begin my explication of Panofsky's "methodological article" with his concluding arguments. As I have mentioned, Panofsky's lecture was delivered to the Kantgesellschaft in Kiel, and his concluding example was a controversial one, Martin Heidegger's *Kant and the Problem of Metaphysics,* published in 1929. By using this example Panofsky not only built a bridge to his philosophical audience, he also entered a debate involving Heidegger and Ernst Cassirer, his friend and mentor, leading associate of the Kulturwissenschaftliche Bibliothek Warburg, rector of Panofsky's Hamburg University, and, at that, the first Jewish rector of a German university. Members of the Cassirer family were art dealers and publishers who advanced the cause of modern art in Germany. They also published the works of Immanuel Kant.[7] Ernst Cassirer was the last great representative of the Marburg School of Neo-Kantianism. He was a full generation older than Panofsky, and published his *Philosophy of Symbolic Forms* between 1923 and 1929. The dispute to which Panofsky alluded might be viewed simply as an episode in the often bitter academic strife of German Neo-Kantianism; but these scholastic polemics were always entangled in political contest and this encounter was soon to end apocalyptically. In 1933 Cassirer left Hamburg and went to Oxford, then to Sweden and America. The Warburg family

had long been major targets of anti-Semitic attacks, and the library of Aby Warburg that had nourished both Cassirer and Panofsky, now in its turn attacked as a subversive threat, was moved from Hamburg to London. Heidegger, perhaps at first believing that his philosophical reformation would serve the revitalization of Germany as an alternative to the modernist technocracies of Russia to the east and America to the west, went on to become the rector of Freiburg, where, incidentally, Panofsky had received his doctorate in 1914. If this particular engagement was abruptly and portentously broken off, however, the questions disputed between the two philosophers are still very much at issue.

In justification of his unprecedented reading of Kant, Heidegger wrote that "an interpretation limited to a recapitualation of what Kant explicitly said can never be a real explication if the business of the latter is to bring to light what Kant, over and above his express formulation, uncovered . . . what is essential . . . is not found in the specific propositions of which it is composed but in that which, although unstated as such, is made evident through these propositions." In order to achieve such interpretation, Heidegger argued, it is necessary to resort to a certain "force" or "violence" (*Gewalt*) which, however, must not be wholly arbitrary. The interpretation, he wrote, must be animated and guided by the power of an "illuminative idea."[8]

When Cassirer reviewed Heidegger's book—the review also appeared in 1931—he praised it as a philosophical achievement but not as a reading of Kant. Heidegger, he said, was not a commentator but a usurper whose project was fundamentally at odds with Kant.[9] The Kantian philosophy according to Cassirer was not primarily directed toward the ontology of *Dasein*—Heidegger's term for individual human existence as "being-there"—but rather toward the "intelligible substratum of humanity," as Cassirer called it, echoing Kant himself, principally developed in Kant's moral and aesthetic philosophy.[10] Heidegger's analysis, Cassirer argued, separated Kant

from the completion of his own thinking. Not incidentally, it also separated the Kantian philosophy from its historical fulfillment in Cassirer's own philosophical anthropology, as in fact Heidegger was to say that the major accomplishment of his Kant book was the refutation of philosophical anthropology.[11]

We must touch however cursorily upon these most abstract questions because it was expressly in response to Heidegger's principle of interpretative violence that Panofsky first formulated the scheme of art historical interpretation that persisted through the later versions of his essay. In considering his response it must be emphasized that Panofsky did not think it possible or desirable to eliminate "violence" since we must always—and *should* always—approach the past on our own personal and historical ground. But Heidegger's principle, Panofsky argued, immediately raises this difficult and fateful question for the general problem of interpretation. Who or what sets the limits for this violence? He dismissed Heidegger's "illuminative idea" as nothing more than the same subjectivity it was supposed to be guiding.[12]

In offering his own answer to this question Panofsky might be said simply to have used Heidegger's own earlier arguments against him. If, as Heidegger had stated in *Being and Time,* published in 1927, "Dasein, and only Dasein is primordially historical"[13] as a corollary of its primordial temporality, then it is always together with the extrasubjectivity, or the intersubjectivity, of a shared historical world that Dasein is to be found. More simply put, human beings always find themselves in traditions that have already shaped their worlds. So, it might be all well and good for philosophers to say that Dasein is constitutively historical, then to move on to the matter of Dasein as such, but to do so leaves behind some fundamental issues for historians. How, for example, is Dasein historical in any particular case? Or, to put it another way, how do we do the history of the worlds presupposed by the existences of real persons like ourselves? Do these

worlds as worlds have histories? These questions —and more might easily be spun out—lead to what Panofsky called his table of "objective correctives." Interpretations are "violent," or most violent, and *not* historical, when they disregard the actual historical relations[14] that complete any human existence. Without the resistance and distance afforded by a sense of other worlds sustaining other persons we commit violence upon the past, and, more generally, upon the unfamiliar. Objective correctives, in short, provide what we have come to call "context," understood in the etymological sense of the situation with which anything must be woven.

With these general issues in mind we may proceed to consider the three distinguishable levels of meaning for works of art Panofsky first defined in our essay. Each level has a characteristic "kind of meaning" which is approached from a subjective starting point. By "subjective" Panofsky meant something like "provincial" or "ethnocentric," grounded in a culturally specific subject —that is, a subject in a particular historical world—and each subjective principle also has an objective corrective, as I have just discussed. Panofsky summarized his "objective correctives" under the general heading of "history of tradition."[15] By this he did not mean that appeal to tradition settles questions of interpretation, rather he meant that works of art (and their interpreters) simply *do* belong to traditions. The methodical acknowledgment of this *is* the business of history, what is peculiarly historical about history. Traditions are the diachronic dimension of context.

Let me briefly outline Panofsky's three levels of meaning.[16] The first is the recognition of images arising from the subjective basis of our everyday experience of our own persons and of the practical world. At this level a *Last Supper* might be thought to show a genre scene, perhaps the meeting of an eating club with a dispute over money. The second level arises from the subjective basis of our own education or culture. If we know the Christian gospels, then we are in a position to recognize the Last Supper as a *Last Sup-*

per. The third level Panofsky called essential or documentary meaning, the subjective origin of which is our own world-view. This is the most problematical level of interpretation, which, as I have already said, would finally be called "iconological."

To return to the first level, called "phenomenal meaning," in the foreword to "*Hercules at the Crossroads,*" published in 1930, Panofsky identified "vital I-experience" as the subjective beginning of the first level of the interpretation of images.[17] In 1931 this idealist formulation gave way to the phrase "vital *Dasein*-experience," perhaps in response to Heidegger, who, as we have just seen, used this term to refer to the fundamental condition of human existence. To formulate the "objective correctives," and thus to provide the basis for the imaginative reconstruction of the historical world presupposed and implied by the work of art, Panofsky adapted his own definitions of style and iconography.

Although Panofsky wrote with passion and great sensitivity about works of art, he was always leery of the notion of the "aesthetic," which suggested to him that art may be adequately understood intuitively, simply on the basis of its presumedly expressive forms.[18] He argued instead that we just plain do see the painting differently if we are told that the girl displaying a head on a silver platter is the wanton Salome on the one hand or the heroic Judith on the other, and, in general he believed that the experience of the particularity of works of art is sharpened, disciplined, and made immeasurably more significantly discussable by the historical definition of context and proper distance, which are thus integral to meaning in the visual arts. Consistently with this Panofsky argued that what we see first in the world are not light, dark, color, and shapes, but rather places, people, and things that are lighted, colored, and have shapes. Art—and especially painting, the example Panofsky had in mind throughout his argument—parallels perception in this fundamental respect, so that the formal elements of art are not the prior ex-

pressive constituents of images but rather the vehicle through which images are presented to us in a certain way, expressionally, to use Panofsky's term. If we interpreted the subject matter of paintings simply on the basis of our practical experience, then there would be no difference for us between image and reality. But a painted image is a mediated perception, the representation of a representation. The man with the guitar is recognizable as a man, but his edges are sharp and wiry; his skin is as white as his old hair and his sightless eyes, and his world is blue. Therefore we see him as a sad and forlorn man. We already see him through an intervening subjectivity—Picasso's—a mediation again mediated by our own response. All of this means that the problem of description to which Panofsky referred in the title of his essay is a very crucial one. It is this: we cannot simply interpret works of art by describing their apparent subject matter because representation is always mediated by a specific *style* which must itself be addressed. Panofsky actually began his essay with an example from the second-century writer Lucian, who—as noted by Lessing—because he was unaccustomed to looking at Greek painting of the 5th century B.C., explained the kind of spatial organization to be seen in the paintings of Polygnotus and his followers such as the Niobid Painter by supposing that some figures must be standing on towers behind others. Panofsky's point is that, if we are to avoid the error of looking at one mode of representation from the standpoint of another, we must be aware of the history of spatial representation, or we must be sufficiently historically aware to realize that there *are* alternative modes of spatial organization.

For Panofsky, the deepest stylistic categories were in fact not simply "formal" but spatial, or spatiotemporal, analogous to the primary imaginative synthesis that constitutes our spatiotemporal world according to Kant and many after him. Panofsky adapted the style categories of Heinrich Wölfflin and especially Alois Riegl—the art historian by whom he was by far the most

deeply influenced—to this Kantian framework. It would take another paper to explain how Panofsky modified the categories of his predecessors —categories such as linear and painterly or haptic and optic—to his new scheme.[20] For present purposes it is enough to say that he redefined them as antithetical *a priori* categories. By this he meant that they were the necessary critical and properly theoretical categories, provisionally defining art itself, that allowed the historian to make judgments about art as art. This redefinition also meant, again in Kantian terms, that the realm of art, even if subject to its own quasi-natural continuities or developments, is in principle a realm of freedom. Accordingly, the judgments these categories make possible allow the art historian imaginatively to recapitulate the artist's peculiarly artistic context of choice, as well as to relate that context to traditions and patterns of style. This brings us back to our major theme: stylistic evaluation counters subjective interpretation by locating a work in a tradition of representation, suggesting place, time, and circumstances of origin, even serving to specify it in relation to traditions of material and craft. Simply put, these categories of possible representation, arising from the historical study of art, and therefore themselves provisional and revisable, make it imperative that we regard any work of art as in principle always different from our expectations and always demanding an effort of understanding. At the same time, of course, granting the radical possibility of works of art and traditions of works of art necessarily also implies the radical possibility of our own arts and traditions of representation.

A simple and powerful reminder of the stakes involved in these arguments is provided by one of the examples Panofsky used to illustrate his essay, the *Mandrill* of Franz Marc. When it was bought by the Kunsthalle in Hamburg, Panofsky wrote, the public was baffled; no one could "see" the mandrill because it was concealed by its very presentation. But just as we must reconstruct the past, so we must adjust to the new in

the present, and the citizens of Hamburg, Panofsky wrote, had made the adjustment to the style of expressionist painting. Fifteen years later, he observed, it was hard to believe the *Mandrill* had created such a stir. Within a few more years, however, the bafflement was explained in other terms, and the incomprehension of the public had been reawakened to be exploited to other purposes. The *Mandrill* toured Germany as an example of degenerate art before being auctioned off at a contemptuously low price.[21] The respect for difference of vision involved in the idea of style had been inverted to proscribe the painting as a specimen of cultural and biological pathology, as more generally the idea of style was being used to establish racial differences, as opposed to the cultural differences implied by the definition of art in terms of context.

Panofsky's second level of meaning, the level of subject matter or iconography, depends upon our literary knowledge. In the simplest case, the iconographer faced with an image whose subject matter is unknown becomes more educated, reading old texts contemporary with the work of art in order to make a match. But iconography is more than the reunion of image and text, otherwise all crucifixions, for example, might appear very differently from one another as long as they could be seen to illustrate the same text. Instead there are what Panofsky called "types," phenomenal meanings so fused with verbal meanings that the two are inseparable in a tradition.[22] These types, like styles, have their own "shapes of time,"[23] and the systematic study of types constitutes the objective corrective at the second level of interpretation. When a work of art is reunited with its text, it is also more or less precisely located in historical space and time, much as it is by style. When it has been located in this way it may be further contextualized; that is, the work of art is more and more able to be understood in terms of the historical world from which it came.

This brings us back once again to our main question of historicization. Panofsky quoted (but did not cite) authors who too readily distin-

guished between what they called "artistically essential" and "inessential" subject matter. By "essential" subject matter, he objected, they simply meant *familiar* subject matter, dismissing everything else as "intricate allegories" or "abstruse symbolism."[24] Such presumed nearness and unproblematic availability of meaning is subjectivity in the sense of parochialism on a new level, and the historian of art, Panofsky argued, cannot accept this distinction. In fact, most scholarship calling itself iconographic before Aby Warburg treated Christian subject matter, and the work of Warburg and his followers progressively defined deep and pervasive alternative traditions of imagery. At the same time, like the Christianity with which they were intimately interwoven, these traditions were more or less pan-European, related by common institutional descent from classical antiquity and closely akin to the prestigious discipline of classical philology that began with Renaissance humanism. But the more general implication of the introduction of classical themes to iconography was the historicization of Christian subject matter. It is entirely thinkable, Panofsky wrote, that by the year 2500 the story of Adam and Eve will have become as strange as those modes of thought that produced the religious allegories from the circle of Dürer. It might even become necessary to explain that when Michelangelo painted the Sistine Chapel ceiling he meant to show the *Fall and Expulsion* rather than a *Luncheon on the Grass*.[25] This was more than a wry comparison of "types." It was Panofsky's friend and associate Gustav Pauli who pointed out that Manet had taken his model for the *Luncheon on the Grass* from a group of river gods in Marcantonio Raimondi's *Judgment of Paris*, which in turn had sources in ancient sarcophagi.[26] (Pauli, by the way, although not Jewish, was fired from his position as director of the Kunsthalle in Hamburg, presumably for buying degenerate paintings like the *Mandrill*.)[27] Manet's repetition of ancient forms in revolutionary modern art had fascinated Aby Warburg in the years before his death in

1929, years during which he wrote of the historical life of symbols in ways that deeply influenced Panofsky. The time would come when an image as self-evidently meaningful as the *Fall and Expulsion* would take its place in the millennial history of types. All subject matter, like all style, including that of our own day, is specific to a time and place.

If Panofsky's first two objective correctives placed the work of art at something like its own historical distance, and thus acknowledged its difference, the third stage of interpretation brought the difference of the work back to the present, placing its world and world-view in juxtaposition to our own. As I have mentioned, Panofsky called this "essential" or "documentary" meaning. The second term, as Panofsky acknowledged, was taken from an article by Karl Mannheim on the interpretation of world-view eventually included among Mannheim's *Essays on the Sociology of Knowledge*, but first published in 1925 in the *Jahrbuch für Kunstgeschichte*.[28] Mannheim considered the art history of Riegl, and Panofsky's critique of Riegl, to be major contributions to the methodological usefulness of the much-mooted idea of *Weltanschauung*. In contrast to the Hegelian view that the fullest expression of a culture is to be found in its philosophy, Mannheim argued, the new art history permitted inferences to be drawn about the unconscious and collective dimensions of cultures and cultural change that interested him as a sociologist.

If Panofsky saw such a potential in his own work he did not say so, and he turned instead to the problem of how we address documentary or essential meaning in a work of art; his paradigm for this address is the encounter with another human consciousness, and is thus not only phenomenological but ethical, and, once again, Kantian; it is as if when we properly address a work of art one noumenal reality is addressing another. That is why Panofsky called this level of meaning "essential," distinguishing what he called its "content" from mere subject matter. It is at this point in the essay of 1931—and not at the

beginning of the essay, as in the later versions—that Panofsky introduced his famous stroller, the acquaintance who meets us in the street and greets us by tipping his hat, a culturally specific gesture to be seen in an early form in the figure of St. George doffing his helmet as he presents the patron of the painting to the Virgin and Child in Jan van Eyck's *Madonna of the Canon van der Paele.* Panofsky referred to the appearance and gesture of his friend—and thus by analogy referred to the objects of the first two levels of interpretation—as "phenomena," an implicit contrast to the noumenal reality they manifest; these "phenomena" give the "impression" of more, "of an inner structure, to whose building up (*Aufbau*) intelligence, character, extraction and background have all contributed." Our friend approaches us as the culmination and unity of his own origin and history, which we may know or may not know, but which he in any case reveals "unwillingly" and "unknowingly." By his sheer presence our friend "gives away" much about himself, his world, and his traditions. Similarly, the specific synthesis and achievement of a work of art, Panofsky wrote, is the "unwilled and unconscious self-revelation of a fundamental relation to the world of the individual artist, the individual epoch, the individual people, the individual culture in equal measure." The greatness of a work of art, he added, depends upon the degree to which matter has been informed by the "energy of a world-view," and in these terms a still-life by Cezanne is not only as "good" (in quotation marks) as a Madonna by Raphael, it is also just as full of content.[29] Panofsky summarized his remarks in the words of a "clever American." Like a work of art, which seems to show the character of its maker and the character of the world from which it came, our friend "only knows what he parades, but not what he betrays."[30]

The "clever American" is Charles Sanders Peirce, whose words Panofsky perhaps remembered from an essay he cited by his friend and student Edgar Wind. Wind argued that whatever objections may be made to the new psychology of the unconscious, it is clear that the interpretation of historical documents requires a far more complex psychology than had been used by interpreters such as Dilthey. "Peirce wrote in a draft of a psychology of ideas: it is the belief men *betray,* and not that which they *parade,* which has to be studied."[31] The key word here is "belief," the assumptions and attitudes indicated by actions. Panofsky understood the whole set and system of such usually implicit principles of behavior as equivalent to "world-view," and he emphasized that world-views are unconscious. What might he have meant by that? He probably intended, as Wind suggested, to refer to the psychoanalytic unconscious; but he also meant to incorporate his version of Riegl's *Kunstwollen* at this level, having adapted it in such a way that it entailed historical affiliation.[32] There are several at least non-intentional factors in his own earlier discussion. To begin, the Kantian representation of the world as spatio-temporal, fundamental as an analogy to his discussion of style, simply and necessarily implied a world-view, or world-intuition, and characterization of specific modes of spatial representation would thus have been integral to the final interpretation. The "expressional" character of images is the consequence of habit and even instinct. At broader levels of style, most artists take their places in more or less long and broad traditions whose histories they may not know or care to know, which they change circumstantially and incrementally, just as artists—until they had iconography to read—were mostly unaware of the histories of the types they repeated, varied, and adapted.

World-views become manifest in works of art together with the historical and imaginative reconstruction of the context of artistic choice; and, just as importantly, we must remember that, according to Panofsky, the subjective beginning of the third level of interpretation is *our own* world-view, those "beliefs," to keep to Peirce's formula, that we ourselves betray, even in the act of interpretation (and perhaps *especially* in the act of in-

terpretation). To have "beliefs" means to act as if certain things were true, and these mostly implicit and unconscious principles, habits, and assumptions make up *our* world-view. This is our essence, an implicit rather than explicit "philosophy" which, precisely because it is also largely unconscious, is the most obdurate level of subjectivity. The final "objective corrective" that checks the tendency to the "violent" imposition of world-view is, Panofsky argued, "the universal history of the spirit." Here I believe it is necessary to plead that the fogginess of the available philosophical language obscures Panofsky's meaning. When we infer principles from actions, or from the results of actions, from works of art, then, Panofsky says, the interpretation of art begins to be like the interpretation of philosophical systems or religious doctrines. We may consider the general example offered by Panofsky's *Tomb Sculpture.* From the mere archaeological fact of burial we infer belief in an afterlife, an important inference no matter how we might understand the meaning of the word "spirit." This principle is easily extended, and if much of the history of art consists of responses to the universal fact of death, so beliefs about how the dead should be placed in relation to what is also believed to be the order of things may be inferred from burial practices and monuments. Traditions of such practices and monuments—and of the attitudes they betray—are culturally specific and, like style and iconography, place works historically. And as these fundamental human possibilities become definite to us, our own world-view becomes clearer at the same time that it takes its place among these possibilities. It is also at this level, Panofsky believed, that the history of art becomes interdisciplinary.

In order to address a work of art at this final level, we must retrace our steps, carefully noting, Panofsky says, "the disposition of lights and darks, the modelling of surfaces, even the way in which the hand of the artist has guided the brush, chisel or burin," not with an eye to locating the work in a style, but, having made this lo-

cation, with an eye to the articulation of what these specific qualities betray. Panofsky is most emphatic in stating that content or essential meaning is only to be found in the work itself and cannot be reduced to any other kind of meaning. Literary sources of the kind that help us in iconography are useless, and even if Dürer had left a text explaining his *Melencolia I,* it would not reveal essential meaning, rather the text itself would simply have to be interpreted. Texts contemporary with a work of art may reveal or state world-views parallel to the one we find in the work, but text and work can never just be equivalent.[33]

As an example of what I think Panofsky means we may consider his essay on "The Neoplatonic Movement and Michelangelo," the last chapter in *Studies in Iconology,* based, however, on work Panofsky had done over a period of some twenty years.[34] After an incomparably sure and incisive description of Michelangelo's art, Panofsky concludes that "the internal conflict of forces mutually stimulating and paralyzing one another" betrays an instinctive lover of stone, a misanthrope, a repressed homosexual, and, as he even suggests in a footnote, a possible agorophobic.[35] These propensities found their cultural expression in Neoplatonism. It was in Neoplatonism that Michelangelo found, Panofsky argued, "an interpretation of life as an unreal, derivative and tormenting mode of existence comparable to a life in Hades." "For this reason he was the only artist of the Renaissance who adopted Neoplatonism not in certain aspects but in its entirety, and not as a convincing philosophical system, let alone as the fashion of the day, but as a metaphysical justification of his own self."[36] Whether or not his inclinations were allowed to determine the programs of great ecclesiastical and dynastic monuments, as Panofsky went on to argue, Michelangelo certainly wrote poems and made drawings on Neoplatonic themes as no one else did. Thus, although representative of the period in which he lived, Michelangelo stands alone in the structure of *Studies in Iconology* itself, and his

world-view is juxtaposed to that of his elder Florentine contemporary, the materialist Piero di Cosimo, and to the optimistic Neoplatonic world-view evident in some, but not all, of Titian's paintings.[37] World-views are not totalizing.

As a final summary of the cycle I have outlined we may consider another of Panofsky's examples, Dürer's *Melencolia I*. As modern viewers used to looking at late Romantic expressionism, our subjective starting point might be the understanding of the engraving as an expression of *Weltschmerz*, of an extreme metaphysical pessimism. How, he asks, returning to his dialogue with Heidegger, might the history of art provide limits for that first interpretation? The interpretation of the *Melencolia I* was a sustained discussion to which Karl Giehlow and Aby Warburg—to name the most important scholars—had contributed before Panofsky and Fritz Saxl offered the version I am outlining.[38] Iconographic study had established that Dürer fused two types to make his image, the types of *acedia* (the allegorical representation of the sin of sloth) and of *Geometria* (an allegorical figure surrounded by the tools of the arts using measure). The choice to join these minor and unrelated types—much less to join them in a self-consciously great and memorable image, was not predictable, nor was it a mere permutational coupling of signs. In order to account for this conjunction, which only seems obvious in retrospect, we must read texts of a different kind from those that help us in iconography, texts that treat broader principles. When we do that, we find the very word "melancholia" depends upon the revival of classical learning in the late Middle Ages. We find that the then physiology and psychology of melancholy was joined to astrology, to the survival of the pagan gods, and to the influence of the planet Saturn, that Renaissance Neoplatonists coupled this dark psychology with the ancient idea of poetic furor, so that it came to articulate part of the modern notion of genius. Dürer was thus commenting upon art and artist—upon his own plight—when he imagined this grand brooding figure. Medieval Christian sloth has become neoclassical melancholy, still retaining the tincture of sin; it is the condition of great imagination, in which there is, however, Panofsky argued, a deeper melancholy, for it is only able to imagine the imaginable, the physical and the measurable, not the metaphysical. At this point the circle of interpretation closes and returns to the naive modern apprehension of *Weltschmerz*. In imagining his own plight, Dürer has imagined a new world historical plight, which is still our own. In fusing and magnifying these two types, and in giving them the gloomy, comet-lighted expressional quality they have, Dürer has brought to apparent life for the first time a kind of mortal suffering and has also made it possible for the first time to feel the effects of a new spiritual dilemma. We were not wrong, therefore, in sensing *Weltschmerz*; on the contrary our understanding of the modern situation—the characteristically modern world-view that makes this such a fascinating image—as it was fascinating to Warburg and Panofsky, and as melancholy has continued to be a leitmotif of the psychology of the modern to the present day—has been greatly enlarged and deepened by the historical interpretation of the content of Dürer's engraving.

I wish to close by raising a few more general issues. Panofsky's philosophical background was primarily Neo-Kantian, and the name of Kant could have come up even more often than it has in this short paper. Of all the fractious variants of Neo-Kantianism available to him,[39] the dominant influence was certainly that of Ernst Cassirer, as I have already noted (although it should be just as evident that Panofsky used Cassirer's arguments critically, shaping them together with the arguments of other writers to his own purposes). According to Cassirer, "the fundamental principle of critical [that is, Neo-Kantian] thinking" is "the principle of the primacy of function over the object," and the true critique of reason is therefore the critique of culture.[40] When Cassirer wrote that art, religion, and philosophy are like cognition he did not mean—as many seem to persist

in understanding both him and Panofsky to have meant—that art is "rational," rather he meant that cognition is itself a shaping force. The paradigm for the idea of symbolic forms, according to Cassirer himself, was provided by Heinrich Hertz, who wrote of scientific hypotheses as "inner fictions or symbols . . . so constituted that the necessary logical consequences of the images are always images of the necessary natural consequences of the imaged objects."[41] "It lies in the very nature of consciousness," Cassirer wrote, "that it cannot posit any content without, by this simple act, positing a complex of other contents."[42] Meaning must be approached through meaning; history itself is a symbolic form, a positive construction that allows the distant in space and time to be addressed. As Cassirer observed, symbolic forms are perspectives.[43]

Panofsky followed Wilhelm Dilthey, as did many others, in distinguishing between the natural sciences and the humanistic disciplines.[44] He departed from Dilthey, however, as did Cassirer, in considering both the natural sciences and the humanities to be fundamentally alike in that their investigative procedures are at base hermeneutic. So far I have avoided the term "hermeneutic" because Panofsky himself avoided it, even though hermeneutics was clearly central to his historical thought and practice.[45] When discussing this matter Panofsky always deferred to the arguments of Edgar Wind, who held that modern science had come around to principles that had been given their classic statement in philology, in the hermeneutics of Schleiermacher and Boekh.[46] The circle of interpretation, Panofsky agreed with Wind in arguing, is not vicious but methodical, and simply describes the conditions under which we do both science and history. Panofsky illustrated the precariousness of the intellectual enterprise with what he called the "good old joke about the tightrope walker." "Papa, why doesn't the tightrope walker fall? Because he is holding onto the bar! But why doesn't the bar fall? Silly child! Because he is holding onto it with all his might!"[47]

Panofsky devoted his life to the study of Western art, and his art history continued to be, in the classical manner, a rhetoric of praise for those individuals who made art and made it possible—for Albrecht Dürer, Michelangelo Buonarroti, Jan van Eyck, Abbot Suger. But if he insisted upon high philological standards for the study of Western art, meaning in the visual arts, as he understood it, is in principle universalizable, altogether inclusive and cosmopolitan, as in fact his methods have been adapted to the study of many traditions. Panofsky changed both style and iconography from the plotting of diachronic series into preliminary methods for establishing the historical context of works of art, thus allowing synchronic explanations to be brought to bear upon art historical change. In Panofsky's scheme, as we have seen, "context" is defined by what he called his "objective correctives." Once this general principle of context had been established, it could be extended and refined— as in fact it has been extended and refined— by considerations of patronage and program, genre, rhetoric, and format, and by the investigation of the "techniques of the observer,"[48] the coordinate history of the construction of spaces and times of use implied by art objects themselves. As such definition proceeds, it is perhaps less and less necessary to have recourse to idealist hypotheses like "world-view." That would only be true, however, if "context" itself were not an imaginative construction on our part, and if it were not still both inevitable and necessary, as Panofsky believed it was, that we address the work of art in the present precisely when we have located it as best we can in the past.

I wish to return one final time to Panofsky and Ernst Cassirer. Before he was the philosopher of symbolic forms, Cassirer was a philosopher of science, who published his *Substance and Function* in 1910. In 1921, he published a long supplement to this book on Einstein's theory of relativity (commented upon before publication, it may be noted, by Einstein himself).[49] He wrote this supplement, he said, because he realized

that the ideas of space and time he had assumed in 1910 could no longer be taken as given. With the theory of relativity, Cassirer wrote, the history of science, and the Western imagination insofar as it was articulated by scientific concepts, had passed into a new third era, in which the mechanical view of the world would be replaced by what he called the electrodynamic view.[50] Panofsky took up Cassirer's intellectual historical scheme for the premodern world, which coincided in fundamental respects with Riegl's great movement from objective to subjective vision, when he wrote his *Perspective as Symbolic Form,* published in 1925.[51] Panofsky was thus in a position to look back at the modern tradition of representation that began with Renaissance perspective, to see it precisely as a "symbolic form," a great and implicative construction of the Western imagination, the emblem of a historical world-view, which had risen from complex and ancient historical roots, shaped the modern world and yielded to another world-view in its turn. I have always read *Perspective as Symbolic Form* as filled with nostalgia not for the Renaissance but for classical antiquity, as if in 1925 Panofsky hoped that the technological world based upon the predictability and control of treating nature as if it were essentially isometric might give way under the pressure of the idea of relativity to a new world of places, more fitted to human vision, not reducible to a single quantitative principle. But the real point of this example is to show how deeply Panofsky was willing to cast and recast his historical imagination. As Cassirer wrote, the purpose of the critical philosophy "was not to ground philosophical knowledge once for all in a fixed dogmatic system of concepts, but to open up for it the 'continuous development of a science' in which there can be only relative, not absolute, stopping points."[52]

If Panofsky was close to Cassirer in some basic respects, however, he was also a deeply different sensibility, an art historian, not an intellectual historian and philosopher. Panofsky might have agreed with Dilthey that the Marburg Neo-

Kantians were too concerned with intellect, too little with feeling,[53] except that, as we have seen, he also recast "feeling" as cultural and historical. Panofsky did not see history as the progressive realization of conceptual unity, and his Kantian formal categories were antinomous hypotheses that allowed the art historian to explore a terrain finally shaped by the complexities of human choice and motivation. The Renaissance invention of one-point perspective was not the victory of Western reason and science, rather it represented the crystallization of new polarities of subject and object, new possibilities for choice, interest, and conflict, from mannerism to modernism, to mention only the history of art. It was a concentrated symbol of those same modern paradoxes Panofsky saw embodied in Dürer's *Melencolia I.*

For Panofsky, all our representations and constructions were historical, beginning with the most fundamental categories of imagination itself. Styles, types, and artistic canons are historical.[54] Panofsky often associated perspective with modern historical consciousness which, I have argued, does not just objectify the past but instead respects it and, precisely in respecting the past, transforms itself.[55] The usual reactions to a thoroughgoing historicism seem to be cynicism and pessimism because it is felt that historicism entails the "relativity" not only of tastes, but of values and mores. But there has also been a more optimistic view, according to which the modern historical sense is not a sign of cultural "crisis" and decline, but rather a major legacy of the Enlightenment.[56] Free of the compulsions based on age-old certainties that our tastes, values, and mores are absolute, and free from the conviction that our having them therefore absolutely distinguishes us from others, it might be thought possible to proceed—not obviously without great difficulty—to the realization of a more universally desirable culture of cultures, a project in which the history of art might play a central role. Traditions of art, and the continual life of these traditions in interpretation, have their

own histories, each heavy with the human gravity and meaning Panofsky unwaveringly believed them to have. In being a historicist in this sense, Panofsky was once again fully and finally in the tradition of Kant, for whom the aesthetic—whose particularity Panofsky understood to be properly cultural and historical—might form the basis for a new cosmopolitanism. In 1933 this project for history—and for the history of art—was ruptured in a terrible upsurgence of precisely those racial and regional centrisms whose destructive energies are still very far from spent.

If for Panofsky the natural sciences and the humanities were both hermeneutic endeavors, the aim of science, he wrote, "would seem to be something like mastery, that of the humanities something like wisdom."[57] It is through history that we understand our own historicity and thus confront so many human possibilities. This is the historicist version of the ideal of the examined life. If it is because of our histories that we think and act as we do in the present, it is also partly because of our knowledge of history that we may act *differently* in the present. The space Panofsky opened for what came to be called "iconology" was not so much the inauguration of an art historical "method" as it was an attempt to establish the discussion of the manifold meanings of the visual arts within the study of human culture. Such discussion has its own rigor and consequences for method, but this should not allow the general heuristic and pedagogical project to be lost to sight in the academic art history to which Panofsky's work has been so fundamental. "Iconology"—especially in its first formulation—was centrally concerned with the question of the uses of the past. On the one hand, he rejected the everyday forgetful blending of past and present and, on the other hand, he rejected the conscious, posthistoricist Nietzschean *Vergessenheit* that has exerted so powerful an attraction in the twentieth century. If we *do and must* live in constant and inevitable continuity with the past, how do we best do that? How, to paraphrase the inscription of Titian's *Allegory of*

Prudence, itself a recurrent object of Panofsky's iconological attention, do we act out of the past in the present in such a way as to enhance the future?[58]

Notes

1. Erwin Panofsky, "Zum Problem der Beschreibung und Inhaltsdeutung von Werken der bildenden Kunst," *Logos* 21 (1932): 103–19; I have used Erwin Panofsky, *Aufsätze zu Grundfragen der Kunstwissenschaft*, ed. Hariolf Oberer and Egon Verheyen (Berlin, 1980), 85–97.

2. Erwin Panofsky, *Studies in Iconology. Humanistic Themes in the Art of the Renaissance* (New York-Hagerstown-San Francisco-London, 1962), preface. Panofsky stressed the collaborative nature of his work, acknowledging his debt to Saxl and Aby Warburg. The article co-authored with Saxl is "Classical Mythology in Medieval Art," *Metropolitan Museum Studies* 4, 2 (1933): 228–80. A pithy and incisive account of Panofsky's essay and its immediate scholarly surroundings is given by Carlo Ginzburg, "From Aby Warburg to E. H. Gombrich: A Problem of Method," in *Clues, Myths and Historical Method*, tr. John and Anne C. Tedeschi (Baltimore, 1989), 17–59.

3. Erwin Panofsky, *Meaning in the Visual Arts. Papers in and on Art History* (Garden City, 1955), 26–54.

4. *The Meaning of the Humanities. Five Essays by Ralph Barton Perry, Augustus Charles Krey, Erwin Panofsky, Robert Lowry Calhoun, Gilbert Chinard*, ed. T. M. Greene (Princeton-London, 1940), 91–118.

5. Erwin Panofsky, "Three Decades of Art History in the United States. Impressions of a Transplanted European," in *Meaning in the Visual Arts*, 321–46.

6. In this essay Panofsky incorporated arguments and conclusions from his earlier theoretical writings and, as always, had accommodated new arguments, for example those of Jacques Maritain, "Sign and Symbol," *Journal of the Warburg and Courtauld Institutes* 1 (1937): 1–11. (Obviously this was the first article in the first number of the new journal.) Panofsky also found congenial intellectual surroundings in Princeton and adopted the term "organic situation" for his version of "hermeneutic" from T. M. Greene, editor of *The Meaning of the Humanities*. I cannot agree with the conclusions of Horst Bredekamp ("Götterdämmerung des Neuplatonismus," in *Die Lesbarkeit der Kunst. Zur Geistes-Gegenwart der Ikonologie* [Berlin, 1992], 75–83) that Panofsky's defense in this essay of the study of "Plato and other philosophers," written against an advocate of Stalin's dismissal of non-Marxist university professors in 1937, just four years after Panofsky's own dismissal by Hitler, amounts to a specific ideological commitment to Platonism as a hedge against

totalitarianism. One need not be a Platonist to study Plato, or the influence of Plato, and Panofsky surely meant that a humanist scholar might, like Lorenzo Valla, at any time show that a contemporary equivalent of the Donation of Constantine is a forgery; more generally, he meant that the study of the past, "free" in the sense that its responsibility is to inference from evidence (which Panofsky believed was problematic but possible) and not to political principles or purposes, might at any time yield alternatives to prevailing political principles and purposes, a possibility unattractive to both Hitler and Stalin (and to many more besides.) The pervasiveness of Neoplatonic interpretation in Renaissance studies so amply shown by Bredekamp is the result of *Zeitgeist* thinking as crude as the application of iconographic method by many of Panofsky's followers and need not be attributed to Panofsky himself. However complex the ideology of Renaissance art may prove to be, Neoplatonism was part of it. An excellent account of Panofsky's reaction to Cassirer's essay of 1924 on the problem of the beautiful in Plato's dialogues is provided by Silvia Ferretti, *Cassirer, Panofsky and Warburg,* tr. Richard Price (New Haven and London, 1989), 142–77.

7. See Georg Brühl, *Die Cassirers, Streiter für den Impressionismus* (Leipzig, 1991); in addition on Cassirer and Panofsky, see Michael Ann Holly, *Panofsky and the Foundations of Art History* (Ithaca and London, 1984), 114–57.

8. Martin Heidegger, *Kant and the Problem of Metaphysics,* tr. J. S. Churchill (Bloomington, 1962), 206–7. Heidegger quotes Kant (see, for example, *Immanuel Kant's Critique of Pure Reason,* tr. N. K. Smith [London, 1963], 310: "it is by no means unusual . . . to find that we understand [an author] better than he understands himself"). These remarks were also to be cited with approval by Ernst Cassirer (*An Essay on Man. An Introduction to a Philosophy of Human Culture* [New Haven and London, 1944], 180) in a chapter that seems to me to be close to Panofsky. Heidegger's precedent, however, is not only Kant but Nietzsche, who was to become more and more important for Heidegger. Nietzsche applies this exegetical principle with a reductiveness and generality that Kant could not have imagined. See Friedrich Nietzsche, *Beyond Good and Evil,* tr. Marianne Cowan (Chicago, 1955), 15–16, and 25–26, where it is argued that the "laws of nature" are the result of bad philology, "only a naive, humanitarian arrangement and misinterpretation . . . for truckling to the democratic instincts of the modern soul."

9. Ernst Cassirer, "Kant und das Problem der Metaphysik. Bemerkungen zu Martin Heidegger's Kant-Interpretation," *Kant-Studien* 36, 1–2 (1931): 17–18. A concise statement of the point at issue is to be found in "A Discussion between Ernst Cassirer and Martin Heidegger," the record of an encounter that took place in March, 1929; see *The Existentialist Tradition, Selected Writings,* ed. Nino Langiulli (Garden City, 1971), 192–203.

10. For the "intelligible substratum of humanity," see Immanuel Kant, *Critique of Judgment,* section 57 (*The Philosophy*

of *Kant. Immanuel Kant's Moral and Political Writings,* ed. Carl J. Friedrich [New York, 1949], 305–7). Kant is summarizing, arguing that the judgment of taste is universal not in that it can be related to a concept (of beauty, for example) but rather in that it points to a transcendental concept arising from "the general ground of the subjective appropriateness of nature for the power of judgment." The fit between the sensation of some things and our faculties manifested in the judgment of taste in itself suggests purpose and compels us "to seek in the supersensible the point of union of all our faculties *a priori:* for we are left with no other expedient to bring reason into harmony with itself." This is the "supersensible substratum of humanity" and it is not hard to see why Cassirer felt it necessary to defend.

11. For Heidegger's remarks on philosophical anthropology, see his letter to the Rector of Freiburg of 1945 (*The Heidegger Controversy. A Critical Reader,* ed. Richard Wolin [Cambridge, Mass.-London, 1993], 65). As I understand him, Heidegger opposed the definition of "man" by the ongoing description and study of human culture in favor of the explication of human "being-in-the-world," for which (or whom) "being" itself is an issue; nor could both kinds of study lead to the same destination ("A Discussion between Cassirer and Heidegger," 199–200). Heidegger regarded anthropology— or philosophical anthropology—to be merely another instance of Western metaphysics, which had both triumphed and rendered itself philosophically superfluous through the triumph of technological rationalism. Authentic Dasein, set apart from the metaphysical in this sense, seems to me to have involved notions of rootedness in the land, very much opposed to the cosmopolitanism for which both philosophical anthropology and historicism might be viewed as major justifications.

12. Panofsky, *Aufsätze,* 92.

13. Martin Heidegger, *Being and Time,* tr. John Macquarrie and Edward Robinson (New York and Evanston, 1962), 445.

14. In his last footnote (*Aufsätze,* 97), Panofsky entertains the possibility of procedures independent of historical "correctives," in which the effort is not made to place the work under investigation in its historical interdependencies. This, he says, is not interpretation at all but rather "freely creative reconstruction," to be measured not against the criterion of "historical truth" (*Wahrheit*) but against the criterion of originality and cogency relative to the point of view from which it is undertaken. It is, he says, unexceptionable as long as it is recognized as "suprahistorical" or "extrahistorical," but should be resisted when it makes claims as history. Panofsky is arguing that we can and do make a great number of historical inferences from what is evident in objects from the past, that such inferences are the peculiar concern of history, and clearly wished to separate such "methodological" problems from the problems of more global interpretation. This position strongly implies that both historical inferences and methods—and the discussion of historical inferences and

methods—constitute a common ground not simply reducible to the principles of any kind of global interpretation.

15. Panofsky, *Aufsätze*, 92–93.

16. For Panofsky's first version of the tripartite synoptic table showing these levels of meaning, repeated with variations in both later versions, see *Aufsätze*, 95. Panofsky wrote of his table as follows: "Certainly such a scheme—which bears no more relation to the actual negotiation of an intellectual process than a geographic grid map bears to the reality of the Italian landscape—is always in danger of being mistaken for 'lifeless rationalism.' And therefore it is finally necessary to emphasize the altogether obvious: those procedures that in our analysis have had to be represented as three separate movements at three separate levels, and also have had to be represented as a border skirmish between subjective habits of violence and objective historicity, are in practice woven into a unified total event, expanding organically, now with tension, now with resolution, that only *ex post* and theoretically may be separated into single elements and actions."

17. Erwin Panofsky, *Hercules am Scheidewege und andere antike Bildstoffe in der neueren Kunst* (Leipzig-Berlin, 1930), viii.

18. The exception would seem to be "The History of Art as a Humanistic Discipline." Here, however, Panofsky discusses the problem of signification—that we only understand from the works of past cultures that they *had* a meaning, and not the meaning itself—and the hermeneutic problem of the reconstruction of the "cosmos of culture," before defining the work of art as a "man-made object that demands to be experienced aesthetically" (*Meaning in the Visual Arts*, 10–14). He argues that anything can be regarded aesthetically by "just looking at it," but also makes a very telescoped phenomenological argument according to which certain objects "intend" to be addressed aesthetically, that is, are rightly intuited as demanding a certain kind of further consideration. This argument quickly becomes involved in the question of whether or not the makers of works of art intended them to "have" such intentions, a question Panofsky avoids. On balance, works of art belong to much larger patterns of cultural signification, and a balance of form and content makes the "eloquent" vehicles of "content," that is, of iconological meaning, which he defines in a close variant of the ideas discussed here.

19. Panofsky, *Aufsätze*, 85.

20. See Erwin Panofsky, "Über das Verhältnis der Kunstgeschichte zur Kunsttheorie. Ein Beitrag zu der Erörterung über die Möglichkeit 'Kunstwissenschaftliche Grundbegriffe,'" in *Aufsätze*, 49–75. The present essay uses the example of Grünewald's *Resurrection* to argue, as Panofsky had since his essay on Wölfflin of 1915, that we cannot describe paintings without interpreting the "formal," that we see not only objects but definite spatial configurations in the "purely visual."

21. See *Degenerate Art: the Fate of the Avant-Garde in Nazi*

Germany, ed. Stephanie Barron (New York, 1991), 294, fig. 293, and 62. The painting was removed from display in 1936. Paul Schultze-Naumburg, the successor of Walter Gropius after his dismissal from the Bauhaus, had written his *Kunst und Rasse* in 1928, comparing photographs of physical deformities and mental patients to images by modern artists; he especially condemned expressionism, which, however, as a German movement, had enjoyed some favor in the early years of Nazi rule (Ibid., 12 and passim).

22. Panofsky, *Aufsätze*, 89–90.

23. Panofsky distinguished between universal time (or chronology) and historical time in terms that clearly foreshadow George Kubler (*The Shape of Time. Remarks on the History of Things* [New Haven and London, 1962]), the difference between the two being in what is comprised by the series that define "historical time." See Erwin Panofsky, "Über die Reihenfolge der vier Meister von Reims (Appendix)," *Jahrbuch für Kunstwissenschaft* 29 (1927): 77ff., and *Aufsätze*, 77–83. Panofsky condensed these arguments in "The History of Art as a Humanistic Discipline" (*Meaning in the Visual Arts*, 7) as part of his explicitly relativistic project of defining a "cosmos of culture." In the original essay Panofsky acknowledged Georg Simmel, but his remarks should also be read in relation to Ernst Cassirer's commentary on relativity (*Substance and Function and Einstein's Theory of Relativity* [Chicago, 1923], 347–456.) I have argued ("'Form,' Nineteenth-Century Metaphysics and the Problem of Art Historical Description," *Critical Inquiry* 15 [1989]: 372–406) that the general notion of "shapes of time" permits seriation without totalization, placing the principle of unity not in history itself but in the critical synthesis of the historian, who, in addition to defining series—or defending definitions of series—must attempt to explain the convergence of series in particular works.

24. Panofsky, *Aufsätze*, 87.

25. Ibid.

26. E. H. Gombrich, *Aby Warburg. An Intellectual Biography, with a Memoir on the History of the Library by F. Saxl* (Chicago, 1986), 273.

27. Gustav Pauli was not only Panofsky's friend but his patron and supporter at Hamburg University. I am very grateful to Horst Bredekamp for sending me a typescript of his article "Ex Nihilo: Panofsky's Habilitation," forthcoming in the *Akten des Erwin Panofsky-Symposiums* (Berlin, 1993), which details this friendship. Bredekamp cites Panofsky's praise of Pauli as an example of the "most German Germany," representative of the deeply progressive currents of Weimar culture with which Panofsky identified. Panofsky can only have remembered Pauli when, in the midst of the McCarthy era, he spoke out in defense of academic freedom, against "persecuting the museum director who exhibits pictures deviating from the standards of Congressman Dondero." (*Meaning in the Visual Arts*, 345.) See also Colin Eisler, "Kunstgeschichte American Style," *The Intellectual Migration. Europe and America, 1930–1950* (Cambridge, Mass., 1969), 544–629.

28. Panofsky, *Aufsätze*, 93; see Joan Hart, "Erwin Panofsky and Karl Mannheim: A Dialogue on Interpretation," *Critical Inquiry* 19 (spring 1993): 534–66; and Karl Mannheim, "Beiträge zur Theorie der Weltanschauungs-Interpretation," *Jahrbuch für Kunstgeschichte* 1 (1921–22): 236–74; and Karl Mannheim, *Essays on the Sociology of Knowledge*, ed. Paul Kecskemeti (New York, 1952), 33–83.

29. Panofsky, *Aufsätze*, 93.

30. Ibid., 94.

31. Panofsky often referred to Wind's work and several times cited this distinction of Peirce's. As a digest of Wind's arguments see Edgar Wind, "Some Points of Contact between History and Natural Science," in *Philosophy and History. Essays presented to Ernst Cassirer*, ed. Raymond Klibansky and H. J. Paton (New York, 1963), 255–64. Peirce is discussed on page 258. The reference is to "Issues of Pragmaticism," *Collected Papers of Charles Sanders Peirce*, ed. Charles Harteshorne and Paul Weiss (Cambridge, Mass., 1934), 5: 297.

32. A good example of such adaptation is the essay on "The History of the Theory of Human Proportions as a Reflection of the History of Styles" (*Meaning in the Visual Arts*, 55–107.) This was first published in 1921 (see Panofsky, *Aufsätze*, 169–204) and must itself have been written as a historical *Abbild* of "Der Begriff des Kunstwollens" (*Aufsätze*, 29–43), published in 1920 (in English, see "The Concept of Artistic Volition," tr. Kenneth J. Northcott and Joel Snyder, *Critical Inquiry* 8 [1981]: 17–33). Panofsky's point in this article is, first, that systems of proportion are culturally specific much in the way that "styles" are, and, second, that unlike the more "intuitive" results of "formal analysis," proportions may be explained—and art significantly interpreted historically—in relation to other cultural forms, in relation both to technique and to larger social and political purpose. Panofsky attributed the reluctance to consider such issues to "the Romantic viewpoint that a work of art is something utterly irrational" (a Romanticism that has been steadily extended to the position that interpretation is also something utterly irrational). In any case, Panofsky argued that "the theory of proportions expresses the frequently perplexing concept of *Kunstwollen* in clearer or, at least, more definable fashion than art itself."

33. Panofsky, *Aufsätze*, 93–94.

34. Panofsky, *Studies in Iconology*, 171–230. Panofsky's *Habilitationsschrift* was adapted to this article, as shown by H. Bredekamp, see note 27 above.

35. Panofsky, *Studies in Iconology*, 178.

36. Ibid.

37. "As Piero di Cosimo might be called the only genuine Epicurean among the many artists influenced by Lucretius, Michelangelo might be called the only genuine Platonic among the many artists influenced by Neoplatonism." The Michelangelo essay comes to a most pessimistic conclusion. Michelangelo reconciled the conflict of classical and Christian values only through capitulation; a second reconciliation was achieved by modern subjectivism, which, however, progressively dissolved both classical and Christian values, a terse commentary on a world plunging into total war.

38. Panofsky cites this example in the essay under consideration (*Aufsätze*, 94–95), and I have supplemented this general argument using Erwin Panofsky, *The Life and Art of Albrecht Dürer* (Princeton, 1955), 157–71. See Erwin Panofsky and Fritz Saxl, *Dürers Kupferstich "Melencolia I"; Eine quellen- und typengeschichtliche Untersuchung*, Studien der Bibliothek Warburg, vol. 2 (Leipzig and Berlin, 1923).

39. Neo-Kantianism, rather than being a simple revival of Kant's philosophy or even an easily definable set of principles, had a complex history, responding to its social, political, and intellectual surroundings through the period of the formation of modern Germany to the rise of National Socialism. See Klaus Christian Köhnke, *The Rise of Neo-Kantianism. German Academic Philosophy between Idealism and Positivism*, tr. R. J. Hollingdale (Cambridge-New York-Port Chester-Melbourne-Sydney, 1991).

40. Ernst Cassirer, *The Philosophy of Symbolic Forms. Volume One. Language*, tr. Ralph Mannheim (New Haven and London, 1953), 79–80. Cassirer refers to his own *Einstein's Theory of Relativity Considered from the Epistemological Standpoint* of 1921, as in note 23 above.

41. Cassirer, *Philosophy of Symbolic Forms*, 75.

42. Ibid., 97.

43. Ernst Cassirer, "'Spirit' and 'Life' in Contemporary Philosophy," in *The Philosophy of Ernst Cassirer*, ed. Paul Arthur Schilpp (New York, 1949) 873–74. This essay was first published in 1930–31 as a critique of Max Scheler's *Die Stellung des Menschen in Kosmos* of 1928. Scheler argued for an opposition between "life" and "spirit," roughly an opposition of "unconscious" and "conscious" of a kind that has now become commonplace. Cassirer argued that Scheler perpetuated a pre-modern "realistic" metaphysics in reifying the poles of this opposition. Instead, he argued, "life" and "spirit" should be seen as a "purely functional antithesis," and we should be concerned with the "in between" realm of the "symbolic forms," that is, with the "many-sided image worlds" we interpose between ourselves and reality.

44. I have found extremely useful Rudolf A. Makkreel, *Dilthey. Philosopher of the Human Studies* (Princeton, 1975).

45. The term "hermeneutic" of course has a complex history, and Panofsky's position in the debate over its use and meaning should be located after Dilthey, in the vicinity of Husserl and Heidegger. As Friedrich Schleiermacher prophetically observed, "it is very difficult to assign general hermeneutics its proper place among the sciences" (*The Hermeneutic Reader. Texts of the German Tradition from the Enlightenment to the Present*, ed. Kurt Mueller-Vollmer [New York, 1988], 73) and Dilthey developed the principles of hermeneutics beyond textual exegesis in ways that were clearly crucial for Panofsky (although again it must be stressed that Panofsky used them critically, for his own purposes). See for

example the reflection on the Diltheyan category of *Erlebnis* in "The History of Art as a Humanistic Discipline" (*Meaning in the Visual Arts*, 14, n.11). Although the prestige of classical philology in Germany was very high, and Panofsky had a classical education, I do not see it necessary to accept the conclusion of Joan Hart ("Erwin Panofsky and Karl Mannheim," 559) that Panofsky saw the potential "cash value" of the "totalizing interpretive schema" of hermeneutics and acted accordingly. Heidegger—to take that example—had generalized hermeneutics in *Being and Time*, not perhaps because it was profitable to do so (although he too was successful) but because it was a useful philosophical method (the tendency of which, it might be noted, is not toward totalization). It might as easily be supposed that Panofsky avoided (not flaunted) the term "hermeneutic" precisely in order to distinguish his enterprise from a narrow association with classical philology.

46. Edgar Wind, "Some Points of Contact between History and the Natural Sciences," 262–63.

47. Panofsky, *Aufsätze*, 96.

48. I have used the term of Jonathan Crary, *Techniques of the Observer. On Vision and Modernity in the Nineteenth Century* (Cambridge, Mass.-London, 1991). Unlike "viewer" or "beholder," "observer" implies the culturally specific decorum and habits of use—as we say, "observing customs"—that give a very different dimension to "seeing" the "visual arts," whose visibility is always part of a sustaining social construction.

49. See note 23.

50. Cassirer, *Einstein's Theory of Relativity*, 353.

51. Erwin Panofsky, *Perspective as Symbolic Form*, tr. Christopher S. Wood (New York, 1991).

52. Cassirer, *Einstein's Theory of Relativity*, 355.

53. Ferretti, *Cassirer, Panofsky, and Warburg*, 182.

54. Panofsky was often criticized for using inferior works in art historical arguments. Scales of values, he responded in 1937 (*Meaning in the Visual Arts*, 18), arise from personal reactions and tradition. "Both these standards, of which the second is the comparatively more objective one [by which he means that it is comparatively more liable to historical study], have continually to be revised, and every investigation, however specialized, contributes to this process." It is, he argued, precisely in the uniform application of art historical methods to all the works of art of a tradition that some will emerge ahead of others.

55. See Wind, "Some Points of Contact," 263. "Every change of our ideas about our ancestors entails a change in our ideas about ourselves and will indirectly affect our behavior."

56. See Makkreel, *Dilthey*, 3–4.

57. *Meaning in the Visual Arts*, 25.

58. Erwin Panofsky, "Titian's 'Allegory of Prudence': a Postscript," in *Meaning in the Visual Arts*, 146–168. The research for this article, as Panofsky acknowledges, was first done with Fritz Saxl.

ANTHROPOLOGY

Introduction

SHELLY ERRINGTON

Not "meaning in the visual arts" but *things* that are used, inherited, circulated, and can be arranged in taxonomic series, have been, for the most part, the focus of archeologists' and anthropologists' attentions. We specialize in *objects*, not "art."

Of course, the same item can be treated as either object or art. For a moment let us use the framed image as a metaphor for all the things currently deemed to be, and studied as, art-objects. Art historians' traditional focus was the image inside the frame; they began by noticing form, color, line, and shape. Anthropologists and archeologists (to continue the conceit) avoided looking directly at the image, but instead looked behind and around it, or studied the materials of which it is composed. Archeologists, finding framed images layered in distinct temporal strata when they went on digs, classified them as falling into tri-partite epocal eras—The Age of Oil, the Age of Watercolor, and The Age of Acrylic. British Social Anthropologists studied how sitting on the framed image bolsters chiefly authority, and how the framed image has been used to validate land-tenure claims; they studied its circulation in restricted exchanges, how its display in ritual expresses the status of its owner, and how it emblematizes the solidarity of the clan. American Cultural Anthropologists sometimes looked directly at the image, seeing its style as a projection of the personality type formed in that particular "pattern of culture"; or they showed that individual artists' works could be discerned even within a single culture's "style" of decoration.

These approaches were current prior to about 1960. The story then becomes far more complex, partly because we are in the middle of any tales we choose to tell, and partly because, like the distinct and bounded cultures we used to believe were the subjects of our study, the knowledges we now produce about them (but who are *they*?) have blurred edges and wobbly centers in the global economy of words and images in which we all participate. To characterize "a discipline" requires the use of a certain poetic license.

One strand of a story about the relation between "Meaning and the Visual Arts" and the practice of anthropology would be to take "visual arts" for anthropologists to be the artifacts now classified as Primitive Art—or, to be more contemporary, "Arts of Africa, Oceania, and the Americas" (by the early 1990s, virtually all museums and university art departments were using the latter term). In the nineteenth century, of course, anthropologists studied the material culture of colonized peoples, not their "art." In the world of High Art, such objects were too far from the canon to enter the category of art, even at the fringes, and the category of *l'art primitif* was occupied by Japanese prints.

Objects made by colonized peoples were born as Art—or so the art dealers' and museum curators' story goes—with their "discovery" as such by Cubists in Paris at the turn of the century, who found masks and effigies in bars and flea markets, hung them on their walls, and claimed to be inspired by them; from then on, it was all (art) history. I would, myself, tell the story of the invention of Primitive Art between the two World Wars a little differently, for Primitive Art's "climb" up from the flea market into the museum did not

happen due to a sudden taxonomic shift that caused a giant leap; it was a gradual process that had to be validated and institutionalized. Here, in any case, it is worth noting at least that Picasso and his friends encountered quantities of l'art negre with which to become inspired in the "Troc" and the curio shops due to the extensive collections of artifacts of colonized peoples made in the second half of the nineteenth century and the first decades of the twentieth.

In those decades, the rage for collecting objects from the European colonies and from the American national frontiers accelerated compared to a century before (when the artifacts brought back by Captain Cook were of little interest to the British, but were snapped up by a German) due to two new venues for display and reasons to collect: state-sponsored public museums and world's fairs. These venues made the artifacts of colonized peoples available for inspection by the Euro-American public on an unprecedented scale. But, at least in the Anglophone world, where museum directors and the organizers of world's fairs formed an interlocking directorate whose theories and sensibilities were formed and informed by "scientific" racism, Social Darwinism, and a speculative account of "origins" that counted as scientific explanation, these artifacts remained material objects, material evidence of a stage in history, or, at best, evidence of the ingenuity of technologically unadvanced people's abilities to adapt to nature.

Nor did the Cubists' "discovery" change the dominant paradigm in this country's natural history museums. Even though European Modern Art dealers began promoting Primitive Art in the 1920s, even though Helen Gardner included it as "art" in her earliest art-history survey textbooks, and even though Franz Boas, the founder of American Anthropology, published a book called *Primitive Art* in 1927—nonetheless, Anglophone archeologists and anthropologists were slow to embrace such objects as "art."

For one thing, anthropologists (in this country) came to inhabit two distinct econiches after the turn of the century: the museum and the university. Many of the actual objects remained in Natural History museums, the bailiwick of museum anthropologists, who were largely still committed to collecting, classifying, and explaining "material culture." Even now, "museum anthropology," particularly in those museums dominated by archeologists, continues to be firmly object-oriented and "scientific" in its orientation.

Academic anthropologists, meanwhile, were moving away from the speculative study of objects from the armchair and inventing modern cultural/social anthropology, whose foundational and enabling practice is fieldwork. In our mythical charter (which does not exactly reflect the facts), it began more or less by accident when the anthropologist Bronislaw Malinowski was incarcerated on an island in the South Pacific during World War I; he made the best of the situation by learning the language and inquiring into the local customs, and the results of his "fieldwork" proved so enlightening that it became the standard practice for those who wish to know how other humans construe their worlds. "Participant-observation" remains our most distinct method (how clever of anthropologists to take the human condition, and call it a "method"!) or, at least, our most distinct practice.

Because doing "fieldwork" was becoming the standard method of anthropologists after Malinowski's invention, academic anthropologists spread throughout the colonized world between the two world wars, and they encountered all sorts of events and ideas and customs previously unsuspected from the armchair; and they encountered many objects, including decorated ritual objects of the sort that Nelson Rockefeller had begun to collect in the 1930s and had begun, with René d'Harnoncourt, to promote as "art" in four exhibits in the interwar period at the Museum of Modern Art. Some anthropologists even wrote about some of these objects as "art." But the dominant assumptions and interests in the United States and Britain mitigated

against anthropologists taking the objects very seriously as "visual arts" on which iconographic and iconological studies should be done.

British "Social Anthropologists" took their project to be Western sociology, and they made a study of roles and institutions, of land-tenure and inheritance rights, of kinship as the "backbone" of society. When they wrote of "art," as some did (notably Raymond Firth, who thought of almost everything decades before anyone else), they tended to see it in functionalist and functional terms—either as fulfilling psychological and practical needs of individuals, or as contributing to the harmonious "functioning" of "society," construed metaphorically (but they thought it was science) as a kind of bounded organism. The commentator who reads objects as having "functions" and understands their "meaning" in those terms is strongly disinclined to look at an object's designs, colors, and material. After all, if one thinks that the function of a totemic animal is to emblematize clan solidarity, the difference between a wombat and a rainbow is of merely superficial interest (or, as the British would say as a jab at their American colleagues, they are merely "cultural" differences, not structural ones, which alone count). Whether the design is cross-hatched or painted, applied to bark or to stone, and what the local associations of the color are —are all of even less interest. This theory of society and meaning almost precludes aesthetic analysis.

Social Anthropologists' blindness to images was compounded by a strong utilitarian streak in British thought which revealed itself in anthropologists of this school as a deep tendency to view the natives as practical, rational men who were sometimes deluded by superstition, but— within their admittedly irrational frames—operated politically by jockeying for position and pursuing political goals; these natives valued their totem animals because they were good to eat, and valued their other symbols because they expressed social solidarity—even if the natives were not themselves fully aware of these reasons.

"Cultural Anthropology" in the United States, meanwhile, was taking a rather different intellectual course. Franz Boas, who came to this country from Germany in the late nineteenth century, rejected the progressivist enthusiasms of the turn of the century (Social Darwinism, eugenics), and substituted a moral and cultural relativism and historicism as the basis of the discipline he was in effect founding. Influenced by German art historians of the nineteenth century (especially Alois Riegl, and Burckhardt through him) who were attentive to decoration and craft as serious forms of "art" and were keen on cultural pattern, Boas directed his attention to the ceremonial objects and basket designs of the peoples of the Northwest Coast of North America in his book *Primitive Art* (1927). But, in truth, Boas' interest in "primitive art" was not much taken up by his students. Being Americans, Boas' students tended to be interested in the "self," in personality, individuality and individuals. (I am relying on Tocqueville for my national stereotype here: "In no country of the world," he wrote, "are the precepts of Descartes less studied and more practiced than in America.") Between the two world wars, Boas' students, such as Mead and Benedict, developed the idea of "culture" as a "pattern" of meaning, or they concerned themselves with the different forms of "self" and "personality" in different societies. Even when they looked at "art," as Bunzel did among the Pueblo, they were likely to find evidence of personality and individuality. Whereas the Saussurian and Durkheimian French of the same era were ignoring the subject or regarding it as derivative of the social order, Americans tended to reify it as foundational and fundamental.

All of that, as I pointed out earlier, was more or less true prior to around 1960. I periodize it that way because between 1945 and 1962 most of Asia and Africa had suceeded in decolonizing itself, and the repercussions in the ways that European knowledge-producers were to think about the former colonies—by then emerging as the "third" world in the Cold War—were begin-

ning to be felt. The status and meaning of non-Western objects for anthropologists and art historians, as well as for the peoples who produce them, begins a different chapter whose narrative threads are now unfolding but whose end is not yet in sight.

To focus just on New York and Anglophone academica during this period, the category Primitive Art was officially institutionalized with the opening of the Museum of Primitive Art in mid-1957. Its core collection was Nelson Rockefeller's, and by 1982, the same core collection had its own wing in the Metropolitan Museum of Art—a sure sign of social and market success. During the three decades between the mid-1950s to the mid-1980s, the study of the objects/artifacts/arts of Oceania, Africa, and the Americas (both the pre-Columbian works of Meso-America and the artifacts produced in North America) became a topic for Ph.D. theses in departments of art history, and anthropologists, too, began to study "primitive art" as a serious subject. Part of the reason for its new-found interest to my discipline and to art historians, I believe, is due to the legitimacy and funding bestowed upon Primitive Art, due, both directly and indirectly, to its institutionalization.

It is also true that anthropological theory was changing radically with the advent of three thinkers who became influential in Anglophone anthropology in the 1960s and 1970s: Claude Lévi-Strauss, Victor Turner, and Clifford Geertz. In their profoundly different ways, their works made it legitimate to have an interest in "religion," thought, consciousness, and meaning, which British Social Anthropology had more or less dismissed and American Cultural Anthropology had more or less psychologized. Each in his own way put the West and the Rest in the same moral, religious, and intellectual universe. Each of them wrote about art. Lévi-Strauss found strangely similar patterns between designs of the art of the New Zealand Maori art and designs of the art from America's Northwest Coast, which could be explained (he hinted) only by the existence of

universal structures of thought; and he found asymmetric and lascivious tatoos used by the Caduveo to separate their own culture from nature. Victor Turner wrote about the "forest of symbols," each symbol having a sensory pole and an intellectual pole, and about the psycho-biological roots of the appeal of the colors black, red, and white; and he wrote meticulously detailed ethnography on how these symbols' meanings were built up in ritual practices. Clifford Geertz's view that humans are meaning-making animals who make a world of their own devising, materializing it in artifacts as well as in social organizations, buildings, and everything else, and who then "read" the world in order to tell themselves what kind of world they live in, led him to claim that "art and the ability to understand it are made in the same shop."

Each of them wrote about art, as I said, but none of them wrote about it very much. It was not at the center of their concerns. But those ideas changed the face of the discipline and made the study of "art" possible. By that I mean that some anthropologists learned to look at the designs (and colors, techniques, textures, shapes) of the artifacts in front of them, as well as to study how the object was used in ceremony, validated authority, circulated in exchange, etc., and to relate the two, to create textured and illuminating accounts of formal pattern in relation to meanings accreted in contexts of use and informed by deep cosmologies. At the same time, as art historians studying African and other arts began doing fieldwork, they began to see the meanings of certain "arts" as activated by performance; they broadened their ideas about "art" to include architecture "performed" by its place in the life-cycle; as they began studying pre-Columbian hieroglyphics aesthetically, they made stunning discoveries about meaning, discoveries that decades of speculations made with utilitarian and positivist assumptions had not revealed. To go back to my initial use of the framed image as a metaphor for all art-objects: art historians whose specialty lies

in looking at what is within the frame, began to look behind it and around it and at how it was used; anthropologists, whose specialty is how the object is used, exchanged, inherited, etc., began actually looking at the image within the frame.

Illuminating work in this tradition, which is sometimes awkwardly called "ethno-aesthetics," still is being done in the 1990s, although now, of course, it includes the issue of the "frame" and the relations between local-global production of culture far more than the work of the mid-1960s did. The truth is, our intellectual apparatus is far stronger for dealing with *things* than with visual meaning (although we do borrow enthusiastically from disciplines who know better than we how to read an image, when it suits us), and we continue our object-orientation in the 1980s and 1990s with new twists. As of around 1980 (Said's *Orientalism* came out in 1979, Foucault was becoming popular, and Hayden White's views on the relations between mimesis and narrative were beginning to have an effect), anthropologists turned their glance firmly away from both the image inside the frame (to continue using the painting to signify all art-objects) and from the uses of the object as a whole, and fixed their gaze steadily upon the *frame*. Lately, we are trying to say something beyond who framed it and why, or the frame as colonial or national imposition—but no modern anthropology can or would want to ignore the frame.

The largest frame of all is the museum itself, and now the study of museology as social history and knowledge-producer has taken hold of both museum anthropologists and academic ones: the study of the politics of collecting, displaying, and representing non-Western peoples and their artifacts has become a significant strand in the disipline, making the boundaries between the museum and the academy more permeable in the last five years or so. (The table of contents of the journal *Museum Anthropology* now reads like the table of contents of the journal *October* . . . but I exaggerate.)

We continue our object orientation in another form, too, by studying the traffic in objects and images, and images made into objects, within a global economy. This study in object-traffic differs from economics because we focus on the cultural categories and discourses that inform and construct those markets. And since commoditization is a historically constructed form of exchange, not a natural one, we as a discipline are also studying shopping malls and theme parks, where objects and images (marketed representations) inform and excite consumer desire.

Panofsky and Lévi-Strauss (and Iconographers and *Mythologiques*) . . . Re-regarded

JAMES A. BOON

Part I of this paper revolves around intricate references to Erwin Panofsky in the sprawling structuralism of Claude Lévi-Strauss—including a surreptitious one in the musical *Finale* of *Mythologiques*, before Lévi-Strauss' visible "return" to art history in *Le Regard éloigné*. Although reference, both manifest and hidden, is pivotal, paradoxes of reception and rereading preclude any hope or desire of demonstrating an "influence" (Panofsky on Lévi-Strauss), much less an "omen" (structuralism in iconography). Rather, I *refer* "reference" itself to both Panofsky's and Lévi-Strauss' styles of exploring meanings.[1]

Part II displays a rhetorical device common to Panofskian iconography and Lévi-Straussian anthropology: the authorial persona of a would-be omniscient sleuth, who coaxes readers along trails of visual or mythic evidence, reserving "eurekas" of unlikely convergence to cinch unexpected, even outlandish, decodings. To dramatize this affinity of discourse, I enact a bit of disciplinary cross-over with two winking devices: 1) Some seriocomic "fieldnotes" garnered from my years of stalking iconographers; 2) A condensed extract from the vastnesses of *Mythologiques*. Iconography I evoke "ethnographically," through heightened glimpses of customary lectures at ritual academic events; structuralism I revisit textually, along laborious analyses of Native American gourds, endowed with an iconology (and organology) rich enough to rival anything known from Europe's "Middle Ages," "Renaissance," etc.[2]

Both Parts are skewed by disciplinary oddities of their author: an ethnographer of certain cultures and conferences who reads Lévi-Strauss-as-reader, along with Panofsky and his aftermath. The paper ends provocatively, enlisting Panofsky himself to question possibilities of demarcating historical styles. Nowadays, for example, sundry critics "deploy" the tricky prefix "post" to *éloigner* the "modernist" phase of any discipline whatsoever. In contrast, my paper might appear "anti-anti-modernist"; it aims to neither resurrect nor "remainder" Panofsky or Lévi-Strauss. Rather I keep rereading both from a future (or sequel) their work helped foster, a sequel that has intensified ironic cross-overs between art history and anthropology, among other disciplines—if disciplines we be.

To repeat: Lévi-Strauss repeatedly revisited Panofsky, who himself possibly invited an iconography (and ethnography?) even of iconography. Readers willing to bear such "returns" in mind may grow less averse to dashes of pastiche certain to season the pages now underway.

Part I. Lévi-Strauss
and Panofsky: "References"

Loin de moi, donc, l'idée de sousestimer, à la façon des formalistes, l'importance capitale des analyses icono-graphiques et iconologiques de Panofsky . . .
—Lévi-Strauss, *Regarder Ecouter Lire*, 1993

In a 1965 "Riposte a un questionario sullo strutturalismo," Lévi-Strauss commended Panofsky's work as authentically structural—or "pleinement et totalement structuraliste," in a later French translation.[3] In a 1972 book on literary, linguistic, synaesthesic, and "musicalist" dimensions of Lévi-Strauss' ethnology, I emphasized that the text of *Mythologiques* (then emerging) represented the activity of inquiry as such, not its results; and I compared its mode to that *circulus methodicus* embraced by Panofsky that ties iconography to a history of style:

> the individual observation assumes the character of a "fact" only when it can be related to other, analogous observations in such a way that the whole series "makes sense."
> . . . If, however, this new individual observation definitely refuses to be interpreted according to the "sense" of the series . . . the "sense" of the series will have to be reformulated to include the new individual observation.

Panofsky's text continued:

> This *circulus methodicus* applies, of course, not only to the relationship between the interpretation of motifs and the history of style, but also to the relationship between the interpretation of images, stories and allegories and the history of types, and to the relationship between the interpretation of intrinsic meanings and the history of cultural symptoms in general.[4]

Lévi-Strauss extended a spirit of *circulus methodicus* even to his boldest style of generalization—so-called universals:

> [S]ince the study of language in general and of the particular languages which have existed or still exist is an endless task, their common properties will never become encapsulated in a final set of rules. If and when universals are reached their framework will remain open so that new determinations can be adduced while earlier ones may be enlarged or corrected.[5]

Pushed to their limits, "universals" shift—become relational. The same may be said of structuralist "facts": concrete details. Indeed, both iconography and structuralism engage details in endlessly circling tales of detection. Why not extend Panofsky's sense of relationship between stories and styles to the styles of story produced in the name of iconography and structuralism, respectively?

Long ago in Princeton, precisely mid-way in 1955 (July 1), Panofsky dated his preface to *Meaning in the Visual Arts*. It gathered thirty years of diversely learned effort under Flaubert's ironic, Devil-reversing dictum: "Le bon Dieu est dans le détail" (p. x). Panofsky stipulated that unlike his Revised Versions of Earlier Articles, except for some bracketed asides, his Reprints of Pieces Published in English and the Translations from the German were made no more perceptive "by pretending to have known more than I did when they were written" (p. v). He urged their contents be checked against subsequent researches by others listed in two tight pages of "bibliographical hints" (p. vi).

Readers, then, are addressed across a figurative bridge between the time-of-writing certain essays and the time-of-prefacing-for-reading. Even when no revision ensues, the interval is filled by non-stop compiling of bibliography, which encourages readers to become iconographers in their own right, perhaps out-detecting the Master. I like to think Panofsky's preface anticipated the last line in M. A. Holly's little book on him, three decades later: "In principle, I think Panofsky would agree, iconology can well be

thoughtfully applied to any cultural achievement, including his own."[6]

A celebrated chapter of *Meaning in the Visual Arts*, "Three Decades of Art History in the United States," with its "Impressions of a Transplanted European," evokes wartime New York in a memorable image, appropriately surreal: "New York was a gigantic radio set capable of receiving and transmitting to a great number of stations which were unable to reach each other" (p. 328). Wartime New York could indeed have enabled Panofsky and Lévi-Strauss—both Jewish refugees from Europe, separated in age by just sixteen years—to reach each other; their stays in its vicinity overlapped. Panofsky, of course, remained. Lévi-Strauss returned. Unwilling, he later recalled, to lead an exile's life forever, he refused permanent transplantation.[7]

Back home, Lévi-Strauss harnessed his distance from New York and the New World, writing "tristes tropes" of Greenwich Village, Fire Island, Chicago/Manhattan, and Caduveo/Bororo/Tupi-Kawahib, among sundry serious and playful inversions that precipitated myth-like order in his *temps retrouvé*. In a mode he later designated "pre- and post-figurative," his stylized recollection kept pastiching Proust, among others—as Proust himself had pastiched (and translated) Ruskin, among others. Lévi-Strauss' recurring homages to Proust's writing-memory include devices and textures of *Tristes tropiques*; the penultimate chapter of *La Pensée sauvage* ("Le Temps retrouvé"); and *Mythologiques'* orchestrations recalling Proust's motif of Vinteuil's *petite phrase mélodique*. Proust even frames Lévi-Strauss' fragmentary chapters ("si peu chronologiques") of *Regarder Ecouter Lire*, perhaps the last *bricolage* in a *Lebenswerk* of remnants and remains ("*restes*"). These explicit references "tip" a Proustian iceberg flowing beneath the surface "tropics" of Lévi-Strauss' structuralist *opera*.[8]

In 1955, then, *Meaning in the Visual Arts* dawned, along with *Tristes tropiques* as well as "The Structural Study of Myth," later reappearing in *L'Anthropologie structurale* (1958), Lévi-Strauss' collection of articles—partly revised, partly reprinted, partly translated—published, coincidentally, in a Doubleday Anchor Book similar to Panofsky's. *Structural Anthropology* "theorized" in high-analytics the very "tropics" narrativized, one could say, in the reflexive prose-poetics of *Tristes tropiques*.[9]

Panofsky, while staying on, possibly remained as distant in his own fashion from *la vie* New Yorkienne and New Jerseyenne. He too crafted a special style of pursuing meaning, commemorated in the gentlemanly reflections of "Three Decades. . . ." Joan Hunt (who reports that Leo Spitzer would have preferred MVA be called *Philology and the Visual Arts!*) finds Panofsky's letters less rosy than the official article.[10] That may be so; but I still prize his elegiac revisionism, whose hues provide a welcome antidote to current fashions in distorted exposés, prone to assume that anything academic—iconography, structuralism, deconstruction, etc.—must be willfully conspiratorial, a game-plan of mandarins or their embittered also-rans.[11]

By the time Panofsky died in 1968, Lévi-Strauss had achieved stupendous professional stature as an ethnologist plus polymath savant who indulged in frequent asides about the Renaissance, the Middle Ages, art history, and more. But 1968 also marked the turning point against structuralist grandiosity. After 1968, beginning with *L'homme nu* (then being composed), Lévi-Strauss portrayed his efforts as a sustained afterimage of its *Finale*, a rhetorically recurring sunset, a kind of *l'homme-Dämmerung cum* bangless whimper.[12] Before 1968, Lévi-Strauss perhaps half-hoped to found a mammoth enterprise of meaning-detection over a world of cultural differences subjugated by Europe's Renaissance-and-since. (We might think of it as an inter-arts version of iconography-iconology for everything not "home" to European high culture.) I say half-hoped because Lévi-Strauss' writings also anticipated the ruination of such aspirations, the

inevitable eclipse of so authorized a style of knowing. And it is the ruins that Lévi-Strauss kept writing, variantly, thereafter.

The present author too has interpreted, variously since 1968, Lévi-Strauss' extravagant variations—his engagement of multiple cultures and disciplines, including ethnography, music, and visual arts from Caduveo, to quattrocento, to Cubists, *et cetera*. Given his emphasis on synaesthesic rites and hybrid myths—translated, transplanted, transformed—I have *nearly* gone so *far* as to imagine his oeuvre retitled "Meaning in the Intersensory Arts." With *Le Regard éloigné*—which Lévi-Strauss officially declined naming *l'Anthropologie structurale trois*—something similar actually occurred; he backed up this retrospective self-*regard* in *De près et de loin*.[13]

The Reticulated Reference

In Frankfurt am Main in 1980, the Insel Verlag published *Anita Albus, Aquarelle 1970 bis 1980: Katalog zur Ausstellung in der Stuck-Villa München*, garnished with a preface by one Claude Lévi-Strauss. The preface reappears as chapter 20 of *Le Regard éloigné* (1983), possibly his most winking work since *Tristes tropiques* (1955) and *La Pensée sauvage* (1962).[14] (The latter's appendix, expurgated from an execrable English transplantation, embedded themes of "wild" classification systems in a medieval allegory of flowers for thought—the book's governing *pensée* pun.) *Le Regard éloigné*'s cover was wittily embellished—front and back—with opposed renderings by Albus of two sides of nature—one *vivante* and curlique, the other *morte* and angular. (A play of contrasts in Germanic versus Latin heraldry also enters Lévi-Strauss' expositions.) Flattened into *The View from Afar*, and de-emblematized, the English version became tame, domesticated, vacant—in sad contrast to the sensorially rich and reflexive French "original."

Lévi-Strauss' preface credits Albus' Pre-Raphaelitish art with revitalizing Dürer's Northern transformation of *l'art italien*, as outlined by Panofsky with an insight from Goethe. Lévi-Strauss salutes Albus via Panofsky-on-Dürer-and-Goethe with rhetorical flourishes that are convoluted, a mite *précieux*, and inclined to chronology-reversing.[15] Thusly:

> In regard to Anita Albus, it is significant that the pre-Raphaelites . . . chose as a point of departure a period in Italian art when it received a great deal more from the painting of Northern Europe than it was to give back through Dürer, as Erwin Panofsky has shown. Furthermore, the origin of the pre-Raphaelite movement reveals a German influence: that of the Nazarenes. To assure a return to the basic disciplines of painting [he brings in Ingres and English artists also] it was the northern tradition born in Flanders in the early fifteenth century, that proved most effective. (VA, p. 251)

In French Lévi-Strauss paraphrases Panofsky's account of a Nordic "particularizing spirit" as follows: it

> pouvait se déployer dans deux domaines, tous deux extérieurs à la nature 'naturelle' ou 'noble' vantée par Goethe, et pour cette raison complémentaires: domaine du *réalisme* d'une part, du *fantastique* de l'autre; d'un côté, l'art intimiste du portrait et la peinture du genre, nature morte et paysage; de l'autre côté, l'art vissionaire et fantasmagorique; soit deux domaines situés "l'un en deça de la nature 'naturelle', l'autre au-delà." (RE, p. 337)

Citing his 1955 Doubleday Panofsky, he converted the English's "*before* 'natural' nature" to *en deça*, and "*beyond* 'natural' nature" to *au delà*. I leave aside both this twist of translation from Panofsky and Goethe's German to pursue the Dürer-Goethe connection, a reference that may "mask" a richer affinity.

Lévi-Strauss' preface waxes eloquent on Albus as a throwback to medieval and Renaissance techniques:

> By subjecting her eyes, her hand, and her mind to asceticism, Anita Albus tried to return to the very origins of Western painting and restore the painter's craft in all its rigor. She learned to use vellum as it was used centuries ago, and rediscovered the bright and opaque hues of the illuminators of the Middle Ages and the early Renaissance by applying successive layers of watercolors. Here, too, she remained faithful to her national tradition. For it was Theophilus, a German monk of the eleventh and twelfth centuries. . . . Evocative, as a person, of Gothic grace and purity, Anita Albus demonstrates through her art that one does not reinvent the painter's craft without taking things back to their beginnings . . . without restoring bit by bit their secrets and methods and the tricks of their trade. (VA, p. 257)

Surely this homage sounds as hackneyed in the French as in translation. This cloying quality is a standard "effect" in Lévi-Strauss' concocted *bricolages* (of *bricolages*)—his analytic contrivances that form his oeuvre's fabric of expanse. Beginning with *Tristes tropiques'* evocation of Chopin's *mélodie rebattue,* whose hackneyed refrain haunted him on the savannahs of central Brazil, Lévi-Strauss composes (as do myths) piece-meal arrangements from tired terms and worn-out tropes—clichés reanimated by recombination and reversal (i.e., backing up to Chopin from Debussy).[16]

In the case at hand, Lévi-Strauss also aligns his own work with Albus and professes a preference for pre-chiaroscuro Italian and Flemish painting and for Japanese art to the nineteenth century. His sweeping judgment of taste relies on Panofsky-Dürer-Goethe, also used to illuminate Albus' place among "contemporary influences":

her loyalty to the Nordic tradition, with its urge to unite the real and the fantastic, brings her close to surrealism. . . . Surrealism, too can on occasion be inspired by the past. It was from Leornardo da Vinci that Max Ernst learned to decipher mysterious figures in the cracks in a wall or in the veining of an old, weathered floor. Anita Albus reverses this method. (VA, p. 256)

Surrealism? Ernst? This brings us to ch. 19 of *Le Regard éloigné*, regarding, it so happens, Max Ernst. Or is the "peinture meditative" of its title Lévi-Strauss' (meditative equivalent of painting, rather than painting that meditates). The confessedly extravagant *Finale* of *Mythologiques* had declared its volumes "the negative of a symphony" or, more precisely, a displaced compensation for the author's inability to compose a musical tetralogy, *à la* Wagner. The Ernst essay remakes *Mythologiques* into a transposition of one surrealist's painted corpus:

> Does some analogy exist between what I have attempted to do in my books, a long time after him, and the role [Ernst] always assigned to painting? Like his paintings and collages, my work on mythology has been elaborated by means of samples from without—the myths themselves. I have cut them out like so many pictures in the old books where I found them, and then arranged them on the pages as they arranged themselves in my mind, but in no conscious or deliberate fashion. The structuralist method . . . is easily recognized in Max Ernst's definition of 1934, where he extols "the bringing together of two or more elements apparently opposite in nature, on a level whose nature is the opposite of theirs." This is a double play of opposition and correlation. (VA, p. 244)

This flourish of meta-*pensée sauvage* ("analogical thinking") sets up the chapter's classic *jeu*

d'esprit cum tour de force in which Lévi-Strauss outdoes his many critics at their game of parodying structuralist-style machines-for-opposition.[17] Literally: He decodes Ernst's celebrated *machine À coudre* that stands in metonymic juxtaposition to the *parApluie*, atop a *table de dissection*. Through a "faux parallélisme" (resemblance), he discloses interrelated differences comically formulated as an integral equation; let us savor the flavor of his sport (*esprit*):

> But this is a false parallel, no doubt, since the second *a* of *parapluie* is not a preposition but an integral part of a morpheme. Nevertheless, it puts us on the trail of a whole system where resemblances and differences correspond: the machine is made *for* sewing, the other device is *against* rain; the machine acts upon material and transforms it, the umbrella offers passive resistance to it. Both articles have a point: the point of the umbrella ensures its protection or, as an ornament, tops off a soft, gently rounded dome, elastic to the touch; the point of the sewing machine is sharp and aggressive and attached to the lower extremity of an angular arm where it bends down. A sewing machine is an orderly arrangement of solid pieces, the hardest of which, the needle, has the function of piercing cloth. The umbrella, in contrast, is covered with a material that cannot be pierced by liquid particles in disorder: rain. (VA, p. 244)

This self-parody, I should stress, appeared soon after Lévi-Strauss completed his *Mythologiques* tetralogy, having earlier feared that he would not live to do so.[18]

The fleet *pièce* on Ernst serves as *Mythologiques'* belated *boutade* in an art history mode that complements the *Finale's* predominant polemical and musicological modes. For example, the tetralogy opened with a discussion of the temporally mirrored cycle of Bach-Beethoven-Wagner/Debussy-Ravel-Stravinsky (code-message-myth/

myth-message-code); it ended midway back along that cycle with Lévi-Strauss' extraordinary analysis of Ravel's *Bolero*.[19] Who has noticed that the partitions of *Bolero* (numbered 0–18, inclusively) amount to nineteen, like the *combined* subsections of *Mythologiques'* famous "Overture" and "Finale"? The sections form a gradual crescendo, through *Bolero*-style transformations, of a musicologically informed polemic that simultaneously frames a *ring* through New World evidence stretched out between the rhymes of *cru* to *nu*. Thus is the West's musical history "bricolaged" into *Mythologiques*.[20] The Ernst essay effects similar operations on the West's art history—in a quasi-parodistic echo of surrealist parody itself.

Drafts of the Ernst essay may have littered the cutting room floor when *Mythologiques* struggled to a provisional halt. Later retrieved, it reengages Lévi-Strauss in art history, both by identifying Ernst's efforts with his own and by backing up to the Middle Ages and Renaissance. It thus reverses, "retotalizingly" (to recall *La pensée sauvage's* counterings of Sartre's dismissal of any "analytical reason").[21] For example:

> In the art of Max Ernst, painting remains essentially what it was from the late Middle Ages and the Renaissance until the nineteenth century, and that is where it derives all its nobility: a scrupulous labor prepared for by a period of reflection, exercise and doubt. Rightly or wrongly, one thinks of Ernst as suffering the terrible agony that Ingres endured before starting certain portraits. (VA, p. 245)

Digression This juncture of historical reversal in Lévi-Strauss seems an appropriate moment for me to digress (on digressions). Lévi-Strauss often digresses into unexpected resemblances across cultures and times, thereby deviating from the proper path of "structuralism" which traces "not resemblances but differences that resemble each other" (to evoke a once-celebrated slogan from

Le Totemisme aujourd'hui).[22] His stray attention to surface resemblances (versus profounder structural "resemblances of differences") resembles, I find, Panofsky's similar proclivity: for example, this digression on sun-gods:

> It should be noted, however, that [Stradano's] Apollonian sun-god was patterned after Michelangelo's *Risen Christ* in Sta. Maria sopra Minerva. At a time when artists, as Durer expressed it, had learned to fashion the image of Christ, "the most beautiful of all men," in the likeness of Apollos, the image of Apollo could also be fashioned in the likeness of Christ: in the judgment of his contemporaries and followers, Michelangelo and the Antique had become equivalent. (MVA, p. 158)

Now, the stray surface resemblance I am noting (between Lévi-Strauss' and Panofsky's digressions into stray surface resemblances) is, similarly, not my profounder point. Rather I seek more nearly a "resemblance of differences" between the Ernst essay and the Panofsky-citing Arbus essay—embodied in another salute to Dürer and Goethe. *End digression.*[23]

Reticulation Resumed

The Ernst piece turns to his large-scale compositions between 1955 and 1965, whose thick paint and intense style "suggest affinities with others: with Gustave Moreau, Gustave Doré, and John Martin; and, farther away in space, with Indian sculptors along the coast of the Pacific northwest; and, further away in time, with Dürer" (VA, p. 246). (Europeanists need to be mindful that likening anything, Dürer included, to Northwest Coast art is Lévi-Strauss' highest praise.) Here Lévi-Strauss does not summon Panofsky summoning Goethe; but Goethe is invoked in another fashion, convolutedly.

The penultimate paragraph compares Ernst's "middle distance" paintings for Paul Eluard's home to "those of the Hopi frescoes at the Awatowi site, or of some other civilization as wise and enigmatic as Egypt seen by the later Greeks and, like Egypt, forever vanished"; it further intones (I "reverse" to French): "mais symboles qui nous restent présents non seulement par la composition graphique, mais aussi par l'attribution à chacun de teintes rares, fines et précieuses dont le choix et les rapports semblent chargés de sens" (RE, p. 331). That keyword *sens* exfoliates into the *sons et sens* of the final paragraph. A primary theme in *Mythologiques* paralleled myth as *sens* and music as *sons*—pure differential in the semantic and acoustical realms respectively. The Ernst essay alludes to this theme, plus its companion scheme of four mega-registers of *sons/sens* interrelations—language (systems of "signs"), myth, music, and math. To these the Ernst essay carefully restores visual art, only apparently excluded. (Anti-modernists might want to polemicize: "The old totalizer appropriates images to his imperialist gaze.") Like a conjurer, Lévi-Strauss conjoins Saussure, Ernst, and Goethe; his words that wink between scientific and tribal logics (*moitiés, bricolage*) got cancelled in the English transplantation (I indicate where):

> If sound and meaning, as Saussure has taught us, are the two indissociable halves [*moitiés*] of linguistic expression, then the work of Max Ernst speaks countless languages—a discourse always expressed by an unbreakable solidarity (between the background chosen and the techniques of execution [*bricolage*] which are able to take advantage of every kind of resource); by the arrangement of volumes, lines, values, and colors; by the pictorial texture; by the subject itself; and so on. As Goethe once said of the vegetable world . . . all aspects in terms of which one can see a painting form a chorus whose singing "guides us toward a hidden law" [*envisager un tableau forment un choeur dont le chant "guide vers une loi caché"*]. (VA: 247); RE 331

Concerted readers of Lévi-Strauss experience an uncanny feeling here, and not just from syn-esthesic effects induced by a painting imagined as a singing chorus. For, Goethe's maxim had al-ready appeared (served as apparition) in Lévi-Strauss' *L'Homme nu* (not unlike that hermetic lily that pops up in the last pages of *Tristes tropi-ques*).[24] Nor is a "law" all that is "hidden"; Pan-ofsky, I suspect, lies concealed as well. *Voyons!*

Mythologiques' *Gesamtwerk* of a *Finale* ends by declaring itself just a Rousseau-esque "*libre rêverie*," an overcooked retrospective or discur-sive sunset (the metaphor Lévi-Strauss retrieves from *Tristes tropiques*, ch. 11).[25] This passage represents the twilight of Lévi-Strauss' *vie d'esprit*, a kind of Dämmerung of l'homme, echoing that of Wagner's *Götter*. All this is manifestly over-blown and meticulously contrived—no less *bri-coleuriste* than everything in Lévi-Strauss and in the myths that, possessing him, he has sought in-tellectually to possess.

Mythologiques' final five paragraphs situate pan-human specificities of systematic meaning *between* Hamlet's overly credulous alternatives of *être/non-être* (a displaced allusion to Sartre's existentialist *être/néant*, often lambasted by Lévi-Strauss?). These final paragraphs also seal Wag-ner's *Ring* as one shadow-opus of Lévi-Strauss' own *opera*. (I have published on this matter at a length that some of my critics call Wagnerian.[26]) So, that's Shakespeare and Wagner. Finally, these same paragraphs invoke Goethe, to clarify the "caractère doublement paradoxal" of Lévi-Strauss' mammoth enterprise, his "ouvrage pét-rie de sens" assumed by so many detractors to be "vide de sens"; I cite:

> Si un résultat s'en dégage, c'est d'abord que nul mythe ou version de mythe n'est identi-que aux autres et que chaque mythe, en paraissant insister gratuitement sur un détail insignifiant et s'y appésantir sans raison avouée, cherche en fait à dire le contraire de ce que dit à ce sujet un autre mythe: aucun mythe n'est semblable. Pourtant, pris dan

leur ensemble, ils reviennent tous à la même chose et, comme Goethe l'affirme des plantes, "leur choeur guide vers une loi cachée".[27]

This *allusion* in "libre rêverie" echoes a *reference* to Goethe fifteen pages earlier, which placed him in excellent company indeed. With *Meta-morphosen des plantes* (cited in its French trans-lation, 1829), Lévi-Strauss names Dürer's *Vier Bücher von menschlicher Proportion*—unlisted in *L'Homme nu*'s copious references. (Was Dürer's work perchance experienced in mediation?) A fi-nal fellow-feeler is saluted, who advanced to general scientific status Dürer's and Goethe's speculations about form: D'Arcy Wentworth Thompson. Thompson, Lévi-Strauss implies, map-ped for nature what he himself maps for culture: parameters of systemic coordinates, continuous transitions, and outlines of external differences that distinguish variant forms, or types, or cate-gories of classification.

Mythologiques, then, reconciles several en-deavors: 1) Thompson's and Goethe's "principle of discontinuity" that limits "the infinitude of pos-sible forms" in any realm; 2) Rousseau's "bot-any," defined as a study of combinations and relationships; 3) Saussure; 4) the genetic code which, "like language, proceeds by the combi-nation or distinctive opposition of a small number of elements."[28] Famous "glyphs" from Thomp-son are the sole pictorial in Lévi-Strauss' *Finale*, just as the scheme of *Bolero*'s nineteen sections is its only chart. Thompson's "graphic form or style" concludes the tetralogy's visual array, harkening back to the "bestiary" of *Le Cru et le cuit* plus cover illustrations erased from English-language editions.[29]

Lévi-Strauss' corpus is peppered with acknowl-edgments of diverse intellectual "mistresses," beyond the famous Marx-Freud-Archaeology trio of *Tristes tropiques*.[30] But where did *Mythologi-ques'* striking Dürer-Goethe-Thompson combina-tion, unreferenced as such, come from? Have readers guessed my speculation? We may owe

Lévi-Strauss' learned outpouring—plus the final "visual art" gracing what he feared would be his dying work—to Panofsky's renowned second chapter in *Meaning in the Visual Arts,* which revisits Dürer's "efforts in the theory of human proportions as a branch of the theory of art," including his doctrine of "geometrical variation" in the *Vier Bücher* (*MVA,* pp. 104–5). A footnote credits the most serious revival of Dürer to D'Arcy Wentworth Thompson's *Growth and Form* (1917); and Panofsky concludes with Goethe, not so much to embrace "nature naturelle" (*en deça* and *au delà*), as to bridge to Dürer and Thompson, plus Leonardo:

> It is no accident that the mature Goethe, having abandoned the Romanticism of his youth in favor of an essentially classicistic conception of art, devoted a warm and active interest to what had been the favorite discipline of Leonardo and Dürer: "to work away at a canon of masculine and feminine proportions . . . to seek the variations out of which character arises, to examine more closely the anatomical structure, and to seek the beautiful forms." (*MVA,* p. 107)

I, an anthropologist, mention this striking nexus neither, as more historicist scholars might, to trace an influence, nor to catch Lévi-Strauss in an unacknowledgment. I mean only to propose a partly obscured affinity between masterly (modernist?) structuralism and iconography, so-called.

The case could perhaps be cinched by citing Lévi-Strauss' conclusion to *Mythologiques'* theoretical polemic before his discourse enters "*libre rêverie*" (*écrit!*):

> The structuralist ambition to link up the sensory with the intelligible . . . is also encouraged by the work of those who, like D'Arcy Wentworth Thompson following on from Dürer . . . have been able to establish a term-by-term correspondence between abstract and intelligible relationships . . . and . . . living forms . . . chief among which is the hu-

man face, usually thought to be a visible expression of the personality, and its qualities of character and feeling. And what forester could say exactly how he identifies a tree from a distance?[31]

That "distance" doubtless sanctifies Lévi-Strauss' own "regard éloigné" of myths and cultures, and of his personal *vécu.* Does, moreover, the same "distance" draw *near* in spirit to Panofsky's insights about Dürer and *l'art italien:*

> Dürer, too, attempted to supplement his theory of mensuration with a theory of movement . . . and with a theory of perspective . . . he attempted to facilitate this very complicated process by reducing the irrational surfaces of the human body to shapes definable by simple planes. . . . Instead of interfering with the final representation, the later Dürer only prepares it; instead of defining contours by circular arcs, he inscribes plastic units into stereometrical solids; to a mathematical schematization of linear design he opposes a mathematical clarification of plastic concepts. (*MVA,* pp. 102–3)

I here sidestep disputes among art historians; e.g., S. Alper's suggestion that Panofsky ranked "the southern aspirations of Dürer over his northern heritage" and thus privileged "narrative" over "description."[32] To me, an *amateur,* Panofsky's passage seems alert to Dürer's northern aspects, nearly declaring Dürer a forerunner of film technique, as Panofsky describes it in "Style and Medium": "The problem is to manipulate and shoot unstylized reality in such a way that the reality has style." Again, however, an anthropologist can only defer to Panofskians versus Alpersites; or perhaps to Anne Hollander, whose *Moving Pictures* argues a continuity between filmic images and Northern "description."[33]

Panofsky argued that Dürer's mathematical clarifications (in counterdistinction to schematizations) achieved conceptual plasticity and stereometric inscriptions (versus mere planar ones). (I

find Panofsky's "reading" of Dürer no less *ste-reometric* than Dürer's art's "reading" of its subjects: call it stereometrics squared.) But I cite Panofsky's formulation of "stereometric inscription" only to propose its affinity with so-called structuralism's desire to render intelligible multiple semiological registers—a desire of intelligibility worthy to be renamed "meaning in the intersensory arts."

Part II. Iconographers and *Mythologiques:* Narrative Devices

For reasons insufficiently explored by anthropolgists Americans seem to be genuinely fond of listening to lectures and of attending conferences and symposia.
—Panofsky, MVA, p. 332

The year Panofsky died, I began graduate school, too late to become his ethnographer. I could still read him, however, and did, including his one nod to anthropology in *Meaning in the Visual Arts* (my epit[gr]aph to part II). With this wink, the ever-prescient Panofsky seemed almost to foresee an "anthropology of us" that has since flourished with the waning of disciplinary pretexts to disclose "primitivity." Indeed, Panofsky's wink, or my reception of it, possibly induced this ethnographer to begin stalking "native" iconographers conferring.[34]

Iconography's ritual gatherings abound in evidence of devotion to visual and textual particulars. Take, for example, "Iconography at the Crossroads" convened in Princeton in 1991; any ethnographer attending could have jotted lively description—thick or thin—of such lively describers. Their papers roamed extravagantly; rethinking issues in Warburg and Panofsky; translating cryptic meanings of crucifixes in light of gender and class; addressing an accent on physicality that befell Christian art with Leo Steinberg's *Sexuality of Christ.*[35]

One offering by an astute social historian of Renaissance Florence (perchance a friend of mine) particularly caught my ethnographic ear. (I here preserve anonymity, to protect "informants.") He explored possible emotions of devotional practices around icons: Responses to nude infants versus bedraped Christs; traditions of cross-dressing crucifixes by female worshippers; male identification with/desire for Christ's genitalia; Church anxieties that monks or laymen might suffer arousal when viewing naked sculptures; the somatic-interpretive theme of victim's erection at crucifixion (like male martyrs at the moment of execution, I thought, *à la Billy Budd*); the popular reception of both glorified and pruriant scenes of bodily agony.

It came as no surprise that the question and answer period proved effervescent. Things culminated when a singular art historian took the floor to declare something like this: There exist but three icons (two crucifixions and one deposition) where Christ's genitals are visible (in the deposition, through a veil gauzily); of these, none demonstrated an erection and none, he added almost as an afterthought, was circumcised.[36]

Customarily this prominent iconographer avoids claiming visual evidence to be definitive, even for highly conspicuous motifs, given the inherent trickiness of "representation." But his comment on the social historian's topics *sounded* certain. The crowd was growing—according to my notes—abuzz and atitter; before anyone queried how positive one could be that the depicted foreskins were utterly intact, the coffee-break, alas, intervened. The art historian's bold observation had driven home the firm resolve of his discipline, "at the crossroads," to uncover the most recalcitrant, variously veiled details. What seemed to matter—my ethnographic surmise ran—was that nothing icono-, however graphic, escape intense perusal.

An earlier conference may help advance my "textual strategy" of dramatizing *their* textual strategies, dramatic enough *sans* ethnographer. The time was 1974 or so; the occasion a year-long series to rekindle the spirit of Panofsky in central New Jersey. Again I lurked, "fond listener to lectures." All the papers struck my fancy; one,

however, was especially memorable for its artfully delayed "eureka." (Again, so to preserve the anonymity of these fieldnotes' unwitting "informant"—a senior scholar, emeritus even then—I here inscribe the lecture as recalled, neglecting any version doubtless published since.)

His presentation broached contents of what art historians know as Europe's "first public museum" in Renaissance Rome. That striking installation—the brainchild of late quattrocento papal agents—gathered various antique statues from medieval pilgrimage shrines where they had been dispersed. Elaborating details of this Renaissance *bricolage* (or so it seemed to me), the lecture concluded with unexpected punchlines of convergent detection that powerfully evoked those intervening Middle Ages, between the monuments' classical origins and their Renaissance re-collection. The iconographic problem: How to explain mysterious pit-marks scarring the renowned "boy pulling a thorn from his foot"? Deducing that the statue had once adorned an isolated pilgrimage column at a medieval harbor, our scholar wondered: Had the boy been stoned and pelted by the faithful who, approaching the elevated statue from a lower vantage, would have taken him as a representation of onanism? (To feel the force of this suggestion, readers must picture it; no slides, by the way, illustrated this particular speculation.)

To rephrase the issue: Had a medieval reinterpretation of remnants of Roman statuary—subsequently *re*-reinterpreted by Renaissance men assembling a "museum"—preserved for posterity traces of alternate assumptions of art observers, produced when the "boy pulling a thorn from his foot" fell victim to over-zealous pilgrims—themselves iconologists (and iconoclasts) of sorts? Rereading Renaissance rereadings of medieval rereadings of Ancient art works, the lecture reserved its most reveberant suggestion for a rather off-hand moment of masterly sleuthing. It is this (modernist?) style of narrative disclosure—playing with furtiveness—that I am disclosing in turn.

Structuralism Likened

Repeat: *Aucun myth n'est semblable.*
—*L'homme nu*

Lévi-Strauss' immensely difficult *Mythologiques* works in similar ways to the Panofskian performances inadequately "ethnographed" ("voyeured"?) above. *Mythologiques* too narrates masterly research into unexpected convergences and punch-line solutions posed in passing. Readers may be reminded of this fact, even addressed as accomplice-sleuths; for example, towards the conclusion of *From Honey to Ashes*:

If any reader, exasperated by the effort demanded by these first two volumes, is inclined to see no more than a manic obsessiveness in the author's fascination with myths, which in the last resort all say the same thing and, after minute analysis, offer no new opening but merely force him to go round in circles, such a reader has missed the point that a new aspect of mythic thought has been revealed through the widening of the area of investigation.[37]

To convey the unrelenting detail, I isolate extracts that circle back through South American materials, before the transition to North American myths and rites in later volumes (HA, pp. 320–33). Lévi-Strauss reviews specific myths of the origin of cultivated plants, some endowed with speech. He mentions long-term evidence that the Nambikwara and Machiguenga cultures of eastern Bolivia exploit languages' plasticity: distort terms, play at muttering, alter consonants, invent slang, remake words through interlingual "osmosis." (Note that *pensée sauvage* constantly redifferentiates; it is not static.) He summarizes ethnographic meanings of specific sound codes (flutes, rattles, whistles, speech, cries, and taps) and of communication modes that differentiate gods and humans, humans and plants, women and men, and allies and enemies.

From these materials Lévi-Strauss extricates a general theme, a formula, and a crystalline dia-

gram (p. 328). The theme: "Music supplements language, which is always in danger of becoming incomprehensible if it is spoken over too great a distance" (p. 326). The key formula: "A melodic phrase is a metaphor of speech" (p. 328), whose force is that "metaphor" (versus metonymy) stands to discourse as "melodic phrasing" (versus harmony) stands to music.[38] This provocative analogy resonates among different channels and arts of message-making. Finally, the diagram, "the structure of the acoustic code"; this redundant (ironic?) visual aid is a prism whose "four diagonals form two isosceles tetrahedra which interpenetrate" (p. 332).

The prism's parallel and oblique lines map several domains: 1) indigenous categories of song, speech, and signal; 2) language styles of insult, courtliness, confusion, and whistling; 3) signallings by name, epithet, tapping, and whistling; 4) diverse instruments (flute, drum, gourd, and shell rattle). Lush categories of an indigenous organology oppose drum sounds to varied jangles of rattles made from nutshells or animals' hooves. The latter accompany dances and imitate ambiguous buzzings of dragon-flys, wasps, and hornets. Such is the *science concrète* operated by analogical codes (*pensée sauvage*) including mythic narratives and the "*mythologiques*" thereof.

Both evidence and analysis exist in and as the cycles of details. Over the course of decoding some general argumentation appears: e.g., parallels between NAMES as *masked* WORDS on the one hand and MUSIC as *masked* LANGUAGE on the other. But generalities remain strands of a narrative concocted (*bricolage*) to place the reader in a relation to the text analogous to the "sleuth's" relation to the myths. *From Honey to Ashes* pursues contrasts in musical modes (human/animal/gods), just as *The Raw and the Cooked* pursued contrasts in naming modes (both music and names are seen as forms of masking).[39] Indeed, proper names are attributed to animals as rattle sounds are attributed to gods. Myths specifically relate a dried gourd's

rattle to purely consonantal vocalizing, understood as an extreme of divine speech; they oppose this speech to regular human speaking, where sounds "properly" alternate consonants with vowels.

At this juncture Lévi-Strauss provides a little "eureka" about god-head gourds—comparable to that iconographic "eureka" evoked above of "why the thorn-boy had pock marks." Implicit mysteries are provisionally "re-solved": mythically, we learn in "just-so" fashion why gourds rattle; ritually, we see why rattles accompany narratives of gods' speaking. However, as in iconography, a "eureka" offers no end-result, only additional departures. Indeed, *Mythologiques* resembles the whole endeavor called iconography-iconology, rather than one case of it.

For readers with endless patience for long amplitudes of transition, the "path" of the gourd clarifies New World systems of meaning that put "metaphors and paraphrases, careful cooking, moderate noise or silence into one category, and the word 'raw,' dirtiness and din into the other" (HA, p. 454). Again, Lévi-Strauss punctuates the sprawl with gourd-gods:

> the gourd which includes within itself all these aspects acts at one and the same time as speaker (in its capacity as a rattle), culinary utensil (as spoon, scoop, bowl, or water bottle), and as a source of intentional or involuntary noise, either because it is used as a resonator for the tapped-out call, or because air rushes in when water pours out. (p. 454)

It is godly-gourdly "concretes," not analytic abstractions, that wind on, recapitulating multiple motives. At one point:

> We come back, then, to the gourd which made its first appearance in *The Raw and the Cooked* in a very unusual role. A Warao myth . . . ogress who wears half a gourd as a head-dress . . . throw(n) into the water . . . to . . . spin like a top. . . . When I an-

alysed the myth . . . I left aside this detail, which now takes on greater importance. (p. 454)

Later:

In order to classify the transformations undergone by the gourd . . . a double coding system, culinary and acoustic . . . the ceremonial rattle and its inverted form . . . the 'diabolical gourd.' One produces sounds, the other is silent. (p. 456)

Again:

At first glance, the use of the gourd as a head-dress has no place in a system in which we have found no other vestimentary symbols. Only much later, in the fourth volume of the present series, do I intend to show that this new code is homologous with the culinary code. . . . At this point, it is enough to stress the *anti-culinary* connotation of the use of a utensil as an article of clothing, the final detail in an ogress's portrait which, if it were imitated by humans, would transfer them from the category of consumers of cooked and prepared food into that of the raw substances which are put into the gourd to be eaten later. (pp. 458–49)

Like a prolonged "eureka," the detail of an ogress' portrait is retrieved from two volumes earlier by the master sleuth, encouraging readers to stay tuned—two volumes later—for consequences of humans imitating ogres.

General Conclusions. . .

Mythologiques is arguably the most demanding opus ever produced in the professional *name* of anthropology. Possibly concealing a reference to Panofsky displaced to *Le Regard éloigné*, it explores the "intersensorigraphy" of the indigenous New World. This "field" of Lévi-Strauss could almost be deemed that *chronotope* (in Bakhtin's sense) most remote from Panofsky's historical home base, Europe's Renaissance.[40] Regardless, both pursuits—iconography and structuralism—excavate meanings from recalcitrant evidence; both styles rhetorically display and withhold hints, converting readers *as readers* into accomplice-sleuths. They may appear "modernist" for playing at furtiveness; for craving (ironically?) omniscience, at least provisionally; and for simultaneously embracing a *circulus methodicus* wherein nothing final can obtain. Here history and "method" alike spiral, and meanings are engaged relationally, through concrete details.[41]

Paradoxically, the very historical distance today claimed from so-called modernism may itself be questioned in either Panofsky's or Lévi-Strauss' terms. I have in mind the latter's now-hackneyed, controversial notion of "cold" (versus hot) societies, which parallels rather nicely Panofsky's view of medieval schemes of space and time or tense. Here's Panofsky:

Just as it was impossible for the Middle Ages to elaborate the modern system of perspective, which is based on the realization of a fixed distance between the eye and the object and thus enables the artist to build up comprehensive and consistent images of visible things; so was it impossible for them to evolve the modern idea of history, based on the realization of an intellectual distance between the present and the past which enables the scholar to build up comprehensive and consistent concepts of bygone periods. (*MVA*, p. 51)

Whether hot/cold (Lévi-Strauss) or modern/medieval (Panofsky), the contrast pertains to societies with/without "historical consciousness" or to eras with/without ideologies that make historical ruptures of *conscience, conscience* as *histoire*. Whatever the deficiencies of such a contrast, it nowhere implies any culture can be "timeless" or any people "without history" in the sense of unchanged from the past.[42]

By the same token either distinction (modern/medieval, hot/cold) raises questions of whether any aspect of disciplinary method can become patly "past." Is not the very notion of something being "bygone" (and/or restorable!) itself an historically contingent construct—one that Panofsky traced to the Renaissance? Ironically, this strange notion—that method lapses—"continues" (repeats?) into "post-modernism" (or, following Lyotard, *vergings* there-toward).[43] The desire to distance modernism (so-called) may, then, be no escape from modernism at all. The desire to distance may keep repeating the legacy of Renaissance style.

. . . Detailed Dimmings

Where do my cycling pastiches and paradoxes leave vexed issues in the meaning of meaning— the *sens* of *sens*, the *Bedeutung* of *Bedeutung*, or either of the other—in Panofsky or Lévi-Strauss? In this *regard* the present ethnographer must defer to more stalwart semioticians than he. Oh, I, too, have dallied in such delicious interdisciplinary waters—*Et in arcadia ego*. Yet even after often rereading Panofsky and Panofskians, I am sure neither what "meaning" means nor, for that matter, what *Et in arcadia ego* means. Panofsky's legendary explorations of this notorious epigram-motto-caption-epithet lead less to any fixity of meaning than to intricacies in the history of receptions and misreadings.[44] To me, his efforts disclose how uncertainty has perdured, specifically, in the meanings of *Et in arcadia ego*, among other meanings. Might this outcome be the precise beauty of Panofsky's iconography, and of Lévi-Strauss' *Mythologiques* alike: "Only the voyage is real."[45]

Lévi-Strauss has long avowed that structuralist decodings repeat at a remove the very properties they order, that *mythologiques* code myths as myths themselves code categories. Whether Panofsky's iconography also qualifies along this "meta" dimension is difficult to judge. Does ico-

nography, as a form of intelligibility, somehow "second" the form of intelligibility it calls "visual arts"? Is Iconography-Iconology an "art of arts" as *Mythologiques* is a myth of myths? One way (*sens*) to an answer might lie in Lévi-Strauss' notion of art's "possession," posed in a pungent hunch back in 1961:

> It seems to me that in Greek statuary, or in Italian painting of the Renaissance, at least from the Quattrocento onwards, the artist's attitude to his model is characterized not only by an attempt to signify, i.e. by the purely intellectual approach which is so striking a feature of so-called primitive art, but also—although I may seem to be uttering a paradox—by an almost covetous attitude which seems to be related to magic, since art is based on the illusion of being able not only to communicate with the being, but also to possess it through the medium of the effigy. I would term this: "possessiveness with regard to the object," a way of taking possession of some phenomenon of great external value or beauty. It is this avid and ambitious desire to take possession of the object for the benefit of the owner or even of the spectator which seems to me to constitute one of the outstandingly original features of the art of Western civilization.[46]

Have iconographers aspired to possess Western art as Western art has aspired to possess its subjects? Does Iconography covet what it represents —art—as art covets what it represents? If so, we may have stumbled upon another "modernist" aspect of both iconography and structuralist anthropology. Alas, the present author—here masked as an anti-anti-modernist practicing neither iconography nor structuralism (or both?)— must leave this issue to those who deem themselves "native" to one or the other pursuit.

Farewell savages/*adieu sauvages*.[47]
. . . *Et in arcadia ego*.

Notes

1. Thanks to participants at the Panofsky-fest for helpful remarks after hearing a preliminary version: I. Lavin, S. Errington, F. Myers, A. Grafton, C. Schorske.

2. Thanks to J. Goldstein, whose lively example of bridging anthropology and art prompted part of Part II.

3. C. Lévi-Strauss, "Riposte a un questionario sullo structuralismo," *Paragone* 16 (1982): 125–28. C. Lévi-Strauss, *L'anthropologie structurale deux* (Paris: Plon, 1973), p. 324.

4. J. Boon, *From Symbolism to Structuralism: Lévi-Strauss in a Literary Tradition* (New York: Harper and Row, 1972), pp. 130–31. E. Panofsky, *Meaning in the Visual Arts* (hereafter *MVA*) (New York: Doubleday, 1955), p. 35n 34.

5. C. Lévi-Strauss, "Structruralism and Ecology," *Barnard Alumni Publications*, 1972; reprinted in C. Lévi-Strauss, *The View from Afar* (hereafter *VA*), trans. J. Neugroschel and P. Hoss (New York: Basic Books, 1985), p. 104; see also J. Boon, "Structuralism Routinized, Structuralism Fractured," *American Ethnologist* 11, 4 (1984): 807–12.

6. Michael Ann Holly, *Panofsky and the Foundations of Art History* (Ithaca: Cornell Univ. Press, 1984), p. 193.

7. C. Lévi-Strauss, *Paroles données* (Paris: Plon, 1984), p. 258. C. Lévi-Strauss (with Didier Eribon), *De Prés et de loin* (Paris: Odile Jacob, 1988), trans. P. Wissing as *Conversations with Claude Lévi-Strauss* (Chicago: Univ. of Chicago, 1991), p. 55. See also, J. Boon, "Claude Lévi-Strauss," in *The Return of Grand Theory*, ed. Q. Skinner (Cambridge: Cambridge Univ. Press, 1985), p. 164.

8. On Proust and Ruskin, see R. Macksey, "Proust on the Margins of Ruskin," in *The Ruskin Polygon*, J. D. Hunt ed.; and P. Kolb, ed., *Marcel Proust: Selected Letters, 1880–93*, trans. R. Manheim (Garden City: Doubleday, 1983), p. 114. See also, J. Boon, "Why Museums Make Me Sad," in *Exhibiting Cultures*, ed. I Karp and S. Levine (Washington: Smithsonian Institution Press, 1991); pp. 267–75. On Lévi-Strauss and Proust, see Boon, *From Symbolism*, ch. 5; and J. Boon, *Other Tribes, Other Scribes* (New York: Cambridge University Press, 1982), p. 212. The Lévi-Strauss references to Proust alluded to are *La pensée sauvage* (Paris: Plon, 1962), ch. 5; *L'Homme nu* (Paris: Plon, 1973), pp. 586–87; and *Regarder Ecouter Lire* (Paris: Plon, 1993), pp. 9–11. I engage Wagnerian and Proustian aspects of Lévi-Strauss' displaced "opera," in J. Boon, "Lévi-Strauss, Wagner, Romanticism: A Reading-Back," in *History of Anthropology*, Vol. 6 (*Romantic Motives*), ed. G. Stocking (Madison: Univ. of Wisconsin Press, 1989), pp. 124–68.

9. Indeed, the two works often cover the same examples in these two modes. See Boon, *From Symbolism*, chs. 4–5; Boon, *Other Tribes*, ch. 7; J. Boon "Between the Wars Bali: Rereading the Relics," in *History of Anthropology*, Vol. 4 (*Malinowski, Rivers Benedict, and Others*), ed. G. Stocking (Madison: Univ. of Wisconsin Press, 1986), pp. 218–47. See also,

C. Geertz, *Works and Lives: The Anthropologist as Author* (Stanford: Stanford Univ. Press, 1988).

10. Joan Hart, "Erwin Panofsky and Karl Mannheim: A Dialogue on Interpretation," *Critical Inquiry* (spring 1993): 534–63.

11. A vivid example is Norman Cantor, *Inventing the Middle Ages* (New York: William Morrow, 1991), chs. 4–5.

12. *L'Homme nu*, p. 620. See Boon, *Other Tribes*, pp. 212–17; J. Boon, "The Reticulated Corpus of Claude Lévi-Strauss," in *The Rhetorical Turn*, vol. 2, ed. G. Jensen and C. Sills (Portsmouth: Heineman Press), pp. 21–43. The implications of 1968 for so-called structuralists are artfully evoked in C. Clément, *The Life and Legends of J. Lacan*, trans. A. Goldenweiser (New York: Columbia, 1983), p. 133.

13. On translating-transposing-transplanting in Lévi-Strauss, see Boon, *Other Tribes*, pp. 212–17. Lévi-Strauss "distances" his "Structural Anthropology" titles in *Le Regard éloigné* (hereafter *RE*) (Paris: Plon, 1983), translated in *VA*, p. xi. He "backs up" this self-distancing (and embraces a certain aestheticism) in the "Epilogue" of *Conversations*, with Eribon (1991), p. 181.

14. Lévi-Strauss, *Tristes Tropiques* (Paris: Plon, 1955[1983]). *The Savage Mind* (Chicago: Univ. of Chicago Press, 1966).

15. On a "counter-chronologiques" throughout Lévi-Strauss' work, including his notion of myth and memory and his critique of historiography, see Boon, "Structuralism Routinized," pp. 808–12.

16. C. Lévi-Strauss, *Tristes Tropiques*, pp. 428–30. I "staged" the Chopin/Debussy episode in National Public Radio's "A Question of Place" ("A Sound Portrait of Claude Lévi-Strauss," 1980) by intertwining Lévi-Strauss delivering his French with English delivered by a radio-actor—both set to the music the passage is written "according to." Backing to Chopin's "hackneyed melody" *from* Debussy, the former is indeed reinvigorated, as Lévi-Strauss hopes. This key passage in Lévi-Strauss' corpus possibly harkens back to Proust's comedy-nexus of Chopin, Debussy, and Wagner (and Poussin!); see Marcel Proust, *Remembrance of Things Past*, vol. 2, trans. C. Moncrieff et al., (New York: Random House, 1981), pp. 841–46.

17. *The Savage Mind*, p. 219. See also Boon, *From Symbolism*, p. 31; C. Geertz, *The Interpretation of Cultures* (New York: Basic Books), ch. 13.

18. To biography-minded readers doubtful of my authority here, let me say that my archives (ironic and true) contain a letter Lévi-Strauss wrote me upon awakening from the anesthesia of a dangerous operation in 1968/9.

19. C. Lévi-Strauss, *The Raw and the Cooked*, trans. J. and D. Weightman (New York: Harper and Row, 1964), p. 30. See Boon, "The Reticulated Corpus," p. 34 and Boon "Lévi-Strauss, Wagner," pp. 125, 162.

20. Lévi-Strauss made the point about the *cru-nu* rhyme in interviews with Jean Pouillon; see Boon in Skinner, ed., p. 170.

21. On spirited "retotalizings," see Lévi-Strauss, *The Savage Mind*, ch. 5.

22. C. Lévi-Strauss, *Le Totemisme aujourdhui* (Paris: Plon, 1961), trans. R. Needham as *Totemism* (Boston: Beacon Press, 1962), p. 77.

23. Many readers today associate any play on "difference" with Derrida, who stole, so to speak, the "thunder" of Lévi-Strauss' formulation ("not the resemblances but the differences that resemble"); or did Derrida "counterfeit" difference-differance? (See J. Derrida, *Donner le Temps* (Paris: Editions Galilée, 1991).

24. *Tristes Tropiques'* Goethean lily blooms on p. 473; many of Lévi-Strauss's hybrid conclusions gather strands from gnostics and magics of yore and yonder into his re-assemblages.

25. Here the *"je"*—suppressed for nearly four volumes—is reasserted over the formal *"nous"* readers would have been mistaking as objective. Lévi-Strauss' translators—the Weightmans—handled with considerable grace the dilemma this "reversal to *je*" and retrospective re-motivation of *nous* handed their task (see Lévi-Strauss, *The Naked Man*, p. 625.

26. Boon, "Levi-Strauss, Wagner," pp. 124–65.

27. Lévi-Strauss, *L'Homme nu*, pp. 619–20.

28. Lévi-Strauss, *The Naked Man*, p. 676.

29. Coincidentally, *L'Homme nu*, capped with Thompson, appeared in 1971, as did Hugh Kenner's *The Pound Era* (Berkeley: Univ. of California Press, 1971) where Thompson's "icons" are woven into modernist poetics (p. 169).

30. Lévi-Strauss pieces together the Marx-Freud-Archaeology "influence" in *Tristes tropiques*, ch. 6.

31. *The Naked Man*, p. 691. The play on near/distant (*près/loin*), an on-going device in Lévi-Strauss' oeuvre, accelerated with his latest books.

32. S. Alpers, *The Art of Describing: Dutch Art in the Seventeenth Century* (Chicago: Univ. of Chicago Press, 1983), p. xxiii.

33. Panofsky's "Style" cited in Anne Hollander, *Moving Pictures* (New York: Knopf, 1989), p. 77.

34. Preliminary versions of these "ethnographettes" appear in Boon "Circumscribing Circumcision," in *Implicit Understanding*, ed. S. Schwartz (Cambridge: Cambridge Univ. Press, 1994), pp. 556–85.; and "Why Museums," p. 257–58.

35. L. Steinberg, *The Sexuality of Christ in Renaissance Art and in Modern Oblivion* (New York: Pantheon, 1983), pp. 157–64. See also J. Boon, *Affinities and Extremes: Crisscrossing the Bittersweet Ethnology of East Indies History, Hindu-Balinese Culture, and Indo-European Allure* (Chicago: Univ. of Chicago Press, 1990), pp. 54–60.

36. For "beginnings" in interpreting such matters comparatively, see Boon, "Circumscribing Circumcision."

37. C. Lévi-Strauss, *From Honey to Ashes*, trans. J. and D. Weightman (New York: Harper and Row, 1966); p. 472; hereafter, *HA*. A bit of this example appears in J. Boon, "Claude Lévi-Strauss" in *The Johns Hopkins Guide to Literary Theory* (Baltimore, 1993).

38. The English version misleadingly translates both *discours* and *parole* as "speech"; *parole* contrasts with *chant* ("song") and *signal* ("signal") on the diagram, and must be distinguished from *discours*.

39. Lévi-Strauss, *The Raw and the Cooked*, pp. 28–29.

40. Some examples of the application of Bakhtin to anthropological evidence are E. Bruner, *Text, Play, and Story* (Prospect Heights: Waveland Press, 1988), pp. 57–58; J. Clifford, *The Predicament of Culture* (Cambridge: Harvard Univ. Press, 1988), pp. 41–42 and Boon, *Affinities and Extremes*, pp. 67–69, 88.

41. Although Lévi-Strauss opposes more intuitive phenomenology strenuously in *Tristes tropiques*, his "spiraling" for endless mythological analyses becomes at times quasi-hermeneutic, *circular methodically*. And for a time, his structural approach and Merleau Ponty's socially oriented phenomenology entered into conversation; see Boon, "From Symbolism," pp. 223–25.

42. The hot/cold distinction (steam engine/clock) is suggested in Lévi-Strauss, *Conversations*, with Charbonnier (1961), ch. 3, with this clarification, so often overlooked: "We should not, then, draw a distinction between 'societies with no history' and 'societies which have histories.' In fact, every human society has a history. . . . But whereas so-called primitive societies are surrounded by the substance of history and try to remain impervious to it, modern societies interiorize history, as it were" (p. 39). For some thoughts on implications of Lévi-Strauss' misunderstood position in this regard, see Boon, "Structuralism Routinized," and Boon, "Between the Wars," p. 241–43.

43. J. Lyotard, *Toward the Postmodern*, ed. R. Harvey and M. Roberts (Atlantic Highlands: Humanities Press, 1993).

44. This paper's delivery version (at the Panofsky fest) played on *Et in arcadia ego* in the fashion repeated in this revision. Coincidentally, in the interval Lévi-Strauss' *Regarder Ecouter Lire* appeared, which reiterated his resolve never to overlook Panofsky and resumed rereading *MVA* by artfully questioning Panofsky's views on Poussin and decodings of *Et in arcadia ego* (Lévi-Strauss, *Regarder Ecouter*, pp. 68, 18–22).

45. Lévi-Strauss, *Le Cru et le Cuit* (Paris: Plon, 1964), p. 33, my trans.; more fully, "seul le voyage est réel, non la terre, et les routes sont remplacées par les règles de navigation." This neglected tenet of structuralist method links to Lévi-Strauss' related conviction that, regarding evidence, "le dossier n'est jamais clos." I used both to conclude (openly) *From Symbolism*, pp. 228–32; compare Panofsky's *circulus methodicus*.

46. Lévi-Strauss, *Conversations*, with Charbonnier (1961), pp. 63–64.

47. "*Adieu sauvages*" may be the most withering moment of self-ironizing, among many, in *Tristes Tropiques* (p. 473).

Making Things Meaningful: Approaches to the Interpretation of the Ice Age Imagery of Europe

MARGARET W. CONKEY

Introduction

Despite the fact that most introductory art history and archaeology books give the subject of "Paleolithic art"—that is, some 20,000 years of image-making—only a short summary that tends to treat it all as a homogeneous bloc of culture, time, *mentalité*, and "art," this is an area of visual studies that has a long and complex intellectual history. As well, there exists an extremely diverse and differentially "patterned" content to the "art," in terms of the media, the forms, and the so-called subject matter, even if *only* considered in the very traditional framework of how and what imagery is distributed through time and space. It is not, however, the point of this essay to provide either the rich intellectual history[1] nor to convey the rich diversity of imagery that is all-too-often lumped under the rubric of "Paleolithic art."[2]

What I would like to do in this essay is three things: First, I will begin with a paraphrase from Svetlana Alpers that I think frames in one approach to interpreting the imagery of "Paleolithic art," an approach that is both timely and potentially fruitful. Second, before pursuing this approach, I want to "get a few things straight," so-to-speak, about the European Paleolithic imagery and it's place in what D. Lewis-Williams has called the "archaeology of human understanding."[3] And third, I will provide the outlines of the approach that I will advocate here, and why I think it has potential in our engagement with "meaning in the visual arts."[4]

To Begin

My inspiration has a simple source: in one of those alumni magazine conversations with faculty, my colleague Svetlana Alpers discussed some of her thoughts about the making and the circumstances of pictures. I have applied to "Paleolithic art" something that she said in reference to Rembrandt, and I have paraphrased this, perhaps even altering its meaning or intent:

> What is extraordinary about much Paleolithic art is not that the imagery is transcendent and provides us with universal values, transcendent values, but that the imagery was created working from right *within* the mundane world. The "artists" are not transcending but deeply involved *with* the world in which they live. They did not *discover* something that is true for all humans at all times in

all places (as in transcendent imagery and art if there really is such stuff) but rather they helped *invent* something that we still find valuable (emphasis added).[5]

While there is much to be said about the history and issues surrounding the ways in which the imagery of "Paleolithic art" has been—more often than not—taken *as* transcendent imagery, I will not focus on that here. This view, however, pervades the popular media and has inspired much of the interpretation of "Paleolithic art" over the past 35 years. For example, a direct linkage can be made between the "anthropological humanism" of the 1930s and later (that motivated the philosophies behind the founding of the Musée de l'Homme in Paris)[6] and the interpretive work of André Leroi-Gourhan, whose structuralist account[7] of Paleolithic image-making drew on a notion of art as a "universal essence" and on his convictions that this "Paleolithic art" is one of (and equal to) the great artistic movements of the historical world, inseparable from a coherent religious system.[8]

While this aura of the transcendental nature of the imagery continues as part of the appeal and engagement with the painted caves, in particular, what I want to draw our attention to here—in our concern to explore meaning in the visual arts— are the ideas that Alpers raises about the image-makers as individuals who were working from *within* their mundane world, very much involved *with* the world in which they lived. For it is this perspective that can lead us in some provocative directions.

Before going further, I want to make it quite clear that I am approaching the interpretation of Paleolithic imagery from the perspective of an anthropological archaeologist. We like to think of ourselves as students of material culture and that our work is simultaneously empirical and interpretive. We argue long, hard, and explicitly over issues of epistemology and "how we know what we know." And there is not yet widespread commitment to or acceptance of the study of past

symbolic and cognitive phenomena. "Paleolithic art" (among other archaeological, especially rock, arts) has long been marginalized in Anglo-American archaeology as too "humanistic" and problematical on grounds of dating (to say nothing of the fact that its very existence has always been at some odds with the stereotypes of its hunter-gatherer makers).[9] Archaeologists are well-known for trying to pirate everything from social theory to extremely technical scientific methods (such as x-ray diffraction of pigment composition) in the service of our interpretive efforts. While the lay public continues to be consumed with a desire to have us tell them, "this is the way it was," many of us insist on both the challenges and possibilities of what is a more realistic situation, namely, that archaeological data and the issues we explore are full of ambiguity, and that this is to be celebrated and exploited.[10]

However, many of us are often put on the defensive—especially when it comes to the topic of "meaning"—by those who can't see how we can do anything without written texts or direct ethnographic sources. While it may come as no surprise then that I will advocate an approach to visual imagery that centers itself within a concern for materiality—for the images, the forms, the media, and the generative processes through which these images came into being—I believe this approach can be sustained on a number of grounds. By taking the stance that, in general, human lives are *simultaneously* materialist and symbolic,[11] and that—especially in the particular historical contexts of the Upper Paleolithic period of Europe—the *making* of imagery is potentially a significant source and manifestation of meanings, I hope to be able to probe into the "archaeology of human understanding."

Establishing Some "Facts"

I have long grimaced at the label, "Paleolithic art," which presupposes the aesthetic and lumps a diversity of imagery made off and on over a

Figure 1. The so-called "Chinese horse" from the site of Lascaux (Dordogne, France), which is the most frequently reproduced image from the entire corpus of "Paleolithic imagery" (Photo by Jean Vertut, with permission).

20,000+ year time period into a single assumedly homogeneous bloc that has, furthermore, been traditionally "explained" in terms of what become monolithic and singular accounts: e.g., hunting magic, a religious mythogram, and, more recently, as shamanistic in inspiration and form.[12] Most know the very familiar icons that have come to "stand for" "Paleolithic art" as a particular period in western art history and/or for the attainment of "fully human symbolic behavior": the Chinese horse from Lascaux (fig. 1); the bull on the ceiling of Altamira, and the fat, "reproductively fertile" female statuettes. Although nearly 90 percent of all images of "Paleolithic art" in introductory art history and archaeology texts can be accounted for by the 3 major icons of Lascaux horse - Altamira bull - female statuettes, a few other increasingly familiar images have been allowed into the repertoire. And, above all, what is rarely appreciated is that there are literally thousands of images on or out of bone, antler, stone, or ivory (often collapsed into the category of "portable art"), and that there are thousands of engravings on cave walls and plaquettes. The nineteenth-century definition of "art" as painting—and easel painting at that (fig. 2)—has gone a long way toward perpetuating the incorrect idea that the primary imagery of

Figure 2. An 1870 woodcut that shows the making of portable art by presumed Paleolithic peoples. Note that this was made prior to the "discovery" of any wall art (Altamira was the first in 1879), but that the slab being drawn upon in this woodcut has been placed as if it were the "canvas" of a painter, and the pose of the "artist" is strikingly reminiscent of the poses attributed to the artists and painters of the time. The woodcut was illustrated as figure 68 in L. Figuier, *L'Homme Primitif* (Paris, 1870).

late Ice Age Europe was cave paintings. But this is another story and is part of the complex intellectual history I noted above.

However, the point here is to step back from familiar icons and consider that there are 1000s of unfamiliar images from the "Paleolithic repertoire." Despite the stereotypic notions, not all animal images are "recognizable" (as horse, deer,

bison, ibex, etc.); not all are done with polychrome pigments, careful shading, or attention to anatomical detail; many are without heads, and others are done on plaquettes that were deliberately placed face down in an interior cave habitation site as part of a pavement or were intentionally (or so it seems) "de-capitated." Other imagery is of humans or anthropomorphs that are only rarely shown to modern audiences: not all females are "reproductively charged" (and besides no one has yet made a sustained argument as to why these images are necessarily about fertility, when it is widely known from ethnographic contexts that fertility imagery is not necessarily isomorphic with the large breasts, etc. that are taken [from our own Western and contemporary ideologies] as unproblematically indicative of the wide and abstract concept of "fertility" [which is itself never explained]).[13] Most humanoid depictions are not clearly identifiable as male or female, but if frequency of imagery is at all relevant, it is the case that humans are relatively rare in comparison to animals and the so-called "signs."

It is *not* the case, as the hunting magic hypothesis held, that the preferred images—it is now known that bison and horse account for 60 percent of the identifiable animal images in the caves, for example—are those that were also the most frequent in the diet. By the last 3000 years of the Upper Paleolithic (14-11,000 years ago), during what is called the Magdalenian period, when the corpus of imagery is most abundant, the primary food animal was often reindeer, which is infrequent to rare in the cave imagery and only slightly more frequent on the portable engraved objects. In reference to one site—La Vache (Ariège, Pyrénées, France)—which has yielded one of the richest Magdalenian assemblages of engraved bone and antler, the culinary list (food refuse) is dominated by ibex, while the imagery list is dominated by bison.[14] The intriguing observation then is that they had ibex in their stomachs, but bison on their mind. Leroi-Gourhan was right in insisting[15] that the animals

depicted were from a bestiary of symbolic significance not from an encyclopedia of either diet or ecology; the animals depicted are likely to have been more "good to think" than "good to eat."

Furthermore, the "Paleolithic art" of Europe is not "*the* origins of art," despite its traditional positioning as such.[16] First, the icons—such as Lascaux horses and Altamira bulls—are themselves not chronologically "at the beginning," for they date to circa 17,000 and 15,000 years ago, respectively. And there is a rich and diverse corpus of imagery in the European sites "Before Lascaux"[17]: carved animal figures in ivory from sites in Germany at 30,000+; incised blocs from southwestern France. Many of the famous female statuettes date to 23-25,000 years ago, and recent direct dates on negative hand images at the newly discovered now-underwater site near Marseilles (Cosquer cave) are at 27,000 years.[18] But even at 27-30,000 years old, these images from European sites are more appropriately classified as "the largest *preserved* corpus of fairly well-dated imagery" than as the origins of art. Image-making seems to be "turning up" in many parts of the world at about this same time period, although there is much discussion and controversy over, for example, the dates on the Australian imagery, some of which has been claimed to be 43,000 years old, or over the Pedra Furada (Brazil) paintings at more than 20,000 years.[19]

Very simply, the classic archaeological account that allowed for the claim that this was the origin of art was that anatomically modern humans (*Homo sapiens sapiens*) first occupied Europe and the Mediterranean, deriving from sites such as Cro-Magnon in southwestern France. With these modern humans, who established themselves in Europe at 35-40,000 years ago, there was art, and this association fostered very "vitalistic" accounts for "why art ?" : the art "came naturally" with the cognitive and behavioral leap towards modern humanity.[20] But the archaeology of early modern humans has, over the last decade, radically re-structured the scenario. Even if

one doesn't accept the "Original Eve, Mother of Us All" hypothesis deriving from genetic simulations and the so-called molecular clock, the fossil and archaeological evidence now strongly supports a scenario in which anatomically modern humans were long ago in Africa—perhaps more than 100,000 years ago—and in the Middle East at 90,000 years ago, where some of them even seem to have been using a tool kit practically identical to that of Neanderthals in the same region.[21] In fact, anatomically modern humans now appear to be relatively late in their "arrival" in Europe, with the possibility, for example, that modern humans were in Australia before they were in France.

The point here is that the cultural developments (including that which we call "art") of modern humans in southwestern and central Europe are, on a global scale, relatively late, and not necessarily pioneering. And with image-making at such places as Apollo 11 cave in Southern Africa attributed to more than 20,000 years, the European imagery no longer stands alone as the primary illustration of "early human art." The European materials do, however, still stand out for their abundance as well-preserved media—bone, antler, stone, cave walls, even some fired clay at 26,000 years ago—and for the sheer volume of images that can be more-or-less well-dated over a time span that may be as much as 25,000 years (or 1250 generations). Contemporary Australian aborigines would, of course, tell us that an image-making "tradition" of this length is not surprising, but we have yet to have the chronological resolution for the European materials that might allow us to assess the nuances of the trajectory of the cultural production of images. What all this means is that the imagery of Ice Age Europe is no longer the "origins," *the* source for the "creative explosion"; it no longer stands alone and as the font of art in our archaeology of human understanding.

At this point in the history of interpreting the "Paleolithic art" of Euro-Russia, there is a certain distancing from evolutionary approaches. For

one thing, there is a considerable amount of "muddle" in the evolutionary models that are still brought into discussion: people can't agree on what "symbolism," "consciousness," or "art" are, much less on how to "measure" them, archaeologically.[22] As well, the past decades in the interpretive milieu have focused more on macro-level approaches that are either systemic or structural and these, in turn, have come under scrutiny. The former (macro-level systemic) have suggested the ways in which the imagery has been adaptive or functioned in solving certain socio-spatial or informational "needs": for example, in initiation ceremonies; to store more necessary information; to "mark" territories or place in an increasingly dense social world.[23] The structural account is, of course, the well-known thesis put forward by Leroi-Gourhan,[24] which suggested that the imagery is the manifestation of certain underlying principles of cosmological and religious significance that were "played out" through the mythogram, the placement of certain imagery on cave walls or on certain artifact types. The cave was seen as a "mythological vessel."

But the interpretive pendulum is now swinging towards more local, historical, and contextual approaches that are compelling for both theoretical and methodological reasons (although they have, without a doubt, been stimulated, if not even mandated by, the predecessor interpretive accounts).[25] There is a convergence of several interpretive influences toward the local, the historically contingent and specific, a convergence that comes from sources as diverse as post-structuralism and structuration theory and the new evidence and scenarios for modern humans as late-comers to southwestern Europe. The latter "fact" is a liberation from vitalistic and progressive evolutionary models, for the questions are now more directed to: "why here?"; "why in these forms, these (changing) media, and of these specific images?"; "why at this point in time and in these particular locales, when modern humans are clearly widespread?";

"what is it about these images that made them meaningful?"

Thus, while it is terribly disappointing to layperson and student that we can no longer claim that the imagery can be explained in terms of a single inclusive account, be it hunting magic or a mythogram, the very reasons that these over-arching accounts no longer "hold" are reasons that give us, I believe, other *entrées* into understanding the imagery. We can now readily recognize the differences in both the circumstances of the images and in the making of the images, and it will be these *differences* that make potent clues. With the structuralist account, we came to see how "reading signification" not only is the way to approach the imagery but also means that many "readings" are both possible and likely: "polysemic," "multivocal," "ambiguous," and "multi-referential" (among other terms) are more explicitly recognized and accepted. As Patricia Vinnicombe[26] reminds us, in discussing the "reasons" for some Australian aboriginal rock art, it should come as no surprise that when the question is "is this art about creative forces of life, or is it about hunting magic, or is it about your ancestors, or is it about 'place,' or is it about kin ties?," that the answer is "yes."

Thus, I would again agree with Alpers who is bothered by the work of art history that is too wedded to the assumption that painters (or other "artists") are trying to communicate meaning, and that believes that the "job" of those who study art is to find its "meaning."[27] While her concern is that she's unclear as to what then happens to the painting in this exercise to "find the meaning," my concern, as an anthropologist, is that it deflects attention away from what might have made the imagery meaningful. Since I am an archaeologist dealing with human cultures for which we lack direct observation as well as historic or ethnohistoric documentation, one might justifiably suspect that my "turn" of phrase— from "what does it mean?" to "why-how-to whom was it meaningful?"—is purely defensive or, at best, a methodological life-raft. But I hope

to show (no matter what my inspiration or motivation) that this turn—to the meaning-*full*—has potential both for understanding the specific imagery of Upper Paleolithic Ice Age Europe and for the more general concern with the archaeology of human understanding.

Lastly, in preparing to lay out the contours of this approach to the meaningful, I want to elaborate just briefly on why we are now in a position to "push" in this direction. I think we have come to conceptualize the imagery of "Paleolithic art" differently; for me, I think of the imagery as the differential production and reproduction of a material and symbolic repertoire. Another phrase would be that of Whitney Davis, who has advocated re-conceptualizing what was once taken to be a (single) overall figurative system (that of "Paleolithic art") to be at least several, "perhaps inter-penetrating" sign systems.[28] When Nancy Munn long ago discussed the Walbiri iconography (of Australia) as involving "standardized systems for visual representation," she coined a phrase that is certainly applicable to much of the paleolithic imagery.[29] There is, for example, a pan-regional standardized system for the manufacture of the Magdalenian *contours decoupées* (fig. 3), from the precise source of raw material—the hyoid (throat) bone of a horse—to the number, type, and location of incisions on the animal head that is depicted.[30] And yet, while many image-sets are seemingly "rule-bound," if not suggestive even of a kind of craft-specialization (the *propulseurs,* fig. 4), other images that we behold today are clearly the "results" of use, re-use, marking, over-marking, and of transformation in the most obvious sense, as when a horse is re-cut as a bison. Images become the source for other images.[31]

Recent research on a previously neglected topic—namely, what were people *doing* in the caves, especially as this relates directly to the *production* of imagery?—has confirmed that sites were used differently, and in specific ways. For example, it is well-known now that the pigments used at Lascaux (Dordogne, France) were often

Figure 3. A selection of *contours decoupées* (cut-out profiles), which have been shown to be strikingly uniform in their raw material, size, shape, and in engraving techniques and placement, suggesting a kind of standardization of the visual representation. (Photo by Jean Vertut, with permission).

mixed in quite complex ways, that perhaps a scaffolding was erected to reach a "suitable" surface in one part of the cave, that a 3-twined rope was used to get in and out of the "well" where the famous so-called "scene" of disem-

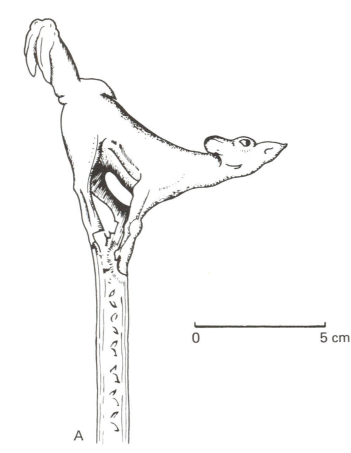

A

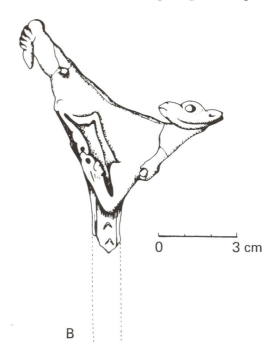

B

Figure 4. Two *propulseurs*, or spear-throwers, from sites in the Midi-Pyrénées, Le Mas d'Azil (left) and Bédeilhac (right) (Ariège), which show striking similarities in form and sculpted object, suggesting a standardization or some kind of contact between the different makers, if not having been made by the same person. The scale is 1:2. (Drawings after Paul Bahn, "Inter-site and Inter-regional Links during the Upper Paleolithic: The Pyrennean Evidence," *Oxford Journal of Archaeology* 1, 3:247–68 [fig. 2, p. 258].)

bowelled bison/stick-figure man/bird-on-a-stick was created, that dozens of more-and-less well-formed lamps were used, and that in some imagery, the pigments were "touched up" with additional layers, often after a time interval long enough to allow the accumulation of a calcite layer between pigment applications.[32] In contrast, there is the so-called Black Frieze at Pech Merle (Lot, France), where Michel Lorblanchet's experimental work has challenged the abbé Breuil's original declaration that this was a cave visited often "by the faithful." Lorblanchet has shown that there are precise but simple "guidelines" to making the images, that the pigments were not mixed or prepared but made to adhere

because a small trough in the cave wall was created to "hold" the pigment from the hand-held charcoal crayon, and that the entire frieze appears to have been done by a single hand and in less than an hour. Other archaeological evidence suggests this frieze was rarely, if ever, "visited" again.[33]

There are other examples, but the point here is that image-making in caves was differential and varied, and it is in these and other clues from the making of images that we can begin to say something about this differential production and

reproduction of the symbolic and material repertoire that we have heretofore too simplistically labelled as "Paleolithic art."

Making Things Meaningful: Theoretical Resources

The image-makers of the Upper Paleolithic world were working from within their mundane worlds, they were deeply involved in the world in which they lived, and they were inventing—not merely discovering—images, materials, forms, and shapes that we today still find valuable. It is its materiality—and all that that implies—as much as the (presumedly) symbolic that makes this imagery of late Ice Age Europe so compelling. But to explore "the material" demands an enriched theoretical platform.

Given that archaeology has for so long had at its disposal the very material "products" of past societies, it is somewhat surprising that our abilities and motivations to exploit these materials have only recently shown promise of "taking off." In part, like the rest of western culture, we have been caught in the western ideology of objects that has artificially separated makers from artifacts and that renders "invisible the social relations from which technology arises and in which any technology is virtually embedded."[34] While archaeology is indeed "uniquely situated" to study the "materiality of social agency,"[35] we have also been too caught up in a limited focus on what Lechtman calls the "hardware" of making and using, in the tangible techniques of object-making[36] and in the forms, shapes, and classifications of the objects themselves. Lechtman, in particular, has been particularly efficacious in demonstrating the importance of understanding what she calls "technological style," and that technology is just as much ideology and social relations as it is "things."[37] And, although it was Leroi-Gourhan himself who promoted the "chaine operatoire" approach to Pa-

leolithic studies more widely, these studies have not, for the most part, achieved their full potential to move out towards the social, the cosmological, or the metaphorical from the study of the operational chain or sequence of technical stages in the making of an object.[38]

In their important review of theories of and for "things" and in their needed programmatics for a theoretically enriched archaeology of technology, Dobres and Hoffman trace the history of understanding of technology from Heidegger. They remind us that it was Heidegger who pointed out that "technology is more about the *relationship* between the intentions of the makers and the things they make"; and, that, he stressed, not surprisingly, "becoming is more important than being."[39] If, as Dobres and Hoffman go on to argue so eloquently (and with substantial "case studies" for support), "technology is a complex cultural phenomenon, embedded in historically specific world views, strategic social action, and human agency, more generally," and, if "technology makes tangible fundamental metaphors of daily social interaction,"[40] what implications does this have for interpretation of "Paleolithic art"? Why and, specifically, how, is "technology" —in its widest sense[41]—one of the potent *entrées* to "art"?

There are additional theoretical "turns" that make this approach worth pursuing, many coming from within the field of art history. For example, in Bryson's critique of the "hold" that Gombrich's work on the psychology of perception has held on much of art history, he succinctly makes the not original but important observation that image-making "galvanizes a *production*, rather than a perception, of meaning."[42] He argues that Gombrich has missed the *social* character of the image and its reality as a *sign*, and that (in his emphasis on perceptual psychology) Gombrich has dehistoricized the relation of the viewer to the image. Whether one agrees with Bryson's critique of Gombrich is not the point, but, indeed, there is a certain interpretive impetus

from a conceptual framework that takes up "making" as social practice and that views image-making as an art of the sign—an art that is, however, "in constant touch with signifying forces outside of painting" or other media.[43] Where can we go with this in "Paleolithic art," once we focus on the fuller ramifications of "making things meaningful"?

Making Things Meaningful
Initial Patterns

From the research so far, it is quite clear to those of us who think often about "Paleolithic art" that the image-makers were people who knew their materials—the fundamental properties and characteristics of bone, antler, pigments, stone, cave walls, stone tools, earth, and "clays"—and they often knew well the potential and actual *transformations* of these materials. While we have traditionally tended to associate with the settled farmers of the Neolithic period the ability to understand how one material could be transformed into a fundamentally different form—especially with such things as clay (ceramics) whose basic properties could be altered by firing, for example —it can now be well-documented that this kind of knowledge was more widespread among pre-Neolithic peoples than is traditionally thought to be the case. It has been particularly from the study of pigments that this kind of knowledge can be demonstrated, and I will provide only a few examples to point to what was clearly, for some Upper Paleolithic peoples, an involvement with complex pigment technologies.

Pigment analyses at Lascaux and from several sites in the French Midi-Pyrénées are among some of the best documented studies so far that show how pigments were mixed—often with minerals or other substances—such that the resulting "product" can be characterized in terms of its binders and extenders. In the wall paintings and in the pigments applied to engraved images on bone and antler from several sites in the French Pyrénées, researchers have suggested they can

identify distinct "recipes," which suggest that the particular Magdalenian makers were not merely experimenting and on a sporadic *ad hoc* basis, but that they regularly followed some "guidelines" or parameters for making their pigments.[44]

At the site of Niaux, for example, the research on the pigment recipes has identified 4 different "recipes" based on some red (hematite) but mostly black imagery (manganese dioxide and some charcoal, as the base). The kinds of materials used for binders (to help the pigment adhere to the walls) include biotite, feldspar, and talc. In the Salon Noir at Niaux (fig. 5)—famous for its circular "room" with black outline animals (and some "signs")—pigment analyses suggest that there were two variations of the same pigment "recipe," which the analysts suggest may have derived from the painters using two "paint pots" of the same basic mix. The analytical techniques applied to the tiny samples of pigment include x-ray diffraction, scanning electron microscope, and proton beam analysis, many carried out by the laboratory at the Louvre.[45] As well, some of the few chronometric dates (there are now about 13 for cave paintings in France) for the pigments themselves were done on the Niaux images, yielding some surprising results suggesting that the paintings were not done at about the same time, as traditional stylistic analyses had suggested, but at at least two different periods within the Magdalenian, after 14,000 years ago. The newly developed AMS (accelerator mass spectrometry) dating techniques for organic materials have allowed these first—and admittedly exploratory—direct datings of pigments, due to the fact that minute samples are all that are required for the analysis, whereas traditional carbon-14 techniques would have required amounts of pigment that would have been destructive to the imagery.[46]

So far, in the French Midi-Pyrénées (Ariège) studies have been carried out for pigments in 12 different caves—on cave walls, portable art, on blocks. French researchers are inclined to think that the different "recipes" have some chronological significance because they have been able

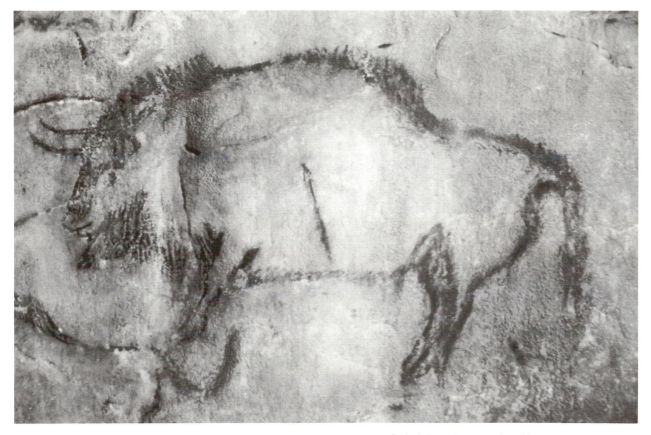

Figure 5. Some of the images from the "Salon Noir" at Niaux (Ariège), some of which have been analyzed by various pigment compositional techniques and some of which have been dated using Accelerator Mass Spectrometry dating methods. (Photo courtesy of Jean Clottes).

to correlate certain "recipes" for cave paintings with the same "recipes" on pieces of portable art excavated from dateable stratigraphic contexts, thus giving a suggestive "date" for the "recipe."[47] However, interpretations here must be preliminary, at best. The French are, by their preferred paradigms, inclined to think about variation in chronological terms, and taking a bit of pigment from one part of an image says nothing about the possibility that other parts of an image could have been done with other recipes, and certainly not all images have been sampled. Other factors could clearly have been "at work" in the selection and use of recipes: certain "recipes" or pigments could have been associated with a certain event, or there might have been

"seasonal recipes"; other pigments or "recipes" might have been associated with certain individual image-makers, with certain genders, status, clans, other social factions, or with the shamans that Lewis-Williams and Dowson believe[48] to have been directly and indirectly responsible for much imagery, especially in the "deep caves."

While these are avenues to be pursued, what the recent pigment studies *have* shown is that we can now make detailed, empirical and previously unimagined inferences about how these peoples conceptualized and used a wide variety of elements and features of their material world—the pigments themselves, and the minerals used as extenders and binders—that, taken together, were then further used to create images that

most likely had cultural, metaphorical, individual, and collective meanings and implications.

At Lascaux, the pigment studies show that some of the imagery there is the result of what we might call a "dialogue" between the raw materials, the techniques for processing and application, and the images that were achieved.[49] The pigments and drawings are there on the walls because of quite complex processing of pigments: grinding, mixing with cave water, mixing with what appears to be a powder of burned bone ash, for example. Many of what we might call "stylistic" attributes of the images seem to be due, at least in part, to the ways in which the pigments were prepared and applied. Black, for example, often appears in the images as a long outline—the result of direct pigment application, as in a drawing (more so than a painting). Red, however, is often mixed into sort of a "slurry," and then used often for shading or the in-filling of imagery.

This intersection of techniques and images is what Lechtman would call "technological style": the very activities that generate or produce the artifacts and imagery are themselves patterned and stylistic.[50] At the same time, the "style" of the resultant image—for example, a black-outline bull or a flat-wash red cow—is just as much a product of the technologies as of the symbolic and conceptual formations that also lie behind the making of the imagery.

Although some (including many archaeologists!) may view the pigment studies as merely the application of new scientific techniques to archaeological data, I see these studies more broadly. They provide a platform for asking—and perhaps answering, at least as well as archaeology can "answer" anything—a range of new questions; they are not merely new data or technical break-throughs. They are, of course, nothing more than descriptive techniques when not considered in the context of questions about social action or cultural intentions.

Most archaeologists have wished to avoid asking about the intentions "behind" the image-making. It all seems so slippery and so impossible to "prove." (And yet many archaeologists are far more willing to assume that behind much of prehistoric economics is the "rational man," or that humans act in an "adaptive" and even "maximizing" manner; things equally difficult to "prove.") However, to understand the intentions of a cultural product is to "interpret it as being in some sense oriented, structured to achieve certain effects."[51] And yet, this cannot be grasped apart from the practical conditions within which image-making and image-using go on. To understand intentions is to think about visual culture as a practice (as much or more than as an object) and practices do not exist without individual human subjects.

The conceptual frame that I am suggesting is that the generative processes—that is, the "technologies"—of the paleolithic images are an "expression of practical knowledge" that is "effected through knowledgeable practice,"[52] and that the imagery itself constitutes "sites" where material practices and representation must have come together to form and re-form the varying human experiences of some people in the late Paleolithic world of Euro-Russia.[53] If the processes embodied in material technologies are themselves social relations, knowledge, and ideology, then our interpretive move could be toward the social relations of production or toward the political dimensions of technologies. For example, what are the consequences for understanding the social production of "art" that the technological systems for pigment mixing can be described as "recipes" or that some of the image-making at Lascaux was effected from a scaffolding? Who (ask Dobres and Hoffman) gets included or excluded?[54] Who obtains the pigments from their sources? Who mixes and who applies? What does it mean for the composition of any "audiences" that the later paintings and engravings in caves seem to be more in the deep caves?[55] Rather than limiting our interpretive focus to the confines of the images themselves—is it a horse or a "fertile female"?—there is the possibility of gaining insights into the productive contexts within which—*and*, more

specifically, with the generative processes by means of which—the imagery comes to be invested with at least some of its meaning.[56] This involves a wider view of technology, one that takes technology as much more than mediator between humans and resources, or as more than a mere vehicle for adaptation.

From the pigment studies alone, for example, we might ask if paintings in the same cave were made with the same pigments or pigment "sets" or "recipes"? Are there patterned differences in the making and using of pigments, such that horses, for example, are done differently than bison? Are what we think of as panels done with the same pigment recipe(s)? Can a combination of evidence point to the number of image-makers involved? Is there any kind of "integrity" to the technologies of a so-called panel, such as Lorblanchet found with the Black Frieze at Pech Merle? And what could this mean in terms of the meaning-full-ness of the imagery?

The ways in which materials are worked and the maintenance or changes in particular technological styles are often efficacious ways through which communities or factions may enculturate, elaborate, and challenge all sorts of values and ideas.[57] Obviously, there are many parameters involved in the study of visual culture; there are the structural properties and possibilities of the raw materials, and the cultural attitudes towards these; there is the social organization of labor; there are the technological modes of production, which may be additive, subtractive, carried out in many or just a few steps, or palimpsests of "making" as with images that generate re-imaging; and there are the possibilities for ritual as integral to the productive processes. Given such parameters, people do organize their technical behaviors along lines that are socially, economically, and ideologically meaningful.

Undoubtedly, it is extremely challenging for archaeologists to make inferences about what an artifact or image "meant" to its creators and their contemporaries. Some of us recognize that certainly this is never an "objective" enterprise distinct from the questions and concerns of the present. While we may be able to argue persuasively that the visual imagery of the late Paleolithic was surely "symbolically charged" and, as suggested above, that it constituted "sites" where material practices and representation must have come together, we must simultaneously recognize that because these images have (selectively) persisted into the twentieth century and are a part of *our* experiences, dialogues, and cultural knowledge, these images are also "sites" for us—where our material practices and our representations (of the past and present) come together to form and re-form our experiences (fig. 6). In the detailing of the materialness and all that that implicates, recent research and theoretical framings have come to the brink of engaging simultaneously with both the making *and* the circumstances of these Paleolithic "pictures." While we should never have the hubris to think we might claim to know with certainty *the* meanings of "Paleolithic art," we can certainly make some interpretive moves toward an enriched and multifaceted understanding of why and how the imagery might have been meaningful.

While there are many other approaches toward more nuanced understandings of the powerful visual legacy that "Paleolithic art" has become—approaches that complement and even stretch the generative technologies approach (if you could call it that) that I have here sketched out—I have selected this as just one set of possibilities within the archaeology of human understanding. We don't necessarily need to find more caves or more sculpted imagery; rather, we have much to learn from more historicized and "local" approaches that shy away from the grand narratives about transcendental imagery that have predominated in our discourses and imagined worlds. A simple but important conclusion here might be to repeat a remark by Mary Ellwood, who has made a most succinct plea for a social and historical analysis of the production of particular artifacts: "We don't need more Chairs of History, we need more histories of chairs."[58] But an even more challenging obser-

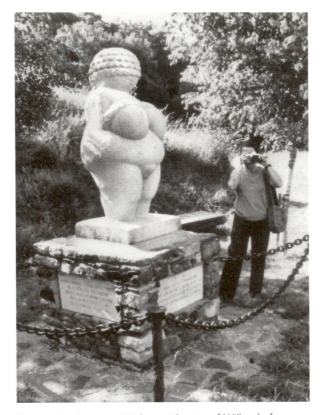

Figure 6. A photograph taken at the site of Willendorf (Austria), which has commemorated the discovery here of the famous statuette known as the "Venus of Willendorf." The original statuette, which dates to about 26,000 years ago, is only 11 cm high, while this statue is obviously larger than life! The point here to reflect upon is how we have selected some of the Paleolithic images and forms to serve as "sites" where representation and material practices come together to form and reform *our* experiences. (Photo courtesy of Olga Soffer).

vation is that of Natalie Kampen, which I'd like to think could motivate our confrontation with meaning in these (Paleolithic) visual arts: "When ancient (visual) culture becomes the subject of engaged study, illuminated by that engagement, it reminds us of our own historical specificity rather than providing us with mythical ideals."[59]

If, in our attempts to interpret the visual culture of the Upper Paleolithic of Euro-Russia, we can do this—with empirical depth and with imaginative power—I am convinced we will have learned

something new—about the past, about the present, and about the relation between the two.

Notes

1. See for example, in Paul Bahn and Jean Vertut, *Images of the Ice Age* (London: Bellew Publishing Co, Ltd, 1988) and in Margaret W. Conkey, *Paleovisions: Interpreting the Imagery of Ice Age Europe* (New York: W. H. Freeman and Co., forthcoming).

2. For an excellent photographic array, see André Leroi-Gourhan, *Treasures of Prehistoric Art* (New York: Abrams, 1965).

3. David Lewis-Williams, "South Africa's Place in the Archaeology of Human Understanding," *Suid Afrikaanse Tydskrif vir Wetenskap* 85 (1989):47–52.

4. The particular approach advocated here is only one part of a more dialectical enterprise in which I myself am currently working on another aspect of the dialectic, which is much more field archaeological. See Margaret W. Conkey, "To Find Ourselves: Art and Social Geography Among Prehistoric Hunter-Gatherers," in *Past and Present in Hunter-Gatherer Societies*, ed. Carmel Schrire, 253–76 (New York: Academic Press, 1983).

5. Russell Schoch, "California Q and A: A Conversation with Svetlana Alpers," *California Monthly* (September 1988): 12, 13, 16.

6. James Clifford, *The Predicament of Culture, Twentieth-Century Ethnography, Literature and Art* (Cambridge, MA: Harvard University Press, 1988), 135–45.

7. Leroi-Gourhan, *Treasures*; idem, "Repartition et Groupement des Animaux dans l'Art Parietal Paléolithique," *Bulletin de la Société Préhistorique Française* 55 (1958):515–527; idem, "La réligion des Cavernes: Magie ou Metaphysique?," *Sciences et Avenir* 228 (1966).

8. See Conkey, chapter 7 in *Paleovisions*.

9. Justin Hyland, "Beyond Description: Rock Art Theory in the '90's," MS on file, Department of Anthropology, University of California, Berkeley. See also Lewis-Williams, "South Africa's Place."

10. Ruth E. Tringham, "Engendered Places in Prehistory," *Gender, Place and Culture* 2 (1994):181–82.

11. Margaret W. Conkey, "Humans as Materialists and Symbolists: Image-Making in the Upper Paleolithic of Europe," in *The Origins of Humans and Humanness*, ed. D. T. Rasmussen, 95–118 (Boston and London: Jones and Barlett, 1993).

12. For the hunting magic interpretation, see S. Reinach, "L'Art et la Magie. A Propos des Peintures et des Gravures de l'Age de Renne," *L'Anthropologie* 14 (1903):257–66, and Henri Breuil, *Four Hundred Centuries of Cave Art* (Paris: Sapho Press, 1952); for the mythogram, see Leroi-Gourhan, *Trea-*

sures and idem, *The Dawn of European Art* (Cambridge: Cambridge University Press, 1982); for the shamanistic account, see David Lewis-Williams and Thomas Dowson, "The Signs of All Times: Entoptic Phenomena in Upper Paleolithic Art," *Current Anthropology* 29, 2 (1988):201–45, and David Lewis-Williams, "Upper Paleolithic Art in the 1990's: A Southern African Perspective," *South African Journal of Science* 87 (1991):422–29.

13. This is a fascinating topic; for important critiques of the assumed interpretations, see Paul Bahn, "No Sex, Please, We're Aurignacians," *Rock Art Research* 3, 2 (1986):99–120; Marcia-Anne Dobres, "Re-Considering Venus Figurines: A Feminist-Inspired Re-Analysis," in *Ancient Images, Ancient Thought, The Archaeology of Ideology*, ed. S. Goldsmith, S. Garvie, D. Selin, and J. Smith, 245–62 (Calgary, Alberta: The Archaeological Association, University of Calgary, 1992); Rainer Towle Mack, "Reading the Archaeology of the Female Body," *Qui Parle* 4, 1 (1990): 79–97; Sarah M. Nelson, "The Diversity of the Upper Paleolithic 'Venus' Figurines and Archaeological Mythology," in *Powers of Observation: Alternative Views in Archaeology*, ed. Sarah M. Nelson and Alice B. Kehoe (Washington, DC: American Anthropological Association, 1990).

14. Henri Delporte, "Piette, Pionnier de la Préhistoire," in *Edouard Piette, Histoire de l'Art Primitif* (Paris: Picard, 1987).

15. Leroi-Gourhan "La Réligion des Cavernes," trans. Annette Michelson, "The Religion of the Caves: Magic or Metaphysics?" *October* 37 (1986):5–17.

16. I was rather horrified to learn than this view of "Paleolithic art" as the origins of western art history is so entrenched that a colleague in the History of Art department would not allow a student to study "Paleolithic art" in my Anthropology course on Prehistoric Art as part of their non-western requirement!

17. Heidi Knecht, Anne Pike-Tay, and Randall White, eds., *Before Lascaux: The Complex Record of the Early Upper Paleolithic* (Boca Raton, FL: CRC Press, 1993).

18. Jean Clottes and Jean Courtin, *La Grotte Cosquer: Peintures et Gravures de la Caverne Engloutie* (Paris: Seuil, 1994).

19. For a fairly up-to-date and appropriately cautious review of the early Australia dates, see Andree Rosenfeld, "A Review of the Evidence for the Eemergence of Rock Art in Australia," in *Sahul in Review, Pleistocene Archaeology in Australia, New Guinea and Island Melanesia*, Occasional Papers in Prehistory, no. 24, ed. M. A. Smith, M. Spriggs, and B. Fankhauser (Canberra, Australia: Department of Prehistory, Research School of Pacific Studies, Australian National University, 1993). As for the Brazilian rock art, the dates are especially controversial in that more than half of the population of practicing archaeologists doesn't even accept the idea that (and the evidence that) humans were in the New World, much less rock painting, before 12,000 years ago.

20. Margaret W. Conkey, "On the Origins of Paleolithic Art: A Review and Some Critical Thoughts," in *The Mousterian*

Legacy, Human Biocultural Change in the Upper Pleistocene, ed. Erik Trinkhaus, 201–227 (Oxford: British Archaeological Reports, International Series 164, 1983).

21. Richard Klein, "The Archaeology of Early Modern Humans," *Evolutionary Anthropology* 1, 1 (1992): 5–14; Paul Mellars and Chris Stringer, eds., *The Human Revolution: Behavioral and Biological Perspectives on the Origins of Modern Humans* (Princeton: Princeton University Press, 1989).

22. Phillip Chase and Harold Dibble, "Middle Paleolithic Symbolism: A Review of Current Evidence and Interpretations," *Journal of Anthropological Archaeology* 6 (1987): 263–96; John Lindly and Geoffrey A. Clark, "Symbolism and Modern Human Origins," *Current Anthropology* 31 (1990): 233–62; Andrew Duff, Geoffrey A. Clark, and Thomas Chadderdon, "Symbolism in the Early Paleolithic: A Conceptual Odyssey," *Cambridge Archaeological Journal* 2, 2 (1992): 211–29.

23. Some examples of these systemic (and functional, adaptive) approaches include Margaret W. Conkey, "Style and Information in Cultural Evolution: Toward A Predictive Model for the Paleolithic," in *Social Archaeology: Beyond Dating and Subsistence*, ed. Charles L. Redman et al., 61–85 (New York: Academic Press, 1978); Clive Gamble, "Interaction and Alliance in Paleolithic Society," *Man* 17 (1982):92–107, and "The Social Context for European Paleolithic Art," *Proceedings of the Prehistoric Society* 57, 1 (1991):3–15; Michael Jochim, "Paleolithic Cave Art: Some Ecological Speculations," in *Hunter-Gatherer Economy in Prehistory: A European Perspective*, ed. Geoff Bailey, 212–19 (Cambridge: Cambridge University Press, 1983); John Pfeiffer, *The Creative Explosion* (New York: Harper and Row, 1982).

24. Leroi-Gourhan, *Treasures* and *Dawn of European Art*.

25. Margaret W. Conkey, "L'Approche Structurelle de L'Art Paléolithique et l'Héritage d'André Leroi-Gourhan," *Les Nouvelles de l'Archeologie* 48/49 (1992):41–45.

26. Patricia Vinnicombe, "Rock Art and Material Property," paper presented at "The Longest Career: To Honor J. Desmond Clark" (1986, Berkeley, CA.); "Rainmaking and Rock Art in Australia," paper presented at ACRA: The Alta Rock Art Conference (1993, Alta, Norway).

27. Schoch, "California Q and A."

28. Whitney Davis, "The Origins of Image-Making," *Current Anthropology* 27 (1986):193–215.

29. Nancy Munn "Visual Categories: An Approach to the Study of Visual Systems," *American Anthropologist* 68 (1966):936–50; and *Walbiri Iconography* (Ithaca, NY: Cornell University Press, 1973).

30. Claire Bellier, "Contribution à l'Etude de l'Industrie Osseuse Préhistorique: Les Contours Decoupées du Type 'Têtes des Herbivores,'" *Bulletin de la Société Royale Belge d'Anthropologie et Préhistoire* 95 (1984):21–34.

31. Perhaps the most extensive and thorough attempts to demonstrate these aspects of "Paleolithic art" are by Alexander Marshack. See, for example, "Methodology in the Analysis and Interpretation of Upper Paleolithic Image: The-

ory versus Contextual Analysis," *Rock Art Research* 6, 1 (1989):17–53, and *The Roots of Civilization*, 2nd ed. (Mount Kisco, NY: Moyer Bell, Ltd, 1991).

32. Arlette Leroi-Gourhan "The Archaeology of Lascaux Cave," *Scientific American* 246, 6 (1982):104–113; Arlette Leroi-Gourhan and J. Allain, *Lascaux Inconnu* (Paris: Editions Centre National de la Recherche Scientifique, 1979); Pamela Vandiver, "Paleolithic Pigments and Processing" (MA Thesis, Massachusetts Institute of Technology, 1983).

33. Michel Lorblanchet "Peindre Sur Les Parois des Grottes," *Dossiers de l'Archéologie* 46 (1980):33–39.

34. Brian Pfaffenberger, "Fetishized Objects and Humanized Nature: Towards an Anthropology of Technology," *Man* 23 (1988):236–52; see also, Marcia-Anne Dobres and Christopher Hoffman "Social Agency and the Dynamics of Prehistoric Technology," *Journal of Archaeological Method and Theory* 1, 3 (1994); Tim Ingold, "Society, Nature, and the Concept of Technology," *Archaeological Review From Cambridge* 9, 1 (1990):5–17; Brian Pfaffenberger, "Social Anthropology of Technology," *Annual Review of Anthropology* 21(1992):491–516; L. Winner, *The Whale and the Reactor: A Search for the Limits in an Age of High Technology* (Chicago: University of Chicago Press, 1986).

35. Dobres and Hoffman, "Social Agency," 6 and 15.

36. Heather Lechtman, "Technologies of Power: The Andean Case," in *Configurations of Power in Complex Societies*, ed. John Henderson and Patricia Netherly, 244–280 (Ithaca, NY: Cornell University Press, 1993).

37. See also Robin Ridington, "Technology, World View and Adaptive Strategy in a Northern Hunting Society," *Canadian Review of Sociology and Anthropology* 19, 4 (1982):469–81; and "Knowledge, Power, and the Individual in Subarctic Hunting Societies," *American Anthropologist* 90 (1988):98–110.

38. Leroi-Gourhan himself felt that this kind of research on gestures and acts could lead to a universal perspective on technological evolution, see André Leroi-Gourhan, *Gesture and Speech* (Cambridge, MA: Massachusetts Institute of Technology Press, 1993). See also further discussion in Dobres and Hoffman, "Social Agency."

39. Martin Heidegger, *The Question Concerning Technology*, trans. W. Lovitt (New York: Garland Publishers, 1977).

40. Dobres and Hoffman, "Social Agency," 3, 7. See also Heather Lechtman, "Style in Technology: Some Early Thoughts," in *Material Culture: Styles, Organization and Dynamics of Technology*, ed. Heather Lechtman and Robert Merrill, 3–20 (St. Paul, MN: West Publishers for the American Ethnological Society, Proceedings, 1977); and "Andean Value Systems and the Development of Prehistoric Metallurgy," *Technology and Culture* 25, 1 (1984):1–36; V. Gordon Childe, *Society and Knowledge* (New York: Harper and Brothers, 1956).

41. As discussed in Dobres and Hoffman, "Social Agency"; Ingold, "Concept of Technology" and "Anthropological Studies of Technology," paper presented at the In-

stitute for Advanced Studies in the Humanities Conference, "Culture and Technologies," University of Edinburgh (July 1991); Heather Lechtman 1977, 1984, 1993; Pierre Lemmonier. "The Study of Material Culture Today. Towards an Anthropology of Technical Systems," *Journal of Anthropological Archaeology* 5 (1986):147–86; idem, "Towards an Anthropology of Technology," *Man* 24 (1989):516–27; idem, *Elements for an Anthropology of Technology*, University of Michigan Anthropological Papers No. 88 (Ann Arbor, MI: Museum of Anthropology, 1992).

42. Norman Bryson, *Vision and Painting: The Logic of the Gaze* (New Haven: Yale University Press, 1983), xii.

43. Ibid.

44. Jean Clottes, "Paint Analyses from Several Magdalenian Caves in the Ariège Region of France," *Journal of Archaeological Science* 20 (1993):223–35; Jean Clottes, Michel Menu, and Philippe Walter, "New Light on the Niaux Paintings," *Rock Art Research* 7, 1 (1990):21–26.

45. Jean Clottes, Michel Menu, and Philippe Walter, "La Préparation des Peintures Magdaléniènnes des Cavernes Ariègeoises," *Bulletin de la "Société Préhistorique Française* 71, C.R.S.M. 87, 6 (1990):170–92; Michel Menu et al., "Façons de peindre au Magdalenien," *Bulletin de la Société Préhistorique Française* 90, 6 (1993):426–32.

46. For example, see Hélène Valladas et al., "Direct Radiocarbon Dates for Prehistoric Paintings at the Altamira, Castillo and Niaux Caves," *Nature* 357 (6373):68–70.

47. Dominique Buisson et al. "Les Objets Colorés du Paléolithique Superieur Cas de la Grotte de la Vache (Ariège)," *Bulletin de la Société Préhistorique Française* 86, 6 (1989):184–91; Jean Clottes, "Paint Analyses."

48. Lewis-Williams and Dowson, "The Signs"; David Lewis-Williams, "Wrestling with Analogy: A Methodological Dilemma in Upper Paleolithic Art Research," *Proceedings of the Prehistoric Society* 57, 1 (1991):149–62; idem, "Upper Paleolithic."

49. Vandiver, "Paleolithic Pigments."

50. Lechtman, "Style in Technology."

51. Terry Eagleton, *Literary Theory* (Minneapolis: University of Minnesota Press, 1983).

52. Ingold, "Concept of Technology," 7.

53. Whitney Davis, "Representation and Knowledge in the Prehistoric Rock Art of Africa," *African Archaeological Review* 2 (1984):8–35.

54. Dobres and Hoffman, "Social Agency."

55. Jean Clottes, "Art of the Light and Art of the Depths," paper Presented at Society for American Archaeology Annual Meetings, St. Louis, MO, 1993.

56. Donald Preziosi "Contru(ct)ing the Origins of Art," *Art Journal* (1982):320–25.

57. Lechtman 1977, 1984.

58. Mary Ellwood, *Material Culture*.

59. Natalie Boymel Kampen, "Ancients and Moderns, A Review of *Pornography and Representation in Greece and Rome*," ed. Amy Richlin, *Women's Review of Books* 10, 9 (1993):11–12.

Re/Writing the Primitive: Art Criticism and the Circulation of Aboriginal Painting

FRED MYERS

Introduction

It is widely recognized now that the MoMA exhibition in 1984, " 'Primitivism' in 20th Century Art: Affinity of the Tribal and Modern," and critical responses to it constituted a watershed in the anthropology of art. Among the principal features of this new geography is a partial destabilizing of the parallel boundaries between indigenous art worlds and the West and between anthropology and Western art writing.

The boundaries had been complex. After years, indeed decades, of attempts by anthropologists to gain official acceptance for non-Western visual arts and aesthetics as serious and deserving objects of inclusion in the modernist canon of visual culture, many anthropologists were surely surprised when critics pulled the rug out from under the whole enterprise. Ironically, art critics did so on grounds that anthropologists themselves had long argued: namely, the inapplicability of the modernist, formal concept of "art" itself as a universal interpretive/evaluative category.[1]

The dominant notion of "art" that came under criticism, in much of the writing, was the notion of an aesthetic experience constituted through the *disinterested* contemplation of objects as *art* objects removed from instrumental associations,[2] a view entirely compatible with the formalist em-phasis of prevailing art discourses.[3] The post-modernist move accepted the importance of cultural "difference," a staple of anthropological criticisms, as a critical challenge to universalist notions of "aesthetics" and went even further than most anthropologists would have gone.

On the one hand, it is interesting that these criticisms of the category of "art" and its effects were *internally* generated, emanating from the "high culture" arena of Western cultural production which seemingly had joined itself to long-standing anthropological suspicions of cultural associations.[4] Indeed, such criticism suggests something that anthropologists for the most part have not recognized fully, that the concept of art has been neither fixed nor monolithic in the West,[5] and that it might even be altered or transformed in dialogue with visual materials from other traditions.

On the other hand, this convergence reiterates the de-stabilization of the boundaries between anthropology and art criticism—and the importance of considering the common roots and entwined histories of the discourses and practices through which "culture" is interpreted. Non-Western practices have become of theoretical significance for the massive and critical debates within the art world itself concerning aesthetics and cultural politics.[6] This is especially true where the critical debates have focused on the inclusion or exclusion of context as relevant to interpretation. Yet, at the same time, anthropology and anthropological concern about the importance of ethnographic context for understanding human activity and products[7] is itself challenged both by avant-gardist emphases on the unmediated and challenging experience of the thing itself as bearing the potential for delivering the "unsettling shock of the new," and by critiques of Western anthropologists' claims to mediate and represent indigenous voices.[8]

Taken as a larger phenomenon, it seems clear that there is a "re-placement" of anthropology and its knowledge within art-world discussions. This move also reflects a change in the nature of

contemporary cultural flows transnationally, flows in which objects (or practices) that might once have been considered ethnographic artifacts enter immediately into a Western art market discourse of aesthetic judgment. While the boundary between the domain of art and anthropology has never been very clear,[9] navigating the translation between art world discourse and that of anthropology is now particularly challenging and demanding of a genuinely dialogical stance.

Art Criticism and Anthropology

It is in these circumstances that I discuss the significance of art critics and criticism for an anthropology of material culture. Not only has the critical evaluation of objects failed to attract the anthropological attention and analysis it deserves, but such critical activity has also been viewed as a location of cultural practice actively *opposed* to ethnography, despite its significant parallels with anthropology. Like anthropology, after all, criticism has culture as its object. Nonetheless, opposition is evident in the response of anthropologists to critical writings about the works of people they study; we anthropologists have often treated criticism as external to its object, as ethnocentric and unable to grasp the real ("true") intentions or meanings of the producer's work. While this seems prominently the case, for example, with Sally Price's (1989) account of the exclusion of Saramaka cloth work from exhibition in art venues, I could as easily offer my own initial responses to some critical writings about Aboriginal Australian acrylic paintings.

In fact, my interest in criticism was raised by the experience of following the movement of Australian Aboriginal acrylic painting into the larger art worlds of Australia, the U.S., and Europe. In this instance, as I have tried to describe elsewhere,[10] a profusion of critical responses—in newspapers, art journals, and catalogs—have

attempted to place these paintings within discourses (as art, craft, antique, or religious object) or to generate a discourse and sensibility for their appreciation. Subsequently, too, conversations with a pair of art historians-turned-critics[11] at a symposium at Harvard's Carpenter Center in 1990 convinced me that the way they had "trained their eye" to Aboriginal painting was worth serious consideration. Thus, my interest is in shifting the anthropological position from one of judging critical writing to that of considering such work as forms of culture itself—as "culture-making." I will take as a rough starting point Donald Kuspit's now somewhat old-fashioned sounding claim that:

> Art criticism . . . is neither description nor evaluation of art. It is a means of entry, through art, into a study of the complex intentions that structure the life-world, and a demonstration of art's structural role in the life-world that produces it.[12]

While my discussion of art criticism is inspired largely by considering the intercultural mediation of non-Western objects, I believe the enterprise has significance more broadly for understanding the relationship between anthropology and art criticism. The main problems I wish to address are the anthropological study of art criticism as a practice of Western "culture-making," the similarities and differences between art criticism and ethnographic interpretation, and the anthropological interpretation (and evaluation) of art-critical interpretations of non-Western cultural artifacts. Given the complex cultural mutualities and entwined histories of art discourses and anthropological discourses on culture, I have, as should become clear, some ambivalence about any simple solutions to this last problem that might a priori privilege anthropological frames of interpretation—or appropriation. In this respect, the condition of cross-cultural or intercultural transaction should be an illuminating boundary case.

Of Categories and Contest

Until recently, a central issue in the anthropological study of visual form has been the question of whether or not the producers have a category of "art." Typically, this has been understood as a question of whether some objects, or classes of objects, are understood as distinct from others in terms of aesthetic judgments, appreciated only in terms of their formal properties, apart from other functions. In practice, this has often meant discovering whether producers have notions of "beauty" or aesthetic quality that determine the value of objects (or performances). Some have rejected this pursuit, finding in the search for even an indigenous aesthetics too much of an application of that conception of aesthetics, art, and judgment that we in the West have inherited from Immanuel Kant's formulation of the three faculties of value assessment: pure reason (logic, truth), practical reason (utility), and judgment (beauty).

My point is that the concern over the existence (or nonexistence) of categories is misleading, if not mistaken entirely. What essentially is involved in the existence and application of categories is human action—that is, of evaluation. The negotiation of such applications and the placement of objects, or performances, within frameworks of value in social life might be grasped more fully if the similarity to the contentious process called "criticism" in the West were recognized. To be sure, the elaboration of criticism as an institution of political, economic, and social impact in contemporary Western societies is not equivalent, in any simple sense, with the practices of evaluation in more small-scale societies that do not have a market, print media, or host of other art institutions (universities, art education, government funding).

Nonetheless, I argue for the consideration of "criticism" as a form of interpretive practice that is not *external* to the production of significance in (or through) art. Rather, it is part of the social—often dialogical and contested—process that underlies collective apprehensions of meaning in many cultural traditions. Is a ritual design "correct"? Is this really a "ritual"? Is the application of yellow ocher in place of brown acceptable in a particular context? Criticism of this sort regularly accompanies performances of Aboriginal image-making in the ritual context and, as ethnomethodologists have always stressed, helps to define what sort of thing is going on.

This formulation *does* raise the question, significantly, of the relationship between critical representations (or mediations), products, and audience(s). In the case of "intercultural transactions," the assumption of a shared set of cultural conventions—between producer and audience—is what needs to be questioned. The work of interpretation requires a significant rethinking of these relations, as recent studies of communication attest,[13] especially because the work of criticism might well be seen as one of cultural brokerage between producer and consumer.

It is not merely the presence of a category "art" that defines our object of study in material culture, but the practices of evaluation, their institutions, and their power to define. Moreover, I am particularly concerned with how criticism is involved in *producing* a sensibility for appreciating or grasping forms of material culture. Thus, art writing, to speak more generally in terms drawn from David Carrier,[14] provides a meaningful or narrative framework for placing particular pieces within a story, a history. And depending on the story, the value of particular pieces is defined by their place in the history. Clement Greenberg[15] in recent years, Wölfflin earlier, and Vasari long ago have held sway in defining such histories for painting and assignments of historical value to particular works and their makers. Of these, Greenberg's work is more concerned with "criticism" (as opposed to art history),[16] as a way to define particularly a sensibility for grasping contemporary works and for discriminating among them.

Before one goes too far down the line of universalism, however, let me make my next point. The interesting location for ethnographic study lies in considering the *institutional conditions* of such cultural mediations.[17] The contexts in which critical evaluations are circulated, for Aboriginal Australian acrylic paintings, are local, national, and global—involving art advisers, state funders, professional art critics, collectors, audiences, and others. Each institution has its own trajectory and discursive traditions, not to speak of its economic grounding. In retrospect, after all, the profusion of postmodern art and theory seems strongly driven by 1980s money in the art market,[18] just as Abstract Expressionism's acceptance and legitimation was integrally involved in post World War II political and economic conditions.[19] For an anthropologist, the lesson is straightforward: we should regard the art world itself—producers, critics, patrons, cultural policies, dealers, collectors, and historians—as embodying a set of discourses and practices for bringing significance to cultural activities.

Acrylic Painting: A Case in Question

This argument is perhaps best grounded in a case from my own research. Perhaps the most celebrated show of Aboriginal painting was the Asia Society exhibition, "Dreamings: The Art of Aboriginal Australia," in late 1988 in New York. (fig. 1) Two years in the planning, most regard it as a critical success. Nonetheless, I remember quite vividly the urgency with which its curators awaited the "reviews." Among the first to appear was Peter Schjeldahl's,[20] in the now defunct *7 Days*, an irritating but direct and honest response. Schjeldahl seems to have got wind of the generally positive (and commercially significant) promotion of the show. Presumably, he also had a sense of the deluge of writing about Aboriginal painting in Australia during the years leading up to the 1988 Bicentennial there.

Essentially, Schjeldahl complains that the disconcerting power of Aboriginal people to challenge his/our view of reality is not sustained in the exhibition. He contrasts this with his experience, some years ago, in Alice Springs.

> Don't go looking for that power of strangeness at the Asia Society. It's not there, except faintly in a few old carvings and paintings on bark. Instead, there is the violence of fences, unconsciously erected by people wanting only good things for aborigines. The show is an American boost for an Australian project to market symbols of the aboriginal religion, which has long been known by such pretty names: 'songlines,' 'dreaming'. The violence lurks in the straight lines of stretched canvases that aborigines are painting with acrylics, using motifs proper to the ephemeral sand- and body-painting employed in their rituals. Promoted internationally, the paintings are seen as a means to build independent wealth and self-esteem for a people gravely lacking both.[21]

Maybe, after all, the cross-cultural transaction will not work. This is a good example of the difficulties, because what Schjeldahl finds to be lacking is something genuinely other and challenging to his/our reality. The acrylics made by Aborigines lack the "dignity" of the "wonderful" wallaby carving made for actual use in ritual. This critic finds that the formal properties of the paintings betray a sad and perhaps devastating situation of cultural domination.

Even so, however stridently critical, Schjeldahl's review *was* publicity, inaugurating a challenge—met by other, favorable reviews. Here, was something! Reviews comprise a major component of the profile or resumé of artists individually and of a movement. Also reviews compete to define the significance or meaning of an exhibition and the works within it.

In the flood of reviews and exhibitions of Aboriginal acrylic paintings in 1988 and 1989, the intercultural accountings were remarkably di-

Figure 1. Upstairs at the Asia Society Galleries, November 1988.

verse. Let me enumerate some of the reviewers' perceptions: Are these works "art," describable in the conventions of Western aesthetics?[22] Are they "good" art,[23] or are they weaker versions of 1970's Neo-Expressionist abstraction?[24] Do they "challenge" Western conventions of the visual imagination (a notion given particular value as consistent with goals of innovation, progress, and freedom in Western art production)?[25] Do they challenge Western conventions of the artist as individual producer—either by their communal production, a feature stressed in several

Figure 2. Papunya Tula Paintings at the Asia Society "Dreamings" exhibition. "Jangala and Two Women at Ngurrapalangu," 1982. Uta Uta Jangala. Acrylic on canvas, 122.5 × 91 cm.

accounts,[26] or by virtue of the fact that "traditionally, all people in the Aboriginal community are artists"?[27] Do these works offer a glimpse of the spiritual wholeness lost, variously, to "Western art,"[28] to "Western man," or to "modernity"? (fig. 2, fig. 3)

One could go on. Do the paintings represent the worthiness of Aboriginal survival and, consequently, the dilemma and indictment of modern Australia's history and treatment of their forbears as less than human, as Robert Hughes and Tom Keneally claim?[29] Are they a conceptual return to our lost ("primitive") selves, as suggested in critic Amei Wallach's subtitle: "Aboriginal art as a kind of cosmic road map to the primeval"?[30] Or do these objects, rather, represent a corruption and degeneration of an authentic Aboriginal vision and spirituality by the commodification of the marketplace?[31] Is this an entry of individualism into Aboriginal social relations through the corrupting economic flow of cash and the marketing techniques of individual shows?[32] Contrarily, are these objects evidence of cultural renewal, creativity, resistance, and survival, as the artists themselves would claim?[33]

Clearly, some of these framings—such as

Figure 3. Papunya Tula Paintings at the Asia Society "Dreamings" exhibition. "Old Man Dreaming at Yumari," 1983. Uta Uta Jangala. Acrylic on canvas, 242 × 362 cm.

those of *New York Times* critic Roberta Smith[34]—could not have circulated as freely or as meaningfully in Australia. It should be important, then, to trace the varieties of discursive space in Australia in comparison to those in the international scene, comparing reviews and discussions in newspapers, Sunday supplements, and art magazines to get a sense of the breakdowns of discourse by nation and class.

Jennifer Isaacs' review of an exhibition at the Blaxland Gallery in Sydney,[35] for example, maintained that the admixture of European materials and venues for Western Desert visual culture is not a loss of authenticity or cultural subordination.[36] The hybrid nature of acrylic painting represents an explosion of creativity, even breaking the bounds of the wrongheaded (to her mind) efforts by some advisors to encourage the singular use of traditional ocher colors, in the interests of "cultural purity." Such policies are reminiscent, in her construction, of the earlier policy of separate development and an unchanging Aboriginal culture.[37]

The colors of paintings from the communities of Balgo and Yuendumu, not restrained by the muted restraint of those produced for Papunya Tula Artists, remind her of the hybrid vitality of country-western hymns she heard at the Pintupi community of Kintore (now known as Warlungurru): "These existed side by side with the spiritual, the total expression of a timeless religion which any who have experienced the Australian landscape in depth will understand."[38] For Isaacs, it would appear, the artistic forms are made sensible by their referent—the Australian landscape—which is ultimately available to *any* Australian, and therefore, one presumes, these Aboriginal productions are a contribution to an (emerging) *Australian* culture.[39]

This is probably an important rhetoric for Australians, as an interpretation that implicitly counters views of "the Aboriginal" as tradition-bound, incapable of change and innovation,[40] unable to enter into the twentieth century, doomed to extinction. It also speaks strongly to art-world discourses of creativity and innovation. The issues and the judgments are complexly intersecting.

And there are more narratives for the paintings, still. Can the story of the significance of these paintings be inscribed as the viewer's or reader's discovery of a broader world of differences?[41] Can the visit of Aboriginal painters to New York be interpreted as *their* discovery of the broader world of modernity? Or are these paintings, as the painters often say, only reproductions of designs that were not created by human beings but which come from their sacred traditions, The Dreaming, and which represent the events of that mythological order?

I want, however, to point out a deeper, implicit narrative shared by those many differing emplotments. Most of the stories produced by the Western viewers have been inclined to see the situation of Aboriginal people as one of "crisis," a term that implies possibilities of solution, change, or of utopias.[42] I haven't time to explore this adequately here, but "crisis" is a conception that depends on notions of history that grew to prominence in the West after the Renaissance. It is not a concept common to Aboriginal thinking about the world. They neither see their situation in the world in anti-utopian terms nor do they see the contemporary painting as a radical break with or challenge to their past.

Moral Stances / Cultural Boundaries

The most noticeable feature of these writers about Aboriginal acrylics is their concern to define a moral stance, to place their interpretation in the context of what they think will *happen* to Aboriginal people, to justify their own situation in relation to the Aboriginals' presence. Yet, ironically, what is equally difficult and striking is how little these writers consider the Aboriginals' views of their own lives and futures. J. J. Healey's persuasive readings of writing about Aborigines[43] shows how white Australian writers define the Aboriginal future only (1) by the relations of dif-

ference—Aboriginal/European or black/white, with the result that the questions of assimilation, segregation, destruction continue to define the readings; (2) by labor conflict and economic struggle (with Aborigines allied with the proletariat in earlier Australian writings); (3) or by the problem of Australian national identity.

These issues recur in the narrative representations of Aboriginal art, inscribed often in questions of pan-Aboriginal identity as resistance to whites.[44] By contrast, to many Aboriginal painters, paintings are not usually seen as done by those one identifies with simply as "other Aborigines" but by a "mother," a "father," "one countryman," and so on. Nor, I think, can specific Aboriginal histories be defined coherently in such general terms as the "Aboriginal encounter with whites."

Context matters. The Aboriginal at the Asia Society in North America is not the Aboriginal over whom Australian writers or moralizers are stricken by conscience, although he/she remains the same for an Australian audience. For a North American audience at the Asia Society, the presence of Aboriginals and their paintings are less defined by a sense of the European conquest (repressed or expressed) as defining the relations between them.

In America, one finds a greater struggle to place the Aborigines and their paintings within the context of art and art criticism, where, for example, the longterm, ongoing arguments about the autonomy of art and its separation from other domains are themselves signifying practices—stories—that define, essentially, what "culture" is in the West. Unquestionably, one of the major issues for art theory is its assertion of autonomy, the occupation of a separate cultural domain, while anthropology has insisted on a holism whereby no dimension of cultural life is naturally to be considered in isolation from others. An anthropologist encounters the category of "art" with a suspicion, a sense of its strangeness, whose sensibilities do not however have much in common with art's own inter-

nal "assault on tradition" and challenge of boundaries.

In this Western historical context, the very separation of an aesthetic dimension—concomitant with the differentiations of people (class, race, and culture) within and between nation-states—was constitutive of art and aesthetics as a particular mode of evaluating, or interrogating, cultural activity and its value. Thus, the critic Clement Greenberg[45] founded his understanding of "art" in opposition to the kitsch of mass culture.[46] Or, to take another example, in his well-known discussions of the autonomy of aesthetics that arose with the bourgeoisie, Adorno argues dialectically that "what is social about art is its intrinsic movement against society, not its manifest statement. . . . Insofar as a social function can be ascribed to art, it is its functionlessness."[47] Against the domination of exchange value, which threatens to reduce all quality to quantitative equivalence, therefore, Adorno conceives the function of art as "a social realm that is set apart from the means-end rationality of daily bourgeois existence. Precisely for this reason, it can criticize such an existence."[48]

Criticism as Collective Interpretation

Let me now turn to a different dimension of my interest in criticism as an institution needing ethnographic inquiry. This involves viewing criticism and evaluation as collective interpretation. In the case of Aboriginal painting moving into this nexus, at the Asia Society show, the critical apparatus of the art world appeared as an enemy (or friendly adversary) to be won over, external to the already-known significance of the paintings to anthropologists (e.g., as tokens of the Dreaming).[49] Nonetheless, presumed critical canons figured heavily in the production of publicity, catalogs, and so on.

The ethnographer makes something different of this than does the anthropologist-curator.

Therefore I want to outline what such an approach would look like. In developing my work, I have tried to learn something about the place of criticism in contemporary Western art practices. Here, I found a substantial literature—largely produced by historians and critics themselves—that has discussed the importance of writing as a defining activity. I try to recognize in participant's own work of interpretation—what the social theorist Anthony Giddens has called their "discursive consciousness"[50]—resonances and congruities on which to draw for understanding how meaning is created. For example, Danto's reflections on the *defining* capacity of "art world" theories,[51] drawing heavily on the supposed theoretical rupture with art history created by pop art,[52] have considerable value for anthropological thinking about cultural activities. Nonetheless, it lacks a broad perspective on the institutional settings of such activity. I also have been excited and challenged by the growing body of work in the arts on the problems of representation and of "Otherness," but these relatively recent avant-garde critical treatments of the art world's productions and consumptions of "difference"[53] have rarely located themselves (or their object) empirically in the social contexts of the art's definition. They do not actually go out and study the "system" that they suppose constitutes a desire for objects.

Now, what is at stake in any exhibition is publicity: to have an audience you first must get people to come to see the show. This publicity depends both on advertising and significantly on reviews, especially in widely circulated periodicals. The work of producing a meaning, a review, an evaluation, begins when an exhibition is planned, with plans for publicity, posters, etc. Grants to support exhibitions require this as a provision. Moreover, the work of interpretation is supported in wall texts, promotional literature, press packets, interviews, catalogs—as well as in the already objectified histories and categories of the objects to be displayed.

Curators and their staffs attempt to get in touch with journals, editors, and reviewers not just to promote a response but also to manage that response. The reputation and contacts of curators or participants can be important, and while some critics refuse to be drawn into such potentially compromising situations—the contemporary interplay among critics, curators, and dealers is such that one must recognize a "network."[54] For anthropologists used to considering communities of interpretation, this network's "collusion," fueled perhaps by money and fame, is not the scandal it seems to be for participants[55] whose expectations of autonomy we do not share.

A final word is necessary on the presentation of the Asia Society exhibition and its inclusion of Aboriginal painters both in performance and in symposium to contextualize the event. An intentional component of the curatorial framing of the paintings, the significance of this presence is open to question—whether it should be understood as a display of Aboriginal people as a contemporary "spectacle of the primitive"[56] or as an attempt to open a discursive space that includes Aboriginal voices within it. Nonetheless, this presence—really a co-presence of Aboriginal and European instead of the temporal separation that has been critical to sustaining the distance of the "primitive"[57]—did affect the critical interpretations.

Producing Sensibility

As a last step, I want to offer a more concrete example of the potential that art criticism has for discerning the significance of cultural activity. I turn to a complex review of an Australian exhibition that was combined with a review of the catalog for the "Dreamings" exhibition.[58] Written by the Australian anthropologist John von Sturmer,[59] a one-time colleague of Sutton, this piece was clearly intended as a token for reviewing the

Asia Society exhibition itself. Its title, "Aborigines, Representation, Necrophilia," bitterly suggests how the critic regards the presentations of that catalogue and its treatment of Aboriginal cultural activity as "art" within a frame that fails to grasp its internal life.

Von Sturmer's critical judgment of the Asia Society enterprise was undoubtedly negative, especially in his perception of it as pandering to ill-informed Americans. This criticism involves a series of issues of Australian national identity that could be relevant to the discussion here, such as white Australian hostility to American cultural encroachment. However, given restrictions of space, I want to consider only how he tells us to look at another exhibition, of the painter Jarinyanyu David Downs from the Fitzroy Crossing area of Western Australia. Downs' use of imagery in acrylics, albeit from an area of Australia a bit distant from those of Papunya painters—i.e., the Great Sandy Desert—draws on a fairly similar aesthetic and religious tradition. His tradition, like that of Papunya painters, offers the possibility of multiple identities with ancestral figures, but these are far more openly represented than is the case in contemporary Papunya painting. Ancestral figures such as *Kurtal*, sometimes *Yapurnu*, and sometimes *Piwi* are the major personae that figure in his oeuvre. (fig. 4)

To enter, "through art into a study of the complex intentions that structure the life-world," as Kuspit writes,[60] requires combining the cultural significance of image-making with the particular construction of individual images. The combination of a command of art-world and anthropological language makes this discussion of Downs' solo exhibition in Sydney illustrative of how a critical discursive space might be opened. Von Sturmer's comments are instructive about what is involved in the development of critical sensibilities for the visual imagination in Aboriginal paintings, articulating the meaning of these visual forms as self-production and as illuminating "the interiority of Aboriginal life."[61] The inter-

pretation by an anthropologist, but in the mode of art criticism, is exemplary of the problem of interpreting an emerging cultural activity of acrylic painting, one for which the appropriate sensibilities are not discursively elaborated and shared between producer and audience. Insofar as Downs' art is innovative even within his own Aboriginal community, its mediation is presumably no simpler for them.

The initial problem is to make the formal constructions of Downs' paintings intelligible communication to the white Australian readers of *Art and Text*. For this, von Sturmer must rely on his own ethnographic understandings of Aboriginal cultures to get anywhere.[62] At first, he says, he was disconcerted by the paintings which were "so smoothed out," "neat," "pre-arranged," "little cartoon figures," "everything framed and packaged." Thus,

> At first glance it is the same oozy sentimentality as cheap French tourist art—cute and at the same time somehow chilling. They hover on the brink of personality like dolls. . . . This effect is produced principally by a certain hollowness in the treatment of the body, especially the face. The central figures stand with their legs planted firmly on the ground, looking out, bland and impassive, like dancers caught in one of those lulls in dancing when the singing has stopped. A moment of *liminality*—and presence.[63]

The importance of these formal features, von Sturmer says, is that attention is not focused on the particularity of their bodies, but on those elements of meaning that are "added" to them: designs, staffs, and headdresses—in other words, the ritual property. Downs' paintings are representations of dance and ritual, "already representations of representations."

This is where the critical step must come—and where interpretation of the acrylics has typically failed—namely, what is a ritual or dance? Such Aboriginal dancing, von Sturmer asserts, is con-

Figure 4. "Kurtal as Miltjitawurru," 1989.
Jarinyanu David Downs. Natural ochres and
synthetic polymer on linen, 183 × 122 cm.
copyright Duncan Kentish.

cerned with revelation, in which, "the real identity of the performer is discovered, made manifest, in the course of the dance. Thus dances become machines for testing claims about reality."[64]

What we (can) see in many of the paintings is the paradox "of static dancers undergoing the shock of transformations. The rudiments of this shock are what we can detect in their faces." Sometimes, "the transformations literally appear out of the top of their heads, flowing upwards out of their bodies," but "elsewhere, in one representation of Yapurnu, it is the bodily lineaments of liminality that are captured with great precision—the typical attitude of abasement, torso

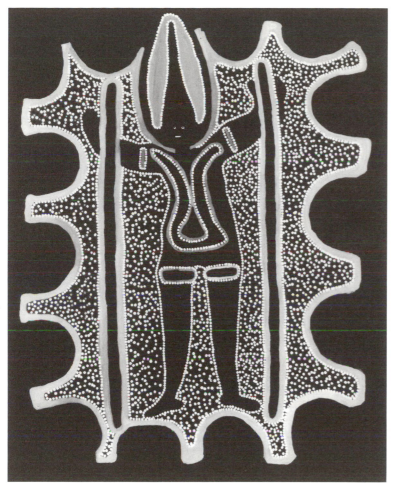

Figure 5. "Yapurnu," 1987. Jarinyanu David Downs. Natural ochres and synthetic polymer on linen. copyright Duncan Kentish.

tilted slightly forward and head bowed."[65] (fig. 5)

In von Sturmer's reading, the paintings go beyond this sort of self-representation. Their formal constructions reveal changing dimensions of something he calls "self-production"—the production of a self in the space outside traditional cultural dictates. Here, a critical perspective and an ethnographic one merge. Von Sturmer interprets the indigenous (Downs') construction of painting to be "an act of self-incantation, which at the same time is accompanied by a self-objectification in the form of the painting itself."

Recognizing this, von Sturmer suggests a cultural process at work in these manifestations of self-production, one in which the "personality's" engagement with the world is being transformed. In these self-objectifications, he says,

> there is . . . a form of self-expenditure, of self-exhaustion, requiring evermore demanding investment of the self. . . . Two routes are available: either Downs can refine or redefine the (self)images he has generated, leading to a routinisation of production, a movement in the direction of tourist

art, a progressive degradation of the limited set of identities available; or else he can achieve the progressive insertion of biography into his own work . . . the creation of a personal history that lies increasingly outside cultural dictates and the fixed points of identity. Painting then shifts from a rather straightforward act of self-depiction to one of self-analysis.[66]

The significance of this interpretation is apparent. It speaks of the conditions under which Aboriginal life is being transformed. But neither the paintings, nor von Sturmer's critical reading, suggest a homogenization of Aboriginal self-representation, a loss of authenticity. Indeed, the continuum that the reader comes to see is one defined by Downs' engagement of new conditions on terms brought from his own tradition.

This critical reading suggests that one cannot even grasp the meanings or the sensibilities embodied by this work if one departs from the local understandings that provide the foundation. Moreover, it is only in formulating this sensibility that the capacity of these paintings to engage the art world, to enter into dialogue with other traditions of visual imagination, can be conceived. At the same time, it is difficult to ignore the underlying (Western) theories of modernity on which von Sturmer draws. Nonetheless, without grasping the cultural particularity, there is nothing for the art world to see in Aboriginal acrylics. But this cultural particularity needs also to be informed by a sensibility to the specific formal devices themselves, rather than reduced to a stock of images that provide a repertoire.[67]

Circulation

Perhaps, it is possible at this point to draw some general conclusions about the relationship between ethnography and art criticism. The broadest frame of concern for any consideration of "art," I would suggest, is one that asks how discourse(s) about "art" and "art making" circulate broadly within the art world proper, as well as within the other institutions, such as primary schools, universities, and government funding programs, that might be considered its auxiliaries. While this position obviously shares space with the considerable postmodern criticism of the universalizing and essentializing narratives of "art,"[68] it also delineates the different stance of ethnographic practice. The space is lacking to develop this in anything other than the briefest terms, but it is important to recognize the dual placement of ethnography—that is, in the ethnographic study of art-critical practices as Western culture-making, on the one hand, and in the differentiation of ethnographic and art-critical practices of interpretation to some set of non-Western objects.

First, obviously, I am questioning the propensity to view such activities of "art criticism" as necessarily *external* to the "art culture" one purports to describe and analyze. I am even a bit leary of doing so in any absolute way in the case of intercultural transactions, although Western art criticism might (for example) import a whole range of alien notions into its interpretation of Aboriginal painting. Far from being an onerous problem, the unfinished nature of interpretation so frequently posed in critical confrontations is perhaps one of the most challenging properties of art culture as a field for theory that fully recognizes the significance of culture as an arena of contest. At a simple level, moreover, I am pointing out that many of *our* (that is, anthropological) analytic models may be indebted to the very art-world debates we now propose to "study"— e.g., those between modernism and postmodernism, those between aesthetic theory and institutional views, and so on.

Second, the recognition of these debates *in the* art world ought not to mean an easy identification for anthropology with anti-elitist or mass-culture positions attacking the boundary, positions that suggest there is no basis for differentiating among objects and practices. The apparent sim-

ilarity of the position of anthropology's traditional subjects to that delineated by critics of "high art" boundaries may be quite deceptive about the deeper cultural processes at work.[69] Here, art-critical writing may be of considerable use.

More complexly, the question of "externality" in relation to such intercultural transactions as the mediation of non-Western objects is quite vexing. I *do* want to acknowledge both the extent to which Western art-critical interpretations of Aboriginal painting may be an aspect of Western culture and Western culture-making and also their similarity, in that regard, to indigenous interpretive practice. At the same time, this similarity suggests one recognize the extent to which any such interpretive activities embody a hegemonic perspective. From the standpoint of Western culture (which is that of the Western art critic), the Western art critic's interpretation/evaluation appears as a continuation of the construction of meaning and value of which the non-Western object is the beginning; art-critical interpretation thus appears internal to the "object" and its meaning. A critical ethnography of Western art-critical practice, however, would strive to show the way the latter imports alien cultural categories in its construction of the cultural meaning of the object. To this extent, a critical ethnography would attempt to take the viewpoint of the non-Western culture—a viewpoint from which the art-cultural practices would appear external. While I might embrace this politics and this empiricism, I think it is difficult any longer to regard the (potential) opposition as mere matters of fact, although they certainly are that. The very confrontation of art criticism and anthropology clearly represent engagements with the politics of culture-making.

Third, therefore, I wish to ask whether anthropological writing should be normative or prescriptive for art practice. Certainly, we ought not to be in the simple position of challenging the claims of those, for example, who inscribe art practices as "spiritually redemptive," but should treat these formulations as "data"—as signifying

practices linked to others. Our writing is not, at the moment, participatory in defining "art" but we are interested in how these practices are put to work in producing culture. Nonetheless, the situation of the anthropologist is not simply one of "wonderment" before this strange phenomenon because art criticism and other art practices, for whom all of culture and its representation provide a field, attempt to position *us* within their discourses. Moreover, if art-critical discourse is a practice of "making" Western culture, then it is difficult to see how anthropology can entirely avoid a critical relationship to it.

Considered from another angle, the question might be what use is there in anthropological writing on these issues? My argument is both empirical and theoretical, drawing an insight that comes from recent work on art worlds but extending the notion of such communities to the difficult challenge of culturally different work and divided audiences. Following Faye Ginsburg's argument about indigenous media makers,[70] I would argue that we are involved in the crucial task of creating a discursive space for these new phenomena. In that sense, my concerns link with those of many scholars, such as the African scholar and film theorist Manthia Diawara[71] who situates his work and that of other Black intellectuals as engaged in creating a "black public sphere." Similarly, Aboriginal anthropologist and cultural critic Marcia Langton recently argued for the necessity of a new critical discourse for reception of contemporary Aboriginal media of all sorts. Let me quote from a recent position paper she wrote for the Australian Film Commission regarding the assessment of Aboriginal film proposals. In that paper, there is a "need to develop a body of knowledge and critical perspective [having] to do with aesthetics and politics . . . on representations of Aboriginal people and concerns in art, film, television or other media."[72]

The responses to Aboriginal acrylic painting that I have read are often quite simplistic, relatively uninformed, ethnocentric. At other times, they are perceptive and even startlingly illuminat-

ing. Rather than simply rejecting some and embracing others, the ethnographer should be considering the enterprise at hand—in which these representations might be considered as the foundations of a broader critical discourse that will constitute the history and context for "Aboriginal painting" in the West, the conventions for its interpretation and also of its innovation. Slowly there is a shift in Zeitgeist, so Aboriginal painting is not seen only as failed authenticity or failed Western art. It develops its own critical discourse, its own sensibilities. Such a discursive space is created out of exhibitions, reviews, performances, symposia, and so on, and therefore suited to ethnography's special talent for finding meaning in the often ephemeral nature of daily events—even art openings—when culture is continually produced and reproduced.

Conclusion

This essay, therefore, represents part of a larger attempt to initiate a more reflexive anthropological approach to art that recognizes an entwined history between anthropological and art institutions and discourses, and also those of indigenous artists and intellectuals.[73] If modernism itself may have been the condition of possibility for anthropological recognition of indigenous aesthetics, then the discourses of art theory and criticism—cultural products themselves, to be sure—can not simply be understood as arbitrary cultural constructions, valueless beyond their own local histories. Firth[74] reminds us of that debt to Western art's internal dialectic and the illumination he gained from early exhibitions of modernism and Western art critical practices. "For some anthropologists, of whom I was one," Firth writes,

> the admission into the graphic and plastic arts of distortion, of change of form from the proportions given by ordinary vision, came as a liberating influence. It was significant,

not only for an appreciation of the contemporary Western art, but also for a clearer understanding of much medieval and exotic art. Like Romanesque painting and sculpture, which have long captured my interest, the painting and sculpture which anthropologists encountered in exotic societies could be regarded, not as a product of imperfect vision, technical crudity, or blind adherence to tradition, but as works of art in their own right, to be judged as expressions of artists' original conceptions in the light of their cultural endowment.[75]

I do not seek simply to create another arena for ethnographic study. Nor do I wish to argue across the disciplinary boundaries, that anthropology is right and art criticism wrong, nor to present the voices of disciplinary practice as multiple or polyphonic. What distinguishes this essay is not an anthropology of art that preserves longstanding boundaries between indigenous worlds and those of the West, but an attempt to get beyond the accompanying analytic angst about "authenticity," "purity," "high/low," and "appropriation." In many respects, these received categories continue to haunt us—as Marx said, "like the dead hand of the past on the living."

I *am* arguing that what is useful about "Aboriginal acrylic painting" and critical writing about it is the emergence of new discourses for considering cultural activity. From an ethnographic location, grounded more in earlier experience of Aboriginal painters in their own settings, I am struck by the tragic problem of subjectivity "locked" into cultural categories, categories such as "art" and "non-art," "primitive" and "modern." Along with Clifford and Ginsburg,[76] I suggest that it is only in attempting to analyze and recognize how these discursive spaces are produced and contested that we can begin to re-situate the categories and hierarchies of value in ways that will reveal the outlines of an intercultural space.

In one sense, the boundaries are already de-

stabilized; anthropological and art writing are part of the same world. Their previous division of labor is ended. Cultural production is not. Indeed, increasingly it takes place precisely across boundaries previously essentialized in notions of "culture" as timeless or of "taste" as disinterested. These emerging forms of "difference"—innovation or creativity, if you like, in one world with complex terrains of power and discourse—demand their own theory or criticism for their sensibilities to be grasped. And it is difficult to see how much this would differ from what anthropologists do.

The problem of reworking received cultural boundaries and hierarchies is a difficult one. The arts, perhaps the most dynamic domain in relations between the so-called "First World" and the rest, are creating new cultural spaces. Unlike economics and politics, the arts—in the West, at least—has always been an arena in which playful, creative re-alignment with received boundaries can take place. Perhaps by exploring these dynamics in art worlds and criticism, we can start to make out the contours of a more genuinely "intercultural" future.

In a recent essay on "multiculturalism," itself an arena most highly developed in the arts, Terence Turner argues that the current conjuncture makes for "the steady proliferation of new cultural identities along with the increasing assertion of established ones."[77] The principal discourse of Aboriginal painters emphasizes their works as vehicles of self-production and collective empowerment. As Danto's conception of an art world might suggest, this is not necessarily an interpretation that is outside the processes of representation themselves. Indeed, it represents an engagement with emerging theoretical discourses in the arts themselves which emphasize, in the framework of multiculturalism, "the self-definition, production and assertion of cultural groups and identities in general."[78] Yet, as urban Aboriginal artist Fiona Foley has claimed,[79] Aboriginal painting does so from its own particular histories and conceptions of collectivity and

power. These differences, or particularities, are what should make this work of interest to the art world—both contributing to its development of a general theory of such cultural activity as "art" and drawing on it for an historical frame. It is in this way, with its recognition of cultural activity more generally as concerned with the capacity for self-creation, that criticism might be recognized as a broad, transcultural process in this historical conjuncture, even while it is built on the recognition of differences and disjuncture. To do so, however, criticism in the art world also should include Aboriginal intellectual voices.

Notes

Acknowledgments: This is really a work-in-progress. It draws on extensive discussions with a number of people, but especially with George Marcus, Faye Ginsburg, and Terry Turner. Portions of the argument developed here are based on those developed in an essay being written jointly by Marcus and me, entitled "The Traffic in Art and Culture," an introduction to an edited volume of new work on the relationship between anthropology and the contemporary art world. An earlier version was presented at the American Ethnological Society Annual Meetings in Santa Fe, New Mexico, April 15-17, 1993. A longer version is forthcoming in *Visual Anthropology Review.*

1. James Clifford, "Histories of the Tribal and the Modern," *Art in America* (April 1985): 164–77. Thomas McEvilley, "Doctor, Lawyer, Indian Chief," *Artforum* 23, 3 (1984): 54–60.
2. Pierre Bourdieu, *Distinctions.* Cambridge: Harvard University Press, 1984.
3. Raymond Firth recently discussed this model as "the theory of art as concerned with disinterested contemplation of the form of the object for its own sake, as end and not as means" ("Art and Anthropology," in J. Coote and A. Shelton, eds., *Anthropology, Art and Aesthetics,* 15–39. Oxford, 1992).

There are two perspectives relevant to the criticism of this notion of art. The first is that of Bourdieu (1984) who emphasizes the extent to which disinterested aesthetic contemplation is a bourgeois class position or habitus—one exclusive of other classes. M. H. Abrams (1985) similarly argues that such a view is a product of eighteenth-century aestheticism, with social and economic undertones:

Far from the theory of 'art-as-such', as he calls it, producing timeless truths about a distinctive class of artefacts, it is actually a way of talking about art that

emerged at a particular historical period in a changing form of social life. Connoisseurship and interest in non-utilitarian aesthetic culture gave prestige and became signs of upper-class status. (Firth 1992, 23)

Pierre Bourdieu has also made a significant attempt to understand the social and historical conditions that have made possible the "autonomy" of different fields of cultural production, "where what happens in the field is more and more dependent on the specific history of the field, and more and more independent of external history" (*The Field of Cultural Production: Essays on Art and Literature.* New York, 1993, 188).

The second perspective is that deriving from the exploration of gender and "cultural" difference, which emphasizes the cultural and historical specificity of the Kantian aesthetic notion and its concomitant ethnocentric power to exclude.

4. In a well-received general text, Robert Layton raises the perennial question of identifying art objects (as distinguished from "ordinary" objects) cross-culturally:

We cannot, as self-respecting anthropologists, assume right from the start that people the world over utilize the same aesthetic criteria as ourselves. Even in our own history, fashions have changed radically. Some peoples, moreover, deny any aesthetic criteria in evaluating what appear to be art objects within their cultural repertoire. (*The Anthropology of Art*, 2nd ed. Cambridge, 1991, 12)

5. But Raymond Firth, who lived through some of these changes, has a richer perspective. "In any definition of art" Firth (1992, 19) writes,

one tends to return to a central notion of an object evoking a diffuse kind of reaction often referred to as aesthetic sensibility. . . . The quality in the art object which provokes this reaction has been described in many ways since classical times but for some centuries has been crystallized as 'beauty.' . . . Yet in some European circles of the mid-1920s such insistence on pleasurable reaction, on beauty, as the sole touchstone of art would have seemed outmoded. . . . In their different ways, all such experimental movements [surrealism, metaphysical art, action painting, pop art, etc.] have focused on challenging the more conventional, accepted views of the nature of aesthetic recognition and aesthetic standards.

6. Hal Foster, *The Anti-Aesthetic: Essays on Postmodern Culture.* Port Townsend, Wash.: Bay Press, 1983. Lucy Lippard, "Sweeping Exchanges: The Contribution of Feminism to the Art of the 1970s," in *Get the Message? A Decade of Art for Social Change.* New York: E. P. Dutton, 1984. Idem, *Mixed Blessings: New Art in a Multicultural America.* New York: Pantheon, 1991. E. Michaels, "Bad Aboriginal Art," *Art and Text* 28 (1988): 59–73.

7. Jeremy Coote and Anthony Shelton, eds., *Anthropology, Art and Aesthetics.* Oxford: Clarendon Press, 1992. Alfred

Gell, "The Technology of Enchantment and the Enchantment of Technology," in Coote and Shelton 1992, 40–66.

8. James Clifford, *The Predicament of Culture.* Cambridge: Harvard University Press, 1988. Jacques Derrida, *Of Grammatology,* trans. G. Spivak. Baltimore: Johns Hopkins Press, 1977. Michel Foucault, *The Order of Things: An Archaeology of the Human Sciences.* New York: Pantheon, 1971. Idem, *Madness and Civilization: A History of Insanity in the Age of Reason,* trans. R. Howard. New York: Vintage, 1973. Edward Said, *Orientalism.* New York: Pantheon, 1978. Trinh T. Minh-Ha, *Woman, Native, Other.* Bloomington: Indiana University Press, 1989. Marianna Torgovnick, *Gone Primitive: Savage Intellects, Modern Lives.* Chicago: University of Chicago Press, 1990.

9. Clifford remarks, in fact, that they are part of the same system:

The two domains have excluded and confirmed each other, inventively disputing the right to contextualize, to represent these objects. As we shall see, the aesthetic-anthropological opposition is systematic, presupposing an underlying set of attitudes toward the "tribal." (1988: 201)

10. Fred Myers, "Representing Culture: The Production of Discourse(s) for Aboriginal Acrylic Painting," *Cultural Anthropology* 6, 1 (1991): 26–62.

11. These were Ann-Marie Brody and Memory Holloway.

12. Donald Kuspit, forward to Arlene Rita Olson, *Art Critics and the Avant-Garde, New York, 1900–1913,* xi. Ann Arbor: UMI, 1988.

13. Don Brenneis and Allesandro Duranti, eds., *The Audience as Co-Author.* Special issue of *Text* 6, 3. New York: de Gruyter, 1986.

14. David Carrier, *Artwriting.* Amherst: University of Massachusetts Press, 1987.

15. Clement Greenberg, "Avant-Garde and Kitsch," in *Art and Culture.* Boston: Beacon Press, 1965a. Idem, "Modernist Painting," *Art and Literature* 4 (1965b): 193–201.

16. See especially Greenberg's major essay, "Modernist Painting" (1965b). For interesting discussion of Greenberg, see Sidney Tillim, "Criticism and Culture, or Greenberg's Doubt," *Art in America* (May 1987):122–27; Thomas Crow, "These Collectors, They Talk about Baudrillard Now," in Foster, ed., *Discussions in Contemporary Culture,* 1–8. Seattle: Bay Press, 1987.

17. I am drawing quite obviously here on Arthur Danto's important conception of "artworlds" as the institutional matrix for bringing meaning to objects as "art." Arthur Danto, "The Artworld," *Journal of Philosophy* 61 (1964):571–84.

18. Nancy Sullivan, "Once Again, with Feeling: the Meta-Modern and the Postmodern in New York's 1980s Art World" (MA thesis, New York University, 1992).

19. Serge Guilbaut, *How New York Stole the Idea of Mod-*

ern Art, trans. A. Goldhammer. Chicago: University of Chicago Press, 1983.

20. Peter Schjeldahl, "Patronizing Primitives," *7 Days* (Nov. 16, 1988).

21. Ibid.

22. A. Wallach, "Beautiful Dreamings," *Ms.* (March 1989). P. Sutton, ed., *Dreamings: The Art of Aboriginal Australia*. New York: Braziller/Asia Society Galleries, 1988. Michaels 1988.

23. K. Larson, "The Brilliant Careers," *New York Magazine* (Oct. 4, 1988): 148–50.

24. R. Smith, "From Alien to Familiar," *The New York Times* (Dec. 16, 1988).

25. As "outsider" art, Roberta Smith (1988) sees the work in the Aboriginal show as "for the most part quite weak." She finds the recent acrylic paintings to "lack a visual liveliness of the Aboriginal efforts that precede them (sic)," meaning the bark paintings. "In addition, they lack the power of the best Western abstract art with which, torn from their original context, they will inevitably be compared" (ibid.) She is most interested in the way the exhibition "can unsettle one's usual habits of viewing and visual judgment, providing a number of issues to wrestle with, without, unfortunately, providing any real resolution" (ibid.) What is positive is that the art presents a constantly shifting ratio of alien and familiar aspects, undermining the efficacy of designating any art outside the mainstream. But the judgment is that "This is not work that overwhelms you with its visual power or with its rage for power; it all seems familiar and manageable" (ibid.). Smith recognizes that the paintings are based on narratives and motifs handed down through generations, but finds them to resemble "nothing so much as a solo show of a moderately talented abstract painter of the 70's."

She is suspicious of the "mercantile intent" of the exhibition, introducing the acrylic paintings to the New York art market, and while seeing the charming bark paintings and carved wood objects to provide context and background for the acrylics, believes them to be there in order "to supply a necessary degree of credibility" (ibid.). For her, the show is didactic, and

> the art does not survive the separation from its original context or materials. Nor does it fare well without a great deal of protective packaging. Accompanying text panels and photographs explain the beliefs and rituals of the 'dreamings,' the narratives wherein humans, animals and physical phenomenon like water acquire spiritual attributes . . . The more you read, the better things look, but they never look good enough. The accompanying material also suggests that these same motifs are more convincing in their original states . . . [ibid.]

26. J. Cazdow, "The Art of Desert Dreaming," *The Australian Weekend Magazine* (Aug. 8–9, 1987a): 6. Michaels 1988.

27. R. Stretton, "Aboriginal Art on the Move," *The Weekend Australian* (Sept. 5–6, 1987): 32. See also J. Isaacs, "Waiting for the Mob from Balgo," *Australian and International Art Monthly* (June 1987): 20–22.

28. R. Hughes, "Evoking the Spirit Ancestors," *Time* (Oct. 31, 1988): 79–80.

29. Ibid., and T. Keneally, "Dreamscapes: Acrylics Lend New Life to an Ancient Art of Australian Desert," *New York Times Sunday Magazine* 138 (Nov. 13, 1988): 52f.

30. Wallach 1989.

31. T. Fry and A. Willis, "Aboriginal Art: Symptom or Success?," *Art in America* (July 1989): 109–17, 159–60, 163.

32. Michaels 1988. P. Taylor, "Primitive Dreams are Hitting the Big Time," *New York Times* (May 21, 1989).

33. Isaacs 1987. Fred Myers, "Truth, Beauty and Pintupi Painting," *Visual Anthropology* 2 (1989): 163–95. Sutton 1988. Warlukurlangu Artists, *Yuendumu Doors: Kuruwarri*. Canberra: Aboriginal Studies Press, 1987.

34. Smith 1988.

35. Isaacs 1987.

36. Isaacs' (1987), review of "Survey of Contemporary Aboriginal Art II," at Sydney's Blaxland Gallery, 1987.

37.

> . . . Those who would 'keep the culture pure' might also have wished that the men and women gathered together wore possum skin belts and public tassels rather than stockmen's hats . . .
> In art terms this attitude, for a long time, kept traditional Aboriginal art in its niche, valued primarily for its meaning, use of traditional materials, and resemblance to older works in major collections. In terms of contemporary art development this meant that until relatively recently for Aboriginal paintings to even reach the market, to get past the local barriers of community art adviser value judgments as well as the value judgments of the various dealers and government-sponsored bodies along the way, they had to exhibit ocher colours . . .
> The situation now has reversed completely . . . It revealed a wonderful explosion of creativity spreading across Aboriginal Australia almost without restraint and yet with the strength, verve and vigour which in the truly traditional and religious sense, clearly comes from the land itself and the attachment of the people to it expressed through their art" (Isaacs 1987).

38. Ibid.

39. However conscious of other representations these constructions are, there is no Derridean suspicion of *origins* or fear of the *transcendental signified* here.

40. T. G. H. Strehlow, *Aranda Traditions*. Melbourne: Melbourne University Press, 1947.

41. J. Cazdow, "The Art Boom of Dreamtime," *The Australian Weekend Magazine* (Mar. 14–15, 1987a):1–2. Wallach 1989.

42. For discussion of "crisis," see Alan Megill, *Prophets of*

Extremity. Berkeley: University of California Press, 1988, 265–66

43. J. J. Healey, *Literature and the Aborigine in Australia.* St. Lucia, Qld: University of Queensland Press, 1979.

44. See Sylvia Kleinert, "Black Canberra," *Art and Text* 29 (1988): 92–95, but also see a self-consciousness about these issues in Vivion Johnson, "Among Others: Reply to 'Black Canberra,'" *Art and Text* 30 (1988): 98–99.

45. Greenberg 1965a.

46. Crow 1987.

47. Adorno in Peter Bürger, *The Theory of the Avant-Garde.* Minneapolis: University of Minnesota Press, 1984, 10.

48. Ibid.

49. For a discussion of the widespread Aboriginal conception signified by use of the term "Dreaming," see W. E. H. Stanner, "The Dreaming," in T. A. G. Hungerford, ed., *Australian Signpost.* Melbourne: F. W. Cheshire, 1956 and for a discussion of its relevance to the understanding of acrylic painting, see Myers (1989).

50. Anthony Giddens, *Central Problems in Social Theory.* Berkeley: University of California Press, 1979.

51. Danto 1964. Idem, *The Philosophical Disenfranchisement of Art.* New York: Columbia University Press, 1986. Idem, "Critical Reflections," *Artforum* 28 (September 1989). Idem, "The State of the Artworld: the Nineties Begin," *The Nation* (July 9, 1990): 65–68.

52. See also Carrier's (1987) extension of this to "art writing" as an interpretive practice.

53. Hal Foster, *Recodings: Art, Spectacle, Cultural Politics.* Seattle: Bay Press, 1985. Clifford 1988.

54. Lawrence Alloway, *Network: Art and the Complex Present.* Ann Arbor: UMI, 1984.

55. See, for example, John Baldessari et al., "Making Art, Making Money: Thirteen Artists Comment," *Art in America* 78 (1990): 133–41, 178. Suzi Gablik, "Dancing with Baudrillard," *Art in America* 76 (1988): 27–29. Carter Ratcliff, "The Marriage of Art and Money," *Art in America* 76 (1988): 76–84. Abigail Solomon-Godeau, "Living with Contradictions: Critical Practices in the Age of Supply-Side Aesthetics," in A. Ross, ed., *Universal Abandon: The Politics of Postmodernism.* Minneapolis: University of Minnesota Press, 1988.

56. Fry and Willis 1989.

57. Johannes Fabian, *Time and the Other: How Anthropology Makes Its Object.* New York: Columbia University Press, 1983.

58. Sutton 1988.

59. J. von Sturmer, "Aborigines, Representation, Necrophilia," *Art and Text* 32 (1989): 127–39.

60. Kuspit 1988.

61. Sturmer 1989.

62. Von Sturmer's own research has been principally in Cape York Peninsula, Queensland, but he has also done substantial fieldwork in Central Australia with the Aranda and also in Western Arnhem Land. All of these locations, however, are outside the particular orbit of David Downs.

63. Sturmer 1989, 133.

64. Ibid.

65. Ibid.

66. Ibid., 134.

67. This analysis suggests that what may be principally of interest to the art world is how these productions are seen as embodying a principle of "self-realization." This principle as the significant dimension of all cultural activity stands currently, I believe, as the central criterion in formulating a discourse of "art." That it is clearly a principle which is exalted into a universal by the workings of international commodity capitalism historicizes it, one presumes, but that hardly detracts from the capacity of such a discursive formulation to help us grasp the projects of acrylic painters. This is especially true in the case of intercultural transactions, in which "culture" is somewhat freed from its traditional moorings. Elsewhere, these conditions led into many of the gestures of poststructural criticism, the "detachment" of signifiers from their signifieds and their "contestation." Here perhaps one should maintain merely that this language may provide us with a framework for grasping the contemporary projects of painters who struggle to make their signifiers capture the world in which they live.

68. Hal Foster, *Recodings: Art, Spectacle, Cultural Politics.* Seattle: Bay Press, 1985.

69. Mark Stevens, "Low and Behold," *The New Republic* (December 24, 1990): 27–33.

70. Faye Ginsburg, "Aboriginal Media and the Australian Imaginary," *Public Culture* 5 (spring 1993).

71. Manthia Diawara, "The Black Public Sphere," *Afterimage* (1993).

72. Marcia Langton, "Well, I Saw It on the Television, and I Heard It on the Radio," Position paper for Australian Film Commission (1992).

73. For a more extensive discussion of these problems and the possible solutions, the reader is directed to the project I have been undertaking with George Marcus (Marcus and Myers, in press). This essay borrows freely from that joint work.

74. Firth 1992, 18–20.

75. Ibid.

76. Clifford 1988. Ginsburg 1993.

77. Terence Turner, "Anthropology and Multiculturalism: What is Anthropology that Multiculturalism Should Be Mindful of It?," *Cultural Anthropology* 8, 3 (1993): 1–19.

78. Ibid.

79. J. Isaacs, "Fiona Foley on Aboriginality in Art, Life and Landscape," in Wally Caruana and Jennifer Isaacs, eds., *The Land, the City: The Emergence of Urban Aboriginal Art.* Special issue of *Art Monthly Australia* (1990): 10–12.

Myth and Structure at Disney World

SHELLY ERRINGTON

Will "guests" on this ride please imagine it read out loud. . . .

About twenty years ago, I visited Disneyland in Southern California for the first time. I went on a ride called "The Blue Lagoon." The scene is magical, with the most amazingly realistic twinkling fireflies. Peering closely as my boat passed alongside them, I could see that they were actually tiny bulbs on filaments of wire, connected, I surmised, to a computer somewhere and programmed to flicker randomly. In the ride "Pirates of the Caribbean" we passed under a bridge and I could see the hair on the pirate's flesh-colored, plastic leg. Later, I saw Lincoln, at that time a miracle of robotics, delivering what was billed as the Gettysburg address (but which turned out to be closer to the Monroe Doctrine). His robot eyes blinked convincingly. At the General Electric Hall of Progress ("*Progress is our most important product*") I saw the nuclear family in its increasingly modern kitchen as it evolved through the twentieth century (the kitchen, not the nuclear family; *it* remained exactly the same). Marveling at the uses to which advanced technology can be put, I saw hologram ghosts thumbing a ride inside the haunted castle. A ride sponsored by Monsanto Chemicals took me *deep deep into the molecule*. The curious thing was that the voice piped into my carlette did not say, "On your left, ladies and gentlemen, you see a molecule." Rather, it took over my inner voice, saying, "What's this we're moving into? Good grief! a molecule! Wow, we're going deeper! That's an electron whizzing by!"— making it impossible to think anything else— one's thoughts were completely usurped. As I left the building, a sign above the exit door announced, "*MONSANTO WISHES YOU A GOOD DAY.*"

Part of the pleasure of being in a Disney theme park, surely, is the pleasure of experiencing realistic artifice anchored by familiar cultural rhetoric and expectations, the pleasure of fantasy made visible and palpable through advanced technology—holograms, robotics, film, and other tools of simulation. Our pleasure in the artifice of simulated worlds is due, it seems to me, not so much to the fact that the simulation replaces the referent, as Eco[1] and Baudrillard[2] each suggests in different ways, as due to the fact that we can see that it *is* artifice, and can marvel at the power of imitation. Our pleasure at the simulation in Disney theme parks is reminiscent of the eighteenth-century European fascination with mechanical dolls; indeed, although Eco and Baudrillard imply that the fascination with simulacra is uniquely American (and simulation as entertainment *is* probably most fully realized in North America), its existence as a cultural form has always struck me, as an anthropologist interested in art-forms, as an extension of a very European obsession— the Renaissance obsession with optical naturalism—transformed, of course, in various ways in the course of several centuries and by new and different technology. (This is not an obsession revealed in the art-forms of most of the rest of the world and for most of human history.)

If we think of Alberti's window[3] as the model for the original form of what, following David

Summers' phrase in *The Judgment of Sense*,[4] I will call "optical naturalism," we note several features. In Alberti's model of optical naturalism, a fixed subject looks at a fixed object. The object is a painting, and that painting consists of markings on a flat surface arranged in such a way that three-dimensional space has been represented in two dimensions. This way of organizing representations pictorially creates "virtual space," again to use Summers' phrasing. Another feature of this Renaissance model of representation is that it necessarily implies a viewer outside the representation, for the markings that create the virtual space are organized around the point of view of a person standing outside the flat surface and gazing at it. Without the existence of a person outside the picture viewing it, the organization of the markings on it, which create virtual space from the viewer's point of view, would have no rationale.

The high-tech realism of Disney theme parks transforms several elements of this model. For one, the flat virtual spaces have been transformed into three-dimensional forms, not by being turned back into three-dimensional "real" objects in the "real" world, but by being transformed into virtual objects, that is, simulations. It is as though the virtual spaces of Renaissance paintings had been transformed through a series of representational technologies—a kind of ride on a high-tech metaphysical Möebius strip, and had come out on the flip side of the same place: after their journey through the centuries, they remain virtual still, even if they have gained a dimension. The flat, "virtual" spaces of the sixteenth century have been re-real-ized to become virtual three dimensional objects—objects that look just like the real thing but are not—or have become "simulacra," simulations for which there is no original.

Another difference from Alberti's window, where a fixed subject views a fixed, flat, virtual image, is that the visitor at Disneyland *moves*, for Disneyland is an amusement park whose main attraction is The Ride. The viewing subject's

movement, in turn, requires or suggests that the virtual world be arranged into a narrative.[5] All rides at the Disney parks have themes, even those that are modifications of traditional amusement-park rides; but the fame of Disneyland is based on the "rides" consisting of the stories that visitors pass through while they sit in strings of carts or boats that move from the beginning of the ride to its end. The sequence of scenes the seated visitors pass by or through is usually organized into a narrative of some sort, however simple it might be. These narrative rides take place in highly controlled spaces, where artificial lighting, the use of animatronics, holograms, and other instruments of simulation technology make possible a startlingly naturalistic illusion.

With some of these intimations about virtual realities and simulations, I visited Disney World in Florida one day in late September of 1992, on a jaunt with friends, which, as an anthropologist, I am privileged to call "fieldwork." In a way, in fact, it was, for, having read Eco on hyperreality, Baudrillard on simulacra and America, and Louis Marin on Southern California's Disneyland,[6] I did not enter the park innocently. Then, too, I enlisted my companions in my fieldwork by presenting a slide lecture to them the night before our visit, suggesting things for them to notice. I lectured to them about Panofsky on the construction of the subject through the history of taste, and about Palladio's Teatro Olimpico, with its re-creation of the "look" of virtual space in a three-dimensional space. I told them my thoughts about how, in subsequent centuries in Europe, perspectival views were increasingly constructed in the built environments—with roads ending in façades, with Versailles-type promenades, with points designated in parks for Scenic Views;[7] I talked about nineteenth-century world's fairs, with their model villages of foreign lands, and of the visitor's movement through them as fictive travel; I told them about panopticons and dioramas, about stereoscopes and miniature villages,

about the invention of *plein air* museums in Scandinavia. I told them about many things, and at the time it all seemed to cohere into a single story—although, since it was off-the-cuff and I later lost my notes, we will never really know.

I do remember, however, posing an issue for them to consider at dinner the next night, after our long and good-spirited day at EPCOT Center, which I had chosen as our field site for the day. The issue I raised for discussion was the argument made by Louis Marin, in his famous article on Disneyland, because that article, in fact, had been the point of departure for my intellectual interest in going on a trip to Disney World in the first place.

Structure versus Narrative

Louis Marin, a French structuralist, wrote an article called "Disneyland: a Degenerate Utopia," in which he argues that Disney's theme park in Southern California suppresses narrativity in favor of structure.

Marin regards the parking lot surrounding it as marking off the "dis-utopic" space of Disneyland, where the visitor leaves his car, thus leaving behind "his daily life of which the car is one of the most powerful markers."[8] From the parking lot the visitor enters Disneyland by approaching the row of booths where a monetary substitution takes place; he buys tickets that allow him to participate in Disneyland life [by going on rides]. Therefore Disney ride-tickets are less a "money," writes Marin, than a "language," with which the visitor can perform his part and create his narrative; he [the visitor] thus leaves behind the pragmatic and utilitarian code for another system of signs, of playful symbols that say nothing (have no effect, no utilitarian end). Although, Marin writes, the visitor can move from place to place at his own speed and make his own choices, thus in a sense creating his own "narrative" through the park, Marin claims that in a deep sense the individual visitor *cannot* make his own narrative, cannot utter his own sentences, so to speak, because

> [the visitor's] freedom, the freedom of his *parole* (his tour) is constrained not only by these codes but also by the representation of an imaginary history. This imaginary history is contained in a stereotyped system of representations. In order to utter his own story, the visitor is forced to borrow these representations. . . . In other words, Disneyland is an example of a *langue* reduced to a univocal code, without *parole*, even though its visitors have the feeling of living a personal and unique adventure on their tour. And since this *langue* is a stereotyped fantasy, the visitor is caught in it, without any opportunity to escape.[9]

In sum, he claims that because the code of fantasy is so constrained, visitors cannot "utter" any individual narratives, *parole* has been eliminated, hence we must substitute a map for a narrative because there is nothing but *la langue*.

Marin provides his readers with three "maps," actually diagrams. (fig. 1) The first one is simply a diagram of the map provided to visitors at Disneyland, an overview of the park that allows people to find their way through it; the second two and his readings of them are successively more schematic and structuralist. It would derail my own story here to go into those readings more deeply, but suffice it to say that, in his view, narrativity is completely foiled in Disneyland, replaced by structure, and that the oppositions and transformations Marin discerns reveal to him that the "truth" of Disneyland is consumption and American domination of the world.

There is much to admire in Marin's approach and insights, but I was not entirely satisfied with the complete dismissal of narrativity, if only because the narratives presented in the rides are surely of basic importance to the visitor's Disney experience. After all, the main ways visitors are aware of participating in Disneyland are by buying things (consuming food and objects) and by

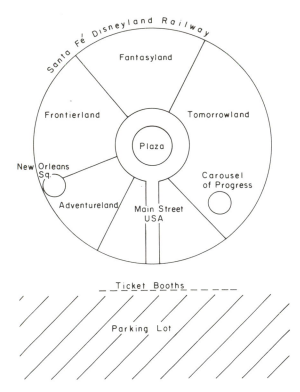

going on rides (consuming narratives). These activities allow them to relive vicariously the codes, the popular culture themes and expectations, that the Disney media presence generated in its television audience. Although Marin mentions rides in passing and gives a paragraph to "Pirates of the Caribbean," his main concern is with the question of how one makes one's way through Disneyland—how one chooses to go from one place to another, and what sort of "story" that creates for oneself as a visitor. As mentioned, Marin concludes that the "stories," the "parole" one "utters" are within a code so constrained that they can hardly be legitimately called individual utterances, and that to understand the meaning an analyzer must study a system of synchronic differences, a "langue," instead.

That assertion of Marin's was the one that prompted me to tell my dinner companions at Disney World in September 1992 about Marin's views, as we sipped wine and ate a rather good meal at Pleasure Island, the only place where alcohol is allowed. (New-style anthropology, as it

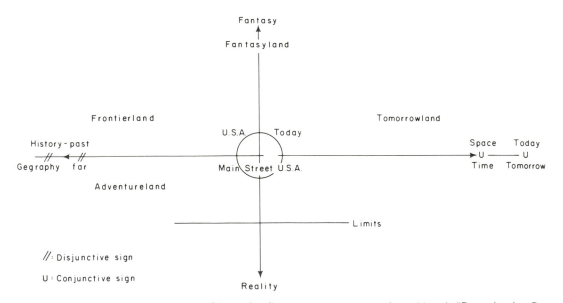

Figure 1. (above and on facing page) Diagrams of Disneyland's structure appearing in Louis Marin's "Disneyland: a Degenerate Utopia." Reprinted by permission of Johns Hopkins University Press.

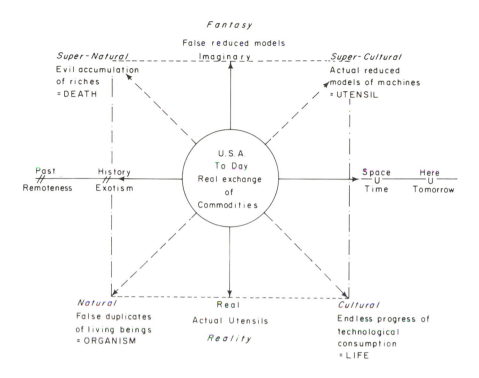

Fantasy

False reduced models

Super-Natural _____ Imaginary _____ Super-Cultural
Evil accumulation Actual reduced
of riches models of machines
= DEATH = UTENSIL

 U.S.A.
 To Day
Past History Real exchange Space Here
Remoteness Exotism of Time Tomorrow
 Commodities

Natural *Real* *Cultural*
False duplicates Actual Utensils Endless progress of
of living beings technological
= ORGANISM *Reality* consumption
 = LIFE

moves towards Cultural Studies, I thought in passing, has many possibilities. If I can study Disney World and have it pass as fieldwork, perhaps I could switch my fieldwork site next time to study chocolate production in Perugia.)

Moving through Disney World

The problem with applying Marin's structuralist analysis to Disney World by substituting a map for a narrative, it seemed to me after a day there, however plausible it might be at Disneyland, is that Disney World is a far more complex place. Even a committed structuralist (which I am not) would be hard-put to convert the sprawling map of Disney World into a tidy structure of paired oppositions, even if she were able to obtain a map.

Officially, Disney World consists of three "worlds," although by my count there is a fourth. One of the official worlds is an exact replica of

Disneyland, called at Disney World "The Magic Kingdom." Another "world" is Disney-MGM, where one can go on rides that show the magic of movie-making. The third is E.P.C.O.T. (Experimental Prototype Community of Tomorrow) Center, which was originally envisioned as a kind of ecological-corporate-nationalist utopia; it purports to be educational as well as entertaining. I count the Vacation Kingdom as a fourth "world," because the hotels and resorts there are all themed, such as Polynesian Resort, Fort Wilderness, Caribbean Beach Resort, and Typhoon Lagoon. Each "world," and some of the attractions in Vacation Kingdom, as well, requires an admission fee. After the visitor pays the fee and enters a "world," all attractions and rides are free, although, of course, purchasing food and souvenirs provides ample opportunity to spend money once one is inside a "world."

Strikingly enough, given its enormous size and complexity, Disney World does not provide maps,

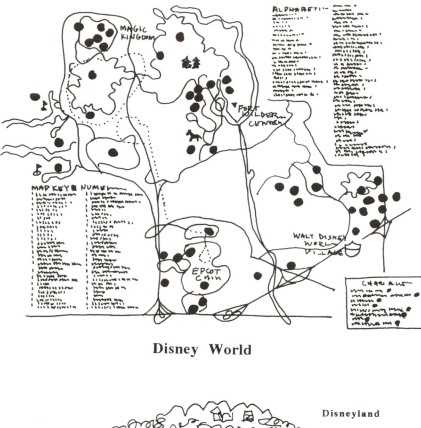

Disney World

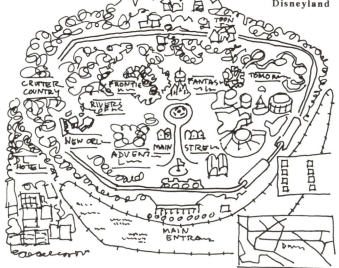

Figure 2. Impressionistic sketches of the maps provided to visitors to Disney World and Disneyland. Drawn by Shelly Errington

and it is difficult to obtain one. Thus the visitor cannot obtain the symbolically and cognitively distanced view of the park from above and as a whole that a map-overview allows. Finally I found one at the back of an official guidebook,[10] but it is clearly intended to guide the visitor in a car to the different worlds available, rather than to provide guidance to the attractions of a world once one enters it. Even more striking are the different forms of the maps provided at Disney World and Disneyland. (fig. 2) The Disney World map is a schematic road-map, accurate cognitively but not visually, and not to scale; whereas the Disneyland map represents the attractions schematically but perspectively, as one would see the entire park from a low-flying helicopter, hovering over it at some distance from the parking lot.

Without a map, without an overview of the attractions, how can a visitor make sense of this park, of these "worlds," in order to move through them? What is their logic of configuration and additions?

A visitor needs a book, at once a guide and a souvenir, that describes each world with its attractions,[11] enabling the visitor to take the first step of the day's journey: Which world shall I visit today—Magic Kingdom, the MGM Studios, Vacation Kingdom, or EPCOT Center?

My friends and I went to EPCOT Center, which is divided into two sections, "World Showcase" and "The Future World."

"World Showcase" is close to Disney theme parks' roots in world's fairs, a showcase of selected nation-states consisting of large but diminished-sized models of "typical" buildings of the country (e.g., Mexico has a pyramid, Canada has Quebec City's Chateau Frontenac), along with a shop featuring imports, a restaurant featuring "typical" food, "typical" live entertainment, and sometimes a ride showing the country's tourist attractions. "Future World" consists of corporate-sponsored pavilions, each serving to educate the public about the future promise of the subject of its business (e.g., the Kraft Foods pavilion is about agricultural technology). World Showcase and Future World are united and visually anchored by a giant almost-geodesic dome called "The Spaceship Earth" (sponsored by AT&T).

After initiating our day at the geodesic dome, we chose to go next to The Future World rather than World Showcase. We were then faced with more choices: will we visit Metropolitan-Life's pavilion The Wonders of Life, or Exxon's pavilion the Universe of Energy, or General Motors' pavilion World of Motion, or one of the several more? When we entered the Met-Life building, we faced more choices: should we eat a healthy snack at Well and Goods, or go on the ride called Cranium Command to see how the brain works, or go to Body Wars, a ride about the immune system? Later, when we were eating lunch at the Kraft Land building, I noted that the lunchroom itself is full of little choice-booths, each with a separate line: Pizza and Pasta; Barbecue; Potatoes; etc. Once you choose Potatoes, you can have fries, baked potatoes with cheese and veggies, baked potatoes with stir-fry, etc.

At every juncture, then, we made choices leading to a finer level of choices, leading to a yet finer level of choices. So, for instance, later in the day when we strolled around World Showcase, we could go to "Canada," or "Norway," or "Germany," etc. Once we chose one "country," we could buy some typical thing, or be entertained by some typical story or music, or eat typical food.

It occurred to me that the structure of choice provided to visitors is like a computer's "menu-driven choices." In menu-driven software, the user is provided with a set of options to choose from. As I write this and look at my own computer screen, I see I have choices among File, Edit, View, Insert, Format, Font, Tools, and Window. If I choose "Format," I can choose to deal with the Character, Paragraph, Section, Document, Border, and many other aspects of the Format. (fig. 3) I do not have to invent anything, or program anything, or even figure out

When an ellipsis follows a command name, choosing the command...

...displays a dialog box.

The shortcut keys for choosing the command appear beside its name.

Figure 3. A "menu" in a computer software program. Reprinted by permission of Microsoft, Inc.

anything. Someone else has already done that for me. I simply choose. I have a lot of options, but it is among a limited number of pre-existing possibilities. Similarly, the visitor to Disney World does not invent alternatives, but chooses from a set of available "options."

I checked this analogy with a computer programmer, in case I had failed to penetrate deeply enough into the logic of the Menu. He made two interesting comments.

First, he asked: How is that different from life? When you go out to dinner, you can choose Thai, or Mexican, or French, or Southwestern. (He lives in Southern California.) When you get to the restaurant, you have to choose an appetizer, a main dish, or a dessert. If you choose a main dish, you can have chicken, beef, or vegetarian.

He had a point, and it made my point. The analogy is powerful precisely because menu-driven choices *are* like life's choices—*as long as* the narrative of life is construed as a series of consumer choices. A visitor moving through the chosen "world" recapitulates the ideal narrative

of a life of consumption. That is what makes Disney World just like "real life," only better, because there is a dis-analogy, as well: The *dis*-analogy is that life's choices do not come in equivalent modules, and there is no cosmic quality control. Hence the superiority of the Disney experience.

This computer programmer's second useful comment was that, as I had described it, the menu-driven choice-structure of Disney World was hierarchical—one level of choices is embedded in the level above it, and you must begin at higher levels (e.g., choose a "world") in order to arrive at lower ones (e.g., eat bratwurst for lunch at the German pavilion). By contrast, in the best computer software, he pointed out, the programmers have gone to infinite trouble to make sure that no choice constrains the next choice, that the user can move from one menu to another one with no prejudice from previous choices.

In point of fact, Disney World allows that freedom of choice in theory, once you find yourself within a particular "world," but it would be enormously inconvenient to exercise it—to shuttle be-

tween Met-Life's Wonders of Life and Kraft's The Land, for instance, going on one ride in the first, lunching in the second, going back to the first for another ride. Still, nothing actually prevents you from doing just that: *you* choose freely to stay in the Met-Life building until you have fully explored it, rather than moving between it and another. Hence you maintain the feeling of free choice, even if effectively you behave like a dot on a normal distribution curve.

At the most general level of narrativity, then, the "story" the visitor makes as he or she chooses a world and moves within it is a narrative of the enactment of the myth of consumer choice. This way of moving through time and space, by making consumer choices, is certainly a form of *parole,* but the story is the story of choices. Nothing else is possible. To paraphrase Marin, at Disney World for a narrative we must substitute—not a map but—a *menu.*

The Ride

At every juncture, then, we made choices that led to a deeper level of menu-choices, a cluster of choices that led to another cluster of choices. The bottom, the level of smallest gradation, the final level of choice, was The Ride. It is there that narrative as we think of it conventionally takes place.

All rides in Disney parks have themes. Some rides are roller-coaster scary, and their main point is speed or the illusion of danger. Disney parks are more famous, however, for the "rides" that form stories, which visitors experience while transported in small vehicles hooked together. In some cases the visitor merely passes by a sequence of scenes that tell a story: Thus a story of technological progress used to unfold in Disneyland in General Electric's Carousel of Progress, in the specific form of the evolution of the Modern Kitchen. (It has long since been removed.) In others, like "Jungle Ride," the story constructed is the story of the visitor's "adventure," as he or she passes through the dangers and amuse-

ments presented by largely tropical peoples and fauna. The visitor's movement in some other "rides" is virtual, as in the trip around America. In it, the visitor stands still in the middle of a circular room, while a 360° projection of scenes of America is screened, having been photographed as the camera moved through the landscape. The camera's point of view puts the viewer behind the camera's eye, giving visitors the sensation of moving through the scenery. Another virtual ride, even more technologically sophisticated, has lately come to Disney World: the interactive ride, in which the passengers "drive" or "fly" at a control panel. (Unfortunately it was not yet installed when I visited, and besides it was to be in a different "world.")

Marin gives short shrift to this aspect of narrativity in Disneyland, The Ride, but it seemed to me basic to the Disney experience. I had originally been drawn to think about and visit Disney World partly due to my interest in realism and simulations in popular culture, but I had also been writing about the representation of cultures in museums, on nationalism, and on narratives of progress. For our group's field site I had chosen EPCOT Center rather than MGM/Disney Studios or Vacation World largely because it purports to be educational, with its representations of nation-states and with its corporate-sponsored pavilions that divide up the natural world into categories of exploitable natural resources. I wanted to understand the content of the stories that were told in rides, but, even more, to discover the narrative structures and metaphors through which they were told.

The Story of Progress

We began our day at EPCOT by entering the geodesic dome Spaceship Earth to see The Story of Communications, sponsored by AT&T. I assumed that this would be another tired and dated but upbeat version of the old story of technological progress, the kind of thing I had seen

twenty years before at the Carousel of Progress in Anaheim. Everyone is familiar with this kind of comic emplotment of history, in which historical stages or nodes substitute for real historical connections. This sort of thing was popular during the second half of the nineteenth century and was a regular feature of world's fairs, and it still makes a regular appearances in some museums of technology, such as Chicago's Museum of Science and Industry, whose exhibition philosophy was derived from the 1893 Columbian Exposition. In 1986 (when I last visited it), the Museum of Science and Industry had exhibits like *What Became Money? From Cowrie Shells to ATM cards*, sponsored by the VISA card; or *The Story of Computing—From the Abacus to the P.C.*, sponsored by IBM. This sort of false history, which arranges human accomplishments and events into "stages" of "development," is closer in spirit to The Great Chain of Being than it is to twentieth-century historical writing, and it was discredited in ethnological exhibits by Franz Boas at the turn of this century; but curiously enough it survives in popular culture.

Expecting the same sort of predictable and uplifting tale at AT&T's Story of Communications, I whispered to one of my friends as we entered it, "Watch this—it's going to be *From Smoke Signals to E-mail*." I was almost right: actually, it was from cave paintings to telephones, illustrated by many animatronic scenes depicting significant stages in that inspiring story. But it changed a little at the peak of human communication history at the top of the dome, which would have been at the story's end in older versions of the progress narrative; a little bit after the stage of telephones, our little vehicles turned around, and we descended, backwards, into the future, gazing upwards into a starry sky full of space ships communicating over vast distances.

This exhibit feels dated, and not just because the animatronics of the first, ascending, half of the story are jerky. The metanarrative of progress that places "European man" at the top and the "savages" and "primitives" at the bottom is

over. Yet, even though that nineteenth-century version of the progress of technology is over, nonetheless, the idea of progress through technology remains very vital in corporate circles, and DW is a place completely committed to telling the tale. I wondered whether the story of the triumph and virtue of technology could be told in a way that did not feel so dated.

After our happy band had been on a few more rides, one of our number, a psychiatrist and mathematical modeller of brains, commented that the rides were structured like the three stages of hypnosis. The hypnotist, he explained, begins the patient's hypnotic trance with something plausible and ordinary that will be accepted with no resistance; the hypnotist then moves to suggest something that will stretch the imagination; and, finally, moves to the completely unimaginable. Thinking about his comment, it seemed to me that Exxon's World of Energy exhibited a new look in progress stories.

In the first stage of what they called Exxon's "traveling theater," we found ourselves sitting on banks of hundred of seats in front of a huge screen to see a film on types of energy—wind, water, fire, and sun. Straightforward enough. Our banks of seats then separated into two sets and moved through a giant door (which magically opened in a wall and then closed behind us), taking us to the next stage, another theater, where, stationery once more, we saw a film on the Miracle of Fossil Fuels. It featured organic debris being deposited deep deep in the earth, being pressurized, and turning into oil. Amazing! After seeing this second stage represented on film, our banks of seats then "traveled" through time, and we moved slowly through a classic Disney display depicting the frightening era when fossil fuels were still merely ferns, complete with animatronic dinosaurs. It was a period when dinosaurs fought epic battles and the lush vegetation flourished in spite of the fact that it was always dark, rainy, and thunderous, and the agonized sounds of herbivores being eaten by carnivores constantly pierced the air. Emerging

unscathed from our trip, we entered the final sta-tionery theater-stage where we concluded our journey through the World of Energy on the brink of the unknown future. A film projected onto a nearly 360° screen led us to speculate about fuels of the future—not just oil, but also wind, air, and water, which are ecologically correct (not that that phrase was used!) and full of promise as sources of energy, but as yet unrealized. Teams of scientists in white coats, however, are working constantly to develop technologies that will tap their power for human use.

This tri-partite "hypnotic" structure functions ideologically the same way the older story of progress did, by recounting the past and present as stages in a great story or adventure that moves smoothly into a better future. The first, "known" stage in the Exxon exhibit was familiar enough and perfectly plausible, declaring as it did that there are multiple possible sources of energy—air, wind, water, and fire. The second stage showed the depositing of fossil fuels—the miracle of unthinkable eons of deposits and pressure, and the fabulous technology that lets us tap it for human use—followed by a plunge into the amazing age of dinosaurs. Our imagina-tions thus stretched, we moved to the third stage of the unknown future of multiple energy sources. The fact that "scientists" (corporations implicitly behind them, but individual scientists are pre-sented as the agents and progress-builders) are working on all of them shows that technologi-cal progress does not unfold automatically, as nineteenth-century stories of progress seemed to assert, and that it may have several paths. The scientists, the narrator, and we the audience were not yet at the end of the story, even though we found ourselves at the end of the ride: Much is yet to be discovered, and science and technol-ogy will make it possible.

Yet this way of casting the story of progress does not feel intrinsically dated the way the line of progressivist time does. For one thing, its inter-nal structure is different. The older tales of pro-gress situated the present as the peak and end

point of civilization, the climax of history. When the omniscient author of these stories explained things, he cast his eyes backwards to origins, and author and audience both took satisfaction in how far we have come since the period when savagery and superstition dominated mankind. Thus the nineteenth century was the era of stages that moved from low to high, from early to late, from primitive to developed, from simple to com-plex. Regardless of the particulars, European civi-lization was cast (by Europeans) as the peak and end point of history. The specific stories of unfold-ing tended to have three stages: savagery, bar-barism, and civilization; feudalism, capitalism, and communism; magic, religion, and science; oral, anal, and genital. In this way of construing the unfolding of history, it was impossible to imagine the shape of a future different from the present, because what could come after sci-ence? . . . or the genital stage? The narrative *had* to stop. And "we," the present peak of hu-man accomplishment, had to be at the apex and final stage.

If, by contrast, progress is structured like the three stages of hypnosis, both the narrator (who is closer to the spirit to the voice-over [as in Disney documentary] than to the omniscient author—there is something significant in that shift)—and the audience are located prior to the story's end, which is nowhere in sight. In the Ex-xon ride, the first stage stated the obvious, infor-ming us about the marvelous technology that has been created already by "us" to extract en-ergy from natural forces. That first stage brought the audience up to speed, to the present, by stat-ing "the facts," not by casting a critical gaze over the primitive past. It was simply not about the past; it did not dwell upon what events led up to the present; it did not suggest explicitly, for in-stance, that "we" are much more advanced than "tribes living in the stone age," nor did it have humorous and endearing Disney depictions of say, the blunderings of the first discoverers of fire. Early human efforts to harness energy go tactfully unmentioned in the Exxon representation, one

suspects because, these days, unlike a hundred years ago, no one wants to gloat about how much more advanced "we" are than the "primitives." Indeed, many people have a yearning to return to the primitive, and an anxiety about whether technology will indeed bring about human happiness, and about whether the supply of natural resources will hold out.

The emphasis, then, in Exxon's exhibit and several of the others we visited was very much not on looking back on how far we have come, but situating ourselves in the present, on casting our gaze to the promise of the future. We late twentieth-century moderns now look out from our present vantage-point in the great line of history, not backwards, to gloat, but forward, to the unknown future, understanding that while "we" have accomplished wondrous things, unknown realms still remain. No longer a series of predictable steps leading comfortably up to the present apex of civilization, the line of history now leads to a present that is less an apex than a brink. We are poised on the brink of an unknown future, full of marvels yet to be explored. In the late twentieth century, even in the Disney version, time is no longer a straight line with "us" at the peak.

Moving through an Alien Medium

Future time is an unknown, so how can one conceptualize or represent it? And how can this vast unknown be converted into a narrative, hence into a Ride?

The future, it seems, is an alien medium, our "path" through it, so to speak, as yet unmarked. We are "explorers," and our movement through the medium is an "adventure." (This figure is repeated endlessly throughout Disney theme parks —I extrapolate from my limited experience, but I am sure it is true—whether the future is at issue or not.)

Let me pause here for an anthropological aside. We humans are creatures who evolved on the ground, with gravity, and in a medium we

can breathe, surrounded by flora and fauna we can eat. Moving across or through an alien medium (like the open sea or through the air) is intrinsically, because phenomenologically, dangerous and frightening. In many societies, perhaps not surprisingly, movement across dangerous territory or alien seas provides a likely setting and potential structure for tales of prowess. One might imagine that, in the Disney view of the future revealed at EPCOT, travel across oceans or through air, by ship or by airplane, would serve well as a trope for movement in the alien medium of future time. But in fact no one cares about the romance of the sea anymore, even if the European voyages of discovery provide apt figures for commemorative refrigerator magnets, like the one found, the day before we went to Disney World, by one of my companions (with her keen eye for desirable kitsch) in the Kennedy Space Center. (fig. 4) Flying in an airplane is even worse. It is a technician's job to fly a plane, and riding on one is now merely part of the tedium of travel, almost as bad as waiting around airports except more dehydrating; and the destination of the flight is known. Both modes of transport have long been bureaucratized. Their technology is known, they are safe, and the industries are highly regulated. Furthermore, both the surface of the sea and the air have no resources to mine and no enemies or alien beings to conquer.

Figure 4. 500 Years of Exploration 1492–1992. A refrigerator magnet bought at the Kennedy Space Center, Coco Beach, Florida

Outer space is another matter because it is a different medium, one eminently suited to be the medium of choice for a ride that propels us into the future. Outer space shows us the shape of our future—still unknown, still dangerous, perhaps inhabited by alien creatures, and in need of very high technology for its exploration. And, luckily, Star Trek has acquainted us all with the basic "look" of our voyaging capsule.

One might think, incidentally, that the deep sea could serve just as well as outer space to stand for an alien future medium: it, too, is largely unknown, a still-dangerous alien medium for human bodies, also in need of very high technology for its exploration, and inhabited by strange and sometimes hostile creatures. Our visit to United Technologies pavilion on The Sea showed, however, that the metaphorical structure for exploring it was derived from outer space rather than the reverse. The elevator down to the exhibit was construed as a space module into the sea, and the exhibit itself was "Seabase Alpha." We were supposed to "explore" it once we got there, but that proved to be impossible because it had no Rides—it was structured like an aquarium-cum-natural history museum. There was nothing to guide us through it, so we wandered around aimlessly, looking at fishes and selecting refrigerator magnets. The knowledge had already been gathered, and was therefore rather static. Curiosity is not enough to propel an "adventure."

No, the future looks like outer space.

Propelling the Narrative

In outer space there are no paths, and no up and down, which is very alarming for us creatures who evolved with gravity and, like all earth organisms, are spatially conservative. Outer space does not have any paths through it; you can get lost in space. Outer space does not provide the setting for any of Bakhtin's chronotopes[12]—perhaps because there is no

chronos and there are no *topoi* out there—just a vast nothingness, punctuated by the odd meteorite. Yet you need a narrative to hold on to out there, in order to make a path through the void. And, being a void, it is a perfect place to screen cultural projections.

We got some clues about how a narrative through the unknown could be propelled when we visited the Met-Life Pavilion on The Wonders of Life. We began with Body Wars, a bumpy and terrifying ride allegedly about the immune system. Here the inner body became the equivalent of outer space, and we traversed it in a tiny spaceship. Before we entered the space capsule (the small theater), the captain briefed us outside via a TV monitor. We will be the crew members on a (tiny) Star Trek-like vehicle which will enter a body and inspect a splinter that has penetrated the skin—for what purpose was obscure to me.

We entered the spacecraft facing a movie screen (a window from which we got a perfect view), sitting on seats which, it turned out, would jiggle and bump at crucial moments in the adventure to come. Our vehicle moved into the bloodstream to where the splinter had penetrated, and we found, already there, a female physician floating around in her spacesuit inspecting the giant and ragged sliver of wood. "We're experiencing some turbulence," our captain tells her, "re-enter the ship immediately, doctor." "In a minute," she answers, but, moving to look more closely at the splinter, she is attacked by a white blood corpuscle, which resembles a kind of giant octopus, obviously doing (to my mind) what it is supposed to be doing. Our captain blasts it with a ray-gun equivalent, thus saving the good doctor momentarily, but before she can reenter the craft she is sucked down a capillary and we follow her in a mad dash in which we bump into walls and collide with floating particles (makes for serious bumps), and eventually move into the brain where we are surrounded with eerie spider-like synapses that threaten to entangle us. Finally we are able to get the doctor on board and we all end up safe. Mission ap-

parently was accomplished and we the crew are commended for a job well done. We exit the spaceship.

What stories are being told here? One is about gender relations: the doctor is a professional woman, but she still dawdles and still needs rescuing by a competent male. Another, probably even less consciously accessible to the creators of the ride than the gender story, seems to be a tale about biomedicine, in which an invasive procedure is used, apparently for no good reason, and on the way destroys a white blood corpuscle as though *it* were the enemy, and crashes into all sorts of tissues and walls, one would imagine to the detriment of the invaded body. In the end result, what is saved, significantly, is the physician. No accident, either, that the physician is represented as a whole organism (a person, in fact), whereas the patient is represented as a mechanical mass of corpuscles, cells, synapses, and flowing liquids, available for invasion and inspection by science.

My point here, however, is that the body's inner workings are represented as a deep unknown medium just like outer space, and the narrative is structured as conflict and rescue, achieved by destroying enemies.

That rather surprised me. I had seen the ride advertised, and the pavilion, too, and I thought it was supposed to be "educational," and I therefore assumed we in the space capsule would be on the side of the immune system, and that the enemy, if there was one, would be some invading pox that had to be destroyed by us fighting alongside the white blood corpuscles. Curious.

War structured several of the other events in the health pavilion, too. I watched the live theater group, The Anacomical Players, do two skits. One concerned a male toothbrush and his female colleague Dr. Flossy fighting off invading Gingivitis. (At one point he "slips" and calls her "Dr. Floozy." This sort of thing just cannot be resisted, apparently.) In another skit, a white blood corpuscle wrestles with an invading virus and wins after being reinforced with Vitamin C and

chicken soup. In Cranium Command, which is worth an analysis in itself, we entered the brain of a twelve year old boy. Basically, the image of the "self" proposed there was the self as composed of warring reified biological entities that had to work together under the military command of what apparently was the will in order to achieve success. (The two mathematical modellers of the brain in our group commented after the ride, "Believe me, *nothing's* in command in the brain." That sounded plausible to me.)

Narrativity is powerful in the Disney experience, then, and its plots are often propelled and structured metaphorically by war and conquest. And so, consuming narratives as well as objects and "knowledge" by choosing among available options, the visitor makes his or her way through a Disney "world."

The Rhetorical Functions of Optical Naturalism

These narratives of consumption, adventure, and war are unmistakably "Disney" because they are cast in the hallmark style of Disney Productions, an almost magically convincing artificial realism, made possible by the use of state-of-the-art technology. Disney theme park scenes and rides, as well as the movement of cartoon characters in animation film[13] are naturalistically depicted, even if the referent is patently not "real."

A Mickey Mouse who walks "realistically" and smoothly through a cartoon movie, or a three-dimensional walk-in rendition of Toon Town (now installed in Disneyland), is merely a local variant on the great and ancient European preoccupation with mimesis generally and visual verisimilitude in particular. While Disney sometimes seems to do it best, it would be a mistake to see the Disney preoccupation with realism as unique or even exceptional: Realism has been one of the hallmarks of popular culture and visual public culture in Europe since the end of the eighteenth

century (a date I choose because of the appearance then of Madame Tussaud's wax museum). Thought about in this way, as being a point on some imaginary scale of entertaining and educational displays produced for popular consumption by the latest technology (whatever it might be), the Disney experience lies somewhere between the wax museum of yore and the computer-generated virtual reality of the future. In fact, my initial desire to visit Disney World was because I wanted a site for "fieldwork," a site locatable in time and space rather than merely in texts, where I could think through some issues concerning simulation as a culturally specific art form.

The word "simulation" brings to mind Jean Baudrillard's piece on "simulacra" and Umberto Eco's essay on "hyperreality." Both Eco and Baudrillard locate the meaning of simulation in its function as a substitute or replacement for reality. In "Travels in Hyperreality," Eco discovers a "secret America," one snubbed by European visitors and American intellectuals, consisting of perfectly scaled iconic representations, of which Disneyland is only a single example. "There is a constant," he asserts, "in the average American imagination and taste, for which the past must be preserved and celebrated in full-scale authentic copy; a philosophy of immortality as duplication. To speak of things that one wants to connote as real, these things must seem real. The 'completely real' becomes identified with the 'completely fake.' . . . The sign aims to be the thing, to abolish the distinction of the reference, the mechanism of replacement."[14]

Baudrillard writes that "Disneyland is there to conceal the fact that it is the 'real' country, all of 'real' America, which in Disneyland is presented as imaginary in order to make us believe that the rest is real, when in fact all of Los Angeles and the America surrounding it are no longer real, but of the order of the hyperreal and of simulation."[15]

Partly due to the fact that I see narratives—myths, if you like—as basic to the Disney park experience, I am somewhat less struck than Eco and Baudrillard are with the doppelgänger effect than I am led to ask about the rhetorical functions that realism serves in the narratives that saturate the visitor's experience of Disney theme parks. Thinking about the rhetorical functions of visual realism allows us to discuss realism and simulation without either apocalyptic speculations about simulacra and the disappearance of the referent (à la Baudrillard), or, obversely but similarly, with anti-Baudrillardian screeds which are themselves grounded in the assumption that realism and objectivity are possible and desirable, that mimesis can be a transparent method. We need not be locked into the conventional pairs, each term of which implies the other—truth/distortion, real/fake, or original/simulacrum.

In pursuing this line of thought, I find Donna Haraway's reading of the American Museum of Natural History in New York[16] suggestive. She provides us an enlightening reading of the sensibility she calls "magical realism" in the nature dioramas in the American Museum of Natural History in New York (henceforth "AMNH") and of the life of Carl Akeley, the inventory of modern taxidermy. She sketches President Theodore Roosevelt's politically powerful white male, upper-class circle, the patrons of Akeley, and their wish to conserve an unspoiled nature and prevent its destruction by "civilization" (the technology, imperialism, and capitalism of which they were, ironically, prime movers). These men, she points out, were deeply involved in three activities: museum exhibition, the promotion of eugenics, and nature conservation. These interests led them to make politically and financially possible the creation of the startlingly realistic dioramas of animals in their natural settings for which the AMNH is now famous. The realism was achieved through technology, primarily the scientific taxidermy perfected by Akeley and the artistic and modeling techniques required for the realistic jungle settings in which the dead but live-looking stuffed animals were placed, with their "exact reproductions of plants, insects, rocks, soil," which

allowed the dioramas to seem to be "a peep into the jungle," in Akeley's phrase.[17] Realism has a special place in Haraway's argument. The power of the stance of realism, she argues, "is in its magical effects: what is so painfully constructed appears effortlessly, spontaneously found, discovered, simply there if one will only look. Realism does not appear to be a point of view."[18]

It is thus extremely suited for a type of museum, the natural history museum, that purports to display objective knowledge, a mode of knowledge that claims not to have a point of view but to display the world as it really is. And, one might add, it is eminently suitable for any displays, like those of EPCOT Center, that claim to be educational, instructive, and at some level "serious."

The term "realism," however, tends to be bandied about very loosely and broadly; it needs refinement. David Summers has made a useful distinction in his book *The Judgment of Sense*[19] between "optical naturalism" and "realism," terms that, he points out, are often used interchangeably. "Realism," Summers writes, properly denotes a *category of subject matter*—to wit, things with a concrete historical reference. What he calls "optical naturalism," by contrast, is a *style* used for depicting objects as they appear to an individual observer. (Thus the style of optical naturalism implies a form of perspectival rendering, an observer, virtual space created on a flat surface, etc.)

In point of fact, realism (a subject matter) and optical naturalism (a style) need not be united in practice: real things can be painted or rendered abstractly or impressionistically or schematically, whereas imagined things can be painted naturalistically; therefore, distinguishing between the subject matter and style and giving them different names, as Summers does, is very useful.

And yet, there is a good historical (not logical) reason they are often used interchangeably: they were presumed to go together and to imply each other during the several centuries when the Renaissance canon was being formed, perfected, and then undermined but not yet exploded in Europe (call it between about 1400 and 1900). The subject matter of painting was presumed to be real, and it was depicted in ways that strived to achieve optical naturalism. This presumed conjoining is basic, for instance, to E. H. Gombrich's theory of Western art-making in *Art and Illusion*:[20] Gombrich believes that Western art between the fifteenth century and the end of the eighteenth was about "making and matching," that is, that the artist modified schemata by "matching" them with visible objects and trying to render them naturalistically, according to how they looked.

It is precisely because "real" subject matter and optical naturalism are linked in the canonical forms of Western art that the divorce between them has the effect of allowing optical naturalism to have the rhetorical function of persuasion. The divorce was effected decisively in the early twentieth century with the collapse of optical naturalism and the Renaissance canon in the high fine arts. Since then, "high" art (painting and sculpture) has been far less "about" imitating the way the world looks than a commentary on itself and its history.[21] Imitating the ways things look has become the purview of science-, natural history-, and historical-illustration, as well as the purview of "low" arts and popular culture, which often retain the figurative and perspectival conventions on which the Renaissance canon rested.[22] These two enterprises often overlap, particularly in science and history museums and entertainments that purport to be educational. Mimesis lives in these realms, not, for the most part, in high art.[23]

In the twentieth century, optical naturalism as a style is often put to use in popular visual culture in order to depict things that are, simply, not there. It is used, rather, to show that they were, or could be, real. It is the style used for natural history and scientific illustrations depicting prehistory—for instance, in visual assertions illustrating what proto-Hominids were really like, or what Jurassic monsters looked like; it is used in science fiction illustration; and it is used in Bible

illustrations and religious dioramas, for instance the sort I encountered in Salt Lake City.

To render any of these subject matters in anything other than an optically naturalistic style would be unpersuasive in the case of, say, visual speculations about the creatures living millions of years ago. Imagine those Jurassic seamonsters in the style of Van Gogh. The picture might be playful and dramatic, but it would not convince; further, the style would bring attention to itself, whereas an optically naturalistic style asserts its own invisibility, its transparency. Or imagine the paintings of Joseph Smith receiving the golden tablets in Palmyra, New York, which one used to be able to find in Salt Lake City. Rendering the scene in the style of Seurat, or, worse, of Braque, or of Modigliani, would be effectively blasphemous for the intended audience—equivalent to asserting that the scene depicted was not real, did not have a historical referent. In short, optical naturalism in popular culture is a visual rhetorical device to make a claim: it asserts that the referent is real, or, at least, plausible, and invites the viewer to take the claim seriously.

Optical naturalism, then, tends to be used now precisely when the status of the real is most questionable, when the object of knowledge is most doubtful. We should understand the style to be a visual rhetorical tool of persuasion, persuasion of the truth value of a myth, or, at least, one that invites us to suspend disbelief about the veracity of an assertion.

The Gombrichian irony, of course, is that, without an actual referent, optical naturalism as a style becomes a schema in Gombrich's sense, just one more schema in the world's myriad schemata, one more "making" without "matching." Another irony is that those things rendered in the style of optical naturalism become recognizable to the audience as "real" only if the "facts" they depict are already familiar and acceptable, the legend already known.

Disney Productions follows this well-established code of plausibility: "serious," "educational" scenes, like the animatronic dinosaurs in the Ex-

xon pavilion at EPCOT Center, look real, and could just as well be in a natural history museum as in EPCOT. By the same logic, those creatures that are patently not real in subject matter (e.g., cartoon characters) are made to seem real on film with naturalistic movement, or in the parks by becoming three-dimensional (like the roaming Chipmunks, or the newly installed Toon Town of Disneyland). Although Disney Productions appears to be about fantasy, and sometimes claims to promote imagination and creativity,[24] fantasy nonetheless "comes to life" by strictly following the code of optical naturalism. No hint of Cubism, Surrealism, or Abstract Expressionism breaks or rebels against the entirely conventional mimetic code.

Gratuitous realistic and historical detail often augments the style of optical naturalism in popular visual culture, and Disney World provides numerous examples of this strategy of persuasion. In AT&T's ride in the Spaceship Earth, for instance, which depicts significant moments of progress in the Story of Communications, "[e]very scene is executed in remarkable detail," we are told in Steve Birnbaum's official guide to Disney World:

> The symbols on the wall of that Egyptian temple really are hieroglyphics, and the content of the letter being dictated by the pharaoh was excerpted from a missive actually received by an agent of a ruler of the period. The actor in the Greek theater scene is delivering lines from Sophocles' Oedipus Rex. In the scene depicting the fall of Rome, the graffiti reproduces markings from the walls of Pompeii. In the Islamic scene, the quadrant—an instrument used in astronomy and navigation is a copy of one from the 10th century. The type on Johann Gutenberg's press actually moves, and the page that the celebrated 15th-century printer is examining is a replica of one from a Bible in the collection of [Los Angeles'] Huntington Library. In the Renaissance scene, the book

being read is Virgil's Aeneid; the musical instruments in that scene are a lute and a *lyra da braccio,* both replicas of period pieces.[25]

. . . and so on.

Jurassic Park (the movie) is an outstanding example of the importance of gratuitous realistic details used in conjunction with optical naturalism (achieved in that case by computer simulations and animatronics) in the interests of a rhetoric of The Real. In the summer of 1993 I heard a speech by Jack Horner, the paleogeologist who is the model for the scientist in the book *Jurassic Park.* Horner was retained by Steven Spielberg as a consultant on "realism" for the movie, in order to advise Spielberg about "accuracy," like the color of dinosaur skin (we do not know) and the texture of dinosaur skin (we do know). This sort of thing was what "realism" was deemed to be about, apparently for both Spielberg and Horner.

To "mythologize," in Barthes'[26] terms, is to make appear natural and in the very order of things that which in fact is merely contingent and historical. Gratuitous realistic details, presented within an optically naturalistic style, anchor the narratives presented at Disney World lightly in a real subject-matter, allowing the viewer to bypass or block out consideration of the larger mythic structures in which the details are embedded. They induce the illusion that the entire myth itself has a mimetic correspondence with The Real. (This issue, raised by Hayden White in *Metahistory*[27] is even harder to raise in Disney World than in the discipline of history.)

The simulations and simulacra of Disney World, like the computer animation in Jurassic Park (the movie), each bolstered by gratuitous realistic details, are best understood as rhetorical devices of persuasion (convincing to people trained in a particular visual rhetoric) that bolster mythic structures (which are already well-known). We go to blockbuster movies to have our mythic structures satisfyingly and plausibly rendered, not to challenge them, and certainly do the same at Disney World.

Those basic myths are completely overt, the furthest thing from a hidden agenda that can be imagined: the myths of free consumer choice, the story of progress, "traditional" gender relations, the naturalness of national boundaries and national genius, the typicalness of a country's "typical" foods, the ability of technology to conquer all problems, and many others that one could pick up with a casual stroll through the park. The overt *message* of these myths hardly requires demystification—hence my greater attention here to the poetics of their presentation than to the content of their politics.[28]

One more thing is worth remarking about Disney World's mythic power. The park acts as a giant device for absorbing narratives and icons that appear in popular culture from diverse sources. My point here is not to complain that everything in the world becomes "Disneyfied" by Disney, but, rather, to remark on the genius of the ability to absorb virtually any icon, image, or story that captures the popular imagination, and convert it thereby into an American myth. Disney animation and Disneyland began this process by incorporating eighteenth-century French fairy tales into Americana (Cinderella is definitely an American girl, though she lived in hard circumstances, long ago, and probably in Europe or someplace like that) and nineteenth-century science fiction (the ride 20,000 Leagues Under the Sea); the Mad Hatter's tea party becomes a gentle ride, and Eeyore and Pooh Bear (*a bear of very little brain*—as Milne pointed out) roam the streets. This process of absorption continues in Disney World's Magic Kingdom, the replica of Disneyland: a seventeenth-century novel makes an appearance, transformed, as Swiss Family Island Treehouse,[29] and so on. Perrault, Jules Verne, Lewis Carol, A. A. Milne, Daniel Defoe are nowhere mentioned: as befits myths, the original authors and the historical circumstances of creation go unnamed. (In any case, most of these tales make their way into the parks only after they have been made into Disney movies, hence the rights to them, or to the Disney version, have been secured.) EPCOT Center, as an

Figure 5. Modern Symbols. Subconscious Comics is drawn by Tim Eagan and published in alternative newspapers nationwide; reprinted with permission.

"educational" site that incorporates "history" as well as futurism, provides even greater scope for the absorption of images and narratives, often in snippets. Thus the ride in the Met-Life Pavilion "Body Wars" appears to be derived from the movie "Inner Space"; the depiction of sperm in the story of human conception told in the 10-minute movie "The Making of Me" in the same pavilion appears to have been borrowed directly from one of the sequences in Woody Allen's movie "Everything You Ever Wanted to Know About Sex But Were Afraid to Ask"; the giant "geodesic" dome in EPCOT Center, "The Spaceship Earth," unashamedly uses the ideas of Buckminster Fuller, who invented the geodesic dome and wrote a book called *The Spaceship Earth,* but, oddly, is nowhere acknowledged.[30]

Perhaps, though, it is not so odd: myths have no authors and no histories. Their point is to be timeless, to transcend historicity, to have a universal validity. Anything tossed up and made visible by the waves of time and process onto the beach of history exists there to be culled by alert imagineers and turned into structures (mythic variety).

What of, then, the distinction between Narrative and Structure, the point of departure for my ride through Disney World?

On the one hand, the more I thought about narrativity in Disney World, the more important it seemed to me if one is considering the visitor's experience—how myths are absorbed by individual subjects.[31] Narrativity pervades the parks: first, in the stories about Goofy, Mickey, Snow

White, and the rest. These narratives are largely implicit, taking the forms mainly of the characters who roam around looking for photo opportunities and of the endless self-consciously kitsch items sold in the shops throughout the parks.[32] Although they have the importance of what Roland Barthes would call the "alibi," they also seem to me the least significant and least interesting features of the parks.[33] Second, narratives are made visible in the rides. And finally, there are the sequential "utterances" (in Saussurian structuralist terms) the visitor makes by moving through a virtual menu of attraction-choices. Narratives are the device by which the visitor *experiences* the park. On the other hand, these narratives are embedded within a single overriding myth comprehensible as a single declarative statement: the myth that technology, directed and owned by corporations, will create a perfect world. Thus Disney World exists as a mythic structure which is at once a material "structure" of buildings and entertainments that can be experienced as narratives, as well as an example of *la structure*.

The materialized mythic structure/*structure* is itself constant and enduring. That myth never changes: from park to park, from "world" to "world," from decade to decade. So, while the parks constantly "change" as the attractions and technology are updated, the updating is always within the same codes. The mythic structure, whether material or ideological, exists in a dynamic stasis in which *plus ça change, plus la même chose.*

Sequential narrativity and synchronic mythic statement are united in Disney World in its incarnation as a "simulacrum"—a replica without an original: a simulated technological world that exists without conflict, without dirt, without struggle between class, race, nation, or genders. And that's a myth, in anybody's book. It is magical thinking, a kind of icon of a wish, a yearning for a future in the form of nostalgia for a world that never was. It also makes it a comfortable, secure, and happy place to take small children.

Notes

1. Umberto Eco, "Travels in Hyperreality," in *Travels in Hyperreality,* trans. William Weaver (San Diego, 1983).

2. Jean Baudrillard, "The Precession of Simulacra," in *Simulations* (New York, 1983).

3. Leon Battista Alberti, *On Painting,* trans John R. Spencer (New Haven, 1956).

4. David Summers, *The Judgment of Sense: Renaissance Naturalism and the Rise of Aesthetics* (Cambridge, 1987).

5. It is worth remarking here that E. H. Gombrich argues that a scene depicted in the style of perspectival realism implies a narrative. See his discussion in chapter IV, "The Greek Revolution," in *Art and Illusion* (Princeton, 1960).

6. Louis Marin, "Disneyland: A Degenerate Utopia," *Glyph* 1 (1977): 50–66.

7. Further thoughts on this topic can be found in Shelly Errington, "Making Progress on Borobudur: An Old Monument in New Order," *Visual Anthropology Review* 9, 2 (1993): 32–59.

8. Marin, "Disneyland," 55.

9. Ibid., 59.

10. Steve Birnbaum, *Steve Birnbaum Brings You the Best of Walt Disney World* (New York, 1990).

11. *Walt Disney World.* (n.p., n.d.).

12. M. M. Bakhtin, *The Dialogic Imagination: Four Essays,* ed. Michael Holquist, trans. Caryl Emerson and Michael Holquist (Austin, 1981).

13. Walt Disney's insistence on realism in cartoon films, long before Disneyland was built, was the reason that Disney animation was so expensive: Mickey's and Goofy's movements had to be smooth and "realistic" rather than jerky, and that required hundreds of cells to be drawn for every scene.

14. Eco, "Travels," 6–7.

15. Baudrillard, "Precession," 25.

16. Donna Haraway, "Teddy Bear Patriarchy: Taxidermy in the Garden of Eden, New York City, 1908–1936." *Social Text* 11 (1984–85): 19–64.

17. Ibid., 9.

18. Ibid., 34.

19. Summers, *Judgment.*

20. Gombrich, *Art and Illusion.*

21. Philip Fisher has made this point persuasively in *Making and Effacing Art: Modern American Art in a Culture of Museums* (New York, 1991), linking these developments to the institution of museums.

22. See, for instance, chapter Seven ("Foreshortening! The Knack of Drawing the Figure in Perspective!") of *How to Draw Comics the Marvel Way.* It begins, "This chapter's a short one—but it's vitally important. Take your time with it and make sure you thoroughly understand all the main points. Without a knowledge of foreshortening, all your figures could end up looking like they were drawn on pyramids by the an-

cient Egyptians!" Stan Lee and John Buscema, *How to Draw Comics the Marvel Way* (New York, 1978; rpt. 1984).

23. Except, of course, where the intent is to be ironic, hostile, or playful about the tradition of optical naturalism; but there the point is not an innocent mimesis of centuries past, but the self-conscious commentary on the history of art that Fisher [*Making*] writes about.

24. For example in the EPCOT area "Journey into Imagination." The introduction in the guidebook to this area reads as follows: "The human imagination is one of the most powerful and mysterious forces in the universe. Although no one really understands the process of imagination, it is the wellspring of creativity. Our ability to imagine and create is the source of all our achievement and progress. Journey into Imagination uses the Disney tools of magic, fantasy and enchantment to remind us that all of our accomplishments begin with ideas." *Walt Disney World.*

25. Birnbaum, *Steve Birnbaum,* 120.

26. Roland Barthes, *Mythologies,* trans. Annette Laves (New York, 1957, rpt. 1972).

27. Hayden White, *Metahistory: Six Critiques* (Middletown, 1980).

28. For a demystification which also makes a serious attempt to consider narrative structure, especially of the historical account presented on the American stage in EPCOT Center's "World Showcase," see Mike Wallace's "Mickey Mouse History: Portraying the Past at Disney World," *Radical History Review* 32 (1985): 35–57.

29. See Steven M. Fjellman's interesting account of the house in *Vinyl Leaves: Walt Disney World and America* (Boulder, 1992), 226–27.

30. The issue of copyright is probably not irrelevant, of course, if one were to try to explain the anonymity causally and economically. Disney recently bought the rights to Toon Town, which appeared in the movie "Who Killed Roger Rabit?" and built it in three dimensions in Disneyland. The Buckminster Fuller work, by contrast, resides in a private, family-owned archive currently in the process of being converted into an impoverished non-profit foundation. The owners of the former idea would be in a financial and media position to sue Disney for copyright infringement, of the latter, not.

31. This point could be regarded as the obverse of De Certeau's, and, being the opposite, is the same (as Structuralists have taught us). See Michel de Certeau, *The Practice of Everyday Life,* trans. Steven Rendall (Berkeley, 1984).

32. A fan of kitsch, I nonetheless avoided these: they *intend* to be kitsch, which rather disqualifies them; but then it occurred to me that they are a *simulation* of kitsch, hence profounder than I realized at the time.

33. Dorfman and Mattelart might well disagree: See their book *How to Read Donald Duck,* which argues that these innocent-seeming comic books are actually about racism, imperialism, and the triumph of global capital. Ariel Dorfman and Armand Mattelart, *How to Read Donald Duck: Imperialist Ideology and the Disney Comic,* trans. David Kunzle. 2nd ed. (New York, 1984).

HISTORY

Introduction

ANTHONY GRAFTON

A quarter of a century ago the historian who worked on high culture tended to be a cringing, tentative creature. History, then as now, had many mansions, as Garrett Mattingly showed in the brilliant essay from which I steal this metaphor. But Clio had apparently reserved all the most impressive rooms for practitioners of very different arts—historians who not only shared few of our interests but also looked on us with varying proportions of pity and contempt. Downstairs, amid the gleaming, dark-polished shelves of the stately library, dignified diplomatic and political historians carved the clear shapes of what even historians of ideas called "real history" from the tightly massed files of government departments and newspapers of record. Beside them, in the modern, fluorescent-lit addition, social historians had already begun to feed serial records in numerical form into early computers—those large, ungainly machines, as threatening to humanists as so many Molochs, which shook buildings when they processed data.

Down in the basement, social historians of a very different stripe were beginning to blow the dust from legal and religious records which they used to produce not a statistical fresco but an anthropological miniature of a time and place. Ululating strangely, they showed us how to read events like texts and reconstruct texts as if they had been events. In the hallways, scholars who practised both sorts of social history at once fought bitterly—and productively—over such vital issues as the nature and results of American slavery. At the back of the house, in the kitchen, a revolution was brewing—one which, under the name of women's history, would give a name and a voice to the hidden history of just over half of the human race. Meanwhile we historians of ideas, prospective or professional, sat in our humble garrets, fascinated and provoked by the rumblings and roarings from below—but still committed, even if we could not very articulately explain why, to the belief that activities like reading texts, decoding paintings, and reconstructing complex systems of ideas deserved their modest place in the historian's memory palace.

In the 1990s, everything is different, and much is better. We have come downstairs and occupied our own front room—one still smaller than the political historians', but more prominent. We continue to read our texts; but we manipulate them with tools begged, borrowed, or stolen from a wide range of original owners. One consequence of growing up in a time of hope and debate was a renewed belief in the validity of our enterprise—especially as Skinner, Darnton, and others showed that it could take on a Protean range of new forms. But another was exposure to precisely those disciplines, questions, and perspectives that initially seemed threatening. We have become as adept as our rivals at the historian's normal method of finding new implements. We too, that is, walk down the charming cobbled back streets and stunning tree-filled atriums of the social and human sciences, see interesting things in windows, smash the glass and steal them. We have benefited from the content, as well as suffered from the style, of much recent work on matters as dry as hermeneutics and as wet—even bloody—as the human body. Like our rivals in once-trendier fields we usually make a mess of our intellectual smash-and-grab jobs,

combining others' methods without regard to age, authority, or provenance—at least from the standpoint of those whose protective disciplinary boundaries we leave in glittering dust on the pavement. But like our rivals, we justify the errors and approximations that mar our calibration of unfamiliar tools by citing the need to think big and travel light—as well as the more plausible ground that texts give us different answers, *pace* Plato, when we ask them unexpected questions. Enterprises such as John Toews' fine-grained reconstruction of Hegelianism, Jonathan Spence's evocation of Matteo Ricci's Chinese days, Keith Baker's close reading of eighteenth-century political thought, or Lisa Jardine's imaginative recreation of the social networks of early northern humanism rival the work done in any other contemporary discipline for originality, breadth, and precision of thought.

No field of cultural history has bloomed more lavishly in the historian's conservatory than those that concern themselves with the visual arts. Cultural history and the study of images have, of course, long been intimately connected. Jacob Burckhardt, whose *Civilization of the Renaissance in Italy* gave cultural historians their abiding model, also wrote the *Cicerone*. But the marriage between formal study of images and their making and wider analysis of cultural forms has not been easy to arrange—as Burckhardt himself admitted when he excluded formal analysis from his *Civilization* even though he was superbly qualified to provide it. In recent years, however, cultural historians (and certain others) have shown themselves willing to take new risks and capture new objectives. We will never have Burckhardt's style, or his culture. It remains true, however, that we may prove able to take his enterprise one step farther.

It has become evident, in the first place, that cultural historians have special qualifications when it comes to recreating social and economic forms and groups, from families to guilds—that is, when it comes to studying the historical germ plasm within which works of art took shape. Art

historians opened this field; the work of Wackernagel long ago, Haskell and Baxandall more recently, showed that intensive archival and bibliographical research could recreate the webs of social relationships that imprisoned (and sustained) painters and other artists. In the last generation, historians have shown that their ways of cutting through the archives yield impressive results for art as well as for politics and religion. Monographs by Goldthwaite, Kagan, Kent, and Montias have lashed some of the most original, impressive, and aesthetically pleasing products of Renaissance art to their original economic moorings. Related—but not identical—work by John Hale and others has related Renaissance painting not so much to the social relations that produced it as to the social and military events it represented. In each case the historian's expertise, as evidenced by wholesale command of archival sources and mastery of contemporary opinion and prejudice, has added a dimension of depth to the excellent work of art historians in the same field. Finally, brave and stimulating synthetic work by historians like Burke and Goldthwaite (at an early stage), Schama and van Deurssen (at a more recent one), has brought the study of subject matter, patronage, and ownership together to recreate period visual cultures in three dimensions. One now sees not only how social relationships shaped art, but also how art shaped social relationships; how the presence (in the Dutch case, the omnipresence) of certain objects, in a certain form of lived environment, gave family life a new emotional tone and substance.

A second growth area—one more problematic than the first in many ways, but also deeply rewarding—lies in the murky region where the formal analysis of works of art intersects the historian's evocation of a larger cultural style. This dangerous, boggy landscape deterred explorers for a long time. It requires of all who enter it a willingness to look (and listen) as well as to read, which goes against the historian's traditionally verbal culture. It demands a readiness to master formalist tools as well as to apply the historian's

favorite implements, common sense and rhetorical pathos. Above all, it forces those who enter it to try to cross the long-standing gulf between the methods of history and closely related fields, with their attention to chronology and their efforts to recreate a wide social and cultural context, and those of fields that dismissed for a long time chronology and context as distractions from the central task of seeing, outside time and space, how a picture or a poem works. The prospect daunted—and still daunts.

Still, in the course of the 1970s and 1980s, brave historians began to dip their toes gingerly into the cold water of formal analysis. To their surprise and gratification, some of their results have proved provocative, others have become canonical, among art historians as well as members of their own guild. Schorske's *Fin-de-siècle Vienna* was perhaps the first large-scale, articulate example of such an approach. But it was accompanied by many parallel efforts, from Brown's analyses of icons and mosaics to Paret's close readings of modern German illustrated books and paintings. It has been followed by, if not a horde, at least a respectable crowd of publications by Schorske's students and others. The works of such very different individuals as Steinberg and Silverman on the nineteenth and twentieth centuries—with their lavish illustrations and close attention to style and detail—attest to the scale of historians' new investment in the visual.

The close personal and intellectual relations that link many of these scholars with art historians reveal a radically changed intellectual situation—one in which historical context no longer merely supplies a few framing pages at the start of art historical monographs, or places a few disregarded images at the end of historical surveys. Naturally, not all roads have been smooth and open. Methodological collisions have resulted in sparks—and, sometimes, wholesale fires. Art historians have not always found historians' efforts to look well-informed or solidly argued, and historians sometimes wish that art

historians would leave them to plumb the archives on their own, unaided by the insights and assumptions of Deep Thinkers like Michel Foucault. But few have been so charred by the heat as to wish to forego the light that even the harshest of these debates have generated. For some time to come, it seems, historians and art historians will work together, and their scholarship is likely to move in unexpected directions.

Perhaps the loftiest—and certainly the most gnarled—branch of this new research enterprise, finally, connects questions of patronage and formal analysis in one broad-gauged study of meanings: a hermeneutics that would ideally interpret both artistic creations and responses to them. Many historians and art historians have tried, in recent years, to work and feel their way into the thoughts and sentiments of art's makers and consumers. They want to know how social ambition and economic need, intellectual programs and religious emotions, traditions of representation and objects of representation interacted to generate an image, and then how ideas and feelings were in their turn generated by it. What did it mean, what did it feel like to build and inhabit an isolated urban Utopia, cut off from the swarming street life of the piazzas outside, or to design and create a Biedermeier sitting room, or to paint (or sit for a painting) of a woman of a lower social class than the artist? Tasks like these challenge the scholar to show both discipline and imagination—two qualities never in long enough supply, and rarely found together. Remarkable efforts have nonetheless been made. It is no accident that some of the most systematic and stimulating historical readings of visual texts have been made by Starn, a historian, sometimes working on his own and sometimes in collaboration with Partridge, an art historian.

Panofsky's example remains a live one for historians, less despite than because of this fervid activity, little of which reached printed completion before his death. The scale of his work, the bravura range of his questions and what now seems the breathtaking boldness of his answers, in-

spired many of those who now read past images in ways very different from his; also some who do not, normally, try to do original work on images. So does his insistence that neither the textual nor the visual is trivial; that neither can or should be reduced to something as tedious as a mere exemplification of the other. So, finally, does his ability to hold on, without ever losing his unfailing charm and ease of exposition, to two principles that most historians still claim to follow: that there was a world back there in the past, to which we would like our work to make some testably reasonable approximation, and that there is a world of thought out there in the present, to which we would like our work to have some living relationship. Panofsky never stopped digging or thinking, never gave up either the back-hoe work of historical excavation or the scrupulous dissection of delicate theories. The essays that follow may suggest that our questions are no longer, quite, his questions. But they also show that his ways of finding answers stand as permanent models of what historical inquiry could be—if only we could muster something like his open mind, endless energy, and bottomless erudition.

Something Happened: Panofsky and Cultural History

DONALD R. KELLEY

In 1516 Erasmus—that "elusive blend of charm, serenity, ironic wit, complacency and formidable strength," as Panofsky called him[1]—wrote a letter to his great rival, Guillaume Budé, responding to the charge that he spent too much time on scholarly trivialities. True, Erasmus responded, he did not devote himself to the great mind-boggling and jaw-breaking abstractions that occupied some scholars; but then (as Budé surely knew) there was much human value in the lowly arts of the *trivium,* in the particular words of authors, and in other readerly concerns and questions of interpretation that occupied both of them. Like it or not, Erasmus added, he was "born for small details."[2] Of course Erasmus was speaking ironically, facetiously, and perhaps sarcastically; for in fact it was his hope, ultimately, to find larger spiritual meaning in the texts to which he devoted his life; and he saw no contradiction in the idea of a lowly grammarian reaching for higher forms of wisdom.

Like Erasmus, Panofsky devoted his life to a "humanistic discipline,"[3] set special store by philology, and was likewise "born for detail." Yet detail, as Panofsky's friend and mentor Aby Warburg famously commented, was precisely where the good God lived; the study of history, we might infer, was the final repository of human meaning. As Erasmus sought a Christian philosophy of life beyond the empty theologism of the Scholastics and in the original and particular language of Scriptures and Patristic tradition, so

Panofsky sought an understanding of the highest achievements of humanity beyond the conventions of formalist aesthetics. In short, he sought the big picture of human culture in the details of the history of western art (a history that was already being fashioned in the age of Erasmus).

What I want to emphasize is this dual goal—this effort to join together close interpretation with more extensive inference, the lives and works of particular creators with broader cultural configurations, the details of humanistic scholarship with the *le bon Dieu, der liebe Gott,* of larger meanings. For me this is the primary source of Panofsky's impact on the study of history.

This sort of vision has not always informed historical scholarship, especially in the Anglophone world. As illustration consider a story recently told about Panofsky by his old friend and colleague, Ernst Gombrich.[4] At a conference in Amsterdam in 1952 (and surely not for the first time), Panofsky showed slides first of a Renaissance church, then of a Gothic church, and then remarked, "Something must have happened." Gombrich associated this with the sort of naive Platonism that had led Panofsky, for example, to define cats according to their participation in a sort of higher "cathood." So Sir Ernst said to himself [and here I quote], "Of course something must have happened; they introduced a new style of architecture. But this is not necessarily the symptom of something else."

Well, it's easy enough to give Dr. Johnson's

stone another kick, to dismiss the conceptual problems of the history of culture in a larger sense; and yet the fact remains that generations of scholars have spent much of their careers searching for this "something else"—trying to identify and to understand the "they" who introduced the new "style," whoever they were and whatever it was, and the problematical phenomenon called "introducing." In effect they have sought the cultural equivalent of the good god in the details of human creations.

The classic illustration of this quest is the question alluded to by Gombrich and defined by Panofsky as "the very existence of the Renaissance."[5] Strange as it may now seem this scholastic *quaestio* was very much on the minds of early modern historians when I began graduate studies in the late 1950s. Had there really been a Renaissance? Was there a "something" underlying the contrasts between the texts and artifacts of the thirteenth century, say, and those of the sixteenth century? Some "real" historians—not only economic, social, and political historians but also medieval intellectual historians like Lynn Thorndike —said: no, obviously not. Historians of literature, music, art, and other creations of the muses said with equal confidence: yes, obviously.

Some of us beginning students wondered what the fuss was all about—"really" all about, since we were (certainly those of us in Garrett Mattingly's seminar in those days) trained to be, and to think of ourselves as, "real" historians. Was it a rivalry between the disciplines, hard and soft? Or between proprietors of different periods, medievalists and Renaissancists? Or was it another version of the old conflict between nominalists and realists—between those who thought history was what really happened ("one damned thing after another") and those who thought that there was a higher (if not spiritual) pattern discernible at least to an initiated few? Or was it between history for real men and history more suitable for the ladies (which was more or less the level of our gender awareness in those days)?

For many of us Panofsky had the most plausible answer to this question, and though neither profound nor novel, it was vividly illustrated and persuasively argued. Something—to adopt the language of the *wie-es-eigentlich-gewesen* school of thought—"something" indeed "happened." Something happened that accounts for the obvious fact that the Villa Rotonda of Palladio (c. 1550) has less in common with Our Lady's church at Treves (c. A.D. 1250) than with the Pantheon (c. A.D. 125).[6] To locate this something more precisely and politically, Hans Baron contrasted the cramped and unperspectived mural of Florence by a trecento artist in the Loggia del Bigallo (1352) with the panoramic view offered by a Florentine engraving of about 1480.[7] What happened was a change not only of historical context but also of human perception and values and of a change in what Gombrich himself recognized as a cultural "climate"; and "Renaissance" was merely the traditional topos and slogan that identified this shift—"the new birth," in the words of Burckhardt, "which has been one-sidedly chosen [to name] the whole period."[8] Nor is it likely, I think, that we will cease to use this name, whatever reality we may wish to assign it.

Of course Gombrich himself has not been unaware of the limitations of nominalism and intentionalism; and elsewhere he acknowledged that there were cultural meanings beyond artistic intention and that, in his words, "psychology alone can never suffice to explain the riddle of history, the riddle of particular changes"[9]; and so he, too, turned to iconology. But in any case Panofsky's answer had nothing to do, really, with a higher cathood. Rather it arose from the invocation of cultural "meaning"—a meaning beyond the details of architectural style and even artistic intention—as a category of historical inquiry and understanding. Whatever "happened" way back then, what is significant to us is the way the details—the evidence, the testimonies, and the creations of that remote age—have been perceived, interpreted, and expressed by later ob-

servers and scholars, and indeed even contemporaries; for many inhabitants of the fifteenth and sixteenth centuries sensed and argued that things of major significance were happening, and that among these were the intangible but very perceptible achievements of the practitioners of the arts—liberal, mechanical, and fine.

Not many American (and still fewer English) historians were trained to appreciate these hermeneutical subtleties, which seemed more suited to the unmanly pursuits dominated by aesthetic appreciation and "impressionistic" judgments. In many ways the "new" (now old) economic and social history of the 1960s reinforced the obtuseness that segregated cultural studies. I well remember a seminar here at the Institute some 23 years ago on the use of quantitative history, run by Carl Kaysen and attended by (among others) Lawrence Stone, Felix Gilbert, and several younger historians on both side of the methodological divide. I remember, too, the lecture given to this group by Carl Schorske on the Vienna *Kunstschau* of 1908 and the questions that this talk received.[10] How could real history utilize paintings when their evidentiary status depended not only on the contingencies of their display but also on the personal judgments of art historians? What conclusions could possibly be drawn from such random and heterogeneous data and arbitrary opinions? To these deliberately obtuse objections Schorske had eloquent answers which (whether or not they convinced his interrogators) hinged specifically on the legitimacy of the sort of evaluative cultural history that Panofsky's work represented.

What Panofsky offered was a way of crossing the old barrier between value-free, objective science and value-laden, judgmental art—and beyond the arid and unreflective practices of the Anglophone history of the post-war years. In general Panofsky set his scholarly work within two frames of reference (as he put it), one defined by a philosophy of art and the other by a philosophy of culture. The first of these was a Germanic tradition of *Kunstgeschichte*, traced back especially to Winckelmann (but also, more remotely, to Renaissance figures such as Dürer and Vasari).[11] The other was associated with more recent (and also Germanic) ideas of culture, especially the philosophy of symbolic forms of Ernst Cassirer and the view of the human sciences taken by Wilhelm Dilthey, who situated the specific objects of art-historical inquiry within "lived experience" (*Erlebnis*) and "the encompassing reality of a cultural system" (*die umfassendes Wirklichkeit des Kulturzusammenhangs*).[12]

Dilthey gives an example of how art gives expression not only to aesthetic but also to "lived experience," to historical milieu, and to what he calls "localization" with reference to Dürer's "Four Apostles" (Munich; Alte Pinakothek), which had originally been given to the city of Nürnberg.[13] While Dilthey himself does not specify how the "Four Apostles" represented *Erlebnis* in his experience or cultural theory, Panofsky describes at some length and with great ingenuity how these figures reflect not only the four temperaments but also four basic forms of religious experience in the period of the Reformation, with St. Paul representing in effect a later version of Dürer's "Melancholia."

One may think of Panofsky's project as situated in the center of two concentric circles, or horizons, of exploration and interpretation. The largest of these is what he called the "cosmos of culture," a "spatio-temporal realm" which was the world of man's own making, as distinguished from the cosmos of nature; and the smaller is the special domain of aesthetic experience.[14] These circles of human life and artistic expression define two overlapping arenas of human will and creativity, which Panofsky distinguished in terms of two different kinds of historical evidence, that is, documents and monuments.

For Panofsky man is a record-keeping animal —"He is fundamentally an historian"—and it was the task of the humanist to reconstruct the meaning of human life from these records

emerging, as Panofsky put it, "from the stream of time."[15] Within this cultural cosmos there is a smaller arena, however, which is that of the fine arts; and here a very special sort of humanist skill is required, as well as sensitivity. For a work of art is more than a record; it is, as Panofsky says, a "man-made object demanding to be experienced aesthetically."[16]

"Aesthetic experience," it is relevant to note, is a key concept of modern philosophical hermeneutics, most notably in the work of Gadamer and Jauss, building on Heidegger and Dilthey.[17] More recently it has entered even into the discussions of historians—for example, in Dominick LaCapra's distinction between the "documentary" and the "worklike" aspects of texts, the first corresponding to historical reality and the second to qualities of "commitment, interpretation, and imagination," following here Heidegger's analysis of the privileged status of the *Kunstwerk*.[18]

Within the sphere of aesthetic experience Panofsky again followed the philological model of interpretation represented by Erasmus and Budé. In a general sense iconography corresponds to the literal and historical, that is, the documentary, meaning of terms and texts, and iconology to the formal, allegorical, or (so to say) spiritual meaning and to the bigger picture, which is the cosmos of culture. Here, by checking art works against documents, the art historian finds connections with specialists in the other humanistic disciplines—a "common plain," Panofsky calls it, which is located in the field of cultural history.

From this standpoint art history is analogous to the sort of historical semantics practiced and promoted by contemporary philologists like Ernst Curtius, Erich Auerbach, and Leo Spitzer, who followed a similar "teutonic" line in linguistics and *Literaturgeschichte*. "It is the belief in the autonomy of the work," remarked Spitzer, "which made possible the whole movement of Humanism, in which so much importance was given to the word of the ancients and of the Biblical writers."[19] Much the same might be said about

the autonomy of the work of art as viewed by *Kunsthistoriker* like Panofsky and Gombrich. Literary texts and works of art are human creations; the task of the humanistic scholar is, in a critical way, to recreate the originals, the intentions of the authors, and their historical meanings.

The method of Spitzer, which (on the analogy of Heidegger's "hermeneutical circle") he called the "philological circle," was congruent with Panofsky's own "methodological circle."[20] As Spitzer moved back and forth from "word-details to inferred forms" in order to "recreate the artistic organism," so Panofsky moved from themes and stylistic and formal details to the individual works of art; and like Spitzer, he denied that this hermeneutical process (both referring, in this connection, to Heidegger) was in any way a "vicious circle"; rather it was a way of finding, restoring, or giving meaning to creations of a bygone age.[21]

Art history is more than doxography, however—more than "the history of works and their authors," as Jauss has defined the old *Kunstgeschichte*.[22] As always, the humanistic interpreter has to take into account not only the meaning of a text or work of art but also the cultural context and environment—the "milieu," Spitzer called it—and this is just where such historical abstractions, concrete universals, or such cultural "Somethings" as the Renaissance come into play. What this signified was a sort of phenomenology of culture, in which art objects or literary texts, representing authentic documentary or aesthetic traces of human life and experience—the details of cultural history—found meaning within the horizons of lived experience and the historical reconstruction of such experience.

So we come back to the larger of the two circles of interpretation, that of lived experience and culture in its broadest sense, bringing us into confrontation with the tradition of cultural history, which can also be traced back to the age of Winckelmann—the first book to display the title *Geschichte der Cultur* being that by Johannes

Adelung (1782). The expression itself was classical in inspiration. "I should have preferred a German term instead of the word *culture*," Adelung explained, "but I know none that exhausts its meaning. 'Refinement' [*Verfeinerung*], 'enlightenment' [*Aufklaerung*], development of capacities [*Entwickelung der Faehigkeiten*] all convey something, but not the whole sense." To scholars like Adelung, Herder, and other late Enlightenment scholars "culture" suggested a more scientific way of defining the historical incarnations of the human spirit—the *Volksgeist* and the *Zeitgeist*—including, of course, all the fine arts.[23]

The fortunes of *Kunstgeschichte* and *Kulturgeschichte* have been linked since at least the eighteenth century, although each has had its separate literary history. In the nineteenth century cultural history became not only a genre but also a discipline practiced by an impressive line of scholars and popular writers and which was recognized as a sub-department of history.[24] Scholars had long distinguished between high and low culture (*geistige* and *materielle Kultur*), and it was under the former rubric that art history was pursued by *Kulturhistoriker* like Franz Kugler and his former student, Jakob Burckhardt, and would be continued by more specialized scholars like Wölfflin, Warburg, Saxl, and Panofsky. Like the other liberal disciplines, the fine arts figured both as a special field of study (in monographs) and as a culminating phase in the development of culture in the broadest sense (in larger surveys of the cultural history, in which literature and art were set not only in long perspective but also in specific context). Panofsky's career began in the heyday of the "new method" of Karl Lamprecht's version of *Kulturgeschichte*, which in the early twentieth century supplanted the old social-evolutionary variety.[25]

Panofsky—as a cultivator of two overlapping fields of humanistic studies and so as a participant in two interconnected traditions of historical interpretation—has had a dual impact on scholarship since his time of greatest prominence a generation or more ago. I cannot speak for art history. One has heard recent voices lamenting "The End of Art Theory" and "Das Ende der Kunstgeschichte"[26]; but I give them little more credence than I do similar proclamations of the end of history or of philosophy; and in this field I see little decline in Panofsky's influence in recent years—although it is true that such citations are often either deferential or an occasion for criticism (or both).[27]

As for cultural history, Panofsky's influence has been less tangible, but he is still a presence in this post-Marxist period of a resurgent—some prefer to call it a "new"—cultural history, which itself proposes to correlate cultural forms with other aspects of social, institutional, and political history. Roger Chartier, for example, compared Panofsky and Lucien Febvre for "attempting in the same period to equip themselves with the intellectual means to conceptualize the 'spirit of the times,' the *Zeitgeist* which, among other things, underlay Burckhardt's entire approach but which, for both Panofsky and Febvre, was what must be explained rather than what explains."[28]

In general what Panofsky's iconological method suggests is a sort of phenomenology of culture expressed in historical form—a system of meaning connecting artistic creations to all of their contexts, both the immediate social environment and the longer temporal and conceptual perspective.[29] What it demands is that special attention be given to the aesthetic dimension of experience, which joins subjective apprehension to objective reality and which sets representation above this reality—or rather holds that reality is accessible only through its various representations. For historians, too, there is no *Ding an sich*, but only cultural traces that must be identified and interpreted.

The result is that historians have had to confront not only facts and artifact but also perceptions and representations of these, and so must consider not only "the history of works and their authors" but also the history of intangibles (and some would say inaccessibles) such as taste, vision, space, and forms, and (most problemat-

ically) reception. Panofsky has been an acknowledged inspiration for one new subject (new for historians anyway) which Jacques LeGoff has called the "history of imagination"—a subject that would make many real historians of the old school roll over in their graves.[30] To these lines of research I might also add the new horizons of popular culture, which iconology has also helped to open up (beginning at least with Spitzer's famous article of 1962 on the deeper meanings of the advertisement for Sunkist orange juice).

In more general terms the influence of Panofsky can be seen in the massive invasion of historical studies by iconographic, iconological, and semiological investigations which add a visual dimension to traditional views of historical phenomena like the Reformation.[31] Such approaches were of course not limited to the canons of high art; and more recently they have been employed to extract historical meaning from such artifacts as needlework, gravestones,[32] comic strips, bookplates, menus, and pornography. As George Kubler suggested, "the ideas of art can be expanded to the whole range of man-made things"[33]—which is in effect what the cultural historians of the last century proposed to do, thus assimilating high to low (*geistige* to *materielle*) culture.

As part of this influence, Panofsky's work has been a locus not only for praise but also for criticism, sometimes justified, sometimes not, by scholars wanting to give distinctiveness to their own work; and this has also helped to preserve his presence in contemporary scholarship. By way of illustration let me point out a few historiographical issues in which Panofsky's writings still figure.[34]

The pivotal question is that of the role of generalization in historical interpretation, of which Gombrich's aforementioned critique is one example. Inferring large patterns from an art-historical base always has its perils, and a number of criticisms of Panofsky's work arise from considerations both of detail and of context.

Lawrence Nees, for example, objects to Panofsky's characterization of Charlemagne's policy (and the earlier work of Schramm on which they drew) as based on a classicist agenda or a *renovatio imperii romani,* and argues especially from contemporary usage of the term *renovare,* which seems to have largely Christian connotations.[35] This critique offers important correctives to Panofsky's views concerning details, but it also tends to neglect the later meanings of Charlemagne's efforts as they were developed in a subsequent tradition and reception. Like the "Renaissance" itself, these meanings were the product of generations of interpretation (and, no doubt and inevitably, of misinterpretation) which have contributed to historical judgments.[36]

Another problem is that (mentioned earlier) of circularity of method which has bothered historians of art and literature for generations. I recall the account given years ago by Walter Jackson Bate in his course on literary criticism, noting the urge to learn more and more about a work (as a document) in order to learn more about its historical context and more and more about the context to learn more about the work, etc., etc. In such obsessive historicism where is art? More to the point, where is history? Carlo Ginzburg has noted the vicious circle involved in linking "the stages in Dürer's religious crisis, known through documentary evidence . . ., by analysis of the figurative evidence."[37] And yet it is out of some such hermeneutical condition that historical interpretation must emerge and that meaning must be approached—even if, as Burckhardt wrote, this meaning may be seen differently by different eyes.

A generation or two ago the question of periodization, of the chronology of changing cultural configurations, stood high on the agenda of many historians, and of course Panofsky's neo-Burckhardtian conception of the Renaissance was a locus modernus of this issue. Elizabeth Eisenstein has complained that Panofsky neglected the vital significance of printing in his

view of ideas of cultural revival, most conspicuously in his treatment of Dürer. Yet Eisenstein herself, in her revisionist views, seems to accept many of Panofsky's premises and ends up producing an even more reified concept of the "Renaissance."[38] More subtle approaches to this question were already current in Panofsky's heyday—for example, in the famous argument of Roberto Lopez concerning the disjunction between economic conditions and artistic achievement in the trecento, presented in the same symposium in which Panofsky gave his paper on Leonardo.[39]

Panofsky's *Gothic Architecture and Scholasticism,* one of the most influential of his books, has also become the locus of criticism because of the very explicit synchronic connections it makes between two spheres of activity and an inferred cultural unity underlying the similarities. The tendency of scholars is both to accept and to carp at Panofsky's broad arguments. Thus Umberto Eco accepts the implications of Panofsky's arguments but puts specific limits on them. Panofsky was correct in seeing "the order in Aquinas's theological system reflected in cathedrals"—and further—"both were reflections of the order in a theocratic imperial system."[40] However, Eco adds, "this political system no longer reflected the economic and social relations of the time." More recently, Charles Radding and William Clark have tried to modify Panofsky's thesis by pointing out more formal interdisciplinary relations between architecture and learning, although at the same time they, too, endorse his interpretation to the extent of recognizing the common "cognitive" background— a version of the idea of *mentalité*—of these disciplinary changes.[41]

It is somewhat easier, perhaps, to charge Panofsky with western and elitist bias, but it is also more that a little unhistorical. Keith Moxey, while acknowledging Panofsky's achievement, has protested his tendency to limit his attention to elite concerns and "works that were securely ensconced in a certain aesthetic canon." Moxey

wants to expand this canon, but surely there is nothing in Panofsky's iconographic or iconological theory that requires confinement in a tradition of western masterpieces. (Panofsky himself, it may be recalled, has written on the silent film.)

A more fundamental problem for contemporary scholars, especially those with ties to literary history, is that of intentionality and what Gadamer has called "the sovereignty of the painting."[42] It is in connection with a postmodern vision of "the end of art history" that Ivan Gaskell has declared that "the model of pictorial model of interpretation derived from Erwin Panofsky's distinction between the pre-iconographic, iconographic, and iconological level was long ago theoretically superseded by the realization that denotation is ultimately indistinguishable from connotation and even that the simplest meaning . . . is culturally contingent."[43] Is it really possible that Panofsky needed to read Foucault and Barthes (cited as authorities by Haskell) to come to this hermeneutical insight? For Panofsky the work of art was indeed the cynosure of attention, but its meaning was nonetheless established with reference to a variety of cultural contexts not necessarily under the artist's control. The same awareness has for centuries informed the philological (and rhetorical) model of interpretation utilized by Panofsky.

These scattered comments suggest that Panofsky's work (beyond the aspects of his work that have been incorporated into historical scholarship) is still a presence on the level both of small details and large conceptual concerns—of particular insights and as a locus of controversies about more general interpretation. From a contemporary, or postmodern, standpoint his writings display both weaknesses and strengths, both of which stem from the traditions on which he drew. Here I prefer to dwell on the strengths, of which I would conclude by pointing out two in particular.

Panofsky was profoundly immersed in traditions of Germanic philosophy. He drew specifically on Cassirer's philosophy of symbolic forms,

which led him to emphasize questions of perception and expression in a framework that was at once historical and aesthetic; and it is interesting to note that his work reflected back on Cassirer's views of Renaissance thought.[44] For the history of philosophy one of Panofsky's most lasting interpretations was that of the paradoxical fortunes of the Platonic idea in Renaissance and modern art, which is still central to the story of modern Platonism.[45] In general this habit of applying to the history of philosophy for problems of historical interpretation has been at once a barrier and an inspiration to historians of the past generation.

The second major strength of Panofsky's scholarship derives from his sense of continuity—a sense that applies not only to the history of western art since classical antiquity but also to the traditions of scholarship to which he belonged. The result was a classicist bias that may grate on modern sensibilities, but it also provides a depth of vision that is lacking in scholars deprived of the sort of classical education that Panofsky enjoyed. He saw not only as a student of Erasmus and Dürer but as a descendant and even a colleague, and this informed the historical perspective which he brought to all of his researches.

This essential quality Panofsky has not passed on to many of his epigones, heirs, and critics. Most practitioners of the "new cultural history" and the "new historicism," for example, seem to lack the sort of scholarly and professional memory—not only a grasp of classical literature but also of their own antecedents—which gave scholars like Panofsky access to the insights, the weaknesses as well as the strengths, of a long tradition of humanistic studies.

But at least they, and/or we, have learned to see beyond the works and authors of positivist history and have begun to awaken from the dream (noble or not) of objectivity. And most of us are willing to admit that beyond the monuments and documents left to us, beyond the lives and works of artists and authors, there are cultural configurations and shifts accessible, through study of the details of works, to historical under

standing. Behind major "mutational changes" like the Renaissance (in Panofsky's words) "something happened" that invites and indeed demands further investigation and reflection. This is a lesson that I, at least, still and always associate with the work of Panofsky, the questions that it posed, the horizons that it opened up, and the various ways in which, through his efforts, the good god of history reveals him or herself in the details.

Notes

1. *The Life and Art of Albrecht Dürer* (Princeton, 1955), 239.
2. Cited by Marjorie O'Rourke Boyle, *Erasmus on Language and Method in Theology* (Toronto, 1977), 37.
3. "Art as a Humanistic Discipline" (1940), in *Meaning and the Visual Arts* (New York, 1955), 1–25.
4. *The Art Newspaper* 28 (May 1993), 19.
5. *Renaissance and Renascences in Western Art* (New York, 1972), 7, with extensive bibliography on the issue.
6. Ibid., 40.
7. *The Crisis of the Early Italian Renaissance*, 2nd ed. (Princeton, 1966), 180.
8. *The Civilization of the Renaissance in Italy* (London, 1950), 104.
9. *Meditations on a Hobby Horse* (London, 1963), 118.
10. Here I rely entirely on my own memory.
11. "Three Decades of Art History in the United States," in *Meaning and the Visual Arts*, 323. According to Felix Gilbert, "From Art History to the History of Civilization: Aby Warburg," in *History: Choice and Commitment* (Cambridge, Mass., 1977), 431, "He regarded art history as an aspect of the history of civilization (*Kulturgeschichte*)."
12. *Einleitung in die Geisteswissenschaften*, in *Gesammelte Schriften*, 1 (Stuttgart, 1959), 49ff. See also Silvia Ferretti, *Cassirer, Panofsky, and Warburg*, tr. Richard Pierce (New Haven, 1989).
13. *Die geistige Welt: Einleitung in die Philosophie des Lebens*, in *Gesammelte Schriften*, 6 (Leipzig, 1924), 316; and cf. Panofsky, *Albrecht Dürer*, 214.
14. "Art as a Humanistic Discipline," 7, 14, passim; and see Michael Podro, *The Critical Historians of Art* (New Haven, 1982), 181.
15. Ibid., 5.
16. Ibid., 14.
17. Gadamer, *Truth and Method*, tr. Garrett Barden and John Cumming (New York, 1982), 55ff.
18. *Rethinking Intellectual History* (Ithaca, 1983), 30. See Heidegger, "The Origin of the Work of Art," in *Poetry, Lan-*

guage, Thought, tr. Albert Hofstadter (New York, 1975), 15–18.

19. *Linguistics and Literary History* (Princeton, 1948), 21.

20. Spitzer, *Linguistics,* 29; cf. Panofsky, *Studies in Iconology: Humanistic Themes in the Art of the Renaissance* (New York, 1962), 11n. See also Joan Hart, "Erwin Panofsky and Karl Mannheim: A Dialogue on Interpretation," *Critical Inquiry* 19 (1993), 534–66.

21. See Carlo Ginzburg, *Clues, Myths, and the Historical Method,* tr. John and Ann C. Tedeschi (Baltimore, 1989), 35–36.

22. *Aesthetic Experience and Literary Hermeneutics,* tr. Michael Shaw (Minneapolis, 1982), xxviii.

23. *Versuch einer Geschichte der Cultur des menschlichen Geschlechts von der Verfassen des Begriffs menschlicher Fertigkeiten und Kentnisse* (Leipzig, 1782).

24. Beginning with the 1912 edition of Dahlmann-Waitz's bibliography of German history.

25. See Horst Blanke, *Historiographiegeschichte als Historik* (Stuttgart, 1991). That Warburg had been a student of Lamprecht is noted by Michael Ann Holly, *Panofsky and the Foundations of Art History* (Ithaca, 1984), 105.

26. See Ivan Gaskell, "History of Images," in *New Perspectives on Historical Writing,* ed. Peter Burke (University Park, PA, 1991), 184.

27. To judge from the *Humanities Citation Index* over the past decade there have been 100–200 references per year to Panofsky's work (maximum 193, minimum 117), especially *Early Netherlandish Painting* (188), *Meaning in the Visual Arts* (145), *Idea* (106), the biography of Dürer (102), and *Renaissance and Renascences* (89).

28. *Cultural History: Between Practices and Representations,* tr. Lydia G. Cochrane (Ithaca, 1988), 23.

29. See Germain Bazin, *Histoire de l'histoire de l'art* (Paris, 1986); Keith Moxey, "Panofsky's Concept of 'Iconology' and the Problem of Interpretation in the History of Art," *New Literary History* 17 (1986), 265–79; Christine Hasenmueller, "Panofsky, Iconography, and Semiotics," *Journal of Aesthetics and Art Criticism* 36 (1978), 289–301; and Göran Hermerén, *Representation and Meaning in the Visual Arts* (1969), 127ff.

30. *The Medieval Imagination,* tr. Arthur Goldhammer (Chicago, 1985), 4, pointing out the applications of collaborative and computerized methods to iconographic research.

31. E.g., R. W. Scribner, *For the Sake of the Simple Folk: Popular Propaganda for the German Reformation* (Cambridge, 1981); Keith Moxey, *Peasants, Warriors, and Wives: Popular Imagery in the Reformation* (Chicago, 1989); and Kristin Zapalac, *"In His Image and Likeness": Political Iconography and Religious Change in Regensburg 1500–1600* (Ithaca, 1990).

32. Panofsky is given special credit in this connection by Phillip Ariès, *The Hour of Our Death,* tr. Helen Weaver (New York, 1981), 113.

33. *The Shape of Time: Remarks on the History of Things* (New Haven, 1962), 1.

34. I omit a large literature by art historians, especially on questions of "iconology."

35. *A Tainted Mantle: Hercules and the Classical Tradition at the Carolingian Court* (Philadelphia, 1991).

36. The best statement of the meaning of the Renaissance is still Wallace K. Ferguson, *The Renaissance in Historical Thought* (Boston, 1948).

37. *Clues, Myths, and the Historical Method,* 36.

38. *The Printing Press as a Agent of Change: Communications and Cultural Transformations in Early Modern Europe,* 2 vols. (Cambridge, 1979).

39. "Hard Times and Investment in Culture," in *The Renaissance* (New York, 1953), 29–54, from a symposium held at The Metropolitan Museum of Art.

40. *The Aesthetics of Thomas Aquinas,* tr. Hugh Bredin (Cambridge, Mass., 1988), 213.

41. *Medieval Architecture, Medieval Learning: Builders and Masters in the Age of Romanesque and Gothic* (New Haven, 1992).

42. *Truth and Method,* 120.

43. See above, n. 23.

44. *The Individual and the Cosmos in Renaissance Philosophy,* tr. Mario Domandi (New York, 1963), e.g., 114, 163.

45. *Idea: A Concept in Art Theory,* tr. Joseph J. S. Peake (New York, 1968).

Panofsky, Alberti, and the Ancient World

ANTHONY GRAFTON

Leon Battista Alberti could do many remarkable things. He leapt from a standing start over the head of a man standing next to him. He hurled lances and shot arrows with astonishing force, and threw a coin so high that it rang as it struck the vaulted roof of the church he stood in. A penetrating observer of society, he divined men's intentions towards him at a glance. He loved to look at dignified old men, but wept when he saw spring flowers or fall fruits, because they made him feel unproductive. He interrogated knowledgable craftsmen about their skills, and eventually became a dazzling (if amateur) painter in his own right, one who could paint or sculpt the likeness of a friend while dictating an essay. The device for projecting images that he designed startled his contemporaries with its illusions of landscapes, the night sky, and the ocean. He trained himself to bear pain without flinching (he sang to distract himself) and even to tolerate the presence of garlic and honey, which had originally made him vomit.[1]

All this we learn from the so-called anonymous life of Alberti, first published in the eighteenth century (sadly, most scholars now take the text as autobiographical and with at least half a grain of salt). The Alberti of this anonymous account—the universal savant, the brilliant man of action, the cultivator of *sprezzatura* before Castiglione—enthralled Jacob Burckhardt, that passionate lover of the life of the Italian streets which Alberti prowled and the Italian landscapes that he found so beautiful. Alberti's character forms the core of the brilliant description of "the universal man"

that lights up the second section of *The Civilization of the Renaissance in Italy*. In both the original account and Burckhardt's incomplete retelling, an encounter with the classical past plays only a supporting role—and a rather frightening one— in the lively cast of Alberti's tasks and hobbies. Both texts tell us that the very experience of textual study—at least when carried out on an empty stomach—proved unhealthy, almost lethal. Burckhardt treats the transition in Alberti's life, however, not as a crisis but as a natural progress from textual studies to science and the visual arts: "finding his memory for words weakened, but his sense of facts unimpaired, he set to work at physics and mathematics." This brilliant, iron-willed student of nature made the perfect prelude, in Burckhardt's eyes, to the true universal man of the High Renaissance, Leonardo. That self-proclaimed "man without letters," scientist and artist was to Alberti "as the finisher to the beginner, the master to the dilettante." Burckhardt's Alberti—the universal man, the friend of artists who did not waste his time among the humanists—dominated the historiography for decades. He made a natural centerpiece for a vision of the Renaissance in which the discovery of nature and of man took center stage, and the rediscovery of classical texts had a strictly subordinate role.[2]

In the years just before the turn of the century, however, the nature and direction of cultural history and the history of art began to shift in momentous ways. The impact of the classical heritage on Renaissance art and artistic theory

attracted attention from many quarters. Not only the brilliantly idiosyncratic refugee from a banking career in Hamburg, but von Schlosser and Giehlow in Vienna, Flemming and a host of others now forgotten broke the unpromising ground of dialogues on art, Neo-Platonic treatises and classical commentaries, searching for iconographical and biographical gold. Major Renaissance artists, like Dürer, and influential theorists, like Alberti, were suddenly revealed playing an unexpected role: as serious readers as well as forceful writers. A century of subsequent work has proved that this approach is necessary (though not sufficient). Students of Alberti's works on the arts, for example, have shown in meticulous detail how closely he based each of his technical manuals for artists on classical prototypes, above all the rhetorical works of Cicero and Quintilian, and how densely he stuffed them with classical references. Unfortunately, the same century's work has not determined exactly how one should approach Alberti's classicism. Each new interpretation of *On Painting*—and every year brings forth a number of them—now routinely rests on an identification of Alberti's major structural source or sources. Unfortunately, some are no solider than Flemming's effort of a century ago, which Panofsky effortlessly refuted, to make Alberti a Neo-Platonist on the strength of a fantastic connection with Plotinus.[3] The great example of the Renaissance's discovery of the world and of man has become a central figure in the classical revival—and, even more paradoxically, the object of an unending paper chase.

Erwin Panofsky—whom, like Alberti, I know only from reading—could do almost as many remarkable things as the inventer of Renaissance perspective. His books, which I and my contemporaries encountered in undergraduate and graduate courses, won many of us to the study of the Renaissance—in cultural history as well as the history of art. They offered an attractive, if practically inimitable, model of interdisciplinary scholarship. Their author, after all, could jump as effortlessly as Alberti, and over higher obstacles.

He leapt with a Nureyev's ease and mastery from visual material to texts, from literature to science, and from antiquity to the baroque. When Panofsky set out to define a Gothic form or the Renaissance view of the past, he retained the sweep and eloquence of a Burckhardt. He had learned, presumably in the years of interaction with Warburg and Cassirer, to see the central forms of cultures as coherent sets of symbols. He had also made discoveries about rhetoric—partly in the course of his collaboration with Fritz Saxl, that master of the capsule summary and the deftly chosen example; partly as a result of having to teach in America. In English, he realised, he could describe the basic western cultural forms to a new public and with a new clarity, partly because he was released from the toils of his Begriff-stricken mother tongue. But if his hypotheses towered into a speculative stratosphere, they were still firmly rooted in empirical soil. Thick, twisty footnotes made clear his mastery of a wealth of texts; numerous plates assembled an equal wealth of visual material.[4] Panofsky, in other words, supported his arguments with—and often built them around—precisely the sort of detailed interpretations of texts and images that Burckhardt had omitted. He seemed to have both the panoramic vision of the parachutist and the microscopic attention to detail of the truffle-hunter. Such at least was my experience of one Panofsky—the Panofsky of *Gothic Architecture and Scholasticism, Studies in Iconology,* and *Renaissance and Renascences in Western Art.*[5]

One of this Panofsky's formulations, in particular, won many hearts. In a series of brilliant essays, the fullest of which was written with Fritz Sazl, he set out to establish the difference between the several renascences of classical texts and forms which took place during the Middle Ages and the full-scale Renaissance which he localised in fifteenth-century Italy.[6] Medieval artists and scholars, he explained, studied individual classical texts or imitated individual classical forms. But they did not see classical forms and their original content—or motifs and themes—as

organically connected, as joint, though different, expressions of a single civilization. Only in the late fourteenth and early fifteenth century did humanists come to see the ancient world as a whole, a coherent culture that stood at a fixed chronological distance from their own. When they did so, the shock of recognition was immense, and the intellectual change involved revolutionary. It was, in fact, every bit as radical as the contemporary transformation of the visual arts by the formulation of a strict system of one-point perspective. Panofsky, characteristically, speculated over and over again on what he saw as these contemporary and analogous changes of cultural focus. The end of the medieval "principle of disjunction" and the creation of a modern system of perspective became, for him, the double expression of a single phenomenon: the rise of a naturalistic art, for whose practitioners the way to nature lay through the antique (eventually, of course, the classical form of realism would be overcome and supplanted, in its turn, by other forms). Panofsky's dramatic but flexible way of putting this point gave those interested in the history of the classical revival a vocabulary and a thesis. He enabled us to argue in detail about humanist scholarship without feeling that we were lost in the pursuit of details that had no larger sense. We owed him intellectual confidence—a hard emotion for intellectual historians to cultivate in the years when "real" political history gave way to quantification. No wonder that his elegant formulations inspired so much research and teaching.

Songs of innocence, however, turn into songs of experience. A richer experience of the texts and problems connected with the early and mid-fifteenth century has made me uneasy about the very claims that made me enter the field in the first place. If Panofsky was right, Alberti ought to be the nexus, the thinker in whom both forms of perspective, visual and temporal, come together. He formulated the rules of perspective, for the first time, in writing. He intimately knew, and celebrated in a phosphorescent prose poem, Bru-

nelleschi and the other Florentines who devised them. He devoted much of his life to the study and use of ancient buildings. And in fact he reappears constantly in Panofsky's work, as a key witness to the existence of a real Renaissance. But the more closely one looks at the texture of Alberti's writing and creative work, the harder it becomes to make him fit Panofsky's splendid model.

Alberti certainly took a passionate and creative part in the fifteenth century revival of antiquity. He studied the ruins of the city of Rome more systematically than any of his contemporaries, except his colleague Flavio Biondo. *De re aedificatoria* is, as Carlo Dionisotti pointed out long ago, not only a pioneering work on architecture but a *summa* of fifteenth-century antiquarian scholarship. Alberti also knew the crafts that his contemporaries used to elucidate ancient texts. He knew the techniques of humanist philology, for example, well enough to enjoy playing with them—always a sign, as Michael Baxandall has pointed out, that one has mastered a skill with difficulty and likes to display the acquisition in public.[7] Guarino of Verona translated Lucian's mock-encomium on the fly into Latin and sent it to Alberti, who was suffering from a fever. The text amused him so much that he immediately sat up and dictated a mock-encomium of his own. Alberti praised everything about the fly. The fly is heroic (he is willing to attack any opponent, without a leader or allies, at any time); he is pious (whenever the ancients sacrificed animals to the gods, the flies were the very first to attend); he and his female companions wear the same fine classical dress as their ancestors and show the same musical talent. Above all, however, Alberti praises the fly's erudition and antiquity. Flies are insatiably curious; in fact, they know the answers to questions that have tormented scholars for centuries. Flies know what Circe fed her suitors to turn them into pigs, what Andromache's breasts tasted like, what flaws appeared in Helen's *nates,* and what beauties adorned Ganymede's *occulta.* So much for exactly the sorts of historical

and mythological questions most beloved of humanist commentators and schoolteachers. Even textual criticism, the humanist science of sciences, came in for its share of mockery at Alberti's hands. The flies, he explains, stood at the origins of ancient science: they had taught Pythagoras his new mathematics. A simple feat of textual criticism proved the point. The texts said that after Pythagoras proved his theorem, he sacrificed "musis," to the Muses. In reality, Pythagoras must have offered his hecatomb of oxen "muscis," to the flies.[8]

Most important of all, Alberti could synthesize his vast treasury of information. His probing, fluent inquiries into the history of western culture show how profound and flexible a historical imagination he had. Like Biondo—and in the teeth of the beliefs of many well-reputed scholars—Alberti argued that in the ancient world Latin had not been a special, learned language, as it was in his day. Rather, it was the ordinary language of the Romans, in which they had discussed everyday business with their wives, their children, and their slaves. Canonical writers like Cicero used it not because it had a special status but because they wanted readers to understand them. Alberti followed their example, he argued, when he wrote his dialogues On the Family in Italian, since he wrote to be understood, as they had.[9] More cogently than Biondo, Alberti turned the scattered hints of Vitruvius into a sharp, lucid, and imaginative history of how architecture was born in Asia, flowered in Greece, and reached maturity—thanks to the efforts of rival architects and the sound moral traditions of Italian patronage—in Rome. In each case, he clearly saw and treated classical culture as a whole, using developments in one area to explain those in another, and imagining Roman society in human and intimate terms—but also as very different from his own.[10]

But these examples of Alberti's historicism are as unusual as they are impressive. For as Eugenio Garin pointed out long ago in an article as short as it was brilliant (it is one page long), Al-

berti often cites or responds to ancient texts and ideas in ways that fundamentally alter, and sometimes radically subvert, the apparent meanings of the originals.[11] Garin supported his thesis with a number of examples of Alberti's inversions of Cicero. But the evidence is even more plentiful than he suggests. Each of Alberti's major works takes a radically eristic stance towards classical sources. On Architecture attacks Vitruvius on myriad details, explicitly and implicitly; the whole book challenges the very ancient source whose content Alberti made available, for the first time, to large numbers of modern readers.[12] On Painting describes itself, in a direct attack on the elder Pliny, as not a mere history of painting but a brand-new treatment of painting as an art—a subject on which no ancient monumenta had survived.[13] On the Family concludes with a book on friendship which, explicitly and implicitly, inverts the idealistic treatment given by Cicero in De amicitia.

Panofsky, of course, insisted that high Renaissance classicism always involved the creative reworking, not the passive repetition, of ancient forms and texts. He admitted that Renaissance artists and scholars frequently found themselves required to mix the classical with the modern, the Greco-Roman with the Gothic. Eventually they learned to appreciate the latter as historically correct, for its period. More than once he went further. In the beautiful essay on Pandora's Box that he wrote with Dora Panofsky, he showed that the most erudite and creative of Renaissance scholars, his beloved Erasmus, had conflated the archaic myth of Pandora with Apuleius' much later tale of Psyche, in order to create an effective but unclassical image of imprudence.[14] In the essay on Poussin in Meaning and the Visual Arts, he showed how radically new forms of sentiment were read into a classical adage, to the point of distorting its grammatical meaning—and how those who did this violence to Latinity expressed a new and powerful vision of the pastoral.[15]

When Panofsky moved from asserting the rigid

purity of humanist scholarship to following its playful, arbitrary qualities, his approach changed —or so it seems to me. In these works—perhaps, one might say, in this second Panofsky, to whom I came later than I did to the first—the classical tradition looks very different than it did in the first. A carnival funhouse replaces the stately hall of symbolic forms that perfectly reflect each Zeitgeist. Historical accident and personal taste dictate the fates and functions of classical motifs. The fixing of the detail complicates—and even contradicts—the desire and pursuit of the whole. Above all, as in textual criticism, error, not accuracy, becomes the determinative element. Just as the occurrence of so-called "separative" errors proves the independence of one manuscript or family of manuscripts from another, so separative "errors" in interpretation enable one to see not only what early modern readers found most useful in their classical motifs, but also what they felt they needed to ignore or distort in the original texts or images. In later writers, the repeated presence of the error proves the persistent influence of the original re-former of the text. Only one difference—though a crucial one—calls for comment: the errors that merely disfigure a manuscript of a classical text may amount to room for creativity in a reworking of a classical artistic prototype.

I would contend that this second Panofsky offers a much more precise model than the first for describing and understanding what Alberti did to ancient texts and forms.[16] Consider just one test case, drawn from *On Painting*. It is the famous story of Zeuxis and the women of Croton. Alberti tells it thus: "The idea of beauty, which the most expert have difficulty in discerning, eludes the ignorant. Zeuxis, the most eminent, learned and skilled painter of all, when about to paint a panel to be publicly dedicated in the temple of Lucina at Croton, did not set about his work trusting rashly in his own talent as all painters do now; but, because he believed that all the things he desired to achieve beauty not only could not be found by his own intuition, but were not to be

discovered even in Nature in one body alone, he chose from all the youth of the city five outstandingly beautiful girls, so that he might represent in his painting whatever feature of feminine beauty was most praiseworthy in each of them. He acted wisely, for to painters with no model before them to follow, who strive by the light of their own talent alone to capture the qualities of beauty, it easily happens that they do not by their own efforts achieve the beauty they seek or ought to create; they simply fall into bad habits of painting."[17] This anecdote reached a vast public in the next two centuries. Writers on beauty, like Trissino and Firenzuola, used it to justify their endless catalogues of the ideal standard for each bit of the female anatomy (those texts that Burckhardt curiously took as witnessing to the enhanced status of women in Renaissance Italy). The story became one of the most popular of those classical and modern tags that floated from text to text in the sixteenth and seventeenth centuries, blurring as they moved. If we can trust the authenticity of Raphael's letter to Castiglione, it even became part of the normal language of the artist's studio.[18]

The story's meaning naturally varied with its use. Panofsky, in his early book *Idea,* points out that Alberti himself used it in diametrically opposed ways—in *De pictura,* as an incitement to the artist to form a conception of beauty based on meticulous study of the real world; in *De status,* as an inducement to artists to base their work on a single coherent idea of beauty. Even Panofsky, however, did not examine the passage and its classical sources as closely as he did its later uses. This was reasonable; he saw Alberti's relation to the ancient past as relatively unproblematic, as belonging to a first phase of excited, whole-hearted rediscovery. But close, comparative study reveals that in this central, vitally influential text Alberti performed as radical and deliberate an act of textual surgery as Erasmus did to Hesiod 80 years later. Alberti drew the story from two standard sources: Cicero's *De inventione* (2.1) and Pliny's *Natural History* (35.64).

He craftily made clear, to the educated reader, that he used both. Alberti located the story in Croton, as Cicero did (Pliny put it in Agrigento); but he described the temple for which Zeuxis worked as that of Lucina, as he thought Pliny did (Cicero made it the temple of Juno). The passage thus amounts to an elegant pastiche, as Nicoletta Maraschio showed in a very attentive examination of it, twenty years ago.[19] As she also pointed out, Alberti's procedure responded in a very precise way to those of the authors that he exploited. Cicero told the story of Zeuxis as justification for his own eclectic use of several sources in *De inventione;* just as Zeuxis had used several models' bodies, Cicero would use several model texts. So Alberti, imitating Cicero, used another textual source as well.

Alberti, however, not only combined the two Latin models; he systematically abridged and altered them. Cicero told a far longer and quirkier tale than Pliny or Alberti. Zeuxis, he explained, asked the Crotoniates to show him their five most beautiful young women. They replied by taking him directly to the *palaestra,* the wrestlers' gymnasium, and showing him many handsome boys (as Cicero remarks, in those days the Crotoniates were great athletes). They then told him the good news: that the boys he saw wrestling had equally beautiful sisters. Unfortunately, bad news followed immediately: he had to infer their *dignitas* from that of the boys. Undaunted, Zeuxis begged the Crotoniates to let him see the five most beautiful virgins for just so long as he needed to transform the truth about them into a *mutum . . . simulacrum.* At last they agreed, and by a public decree gave him the power to choose his models. The point of the story is evidently double. A teacher's joke, inserted by Cicero to liven up the beginning of a textbook, it turns on a Roman's negative view of Greek naked athletics (and, perhaps, the adult Greek male's love of boys). It also shows the Roman's clear awareness that to paint a nude, the painter needed a naked model—and that respectable women and their parents could find this require-

ment of his art, with its erotic suggestiveness and social inversion, unacceptable. The story of Zeuxis had an erotic edge as well as a literary moral.

Alberti's version of the story, unlike its source, scrupulously avoids all erotic suggestion. The gymnasium and the Crotoniate boys have disappeared. Paradoxically—and, no doubt, deliberately—he has changed places with his source. Cicero, who used the painter and his models as an analogy for the rhetorician and his sources, described the episode in vivid physical terms. Alberti, who actually meant to tell painters how to paint and patrons what to buy, retold it abstractly. Alberti not only used Cicero's and Pliny's material, in short, he rewrote it to fit the ethical and aesthetic program for which he hoped to win support—one that emphasized the emotional, but denied the erotic, effects of painting in what ultimately became a very influential way (one might compare his account of sexual intercourse, one of the more displeasing male fantasies in the western canon, in *On the Family*). Because Alberti manipulated standard sources that his intended readers knew intimately, he could feel confident that they would understand and emulate his revision of the very authorities he used (as indeed, every one of them did, sharing the separative error with the intermediary source that shaped their vision of the ancient artist at work).

Alberti's attack on the passage seems no more classical and no less radical than that of his chief late-medieval predecessor—a man whom Panofsky would have tied rather to "i primi lumi" than to what he took as the pure classical revival of the fifteenth century. Boccaccio told the story of Zeuxis in some detail in his commentary on Dante. Characteristically, he celebrated exactly the implications that Alberti chose to ignore, and cheerfully praised Zeuxis for having examined not only all the Crotoniate boys, but also all of their sisters, in his (admittedly hopeless) search for ideal beauty.[20] Alberti's version of the story, though better adapted to a Christian, moralising

readership, is no more scrupulous, no more in-spired by a desire to reproduce ancient books or ancient life as they really were, than Boccaccio's.

It may seem curious that Alberti, who read the classics with such dedication, applied them with such arbitrariness. In fact, however, his rewritings of his sources fell within the norms of a certain kind of humanist practice. In his youth Alberti had studied with Gasparino Barzizza, who taught his pupils precisely to show their respect for and in-dependence from classical sources at the same time. "Imitation," he explained to them, "is car-ried out in four ways, by addition, subtraction, transferral, and transformation"—never by straight copying. Simple verbal changes could make a single sentence new: "If Cicero says, 'Scite hoc inquit Brutus,' I will add, 'Scite enim ac eleganter hoc inquit ille vir noster Brutus.' See how it seems to have a different form now."[21] Mature human-ists as well as schoolboys practised the same form of aggressive imitation or emulation. Maf-feo Vegio, the Roman cleric who wrote a thir-teenth book for the *Aeneid,* spoiled the epic for generations of schoolboys, by grafting onto the real text a pastel-colored sequel in which Aeneas buried Turnus, married Lavinia, ruled his peoples, and finally ascended to heaven, to become a star. Yet Vegio knew what he was doing. He saw, under the august surface of Virgil's text, the same tensions that have bothered modern readers: the harm done by Aeneas in his travels, the innocent sufferers, the strange ending, so much less hu-mane than that of the *Iliad,* in which Aeneas sav-agely kills Turnus, and the latter's death scream is the last sound heard. Vegio rewrote the poem, in short, because he understood it so well—just as Dante had inflicted Christian senses on Virgil be-cause he understood the pagan ones so well. The boundaries between vernacular and classi-cal culture, late medieval and Renaissance schol-arship are simply not so sharp as Panofsky drew them. Ironically, the second Panofsky thus pro-vides the best guidance in how to criticise the first.

To establish that Alberti's procedures fell within

normal tolerances is not to explain why he chose them so consistently. But it seems possible to connect his commitment to emulative reading with a larger aesthetic project. Alberti loved the classics. He used classical rhetoric as his model of a well-organised intellectual discipline, took classical architecture as his prime source of prin-ciples and design elements, and pleaded for the unique intellectual and practical value of a classi-cal education. But he also insisted, in his famous letter to Brunelleschi and elsewhere, on the legit-imacy of the modern: on the power and unique-ness of the achievements of his fellow Florentines. His account of the family, with its systematic blur-ring of the distance between the ancient Romans and the ancient Alberti, used classical materials to find a voice for the ideology of later medieval merchant life. His architecture—like the Holy Sepulchre that he built for Giovanni Rucellai, with its classical inscription superimposed on a little gem of a Gothic building, or the Malatesta Tem-ple at Rimini, with its triumphal arch superim-posed on a Christian church, or—if indeed it reflects Alberti's ideas—Pienza, with its sym-phonic interweaving of pagan and Christian, an-tique and modern forms—regularly combined classical and modern elements in radically novel ways.[22] Alberti, in short, committed himself throughout his life to making classical texts, ideas and forms live in what he recognized, quite hap-pily, as a non-classical world. His appropriations of specific texts amount to something more than a set of emulative readings of passages. They made manifest a self-conscious, creative, and wholly consistent relationship between classicism and modernity. Applied to the study of this rela-tion, the first Panofsky's model fits only part of the evidence, and obscures almost as much as it re-veals. By contrast the second Panofsky's phi-lological work, with its cheerful admission of the shaping power of accident and the distorting pressure of personal taste, remains exemplary.

Three morals remain to be drawn, and one question to be asked. First, the tensions in Panof-sky's thought were organic parts of it; for the

philological seeds of the second Panofsky's brilliantly revisionist work were sown at the very start of his career—for example, by the lovably pedantic Greek teacher whose charming sermon on the importance of a comma in Plato Panofsky evoked in his memoir.[23] The second Panofsky's work demonstrates the continued utility of a highly traditional philological method, when applied with art and taste. Second, though the perceptions of the second Panofsky were sometimes very narrowly defined, their implications were very wide: more than once they undermined the wonderfully bold and lucid symbolic forms that Panofsky pursued them to support. Third, Panofsky's work on the vision of antiquity, like his work on perspective, drew both energy and tension from his ability to tolerate internal contradictions and function, brilliantly. The question that remains is simple: what factors—political, cultural biographical—explain the prevalence of the first Panofsky, the continual reappearances of the second, and the varied ways in which both segments of his individual talent interacted with the classical tradition?

Notes

1. See the splendid edition and commentary by R. Fubini and A. M. Gallorini, "L'autobiografia di Leon Battista Alberti," *Rinascimento*, ser. ii, 12 (1972):21–78, and the translation, also with very helpful discussion, by R. Watkins, "L. B. Alberti in the Mirror: An Interpretation of the *Vita* with a New Translation." *Italian Quarterly* 30 (1989):5–30.

2. See W. Kaegi, *Jacob Burckhardt,* iii (Basel and Stuttgart, 1956), 657–58, 720–22.

3. E. Panofsky, *Idea,* 6th ed. (Berlin 1989).

4. The quality of Panofsky's plates was at its lowest in his works on general cultural problems; far higher, of course, when he investigated Dürer or early Netherlandish painting.

5. Research on Panofsky's life and thought is clearly entering a growth spurt, parallel in some respects to the recent spurt of interest in Warburg. Some orientation is provided by a helpful review of a recent congress: S. Grobé. "Platon in Hamburg," *Kunstchronik* 46 (1993):1–14. In the current essay I concentrate on Panofsky's American career, making no effort to trace the earliest versions of his thinking or to solve such complex questions as that of his relation to Warburg—which does not mean that I accept all or any of the answers that have been proposed up to now.

6. E. Panofsky and F. Saxl, "Classical Mythology in Mediaeval Art," *Metropolitan Museum Studies* 4 (1993):228–80; see also the brilliant short statement in *Kenyon Review* 6. My generation met this argument in *Renaissance and Renascences in Western Art* (Stockholm, 1960).

7. M. Baxandall, *Painting and Experience in Fifteenth-Century Italy,* 2d ed. (Oxford, 1988).

8. L. B. Alberti, *Opuscoli inediti,* ed. C. Grayson (Florence, 1954), 45 ff.

9. L. B. Alberti, *Della famiglia,* Proemio del libro terzo; in *Prosatori volgari del Quattrocento,* ed. C. Varese (Milan and Naples, 1955), 413–17; for the context see R. Fubini, *Umanesimo e secolarizzazzione da Petrarca a Valla* (Rome, 1990), with references to the earlier literature.

10. L. B. Alberti, *L'architettura,* ed. and tr. G. Orlandi and P. Portoghesi (Milan, 1966), 6.3; cf. the classical analysis offered by R. Krautheimer in his Marburg inaugural, now available in his *Ausgewählte Aufsätze* (Cologne, 1988).

11. E. Garin, "Fonti albertiane," *Rivista critica di storia della filosofia* 29 (1974):90–91, developed further in his *Rinascite e rivoluzioni* (Bari, 1975). Cf. Fubini and Gallorini, "L'autobiografia."

12. See esp. 6.1 and 9.10.

13. 2.26.

14. D. and E. Panofsky, *Pandora's Box* (New York, 1956); cf. the German edition with a Nachwort by P. Krumme (Frankfurt and New York, 1992).

15. E. Panofsky, *Meaning in the Visual Arts* (Garden City, 1955), chap. 7.

16. I do not mean to suggest that there were only two Panofksys (or Albertis); in each case, surely there were many original heads under one capacious hat.

17. 3.56; tr. C. Grayson (London, 1972).

18. I use the annotated text in *Scritti d'arte del cinquecento,* ed. P. Barocchi, II (Milan and Naples, 1973), 1529–31.

19. N. Maraschio, "Aspetti del bilinguismo albertiano nel 'De pictura,'" *Rinascimento*, ser. ii, 12 (1972):193–228.

20. G. Boccaccio, *Tutte le opere,* ed, V. Branca (Verona, 1965), 6:305–6.

21. G. W. Pigman, "Barzizza's Treatise on Imitation," *Bibliothèque d'Humanisme et Renaissance* 44 (1982):351.

22. For two complementary recent discussions of Pienza, both of which take Alberti's involvement as to some degree likely, see A. Tönnesmann, *Pienza* (Munich, 1990), and C. Smith, *Architecture in the Culture of Early Humanism* (New York, 1992).

23. See *Meaning in the Visual Arts,* epilogue.

"Item Perspective ist ein lateinisch Wort, bedeutt ein Durchsehung": A Reformation Re-Vision of the Relationship between Idea and Image

KRISTIN E. S. ZAPALAC

Some seventy years ago, Erwin Panofsky began his Warburg Institüt lecture on "Perspective as 'Symbolic Form'" with a quotation from Albrecht Dürer's notes on perspective:

"Item Perspective ist ein lateinisch Wort, bedeutt ein Durchsehung." ("*Perspectiva* is a Latin word which means [a] 'seeing through.'") This is how Dürer sought to explain the concept of perspective. And although this *lateinisch Wort* was used already by Boethius, and did not originally bear so precise a meaning, we shall nevertheless adopt in essence Dürer's definition. We shall speak of a fully "perspectival" view of space not when mere isolated objects, such as houses or furniture, are represented in "foreshortening," but rather only when the entire picture has been transformed—to cite another Renaissance theoretician—into a "window," and when we are meant to believe we are looking through this window.[1]

In this paper I want to push Dürer's "seeing through" still further than Panofsky did in order to examine a special case of that constructed "seeing through" as an expression of the late medieval understanding of the relation between divine enlightenment and human reason, to examine the meaning of "seeing through"—and thus of the visual arts—and how it was transformed by Lutheran thought.

Elsewhere I have analyzed cases in which the technique of perspective was used by German artists of the late fifteenth and early sixteenth centuries to "illuminate" the relation between the witness' statement under oath in the temporal courtroom and the witness' fate at the Last Judgment.[2] Here I want to begin by looking at a much more familiar work from the Low Countries and from the early fifteenth century—the Ghent altarpiece by Jan van Eyck (fig. 1). Although I intend to skirt much of the debate about that work, another name for this part of my paper might be "Once Again, Once More: The Ghent Altarpiece."[3]

For obvious reasons, Jan van Eyck's use of perspective—however "incorrect" "from a purely mathematical point of view"[4]—was of greater interest to Panofsky in "Perspective as Symbolic Form" than the other means by which—to adopt Panofsky's phrase—the "picture has become a mere 'slice' of reality, to the extent and in the

Figure 1. Jan (and Hubert?) van Eyck, Ghent altarpiece, *Annunciation* (detail of upper portion), wings closed. St. Bavo, Ghent. Photograph: A.C.L.—Brussels.

sense that *imagined* space now reaches out in all directions beyond *represented* space, that precisely the finiteness of the picture makes perceptible the infiniteness and continuity of the space."[5] It was some thirty years later, in a note in *Early Netherlandish Painting,* that Panofsky provided a solution to the puzzle of the competing light sources in the upper portion of the Ghent altarpiece's exterior panels.[6] When the altarpiece's wings are closed, we seem to peer through four openings to glimpse Mary and the Angel in a space that is an extension of our own—a perception rooted less in a mathematically based linear perspective located in floor tiles and ceiling beams, than in light, that is, in the fact that—as Panofsky long ago pointed out—it is the light from *our* realm, from the window to our right in the wall of the Vijd chapel, that appears to cause the shadows painted on the tile floor by the frame itself as well as those giving depth to the two figures.[7] Yet through the windows in the rear of the painted apartment, in its fictive east wall, falls a mysterious light from the north, a light identified by Panofsky as a divine light, one that pierces the immaculate flask without marring it, signifying—as Millard Meiss, Erwin Panofsky, and others have shown—the action of the Holy Spirit at the moment of conception.[8] That divine light points toward another type of "seeing through." We locate Mary and the angel in our temporal world of shadow and passing time only to discover in the window opening onto the city beyond and in the light piercing our shadows from the north a penetration of our temporal sphere by the light that is outside of time.[9] We peer through our window only to glimpse another window beyond, one illuminated not by natural light, however hallowed by its passage through cathedral glass, but by the glory of God.

This is confirmed on the upper panel of the interior of the altarpiece (fig. 2), where John the Baptist is identified, in a line shown by Panofsky to have been taken from a sermon by Peter Chrysologus, as "LUCERNA MUNDI, DOMINI

TESTIS"—"lamp of the world, witness of the Lord."[10] Enthroned at the left hand of the Godhead, the Baptist is literally radiant with the divine light of the Godhead just as Moses (Exod. 34) and Christ (Matt. 17:2) had been in the bible. As Peter Chrysologus' source, the Gospel of John, had stressed, the Baptist "was not the light, but was sent to bear witness to that light" (1:8); nevertheless, John continues: the Baptist was "a burning and shining lamp"—a *"lucerna ardens et lucens"* (5:35). At the right hand of the enthroned Godhead, an inscription taken from the Wisdom of Solomon identifies the enthroned Virgin as "more beautiful than the sun and all the order of stars; being compared with the light she is found the greater. She is in truth the reflection of the everlasting light, and a spotless mirror of God."[11] Enthroned in Heaven on the interior panel, the Virgin too is literally radiant with the divine light of the Godhead at her side—just as the glass flask in the Annunciation visible when the wings are closed, representing the Virgin's womb, is radiant with the brilliant light entering obliquely through the fictive east window in the Virgin's chamber, a light focused by the flask and its contents and reflected on the wall behind.

The oldest surviving depiction of the Incarnation as a piercing of glass by the Holy Spirit represented as rays of light appears to be the Annunciation painted by Melchior Broederlam for the exterior of a Dijon altarpiece in the last years of the fourteenth century.[12] In Broederlam's panel, as in contemporary manuscript illuminations, God the Father and the dove of the Holy Spirit clarify the source and meaning of the light. On the exterior of van Eyck's altarpiece neither is visibly linked to the light-filled flask.[13] Only the Holy Spirit appears at all, hovering not in the light but above the head of the Virgin. It is the inscription on the Virgin's throne on the *interior* that both reiterates and gives the eternal atemporal explication of the action taking place in the temporal world on the wings' exterior, pointing to the Godhead as the source of all true enlightenment.

In teaching the viewer familiar with the opened

Figure 2. Jan (and Hubert?) van Eyck, Gent altarpiece, *Godhead, Virgin and John the Baptist in Glory* (detail of upper portion of interior panel), wings open. St. Bavo, Ghent. Photograph: A.C.L.—Brussels.

retable to see "through" the historical scene before her in the present when the wings are closed, to an internal image of the brilliant Godhead itself,[14] Jan van Eyck gave visible form to the language of Augustine and his successors. Quoting from John's Gospel, "and the life was the light of humankind," Augustine had commented: "and from this very life are human beings illuminated . . . the human being is made in the image of God, and has a rational mind by which it can receive wisdom. . . . By that light John the Baptist was illuminated; by the same light also was John the Evangelist himself illuminated. . . . But perhaps the slow hearts of some

of you cannot yet receive that light, because they are burdened by their sins, so that they cannot see. . . . What is [the blind man] to do? Let him become pure, that he may be able to see God. . . . 'Blessed are the pure in heart; for they shall see God.'"[15]

According to Augustine, the divine light illuminates not only the luminous mirror of virginity, lights not only the lamp of the Baptist, but reaches even to our own realm, allowing us to see *now* through the glass, however darkly, to share the vision of the Godhead granted to Augustine and Monica, and, later, to Dante in *Paradiso*.[16] Although Augustine himself had demonstrated a deep distrust of the visual arts,[17] it was nevertheless an Augustinian understanding of the divine light's capacity to pierce human darkness that was turned by Abbot Suger of St.-Denis into a powerful argument for the role of the visual arts in religious experience. In this, Suger was strongly influenced—as Panofsky has recounted—by the Pseudo-Denis (Pseudo-Dionysius) whom he regarded as the titular saint of his own abbey. To quote from Panofsky's translation of the *De Coelesti Hierarchia*: "Every creature, visible or invisible, is a light brought into being by the Father of lights. . . . This stone or that piece of wood is a light to me . . . that is to say, they enlighten me (*me illuminant*) . . . and soon, under the guidance of reason, I am led through all things to that cause of all things." "Every perceptible thing," Panofsky comments,

> manmade or natural, becomes a symbol of that which is not perceptible, a stepping-stone on the road to Heaven; the human mind, abandoning itself to the "harmony and radiance" (*bene compactio et claritas*) which is the criterion of terrestrial beauty, finds itself "guided upward" to the transcendent cause of this "harmony and radiance" which is God.[18]

In contrast to other Annunciations of the early fifteenth century, that on the exterior of the Ghent altarpiece requires that its viewer complete the action—requires that its viewer see, know of, or

better still, "reflect on" the Godhead whose representation is physically hidden by the very wings that allude to its presence within. Teaching the viewer to look within or to "see through" the painted historical scene of the Annunciation to the eternal truth hidden within, van Eyck gave concrete form to what the Pseudo-Areopagite had called the "guiding upward" and Augustine had characterized more extensively as a love-illuminated progress from sense perception, through the discursive analysis of images recalled from the memory, to intellectual apprehension of the divinity.[19] Nor should this surprise us. As a genre the winged altarpiece displays its connection to the winged reliquary and the tabernacle, both objects designed to display in dross material the sacredness of the object normally concealed in their hearts to trigger at least a mental "seeing through" to the sacred heart.[20]

The *locus classicus* of this "seeing through" was the Mass itself, in which common bread and wine were essentially transformed by priestly action and divine promise into body and blood while retaining their original appearance, a fact confirmed for the late medieval faithful by the omnipresent representations of Pope Gregory's vision of the Man of Sorrows himself on the altar during Mass, by less familiar visions of priests pregnant with the body of Christ during the celebration, and by the period's extreme emphasis on the real presence of Christ's suffering body in the host that was elevated in the Mass and paraded through their cities' streets during the octave of Corpus Christi.[21] That same "seeing through" or insistence on a greater spiritual reality hidden by mere physical appearance could have chilling consequences—the "Holy Blood" altars and pogroms that proliferated in the southern part of the German empire at the end of the medieval period did so in association with allegations that Jews had stolen or stabbed the consecrated host (or a Christian child) in a reenactment of the crucifixion, allegations that made sense only from the peculiar perspective of late medieval eucharistic piety, certainly not from that of the Jews charged.[22]

At the other end of the spectrum, but equally a part of what the Dutch scholar Johan Huizinga would characterize as the medieval longing "to give concrete shape to every conception . . . to embod[y] in visible forms all holy concepts," stood the "scrupulous" but illusionary "realism" of the Ghent altarpiece.[23] The illusionism of the Ghent altarpiece, closed outside the Mass, and during penitential seasons, nevertheless stood as a visible/visual marker of the divine heart at the center of things, sending its rays into the temporal world.[24] Nevertheless, that perspective disguised an inner tension. When, as Michelangelo complained, the painters of the Low Countries strove "before all things, to render exactly and deceptively the outward appearance of things,"[25] it was with a specific goal in mind. More recently and more explicitly than Panofsky, James Marrow has insisted that the northern artists of the fifteenth century "not only comment[ed] in a new manner upon the relation of [their] scenes to the laws of the physical world, but [they] also force[d] the viewer to an equally important acknowledgment of his relationship to the figures and events in terms of his own experience of time and space."[26] I have quoted Michelangelo from Huizinga's *Waning of the Middle Ages* because of my sense that the Dutch scholar would have relished the paradox involved in my example of late medieval perspective: it was these illusionistic techniques, techniques for creating the illusion of depth, or rather, the illusion of space, on a two-dimensional panel where no depth existed, which van Eyck and his contemporaries used to re-present in terms accessible to the mortal viewer relationships explicitly outside and inaccessible to her temporal-spatial experience.[27] A late descendent of the Augustinian progression from sense perception to apprehension of the divine expressed in spatial rather than temporal terms, van Eyck's altarpiece conceptualizes not infinity but continuum, locating the viewer, with the Virgin Annunciate and Abbot Suger, "in some strange region of the universe which neither exists entirely in the slime of the earth nor entirely in the purity of Heaven."[28]

This, then, was the altarpiece Albrecht Dürer would refer to in laudatory terms as "a most precious painting, full of understanding."[29] "*Hoch verständig*" is the German phrase I have translated as "full of understanding." In writings of the sixteenth century, "*verständig*" appears often in conjunction with "*Weisheit*"—"wisdom," particularly in contexts that emphasize spiritual understanding. Thus, when the time came to build the Lord's tabernacle, Martin Luther's Moses called on the "understanding people among you to come and make what God has commanded."[30] Such "understanding" was given to women as well as men, but particularly to Bezaleel, who supervised the construction and who was "filled with the spirit of God, so that he was wise, understanding, and skillful."[31] From Luther's Bezaleel to Dürer's van Eyck, the artists who craft the Lord's tabernacles must be "*hoch verständig*" —full of understanding—and skilled in embodying that understanding in the objects they create.

As had been asserted of Bezaleel, Dürer argued that "often God gives to one person the understanding (*Verstand*) to make something good."[32] In fragmentary notes dating from 1512, Dürer appears to go still further, claiming not only an inspired freedom from developments within a genre, but also a creative inventiveness equal to God's. "Many centuries ago," he wrote, "the great art of painting was held in high esteem by mighty monarchs—they made the leading artists wealthy, since they considered such inventiveness a creativity conforming to God's." The ancients, Dürer explained, had likened that inventiveness to God's, because "a good painter is so filled internally with figures, that thanks to these internal ideas if [the painter] could live forever, he would always be able to pour out something novel in his work." In his 1924 essay on "Idea," Panofsky showed just how bold Dürer's claim would have sounded to those familiar with Seneca's description of divine creativity: "these patterns of all things has God within himself . . . he is filled with these figures, which Plato calls 'ideas.'"[33] Joseph Koerner has written recently that "at the moment when an art-

ist asserts that he not only imitates the natural, God-created world but also produces something totally new, he elevates himself from the secondary status as image of God to become truly another god, an *alter deus*."[34]

Martin Luther, the man Dürer credited with having "delivered me from great anxiety,"[35] would have said that it was only when the artist claimed that his internal figures possessed truth —a claim Plotinus had made for Phideas' figure of Zeus[36]—that the artist set himself up as an *alter deus*. As I have argued elsewhere, it was, in fact, Luther's retranslation of *yetser* in Genesis 6:5 and 8:21, his sense, based on that passage and his own experience, that "all the imaging of the thoughts of [the human] heart was delusive and deformed all the time" that convinced him of the impossibility of the sort of "seeing through" from the temporal to the spiritual realm that was beloved by late medieval theologians and modeled by Jan van Eyck's altarpiece.[37]

In *De anima* Aristotle had written that "images are like sense-perceptions, except that they are without matter . . . thoughts [are not] images, but they will not exist without images." "Hence," according to Aristotle, "the soul never thinks without an image."[38] If Aristotle unwittingly agreed with the author of the flood account in Genesis, at least as that author would be understood by Luther, the rabbis of the first centuries of the common era, whose linguistic and theological understanding would influence Jerome's translation of that book into Latin, understood *yetser* differently in this passage. Here, as nowhere else, they understood it to refer not the action of "forming" or "shaping"—to "imaging"—, but to twin impulses of good and evil resident in the human being. Aristotle's strong assertion about the essential role imaging played in human thinking therefore required modification by the Jewish and Christian philosophers who revered his work. As we have seen, Augustine had written that some purification of vision, some movement beyond the mere image impressed on the mind by sense perception, was possible in this realm. Similarly, in the next century, the Christian Aris-

totelian Joannes Philoponus had felt bound to limit Aristotle's conclusion to "practical thinking,"[39] a precedent that would be followed by the two great thinkers of the High Middle Ages: Maimonides and Thomas Aquinas.[40] The latter thinker carefully reframed Aristotle's maxim, applying it only to the material realm: *intellectus noster intelligit materialia abstrahendo a phantasmatibus"* ("our intellect understands the things of this world by abstracting from images").[41] His great predecessor Maimonides wrote of the good and evil inclinations,[42] but also of an intellect damaged by the Fall: "When Adam was yet in a state of innocence [he] was guided solely by reflection and reason. . . . After man's disobedience, however, when he began to give way to desires which had their source in his imagination and in the gratification of his bodily appetites . . . he was punished by the loss of this intellectual faculty."[43] "The fruit of the temptation," according to Murray Wright Bundy, is "in this view, . . . the substitution of imagination for intellect."[44] Despite the limiting, almost Lutheran sound of this analysis, Maimonides—like his Christian contemporaries—held that it was possible to progress beyond sense-linked imagination to vision and prophecy.[45] Only for Martin Luther and his followers was the substitution of imaging for the intellectual apprehension of the divine Adam may have experienced before the Fall irreparable in this realm. His own experience and his retranslation of Genesis 6:5 taught the Wittenberg reformer to follow Aristotle in this case—it was because he agreed with Aristotle that humankind "*never* thinks without an image" that he could write that "when I hear or think about something, it's not possible for me not to make a picture of it in my heart; whether I want to or not, when I hear [the word] 'Christ,' an image of a man who hangs on a cross appears in my heart, just as my face naturally appears in the water when I look into it."[46]

Luther wrote that early on in the middle of his dispute with the iconoclast Andreas Karlstadt; far from being the "tangential issue" it was labeled by one recent scholar, the issue of images and

imaging would remain central to the reformer's thought.[47] Near the end of his life he would still insist that "we cannot recognize the naked God or comprehend what he is. It is for this reason that these coverings are necessary. . . . And it is therefore insane to do like the heretics and dispute about God and the nature of divinity."[48] When God chose to appear to human beings, it was, according to Luther, *per imaginarium visionem* ("through imaginary vision"). Thus when God appears to Abraham "in a vision" in the fifteenth chapter of Genesis, what Abraham sees is, according to Luther, an "Idea"—a word that surely carries its full Platonic weight. It is, further, an "Idea" imaged (*"imaginaria Idaea"*), but imaged without thought (*"sine speculatione"*).[49] Far from being *"verständig"* or capable of becoming so, humankind was, because of Adam's sin, permanently in the position of Christ's disciples in Matthew's account: "Then Peter answered, and addressed [Jesus], 'Explain this parable to us.' And Jesus answered him, 'Are you then still so *unverständig?'* "[50] To this, Luther responded "yes":

> because we can't grasp it otherwise it's necessary to depict spiritual matters in such images. God doesn't have the human form in which Daniel paints him: a lovely old man with snow-white hair, a beard, wheels and fiery streams, etc. . . . We must paint such a picture of our Lord God for the children, and even for those of us who are learned.[51]

Augustine had written of Christ's life as "enlightening" human reason in his commentary on John's gospel; Luther's contemporary Berthold Pürstinger, bishop of Chiemsee, wrote that God had made humankind *"verständig"* in order that they learn and recognize and love truth.[52] In contrast, Luther found himself forced to conclude regarding Augustine's commentary that "St. Augustine was human and one isn't required to accept his interpretation."[53] To the bishop of Chiemsee he did not respond directly; nevertheless, Luther did write to Johann Brenz that Christ

had said "I am the way, the truth, and the life." Christ "did not say 'I give you the way and the truth and the life' as if he effected all these things in me." "We are justified," Luther insisted, "by Christ—and not by the love and the gifts that proceed from faith."[54] The progress Augustine had posited between the sight of the eyes and the sight of the mind was the crux of the epistemology Luther rejected. From 1525, Luther argued that physical and rational seeing (imaging or mental conceptualizing) were *not* successive stages on a ladder leading to contemplation of God; they were instead essentially the same thing. Seen in this light, the *"verständig"* heart was one that understood and accepted its limitations; it accepted that the gap between the creator and creation was unbridgeable in this world. According to Luther, the attempts by theologians to pierce the veil of Scripture "do not illuminate, but are empty dreams."[55]

It was not theology, but historical events like the incarnation itself that had clarified the promise until then hidden in the Hebrew Scriptures.[56] *Events* had redeemed humankind. Luther defended visual images as literal re-presentations of these events, of God's "will to sign" or self-revelation in historical time.[57] Nevertheless, not even these events could illuminate the mind's understanding of anything more than the historicity of the event. This gives a different slant to the charges bandied by Albrecht Dürer and Willibald Pirckheimer in an argument over the Eucharist: to the charge that "the things you speak can't be painted," Dürer had replied, "on the contrary—you propose things that can't be said or even conceived in the mind."[58] As Leon Batista Alberti, the source of Panofsky's "window" paradigm, had insisted in his own work on perspective: "things that are not visible do not concern the painter, for he strives to represent only the things that are seen."[59] The Lutheran altar could therefore be marked by an altarpiece, but not by one that taught the viewer to "see through" God's self-revelation in the temporal realm to a vision of the Godhead uncovered.

Figure 3. Michael Ostendorfer, *Altarpiece for Neupfarrkirche*, wings closed. Museen der Stadt Regensburg.

Koerner has argued that the lack of "illusion of a continuous space in which events occur" in Lucas Cranach's *Law and Gospel* panels and woodcuts is intentional, intended to "purge [the scene] of any . . . experiential immediacy."[60] They are, in his words, "Lutheran *Merckbild*[er]" which "cipherlike, [eschew] formal coherency" and insist on their status as "inadequate sign[s] for something far greater" without, however, inviting the viewer to "see through" them to that greater something.[61]

If Cranach's *Law and Gospel* image functioned as a sort of rebus, an altarpiece by another Lutheran artist illustrates a more conservative version of the newly "reformed" perspective.[62] Commissioned for the Lutheran "New Parish Church" in Regensburg when it was reopened after the Interim, the winged altarpiece (fig. 3) was painted by Michael Ostendorfer, an artist ironically better known for his large woodcut of the same church in its earlier incarnation as a wooden pilgrimage chapel built to honor the Virgin on the site of the synagogue destroyed in 1519.[63] We are fortunate in having not only the altarpiece itself, today in the Regensburg Stadtmuseum, but also a description of its appearance and function in the detailed church regulations written in the 1560s by the pastor Nicolaus

Figure 4. Michael Ostendorfer, *Altarpiece for Neupfarrkirche,* wings opened. Museen der Stadt Regensburg.

Gallus.[64] Gallus prefaced his remarks about the altarpiece by distinguishing between "those images and paintings, which depict certain good histories from the scriptures, and are used not for idolatry or heresy, but stimulate good and useful recollection, in contrast to the other manifold, papist, lying, idolatrous, useless images and paintings." Because of this "danger of idolatry," he wrote, the representation of the coronation of the Virgin on the high altar had been replaced by an altarpiece "on which one sees the totality (*summa*) of evangelical preaching of the old and new testaments." Just exactly what Gallus meant by *summa* is clarified by his account of the segments of the altar. "On the exterior of the two wings and the lower part of the predella," he wrote, "is the entire noble history of Christ whose merit is our salvation: his conception, birth, circumcision, presentation in the temple, crucifixion, entombment, resurrection, ascension, and, Pentecost." The interior of the altar (fig. 4) is dominated by what Gallus described as "the whole

ministry as the only means ordained by God for the gathering of his church and the distribution of the merit of Christ." "That is," Gallus explained, "how God the Father through the Holy Spirit himself consecrated our Lord Jesus Christ our sole high priest . . . not only our savior, but also our only preacher and teacher. . . . Thereafter, how the son, our Lord Jesus Christ consecrated his twelve apostles and sent them out." Finally, Gallus described the lower portion of the central panel; it shows how "the servants called and sent out later carry on the preaching of Christ and his apostles." The interior of the wings is organized in the same fashion, showing on the right the circumcision of Christ and then the baptism "by which he intended to suspend the symbol of the old testament in his own body and endow the new testament," and, finally, "how we are accustomed to administer baptism in Christ's church today," and on the left a Passover meal at which "Christ himself still eats the old pascal lamb with his disciples, and how after-

wards in the new pascal lamb, that is, in his own passion and death, he endows a new memorial in the Holy Supper of his body and blood; and how we now also hold the [Lord's] Supper in our churches."[65] I have quoted at length from the Lutheran pastor's account of his altar's iconography in order to demonstrate his understanding of its construction and his/its absolute insistence on historicity. Here is no view into a reality beyond our own, no painted explication of the relations among the members of the Trinity or the theological mystery of the presence of Christ in the eucharist. The believers gathered around the Lutheran altar held that Christ was present in the eucharist not because his presence could be explained in terms borrowed from Aristotle, but because Christ had promised at a specific moment in historical time and space—at the Last Supper held around a table with his disciples—that he would be present whenever that action was performed. In contrast to Jan van Eyck's Ghent altarpiece which draws the viewer in to a vision of the timeless Godhead, the Lutheran viewers were not meant to "see through" Ostendorfer's altarpiece, not meant to locate themselves, as had Abbot Suger, "in some strange region of the universe which neither exists entirely in the slime of the earth nor entirely in the purity of Heaven."[66] Instead of a perspectival technique that appears to link temporal and atemporal, finity and infinity, in a linear continuum, Ostendorfer linked his present with the events of history, establishing an *historical* continuum and an historical hierarchy in which precedent was given to priority. His viewers were to see in the historical events of Christ's life the origins of the ceremonies and mandate of the Lutheran church. Recollecting the events of God's self-revelation in the temporal realm, his viewers were led through them to the recognition of the right place of the Lutheran church in salvation *history*.

We have already noted the irony implicit in the fifteenth-century artist's depiction of atemporal relationships "in light-filled, spatially coherent contexts" that "implicitly made new claims for the relation of their works to the visual experiences of their beholders."[67] Martin Luther's revolutionary epistemology recognized the inevitability of such images, at least in the mind but denied them any revelatory power. The uses of perspective, technically construed, were to be directed to the things of this world.

Medieval theologians and artists had seen in the Godhead the source of all true light and enlightenment; Dürer located the mastery of the artist over the things of this world in the physics of sight. In contrast to Alberti, who had maintained a careful neutrality on the issue, Dürer's first proposition on perspective stated that the lines that form the cone between the object seen and the eye seeing have their origin in the eye rather than in the object—that they "extend from the eye out."[68] A certain focusing may sometimes be necessary, as is implied in the "somewhat phallic pointer" used by the artist who follows Dürer's printed advice for capturing a woman's nakedness on paper.[69] Joseph Koerner has linked the mastery implied by Dürer's machine for reproducing the visible world—especially in the woodcut demonstrating its utility—with the artist's poem "On the Evil World";

> He who lies naked with naked women,
> And, through struggle, conquers himself,
> So that his heart commits no movement. . .
> He has the courage of a pious man.[70]

Nevertheless, I want to close not as Koerner did, with Hans Baldung Grün's "disfigurment" of Albrecht Dürer's creative hermeneutic, but with a peculiar sort of shrine cobbled together from a painting by Dürer and one by Martin Luther's friend Lucas Cranach decades after the deaths of the two artists, and with an act of "seeing through" that has more to do with the artist "seeing through" Dürer's machine than with the act of "seeing through" van Eyck's *Annunciation* to the interior glory of the Trinity in the Ghent altarpiece. According to the inventory taken c. 1628 of the picture cabinet of the Catholic prince, Elector Maximilian I of Bavaria, a Cra-

Figure 5. Lucas Cranach the Elder, *Lucretia* (seventeenth-century state, prior to twentieth-century restoration). Alte Pinakotek, Bayerische Staatsgemäldesammlungen, Munich, Inv. No. 691.

Figure 6. Albrecht Dürer, *Lucretia*. Alte Pinakotek, Bayerische Staatsgemäldesammlungen, Munich, Inv. No. 705.

nach *Lucretia* (fig. 5), made more modest with painted draperies now removed, was hinged to cover Dürer's *Lucretia* of 1524 (fig. 6).[71]

Despite the conspicuous virtue of its heroine, her frequent appearance as one of the four cardinal virtues, and her occasional association with Christ's sacrifice,[72] it is all too clearly desire rather than devotion that the Lucretias of this pseudo-shrine were intended to incite.[73] The sixteenth-century moralist and defender of the proscriptions of the Council of Trent Johannes Molanus connected such images with the "pagan practices" described and proscribed in the second century of the Common Era by Clement of Alexandria; the pagans, according to Clement (as paraphrased by Molanus), looked "at naked Venus on painted panels while lying in bed, and also [had] diminutive Pans, naked girls, drunken satyrs, and erections exposed in pictures." Together with his second-century predecessor, Molanus concluded that: "not only the use of these but even the memory of the sight and hearing of them must be given up. Your ears are defiled and your eyes prostituted. Still stranger is the fact that your looks commit adultery before your embrace."[74] Seen in this light, poor Lucretia was adulterer's victim not once, at the hands of Tarquin, but many times—at the hands of Christians as well as Tarquin's fellow pagans. An example from the early sixteenth century, three years before Luther posted his ninety-five theses in Wittenberg: the elaborately painted and carved bridal bed attributed to Lucas Cranach in an epithalamion written by Philipp Engelbrecht for Johann of Saxony's wedding. According to the poet, the bed featured, among many figures, a Venus rather explicitly teaching her son the art of love and Lucretia "with her garment slipping from her swelling breasts."[75]

A century later, the Bavarian elector possessed (commissioned?) not a carved and painted bed, but a "shrine" that offers another perspective on the problem of "seeing through." Not about light, whether celestial or "natural" in origin, the doubled *Lucretia* was, nevertheless, about

knowledge—and about control. Closed, the Ghent altarpiece depicts the historical "event" of the Annunciation while allegorizing the relation between Virgin and Godhead (revealed by the opened altarpiece and its inscriptions) in the light-illuminated flask. Closed, this early seventeenth-century "shrine" hinted at—titilated the viewer with—what was concealed (by the closed wing and) by the courtdress so coyly added to Cranach's *Lucretia*. Opened, the Cranach/Dürer "shrine" revealed not the Godhead and Virgin in glory, not a tabernacle with its host, not the relics of a Christian saint, but the owner's control of the privileged view, of the precious work of a prized artist, of the viewer's ability to see what the inventory described as the "naked" *Lucretia* of Albrecht Dürer, a view linking viewer and owner to Dürer's controlling artist with his "*verständnis*" of sexual rather than divine secrets. If the "seeing through" it modeled was not that of the fifteenth-century altarpiece, it was nonetheless powerful, as Molanus' proscription acknowledged.[76] But that, dear Reader, is another story.

Notes

1. "Item Perspective ist ein Lateinisch Wort, bedeutt ein Durchsehung." So hat Dürer den Begriff der Perspektive zu umschreiben gesucht. Und obgleich dies "lateinisch Wort", das schon bei Boethius vorkommt, ursprünglich einen so prägnanten Sinn gar nicht besessen zu haben scheint, wollen wir uns doch die Dürerische Definition im wesentlichen zu eigen machen; wir wollen da, und nur da, von einer in vollem Sinne "perspektivischen" Raumschauung reden, wo nicht nur einzelne Objekte, wie Häuser oder Möbelstücke, in einer "Verkürzung" dargestellt sind, sondern wo sich das ganze Bild—um den Ausdruck, eines andern Renaissancetheoretikers zu zitieren—gleichsam in ein "Fenster" verwandelt hat, durch das wir in den Raum hindurchzublicken glauben sollen.

Erwin Panofsky, "Die Perspective als 'Symbolische Form,'" *Warburg Institut. Vorträge 1924–1925* (Berlin, 1927), 258–330; here, 258. I have quoted from the new translation by Christopher Woods, entitled *Perspective as Symbolic Form* (New York,

1991), 27; my sole modification of his translation is noted in brackets. Unless otherwise noted, quotations from this work are taken from Woods' English translation. The text of Dürer's notes is found in "Abriss der perspectiva naturalis nach Euklid" ms (1507/9), London 5228, fol. 202; printed in *Dürer: Schriftlicher Nachlass*, ed. Hans Rupprich (Berlin, 1966), 2: 373. Panofsky retains Dürer's term, but in the sense of "seeing through" explicitly framed windows to a room within, in Erwin Panofsky, *Early Netherlandish Painting, Its Origins and Character* (Cambridge, Mass., 1953), 1: 19.

2. *"In His Image and Likeness": Political Iconography and Religious Change in Regensburg, 1500–1600* (Ithaca, 1990), 45–49, figs. 11–14. For a somewhat different reading of the role of vision in late medieval and Lutheran piety in general—and an argument that the techniques of linear perspective served not to enhance the viewer's experience of "seeing through" the things of this world into the next, but rather to distance the viewer who might then read the depiction itself as "mere object"—see Robert W. Scribner, "Popular Piety and Modes of Visual Perception in Late-Medieval and Reformation Germany," *Journal of Religious History* 15 (1989): 448–69.

3. I should, perhaps, here make explicit my use of "Jan van Eyck" only as a shorthand for the creator of the assemblage as a whole, intentionally avoiding the debate over the altarpiece's inscription and the roles of Hubert and Jan van Eyck.

4. Panofsky, *Perspective*, 61.

5. Panofsky, *Perspective*, 60–61; and Panofsky, *Early Netherlandish Painting*, 1: 19–20.

6. Panofsky, *Early Netherlandish Painting*, 1: 147, 208, and 417n.

7. Panofsky, *Early Netherlandish Painting*, 208 and esp. 417 (n. 2).

8. Panofsky, *Early Netherlandish Painting*, 144; Millard Meiss, "Light as Form and Symbol in Some Fifteenth-Century Paintings," *Art Bulletin* 27 (1945): 177–81, and n. 27 (referring to K. Smits, *Iconografie van de Nederlandsche Primitieven* [Amsterdam, 1933], 47, whose reading was alluded to by Panofsky in "The Friedsam Annunciation and the Problem of the Ghent Altarpiece," *Art Bulletin* 17 [1935]: 468); Brian Madigan, "Van Eyck's Illuminated Carafe," *Journal of the Warburg and Courtauld Institutes* 49 (1986): 227–30.

9. A simpler (at least mathematically) insistence on the location of the events of the temporal sphere in the atemporal city of God is given symbolic form by the adoration of the lamb painted in the lower of the two central interior panels: when the altarpiece was opened during Mass, the viewer would perceive the elevation of the consecrated host by the priest, with its accompanying call for adoration, against the "background" of the eternal adoration of the lamb described by John's revelation and embodied in van Eyck's painting.

10. Erwin Panofsky, "Once More the 'Friedsam Annunciation and the Problem of the Ghent Altarpiece,'" *Art Bulletin* 20 (1938): 441–42; *Early Netherlandish Painting*, 220.

11. "HEC EST SPECIOSIOR SOLE ET SUPER OMNEM STELLARUM DIS-POSICIONEM LUCI COMPARATA INVENITUR PRIOR. CANDOR EST ENIM LUCIS ETERNE ET SPECULUM SINE MACULA DEI." Quoted from Elisabeth Dhanens, *Van Eyck: The Ghent Altarpiece* (New York, 1973), 80; cf. Panofsky, *Early Netherlandish Painting*, 147–48 for discussion on van Eyck's "illumination" of this passage in the *Madonna in a Church*.

12. Meiss, "Light as Form and Symbol," 178 and notes 16 and 17. For other connections—stylistic, iconographic, and chronological—between the Broederlam Annunciation and Annunciations attributed to van Eyck: Panofsky, "The Friedsam Annunciation," 442–49.

13. As my argument here should make clear, I do *not* consider it "evident," as Philip does, "that a bust of half-figure of God the Father must have appeared . . . in the Ghent altarpiece, where it was undoubtedly shown in the upper part of the framing structure." Lotte Brand Philip, *The Ghent Altarpiece and the Art of Jan van Eyck* (Princeton, 1971), 73.

14. Although she later abandoned this argument (presumably influenced by the shrine-turned-inside-out argument of Philip, *Ghent Altarpiece*, 95–97), in her 1976 dissertation Carol Jean Purtle argued convincingly that even though the two middle panels might not actually move in such a way, "by a special act of 'thinking beyond' the space between the angel and the Annunciate, . . . the viewer who retains a mental image of the Ghent interior would have no difficulty visualizing behind the center panels . . . the figure of the triumphant Christ." In her dissertation, Purtle quotes Carla Gottlieb on this point, "the two middle panels of the Ghent Annunciation are meant to function 'like the leaves of an iconostasis door' which, when opened, reveal 'seated the Lord in Glory, as he appears in the wall at the back of the altar of pre-Gothic churches.'" Purtle, *The Marian Paintings of Jan Van Eyck* (Ph.D. diss., Washington University, 1976), 1:47.; quoting from Gottlieb, "En ipse stat post parietam nostrum: The Symbolism of the Ghent Altarpeice," *Bulletin des Musées Royaux des Beaux-Arts de Belgique* 19 (1970):75–100, here 78. Cf. Purtle's revised (weakened) statement on page 38 of the published version of her dissertation (Princeton, 1982): "The contemporary viewer of the Vijd Chapel, therefore, would very likely have been familiar with the significant pairing of the Annuciation and the Coronation on the exterior and interior spaces of the Ghent Altarpiece. . . . In changing the design for the chamber of the Annunciate, then, it appears that part of Jan's intention was to make a fuller amplification of the traditional themes of salvation and espousal that connected the Annunciation *thalamos* to the symbolic figure of the crowned Virgin on the interior of the altar. It also appears, however, that in creating the foreground sacristy space, Jan shows the viewer a familiar but unconventional image that connects the Annunciation theme to both the eternal high priest on the alter's interior and to the contemporary priest in the chapel offering Mass for the eternal salvation of the Vijds and the Borluuts." Cf. Carla Gottlieb, *The Window in Art: From the Window of God to the Vanitiy of Man. A Survey of Window Symbolism in Western Painting* (New York, 1981), 119–25.

Philip, *Ghent Altarpiece*, 91, also emphasizes that "the image of the Heavenly Bridegroom. . . actually exists behind the [narrow central panels of the Annunciation]. The invisible presence of Christ is therefore not just 'an idea' in the exterior view, but a factual physical reality." Nevertheless, despite the fact that she says that "the enthroned figure in the Deësis group signifies Christ as the entire Trinity," her insistence that the enthroned figure within relates to the Annunciation as Christ, the heavenly bridegroom, requires that she find another God the Father to complete the God—Holy Spirit—Mary sequence of the traditional Annunciation. This God the Father she locates as a bust high in the putative marble tabernacle framing the altarpiece. Cf. Philip, *Ghent Altarpiece*, 73. Philip's general location of the Ghent altarpiece in the genre of "tabernacle" is made problematic by her corollary that "What we see in Van Eyck's Annunciation is the interior of the golden shrine, whose exterior is presented in the main view of the retable" (96). While it is true that in the Ghent altarpiece "We are granted a view into the inner sanctum of Heaven which, in a multitude of symbolic detail, discloses to us the whole glory of the divine promise" (96), this is emphatically *not* because the upper zone of the closed altarpiece "depicts the opened interior of the golden shrine," while the upper zone of the opened altarpiece depicts "the inaccessible facade of the golden shrine" (97). Such a view turns the familiar medieval practice of looking through the material world to the spiritual meaning or message hidden within on its head. There is no need to complicate the familiar move modeled in the upper portion (closed normally—open for Mass or open only on feast days) from Annunciation in historical time to spiritual interpretation outside of time, i.e., from historical scene/reading to spiritual scene/interpretation.

15. Augustine, *Tractates on the Gospel According to St. John* I, 18; quoted from *A Select Library of the Nicene and Post-Nicene Fathers of the Christian Church*, ed. Philip Schaff (Grand Rapids, 1956), 7: 13.

16. Augustine of Hippo, *Confessions* IX, 10; Dante Alighieri, *Paradiso*, XXVI.

17. Augustine, *De doctrina christiana* II, xvii. Cf. my discussion in *In His Image and Likeness*, 7–9.

18. Erwin Panofsky, "Introduction," *Abbot Suger on the Abbey Church of St.-Denis and its Art Treasures* (Princeton, 1979), 20. Cf. "when—out of my delight in the beauty of the house of God—the loveliness of the many-colored gems has called me away form external cares, and worthy meditation has induced me to reflect, transferring that which is material to that which is immaterial, on the diversity of the sacred virtues: then it seems to me that I see myself dwelling, as it were, in some strange region of the universe which neither exists entirely in the slime of th earth nor entirely in the purity of Heaven; and that, by the grace of God, I can be transported from this inferior world to that higher world in an anagogical manner." Abbot Suger, "Liber de rebus in administratione sua gestis" (1148/49), trans. Panofsky, *Abbot Suger*, 63–65.

19. Augustine, *Confessiones* IX, 10.

20. On connections between the altar retable and the reliquary, see Joseph Braun, *Der christliche Altar in seiner geschichtlichen Entwicklung*, vol. 2 (Munich, 1924), 285, 303, 361; and Harald Keller, "Der Flügelaltar als Reliquienschrein," in *Studien zur Geschichte der europäischen Plastik. Festschrift Theodor Müller* (Munich, 1965), 125–44.

21. Braun, *Der christliche Altar*, 451–463; Bernd Moeller, "Piety in Germany around 1500," in *The Reformation in Medieval Perspective*, ed. Steven Ozment (Chicago, 1971), 50–75; Charles Zika, "Hosts, Processions and Pilgrimages: Controlling the Sacred in Fifteenth-Century Germany," *Past and Present* 118 (1988): 25–64. On these developments in art see especially the classic studies: Emile Mâle, *L'Art religieux de la fin du moyen âge et sur ses sources d'inspiration* (Paris, 1908)—recently translated for the Bollingen Series by Marthiel Mathews as *Religious Art in France* (Princeton, 1986)—and Erwin Panofsky, "'Imago Pietatis.' Ein Beitrag zur Typengeschichte des 'Schmerzensmanns' und der 'Maria Mediatrix,'" in *Festschrift für Max J. Friedländer zum 60. Geburtstage* (Leipzig, 1927), 261–308.

22. On late medieval eucharistic piety: Peter Browe, *Die Verehrung der Eucharistie im Mittelalter* (Munich, 1933; repr. Rome 1967, Sinzig 1990) and Miri Rubin, *Corpus Christi: The Eucharist in Late Medieval Culture* (Cambridge, 1991). On the ritual murder accusations: Ronnie Po-chia Hsia, *The Myth of Ritual Murder. Jews and Magic in Reformation Germany* (New Haven, 1988), esp. 54–56; and Hsia, *Trent 1475: Stories of a Ritual Murder Trial* (New Haven, 1992). For a more general description of the mindset making possible such concretization of religious metaphor: Johan Huizinga, *The Waning of the Middle Ages. A Study of the Forms of Life, Thought and Art in the XIVth and XVth Centuries* (New York, 1954), 165–74, 191–206, 226–42.

23. Huizinga, *The Waning of the Middle Ages*, 152, 274.

24. On the relative "openness" of the Ghent altarpiece: Elisabeth Dhanens, "La Visite organisée du retable de Gand, XVe–XVIIIe Siècle," *Gazette des Beaux-Arts* 89 (1977): 153–54.

25. Quoted from Huizinga, *Waning of the Middle Ages*, 265.

26. James Marrow, "Symbol and Meaning in Northern European Art of the Late Middle Ages and the Early Renaissance," *Simiolus* 16 (1986): 150–69, here 160–61. Marrow's reference is specifically to the Boucicaut Master.

27. For one of the few discussions connecting spatial illusionism in Flemish art with devotional use of the panels, see Craig Harbison, "Visions and Meditations in Early Flemish Painting," *Simiolous* 15 (1985): 87–118.

28. Suger, "De administratione," trans. Erwin Panofsky, *Abbot Suger*, 65. Cf. Panofsky, *Perspective as "Symbolic Form,"* 65–66.

29. "Darnach sahe ich des Johannes taffel; das ist ein über köstlich, hoch verständig gemähl, und sonderlich die Eva,

Maria und Gott der vatter sind fast gut." Albrecht Dürer, entry for 10 April 1521, *Tagebuch der Reise in die Niederlände* (ms), printed in *Schriftlicher Nachlass*, vol. 1 (Berlin, 1956), 168.

30. "Und wer unter euch verstandig ist, der kom und mache, was der HERR geboten hat." Martin Luther, *Deutsche Bibel* (1545), 2 Mose 35:10; reprinted in *D. Martin Luthers Werke. Kritische Gesamtausgabe* (Weimar, 1883-), Section 3: *Deutsche Bibel*, 8: 312–13.

31. "hat in erfüllet mit dem geist Gottes, das er weise, verstendig, geschickt sey." Exodus 35:31 = Luther, *Bibel*, vol. 8, p. 315; on women: Exodus 35:25 = Luther, *Bibel*, vol. 8, p. 315. Cf. the "wise of heart" of Luther's 1523 translation: *Bibel*, vol. 8, pp. 312, 314—the source of Tyndale's translation and thus of the Authorized English version.

32. Such a divine gift was independent of developments within the artistic genre itself; thus, according to Dürer, that artist's equal might not be found among contemporary artists, or for a long time before or after. Erwin Panofsky, *Idea. Ein Beitrag zur Begriffsgeschichte der älteren Kunsttheorie* (1924; 2nd ed., Berlin, 1960), 69. My translation here and in what follows differs slightly from that given by Peake: *Idea. A Concept in Art Theory*, trans. J.J.S. Peake (Columbia, SC, 1968).

33. Panofsky, *Idea*, 2nd ed., 69–70.

34. Joseph Koerner, *The Moment of Self-Portraiture in German Renaissance Art* (Chicago, 1993), 138.

35. Albrecht Dürer to Georg Spalatin, letter reprinted in *Schriftlicher Nachlass*, 1: 85–87.

36. Panofsky, *Idea*, (1968), 26–27. Cf. Murray Wright Bundy, *The Theory of Imagination in Classical and Medieval Thought* [*University of Illinois Studies in Language and Literature*, vol. 12, no. 2–3 (Urbana, 1927)], 112–14, on Phidias' place in the debate between Apollonius and his Egyptian friend Damis, especially Apollonius' vote in favor of imagination/phantasy over *mimesis*: "Phantasy wrought these, an artist wiser than imitation. For imitation can only fashion what it has seen; but phantasy what it has never seen. For imitation can conceive of its ideal only on the analogy of reality, and many times fear [of the charge of impiety] restrains it. Phantasy, however, is never restrained, for without fear it marches to the realization of its conception." (114)

37. I quote here from Philipp Melanchthon's commentary on Genesis, the first instance I can find in which *yetser* is translated not as "tendency" or "inclination" or their verbal equivalents:

Videns Deus quod multa esset hominis malitia in terra, & omne figmentum cogitationum cordis eorum vanum & pravum omni tempore.

Philipp Melanchthon, *In obscuriora aliquot capita Geneseos annotationes* (Hagenoa: Johann Secerius, 1523), fol. Kiii' = *Commentarius in genesis*, in *Opera omnia*, ed. Caspar Peucer (Wittenberg: Johannes Crato, 1562), 2: 396–97. The same translation appeared in the published Latin version of the lectures Luther himself delivered on Genesis in 1523/1524: *In Genesin, Mosi librum sanctissimum . . . declamationes* (presumably read as lecture 1523/24; published 1527), *Werke*, 24:169. I am treating this as Melanchthon's discovery because Luther's lectures were not edited and published until 1527 and because there was no discussion of the passage in the German version of the lectures published by a different editor in the same year (i.e., 1527).

For fuller discussions of this passage and the translation of *yetser* as *figmentum* and *imaginatio*, see my *In His Image and Likeness*, 10–18, esp. n.102. A further indication of the importance of the two Genesis passages for Luther's thought is their underlining in his personal copy of the octavo Hebrew bible printed at Brescia by Gersom ben Mose Soncino in 1494: cf. *Werke* vol. 60 (1980), 260.

38. Aristotle, *De anima* III, 8 and 7 = ¶432ª3 and ¶431ª8; translated by D. W. Hamlyn (Oxford, 1968), 66, 63. I was led to search for these passages by Sergiusz Michalski's reference (without source) to "Aristotle's dictum 'to think means to consider with the help of images'" in *The Reformation and the Visual Arts. The Protestant Image Question in Western and Eastern Europe* (London, 1993), 183.

39. Philoponus, commentary on *De anima* ¶430ª16 = *Philoponus On Aristotle on the Intellect (de Anima 3.4–8)*, trans. William Charlton (Ithaca, 1991), 111–12.

40. On Maimonides: Bundy, *Theory of Imagination*, 393–94.

41. Aquinas quoted from Anthony Kenny, "Intellect and Imagination in Aquinas," in *The Anatomy of the Soul. Historical Essays in the Philosophy of Mind* (Oxford, 1973), 62.

42. Maimonides, *Guide of the Perplexed*, trans. M. Friedländer (New York, 1881), III, xxii = 99–100, where references to "good and evil inclinations (*yetser ha-tob, ve-yetser hara*)" are combined with quotations from Genesis in which the same translator translates *yetser* as "imagination." Citations hereafter are to this translation. Cf. the translations of the ever problematic *yetser* given by the following translators (in editions of the *Guide of the Perplexed* taken at random from the library shelves at Washington University in St. Louis): Shlomo Pines (Chicago, 1963), 489–90 (where "inclination" is used consistently); S. Munk (Osnabrück, 1964), 3: 168–70 ("*penchant*," consistently); David Gonzalo Maeso (Madrid, 1983), 440 ("*deseos*" in translation of Genesis passage; "*inclinación*" elsewhere).

43. Maimonides, *Guide of the Perplexed*, I, ii = p. 36; paraphrased by Bundy, *Theory of Imagination*, 211.

44. Bundy, *Theory of the Imagination*, 211–12.

45. Cf. Maimonides, *Guide of the Perplexed*, part I, 44–47, 78–82, 106–12, 252–59, 334–37; and esp. part II, 173–81.

46. Martin Luther, "Wider die himmlischen Propheten, von den Bildern und Sakrament" (1525), *Werke*, 18:83. I am not, of course, implying that Luther owed his understanding of the human as an imaging animal to Aristotle; for his use of Aristotle's *De anima* in particular, see the "Personen- und Zitatenregister" to Luther's *Werke*, 63: 42.

47. *"Nur eine Randfrage."* The quotation is from Margarete Stirm, *Die Bilderfrage in der Reformation* [*Quellen und Forschungen zur Reformationsgeschichte* 45 (Gütersloh, 1977)], from whose work I have profited greatly despite her rather static view of Luther's complicated theology. As I have argued in *In His Image and Likeness*, the post-lapsarian limitation of the human intellectual faculty to image-based understanding was crucial to Luther's entire epistemology and to his attack on both Catholic and sectarian soteriologies.

48. Luther, *In Primum Librum Mose Enarrationes* (delivered as lectures 1535–1545; edited and published 1544–1550), *Werke*, 42:9–10, 11. Similarly, Luther dismissed the Augustinian distinction between lower and higher reason or intellect as irrelevant; ibid. 138.

49. Luther, *Enarrationes, Werke*, 42: 555.

50. Matt. 15:15–16 as translated by Martin Luther: *Bibel,* 6: 72–73.

51. Martin Luther, "Sabbato paschae. 20. Aprilis. A prandio" (1538), sermon notes taken by Georg Rörer; printed in *Werke,* 46: 308. Cf. the thunderings of the Puritan preacher William Perkins: "So soone as the minde frames unto it selfe any forme of God (as when he is popishly conceived to be like an old man sitting in heaven in a throne with a sceptre in his hand) an idol is set up in the minde. . . . A thing faigned in the mind by imagination is an idol." Quoted by Frances A. Yates, *The Art of Memory* (Chicago, 1966), 278. More recently: Michalski, *Reformation and the Visual Arts*, 182–83. Maimonides, a more subtle (and supple) intellect, had written of the image/idolatry problem in language that would have been quite familiar to the reformers debating the problem in the 1520s: "You must know that idolaters when worshiping idols do not believe that there is no God besides them; and no idolater ever did assume or ever will assume that any image made of metal, stone, or wood has created the heavens and the earth, and still governs them. Idolatry is founded on the idea that a particular form represents the agent between God and His creatures." Maimonides, from the chapter "Belief in the Corporeality of God is equal to the sin of Idolatry," *Guide of the Perplexed,* Part III, 133.

52. "Deszhalb hat got den menschen verständig gemacht, domit er lerne und erkenne auch liebe habe die warhait." Berthold Pürstinger, bishop of Chiemsee; quoted from *Grimms Wörterbuch,* 12: col. 1573.

53. Martin Luther, "Das Evangelium ynn der hohe Christmesβ auβ S. Johanne am ersten Capitel," *Weihnachtspostille* (1522), *Werke,* 10: part 1, 203, 204.

54. Sagt er doch: 'Ich bin der Weg und die Wahrheit und das Leben.' Er sagt nicht: 'Ich gebe dir den Weg und die Wahrheit und das Leben', als ob er von auβen her all dies in mir wirkte . . . daβ wir in ihm vor Gott gerecht sind—und nicht in der Liebe und in den Gaben, die aus dem Glauben folgen.

Martin Luther in postscript added to a letter from Philipp Melanchthon to Johann Brenz; quoted in Wilhelm Pauck, "Luther und Melanchthon," in *Luther und Melanchthon. Referate und Berichte des Zweiten Internationalen Kongresses für Lutherforschung, Münster, 8.–13. August 1960,* ed. Vilmos Vajta (Göttingen, 1961), 11–31, here 21.

55. Luther, *Enarrationes* = *Werke,* 42: 173.

56. On the historical nature of God's self-revelation, see Erich Seeberg, *Studien zu Luthers Genesisvorlesung; Zugleich ein Beitrag zur Frage nach dem alten Luther* [*Beiträge zur Förderung christlicher Theologie* 36, 1 (Gütersloh, 1932)], 86–97.

57. *Voluntas signi* was a phrase adapted by Luther from the Scholastics for whom it distinguished what God had made accessible to humankind *en masse* from God's essential will (*voluntas substantialis*), regarded by the Scholastics as hidden from minds without grace or scholarship and by Luther as entirely hidden. Cf. Luther, "Wider die himmlischen Propheten," *Werke,* 18: 82–83 and Luther's introduction to his illustrated *Passional* (added in 1529 to the *Bett buchlin* which had been in print since 1522), *Werke,* 10: part 2, 458–59.

58. Kaspar Peucerus (=Caspar Peucer, the editor of Melanchthon's *Opera omnia* [Wittenberg, 1562], cited above, note 32), *Tractatus historicus de Phil. Melanchthonis sententia de controversia Coenae Domini* (Amberg, 1596); quoted in *Dürer: Schriftlicher Nachlass,* I: 306; Heinz Lüdecke and Suzanne Heiland, *Dürer und die Nachwelt. Urkunden, Briefe, Dichtungen und wissenschaftliche Betrachtungen aus vier Jahrhunderten* (Berlin, 1955), 46, commentary 267–69; translated: William Martin Conway, ed., *The Writings of Albrecht Dürer* (New York, 1958), 133 (where "concipi" is translated as "figured"). Michalski, *The Reformation and the Visual Arts,* 169–80, is the only work of which I am aware that attempts to explore the link between the reformers' conflicting views of the Eucharist and their views of the visual arts. Excellent as it is an an overview, in its breadth it tends to overemphasize the dichotomy between word and image in Lutheran thought. Whether as a result of this, or because of the limitations of the secondary source from which he paraphrases Dürer's part in the discussion, Michalski (193) gives only half of the argument between Luther and Pirckheimer, implying that Dürer favored words over images for the communication of "complicated religious truths."

59. Leon Batista Alberti, *De pictura,* I, 2; translated in Leon Batista Alberti, *On Painting and On Sculpture,* ed. and trans. Cecil Grayson (London, 1972), 37.

60. Koerner, *Moment,* 375.

61. Koerner, *Moment,* 383.

62. On the Lutheran altar and altarpiece: Helmuth Eggert, "Altar in der protestantischen Kirche" and "Altarretabel in der protestantischen Kirche," in *Reallexikon zur deutschen Kunstgeschichte,* ed. Otto Schmitt (Stuttgart, 1937), vol. 1, cols. 430–439, 566–602; Paul Graff, *Geschichte der Auflösung der alten gottesdienstlichen Formen in der evangelischen Kirche Deutschlands bis zum Eintritt der Aufklärung und des Rationalismus* (Göttingen, 1921), 1: 99–101, 411; 2: 65–69.

63. Michael Ostendorfer, *Schöne Maria of Regensburg*

(single-sheet woodcut 1520) = Geisberg 967, Passavant 13, Winzinger 245. On Ostendorfer, see the dissertatin by Arnulf Wynen: *Michael Ostendorfer (um 1492–1559). Ein Regensburger Maler der Reformationszeit* (typescript, Freiburg i. Br. 1961). On Ostendorfer's altarpiece, cf. Carl C. Christensen, *Art and the Reformation in Germany* (Athens, Ohio, 1979), 145–47.

64. Nicholaus Gallus, "Kirchenordnung der neuen pfarre zu Regenspurg" (much corrected autograph ms. 1567?); printed in *Die evangelischen Kirchenordnungen des XVI. Jahrhunderts,* ed. Emil Sehling, vol. 13 (Tübingen, 1966), 452–89/ This description, valuable for its account of the communicants' circumnavigating (*"herumbgehen"*) the altar in order to receive the elements, and for its brief account of the contents of the now lost predella, has been overlooked by those few art historians who have discussed the altar.

65. Mit den bildnissen (gleich wie auch mit andern mehr dingen, als orgeln schlagen, figural und lateinischen gesang) halten wir (den verstand unser christlichen freiheit gleicherweis darin anzuzeigen) dis mittel, das wir sie nit allerding abtun noch zuviel damit machen; machen auch die unterschied deren bildnis und gemelde, so gewisse gute historien der schrift haben und nit zu abgötterei oder aberglauben gebraucht werden, auch sonst gute, nüzliche erinnerung geben mögen, gegen den andern vielfältigen, bäpstischen, lugenhaften, abgöttischen, unnützen bilden und gemelden.

Also haben wir dem köstlichen, steinern Marienbilde und vielen wächsenen, ganzen mannen- und frauenlengebilden, von wegen vorbegangener, etlicher armer leutlin, auch noch gegenwertiger und künftiger gefahr der abgötterei vorlengs getan, wie Ezechias tat der ehernen schlangen. Hernach ist gleicherweis die coronatio Mariae zur himmelkönigin, auf dem hohen altar, viewol verdeckt, dennoch hinweggereumt, dargegen aber anstat aufgericht ein gemalte tafel auf demselben altar, darin die summa der evangelischen predigten altes und neues testament zu sehen.

Am vordern teil auf den zween flügeln auswendig und dem untern teil des sargs [predella] ist die ganze fürneme historia Christi als des verdiensts unser seligkeit: sein empfengnis, geburt, beschneidung, opferung im tempel, creuzigung, begrebnis, auferstehung, himelfart, sendung des Heiligen Geists.

Im innern teil der tafel ist das ganz ministerium als das einige, von Gott verordnete mittel zu samlung seiner kirchen und austeilung der verdienst Christi, nemlich wie Gott der Vatter durch den Heiligen Geist den Son, unsern Herrn Jhesum Christum erst selb weihet zu dem einigen unserm hohenpriester, das ist: nit allein zu unserm seligmacher, sondern auch zu dem einigen unserm prediger und lerer, mit diser stimm: Dis ist mein lieber Son, an welchem ich wolgefallen hab; den solt ir hören.

Darnach, wie der Son, unser Herr Jhesus Christus, fer-

ner seine 12 aposteln weihet und sendet mit diesem befehl: Gehet hin in alle welt, prediget das evangelium aller creatur und teufet sie im namen des Vatters und des Sons und des Heiligen Geists; und leret sie halten alles, was ich euch befolen habe.

Wie auch zum dritten die hernach berufene und gesandte diener die predigt Christi und seiner apostel führen in dieser summa: Tut buße und glaubt dem evangelio! zugleich auch damit die sünde vergeben in gemein und in sonderheit.

Auf den gemalten flügeln inwendig steen die heiligen sacrament.

Als erstlich auf dem rechten flügel zu oberst stehet das sacrament der beschneidung Christi. Darunter dann die tauf Christi, als der damit das zeichen des alten testaments in seinen eigen leib hat wöllen aufheben und das neue stiften. Zu unterst stehet, wie wir die tauf in der kirchen Christi itzo pflegen zu halten.

Auf dem linken flügel stehet, wie der Herr selb noch das alt osterlemblin isset mit seinen jüngern, darnach des neuen osterlemblins, das ist: seiner selbeigen leidens und sterbens, das neue gedechtnis stiftet im heiligen abendmahl seiner leibs und bluts; und wie wir das abentmahl itzo auch in unsern kirchen halten.

Zurücks auf dem altar, da die communicanten herumbgehen, stehet die lezt herrlich zukunft christi am jüngsten tage, in wolken herabfarend, wie da die gleubigen und auserwelten, beide lebendige und tote, sampt den heiligen, lieben engeln ihm auch entgegenfahren in ewige freude und seligkeit; die ungleubigen und verdampten aber dargegen sampt den teufeln werden ausgestoßen in die pein des ewigen, hellischen feuers, welches beides dem verdienst Christi und dem predigampt in dieser welt, ob man es gleich itzo weder siehet noch glaubt, entlich wird in jener welt gewislich volgen und ein jeder seinen teil erfaren.

Zu unterst am hintern teil des sargs ist das exempel des reichen mans in der helle und armen Lazari in der schoß Abrahae hiezu gemalet.

Uber diese tafel sind wenig andere gemelde in unsern kirchen, als nit mehr denn transfiguratio Domini, institutio coenae, die tauf Christi und absolution der sünderin in der neuen pfarr. In den andern kirchen sind ihrer fast noch weniger und alles aus der historien Christi.

Gallus, "Kirchenordnung," *Die evangelischen Kirchenordnungen,* 13:481–82.

66. Suger, "De administratione," trans. Panofsky, *Abbot Suger,* 65.

67. Marrow, "Symbol and Meaning," 58.

68. "Dy erst furnemung oder suposizt ist, daß al dÿ lini, dÿ fom awg aws gend, dy gend durch gerad lini, dy ein unterscheid von ein ander haben, und unter dem selben gesicht wirt begriffen ein conus, der sich mÿt seiner scheitell oder spiz ins awg wirfft." Albrecht Dürer, "Abriss der perspectiva

naturalis nach Euklid" ms (1507/9), London 5229, fol. 77; printed in *Schriftlicher Nachlass*, 2: 374.

Cf. Alberti: "philosophers . . . say that surfaces are measured by certain rays, ministers of vision as it were, which they therefore call visual rays, since by their agency the images of things are impressed upon the senses. These rays, stretching between the eye and the surface seen, move rapidly with great power and remarkable subtlety, penetrating the air and rare and transparent bodies until they encounter something dense or opaque where their points strike and they instantly stick. Indeed among the ancients there was considerable dispute as to whether these rays emerge form the surface or from the eye. This truly difficult question, which is quite without value for our purposes, may here be set aside. Let us imagine the rays, like extended very fine threads gathered tightly in a bunch at one end, going back together inside the eye where lies the sense of sight." *On Painting*, 41.

69. Koerner, *Moment*, 446.

70. Koerner, *Moment*, 444–47. Quoting Dürer, "Von der bösen welt" (1510), *Schriftlicher Nachlass*, 1: 134.

71. "Lucretia lebensgröße vom Lucas Cranach auf Holz Ao 1524 gemalt, wann dises stückh aufgethan wirdt, Ist darunder Lucretia nackhendt von Albrecht Dürer ao 1518 gemalet." Description from inventory written c. 1628 for Kammergalerie of Kurfurst Maximilian I of Bayern. Dürer's *Lucretia* had appeared in the earliest inventory of the electoral collection, completed in 1598 by Johannes Fickler, jurist and collector; since early 17th century it had been hidden behind a wooden panel—at first one painted by Peter Candid with an image of Cato Uticensis, later Cranach's *Lucretia*. Gisela Goldberg,

catalogue entry for Dürer's *Lucretia* of 1518, *Alte Pinakothek München* (Munich, 1983), 174. Cranach's *Lucretia* was overpainted in the early seventeenth century (presumably on order of Maximilian I) with a red drapery (photos survive of overpainting). Goldberg, catalogue entry on Cranach's *Lucretia, Alte Pinakothek,* 151.

72. Augustine, *De civitate Dei* 1: 19. On her appearance as a Lutheran political icon, see my *In His Image and Likeness,* 119–26.

73. The justification of painted images as "exciting devotion" was attributed to Thomas Aquinas. Cf. David Freedberg, "Johannes Molanus on Provocative Paintings: *De historia sanctarum imaginum et picturarum*, book II, chapter 42," *Journal of the Warburg and Courtauld Institutes* 34 (1971): 229–45, esp. 233.

74. Molanus, *De historia sanctarum imaginem et picturarum* (Louvin, 1573), book II, chapter 42; translation in Freedberg, "Johannes Molanus," 245.

75. The design of the Torgau bed for the wedding of 1513, was attributed by the poet to Lucas Cranach. Venus instructs Cupid in new "Listen" and "befühlt mit der Hand, prüfend seine Geschosse"; Lucretia is displayed so that "das Gewand gleitet von dem gewölbten Busen." Engelbrecht's epithalamion, published at Wittenberg by Johann Bronenberg in 1514, is summarized in G. Bauch, "Zur Cranachforschung," *Repertorium für Kunstwissenschaft* 17 (1894): 421–35, here 424–25.

76. For this subject in general, see David Freedberg, *The Power of Images. Studies in the History and Theory of Response* (Chicago, 1989), 317–77.

Pleasure in
the Visual Arts

RANDOLPH STARN

Nunc autem oculo est [camera picta] delectabilis,
cordi letabilis et singulis sensibus humanis amabilis.

Now [the painted room] is again a delight to the eye,
a joy to the heart and a pleasure to all the senses.
City Council minutes, Siena, 1316

Since border crossings have become as frequent in the academic world as in the real one, historians and art historians could make an interdisciplinary feast of the archival tidbit I've begun with.[1] The text is a particularly poignant example of returns from documentary research on art because it refers to the restoration of frescoes in Siena's town hall which no longer exist, except in the recording notary's words. That they are recorded there at all, with bombastic eloquence at that, should whet the appetites of social historians of art. The notary was a public official describing a civic commission in the combination of fortress, office building, municipal showplace, and redevelopment project that the *palazzo pubblico* had become by around 1300. We don't ordinarily think of notaries or of city councils as connoisseurs, so the document testifies for a society that was artful in more ways than one. Not to forget iconography—still a royal interpretive road, for all the recent traffic to the archives— "delight to the eyes" recalls medieval theories about the metaphysical preeminence of light and the primacy of vision among the senses. Scholars who have taken the "linguistic turn" could object that all this is just language, so there would be room for them at the interdisciplinary table. Feminist critics could make do with pointing out that the gaze in question was male.

One topic we can be fairly certain such a symposium would not address at any length is the one the document is ostensibly about—pleasure in art. Scholars with historical interests in art ordinarily leave that subject to an odd mix of am-

ateurs (gallery goers, art book lovers, art appreciators) and professionals (critics, philosophers, writers, artists) given to public expression of their feelings on the matter. I suppose this is understandable from historians. Our professional rhetoric is obsessed with the rigors of research and the burdens of objectivity, and the historical record contains too many crimes and catastrophes to allow for much unalloyed pleasure. It is more difficult—*prima facie* anyway— to understand why art historians are quite so professionally squeamish as I am alleging they are, particularly because one traditional definition of works of art as such is that they are pleasurable. No doubt most people have responses like the Sienese notary's at one time or another. (As I write this, I am being appropriately tweaked by remembering Sydney Freedberg's mellifluous prose and Millard Meiss' beatific smile while he worked.) However, my point is about professional turf, not personal taste, and in that limited sense it is surely fair to say that pleasure in the visual arts has not been a major topic for art historians or historians, either.

There are good historical reasons for this. Panofsky's role was arguably crucial. Perhaps this will suffice to explain, even excuse, this essay coming from a historian, albeit one who has written about art and was practically converted to Renaissance studies by Panofsky's work. At the outset, though, I should admit to other motives as well. For one, I want to indicate the costs to a "humanistic discipline" concerned with "meaning in the visual arts" of neglecting *homo ludens*

and the meaningfulness of pleasure. Then too, I would like to stretch Panofsky's terms, in large part because humanity, meaning, and the visual arts can hardly be claimed for a single discipline.

A historian can offer some account of how pleasure, seemingly fundamental to the very definition of art, turned out to be somehow dispensable in writing its history. This will evidently be a history of loss, or as loss. But I also want to suggest what some of the historical alternatives are. This will be a history of discarded potential, history as retrieval. Finally, since history is also about the present and the future in the guise of the past, I want to consider what such a recovery, in all senses of the word, might entail.

It would be a truism, if it were remembered more often, that histories are also stories of forgetting. The story of art history that Panofsky relates as an epilogue to *Meaning in the Visual Arts* is told as a personal and professional vindication.[2] The tone is so urbane that only the absence of fanfare betokens how much the account is one of shattered lives, worlds, and cultures.

The definition of the history of art at the beginning of the essay already represents a kind of loss: Panofsky defines art history as "the historical analysis and interpretation of man-made objects to which we assign a more than utilitarian value, as opposed to aesthetics, criticism, connoisseurship, and 'appreciation' on the one hand, and to purely antiquarian studies on the other" (p. 322). This is obviously a very strict construction. Not only does it limit art history to one modern professional branch whose native tongue, "it so happens" (p. 322), is German; it also excludes plenty of German art historians and whole collateral disciplines concerned with the visual arts in one historical context or another. The ensuing account of the late arrival of the profession in this country says more about the stakes than may have been intended: "At the beginning [before the 1920s], the new discipline had to find its way out of an entanglement with practical art instruction, art appreciation, and that amorphous mon-

ster 'general education' " (p. 324). Evidently the rather unfortunate quip *was* intended about the art historian looking to an English gentleman "like a fellow who compares and analyzes the charms of his female acquaintances in public instead of making love to them in private" (p. 323).

There is as much cultural politics as intellectual history in these passages. The definition I've quoted proclaims what art history is not, against would-be professional rivals; the second passage salutes the liberation of the fledging specialization from the monstrous embraces of the practical, dilettantish, and general; the third is a backhanded celebration of professional (masculine) denial and propriety against aristocratic profligacy and feminine temptations. So much for the generalists, the aesthetes, the technicians, whether connoisseurs, antiquarians, or artists. They are relegated to the margins of proper art history as amateurs (if not English voluptuaries) or as support staff. With this, the "art love" of the amateur and the feel of contact with art work are marginalized too. At least in theory, the proper art historian's pleasures are personal and unprofessional.

This view might seem less cramped if accompanied by the philosophizing of Panofsky's early writings. But that was not the way of his later work, and from what we know of his theoretical pronouncements, philosophical arguments would not have much altered his position. Michael Podro, Joan Hart, and Michael Ann Holly have shown how the neo-Kantian project in German art history sought to render the discipline credible in the teeth of late nineteenth-century positivist science.[3] This called for heavy infusions of philosophy, psychology, *Geistesgeschichte*, and system. From the neo-Kantian and neo-Platonic altitudes to which the early Panofsky aspired pleasure was a suspect topic, more suspect than it was for Kant or, perhaps, for Plato. The trajectory of the later essays on love in *Studies in Iconology* consistently subsumes and neutralizes "sensual love," making it safe for higher syntheses with reason and intellect com-

ing out on top. The many pages on Venus, Cupid, and assorted demigods are nearly blank on the pleasures of viewing. While the essays certainly are pleasing for their zest and elegance in the iconological chase, the interpretive project seems in itself inhibiting because it has settled into sorting out motifs and texts from antiquity through the Renaissance in light of shared, and highly intellectualized, "intrinsic meanings." Whether such meanings were underlying causes, as Panofsky claimed, or imposed analogies, as critics have insisted, his pleasure shows mostly in ingenious solutions to iconographical puzzles or in expressions of delight at the look of pictures quickly dampened by iconographical chores.[4] Panofsky, *am Scheideweg*, takes the path of virtue.

Knowing worldliness ends up conferring a higher mission on art history in the partly autobiographical epilogue essay.[5] Cosmopolitanism is a major theme—and message. So, for example, the picture of noble academic traditions lost to the Nazis; the sad assertion, to counter any hint of "retroactive German patriotism," that "every page" by a select group of French, English, and Dutch writers on art "outweighs a ton of German doctoral theses" (p. 323); the upbeat responsiveness, complete with "cozy dissipation" (p. 331), to New York in the 30s; and, from the subtitle on, the role of the "transplanted European," who clearly meant to be seen as flourishing on both sides of the Atlantic. Emotion, will, and the senses are the usual suspects in cases of pleasure, and these were not at all abstract threats to cosmopolitan civility between the 1930s and the 1960s. For the assimilated Jewish intellectual it was important to be more genteel than the gentiles; for the "transplanted" European scholar the Apollonian side of the old world's culture was the most civilized of offerings to the raw new one. Amidst ideological and real alarms, it was reassuring that there were steadying liberal values in the Grand Tradition of Western Civilization to rally around.[6] Pleasure was not likely to be one of them in the new Iron Age of Fascism and the guilty peace of the Cold War.

Clearly Panofsky is not to blame for this art-historical anhedonia. For one thing, counter-arguments and aversions to hedonistic aesthetics have an ancient pedigree and are on the whole the dominant tradition in Western philosophy.[7] Besides, criticisms and revisions of Panofsky's methods have not exactly wallowed in pleasure. This has something to do with the academic ritual of turning theses on their head or feet without much changing the parameters of an argument. Self-consciously materialist art historians, for example, have easily found meaning in the materials, social functions, and consumption of art, but they have not dwelt on pleasure, except as a form of false consciousness. The rage for documentary research demands archives not art—I remember watching art historians working day after day in the old reading room of the Archivio di Stato in Florence while footsteps from the Uffizi Gallery echoed overhead. Structuralisms long since retired in other fields but just now being heralded or reviled as the wave of a semiotic future in art history analyze formal systems of signs rather than the sensations signs may arouse. Freudians are constrained by Freud's association of pleasure with death and of art with only ersatz gratification. Some post-modernist critical-historical work is more frankly pleasure-seeking, but these pleasures usually turn out to be prompted by the cheerless oppression of some supposedly totalizing system of political economy, patriarchy, or knowledge-paradigm.[8]

Only against so much denial and indifference would it be surprising that there are reputable ways of having meaning for pleasure in the visual arts, and vice versa. There are quite disreputable ways too of course, but on this occasion I want to come at the matter as Panofsky might have done.

To do this we need illustrative texts and images drawn largely from the Western High Culture from antiquity through the Renaissance. We should also be alert to principles presumed to underlie phenomena, for in the last analysis the

iconologist is supposed to arrive at an understanding of the "manner in which, under varying historical conditions, the general and essential tendencies of the human mind were expressed by specific themes and concepts."[9] Otherwise our historical accounts would not be explanations anchored outside the flow of history in "a higher order of knowledge," and we would have failed to contemplate the relationships between form, idea, and content which is the highest goal of art history "as a humanistic discipline."[10] If we do not scale these heights, there is the consolation that, according to some careful readers, Panofsky did not get much beyond tracking ideas and motifs.[11]

The print in figure 1 is a tutelary image and text for this exercise from an 18th-century encyclopedia. Rhetoric is shown and described in the text as a figure of "agreeable" qualities: her dress is "superb"; "her beautiful hair expresses the beauties of eloquence"; her seven-stringed harp is laced with the flowers of poetry; demonstrative rhetoric makes the orator rejoice and delight in its headlong flight. But this is not the "mere" pleasure of the low end of formulaic oppositions to the high reason of philosophy and the philosophers. The lightning bolts in Rhetoric's right hand are weapons against "error, fraud, and the darkness of ignorance"; the ministrations of rhetoric, we are told, enable us to understand long and diverse arguments. Of course this is hyperbole through and through, not surprisingly from Rhetoric. The print represents a minor skirmish in an ancient battle between sophists and philosophers, rhetoric and logic, appearance and truth, and a long string of surrogates. But the familiarity, not to say banality, of the case is a seal of authenticity for a long-standing argument against the preemptive claims of philosophy and reason on meaningfulness *and* pleasure.

Ut pictura rhetorica, ut rhetorica pictura—the connection between rhetoric and picturing is as old as the sophists.[12] It still manages to generate

new insights, partly because the objections to the changeling pragmatism of rhetoric are at least as old and, in principle at least, more often dominant. To take a recent example, the "discovery" of rhetoric not only as a discipline but also as a *culture* has transformed the last generation of Renaissance studies.[13] The training and allegiances of earlier scholars lay primarily with philosophy and philology. Panofsky, for his part, was indebted to Ernst Cassirer, whose philosophy of "symbolic forms" read Kant's aesthetics as epistemology or metaphysics. I want to come back to this, but for now it is worth noting that Panofsky was evidently not attuned to the rhetorical versions of cultural history arising in his own ambience—for example, Ernst Robert Curtius' analyses of post-classical literary tropes or Paul Oskar Kristeller's rewriting of Renaissance humanism as rhetoric.[14]

In the classic formula, the aim of rhetoric is "to move, to delight, and to teach" (*movere, delectare et docere*). Pleasure and knowledge are taken to be complementary. Whereas the philosopher, according to Cicero, "sequester[s] the soul from pleasure" in seeking "knowledge and clear perception . . . , all tending to a single conclusion and incapable of misleading," the orator combines an understanding of language and its charms with the "wise thinking" of the philosophers—and of many other sources besides.[15] The orator needs to persuade, cajole, castigate, and communicate with his audience and to improve it. This agenda has a long, complicated life and an elaborate literature. The important point here is that the rhetorical argument is as persistent and, given its premises, as persuasive as the philosophical one, and that it specifically extends to images in art.

Jacqueline Lichtenstein sums up one extension: "the renaissance of painting, first in Italy, then in France [can be understood as] inseparable from a renaissance of . . . Ciceronian rhetoric, a reactualization of the myth of the orator. The recognition of painting in its renaissance is the corollary

Figure 1. "Rhetoric," from: Abbe Petity, *Encyclopédie élémentaire*, 3 vols. (Paris, 1767), vol. 3, frontispiece to section on Rhetoric [p. 116], in Philippe Hamon, *La Description littéraire de l'antiquité à Roland Barthes: une anthologie* (Paris, 1991): 31. The accompanying inscription reads:

RHÉTORIQUE: Cette Déesse assise sur une chaire, annonce la supériorité des Orateurs. Ses superbes habillements désignent la majesté du stile; sa belle cheveleure exprime les beautés de l'Eloquence; les foudres qu'elle tient de la main droite, sont de puissantes arms pour dissiper l'erreur, la fraude, et les ténèbres de l'ignorance. [L]e caduçé de Mercure qu'elle porte de la main gauche, est le simbole du Dieu de l'Eloquence. [L]e lyre a sept cordes entrelassée de fleurs de toute espèce, est l'allégorie simple et naturelle de la Poësie.

Ovide, Hésiode, et Nazianzène entendent par la Chimere, les trois parties de la Rhétorique. [L]a Judicielle exprimée par le Lion, à cause de la frayeur qu'elle donne aux criminels. [L]a Démonstrative figurée par la Chèvre, parceque l'orateur se réjouit pour ainsi dire, et prend plaisir à se donner carrière. [L]a Déliberative désignée par le Dragon ou Serpent, pour nous faire comprendre la diversité des arguments, et longs circuits, dont il faut user en persuadant.

to a reevaluation of the spoken word, a redefinition of the hierarchies of discourse that places oratory at its summit, strips writing of its privilege, and restores painting to its splendor."[16] In the seventeenth-century quarrel between the "Poussinists" and the "Rubensists," for example, Roger de Piles' brilliant defense of color over drawing parallels Cicero's redemption of rhetoric from Platonic suspicion by rejecting, among other things, the elevation of reason over pleasure. If anything, the sensuous beauty and mimetic allure of color render it superior to the mere linearity and abstractness of drawing while appealing to the intellect quite as much as draughtsmanship—more so according to de Piles. Painting that only instructs, he archly observes, is for "men of letters . . . who have a refined character to uphold in the world . . . in subtle discourses and learned commentaries [that] would be cruelly affected if their perception were disturbed by some affective force."[17]

There is much more to be said here again, but I want to turn to rhetorical tropes traditionally associated with picturing and with pleasure. Philippe Hamon deals with these in a recent anthology of texts on "literary description," a somewhat misleading title because "literary description" does serious epistemological and philosophical work.[18] *Ekphrasis* is probably best known in connection with the visual arts, largely because the classic ekphrastic exercise, that is, a vividly ornamented literary description, was to describe real or imagined pictures on the model of Philostratus or Lucan. The term has been picked up in this sense by art historians.[19] But there is a whole raft of overlapping or interrelated words and practices, Greek and Latin: *enargeia, energeia, evidentia, illustratio*. The staying power of the term *hypotypose* is such that the following definition could be taken over from classical rhetoric in a nineteenth-century writing manual, then republished by Gérard Genette in 1968: "Hypotypose paints things in such a vivid and energetic manner, that it puts them as it were under our eyes, and makes of a narrative

or a description, an image, a *tableau*, or even a living scene."[20]

In the entry for "Descriptions" in the great *Encyclopédie* (1751-1780) a description "painting" its objects and making them "present" is pleasing when those objects are "agreeable," and even when they are disagreeable. This is so on the (Aristotelian) principle that the mind compares ideas arising from words with the ideas that would come in the presence of the actual objects being described—hence our pleasure is doubled in looking at attractive images. The distress we would feel in the face of some real displeasure is converted into the pleasure of knowing that the representation is not real. Moreover, description exercises the imagination, its inventive capacity for research and development, so to speak; and these exercises are generally pleasurable. Finally, description has critical functions. It takes into account the point of view, changing aspect, and defining features that the more monochromatic, categorizing, and generalizing operations of reason cannot do so well, or so "delightfully."[21]

Predictably, art historians self-conscious about the philosophical and scientific credibility of their profession, not to mention antiquarians and museum people claiming unapologetically to have sciences of their own, have not taken up the rhetorical argument. It is more surprising that they have mostly bypassed philosophical aesthetics, the most influential line of thinkers for him— Schiller, Kant, and Hegel—were, when they wanted to be, aestheticians. A particularly revealing omission in a professed neo-Kantian literature is Kant's early *Observations on the Feeling of the Sublime and the Beautiful* (1763).[22] "Feeling" is a key word that marks more than a preliminary to the *Critique of Judgment* written some thirty years later. The common denominator of feeling for Kant is clearly pleasure. "Finer feeling," he writes, "is of two kinds: the feeling of the sublime and that of the beautiful. *The stirring of each is pleasant, but in different ways*" (pp. 46–47). There follows a mapping of contrasts be-

tween the sublime and the beautiful. Kant is explicitly not concerned with rational understanding: "We do an injustice to another who does not perceive the worth or the beauty of what moves or delights us, if we rejoin that *he does not understand it*. Here it does not matter so much what the *understanding* comprehends" (p. 72). The text continues: "These principles are not speculative rules, but the consciousness of a feeling that lives in every human breast" (p. 16). Human breasts west of Koenigsberg and east of Dublin no doubt, but the point is that Kant is generalizing on the basis of aesthetic and moral intuition which, together with reason but here even more importantly than intellect, defines the nature and dignity of humanity.

The more methodical formulation in the *Critique of Judgment* preserves an emphasis that could hardly be divined from Panofsky or Cassirer, Panofsky's mentor in these matters. "The beautiful and the sublime agree in that they are pleasing on their own account," we read in Kant's account of what he now calls "disinterested pleasure." Such pleasure depends neither on sensation nor on "a definite concept"; it is immediate, attuned to the spark of accord between the stimulus presented to the imagination and the faculty of understanding or reason. "Hence both kinds of judgment [as to the beautiful and the sublime] are *singular,* and yet profess to be universally valid . . . , despite the fact that their claims are directed merely to the feeling of pleasure and not to any knowledge of the object."[23]

As the *Critique* goes on to indicate the differences between the beautiful and the sublime, another binary set of aesthetic oppositions begins to emerge. These remain, nevertheless, subdivisions of pleasure; pleasure is still the overarching category where aesthetics is concerned. Whereas beauty relates to form and is therefore necessarily limiting, a sense of limitlessness opens up in the experience of the sublime. Quality inspires delight in one, quantity provokes it in the other; one contributes to the "furtherance of

life," the other is convulsive and explosive. Kant concludes that "beauty conveys a finality in its form in making the object appear, as it were, preadapted to our power of judgment, so that it thus forms of itself an object of delight . . . , [but] that which . . . excites the feeling of the sublime, may appear in point of form to contravene the ends of our judgment, to be ill-adapted to our faculty for imagining, and to be, as it were, an outrage on the imagination."[24]

Under the auspices of pleasure, we have tapped into a vein of contrasts with an important future in writing on art—Nietzsche's Apollonian and Dionysian spirits, Wölfflin's Linear (Renaissance) and Painterly (baroque) styles, postmodernist Beauty and *Jouissance*.[25]

That we have struck, so it turns out, a discursive mother lode on art is one more indication that there is nothing new about supposing that pleasure matters to what the visual arts mean. This proposition is a kind of *ricorso* that brings displaced truths back to light. It also leaves us in the somewhat ludicrous position of having to be serious about pleasure.

To begin anti-climactically, subjects meant to please are hardly uncommon in art and, usually more discreetly, in art history. Erotica are the classic example; what we might call the *Festpiece*—i.e., representations of celebrations, games, dancing, ritual eating and drinking—is another. The visual joke or pictorial pun is a professional status symbol and calling-card in Italian Renaissance art. Pastoral landscapes were conventionally painted as "places of delight."[26] And so forth. These subjects already figure in the charter myths on the origins of Western art—so, for example, the tale of Butadis obligingly inventing sculpture so that his lovesick daughter could "see" and "touch" her absent lover; or Dionysus' command that his feast be shown in his temples; or the grapes painted by Zeuxis that tricked viewers and, more tellingly, birds into wanting to eat them.[27] Whole histories could be written along these lines, both because the motifs in-

volved are frequently trans-historical and cross-cultural, and because they are at the same time historically and culturally conditioned. The erotic appeal of this fin-de-siècle's sex idols will surely become as dated as powdered wigs, furbelows, and flappers, and jokes tend to be poor travelers. Either way, tracking generic themes or singling out variations, it would be hard to imagine a good argument against updating the role of pleasure in what used to be called the "history of taste."

Like some home remedies, the simple recipe is, however, stronger than it may appear. Professional paradigms have clashed quite spectacularly over the subject of pleasure. David Freedberg on the erotics of images launches a wholesale assault on what he takes to be the repressive elitism and intellectualism of his fellow art historians. This leads to a bruising critique of the privileges accorded to art over and above non-art or "mere images," to a revindication of the viewer's emotional responses to images, and to a vast array of lore on the beguiling capacity of the image to absorb, project, and stand in for the beholder's desires.[28] Paul Barolsky's book on visual jests in Italian Renaissance art starts with "the curious fact" that so little attention has been paid to "wit or humor in art" and ends with a critique of "overly zealous Neoplatonizers of the twentieth century" who turned a cool eye to the comic, the satirical, and the sensuous.[29] Without actually being told that Renaissance Neoplatonism is a modern invention we are reminded that the conception was developed in twentieth-century Hamburg, London, and New York, whatever we might say about Renaissance Florence, Venice, or Rome. The modern version, on this account, was far more coherently systematic and idealizingly otherworldly than the Renaissance texts, singly or together, ever were.

Film criticism and film history are a conspicuous modern, or post-modern, case of a multiplier effect coming with the thematization of pleasure.[30] Some of the most productive initiatives stem as much from the pleasure problematic as from the

relative newness or the technical peculiarities of the medium. The focus on the production and consumption of desire in film has stirred up a theoretical and analytical flurry on "scopophilia," the "gaze," and the *jouissance* of the eye. This leads in turn to a self-conscious critique of commonplaces in Western art theory since the Renaissance—for example, that vision is neutral (it is heavily gendered in film), unifying (it reflects the camera's view in film), or continuous (film plays on more or less arbitrary shifts and juxtapositions). A characteristic neo-iconoclasm in all this is the critics' fascination with the allure of the image which is then condemned as a capitalist and sexist ruse.

More is obviously at stake than subject matter in these revisionary associations of pleasure and art, but I want to keep the risks low for just another moment. The fact that people have taken or were supposed to take pleasure in looking at art should be an incentive for historians. No special virtue, grand theory, or higher criticisms are required beyond interpretive commitments that are made routinely for scholarship in the humanities. The ritual professions of respect for the artifacts of human culture and the amazing variety of responses to them ring hard and hollow indeed with pleasure left out.

Even so, it will not do to stop at the pragmatic rationale I've offered so far. The challenges to professional paradigms, so I have suggested, are too fundamental to deal with simply by adding a pleasure rubric to a list of "new" topics—which always look outmoded when fashions change anyway. Besides, the question is not whether methodological and interpretive preferences depend on theorizable assumptions—surely they always do—but whether the theoretical ground will be explicit or not. This is not historians' or art historians' customary turf, but that is no excuse for abandoning the territory or farming it out to others. Scholars like the early Panofsky who were largely responsible for setting this century's agendas in the humanities certainly did not shy away from theorizing. Their presumptuous meddling with heady issues may turn out to be one of

the vital links in humanities scholarship from the early part of the century to this end of it.

I have already cited rhetorical theory, literary description, and philosophical aesthetics as Western sources of more or less approving reflection on the pleasures of art. Perhaps the single most important lesson of those traditions in this context is that there are powerful alternatives to the binary thinking on which the opposition or incommensurability of meaning and pleasure have been constructed. So long as rationality, objectivity, and clarity are arrogated categorically to the former while emotion, subjectivity, and obscurity are consigned to the latter there is very little room for reevaluating the interrelationship of both, except as best of enemies. Such contrasts have almost always worked to devalue some of the most insightful thinking and writing we have about art as, literally, dilettantish.[31] This is unfortunate, not least for professionals. I suspect that "amateur" thinking and observation must be responsible for some of the most telling cues to "real" art history.[32]

Be that as it may, I am well aware that I have been skirting the problem of definition all along. My small faith in offering a very satisfactory definition of "pleasure in the visual arts" is admittedly a large part of the problem. People proverbially know what they like without much caring what others think. Those who do think about definitions tend to divide routinely along the lines of a perennial stalemate. Some refer to subjective universals, to "everybody's" pleasure in, say, symmetry, mimetic likeness, or color; others locate the pleasure potential in the "form," "idea," "concept," or "structure" of the art object "itself." Both positions essentialize the reception or the production of aesthetic pleasure in contrast to the relativizers, conventionalists, or historicists, for whom pleasure depends on context, ideology, period conventions, social utility, or specific interests. A long history of claims and counterclaims hardly promises an easy exit.[33]

It does suggest, however, that the problem is not likely to go away—so we may as well decide how to live with it. A provisional solution would, at a minimum, factor phenomenological, formalist, and circumstantial accounts into a calculus of pleasurable effects and affects. My own way of negotiating this particular gamut is what I'll call aesthetic transilience. That the language is a little portentous but (I hope) quite transparent suits the case well enough. There is something wondrous *and* quite clear about the "leap through or across" (*trans+silire*) that, I would argue, characterizes pleasure in many things, including the visual arts.

The main lines of such an argument can be sketched out roughly as follows.[34] We commonly, if not perhaps exclusively, experience pleasure with the transformation of materials or states of affairs from one condition to another. Indeterminacy and the sense of being betwixt and between supply the pleasures, sometimes guilty or frightening pleasures to be sure, of release, of liberation from fixed rules and routines. At the same time, the provisional assurance of beginnings and endings accompanying such transformations tends to be regarded as pleasingly finite, orderly, and comforting. Objects classified and looked at as works of art are privileged formal sites (and sights) because they deliberately promote and display such transilient pleasures. The artist is a specialist at making "leaps through or across" materials or states of affairs visible; the artworld of training, the market, art criticism, art history, collecting, etc. operates its own institutional conversions of objects into art works. Circumstances change of course. Therefore, statements in general about phenomena and forms of aesthetic pleasure have to be situated in particular historical settings. Indeed, the interpretive framework I've been outlining here calls attention to processes and so to changes in time, place, and medium. In this roundabout way we come back to history, after all.

Supposing that this sketchy case could be made convincing—plausible at least—in some detail, what difference would it make? Or to

adapt Barnett Newman on art theory and artists, would it matter as ornithology matters to birds? As I have already said, there is no real choice between theory and non-theory; if anything, the current rush of traffic across disciplinary lines has increased the need for some reflective distance from which to take bearings in unfamiliar terrain. Nor do I think that the case I've outlined is unhistorical or, for that matter, unarthistorical; as I have tried to show, it is underwritten by some venerable convictions about art and it calls for historical engagement with specific works, artists, and settings in time and cultural space. From the perspective of this fin-de-siècle, it is the iconophobia, however unintended, of "seeing through" art to preestablished iconographical, social, or semiotic scripts that has come to seem dated.

I had just written these lines when I came upon an editorial in *Art Bulletin* in which an imaginary student brings the real editor up short "by asking whether she can do [graduate study in art history] without risking the lessening of the pleasure she has in looking at works of art." Her reluctantly chosen alternative is, of all things, graduate school in history. The editor tries to change her mind but can offer only "feeble reassurances." She remains unconvinced. Readers will draw their own conclusions.[35]

Notes

1. First published by one of the indefatigable nineteenth-century editors of documents on art, Gaetano Milanesi, in *Documenti per la storia dell'arte senese*, 3 vols. (Siena, 1854-56), 1:180–81; I found it again in a recent social and institutional history, Daniel Waley, *Siena and the Sienese in the Thirteenth Century* (Cambridge 1991), 13. I want to recall, with pleasure and thanks, conversations on the subject of this paper with Svetlana Alpers, Shadi Bartsch, Carol Clover, Catherine Gallagher, Anthony Newcomb, Loren Partridge, Patricia Reilly, Frances Starn, Barrett Watten, Deborah Zafman, Ines Zupanov, and the Early Modern Study Group.

2. Erwin Panofsky, "Epilogue. Three Decades of Art History in the United States, Impressions of a Transplanted European," in his *Meaning in the Visual Arts: Papers in and on Art*

History (Garden City, N.Y., 1957), 321–46; first published as "The History of Art," in *The Cultural Migration*, ed. W. R. Crawford (Philadelphia, 1952), 82–111. I cite the 1957 paperback ed. in the following paragraph.

3. See Michael Podro, *The Critical Historians of Art* (New Haven and London, 1982), 218–42; Joan Hart, "Reinterpreting Wölfflin: Neo-Kantianism and Hermeneutics," *Art Journal* 42,4 (1982): 292–300; and Michael Ann Holly, *Panofsky and the Foundations of Art History* (Ithaca, N.Y., 1984).

4. See, e.g., Panofsky's vivid and empathetic description of Piero di Cosimo's style shifting abruptly from "the strange lure emanating from Piero's pictures" to their iconographical content—"It is this content which will be discussed in this chapter": "The Early History of Man in Two Cycles of Paintings by Piero di Cosimo," in *Studies in Iconology: Humanistic Themes in the Art of the Renaissance* (New York, 1962; first ed. Oxford, 1939), 33–34. "Intrinsic meaning," it will be recalled, comes from the celebrated "Introductory" on method in *Studies*, esp. p. 14. The recent bout of soul-searching over "theory and method" has generated a considerable literature on the history of art history in which Panofsky has come in for fresh attention, much of it critical. For an international sampling, see, besides the works cited in n. 3, Donald Preziosi, *Rethinking Art History: Meditations on a Coy Science* (New Haven and London, 1989), 111–21; Hans Belting, *The End of the History of Art?* trans. Christopher S. Wood (Chicago and London, 1987); and Georges Didi-Huberman, *Devant l'image: Questions posées aux fins d'une histoire de l'art* (Paris, 1990).

5. There are intimate variations on this in *Dr. Panofsky and Mr. Tarkington: An Exchange of Letters, 1938-1946*, ed. Richard M. Ludwig (Princeton, 1974); I cite the 1957 ed. again in parentheses below.

6. This was implicitly the spirit and openly the program of the great essay on "The History of Art as a Humanistic Discipline" (*Meaning in the Visual Arts*, 1–25) and of the circle around Princeton professor T. J. Greene who edited the volume *The Meaning of the Humanities* (Princeton, 1940) in which the essay originally appeared.

7. So, e.g., in a charter text, early modern iconophobia, and modern philosophers' suspicion of art: see, respectively, Cynthia Hampton, *Pleasure, Knowledge, and Being: An Analysis of Plato's Philebus* (Albany, N.Y., 1990); Jacqueline Lichtenstein, *The Eloquence of Colour: Rhetoric and Painting in the French Classical Age,* trans. Emily McVarish (Berkeley and Los Angeles, 1993); and Arthur C. Danto, *The Philosophical Disenfranchisement of Art* (New York, 1986).

8. Ernst Gombrich, "Huizinga and 'Homo Ludens,'" in *Times Literary Supplement* (14 October 1976): 1089 (quoted by Paul Barolsky, *Infinite Jest: Wit and Humor in Italian Renaissance Art* [Columbia and London, 1978], 2), was already complaining that in "the history of art, we have become intolerably earnest. . . . The idea of fun is even more unpopular among us than the notion of beauty." The sometimes testy

defenses coming from the aesthetic traditions of art history in Britain, and to some extent in France, have a similar moral: see, e.g., Kenneth Clark, *The Other Half* (London, 1977), 77–95. My own impressions in this paragraph are based on unsystematic conversation and reading. A recent manifesto on art-historical method and the responses to it in the main organ of academic art history in the U.S. conveniently illustrate most of the points I am making here: Mieke Bal and Norman Bryson, "Semiotics and Art History," *Art Bulletin* 73,2 (1991): 174–208; subsequent correspondence in ibid., 74 (1992) and 75 (1993).

9. "Art as a Humanistic Discipline," 39

10. All three elements, Panofsky writes, as close as he comes to a definition of pleasure in art, "enter into what is called aesthetic enjoyment": ibid., 16.

11. See, e.g., Podro, *Critical Historians of Art*, 178–208.

12. Still basic here: John R. Spencer, "*Ut rhetorica pictura*: A Study in the Quattrocento Theory of Painting," *Journal of the Warburg and Courtauld Institutes* 20 (1957): 26–44; Rensselaer W. Lee, *Ut pictura poesis: The Humanistic Theory of Painting* (New York, 1967).

13. William J. Bouwsma, *The Culture of Renaissance Humanism* (Washington, D.C., 1973) is still one of the best surveys. My choices to bring these developments up to date include Marc Fumaroli, *L'age de l'éloquence: rhétorique et "res litteraria" de la Renaissance au seuil de l'époque classique* (Geneva, 1980); Anthony Grafton and Lisa Jardine, *From Humanism to the Humanities: Education and the Liberal Arts in Fifteenth- and Sixteenth-Century Europe* (Cambridge, Mass., 1986); and John Monfasani, "Humanism and Rhetoric," in *Renaissance Humanism: Foundations, Forms, and Legacy*, ed. Albert Rabil, Jr., 3 vols. (Philadelphia, 1988), 3: 85–170.

14. See Paul Oskar Kristeller, "The Cultural Heritage of Humanism: An Overview," in *Renaissance Humanism*, 3: 515–28. On scholarship in the humanities in interwar Germany I particularly want to mention the work of Carl H. Landauer, which he has generously shared with me: Carl Hollis Landauer, "The Survival of Antiquity: The German Years of the Warburg Institute" (Ph.D diss., Yale University, 1984); and, in particular, "Erwin Panofsky and the Renascence of the Renaissance," *Renaissance Quarterly* 47 (1994): 255–81. See too Silvia Ferretti, *Cassirer, Panofsky, and Warburg: Symbol, Art, and History*, trans. Richard Pierce (New Haven and London, 1989).

15. Cicero as quoted from the *Tusculan Disputations* II, i, 4, and *De oratore* I, xxiii, 108, by Jerrold E. Seigel, *Rhetoric and Philosophy in Renaissance Humanism: The Union of Eloquence and Wisdom, Petrarch to Valla* (Princeton, 1968), 8. Seigel's chapter, 3–30, "Rhetoric and Philosophy: The Ciceronian Model" is still a model discussion.

16. Lichtenstsin, *Eloquence of Color*, 33. See on the rhetorical origins of Renaissance art theory Michael Baxandall, *Giotto and the Orators: Humanist Observers of Painting in Italy and the Discovery of Pictorial Composition, 1350-1450* (Ox-

ford, 1971; corrected ed. 1986); and on modernist variations, Wendy Steiner, *The Colors of Rhetoric: Problems in the Relation between Modern Literature and Painting* (Chicago and London, 1982). For *delectatio* as applied to Renaissance art theory, see David Summers, *Michelangelo and the Language of Art* (Princeton, 1981), 95, 172.

17. De Piles as quoted by Lichtenstein, *Eloquence of Colour*, 162. The most complete work of reference is Bernard Teyssedre, *Roger de Piles et les débats sur les coloris au siècle de Louis XIV* (Paris, 1964); for further analysis: Thomas Puttfarken, *Roger de Piles' Theory of Art* (New Haven and London, 1985).

18. Philippe Hamon, *La description littéraire: anthologie de textes théoriques et critiques* (Paris, 1991).

19. Pioneeringly by Svetlana Alpers, "*Ekphrasis* and Aesthetic Attitudes in Vasari," *Journal of the Warburg and Courtauld Institutes* 23 (1960): 190–215. For the most recent work, see James A. W. Heffernan, *Museum of Words: The Poetics of Ekephrasis from Homer to Ashbery* (chicago, 1993).

20. Hamon, *Description littéraire*, 30.

21. Hamon, *Description littéraire*, 206ff; cf., however, the strong arguments for the complicity of art-historical description in Renaissance conventions of "the semantic function" by David Summers, "The 'Visual Arts' and the Problem of Art Historical Description," *Art Journal* 42 (1982): 301–10.

22. I use the edition and translation by John W. Goldthwait (Berkeley and Los Angeles, 1960). So far as I know, the other classic authors on the sublime, particularly Edmund Burke and Coleridge, did not influence the art-historical project, either. For the literary and philosophical issues at stake, see, esp., Steven Knapp, *Personification and the Sublime: Milton to Coleridge* (Cambridge, Mass., 1985).

23. I use the selections in *The Philosophy of Kant*, ed. C. J. Friedrich (New York, 1949), 299.

24. Ibid. 300.

25. To my knowledge, the connections and contrasts suggested here have not been fully explored. However, I have found two books particularly stimulating and informative on modernist and post-modernist categories for visual experience and art: W.J.T. Mitchell, *Iconology: Text, Image, Ideology* (Chicago and London, 1986); and the magisterial volume, despite its title, an encyclopedic intellectual history of "the visual" in Western thought, by Martin Jay, *Downcast Eyes: The Denigration of Vision in Twentieth-Century French Thought* (Berkeley and Los Angeles, 1993). For Nietzsche, see esp. Alexander Nehamas, *Nietzsche: Life as Literature* (Cambridge, Mass., 1985), 12–17. Besides the work of Joan Hart (see n. 3 above) on Wölfflin, see Martin Warnke, "On Heinrich Wölfflin," *Representations* 27 (Summer, 1989): 172–87, for the context of Wölfflin's *Principles of Art History*; on the *jouissance*/beauty opposition, which figures in one form or another in much recent feminist criticism, Mary Bittner Wiseman, *The Ecstasies of Roland Barthes* (New York and London, 1989), 86–197, was especially useful for my purposes.

26. The classic work is Johan Huizinga's *Homo Ludens*

(Boston, 1964). Barolsky, *Infinite Jest,* though focused on Renaissance Italy, is the one survey I know of pleasure motifs in art; on pastoral I borrow from the title, a translation of *locus amoenus,* of Robert Cafritz, Lawrence Gowing, and David Rosand, *Places of Delight; The Pastoral Landscape,* exh. cat. (New York, 1988).

27. The *locus classicus* is Pliny's *Natural History:* see *The Elder Pliny's Chapters on the History of Art,* trans. K. Jex-Blake, intro. and commentary E. Sellers (1896; repr. Chicago, 1967). For absorbingly fresh and learned meditations on such originary tales, see Maurizio Bettini, *Il ritratto dell'amante* (Turin, 1992).

28. David Freedberg, *The Power of Images: Studies in the History and Theory of Responses* (Chicago and London, 1989), esp. chaps. 1, 12, and 13.

29. Barolsky, *Infinite Jest,* 1, 166ff; cf., more recently, Horst Bredekamp, *Botticelli, Primavera: Florenz als Garten der Venus* (Frankfurt am Main, 1988), 64–68.

30. Kaja Silverman, *The Subject of Semiotics* (New York and Oxford, 1983); *The Cinematic Apparatus,* ed. Teresa Lauretis and Stephen Heath (London, 1980); and the chapter on cinema ("The Camera as Memento Mori: Barthes, Metz, and the Cahiers du Cinema") in Jay, *Downcast Eyes,* 434–90, are valuable introductions.

31. Steiner, *Colors of Rhetoric,* is especially eloquent in theory and critical practice on this point, as is Danto, *Disenfranchisement of Art.*

32. For an attractive recent sampler: *Writers on Artists,* ed. Daniel Halpern (San Francisco, 1988).

33. Particularly useful surveys, both lamenting the problem of definition but insisting on the criterion of pleasure, however fuzzily defined, in aesthetic experience: Rudolph Arnheim, "Emotion and Feeling in Psychology and Art," in his *Toward a Psychology of Art* (Berkeley and Los Angeles, 1966), 292–319; Diane Collinson, "Aesthetic Experience," in *Philosophical Aesthetics: An Introduction,* ed. Oswald Hanfling (Oxford and Cambridge, Mass. 1992), 111–78. For similar indeterminancies and insistences in science, cf. Lionel Tiger, *The Pursuit of Pleasure* (Boston, 1992), 80: "the neurophysical basis of pleasure has not been identified. . . . [S]ince both pain and pleasure cause still-unspecified neural activity, and since pleasure itself cannot be traced, it is most efficient to trace taste preferences in order to try to determine their sources."

34. I cite the following works not as sources and certainly not to make their authors responsible for the argument but out of a general sense of affinity: Stephen Bann, *The True Vine: On Visual Representation and the Western Tradition* (Cambridge and New York, 1989), esp. chap. 6, "Art and Metamorphosis," 157–204; Leonard Barkan, *The Gods Made Flesh: Metamorphosis and the Pursuit of Paganism* (New Haven and London, 1986); Paul Barolsky, *Walter Pater's Renaissance* (University Park, Pa. and London, 1987); Arthur C. Danto, *The Transfiguration of the Commonplace: A Philosophy of Art* (Cambridge, Mass. and London, 1981); Philip Fisher, *Making and Effacing Art: Modern American Art in a Culture of Museums* (New York and Oxford, 1991), esp. chap. 9, "A Humanism of Objects," 233–53; David Summers, "Real Metaphor: Towards a Redefinition of the 'Conceptual' Image," in *Visual Theory: Painting and Intepretation,* ed. Norman Bryson, Michael Ann Holly, and Keith Moxey (Cambridge and Oxford, 1991), 213–59; Richard Wollheim, *Painting as an Art* (Princeton, 1987).

35. Richard Brilliant, "Editorial: 'Where's the Poetry?'" *Art Bulletin* 75,3 (1993): 374.

LITERATURE

Introduction

W.J.T. MITCHELL

The relation of language to painting is an infinite relation.
Foucault, *The Order of Things*

What can literary and textual scholarship teach us about meaning in the visual arts? The answer seems to be both everything and nothing. Everything if we follow the rhetorical tradition that Marc Fumaroli traces through Panofsky and Curtius, a tradition that harbors "symbolic forms" that are stored in the "same memory," and "which may be mirrored in texts as well as in visual works." Nothing if we adhere to the Cartesian and Modernist tradition that, according to Fumaroli, "has insisted upon the unbridgeable gulf between plastic and literary forms, between the visible and the word."

Between this "everything" and "nothing" lies *something,* a space of negotiation between the seeable and the sayable, a space that might be called "representation," or "discourse," or "literature," or "visual art"—or simply, "the world." The most salient contribution that literary and textual scholarship has brought to the visual arts has been a heightened sense of the heterogeneous, stitched-together character of all forms of mediation (not just literature and fine art, but cinema, television, theatre, and other media), and an accompanying sense that reading and seeing, saying and displaying, are mutually implicated processes, distinct, inseparable, and dialectically engaged. "Dialectics" is simply the name for the space opened by the all-or-nothing relation of language and visuality, our inability to think the relations of images and texts without alternating between figures of difference, opposition, and "unbridgeable gulfs," and figures of identity, similitude, and synthetic "symbolic forms." Images *are* texts: we read, decipher, decode, and translate images, just as we do texts.

Images *are not* texts: no reading, description, interpretation can take the place of the visual presence and tactile density of an image. The relation of images and texts might best be designated with an invented notation that overlays "versus" with "as," a "vs/as" that combines similitude with opposition, identity with difference, equivalence with contradiction.

Dialectic is a two-way street. If "literature" has brought textual issues into a dialectical relation with art history, it has not been able to do so without experiencing a change in its own proper domain of the textual. Panofsky's work has spawned various "iconologies" of the textual, and literary studies may find itself increasingly encroached upon by the visual realms it once dreamed of colonizing. Increasingly, the academic division of knowledge along traditional sensory, semiotic lines (verbal/visual; literature/art/communication) begins to seem obsolete, and advanced scholarship finds itself moving into strange border regions. The erosion of the boundary between art and literature is not merely a fraying of the "visual/verbal" seam, but an undermining of the barriers between popular and polite culture, fine art and kitsch or pornography. What is the relation, for instance, between Wendy Steiner's modernist literary/artistic interests, Panofsky's humanistic civility, and the possible "satanocracy" Steiner unfolds in the "pornographic" photographs of Robert Mapplethorpe. Even to label Mapplethorpe's photos as pornography (as Steiner does) is to weigh in decisively on one side of a debate about the proper textualizing of these images, how to *name* what is seen *in* them, what they are seen *as.* Both

the prosecution and the defense of these images must rely on a textual system in which labels like "pornography" and "art" must be stabilized by distinctions between "aesthetic disinterest" and "prurient interest," formal timelessness and ephemeral titillation. Yet, as Steiner shows, it is the perverse accomplishment of Mapplethorpe's images that they press with unerring precision on an exposed nerve that short-circuits all these distinctions. That is why no one except perhaps the defense lawyers are really happy with the verbal defense of Mapplethorpe's images, and yet within the terms of legal discourse no better account seems available. What "literature," or at least the writing associated with law and aesthetics, brings to the meaning of this body of visual images is, in short, a sense of inadequacy and ambivalence, a feeling that we do not yet know how to address these images.

Mapplethorpe's aestheticizing of pain and dangerous sexuality has its roots, not only in pornography, but in that vast aesthetic reservoir of kitsch motifs known as the sublime. This is the realm of negative visuality that Pascal associated with the fear of infinite regression into the abyss of imagination. It is also the tradition Marc Fumaroli associates with the post-Cartesian gulf between words and images and the failure of words Steiner finds in discussions of Mapplethorpe's images. Yet Cartesian visuality, as Philip Fisher demonstrates, has another textuality besides this self-cancelling stammering on the edge of the subliminal abyss. This is the discourse or "poetics" of *wonder.* Wonder might be described as the initiating moment in a process by which the gulf between the visual and the verbal is re-marked and overcome. It is that moment when we see something we do not understand, and yet are stricken neither with fear nor indifference, but with a curiosity that leads on to explanation. Fisher's examples include 1) the geometrical idea of proof, as analyzed by Plato and Descartes, with its interplay between the visual display of diagrams and symbols, and the sequential, discursive process of moving through the steps toward

a solution of the problem; 2) the appearance of striking natural phenomena like the rainbow, whose visual impact provokes a "history of explanations"; 3) the appearance of "new works of art . . . where no description yet exists."

Fisher's account of wonder opens up a middle region in the "all or nothing" relation of difference/identity between the visual and the verbal. Rejecting both the humanist rhetorical synthesis of word and image in memory, and the Pascalian "abyss of lenses" opened by imagination, Fisher notes Descartes' insistence on the visual as a distinct, concrete form of experience, a visuality that is neither remembered nor imagined. This "deep use of the visual" is activated, not only at the initial moment of wonder, the encounter with the strange or remarkable visual phenomenon, but within the steps of Cartesian procedures of thinking. "Just as in a chess game, he . . . wants to design a way to make sure that every necessary fact is visually present to the mind at the moment when this next step is being weighed." Inactive pieces are "removed from sight," just as in a mathematical proof, each step of the solution is isolated for visual display to prevent the mind from being distracted by the memory of previous steps. The interplay of the instantaneous visual gestalt and the sequential, discursive process thus becomes a kind of micro-technique of wonder, a method of scientific discovery.

The visual emerges in these essays, then, as a site of eloquence (Fumaroli's rhetorical emphasis), sublime inarticulacy (Steiner's Mapplethorpe), and discovery (Fisher's wonder). My own contribution might be described as an attempt to generalize the new institutional and technological conditions of the visible that have made it seem an inevitable topic for those interested in language, discourse, and textuality. Panofsky's "iconology," as the very name suggests, was already a reflection on the encounter of the verbal and visual, the logos and the icon. My argument is that a new formation called "visual culture" is emerging in the social sciences and humanities, a development that responds to the increasing

permeation of everyday life by forms of visual mediation and display. This new horizon of cultural studies is reconfiguring the disciplinary maps, the boundaries between different forms of expertise and pedagogy that have constituted academic knowledge. The seemingly wayward intrusions of literary scholars into visual aesthetics, the logic of scientific discovery, the nature of mathematic proof, the emotional effects of pornography, are from this point of view, not accidental phenomena, but necessary developments within a new paradigm. Similar developments could be traced, I argue, within disciplines like anthropology and art history, where the materiality of textual objects, the production of social space, and the vernacular understanding of "ordinary" visual experience, make the dialectics of word and image, the articulable and the visible, a central focus for research. If this argument is right, what literary and textual scholarship have to teach us about the visual arts is surely no greater than what the visual has to teach us about language. What the visual and the verbal have to teach each other is still both everything and nothing, and even more—or less—in the space between.

A Student of Rhetoric in the Field of Art History: from Curtius to Panofsky

MARC FUMAROLI

It is sometimes necessary to come back to the original and seminal texts. It is a principle of philological wisdom that may be welcome in a Panofsky symposium. I shall therefore begin this tribute to the Princeton master with two quotations from very famous texts, whose literal meaning is often obscured or forgotten. The first one is the main source of twentieth-century modern Art theory: Guillaume Apollinaire's *Les Peintres cubistes,* 1912. We read there: "Avant tout, les artistes sont des hommes qui veulent devenir inhumains. Ils cherchent péniblement les traces de l'inhumanité, traces que l'on ne rencontre nulle part dans la nature. Elles sont la vérité, et en dehors d'elle nous ne connaissons aucune réalité."[1]

This sort of sublime and compelling utterance, which has thrilled several generations of Europeans, has today lost its immediate power. But I want to quote, in chronological disorder, an even more famous text, dating back to 1637. It comes from Descartes' *Discours de la méthode:* "Ceux qui ont le raisonnement le plus fort, et qui digèrent le mieux leurs pensées afin de les rendre claires et intelligibles, peuvent toujours le mieux persuader ce qu'ils proposent, encore qu'ils ne parlassent que bas-breton et qu'ils n'eussent jamais appris de rhétorique."[2]

Both of these texts may be superposed. They have, each on their own level, a common summoning content. The *tabula rasa* presupposed by the Cartesian *Ego* is no less radical than the methodic *inhumanité* Apollinaire required of the creative self. Cartesian or Apollinarian modernity supposes the elimination of memory, and rhetorical invention founded upon a shared *sensus communis.* This superposition has abrasive potentialities which are today all around us. I dare to say that "we" (in a commonsensical meaning alien to the "nous" of Apollinaire in 1912) are more inclined to agree with the scholar who published *The History of Art as a Humanistic Discipline* in 1940, than the imprudent, if great poet, who invited artists to become *inhuman* before the two world wars had taken place!

Meaning in the Visual Arts reached the French public, in Bernard Teyssèdre's translation, in 1969. When I read it for the first time, then, I was struck by footnote 18. There Panofsky quoted at length a Letter to the Editor published in the *New Statesman and Nation* in June 1937. Written by an English Stalinist, this letter considered that it was morally sound that Stalin should fire professors who insisted on teaching Plato and the classics of Western philosophy from Russian universities. This sort of teaching, according to this moralist, was aimed at barring students from an immediate and fresh access to the study of Marxism, the modern scientific truth. Panofsky contented himself with the following brief comment: "Needless to say, the works of Plato and other philosophers also play an antifascist role in such circumstances, and Fascists too recognize this fact."

Twelve years earlier, the French translation of a book appeared which, in the field of literary studies, has had a decisive impact upon my generation: *European Literature and the Latin Middle*

Ages by Ernst Robert Curtius. In the preface to the 1953 (second) German edition Curtius had written: "This book doesn't content itself with scientific purposes; it attests a concern for maintaining Western civilization."

And furthermore, the great German Romanist Curtius quotes George Saintsbury's maxim: "Ancient without Modern is a stumbling block; Modern without Ancient is utter and irremediable foolishness."

Recently I happened to read the unpublished, pre-World War Two correspondence between Curtius and a French poetess, Catherine Pozzi. It throws an extraordinary light on the genesis of Curtius' masterwork, and its philosophical significance. Curtius, who did his best since 1918 to awaken the French from their own nationalist conceit, is just as indignant about the so-called Nazi national revolution in Germany. He describes with a stern lucidity the budding lawlessness of the new regime and its cynical violence. But he is a scholar, not a hero, and in 1933 he wrote:

> Je fais un cours sur la littérature latine du Moyen Age qui m'intéresse passionnément. . . . Je suis lassé de toute modernité. Les siècles obscurs me reposent. . . . Je me tapis dans mon coin. Le présent me dégoûte. Je ne désespère pas de l'avenir. Il nous apportera de nouvelles révélations de beauté et de bonté. Mais vivrai-je pour les voir? La beauté incréée ne vaut-elle pas mieux? Mais comment y atteindre?

> A spark disturbs our cloud.
> But at present I realize
> more the cloud than the spark.[3]

The reading of this correspondence makes clear what an immense labour of hope and love his *European Literature and the Latin Middle Ages,* started as a University course in 1928–1929, had been for him until the end of World War Two. When it appeared in German in 1948, dedicated posthumously to Aby Warburg and to the great Romanist Gustav Grober, it looked like a dove

above the ruined landscape of Europe. Harald Weinrich has made an excellent report about the reception of the book in Germany since 1948, and notably, the effect it had upon himself, in a Princeton lecture since published in *The Romantic Review* in 1978.[4] On several occasions in his correspondence with Catherine Pozzi, Curtius mentions their common friend James Joyce, then working on *Finnegan's Wake.* He says to his correspondent, that this new novel in order to be correctly understood, will require a full acquaintance with Giambattista Vico's *Scienza Nuova.* This first-hand information is retrospectively illuminating for me. When I first discovered Curtius' masterwork, in the early sixties, I was engaged in reading Vico's opening lecture, *On the Study Method of Our Time* (1708), where the Neapolitan humanist launches his first fierce attack against the excesses of Cartesianism, and defends the traditional primacy of rhetoric in the teachings of the humanities. Without being fully aware then of the issues at stake for us in these seventeenth-century debates, I was nevertheless struck by the correspondence between Vico's thesis and the role a philologist like Curtius had attributed in his masterwork to rhetoric as the framework for the correct reading and understanding of Western Literature. And when I at last had the opportunity to read Panofsky's *Meaning in the Visual Arts,* in the early seventies, I was ready to recognize the methodological kinship between the two German scholars—both admirers of Aby Warburg—who worked on both sides of the Atlantic since the thirties, and Vico, whose *Scienza Nuova* is after all the Italian seed of the French Romantic Renaissance from Ballanche to Michelet. Since then I am personally convinced that this alliance between the Warburg school, the best of German Roman philology, and the most able spokesman for the Ancients in the eighteenth century, has been the main spiritual home and guarantee against the dominant anti-humanist trends at work in the modernist poetics of Apollinaire, and in the Cartesian *Cogito* in our century. I should like to ponder this alliance today. There is more here, I think,

than a nostalgic and respectful look at the past and its scattered achievements: there I see a living moral and scientific force, a spark illuminating our own clouds.

So, before assessing how Panofsky's method may be fused, without losing its own sharpness, with the same field of reunified and enlarged humanities as Curtius' one, I should like to recall briefly the latter's originality and enduring contribution to literary studies. I hope that this suggestion of synthesis will be attuned to this symposium, and to our host's expectations, Professor Irving Lavin. I cannot forget that he has himself pointed out the same direction in his excellent Washington lecture: *The Art of Art History.*

Nineteenth-century positivism, the radical heir of Cartesianism, has split up academic literary studies and teaching into *res* and *verba*. *Res*, related to the outside world, was left to biographical and referential research; *verba*, related to the subjective talent of the author, was left to stylistic and philological scrutiny. This split reflected the Cartesian division between the knowing subject, related to positive science, and the sensitive or irrational subject. The task of the literary historian was therefore to separate the expression of the subjective self, from the objective facts to which this expression may be related. Rhetoric was rejected from literary studies on the double grounds of a formalist hindrance to free subjective expression, and of an archaic cloud obscuring scientific truth. Curtius took a contrary stance, following the path opened up by Norden and Dilthey. He discovered—or rediscovered—that the Cartesian division between *res* and *verba* was not applicable to the *res literaria*. In the rhetorical regime of literature, *res* and *verba*, invention and style, have in the Western past, as in the most self-conscious contemporary writer, James Joyce, been a *continuum*, not two ontologically different realms. *Res* were themselves *semina dicendi*, sentential meanings, which have their home in collective memory, their kernels in classical texts, and their structure in the "places" among which rhetorical-literary invention moves in order to find the proper contours of the thing it

has to say or write; order and style gave to the matter thus gathered the appropriate form in order to exert an effect upon the auditor or the hearer. It has been haughtily objected, notably by Edgar Mertner, that Curtius' *topos Forschung* does not conform technically to the rhetorical tradition, which distinguishes between *sedes argumentorum* and *loci propria*, as logical devices from *argumenta* and *loci communes*. I believe that Curtius' inventive notion of *topos* coincided with Vico's rhetorical *universali fantastici*. This "error" was therefore a bold reinterpretation, attuned to the experience of Christian literature, of Cicero's rhetoric, according to the views of Vico's *Scienza Nuova*. *Res, res literaria*, in this generous vision, are forms of human experience accumulated and ordered by a collective and proleptic memory; the "jurisprudence of humanity," according to Vico's definition of literature; it is in this storehouse of endurable forms that the inventive *ingenium* has to journey before finding the right response to new challenges, in prudent agreement with contemporary commonsense. This rhetorical artistic *ingenium* is not alienated from its natural and social embodiment like the Cartesian *raison* or the Apollinarian *génie*: it possesses mnemonic resources to shape itself into a human, that is tried out, form. Literature is the most complex and complete use of the rhetorical *ingenium*.

A friend and client of Carl-Gustav Jung, Curtius became a friend and admirer of Aby Warburg in 1928. In the winter of that year, he attended Warburg's famous lecture on the great project *Mnemosyne*, given at the Hertzian Library in Rome. Warburg died the following year. But Curtius, who had been an enthusiast about the project, never forgot this decisive meeting. It may even be argued that *European Literature*, as well as the study on the Muses published in 1939, were his response to the Warburg *Mnemosyne* project. Another response was Mario Praz' *Romantic Agony* and *Seventeenth-Century Bibliography of Emblem* books, two typically Warburgian explorations of complete systems of *topoi*. Curtius found in the *topoi*, re-used often with striking originality, by medieval and Renaissance writers,

the equivalent of Jung's archetypes, of Warburg's mythical places of memory, and of Vico's *universali fantastici,* a vast and relatively autonomous framework of symbolic forms where the poetical, philosophical, and social experience of the West has been treasured and constantly renewed since Antiquity. Even style, the persuasive new form that this mnemonic fount of accumulated wisdom has to receive in order to find new effectiveness, had its own objectivity and relative transcendence from circumstances and whims. Curtius enucleated in the medieval "longue durée," what Vico called the *corsi* and *ricorsi* of classic and mannerist styles, the first moulded on a few models of naturalness, the second eclectic and above all virtuous, up to the point of ostentatious artificiality. Why can this rhetorical tradition be called humanist? Curtius hated the insipid moralistic abuse of the word. He liked to say, in a Platonician outburst: Humanism is nothing if not an enthusiasm of love. He insisted that humanist literature deserved this name because founded on well-tried precedents crystallized in symbolic forms and classical texts, and confronting through them the past experience of humanity with the new contemporary one. Time transfigured in mnemonic places was the fundamental compass of European wisdom. Antihumanism, either in the Cartesian school of modernism, or in Apollinaire's, abstracted human reason or unreason from any reliance on the scale of wisdom summarized and symbolized in the literary tradition.

Far from being limited to medieval Latin Europe, this rhetorical approach, and the method of study it implies, could and, since Curtius, has been extended to Early Modern and Modern literature. If today we expect a renewal of literary studies in France, after the failure of different forms of scientism and positivism in the *sciences humaines,* it will obviously be along Curtian lines. I am happy to say that I work in perfect intellectual agreement with Curtius' best follower and commentator, Harald Weinrich, who is a German citizen, and my full-time colleague at the Collège de France.

Why does Art history, as exemplified by Panof-

sky's *Meaning in the Visual Arts,* relate so naturally to literary history as exemplified by Curtius' *European Literature and the Latin Middle Ages*? This question has haunted me since I first read Panofsky, and it is, I think a good question to raise today if we agree that, at the end of this century, when the modernist credo has become less credible, the future lies in a wise reunification and renewal of the field of humanities.

It is not so much, in my view, their common philological and critical exactness, nor their common use of definite concepts, like classic and mannerist, that sum up the kinship between Panofsky as Art Historian and Curtius as a historian of literature. It may be correctly assumed that this common ground of critical *acribia* was the general heritage of European and German Romance philology. What brings them so close, in spite of their specialized fields, visual images, and literary texts, is their common rupture with the positivist assumptions of modern history and philology. This positivist rationalism could easily be associated with nationalism, which is absent in the generous Romanist Curtius and is subtly derided in Panofsky's polemics, for example, when he stresses the indebtness of Albrecht Dürer's classicism to quattrocento Italian artists. The antipositivist stand in both Panofsky and Curtius is manifest above all in their common reliance on rhetorical notions in describing and understanding the working of the topical and inventive imagination. Both, before any theory, were magnificent performers of what they, as historians, tried to resurrect. Curtius, not only in his correspondence and essays, but in his scientific work as well, is a foremost and virtuous writer. Panofsky's own humanity combines moral insight and literary grace: he knows not only how to prove, but how to revive the contradictory human facets of his subjects, their natural evidence. In his magnificent piece about Suger, Panofsky exposes the elusive personality of the Abbot of Saint-Denis to the proof of the different places of human experience, character, temperament, national type, social *persona,* culture, taste; and his narrative synthesis, imbued with humour and sympathy,

equals the art of the best novelists by its power of bringing alive a superb example of balanced and ogival humanity. This is a scientific, literary, and moral portrait, this is history, the history of art, at their best at one and the same time. But Panofsky's rhetoric was inseparable, like the Classical and Renaissance rhetoric he understood as few others did, from the philosophical quest for truth. This philosophical background, far from being impaired by literary skills, is serenely asserted in the concluding chapter of *Meaning in the Visual Arts*. Cassirer's friend quotes Goethe and Kant, and locates himself in a tradition of thought that goes back to Cicero's New Academy. This tradition allows him to relate artistic and literary invention to the same memory. This memory, vital and ideal at the same time, harbours symbolic forms that may be mirrored in texts as well as in visual works, and generate plastic or literary eloquence. Humanistic emblematic language combined both regimes of expression. The memory-imagination is a store of "universals" which are not deduced from reality by discursive abstractions, but give form and meaning to nature through intuitive synthesis. This storehouse of mnemonic forms enables a mutual understanding and reciprocal stimulation between inventors of literary texts and inventors of artistic images. It implies, between literary texts and visual images, rhetorical operations such as transposition, interpretation, variation, and combination.

The description Panofsky gives of the genesis of Dürer's etchings or drawings does not rely only upon logical outward deductions: it reconstructs the poetic logic of imaginative invention, according to the four major rhetorical figures: metaphor, metonymy, catachresis, and irony-allegory. The last chapter of *Meaning* is the birthplace of Panofsky's major achievement as a philosopher-historian of art: *Idea*, a book that fortunately reached France much earlier than its belated translation, in 1983, led us to believe. The influence of this book on French literary studies cannot be overemphasized. It has merged with the influence of the Latinist and Romanist

Alain Michel, who has renewed Ciceronian studies along the same lines as Panofsky.[5]

Since the nineteenth century Cicero's major role in the Western tradition has been generally understated, notably in France. Cicero has been viewed as a rhetorician and a translator: he could not therefore be an original thinker. Michel has shown that the Ciceronian synthesis of rhetoric and philosophy, of Aristotelism and Platonism, was an original Roman achievement, and a fertile and enduring one. We may now trace, through Renaissance and Renascences, *corsi* and *ricorsi*, the seminal and central function of Cicero in the development of western thought, neo-Latin and vernacular literatures, and the arts. Vico's *Scienza Nuova* has been, at the height of the quarrel between Ancients and Moderns, the most powerful reassertor of this humanist tradition. What Panofsky's *Idea* revealed to us, was the pregnancy of this tradition and its fertility for European Renaissance Art. Aristotelian pragmatism combined with Platonic idealism, according to the liberal Ciceronian synthesis, allowed experience of the phenomenal world to be enlightened and shaped by proleptic forms, themselves inherited from the collective experience of Western humanity. These forms are not a logically deduced system, but a theater of memory where ingenious invention may find the matter and the models for new ideas, responding accordingly to time, person, and place, in the everchanging world of human history. Panofsky insisted upon the aesthetic flexibility of the Ciceronian idealist rhetoric, able to sustain classicism as well as mannerism. He showed convincingly its liberal and shifting fecundity, capable of thinking unity and multiplicity at the same time. But what emerges from Panofsky's *Idea*, as well as from recent French studies on rhetoric, is the common ground that this new understanding of Ciceronism offers for literary and artistic studies. Modern Art theory, in spite of its debt to a poet, Apollinaire, has insisted on the unbridgeable gulf between plastic and literary forms, between the visible and the word. A less systematic version of this view was not unknown to the rhetorical

tradition. It is a founding presupposed principle of Ciceronian rhetoric, borrowed from Plato and Aristotle, reasserted by Vico, that human experience ranges far beyond language, and that by its multifaceted and ingenious figures rhetorical invention essays what escapes unilateral words. The visual arts therefore offer another order of figures able to mean what is beyond the grasp of words. But artistic invention, unless it claims to be an *ex nihilo* creation, is no less rhetorical than that of the orator or the poet. The artist's invention draws upon a common mnemonic world of "places," and symbolic forms, mapping the multiple richness of human experience. And their style, through metaphorical transpositions, may be appreciated and assessed according to analogous standards. At least if we intend to reconstruct the meaning of literary or visual works, invented according to these rhetorical assumptions, we may and must learn again how a Rubens painting could resound at once with Seneca's Stoïc amble or Ovid's Epicurean savours. Panofsky's own literary learning and sensitivity played a major part in his reconstruction of the full intended meaning and aesthetic effects of works by Old Masters.

There are, in the Western tradition, departures from the main Ciceronian line. Panofsky, like Curtius, was perfectly aware of this. Curtius has devoted brilliant pages to the theological domination of twelfth- and thirteenth-century learning. Panofsky has devoted a major book on the scholastic background of the invention of the Gothic style. The Cartesian *Ego*, which claims to do away with rhetoric, has been the cornerstone of a new rationalist rhetoric, which has been immensely productive. The Rimbaldian *Je est un autre* is no less rhetorical, as Apollinaire's *Peintres cubistes*, a topical and tropical text, shows abundantly. But even these departures and ruptures can be measured and understood in relation to or in reaction against, the main liberal tradition of the West, which after all is best qualified to understand the whole gamut of human experience, since its central assumption is the infinite variety of humanity and its access to form in different times, places, and persons. It allows us, I think, to follow Panofsky and Cassirer in their reconstruction of the theological and devotional context of the arts, and even of art theory (the theology of images and symbols) *before* the birth of Aesthetics in the eighteenth century, as an independant chapter of philosophy and epistemology.

I apologize for this rather too allusive apologetics for a prospective *New Science* of which Panofsky and Curtius were the forerunners in this century. This New Science was budding in the thirties; it was scattered by the European and German tragedy; it was nevertheless never interrupted. It is this legacy, which has remained alive here in Princeton, in the Warburg Library in London, in Curtius' Germany, in Italy, and in France, that needs now, when we are entering at last the post-war period, to be reunited, rethought, re-energized. I would have preferred to content myself with listening to the apposite lecture that the greatest French Warburgian, the late André Chastel, should have delivered here today. I hope I have been faithful to the living and burgeoning legacy of these Masters.

Notes

1. Guillaume Apollinaire, "Sur la peinture," *Oeuvres en prose complètes*, vol. 2, Paris, Gallimard, Biblothèque de la Pléiade, 1991, p. 8.

2. René Descartes, *Discours de la méthode, Oeuvres*, Paris, Gallimard, Bibliothèque de la Pléiade, 1937, p. 202.

3. Correspondence inédite Ernst-Robert Curtius—Catherine Pozzi, à paraître dans les *Actes du Colloque Curtius*, publiés par l'Université de Mulhouse, sous la direction d'André Guyaux.

4. "Thirty years after Ernst-Robert Curtius' book, 'Europäisches Literatur und lateinisches Mittelalter,'" *Romanic Review* 69 (1978), pp. 261–278.

5. Among the works of Alain Michel, I shall content myself to quote *Les rapports de la Rhétorique et de la Philosophie dans l'oeuvre de Cicéron*, thèse publiée aux Presses Univesitaires de France, Paris, 1960, and *La Parole et la beauté*, Etudes anciennes, Les Belles Lettres, Paris, 1982.

The Poetics of Wonder

PHILIP FISHER

In his intriguing essay of 1954 on Galileo and aesthetics Panofsky speculated that an aesthetic commitment to the perfection of the circle and sphere in nature worked as a kind of perturbation causing Galileo to ignore Kepler's major discovery that the orbits of the planets were elliptical. Aesthetics, Panofsky wrote, "prevented him from differentiating between ideal form and mechanical action and thereby served to keep his theory of motion under the spell of circularity. . . . Just this geometricization of nature, or to put it another way this materialization of geometry — made it difficult for him to deny the privileged status of circularity in physics and astronomy while accepting it as an axiom of mathematics and aesthetics"(29).

Panofsky's small allegory of the relation of aesthetics to thought, including the claim that Galileo was "under the spell" of the circle, reaches back to the most powerful and traditional claim about the relation of the passions to thought, to rationality, and to the very idea of intelligibility itself. Behind Panofsky's argument lies the traditional claim that the passions, in Cicero's phrase are "perturbations" that impede thought. Cicero was denying the even stronger claim that the passions are *morbus* (diseases) when he made his more limited warning against them as perturbations. Anger and Fear were the two paradigmatic passions for Greek and Stoic thought and it is easy to see the force of Cicero's denigrating term with these two cases.

My own work on the passions, including that passion set first of all others by Descartes, the passion of wonder, *L'admiration,* explores at least

in this case, the opposite hypothesis: namely, that poetics and thought, aesthetic attention and the stages of problem solving are intimately and fruitfully connected. More strongly put, in the words of Socrates in Plato's *Theaetetus:* Philosophy begins in wonder; wonder (*thaumos*) is the only *arche* or origin of philosophy.

To grasp the force of Descartes' *L'admiration* we must first separate this high and rigorous idea of wonder from the demotic contamination of miracles, monsters, the merely odd or strange, and from those Baroque collections called *Wunderkabinetten,* from all, that is, that Descartes called the realm of astonishment. With this carefully isolated notion, Descartes' technical analysis of the relation of wonder to learning can lead us to the heart of three intriguing and related kinds of experience where thinking and aesthetics can be set in a nuanced relation.

First, the realm of the geometrical idea of proof, or thinking by steps, especially diagrams and symbolism set the act of thinking in relation to the visual. The example that I will examine later in this essay is the moment in the Platonic dialogue *Meno* in which a square with an area twice that of a given square is constructed.

Second the realm of aesthetic phenomena in nature, phenomena that strike us, attract our contemplation and thought, and lead us to the path by which they might be understood. Of this, the best example would be the history of explanations of the rainbow, a master case for the relation of pleasure, to wonder, to thought in the realm of natural phenomena.

Third, the essential case of how we think our

way through new works of art, especially those produced in our own time, unprecedented works that we—our generation—are the first to see and to be compelled to make intelligible. As artists "make it new" we find ourselves face to face with works where no description yet exists. The works are, we could say, pre-historical in the sense of being not yet endowed with a history, not yet set in a narrative of precedents and ancestors, not yet arranged in genres. For these works the very term "meaning" may be said to be a premature term or a clue that we are dealing with trivial, propagandistic art that has the fault of too obvious, too insistent meaning, or rather, not meaning at all but message. With new works we need the techniques of exploratory intelligibility, curiosity, and persistent attention led on by delight. In fact our relation to the unprecedented works of our own time mirrors what we must undertake with works from another culture that have been produced within an aesthetic of which we are ignorant, e.g., the Japanese work of nearly ten centuries ago *Tale of Genji* or the statues of Easter Island.

Both categories of works—those of our own time and those of remote cultures—are not cases where we can give a definitive reading, but they are works for which the partial, and partially incorrect, steps of explorative intelligibility provide, as in the example of the rainbow and the example from mathematics, something like a theory of attention, curiosity, and exploration intended by the phrase, "philosophy begins in wonder," or by the remarkable Cartesian claim, reversing, as he said, all earlier work in the field of the passions, that wonder (*L'admiration*), was the first and unique passion of a civilization defined not by war (where anger is the first of the passions), not by faith or its stoic alternative (where fear is the key passion), but by learning and by science. Here we must include within science the widest sphere in which we can be attentive, puzzled, thoughtful, and in the end satisfied.

Cartesian Wonder

As he begins to ask about the order and number of the passions in the second part of his book on the passions, Descartes arrives at the passion of wonder (*L'admiration*). "Whenever the first encounter with an object surprises us, and we judge it to be new or very different from what we knew before or even what we had supposed it to be, we are caused to wonder at it and are astonished (*étonnés*) at it. And since this can occur before we know whether this object is useful to us or not, it seems to me that wonder is the first of all the passions." It is first because it occurs before we know whether it is useful or harmful and therefore whether we love it or hate it, whether we feel desire or aversion for it. Each of these four responses depends on knowing whether the object is useful, good for us, or the opposite, harmful for us and therefore to be avoided or hated. Wonder occurs first. Unlike such passions as love and hate, desire and aversion, that occur in pairs, wonder has no opposite as Descartes goes on to observe. "It has no opposite because, if the object that presents itself has nothing in it that surprises us, we are not stirred by it and we consider it dispassionately."

We could say that since wondering at the object is what causes us to pause and notice it, the opposite is not some other kind of experience of it, but the state of not having an experience at all. Spinoza, who disagreed entirely with Descartes about wonder, and thought it an unimportant state, described wonder as a kind of stunned response to an object. We wonder at an object when in its presence the novelty of its features does not remind us of anything else. The mind does not move from this to that. And since for Spinoza such motion is the essence of the mind itself, wonder is a kind of defective state of the mind, because in wonder the mind is not really itself—it is not in motion. Wonder has a natural opposite for Spinoza in contempt. In the passion of contempt the mind in the face of an object is

so little held by its characteristics that at every moment it thinks of something else. Spinoza's pair of definitions of wonder and contempt, the one being the mind stalling in the presence of an object, breaking down, and the other, the mind in flight from it so that it never enters the association of thought which is the mind's chief activity, make clear the more encompassing and powerful definition of Descartes.

The idea of wonder is expanded by Descartes in a second definition: "Wonder is a sudden surprise of the soul that brings it about that the soul goes on to consider with attention the objects that seem rare and extraordinary to it." Its use to us is that it "makes us learn and retain in our memory things that until then we were ignorant of." The passion leads us to apply our understanding which our will engages in a particular attention and reflection. Those who lack a natural inclination to the passion of wonder are ordinarily very ignorant.

The capacity to feel wonder falls midway between, on the one side, a stupidity that never wonders because it never notices anything. Nothing strikes dull minds as interesting, genuinely fresh or new. This is the alternative of dullness. The second alternative is just the opposite: those who find everything amazing or striking, even the trivial differences of surface, monstrosity, oddness, and the merely strange. This addiction to marvels Descartes calls astonishment (*L'étonnement*—the French word is derived from the word for thunder, as our word thunder-struck, is) and it is the distinction between astonishment and wonder that saves the second for intellectual, scientific uses. To be dumbfounded by miracles or tricks, the bizarre and the odd is just as hostile to the process of wonder as the stupidity that finds nothing surprising. Astonishment is the pleasure we take in the face of the magician's tricks. It never leads to explanation or even to thought. Astonishment is a technique for the enjoyment of the state of not knowing how, or why.

In addition to the alternatives of a dullness in-capable of noticing the new and an astonishment that happens too commonly to be anything more than a confusion about the odd and the superficial, there remains a third alternative which Descartes does not consider. Hume and Hobbes, among many others, have claimed that fear is our fundamental response to suddenness and to the unexpected and the strange. Hume, for one, makes this claim in his section on the passions in his *Treatise of Human Nature*, writing that all unexpected or sudden experiences evoke either fear or a state of turbulence, motion from this to that in the mind, which we read as fear. For Descartes, the pleasure and interest that we take in the rare and unusual is part of a purely intellectual curiosity that seeks to make sense of whatever is new within experience by means of understanding. Wonder, curiosity, and successful explanation notice the world and then renormalize that world, by fitting the exceptional back into the fabric of the ordinary.

In a world not yet sufficiently familiar, the predictable response to the extraordinary is a feeling of alarm that the novelty will turn out to be dangerous to the fragile order that maintains the self. Cartesian wonder is a middle state made possible by a history of confidence and familiarity, an overcoming of randomness by the installation of an ordinary world and the surpassing of fear by pleasure as the response to the unexpected. The state of wonder that leads to curiosity and investigation is the beginning of philosophy and the first of the passions, but, for Descartes it is not the end.

Once the unexpected is questioned and found to be a varied form of the familiar, then wonder is over in this individual case. But just as wonder arises, leads to thought, and thought in its turn leads to an explanation that dispels wonder—as in the phrase "Oh, so *that's* what it is!"—so, too, in the larger frame of time the capacity to feel wonder, in general, undergoes an exhaustion.

That the unusual leads to pleasure rather than fear must be based on our general success with

explanation, our mastery of experience that lets us renormalize most situations. That we do not find ourselves for the most part defeated by the unusual, left baffled in an unresolvable way so that we "give up" and think of something else, provides the experiential base for the pleasure of the sudden, the unexpected, and the extraordinary. If each unprecedented thing should, in experience after experience of novelty, turn out to be life threatening, then fear would be the response to novelty that our actual experiences itself would bear out and train us to feel. Similarly, if what struck us at first as unusual were to remain, for the most part, permanently baffling, then, once again it would not be wonder but indifference that we would feel. Preferring not to be frustrated and have the weakness of our powers of explanation proved to us again and again we would write off the novel as the uninteresting after a long training by experience.

The fact of wonder is, then, itself a profound experiential result. Against fear it is possible precisely because the novel is not usually threatening. Against indifference, wonder has survived because on the whole wonder is a technique of curiosity, interest, and attempted explanation that has often paid off in renormalizing the extraordinary about which we begin by feeling wonder. In *Hamlet* the appearance of the ghost of the dead king leads Horatio to say "O day and night, but this is wondrous strange!" (I.v.164). The unexpected he calls by both its names: wondrous and strange. At the same time he reminds us of the ordinary and familiar: day and night. Hamlet answers him with a remarkable line that picks up Horatio's phrase "wondrous strange." He says "And therefore as a stranger give it welcome." The moment of wonder or the appearance of a stranger are the classic opportunity for fear. Yet just as hospitality makes the stranger welcome and testifies to the empirical experience that on the whole this has not proved disastrous, so too the experience of wonder welcomes the strange as a stranger is welcomed. It too benefits from a history of experiences of too frequent fear that in

the end proved baseless. Wonder and hospitality in Hamlet's phrase, rely on the harmlessness of the world, in most of the unexpected ways we find it.

Wonder is the hospitality of the mind or soul to newness, but only where the security of the self has already been secured so deeply that security, a feeling implying the reality of fear, but its suspension, can itself be forgotten. The privileged position of Descartes' generation within a truly new visual world of Galileo's telescope and Kepler's laws did not uniformly produce a renaissance of wonder, a uniquely situated generation for the speeding up of explanation and speculation. Although the balance between fear and pleasure in the face of the unknown is an empirical fact in that it depends on a history of intellectual success and an atmosphere of almost cosmic, as opposed to social peace, that general balance does not translate for every person living at a time or within a context of confidence in knowledge into an interior balance of the same kind. In confident times there are still many apocalyptic thinkers and within the general intellectual conditions of wonder that are one of the powerful features of seventeenth-century science and philosophy, the exceptions can, from their side, make clear just what the structure of wonder itself was, but now by seeing it from the dark side of the same mirror.

Pascal's Alternative: Imagination, Terror, Abyss

Descartes' regrounding of the passions in wonder has, in the work of his near contemporary Pascal (d.1670), its antiphonal voice. Pascal, whose greatness as a mathematician equals that of Descartes and whose scientific consciousness spans the years from Galileo to the early work of Newton, calls up the same experiences that in Descartes lead to the aesthetics of wonder with its pleasure and then to explanation, but subjects those experiences to a religious capture that

is unmistakably part of an aesthetics of fear. Pascal's single most often quoted saying contemplates the universe of Kepler, Galileo, and Newton, but with a newly intensified and justified fear: "Le silence éternel de ces espaces infinis m'effraie" (The eternal silence of these infinite spaces terrifies me). In Pascal, the word *effraie* with its active violence—to frighten, to terrify—works in a matrix with the Cartesian words for wonder (*L'admiration*), marvels (*merveilles*) and astonishment (*L'étonnement*). The very things that in Descartes would fall into one or another of these two categories of wonder or astonishment with their opposite intellectual and moral consequences shift in Pascal into this more important third term, the terrifying. What Descartes calls a wonder, Pascal will often call an abyss (*une abîme*).

In Pascal's longest and most stunning picture of the human condition he places man between two infinities, the infinitely large of the universe in the face of which man is insignificant, and the infinitely small, in the face of which he is a monster. Each of these two infinities would usually call up a catalogue of wonders, of pleasures, of astonishments, but for Pascal, each is an abyss. In his invocation of the minute, Pascal seems at first to be leading toward an encomium—the rhetoric of wonder—but by prolonging and extending the contemplation he leans us over his abyss. In his evocation all of the key words are set together for his aesthetics of terror.

But to offer him another prodigy (*prodige*) equally astonishing (*étonnant*), let him look into the tiniest things he knows. Let a mite show him in its minute body incomparably more minute parts, legs with joints, veins in the legs, blood in the veins, humours in the blood, drops in the humours, vapours in the drops: let him divide these things still further until he has exhausted his powers of imagination, and let the last thing he comes down to now be the subject of our discourse. He will think perhaps that this is the ultimate minuteness in nature. I want to show him a new abyss (*abîme*). I want to depict him not only the visible universe, but all the conceivable immensity of nature enclosed in this minute atom. Let him see there an infinity of universes each with its firmament, its planets, its earth, in the same proportion as in the visible world, and on the earth animals, and finally mites, in which he will find again the same results as the first; and finding the same thing yet again in the others without end or respite, he will be lost in such wonders (*ces merveilles*), as astounding (*étonnantes*) in their minuteness as others in their amplitude. For who will not marvel (*qui n'admirera*) that our body, a moment ago imperceptible in the bosom of the whole, should now be a collossus (*une collosse*), a world, or rather a whole, compared to the nothingness (*néant*) beyond our reach? Anyone who considers himself in this way will be terrified at himself (*s'effraiera de soi-même*) and seeing his mass as given him by nature, supporting him between these two abysses (*ces deux abîmes*) of infinity and nothingness will tremble at these marvels (*ces merveilles*).

Pascal's images are meant to pulverize that classically proud boast of humanism: man is the measure of all things. Man is the creature who, terrified of his measure when set within the measures of nature, becomes, in the end, terrified not of nature, but of himself, the creature between two abysses. Within Pascal's thought we pass subtly from the seen to the imagined, from the visual to the imaginary extended by simple extrapolation. The mite's leg, bloodstream, and humors are all potentially visible, but what follows is only imagined, and it is the imagination rather than sight—that locus of wonder for Descartes—that swamps the world of the visible by sinking it into the endless extension that the imagination proposes to the visible. Pascal is anti-scientific to the extent that the imaginary comes to give its tone to the visible rather than the visible to the imagin-

ary. The blood circulating in the leg of the mite is a tender image not a terrifying one. It is only the dizzying vortex of worlds within worlds that can later capture and efface our first tender response to the actual part of this scene.

Pascal makes clear the path by which the very discoveries of the new science could be reabsorbed back within the religious sensibility and used against themselves and he does so by casually using the visible as just one short segment of inner vision, that is, of what we can imagine.

Pascal's is an abyss of lenses. The new microscope of van Leevwenhoek and the new telescope of Galileo reawakened a theological horror of these infinities which, instead of exhilaration and curiosity, unleash profound depression and terror. Only the geology of the nineteenth century in combination with Darwinian thought, which set man within an infinity of time and development, could have added a third insult to Pascalian nature equal to the telescope and the microscope. But here too Pascal slips from the physical to the imaginary. Geological time, for example, asks us to set our history within some millions of years and not the 6,000 years of the Biblical story, but these millions of years are not infinity at all. In fact, the exact time of cosmology is decisive in understanding the size of the universe. The microscope revealed ever smaller mites, bacteria, and finally viruses and proteins, but it did not reveal infinite regress, worlds within worlds, in a dizzy spiral. The scales of the universe were suddenly expanded, but Pascal willfully merges the very large into the infinite, the very small into a second infinite, then calls each an abyss.

The words of Descartes, *L'admiration* and *L'étonnant* are, by using the same technique, sunk within a framework of human powerlessness and insignificance. The very appeal of wonder to human powers of discovery and pleasure in being able to contemplate the marvelous are, in Pascal, neutralized or poisoned by the more powerful theological vocabulary. Each infinite turns itself into an abyss. Each subject of wonder like the blood in the mite's leg, falls into an infinite regression of a dizzy and almost nauseating

kind. The marvel gives up and puts on the black suit of the terrifying.

In Pascal the last stand of the contemplative aesthetics of fear takes place within the mathematical and scientific new world of the seventeenth century itself, not opposite it in the contemplation of demons or the eternal fires of hell, those more familiar topics of theological terror. What kind of an aesthetics does Pascal set in front of us? The crowding together of extremities is well known as a central device of Baroque art, as is the use of the infinite. In the Baroque aesthetics of strong effects the lightest and the darkest sections of a work are crowded next to one another, while vast spaces are implied between things. Round domes or ceilings are painted to seem to disappear into skies and infinite regress. Pascals image and Baroque aesthetics are two elements within the Counter-Reformation's terrorism directed at the new scientific spirit.

In Pascal Baroque aesthetics joins forces with the Inquisition to set up an inner reign of terror (man *terrified at himself* in Pascal's stunning phrase) to re-humble man and win him back for a template of fear. Descartes' dismissal of fear in his book on the passions is equal in importance to his vision that the alternative to wonder is anger (the irascible). Descartes calls fear "a coldness, a perturbation and astonishment (*étonnement*) of the soul which takes from it the power of resisting the evils which it thinks lie at hand." The coldness is the opposite to the warmth not only of delight and wonder but of the very different heat of anger. That Descartes calls fear an astonishment takes account of the fact that like wonder, fear is linked to sudden and surprising experiences. Here we see the deeper reason for his repudiation of astonishment (*l'étonnement*). It is not only that astonishment is an excitement in the superficial differences, the odd and the monstrous, and that it has no drive towards questioning and learning. Instead it is its deep connection to fear and to a conception of human nature grounded in fear that sets astonishment at the opposite moral pole from wonder in Descartes' thought.

Pascal whose primary word is always aston-

ishment rather than wonder works through the same materials as Kepler, Descartes, and Newton. Harvey's masterpiece on the circulation of the blood stands behind his vision of the blood in the mite's leg. Pascal reshapes these materials to deform their psychological consequences. In Pascal a whole century's excitement at being the first human beings to look through microscopes and telescopes (a thrill clearly felt in those passages in the work of Pascal's equally religious contemporary, the Puritan John Milton, when he describes in *Paradise Lost* looking through the telescope of Galileo) chills to depression and to a feeling of insignificance and human frailty. This frailty is the preparatory step to a total surrender of the spirit to religious discipline, to Biblical truth, and to reliance purely on God. It is a only a prelude to the collapse and then surrender that led Pascal after his mystical experience that took place, he notes almost like a laboratory scientist, between 10:30 and 12:30 on the night of November 23, 1654 which led to his entry into the disciplined Jansenist community of Port Royal and his *"renunciation totale et douce,"* his total and sweet renunciation and his *"soumission totale a Jesus Christ et a mon directeur,"* his total submission to Jesus Christ and to my spiritual director. The Pascalian is not an alternative comportment of the self but a step on the way to its collapse and the sweeness of its abolition.

Alongside the strongest version of the intellectual design of fear, as an alternative to Cartesian wonder, in the atmosphere of the new scientific world of the telescope and the microscope, this contrast between Descartes and Pascal brings into a new importance what we might call the protective side of the visual within thought. Pascal's turn depends on sliding from the visual to the imagined, by means of repetition and extrapolation without end. Mechanical repetition and extension are two of the essential poetic features of the thought structures of paranoia and obsession, those two mad versions of an intellectual science driven by fear. The imagination is a projective power, operating in just those realms where nothing is known or can be known.

Wonder is a response to the visible world and by insisting that the main locus of thought is the visible world, the part played by the projective imagination disappears in our work of installing a normal world. Because aesthetics is also a science of the sensory, that is above all of the visible. Aesthetics and the scientific (or Cartesian) use of the passion of wonder within experiences of the extraordinary unite in sheltering themselves within what we have to now see as the protection of the visible. The imaginary, as we meet it in Pascal, although it seems to flourish within the same materials and even overlaps at first with the same range of feelings (the astonishing, the marvelous, the wonderful) differs fundamentally in ways that we can see by noticing that the imaginary has nothing to do with the extraordinary. The imaginary is quite simply free of the whole lawful play between the ordinary and the extraordinary. To put it even more strongly, the imaginary is also in its nature all that can never be experienced. The imaginary like the Wittgensteinian ordinary, but in the opposite direction, is exactly all that is not experience. The two realms of the ordinary and the imaginary define from opposite sides of negation just what our notion of having an experience is about and how that experience is connected with noticing something or wondering at it.

With this point we circle back to the essential definition of wonder with which we began: a sudden experience of an extraordinary object that produces delight. Descartes places wonder first among the passions because it is the origin of intellectual life. To notice a phenomenon, to pause in thought before it, and to link it by explanation into the fabric of the ordinary: this is the essence of science in the widest meaning of the term.

Wonder and Learning

The claims made for wonder in Descartes's analysis mark out an epoch in the description of human nature. He sets wonder first because it is by means of wonder that man learns. To profit from

wonder man cannot be either inattentive or passive, since in these cases he would not notice differences, nor can he feel himself to be living in a world that is fragmented, anarchic, and unpredictable. The premise of wonder is that we live in a lawful world, one in which the laws of nature, no less than the extraordinary or singular events that seem at first exceptions to the laws and regularity of nature, provide pleasure. The experiential world in which wonder takes place cannot be made up of unordered, singular patches of experience. We wonder at that which is a momentary surprise within a pattern that we feel confident that we know. It is *extra* ordinary, the unexpected. For there to be anything that can be called "unexpected" there must first be the expected. In other words, years or even centuries of intellectual work must already have taken place in a certain direction before there can be a reality that is viewed as ordinary and expected. Only this makes possible the rare and privileged moment, against this normative frame, when the *extra* ordinary can take place and evoke wonder. This is what we mean by the difficulty of seeing, in the sense of noticing, the everyday, the customary, the obvious. This is the intellectual or scientific "ordinary" which makes up a second layer over and above the everyday world of houses, shoes, appointments, and politics. Wonder is the middle condition between an unawakened intellect and a systematic knowledge so complete that there no longer exists anything unexpected.

In Descartes we can now see that he has displaced anger and desire as the first of the passions because, like Aristotle, he defines man as a being whose first delight is knowledge. Descartes preserves this distinction between use and pure delight in knowing by claiming that it is the passion of wonder that distinguishes man from all other living things. Animals act and even think, but they do so in the light of interests that draw them towards the objects of their interests in desire and away from the objects hostile to their interests in aversion. Wonder, which occurs outside and prior to any knowledge about whether the object falls within the realm of desire or aversion, marks off human experience as differentiated by this phase that is not superior to interest—disinterested—but prior in time to interest. This is the second meaning of saying that wonder is the *first* of the passions.

Descartes' wonder has, like Plato's anger and spirit, a natural affinity to youth with its confidence and freshness. Youth is inevitably the stage of life in which even essential and prominent experiences are novel. The mistaken prolonging of wonder that Descartes calls blind curiosity, resting as it does in that trivial or marginal novelty of surface that is a constant feature of reality, amounts to the attempt of middle age to retain what was one of the natural features of youth.

The scientific pathos of the liquidation of wonder by explanation runs like a thread through Descartes work. His book with its many warnings against blind curiosity or astonishment—these false twins of wonder—expresses caution and even fear of wonder in its everyday forms. He asks us to contemplate the beginning and the end of the string of thought, the "Ah!" of wonder and the "Oh, so *that's* what it is!" of successful explanation, where the word "that" reminds us that to explain is to recognize something that we already know underneath the apparently extraordinary. Explanation re-normalizes temporary or apparently extraordinary anomalies, bringing them back into the ordinary world.

The pathos comes form leaving out the middle, or the process of thought itself to contemplate only the moment of fixing on a problem, and the final moment of solution. And it leaves out the question of whether there ever is a final moment of complete explanation. With Descartes and earlier with Plato, it is precisely in this middle that the method of science meets and thrives by means of the charge of wonder. We notice by means of an experience of wonder brought on by the sudden, unexpected appearance of an object, but within the process of thought it is against the background of frustration and of effort in directions that have proven fruitless, against the errors

that are the real point of "trial and error" that the surprise of finally "getting it" takes place.

One and Only One Step

The first major work of Descartes was his *Regulae* or *Rules for the Direction of the Intellect,* and in this manual where he worked out the rules for the orderly and secure work of the mind we can see a clear relation to the later description of wonder in his final published work. What the rules seek to do is to create a situation where only one step of the problem stands before the mind, isolated from all irrelevant details and distinct as a step from any earlier or later steps of the same chain of reasoning. Descartes wants to make it possible, as in a chess game, to have only a single move to make. Just as in a chess game, he also wants to design a way to make sure that every necessary fact is visually present to the mind at the moment when this next step is being weighed and that, as in chess, pieces that have been made inactive have been removed from sight. On the chess board, the player's glance can take in every piece, its position and its possibilities. At the same time, nothing is on the board that is not part of the situation at the moment, that is, the game itself.

Many of Descartes' rules are designed to create for the mind, in the process of thinking, exactly this drama of thought: one and only one move, the presence before the mind of every relevant fact, and the elimination of every irrelevant detail. For Descartes a key means to this chessboard situation is the use of diagrams and the use of algebraic symbolism. In the diagram every detail is present to the eye at once. What is eliminated is the use of memory within thought, replaced by a deep use of the visual. Descartes mistrusts the memory as a place to store all the facts that we need for this one step of thought because one or another might drop out of the mind at a crucial moment. But even more, if the memory is used, the mind also has to keep re-

viewing. In passing one by one over the facts stored in the memory, it distracts itself from looking at the single, carefully articulated gap that it has to leap.

The diagram or equation brings the simultaneity of the visual sense into play and suppresses the memory. This was, as we saw in the very beginning of the discussion of wonder, one of the key details of wonder. Here again there is a certain antagonism to memory because it involves both repetition and recognition. Descartes insists on the crowded, simultaneous space of a diagram or equation over against reliance on the movement between memory and thinking that all work without diagrams involves. Within the diagram the details are pressed as close together as possible, almost as though they were already solved. But how does a diagram or equation articulate exactly the state of the problem up to this step or gap where we now find ourselves?

Descartes himself, in the *Rules,* uses a problem applying the Pythagorean theorem to demonstrate how symbolic notation isolates one and only one step within a process of thought. We usually think of the Pythagorean theorem in its overall form: $c^2 = a^2 + b^2$ which expresses visually the whole process, but no individual step within it; the square of the hypotenuse is equal to the sum of the squares of the other two sides. The equation makes possible a number of facts or problems: $a^2 = c^2 - b^2$ or $b = \sqrt{c^2 - a^2}$ as well as a number of others, each of which would define one problem in the family of problems possible in the more encompassing equation. It is important to notice that the general form in which we remember the equation—$c^2 = a^2 + b^2$—is a form that does not define any goal that we would usually be trying to reach. We would almost never be trying to learn c^2.

Descartes' diagram defines the visual situation at the outset of the problem in which all that is known is represented, along with what remains unknown. A parsimony of symbols requires that we do not label or invent references for details of the drawing that are not under consideration; for

example, a letter d to represent the sum of the two sides a and b, or an angle ø to represent the angle between sides a and b. These facts exist, but the problem does not concern them. The essence of symbolism (algebra) consists in symbols referring to actual discrete entities within the problem, and that there be no more symbols than the problem requires. Here is the literal meaning of Descartes' larger program of clear and distinct ideas. The diagram for the problem of finding the length of the third side c is as follows.

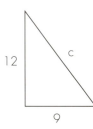

Within the act of thinking itself it is neither this diagram of the problem as a whole, nor the general formula that is important: each is a summary or reminder of the general case. In using the Pythagorean theorem to find the length of the third side of a triangle whose first and second sides are of length 9 and 12, Descartes observes that a mathematician would write: $\sqrt{225}$ meaning that what must be found, the length of the third side, is the square root of the number gotten by adding together the squares of the other two sides. Obviously, this is not the first step. In fact, it is the next to the last one. It is, however, a statement of one and only one step of the problem because only one operation—that of taking a square root—is proposed. The formulaic element $\sqrt{225}$ is an instruction to take that step and the number is given on which the operation will take place. Many earlier steps have already taken place such as squaring the number 9, squaring the number 12, and then adding together the two results (81 and 144) to get the number 225 on which the next operation will take place. Each step has its own representative diagram or equation in which only the act to be done next is made

visible. Each representation is a highly charged moment of instruction. In this cast the steps would be:

1. a
2. a^2
3. b
4. b^2
5. $a^2 + b^2$
6. $\sqrt{a^2 + b^2}$

The two versions of the equation: $c^2 = a^2 + b^2$ and $c = \sqrt{a^2 + b^2}$ actually describe two different steps or moments within the process of thought. Descartes points out that to see step number 6 clearly the equation should be written $\sqrt{81 + 144}$ and not $\sqrt{225}$. The second equation fails to keep distinct for the mind the actual things represented. The number 81 represents the square of 9 or, geometrically, the square with a side 9. The number 144 represents the square of 12 in the same way. But the number 225 actually represents nothing at this point; it cannot be attached to any part of the diagram. As the sum of two squares it is not anything literal within the terms of the problem. A diagram must represent not only a single moment of the action of thought, it must also preserve the distinct parts and use no symbols that fail to refer to a distinct part. At the moment after adding $a^2 + b^2$ we do not use an arbitrary letter k to represent this quantity so as to say, now take the square root of that sum (which I am calling for convenience k). We cannot write the step as \sqrt{k}. But this is just what we seem to be doing in writing $\sqrt{225}$, because both k and 225 are transitional composites that have no reference in the problem itself. We could not put our letter k anywhere on the diagram. The diagram keeps symbolism honest in inventing only the minimal number of algebraic symbols—a, b, c in this case—and in controlling our own awareness of those moments when something has been created in the process of thought that no longer refers. Thus, the step must be represented algebraically as $\sqrt{a^2 + b^2}$.

What is Descartes trying to isolate by means of these rules in which symbolism and, above all,

the force of visual simultaneity takes over to control what we know to be a temporal problem—the steps of a proof? What we are looking at here in this sample case is the motivation behind Descartes' greatest accomplishment, his Analytic Geometry which brought algebraic equations into geometric, visual representation by means of what we still today call Cartesian co-ordinates, the graphing system for solving equations in more than one unknown.

By means of the interplay between symbolism and the visual Descartes breaks down any complex problem into just those steps that can be leaped over in a single intuitive moment of seeing. Each one leads to a moment of exclamation: "There!" or "Ah!" or "Now I see it!" The intuition is clear, distinct, and certain. The rules, diagrams, and equations set up the stage for the simplicity and confidence of this instantaneous act of "seeing." We complete the step and move on to arrange the next one. Each step of thought has the potential to leave us stalled in front of it saying, "I can't get it!" "I don't see what happens." "I can't see it." This experience of duration, of not getting it is the background to the sudden moment of saying, "I get it!"

Each of these moments is a moment of wonder—a pure experience of one and only one new thing. And this experience of wonder occurs as the aftermath of the duration within which we say, "I just can't see it!" Often at the moment of getting it, we smile. Each of the passions has its own instantaneous physical act—the tears of grief, the red face of anger, the pallor or trembling of fear. Of these, it is the smile of wonder that often appears on the faces of the Greek statues of the gods.

For Descartes a diagram clears away the clutter of details in order to structure those that remain so that this and only this one thing stands ready for thought. What is important for Descartes in traditional Euclidean geometry and in arithmetic is that these are the only disciplines that had ever become clear about just what constituted one and only one step. If we look at a

proof in Euclid and see that it has 16 steps, we might ask: Why aren't there 7 steps or 91? Why is a step just this much and not smaller or larger? In philosophy this question had never been solved, although the medieval use of the syllogism was one attempt to do so. In the dialogues of Plato, Socratic conversation is also an attempt to isolate, by means of the question and answer style, this problem of one and only one step of thought. Only in mathematical proof had the unmistakable clarity about what constituted a complete and yet distinct step of thought been secured. It is for this reason that both Newton's *Principia Mathematica* and Spinoza's *Ethics* were written in the form of geometric proofs.

Descartes recommends practicing thought by going over small problems like this one of the third side of a triangle so as to learn to recognize the feeling of certainty. Even though we are not actually doing any new thinking in solving a problem within a formula that already exists for the general case, we can observe in a unique way within these already given problems the fact of what one step looks like, what adequate symbolism is at any moment, what the distinction between relevant and irrelevant details feels like, but above all, what the feeling of "getting it" of crossing the small gap of the unknown is like. We can watch ourselves learn in this small controlled repetition of thought. This is the meaning of Cartesian certainty and its link to clear and distinct ideas.

So far we have seen what we could call a "wonder-like" experience in the small steps of the proof, as Descartes has set it up by his method. Because we move around in what is already known, there is no true example of discovery here. In science or mathematics each new person, doing a problem that is new to him or to her, is recreating the moment at which the first person saw this relation. Wonder is a relative fact. It concerns what is new to me, what is my first experience of a Chinese landscape painting, or of a mathematical proof, or of playing through the moves of a chess masterpiece. This is one

reason why the kind of practice that Descartes suggests lets us at least recognize discovery and certainty when we do reach them ourselves. Plato in the dialogue *Meno* set out to show actual discovery itself, a moment of learning which is also a moment of wonder. By looking carefully at this example we can see the full meaning of the poetics of thought, much of which is now clear as a result of this analysis of Descartes.

Plato's *Meno* and Learning By Wonder

In Descartes, we follow a set of steps that have the disadvantage that every step goes in the right direction. The proof is unalloyed progress. As a result we see no representation at all of trial and error which we know make up a decisive part in learning and discovery. By contrast, in Plato's *Meno*, it is precisely the process of making mistakes as parts of the search for an answer that we find before us, mixed with confusion, false starts, and backtracking, all of which prepare for the moment of being "lost in wonder" that makes the answer a flash of discovery. The Platonic wondering is also a wandering—an erring—that more accurately represents the process of thinking than the display that Descartes acknowledges to be a perfect exercise on which we practice a psychology that we will have to learn to apply elsewhere.

The pages of the *Meno* in which Socrates elicits from an untaught boy the proof of a complex and unexpected theorem in geometry are the best demonstration that we have of the process of reasoning and learning. By the end of the demonstration the boy knows one clear thing that he did not know before, or, to use Plato's vocabulary, one thing that he did not know that he knew before. He also knows how to do something. In this case knowing something is less important than knowing how to do a certain procedure. Furthermore, once the boy has learned how to double the area of a square he has also learned how to teach this to anyone else. He has

not learned a formula, but has participated in a discovery that puts him in possession of the full internal logic of what it is that he knows and just what the order of the steps must be. In terms of the distinction Descartes made about his own work on the rainbow, the order of discovery and the order of exposition are here the same.

At the heart of this short instance of learning is a moment of wonder composed of intellectual surprise, the unexpected and the pleasurable. It is also a moment that once again depends on the power of the visual—a diagram—to make possible, because of the simultaneity of many details before the eyes and mind, a flash of insight that yields the solution. Because the learning that we see in the *Meno* is a discovery, it is also a model for thought in general. This Descartes' example of applying an already known general case—such as the Pythagorean Theorem—to a local instance can never be.

Socrates sets in front of the boy a diagram of a square. Each side has a length of 2. The area of the square is therefore 4. The question is: how can the area be doubled? How can we get from this square to a second square with an area of 8? The structure of the problem is significant. There is an explicit question to which an answer must be found. We have in front of us all of the elements of the question—a square, the length of a side that composes it, the notion of doubling. Only by working with and transposing these already given elements will the answer appear. Because diagrams play a key part in thinking within Socrates' example and within the aesthetics of thought, I will reproduce the diagram for each stage of the process. First we have the known square.

Square side 2 Area 4

The boy's first attempts will exploit the most obvious line of thought. Since we want to double

the area, we must double the length of the side. He tries the answer "4." When we draw the new square we find that it has an area of 16, not eight. The first try was an error, but a rational error, quite different from a guess of "7" or "613" mere random numbers that would show that he wasn't thinking at all.

Square side 4 Area 16

By comparing his new area of 16 to the desired goal 8, the boy sees that he has overshot the mark, but in a very significant way. He has gone exactly twice as far as he wanted. His first mistake preserves the "doubling" arrangement, but he doubled the answer rather than the area. His second answer is, then, with great intelligence, "3." Since his first answer took him twice as far as he wanted to go, he now thinks that if he goes halfway between 2 and 4, he will end up halfway between the areas of 4 and 16. His guess of 3 give a third square, now with an area of 9.

Square side 3 Area 9

After his first wrong answer he did not turn back to the starting point, erasing the mistake from the page or from his mind. The error itself exists and is part of the material of the problem as he now sees it. His solution will, in the end be the outcome of his history of errors. Even more

important, we cannot unthink. His relation to the problem is no longer an innocent one. Now he has this error to carry around with him. He looks at the wrong answer, comparing it to the answer he wants, and cleverly chooses halfway between, as though he knew the series $2^1, 2^2, 2^3, 2^4$. . . or 1, 4, 8, 16, sensing intuitively that 8 lies between 4 and 16 in the series of powers of 2. In this series 8 is the cube of 2, the side is the exponent.

Now the boy has reached perplexity. In Socratic terms the boy now, at last, knows that he does not know. This helplessness is also part of the process. He has exhausted every obvious, reasonable step in terms of the given words and in terms of what he already knows. But now Socrates returns to the first mistake—the square of 16 that is twice as large as we want. He superimposes the first square, with a side of 2, and we see that we have four of these squares.

Four squares of 2

Now he asks the decisive question: how might we get half of this square that would still be a square. If we drew a line across the middle we would have half, that is an area of 8, but it would be a rectangle.

Two Rectangular Areas of 8

If we drew a line from corner to corner it would be an area of 8, but it would be a triangle.

Two Triangular Areas of 8

Socrates then draws the line that solves the problem. He draws the diagonals of each of the four little squares.

One Square of area 8

Almost by miracle we find, tilted on its side the square that must be half of the area of the whole because it is half of the first small square, plus half of the second, plus half of the third, plus half of the fourth. This ingenious re-picturing of the problem is the moment of wonder. Instead of seeking to double something, he finds half of something. He reverses the problem. At the same time, he rotates the square in space. All earlier trials had kept the lines vertical and horizontal. It is important to notice that it was in making the first mistake that the boy gave us this square that was too large, but that led, once we contemplated it a certain way, the solution to the problem. The mistake had to be made.

Next, the ingenuity or cleverness of the unexpected solution also arises out of a persistent set of trials and errors with the question of how to cut the large square in half. The second answer, the diagonal line that gave us two triangles, actually only needed to be used in an unexpected way to get the new square. Within these trials and errors we see, that after a certain amount of time we have put in play many things that were never in the original diagram—the diagonal line or lines, the square made up of smaller squares. The solution upsets the mental categories with which we began. We were trying to find something larger than the first square, but could only do it by finding something smaller than a square that was never given in the statement of the problem. The two areas of 4 and 8 can only be connected by means of a third, imaginary area of 16, that was never included in the statement of the problem, but to which they are both in a clear relation even while always remaining in an obscure relation to one another.

The problem, we might say is solved by sinking both the problem and the solution into a third thing of which they are each a part. This submerged relation is clear in the final diagram. The surprise and unexpected direction of the solution —the rotation of the square, 45 degrees from where we expected to see it—the fact that the solution was found in the relation "one half" rather than in the relation "double" with which we began; and the fact that it was the process of finding out that one was wrong (creating the square of 16) while not letting go of the error: these are the components that are a remarkable miniature version of thought itself, the poetics of thought. All poetics involves making an artifact. Here it is the imaginary object—the artifact of the square of 16, divided in four by small squares with their diagonals, divided in fact into eight triangles, four of which also happen to make up the needed square—that is the invented or made thing within the problem.

The moment of wonder is only important in that it takes place within and by means of a process that can be stated as a sequence of precise single steps of thought, a series of attempts, distinct acts of construction, in which each time one

new thing is done. At each moment it is clear just why one would do this step next, why this would be the next attempt. At each moment we could say out loud—as Socrates does in the dialogue —"Isn't it obvious that. . . . Now, isn't it true that. . . ." The answer each time is, "Yes." The proof is on the one hand plodding, dogged, and mechanical while being, at the same time, ingenious, imaginative, and wonderful. The interconnection between these two seemingly opposite series of qualities describes the relation of science to wonder, and it makes clear the passionate energies that are inextricable from exacting thought.

The design of question and answer in the Socratic method is the first and probably the best attempt in philosophy to take over from geometry and science the Euclidean proof in which exposition and discovery follow the same path and in which the questions to someone who does not know make certain at every moment that he has taken the last step with certainty. If he were not certain he would raise objections or announce his confusion. By saying "yes" to each question, he controls the thinking of Socrates so that only one step is taken at a time, and, equally important, the passage to the next step always goes by an obvious route. If the route is not self-evident, then a step has been left out. The order and the atomization of the argument into single steps make up, when taken together, the relation of certainty to surprise which is the relation of wonder.

In Plato's small drama of learning, the tension that builds up in the mind of the student is made up of perplexity and, to some extent, frustration. Both follow on the recognition that "I don't know," which is, here, reduced to the statement, "I don't know what to try next." Knowing that one does not know is a classic step, in the Socratic method, on the way to knowing, and being certain of what one knows.

The psychological states of being perplexed and frustrated are not accidental within thinking. They are often prolonged and agonizing, as anyone who has ever taught geometry knows. We say over and over, "I can't get it!" or "I just don't see it!" We trace and retrace the steps, hunting for a way out, but we find ourselves back at one of the many dead ends. The details of the problem disintegrate into a set of facts that seem to have no real connection to one another: just the opposite feeling to that of the "fit" of a solution. We come to doubt that we have all the facts, or that we have failed to discard certain details that keep taking up time but lead nowhere.

In all of this time, which can last for hours, the tension and frustration mount. In fact, there might be no solution. The situation might be impossible. The paths of the problem take on the feeling of a labyrinth that leads again and again to a dead end. Then unexpectedly, and in a second of time the answer strikes us. The pieces assemble into a tight, interconnected condition where everything fits.

The experience of exhilaration in the moment of solution is in some direct way related to the perplexity and to the disintegration of certainty and direction that preceded it. Perplexity is the mental state of being "lost." At this point it is clear what Theaetetus' state of being "lost in wonder" was about. One of the basic feelings as you face an unsolved geometry problem of this kind is that you are immobilized in front of it. It doesn't go away, and you can't make any progress. Such immobility defines part of the feeling of freedom in the moment of wonder, a moment when we suddenly race ahead, cover all the distance to the solution in an instant. The normal reaction at the moment of solution is to race back through step after step, seeing them for the first time as certain and right.

The relation of frustration to this moment of discovery points to the deep inner plausibility of Plato's theory that we never learn anything at all. Rather we have forgotten it, and in learning something we remember knowledge that we have always had. What is intriguing here is just how similar the experience of being stalled in front of a problem is to the situation where we are trying to remember a name that we know we know but

cannot think of. The pressure on ourselves to remember it, the tension and frustration feel nearly identical to the experience of working at a geometry problem that we can't get. Since the problem is one that we have never done before we cannot (in our sense of the word) already know it. But in working to remember a name we strain and concentrate and then, suddenly, by surprise it "leaps into the mind." The suddenness of its arrival, the pleasure and relaxation of tension in remembering has the same structure of feeling as the sequence for solving a problem. This is the acute and telling side of Plato's theory that knowing and remembering are closely related. This psychological similarity does not depend at all on believing the theory that we have lived many earlier lives—the theory that Plato uses to explain the similarity between the experience of learning and the experience of memory.

The moment of seeing a solution for the first time is the quintessential intellectual experience of wonder. The exclamation "Aha!" or, as we always say for Archimedes, "Eureka!" which we now refer to by the nearly technical term of "Aha-erlebnisse," contains the passionate moment of learning itself. Plato, like many later thinkers, took geometrical reasoning as the model for all thought for two reasons: first, because the exact chain of proof could be exhaustively stated in a rigorous manner; and second, because the experience of the novice in looking at each new step, once all previous ones are felt to be certain, is the experience of "Aha, now I see it!" Each step recreates the experience of wonder and then the transformation of wonder into certainty. One important feature of Plato's proof in the *Meno* that all learning is a form of remembering depends on the experience of surprise and pleasure that is expressed in the "Aha!" experience. If we picture the moment of confusion in any problem or reasoning just before we "see" the answer, that prior state is psychologically identical to the state in which we are trying to remember something that we are certain that we know, but cannot for a moment remember, such as the name of a street on which we lived twenty years

earlier. Suddenly, the name appears in the mind and the release of the tension of trying to remember occurs and we say "I've got it!" The state of tension as we look at a figure in geometry and try to get the next step of the proof, and then suddenly "see" the next step, saying "I've got it!" is so strikingly similar to the act of remembering something that Plato's argument, carried out by means of a geometric proof in the *Meno*, that all learning is remembering becomes at least psychologically plausible. The process of Socratic Dialogue is designed to reason by means of a verbal equivalent to the step by step sequence of moments of "seeing" that something must be so. Both Newton and Spinoza wrote using the Geometrical method because, in addition to the large scale rigor of the method, the step by step process builds in the experience, for the reader, of the act of discovery that occurred earlier for the scientist or philosopher, and that sequence of small scale acts of "seeing" is, precisely, the sequence of wonder.

In Socrates' demonstration, the moment of learning one new thing is isolated before us along with the experience of suddenness and surprise that make up the pleasure of the moment of learning. The relation of being lost in wonder to the moment of intellectual wonder itself is also clear within Socrates' example, since, in dramatic terms, the darkest hour (after the failure of the second attempt, the proposal of a length 3) is in terms of the Baroque aesthetics of crowding dark and light together, right next to the moment of illumination. One final puzzle about these few pages within the *Meno* will force us to turn Socrates' demonstration itself in a surprising direction, like the square that Socrates rotates 45 degrees after he has had us considering only upright, standing squares for the whole time of thinking about the problem.

Socratic Silence

If we return to the original question that Socrates asks, we might notice that he asks only how we

would double the area of the square. The original square has sides of length 2. Why does Socrates not ask just how long the side of the new square will be? Once we reach the end of the problem we do not know this length. It is passed over in silence. Naturally, it is not necessary to know it, since the one and only question was how to construct a square double the area of a given square. Yet every one of the boy's attempts at an answer involved a guess about the length of the side of the new square—4 or 3. Why does this question of the length disappear from the problem?

What drops into silence here is the fact that the side has no rational length, it cannot be measured. It can be expressed by an irrational number, two times the square root of two, but the square root of two cannot be expressed by any fraction. Earlier in Greek geometry it was the very scandal of this irrational number 2 which is the outcome of trying to compute the length of the diagonal of a square with a side of length 1 by means of the Pythagorean Theorem, that led to the crisis within Pythagorean mathematics, a crisis connected to its mysticism and to its secrecy. According to legend the discoverer of this problem was put to death. He had at the very heart of the rational, reached the irrational.

The example that Socrates has chosen here is one where geometry parts company with measurement or from arithmetic. To construct the square is a geometric solution, one that yields complete satisfaction, but it is a solution that does not depend on knowing any of the lengths, or even assigning a length in the first place. The given square can be exactly doubled with a compass and straight edge—not a ruler, the straight edge need have no markings and can be of any length. To measure the length is impossible. No ruler of any size will yield a whole number answer for its length: this is the meaning of saying that it cannot be expressed as a fraction. The denominator of the fraction is the length of the ruler, the numerator is the whole number measure in terms of that ruler. This mysterious fact remains hidden within Socrates' proof at just that moment

when we stop talking about numbers (after the failure of the guess of "3").

But even this is not the whole meaning of the irrationality of this expression. Both Aristotle and Euclid give elegant proofs to demonstrate that when we ask about the length of the diagonal of a square whose four sides each measure one, the number that would solve this problem would have to be both odd and even. It would have to be divisible by 2 (even) and not divisible by 2 (odd). It is not only unmeasurable but ruled out by logic itself, the law that the same thing cannot both be and not be something—in this case, divided by 2. Since this law is fundamental to the act of thinking, this number cannot be thought about. And yet the problem of this number turned up in no remote corner of mathematics but in the simple question of the length of the diagonal of a square whose side is 1.

If we set aside the problem of logic for a moment (odd and even at once), the irrational length "the square root of two" is not a subject of wonder because it is in Socrates' time irrational, a threat to mathematics itself which will have to be, just like Socrates own pair of squares, built into a more encompassing structure before it can be a candidate for wonder, that is, for surprise and then explanation.

Wonder is a feature of the middle distance of explanation, outside the ordinary, short of the irrational or unsolvable. What falls into this far distance of the irrational, the unsolvable and the unthinkable can, in time, move into the horizon of wonder or even into the core of the ordinary. Wonder is both personally and historically a moveable line between what is so well known that it seems commonplace and what is too far out in the sea of truth even to have been sighted except as something unmentionable. This moving line, as it changes from period to period, lights up our interest and passion for explanation. It attracts us to itself. It is the horizon itself of the ordinary and the everyday which is constantly changing its location. The feeling of wonder, when and where it surprises us, notifies us of just where that boundary is at the moment. This we could call the part

played by wonder in drawing us to the zone of un-solved but solvable questions.

Socrates does not ask the question, "How long must the side be to double the area of a square made up of sides with a length of 2?" Within the mathematics of his day this is not a question. The expression "twice the square root of two" can be given an approximate answer: 2.2832..... But the dots that trail off into an infinite decimal tell us that the answer is approximate. We can say the answer is "2" or "2.3" of "2.28" or "2.283" and so on. The answer is not correct, but varies depending on how exact you need to be at the moment.

The disappointment when we hear this type of answer, "Well, it depends on what you need," shows why the question is asked in the way that it is and why Socrates constructs his demonstra-tion of rational thought on the basis of a problem that had hidden within it the very irrational itself. It is this moveable line of wonder that also makes up our capacity to distinguish what is a question or problem at any moment and what is not. The irrational itself is only relative and represents like wonder itself a certain horizon of the moment. In this case the word "irrational" shows the col-lapse of the requirement that we be able to measure—that is to create a ratio between two things. Arithmetic and algebra can use the ex-pression "twice the square root of two" within calculations without falling into the logical abyss that any attempt to say what the square root of two finally is. Only the requirement of a ratio, the problem generated by the physical act of mea-surement is permanently impossible thus making the number "irrational." None the less, the fa-mous statement of modern mathematics—God made the integers, the rest was made by man—finds in Socrates' silence a tacit nod of agreement.

Socrates silence, once we violate it by bringing up the very thing that his discretion conceals, tilts his problem 45 degrees. But now we can see that the design of the question is a key component of being able to answer it at all. One question, "How long must the side be of a square twice

the area of this given square?" would lead to an abyss of thought. The other question, "Can you construct a square exactly double the area of this given square?" skates over this very abyss be-cause it uses but never brings up certain things. The very water in which thought would drown is frozen over to let the skater pass.

It is a remarkable fact about the saying "phi-losophy begins in wonder" that in the dialogue *Theaetetus* shortly before Theaetetus spoke of himself as lost in wonder he had mentioned in passing exactly this problem of squares of area 3 or 5 or 8, the squares that had led to the proof of the irrationality of the expression, the square root of two. Just as in the *Meno* the problem itself is passed over in silence. Aristotle was the first, in his Posterior Analytics I, 23, to jump on the ice it-self and break through to demonstrate that the number is a logical impossibility. What is clearly known within the silence of Plato and Socrates is at last spoken by Aristotle and then Euclid.

But in the Socratic silence what becomes clear is that the poetics of thought depends on a nego-tiation around certain topics as well as a direct engagement with others or with other versions of the same problem, as in this case. The moving line of wonder is the mechanism of this engage-ment with some but not with other problems. So-cratic silence is one side of the coin of a poetics of thought.

By tracing out the scientific claims for wonder in Descartes' book on the passions and then using examples from Descartes and Plato to show the small scale meaning of the experience of wonder within thought we have now reached the point where both the aesthetic side of wonder and the scientific side are before us. The aesthetics of wonder seemed at first to limit itself to our first in-stant of being struck by an object within nature. We say that in wonder the object calls out to us, making a claim on our attention. Built into this idea of a first instant is the fact that wonder must trail off as the experience progresses. Unlike de-sire whose climax of intensity occurs near the end, just before satisfaction, wonder like each of the

primary passions—fear, anger, and mourning—has its peak of intensity in the first moments and then declines or complicates itself.

What does wonder change itself into if it does not simply fade? Descartes answer is that it leads to the search for explanation, or as Socrates said, it leads to philosophy. Within the idea of reasoning that we see in Descartes and Socrates, wonder continues to play a part in the moment by moment experience of intuition. Within the frame of a well-designed local question, we suddenly "get it." The suddenness, surprise, unexpectedness of direction as well as the pleasure in the outcome that when taken together make up the psychological elements of this experience, repeat, but not in an intellectual-aesthetic form, the very features of the first experience of wonder itself.

The connection of wonder to scientific explanation follows from two things. First, from our turn from the experience as a whole to the contemplation of its details. Since explanation drives us to produce as many details as possible that fit within the explanation, the number of separate experiences and points of explanation is potentially very large. Each can be a separate step of thought, a distinct experience of "Now I see why that is so!" Second, the experience of wonder also occurs repeatedly and in surprising directions because, as we saw in the problem of the two squares from the *Meno*, the solution often comes by inserting the problem into a wider frame than was initially given, within an artifact

that has come into existence during the process of thought itself. Or, the explanation is seen at a moment of restating the terms in equivalent but imaginatively different symbols which have their own built in paths of thought. In combination these two details of explanation lead to an unpredictable number of turns and surprises within any explanation and to the fact that every explanation will be not one answer but a series of details each of which fits what we can notice within the original experience once we have attended to it closely. Cartesian wonder is what makes us interested in this and not that, and it is what binds us to it long enough to discover its nature in detail.

Why does the description of discovery not limit itself to the first person who solves a given problem or who takes a step of thought and even in his or her case, only to the first day on which the act of seeing takes place? As we read through a proof like that in the *Meno* we experience the same surprise, suddenness, and unexpected direction within the solution to the question. Even though we have not ourselves discovered it for the world, we have discovered it for ourselves. Since it is new to us it takes effect in the moment as though it were new per se. Wonder is a horizon-effect of the known, the unknown, and the unknowable. It is a highly personal border of intelligibility; the place where at this moment in our own history and development, we are able to see a question. The place where we are able to say "I wonder."

"The Vast Disorder of Objects": Photography and the Demise of Formalist Aesthetics

WENDY STEINER

Erwin Panofsky begins his essay, "The History of Art as a Humanistic Discipline," with an anecdote of Kant on his deathbed, insisting on standing up until his doctor takes a seat, because "The sense of humanity has not yet left me."[1] Such civility is hard to imagine nowadays, and Panofsky foresees the advent of a "satanocracy" if things continue as they have. It occurs to me that I might be a prime contributor to that satanocracy for displaying Robert Mapplethorpe's pornographic photographs in a conference honoring Panofsky, and if so, I hope that both he and you will forgive me.

I would turn to another anecdote. On the witness stand in Hamilton County, Ohio, a well-dressed woman, under oath, sat torturing a handkerchief. She herself was not on trial, but another museum director was—Dennis Barrie of the Contemporary Arts Center in Cincinnati. The woman, Janet Kardon, had curated an exhibition of Robert Mapplethorpe's photographs which eventually travelled to Cincinnati where seven pieces were declared by the local authorities to be obscene. Both the art center and its director were defendants in "the first obscenity proceeding against an art gallery in American history."[2]

The prosecutor, Frank Prouty, asserted that these photographs of what the *New York Times* called "anal and penile penetration with unusual objects"[3] were without artistic value, an essential element of obscenity charges. But Ms. Kardon disagreed. She pointed to Mapplethorpe's sensitive lighting, texture, and composition, calling "a self-portrait of Mapplethorpe with the handle of a whip inserted in his anus 'almost classical' in its composition [fig. 1]. . . . [A]n image of a man urinating into another man's mouth was remarkable because of the strong and opposing diagonals of the design. Another photograph demonstrated Mapplethorpe's fondness for 'an extremely central image,' she said. 'That's the one where the forearm of one individual is inserted into the anus of another individual?' Prouty asked. 'Yes,' she replied. 'The forearm of one individual is in the very center of the picture, just as many of his flowers occupy the center.'"[4]

This interchange is a moment in the history of art that deserves commemoration. Seldom do we see an ideology so clearly in collapse, as strained and tortured as the handkerchief in witness Kardon's fingers. Robert Hughes terms this testimony "the demise of American aestheticism," "the kind of exhausted and literally demoralized aestheticism that would find no basic difference between a Nuremberg rally and a Busby Berkeley spectacular, since both, after all, are examples of Art Deco choreography."[5]

The justice of Hughes' criticism is obvious, although now that he has pointed out the formal correspondence between Nazi rallies and Holly-

Figure 1. Robert Mapplethorpe, *Self Portrait*, 1978. © The Estate of Robert Mapplethorpe

wood musicals I will never be able to look at *Babes on Broadway* in quite the same way. But the fact is that none of the other specialists called to explain what made these photos art did much better than Ms. Kardon, though they did not strain credibility quite as severely as she did. The Mapplethorpe affair marks not so much the demise of aestheticism as a crisis in aesthetics as such. Neither the expert nor the layperson can say what makes art art, and though aesthetics has always been an area of opinionated speculation rather than scientific truth, there have been times of greater consensus than today, and times when the lack of consensus has been less costly. At the moment, the vacuum in aesthetic theory in America has propelled art into the realm of politics, where the virtuality of art, its symbolic reality, and its subtle contradictoriness are simplified into a literalism that confounds practitioner, expert, and layperson alike.

It is no accident that photography has provoked so many aesthetic scandals in our day. It necessitates an aesthetics of content, a project that could not be further from the prevailing aims of twentieth-century art theory. "It is as if the Photograph always carries its referent with itself," Ronald Barthes writes in *Camera Lucida*. "This fatality (no photograph without *something* or *someone*) involves Photography in the vast disorder of objects."[6]

Panofsky (p. 11) argued that we can perceive *any* object aesthetically "when we just look at it (or listen to it) without relating it, intellectually or emotionally, to anything outside of itself." But recent photography has made this kind of disinterested interest all but impossible, while still insisting that photographs are art. I would like to sketch out quickly some of the ways in which photography has made "the vast disorder of objects" an inescapable and unprecedented part of aesthetic experience.

Andres Serrano, for example, shows how problematic the notion of "content" becomes in photography. Three 1987 photos, *Blood, Milk,* and *Piss* are, respectively, red, white, and yellow expanses in which the distinctions between form, material, subject, and theme are obscure. *Circle of Blood* looks like a Malevich abstraction, but it is at the same time transparently representational, and even autobiographical. And *Piss Christ* (fig. 2), which provoked the lawmakers' attacks on Mapplethorpe, makes sfumato out of pee, a golden glory out of desecration.

Ronald Barthes (p. 31) connected photography to theater in arguing that "The *camera obscura* . . . has generated at one and the same time perspective painting, photography, and the diorama, which are all three arts of the stage; but if Photography seems to me closer to the Theater [than to painting], it is by way of a singular intermediary . . . : by way of Death . . . the first actors separated themselves from the community by playing the role of the Dead: to make oneself up was to designate oneself as a body simultaneously living and dead." Mapplethorpe makes the connection between photography and death explicit in his last self-portrait, taken as he was dying of AIDS and Serrano plays out this connection to a grisly extreme in his Morgue shots. But Serrano evokes the theater in ways that Barthes did not anticipate. His photographs of the Ku Klux Klan force us to consider the dramatic circumstances under which these works came into existence. How did a photographer of mixed race get Klan members to dress up for him and allow him to shoot them with film (fig. 3)? What was going on in their minds and in his, and how does this clash of ideologies affect our spectatorship?

Serrano, of course, is far from the first to force the drama of the shutter's release into the meaning of the resulting photograph. Every technically demanding subject—from vampire bats in inaccessible caves to moon shots—makes us think about how the picture could possibly have been taken. But many contemporary photographers expose not so much the physical as the psychological and epistemological difficulties in the tak-

Figure 2. Andres Serrano, *Piss Christ*, 1987. Photo courtesy Paula Cooper Gallery

Figure 3. Andres Serrano, *Klansman* (*Great Titan of the Invisible Empire*), 1990. Photo courtesy Paula Cooper Gallery

Figure 4. Sally Mann, *At Twelve*. © Sally Mann: Courtesy Houk Friedman, New York

ing of a picture. Sally Mann's work is often dominated by these problems. In her photographs of children (fig. 4), the inequality of understanding between artist and subject or audience and subject is very troubling. Mann's remarkable collection *At Twelve* (1988) revolves on this issue, as does the commentary surrounding it by Mann herself. "What knowing watchfulness in the eyes of a twelve-year-old . . . at once guarded, yet guileless," Mann exclaims. "She is the very picture of contradiction: on the one hand diffident and ambivalent, on the other forthright and impatient; half pertness and half pout. She disarms me with her sure sense of her own attractiveness and, with it, her direct, even provocative approach to the camera."[7]

The novelist Ann Beattie, who comments on the pictures, is clearly fascinated by this problem, but also frightened. Her fear has to do with a sense of fair play that the photos threaten. Painted subjects are not usually real, and painters seldom contrast a subject's innocence to our knowledge with such skepticism or honesty. But the actuality of the photographic subject ties Beattie up in knots trying to "save" the girls and the pictures. The girls in one image, she says (p. 10), posed unknowingly by a vagina-shaped scar in a tree (fig. 5), "transcend their proximity to the tree in part because we *want* them to transcend it."

The problem is one of ethics, a proposition that those who pose, those who make themselves available to our view, becoming objects of our gaze, be able to support the consequences of our thoughts upon that viewing. This reasoning is a piece of tremendous moral delicacy, forcing us to consider whether we as viewers can face the disparity between our thoughts and the girls', our response and their intention. Even more shockingly, we must ask ourselves whether we can accept the possibility that there is no such disparity, that our belief in it springs from a desperate fiction of innocence that we displace onto these children. "They are children, after all," says Beattie (p. 7); "we still feel an urge to protect them. While for them looking into a camera lens is

analogous to looking into a mirror, what they mirror for the viewer, with their attitudes and their dead-on eye contact, is us. We are their mirror, they are ours."

Thus, the photographic arts embarrass us by our lack of an aesthetics of content. They do so, of course, because they belong to reality in a way more literal than any other kind of aesthetic representation. As Rudolf Arnheim explained,[8] photography by definition represents not the general nor the characteristic but what is peculiar to one moment of time. It embraces accident, since not everything in the lens' view can be controlled. It represents a fragment of a larger world, and so it always implies that world, of which it is a sample or an accidental element. The premise of photography is that an artist inhabited some reality at a particular moment, intruded into it, but that the reality was not created by the artist.

According to Andy Grundberg, photography critic for the *New York Times*, photography is "the most stylistically transparent of the visual arts . . . the subject matter of photography is often mistaken for [its] meaning and value"[9] and transformed, in the process, into the sublimity of art. "Graffiti and gutter trash have been turned into painterly abstractions; the sick, mad and dispossessed have been shown in poses that mimic Renaissance compositions."[10] But not everyone reads this glorious transmutation as a good thing. Susan Sontag in particular finds it pernicious. In her 1977 essay *On Photography*, she argues that "photographic images tend to subtract feeling from something we experience at first hand and the feelings they do arouse are, largely, not those we have in real life." She continues, "photography does its worst damage when it dulls one's sensitivity to the real existence of that content, the moral and ethical qualities it possesses as a thing, not as an image."[11]

An art that is indistinguishable from its real subject or an art that blocks out reality—photography is an archetype of our conflicting fears of aesthetic liminality. Though for many people it is

still not quite a legitimate art, it is more potent than either painting or literature, and it exercises its power—for example, in ads—over that fearsome part of the population known as "the masses." Pornographic photography is especially frightening because it marks another kind of bound between thought and deed, and like every such liminal zone it is fraught with fear—fear that fantasies will come true, will invade the world of public action—and the opposite fear, that there will be no such crossover, that the pleasure and energy of this realm will have no realization outside it.

Pornographic photos interrogate the very act of viewing, making the viewer self-conscious, drawing the photographer's role as viewer into the dynamics of the work, and questioning the subject's role as victim or accomplice in the viewing. They add to the threatening realism of any photograph a thematization of the act of looking —of voyeurism, peeping, leering, examining, adoring. This is a central issue in self-portraiture. In one of Mapplethorpe's indicted works, for example (fig. 1), the photographer, with bullwhip sticking like a devilish tail from his rectum, turns round to the camera—to us—registering the fact that we are looking, that he knows we know what are his pleasure and his pain. But do we know what *our* pleasure and pain in the viewing might be, how we place ourselves vis-à-vis this sign, this fact? This work is confrontational, teasing, searching, and it has caused many people extreme anxiety.

Mapplethorpe marshalled all the frightening ambivalence photography could offer in his gay, sadomasochistic images. If we think of Arnheim's account of what makes photography distinct from painting, we see how little his claims apply to this artist. Mapplethorpe's images seem the antithesis of the accidental—obsessively controlled, shot inside in a studio, meticulously composed. They do not "capture a fleeting moment" so much as mimic archetypal forms and classical poses—Vitruvian Man, Greek statuary, Renaissance nudes. They do not stand as fragments or samples of a larger reality beyond them, but images complete in themselves, a centripetal world of art that seeks perfection, conquering reality in the name of art rather than documenting nature's factual imperfection. Mapplethorpe's work is timeless rather than marked by any temporality of its subject, and it constantly makes us aware that an artist has created it. Far from a revolt against form, Mapplethorpe has created some of the most formalist art in the contemporary canon. In fact, most critics who dislike his work find it too close to fashion photography and a hothouse aesthetics that seems precious and overdone at this point in art history. In all these respects, as Janet Kardon has written, "Mapplethorpe dissolved the boundaries between photographs, painting and sculptures [and theater]. He made photographs not just a means of conveying visual information, but allowed it to achieve a monumentality we associate with paintings."[12]

The one respect in which Mapplethorpe's photographs do conform to Arnheim's description is his choice of low-life subjects. The sadomasochistic works are the prime example, but the lushness of all his images conveys some hint of transgression. It has been endlessly remarked that Mapplethorpe's flowers look like genitalia, and that the formal beauty of his work is part of a program meant to show the sensuality of all experience.[13] These photographs are not merely an aesthete's art but a hedonist's art; they not only deliver pleasurable images but raise the spectre of unlimited pleasure.

Or perhaps, as some critics have suggested, the expression of this pleasure in classicist form implies sexual fixation, a cold classicism always failing in consummation. Kay Larson and Peter Schjeldahl have written eloquently in this vein. "Love," says Larson, "which might make room for the less than beautiful, is not part of this horizon. Relentless desire, clarified and rarefied by the photographer's passion, expands like a mushroom cloud beyond its origins in homoeroticism to implicate a decade indulging its obses-

Figure 5. Sally Mann, *At Twelve*. © Sally Mann: Courtesy Houk Friedman, New York

sions (and fearful of the consequences)."[14] Schjeldahl and others have compared Mapplethorpe to Keats:

> Radically amoral, in a way not so much art-for-art's sake as *everything*-for-art's sake, Mapplethorpe's work is ruled by the eye's appetite for perfect images of desire and fascination. His work is not about gratification, either sexual or aesthetic. Elegance spoils it as pornography and avidity wrecks it as fashion. It is about a strenuously maintained state of *wanting*. The effect is a Keatsian, bittersweet, personal ache, given social bite by its kinship to the overstimulated demand that is the fly-wheel of today's consumerist, narcissistic culture.[15]

If the act of looking is like being seduced, it is also like being stonewalled, or seduced by the promise of frustration.

During the Mapplethorpe trial, expert witnesses were called to the stand to explain the offending photographs to the jury. Ms. Kardon found these works valuable for "portraying a part of the artist's life and society in the late 1970s, a moment in history that will probably never happen."[16] Martin Friedman praised them as reflections of the world we live in. Dennis Barrie, the defendant in the trial, found a tortured image "an excellent example of an artist working through these issues."[17] Rather than explaining what art is or what the photographs meant, these statements revealed some of the things the experts liked Mapplethorpe's art for doing, or—more likely—things they thought the jury would like it for doing.

As the testimony piled up, the assortment of tasks that Mapplethorpe's five sadomasochistic photographs were said to perform became really impressive. They caused introspection; created a "tension between the physical beauty of the photograph and the brutal nature of what's going on in it"; and constituted a "healing diary."[18] To their formal virtues were added technical ones—beautiful printing and high-quality paper—and historical virtues—a distinguished list of photo-

graphers in whose traditions Mapplethorpe had worked. All of these are worthy traits, of course, but none is either definitional of art or an adequate description of the photos' import. And all of them reinforce the puritanism that brought the museum to trial in the first place.

This puritanism led the CAC's director, Dennis Barrie, to swear under oath that the works are "striking, not titillating."[19] Though to a heterosexual viewer, perhaps, this is the case, one cannot be so sure that *no one* finds these images exciting. The jury were also reassured that the photos are a record of a peculiar moment in sexual history "that will probably never happen again."[20] Despite the chastening effect of AIDS, it is surprising that people as sophisticated as these experts would assume that gay sadomasochism has been utterly eradicated. This argument turns sadomasochism into a kind of dodo, safely and educationally immured in art. Over and over, the jurors heard that "Art is not always pleasing to our eyes. Art is to tell us something about ourselves and to make us look inside ourselves and to look at the world around us."[21] Or else they were told to judge the quality of the works by "look[ing] at them as abstract, which they are, essentially."[22]

All these characterizations ignore the naughtiness, the wicked humor, the irony, the titillating contradictoriness, the perversity of these works of art. The photographs are camp and confrontational. They are rude. They put the viewer on the spot—"Oh, you're so shocked, are you? Then why are you still looking?" There is a pleasure in being shocked, in being ridiculed for one's conventionality, in looking at a piece of wit in which the absolutely most proscribed taboo is presented as formally pleasing. I am not sure that these pleasures are my favorites—Rabelais is not always my cup of tea—but I would not deny them either.

The point is that everything that involves aesthetic judgment involves a personal revelation of preference, of pleasure or displeasure, and photography at the moment is making this point

more clearly than any of the other arts. As Barthes argues (p. 18), "Photography is an *uncertain* art, as would be . . . a science of desirable or detestable bodies." This uncertainty is the inevitable product of an immersion in "the vast disorder of objects," and it forces questions about the relation between meaning, material, form, and content that Panofsky would not have ignored, I hope, but enjoyed.

Notes

1. Erwin Panofsky, "The History of Art as a Humanistic Discipline," *Meaning in the Visual Arts* (Chicago, U. of Chicago Press, 1982), p. 1.

2. Kim Masters, "Cincinnati art center faces obscenity trial," *Philadelphia Inquirer*, September 7, 1990, p. A1.

3. Isabel Wilkerson, "Test Case for Obscenity Standards Begins Today in an Ohio Courtroom," *New York Times*, September 24, 1990, p. A4.

4. Stephan Salisbury, "Arguing obscenity," *Philadelphia Inquirer*, October 1, 1990, p. D7.

5. Robert Hughes, "Art, Morals, and Politics," *New York Review of Books*, vol. 39, no. 8, April 23, 1992, p. 21.

6. Roland Barthes, *Camera Lucida*, tr. Richard Howard (New York: Hill and Wang, 1981), p. 6.

7. Sally Mann, *At Twelve: Portraits of Young Women* (New York: Aperture, 1988), p. 14.

8. Rudolf Arnheim, "On the Nature of Photography," *Critical Inquiry* (September 1974), p. 157.

9. Andy Grundberg, "Blaming a Medium for Its Message," *New York Times*, August 6, 1989, sec. 2, p. 1.

10. Andy Grundberg, "Cincinnati Trial's Unanswered Question," October 18, 1990, p. C17.

11. Susan Sontag, *On Photography* (New York: Doubleday, 1977), p. 168.

12. Quoted in Emily Friedman, "Robert Mapplethorpe: Exhibit to open by photo artist," *Daily Pennsylvanian*, December 6, 1988.

13. For example, Edward J. Sozanski, "Distinctive Artistry in Photographs," *Philadelphia Inquirer*, Dec. 18, 1988, p. 6-V.

14. Kay Larson, "Getting Graphic," *New York*, August 15, 1988.

15. Peter Schjeldahl, "Taste and Hunger: The Mainstreaming of Mapplethorpe," *Village Voice*, August 10, 1988, p. 48.

16. Stephan Salisbury, "Defense begins in art trial," *Philadelphia Inquirer*, October 2, 1990, p. D1.

17. Isabel Wilkerson, "Curator Defends Photo Exhibition," *New York Times*, October 4, 1990, p. A19.

18. Kim Masters, "Jurors View Photos of Children," *Washington Post*, October 3, 1990, p. C2.

19. Stephan Salisbury, "Museum director defends exhibit," *Philadelphia Inquirer*, October 4, 1990, p. C10.

20. Stephan Salisbury, "Defense begins in art trial," *Philadelphia Inquirer*, October 2, 1990, p. D1.

21. Isabel Wilkerson, "Jury Selected in Ohio Obscenity Trial," *New York Times*, September 28, 1990, p. A10.

22. Testimony of Evan Turner in *State of Ohio v. Contemporary Art Center and Dennis Barrie*, case nos. 90CRB11699A,B and 90CRB11700A,B.

What Is Visual Culture?

W. J. T. MITCHELL

The following essay was initially drafted as an internal memo to the Faculty Working Group on Visual Culture at the University of Chicago in the summer of 1993. Although it builds upon the discussions of this group, and owes a great deal to the expertise and critical remarks of its members, it should in no way be seen as a manifesto of any group consensus, but a working paper that succeeded only in producing controversy and clarifying dissensus. In particular, the specific proposal and syllabus for a course in Visual Culture, with its emphasis on semiotics and sign theory as a starting point, was firmly rejected by most of the group in favor of an introduction that would stress visual experience as its point of departure. These remarks, then, should be regarded as something like a failed attempt at a manifesto. Nevertheless, I would like to thank my colleagues in literature, film, and art history who deserve much of the credit for any good ideas (and none of the blame for the bad ones) that appear in this document: Bill Brown, Mary Carbine, Tom Cummings, Courtney Federle, Miriam Hansen, Jim Lastra, Paul Rogers, Mark Sandberg, Joel Snyder, Barbara Stafford, and Katie Trumpener.

Among the revolutions in higher education in the last twenty-five years has been an explosion of interest in visual culture. The most obvious evidence of this development has been the emergence of studies in film, television, and mass culture, alongside a new social/political/communicational order that employs mass spectacle and technologies of visual and auditory simulation in radically new ways. But there have been less-public developments as well in the sphere of the professional study of culture. The revolution in that vast, indeterminate field known as "literary theory," new philosophical accounts of representation and its relation to language, and new developments in art history have laid the groundwork for thinking of visual realities (including everyday habits of visual perception) as cultural constructions, therefore interpretable or readable, therefore of at least as much interest to students of culture as the traditional archives of verbal and textual production. As a practical matter, one is no longer surprised to hear of sociologists and anthropologists writing about museums and works of art, or to encounter literature professors showing slides and films in their classes, or to find art historians reading in linguistics, rhetoric, and anthropology and taking their students to shopping malls as well as to art museums. In short, the separation of humanistic disciplines into "verbal" and "visual" camps, with the visual in the distinct minority, has broken down along with the distinction between high art and mass culture.

This is not necessarily a good thing. The emergence of a new hybrid discipline called "visual culture" may be a bit too easy, given the current meteoric career of something called "cultural studies." One simply attaches "the visual" to the "cultural" and everything follows. The "interdisciplinary" character of efforts to work across the verbal and visual media can easily become a merely undisciplined and amateur pursuit, or an automatism that unreflectively grafts homogenous notions of culture onto received ideas about the visual. On the other hand, one shouldn't underestimate the resistance of tradi-

tional disciplines to cross-disciplinary poaching. Art historians may not readily welcome the intrusion of literary theorists applying the latest narrative or textual theory to the analysis of visual imagery. The rapid professionalization of cinema studies has also left film scholars wary of scholars from other disciplines who analyze movies without a proper training in the specific formal and historical features of the medium. While the general study of visual culture may seem like an idea whose time has come, it is by no means self-evident how it ought to proceed, what its leading questions should be, and whether it really constitutes an emergent field with a potential curricular and disciplinary identity, or a transitory and ad hoc development. Even more fundamental is the way that visuality, like other emergent "minority" dimensions of cultural expression, may be calling into question the very notion of professional expertise itself, and raising doubts about the proper locations of cultural competence and literacy. A generation raised in a culture of video, television, and mass global dissemination of images may find that its acquired background knowledge of new visualities goes well beyond the expertise of an older generation of experts with professional training in painting, photography, sculpture, and the graphic arts of the still or moving image.

A group of scholars at the University of Chicago from programs in literature, art history, and film studies who share an interest in questions of visuality has been working together on the problem of visual culture during the last year. As the composition of the group indicates, there is a pragmatic commitment at the outset to interdisciplinarity, and a refusal of the notion that visual culture can be left to the art historians or to specialists in media. This commitment goes beyond the aim of uniting humanities scholars around the problem of visual culture. Our sense is that the field must also include the social and natural sciences, and that non-Western concepts and practices of the visual must be a central component. The study of human visuality cannot avoid the crucial role of vision and imaging in the construction of the very notion of cultural "otherness"; it cannot bypass the larger implications of what Guy Debord has called "the society of the spectacle," nor can it ignore scientific accounts of vision and imaging, whether addressed to the "natural" construction of the eye and the visual system in its relation to the other senses, or to the science and technology of imaging and the various prosthetic extensions of the visible. One of the things that makes the study of visual culture exciting, in fact, is that it forces humanists to explore the boundaries of culture (the "natural" construction of animal vision, for instance, or the mechanical, electronic, and digitalized technologies of visual reproduction) rather than to take culture for granted as the stable field in which studies are to be conducted. The same might be said of the emphasis on "the visual" as the specific dimension of culture to be investigated. The question immediately arises: visual as opposed to what? The aural? The linguistic or discursive? The realm of the "invisible"?

Visual culture becomes a provocative concept, in other words, only when its boundaries are put into question, and the tensions between its terms are made manifest. One cannot simply graft a received notion of visual experience on to a received notion of culture. One has to begin by reckoning with those parts of culture that lie outside the visual, and with those parts of the visual that lie outside of culture. One must also register the specific tension that resides in the relation of the two key terms. Culture has traditionally been understood largely as an affair of language and texts. Although images, visual objects, and performative activities have been understood as vehicles of cultural expression, the meaning of these things has generally been referred to verbal codes of discourse or narrative. One of the provocations of the very notion of visual culture, then, is that it requires us to ask whether there are dimensions of culture that lie beyond or outside of language, whether images, for instance, are vehicles of experiences and meanings that cannot be translated into language.

Any strong notion of visual culture would be

required, it seems, to give a positive answer to the last question. That doesn't mean that visual culture must programmatically exclude verbal material from its investigations. On the contrary, a moment's reflection reveals that language is never employed, whether in writing, speech, or gesture, without complex and numerous intersections with visual experience. Writing and print communication are forms of language made visible; speech is often accompanied by visual communication, and when it is not (as in radio broadcasts or telephone conversation) the absence of visual access to the source is a crucial part of its effect and meaning, its creation by indirect means of spaces, places, and images; gesture language, the signing of the Deaf community, is a fully articulate language carried exclusively through the visual channel.

The notion that visual culture constitutes a dimension in some sense "outside" or distinct from language, then, doesn't mean that it has no relation to language. On the contrary, the study of visual culture has to include its relation to language and forms of discourse. If the concept has any power, it shouldn't merely supplement or reinforce what we have already learned from phonetic and aural and "non-visual" models of language, but make the whole field of verbal expression look different. The mediation of visual experience in verbal descriptions, for instance, is typically accompanied by concessions that the words are "no substitute" for a visual representation, even as the description attempts to provide just such a substitute. In the context of visual culture, the curious ambivalence about the ability of language to stand in for the visual becomes a central problem rather than a minor curiosity in the study of rhetorical ornaments. The whole domain of the "spatiality" of language (from inscription to description to formal patterning and figurative imagery) takes on a new importance when verbal culture is placed in the framework of the visual. More pragmatically, we might say that the new developments in art history, cinema studies, and mass media don't simply constitute a new body of information to be added to the study of literature, philosophy, and history, the traditional "text-based" subjects of the humanities. The emergence of visual culture is a challenge to traditional notions of reading and literacy as such; it is as much a revolution in verbal culture as it is in the study of the visual image proper.

Another verbal tradition that looks different from the standpoint of visual culture is philosophy, the traditional home of the pure logos and the invisible truth. Visuality and the apparatus of visual representation have consistently been central to philosophical models of the mind, providing pictures of subjectivity, consciousness, and the automatisms of perception. These pictures of and in the mind, the mechanisms of memory and imagination, even the abstract, diagrammatic images of reason, also seem central to visual culture. Plato's Cave, Aristotle's wax tablet, Locke's *camera obscura*, Freud's magic writing tablet, Wittgenstein's Duck-Rabbit are what might be called "metapictures," powerful metaphors that allow complex theories to be (in Wittgenstein's words) "taken in at a glance." As metaphors, of course, they are somewhat homeless: most philosophers treat them as mere ornaments or illustrations to the "real" philosophical argument, which is linear, discursive, and literal. Students of visual art and media may be tempted to ignore them because they are not "real" pictures, and their visuality is only notional or metaphoric. These pictures are, however, absolutely central documents of visual culture as constructed in Western philosophical traditions. They have all sorts of relations to actual practices of visual display, of image production and consumption. They are the place, in fact, where human visuality itself is pictured.

The challenge to disciplines that have taken the visual image as their central object is equally complex and far-reaching. From the standpoint of a general field of visual culture, art history can no longer rely on received notions of beauty or aesthetic significance to define its proper object of study. The realm of vernacular and popular imagery clearly has to be reckoned with, and the

notions of aesthetic hierarchy, of masterpieces and the genius artist have to be redescribed as historical constructions specific to various cultural place-times. The genius and the masterpiece will not disappear in the context of visual culture, but their status, power, and the kinds of pleasure they afford beholders will become objects of investigation rather than a mantra to be ritually recited in the presence of unquestionable monuments. My sense is that the greatness of authentic artistic achievements will not only survive juxtaposition with the productions of kitsch and mass culture, but become all the more convincing, powerful, and intelligible.

The study of film and mass media will have to resist a pair of temptations. The first is the tendency for a new discipline to circle its professional wagons prematurely around a "proper" object of study, to close itself and its object off from literature, philosophy, history, and the history of art. The second is the temptation to the levelling of all distinctions of quality, the resort to an "industrial" view of film and mass culture that denies the possibility of individual authorship or intervention, and produces blanket condemnations or celebrations of an entire field of cultural productions.

I certainly don't mean to suggest that specialists in all these fields have failed to recognize these challenges and problems. In fact, what offers some hope for the possibility of a coherent discipline of visual culture is precisely that the self-critical tendencies of its principal constituents are all converging along the lines I have described. What sort of curriculum, sequence of skills, canonical readings, and issues will emerge to make visual culture a pedagogical reality is, at this point, an open question. There is no systematic critique of visual culture on which to construct a curriculum or even a syllabus, much less a discipline. On the other hand, there does seem to be a body of questions and debates, what we might call the "dialectics" of visual culture, that can be organized around specific texts and images. There are also some blind alleys that can

be avoided at the outset. A comprehensive, global historical survey is clearly out of the question (though the densely articulated presentation of specific historical moments and events is surely one desirable feature of such a course, as would be the critical analysis of some classic "master-narratives" in visual culture, especially those accounts of "Western realism" as a kind of evolutionary progress). An organization of the curriculum around traditional artistic genres or media-types runs the risk of simply replicating existing disciplinary divisions (though the relations among genres and media-types, their hierarchies, oppositions, and interactions, would clearly be a topic for investigation). The point of a course in visual culture, in short, would be to provide students with a set of critical tools for the investigation of human visuality, not to transmit a specific body of information or values. If the questions and debates are posed frankly, as the very substance of the course rather than as something already settled, then information, values, and exposure to the finest productions of visual culture will inevitably follow.

1. The Syllabus

The following syllabus is deliberately quite abstract. Many different readings and visual examples could be employed to focus discussion, and it's highly unlikely that all the topics named here could be packed into a single year. There are also many possible topics that are not mentioned here, or different ways of formulating the topics listed. These are simply some of the topics that have surfaced most frequently in our discussions, arranged in a sequence that aims 1) to provide a cumulative acquisition of skills and concepts, from the most basic, general questions about visual culture (in the first term) to more specific, densely articulated areas in the subsequent terms; 2) to ensure a sequence of de-disciplinary juxtapositions or text/image "clusters" that cannot easily be referred to single fields of expertise.

The rubric of "Signs/Bodies/Worlds" could easily be replaced by other terms ("Visuality/Figure/Space," for instance). The terms are less important than the double purpose of sequential learning and transdisciplinary interaction.

VISUAL CULTURE:
SIGNS, BODIES, WORLDS

First Term: SIGNS: Images and Visuality; the Sign and the Image; the Visible and Readable; Iconography, Iconology, Iconicity; Visual Literacy; Visual Culture and Visual Nature; Visual Culture and Visual Civilization (mass culture vs. art; visual aesthetics vs. semiotics; hierarchies of visual culture); societies and spectacles; taxonomies and histories of visual media (a "natural history" of visual culture); Genres of Visual Art; Representation and Reproduction

Second Term: BODIES: Race, Vision, and the Body; Caricature and Character; Images of Violence/Violence of Images (iconoclasm; idolatry; fetishism; sacred, profane, and forbidden images; censorship, taboo, and stereotype); Sex and Gender in the Visual Field (the Naked and the Nude; the Gaze and the Glance); Gesture Language; Invisibility and Blindness; Pornography and Eroticism; the Body in Performance; the Display of Death; Transvestism and "Passing"; Images and Animals

Third Term: WORLDS: Institutions of the Visible; Images and Power (vision and ideology; the concept of the "visual regime"; perspective); Visual Media and Global Culture; Images and Nations; Landscape, Space (empire; travel; the sense of place); Museums, Theme Parks, Shopping Malls; The Circulation of the Visual Commodity; Images and Public Spheres; Architecture and the Built Environment; the Ownership of the Image

The first term is organized around the concept of the "sign," not in order to capture visual culture in the net of semiotics, but to raise the question of the visual sign, and thus of the whole relation between the visible and the readable. A basic aim of this term is to enhance the students' visual literacy, to give them tools for the interpretation of images and of visual experience more broadly conceived. Here also the basic questions of the course are broached: What is the boundary between visual culture and visual nature? What is an image? (are all images visual?) How do images function in consciousness, in memory, fantasy, and perception? What is the relation between visual images and visuality in general? What is a visual medium? How are the differences among media defined (on this question, incidentally, it is more a matter of eliciting students' tacit knowledge than of having them read authoritative texts; they are often quite sophisticated about media)? How do images communicate and signify? What is a work of visual art? What is the relation between art and visual culture in general? How do changes in the technologies of visual reproduction affect visual culture?

For some of these questions, the canonical texts will seem quite obvious. Walter Benjamin's "The Work of Art in the Age of Mechanical Reproduction" is probably unavoidable; the entire concept of "Visual Culture" seems unthinkable without his work. Erwin Panofsky's "Iconography and Iconology" is still a marvelous introduction to the interpretation of images, and his comparison of looking at painting to greeting other persons has deep resonances for the whole issue of visuality and alterity. The construction of visuality as a social field can then be elaborated in a number of directions: with a starting point in Sartre's critique of "the gaze" (in *Being and Nothingness*) one can move to Franz Fanon's "The Fact of Blackness," or the discussion of social "invisibility" in Ralph Ellison's prologue to *Invisible Man,* or one can take up Fanon's "Algeria Unveiled" for a discussion of the intersection of race and gender difference in the display and concealment of the (Algerian) woman. For the

discussion of "nature and culture" I have employed the texts on animal responses to painting by Pliny the Elder and Leonardo da Vinci: these have the virtue of showing that the nature/culture division in early texts on visual representation was not exactly an "objective" matter, but intricately involved with questions of politics and the construction of cultural "others." Ernst Gombrich's essay on "Nature and Convention" in the construction of visible images is useful for illustrating the "naturalist" argument in a modern context, and Norman Bryson's critique of Gombrich in his essay, "The Natural Attitude," provides arguments on the conventionalist side.

These are clearly not the only texts that might be used for discussion of the "natural" frontiers of visual culture. Bishop Berkeley's classic text, *Visible Language,* might be excerpted to illustrate the argument that visual perception as such is a learned, conventional, even "linguistic" practice. Rudolf Arnheim's work on automatic responses to basic visual forms (symmetry, sequencing, balance, motion, hierarchy, etc.) could certainly be useful, along with the rather different orientation of J. J. Gibson's work on visual perception. The point of these readings, clearly, is not just to place "authorities" before the students, but provocative texts that have to be read carefully and contextualized.

The key to the selection of texts, in my view, is that they speak to the question at hand, but in ways that will continue to resonate for other issues as well. For the question, "what is an image?" I have assigned the episode of the Golden Calf in Exodus. It not only has the virtue of providing a concrete example of what images do, how they affect their beholders; it also has the salutary effect of strangeness and familiarity —a sense of the uncanniness of the image. Some students will already know the text; most of them will think they already know what it says and means, and will be able to produce an account of its connection to (and difference from) modern accounts of idolatry and image-worship. They may not have noticed that the two accounts of the creation of the calf (as an artifice made by

Aaron and as a spontaneous, self-creating object) speak to the issue of "cultural" and "natural" accounts of image production. Or that the struggle between an invisible God who expresses himself in written signs, and visible gods who appear in material, natural forms, bears upon the relation of words and images, reading and seeing, that is the fundamental topic of the course. The Golden Calf can continue to be a touchstone for later topics (images and violence; mass spectacle and the public sphere) as the course proceeds. When the discussion arrives at the question, "what is visual art?" and begins to struggle with the relation of art and mass culture in (say) Clement Greenberg's "Avant Garde and Kitsch," the accusation of "philistinism" takes on a new depth, as do the remarks on idolatry and sublimity in Kant's aesthetics.

Texts such as Wittgenstein's discussion of the Duck-Rabbit and "seeing-as" in *Philosophical Investigations* can play a similarly multiple function. The Duck-Rabbit by itself is an excellent provocation to all sorts of concrete observations on the beholding of images: the role of beholder projection, the doubleness or ambiguity of images as material objects and "virtual" presences, the relation between looking and labelling, seeing and interpretation. Wittgenstein also puts the whole model of the spectator as a camera under the most severe scrutiny, a model that of course has a wide currency in numerous texts on the psychology of visual experience, and in accounts of the cultural impact of photography. If the Duck-Rabbit passages are juxtaposed with texts such as Locke's comparison of cognition to a *camera obscura* or Plato's Allegory of the Cave, the whole problematic of visual culture, models of spectatorship, and the apparatus of image production begins to come into focus.

2. Pedagogical Issues

It should be clear that visual culture needs to be taught by an interdisciplinary team, one that is willing to have regular staff meetings to discuss

materials, share knowledge, and explore common problems. A skeleton crew would consist of participants from film, literature, and art history, but resource persons in the social and natural sciences should be tapped as well.

As for the practical conduct of the class, I have just two suggestions. The first is that the amount of visual material be carefully measured. If a picture is worth a thousand words, then it may be possible to forego the lecture illustrated with a hundred slides, at least as a standard routine. The students are already distracted by thousands of images every day; the point of a critical approach to visual culture surely ought to be to encourage concentration, contemplation, and prolonged consideration of specific visual images and experiences. There is nothing wrong with spending an hour on one or two slides.

The second suggestion has to do with the production of visual examples and conceptual schemes for organizing the field of visual culture. Much of this material can be generated by the students. I'm a firm believer in adaptations of the fine old tradition of American elementary education, the ritual called "show and tell." (The very terms of this ritual, as it happens, echo the dialectic between language and the visual that is basic to visual culture.) In relation to each cluster of readings, students can be required to produce material examples of visual culture (texts, images, objects), and to explain their relevance in brief presentations. What are you likely to get if you ask students to bring in a contemporary image or object that has a cultural function similar to the Golden Calf? Don't be surprised if the students show up with a teddy-bear, a crucifix, a television set, a magazine ad, a reproduction of an old master, or a dinosaur action-figure. The key to the success of this tactic is, of course, the kind of explanation that comes with the example, and the ability of the group to make the examples cohere as a differentiated array: what is it they exemplify, and what do they amount to as an improvized collection, a kind of preliminary "field-work" in visual culture? Bad examples can make for good arguments, and vice versa.

It's important to realize that the students are capable of producing more than examples: they also command a body of terms, distinctions, prejudices, and assumptions about visuality and images that constitute their tacit knowledge of visual culture. If one asks them to map out their common understanding of the differences between kinds of visual art (painting, sculpture, architecture) or visual media (writing, printing, computer languages, graphic prints, photography, film, television) on a grid that correlates them with distinctions of audience, modes of production and consumption, cultural status, technical and material means, readability, etc., one finds a rich, if often unreflective, vocabulary. Making this vocabulary explicit will help the students see the relation of their understanding of visual culture to the arguments of (for instance) Lessing's *Laocoon*, that there are "time" arts of language, sound, and non-visual experiences, and "space" arts of visual representation. It may also open up the possibility of a historical sense of Lessing's attack on the "confusion" of space and time, language and vision, and its distance from our own moment when this confusion seems to reign supreme, when all information, visual or verbal, seems interchangeable in the digitalized flows of discourse networks.

I have also found it useful as a collaborative class project to compile a Glossary of Keywords in Visual Culture (somewhat on the model of Raymond Williams' *Keywords*) with each student responsible for providing a brief reference essay with bibliography on terms such as "idol," "icon," "gaze," "spectacle," "panopticon," "voyeurism," etc. This glossary can then be duplicated and circulated as a handbook for the use of the entire class. This project has several uses. It provides a common lexicon of definitions and contested concepts that will make discussions more efficient and rigorous. It engages the students in a writing assignment that is actually useful and public, destined for employment by their classmates rather than solitary evaluation by the instructor. In its complex network of cross-referencing, it provides a practical demonstration

of the collaborative process of knowledge production, and works (one hopes) to overcome the alienated, privatized, and fragmentary character of the typical "humanities" writing assignment.

3. Objections and Questions

It may be useful at this point to address some questions and objections that the notion of visual culture as a field, a curriculum, or a course of study are likely to arouse.

1. Isn't "visual culture" too broad and amorphous a rubric? One can't cover the history of visual art in a year, so how can one hope to do justice to such a wide-ranging topic? How can one even think of this as a "field" when the boundaries are still in question?

This question is based in the "coverage" model of instruction, one whose obsolescence is becoming evident even to college administrators. One can't, of course, "do justice" to even a single epoch of art history (modernism or the Renaissance) in a year. Scholars who spend a lifetime on these topics will know that the justice entailed by real coverage of a period, an artist, or a visual medium is an impossible standard. The point is not to "cover" the field of visual culture, but to introduce its central debates and dialectics—its various boundaries, both internal and external.

2. Isn't the highjacking of complex texts like the Allegory of the Cave or the Golden Calf for the purposes of an introduction to the basic issues of visual culture likely to neglect their historical specificity and the full intricacy of their meaning? Don't we run the risk of superficial readings which will reduce Plato's Cave to a simple polemic against visual images or flatten out the distinctions between our own culture and those of other places and times?

This question presents a more serious challenge. If it just means, however, that these texts

and images can only be "done justice" by experts, that only philosophers can teach Plato and only rabbinical scholars can teach the Bible, then we are back to square one. If it means that we have a responsibility to teach these texts and images well, to draw on expert resources where possible to enrich our presentations, and to help students grasp their internal complexity and external relations in the most refined way possible, then who would disagree? There is no way to construct a syllabus or a methodology that is invulnerable to simple-minded reductions of texts and images to "great ideas" or reassuring cliches. But one can construct a rich array of examples and questions that, as Stanley Cavell has put it with regard to movies, are worth teaching badly. If visual culture is a real subject, it will be worth at least that much.

3. Given the prevalence of visual culture in late twentieth-century daily life, isn't a course in this topic simply an act of collaboration and complicity with the "society of the spectacle"? Wouldn't we be better advised to insist that higher education maintain its commitment to verbal culture, to literature, fine art, and philosophy as opposed to things like advertising, television, and cinema, which the students will "get" as a matter of course, and which they already understand? Aren't we just "giving in" to popular demands in offering a course in visual culture?

If the course merely consists of an uncritical presentation of contemporary visual culture, and allows students to focus exclusively on the products of mass media, then it will certainly be a failure. But if it provides a critical perspective on these phenomena, places them in historical or analytic contexts, and makes explicit their relation to "high" art and elite forms of visual culture, it will enable intelligent resistance to mass media and a heightened (though less mystified) appreciation of the visual arts. As for the worry that students will somehow "miss" the traditional cultural values provided by literature, philosophy, and history, the course will have ample represen-

tation of these genres of writing, and it will have the virtue of connecting them to a coherent set of questions and problems, rather than merely assuming that it is good for students to read great books.

4. Isn't this course as presently conceived far too "Western" and Eurocentric in its emphasis on classic texts such as the Bible, Plato, Leonardo da Vinci, and classics of modern criticism and theory? Shouldn't the texts and images of non-Western cultures be more amply represented in the curriculum?

Yes. The course as presently described *is* excessively Eurocentric in its readings, if not in its principles. This will have to be corrected, not merely by "adding on" some representative samples of non-Western texts and images, but by making sure the dialectics of visual culture are more fully explored. The "other" of high modernist art, for instance, is not merely Clement Greenberg's kitsch and mass culture, but Meyer Schapiro's "primitive" art, specifically the art of Africa. The flows of influence, appropriation, and resistance between different visual cultures—Chinese landscape in 18th-century England, Haitian vernacular images in the New York art world of the eighties, postmodern museum design in Moscow in the nineties—must be explicitly thematized. Once again, "coverage" is out of the question; the point is to ensure that the problematics of cultural difference, and the role of visuality in those problematics, is foregrounded as a topic in itself, and inter-articulated with other topics.

I want to close with some reflections on the relation of visual culture, as conceived here, to Erwin Panofsky's influential formulations of the basic task of art history, particularly in his essay, "The History of Art as a Humanistic Discipline." Panofsky is widely regarded as the most universalist and all-embracing of art-historical theorists; he clearly recognized the need for art history to be interdisciplinary, to deal with "third-rate art"

as well as masterpieces, and to engage with philosophy in order to encourage theoretical self-reflection and avoid becoming a merely practical, connoisseurial, or curatorial profession. Yet Panofsky's authority and prestige have too often seemed to have just the opposite effect on the profession of art history, reinforcing its resistance to theory and to what are seen as incursions from other disciplines.

Panofsky's "The History of Art as a Humanistic Discipline" (in *The Meaning of the Humanities*, ed. T. M. Greene, 1940) was written at a time when "culture" could be (indeed, *had* to be) rigorously opposed to "nature," when "science" and the "humanities" were twinned but distinct disciplines, each charged with the task of overcoming "chaos" in order to construct a cosmic order: "science endeavors to transform the chaotic variety of natural phenomena into what may be called a cosmos of nature, the humanities endeavor to transform the chaotic variety of human records into what may be called a cosmos of culture." (6) He also wrote at a time when "culture" was a "discredited word," (2) under attack by barbarians on the left and the right, communism and fascism. The distinct mission of the humanities, the urgency of its preservation of the aesthetic sphere in the Kantian sense (Panofsky's essay begins with an anecdote of Kant's holding on to his sense of "Humanity" on his deathbed) is dramatized by its relation to a host of emergent anti-humanisms, rejections of bourgeois individualism, and of liberal ideology.

Now we write of the arts, and of visual culture, when liberal ideology has "won," when communists and fascists have been defeated or absorbed into the hegemony of a new world order, when capitalism and bourgeois individualism seem completely unopposed while "humanism" seems more obsolete than ever within the "humanities," and "culture" appears to be a universal solvent for all disciplines, media, and forms of life. Panofsky's clarity of moral, political, and disciplinary purpose now seems residual, archaic, even as its ideological foundations seem not

merely dominant, but without significant opposition. Perhaps this just shows that an ideology needs an antagonist against which to flex its muscles. But it surely also indicates that we occupy a different historical moment, one in which the boundaries and oppositions that could found a "history of art" have shifted quite drastically.

The boundaries that structure Panofsky's "humanistic discipline" are: 1) the division between nature and culture; 2) the Kantian categories of "space and time," historicized and relativized to produce autonomous, independent cultural traditions, or "frames of reference," generally based in ethnic or national identities (thus, "if we knew by some concatenation of circumstances that a certain Negro sculpture had been executed in 1510, it would be meaningless to say that it was 'contemporaneous' with Michelangelo's Sistine ceiling" [7]; and 3) the division between the work of art and non-art, the "monument" and the "document," the "primary material" of art history, and its "secondary material." Although Panofsky insists that "the art historian cannot make an a priori distinction between his approach to a 'masterpiece' and his approach to a 'mediocre' or 'inferior' work of art" (18), he never questions his equally a priori distinction between the work of art and other forms of visual culture.

Panofsky readily acknowledges that the logic underlying these distinctions is circular ("the beginning of our investigation always seems to presuppose the end, and the documents which should explain the monuments are just as enigmatical as the monuments themselves" [9]). Moreover, the identity of "monuments" and "documents" is relative to the disciplinary context: "everyone's 'monuments' are every one else's 'documents'"; for a legal historian, for instance, Panofsky thinks that a picture would be a mere document, while the contract commissioning the picture would be the "monument" (actually, this may show just how untransferable and discipline specific the notion of the Kantian artistic monument is, since it's highly unlikely that a legal historian would regard a contract as a "monument," though he might think of it as the primary thing to be explained).

Panofsky's notion of art, moreover, is not merely circular but self-contradictory. It begins with the familiar appeal to Kantian aestheticism, the opposition between the beautiful and the practical object, and the concept of aesthetic autonomy, the contemplation of an object "without relating it, intellectually or emotionally, to anything outside of itself"; "only he who simply and wholly abandons himself to the object of his perception will experience it aesthetically." (11) Since this means that, in principle, anything, even a work of nature, can be seen as a work of art (a tree, for instance), Panofsky needs to rescue his boundary by appealing to "intention" as a way of discriminating objects that "demand" to be experienced aesthetically, as from those (like trees or traffic lights) that we can, as a "personal matter," choose to experience this way. A "man-made object . . . either demands or does not demand to be . . . experienced" aesthetically. (11) Panofsky doesn't notice that this appeal to intention immediately undermines the principle of autonomy by relating the object to something (a "demand") located outside itself, and that it opens the door to the Duchampian readymade. He does concede on other grounds, however, that the appeal to intention solves nothing: intentions cannot, he admits, be defined or determined; they are relative to place and time; they are "inevitably influenced by our own attitude"; the very criteria for the "aesthetic" are notoriously shifty ("form" and "function" are the terms that are changing places in the moment of Panofsky's essay). Even the firm ethnic divisions of cultural relativism are under siege: "We have all seen with our own eyes the transference of spoons and fetishes of African tribes from the museums of ethnology into art exhibitions." (13) Panofsky rescues himself from the charges of circularity and self-contradiction by re-naming his position an "organic situation," a kind of pragmatic muddling through built on the cooperation of history, theory, and connoisseurship. And

who is to say that we, in the late twentieth century, are in a position to do much better? In fact, Panofsky's candor about the contradictions of his own "organic situation," his admission that neither art nor the discipline addressed to it can maintain its own boundaries or criteria with any rigor, are exactly what makes his essay now seem most up to date. It is the permeable boundaries between the various "insides" or "outsides" of disciplines that are most noticeable in the study of culture in the late twentieth century. The boundaries have eroded between the aesthetic and the non-aesthetic, between the museum of "art" and the museum of "natural history" or "technology," or (for that matter) between the museum and the department store or the theme park.

One can deplore these developments as a degradation of eternal standards, or as the predictable corruption of advanced capitalism; one can celebrate them as the hyper-fun of advanced postmodernism. Or one can do neither, and attempt to assess dialectically and historically the contemporary relations of artistic institutions to what lies outside them in what I have been calling "visual culture." This will not rescue us from the contradictions of what Panofsky called an "organic situation," but it might provide a way of making those contradictions the very subject matter of the field, rather than embarrassments to be finessed in the name of disciplinary coherence.

SCIENCE

Introduction

M. NORTON WISE

When Donald Kelley at this conference described the trajectory of recent historiography in terms of a passage through a house of many rooms—with social history moving into the kitchen, bedroom, and bathroom—his metaphor found ready reflection among other participants. It is an image that works well also for the history of science. This rather specialized subject emerged as a recognized field only in the early 1950s. At that time and continuing into the sixties, its subjects and methods were those of the history of ideas. Alexandre Koyré, with his idealist interpretation of Galileo's work and of the scientific revolution generally, stands as the undisputed godfather of the discipline in this early phase. Its practitioners pictured themselves, along with their subjects, as occupants of the study, more than any other room in the house, and they located the motive force of scientific development in the ideas and theories of individual genius. The work of Thomas Kuhn, although deeply indebted to Koyré, marks a sweeping turn away from this tradition between the first and second editions of his *Structure of Scientific Revolutions* (1962; 1970), when in the well-known "Postscript" his concept of "paradigm" settled down to a set of exemplary problem solutions, not a set of ideas and certainly nothing so sweeping as a world view.

By the late 1960s the history of ideas had been removed to the attic, where it remains a heritage more often honored than visited. Instead, historians of science have been making their own odyssey through the remaining rooms. Sharing intellectual movements with many other fields, they have made all the well-known turns: the anti-positivist turn, the social turn, the anthropological turn, and even the linguistic turn. These many shifts of emphasis and location had taken the field by the late 1980s from the attic of the mind into the basement as well as the kitchen, from where the plumbing and the furnace, like the stove and the washing machine, send their support systems through the house, attended by people of skill and technical knowledge. Attention has focused on the techniques, instruments, and practices that ground scientific investigation, highlighting the fact that knowledge is constituted by the capacity to build and to act as much as by the capacity to think.

Professor Gerda Panofsky made an apt observation at the conference. She had noticed that Fuld Hall, the main building at the Institute for Advanced Study, has two stones commemorating its birth, both located in the front wall. One at foundation level reads 1936; one on the second story reads 1934. Following this logic, the attic was built before the basement. The problems of that top-down view—that ideas and theory drive the scientific enterprise—are the ones that "science studies" (history, philosophy, sociology, and anthropology) have been wrestling with for some time, while elaborating the virtues of bottom-up construction.[1]

This movement continues to extend its reach. But quite recently new spaces have been opening up. Science studies have moved into the parlor and the garden, domains of discourse and of representation, and most recently into the TV room, where the media of simulation in popular culture look very like those in the computer graphics laboratories that are claiming central attention in all of the sciences. This journey

through alternative rooms has taken us away from the purity of forms, the search for essences of knowledge, which characterized both science and the history of its ideas during their modernist phase, lasting into the 1960s. That is the period in which Tony Grafton's "first Panofsky" (this volume) was fairly well known and when the concept of the Scientific Revolution defined many of the problems of the history of science. The discipline has since moved into the period of his "second Panofsky," where the messiness of history, the leaks in the roof and banging pipes in the basement, reflect on the structure of the house, undermining its purity; but where also the complex interactions going on in lived spaces heighten one's awareness of science as a cultural enterprise. Martin Kemp (in the essay that follows) describes similar alternatives available in Panofsky's writings, one stressing the "symbolic forms" of Ernst Cassirer's neo-Kantian program, the other the more empiricist resources of Edgar Wind.

So in opening up the whole house, we have become students of culture, prepared to interrelate activities in all of the rooms in order more fully to understand the resources upon which scientists have drawn to generate instruments and ideas for exploring the natural world, but also to understand their participation in the larger culture of economic, political, religious, and artistic action. One salutary effect has been an opening up of the visual domain, which the modernist aesthetic of purity and self-reference had reduced to a secondary, sometimes even degraded, but at least superficial means for expressing the truths of either nature or history. Sketches and drawings, although used constantly in scientific practice in a heuristic role, to work out structures for atoms and molecules, to suggest interactions, and to think about spatial and temporal relations, were from the late nineteenth century increasingly rejected as realistic depictions of objects supposed to underlie observable phenomena. So far as physics is concerned—and the fact that physics came to

be seen as the fundamental science, the foundation of all others, is here quite relevant—the movement that prioritized theoretical abstraction began with electromagnetic theory and thermodynamics and continued into relativity and quantum mechanics. In the process, visual representations were rejected as being constitutive, rather than merely illustrative, of scientific explanations.

This point can be made more concretely with two observations, one drawn from physics as the exemplary science, the other from science studies. Physics in the twentieth century, which can well be called "modernist" physics, has until recently made the simplicity and abstraction of Einstein's theory of relativity and of Heisenberg's and Schroedinger's theories of quantum mechanics into the epitome of scientific knowledge. Einstein himself expressed this view in a radically idealist form in 1934: "Nature is the realization of the simplest conceivable mathematical ideas. I am convinced that we can discover, by means of purely mathematical constructions, those concepts and those lawful connections between them which furnish the key to the understanding of natural phenomena. . . . In a certain sense, therefore, I hold it true that pure thought can grasp reality, as the ancients dreamed."[2] With this goal, the holy grail of physics became the unification of relativity and quantum mechanics in one grand mathematics for the world. It is important to recognize that this idealization of abstract universality has a history, that it did not gain ascendency without contest. A vehement debate raged especially in German scientific circles for over thirty years over whether *Anschaulichkeit*—connoting both intuitiveness and visualizability—ought to be a requirement for valid physical theory. This debate was part of the more familiar one over abstraction in art, which led to the infamous exhibition of degenerate art, *entartete Kunst*, from 1937. The "German physics" movement, which centered around experimentalists rather than theorists and held a strong position in

the early years of the Nazi regime, found a similar degeneracy in relativity and quantum mechanics. They attacked the *unanschaulich* and esoteric character of these theories with standard weapons, notably with anti-semitism but more generally with charges of betraying the realist and socialist values of the people. In physics as in art, however, *Unanschaulichkeit* won the contest in the long run and internationally.[3] Visual realism became a mark of the primitive, or of nostalgia for a lost security. Pictures not based on mathematical forms, but on mechanical models, for example, lost the persuasive force they had often had in the mid-nineteenth century.

The second observation is that science studies, which have often taken physics as their model science, have in many ways shared its values. *Isis*, the official journal of the history of science in the U.S., still contains very few pictures. Journals in philosophy of science typically contain none. Pictures that are printed serve illustrative purposes only; they are not treated as carrying argumentative weight on their own. They are not treated as text. And for that reason, perhaps, very few scholars in the past have paid much attention to the manner in which visual representations are made, nor to the meanings carried by artistic style.

But the move to cultural history is changing all of that. Within the last five to ten years, the work of art historians has become important for explanations of what has been depicted in the sciences, how it is depicted, and what content different modes of visual representation have contained. Both intellectually and historically, this concern continues the emphasis on instruments and practices but brings it more fully into the publicly accessible spaces of the house. In this context, a theme of renewed importance is one that Erwin Panofsky himself opened up: perspective drawing, and seeing, in the Renaissance (see Kemp), with attendant grids, strings, and other sighting devices to produce the required projections. These developments contributed directly to geometrical optics and indirectly to the representation of celestial and terrestrial motion in rectangular Euclidean space, with inertial motion in straight lines. Apparently it structured as well what has sometimes been called the "optical epistemology" articulated by Descartes, Locke, and Condillac, according to which our knowledge of the world should be regarded as a projection on the mind, like the projection of light rays on the retina effected by the eye.

This is only the most well-worked domain of art and science. Large books and important articles are regularly appearing which analyze everything from how artists' renderings expressed medical understanding of disease and the body in the eighteenth century, to the relation of physiology to cubist painting, to the symbiosis between Vienna-circle positivism and Bauhaus architecture.[4] Even more indicative of new directions, recent and projected conferences include: "Visualization in the Sciences" (Princeton, 1992–93), "The Architecture of Science" (Harvard, 1994), "Visualizing Science: Visual Representations in Science and Technology" (U. of Texas, 1994), and "The Visual Culture of Art and Science: From the Renaissance to the Present" (Royal Society, London, 1995). What will come of all this activity in the long run is uncertain, but it seems unlikely to go away soon, for it surely expresses the dramatic turn to visual modes of knowing and explaining in all areas of contemporary culture. Most apparent academically are the computer graphics spreading throughout the sciences, used not only to simulate dinosaurs for "Jurassic Park" but to design synthetic materials, to experiment on brain "tissue," and to explore the mathematical structure of fractal geometry. In each of these areas, the modes of representation used are crucial to the knowledge established. That recognition for the late twentieth century supplies great impetus for reexamining the role of visual culture in the sciences throughout history. Erwin Panofsky could only have been pleased to witness this change

in direction, for which he serves as a ready resource.

Notes

1. Examples are: Steven Shapin and Simon Schaffer, *Leviathan and the Air-Pump: Hobbes, Boyle, and the Experimental Life* (Princeton, 1985); Martin J. S. Rudwick, *The Great Devonian Controversy: The Shaping of Scientific Knowledge among Gentlemanly Specialists* (Chicago, 1985); Timothy Lenoir, ed., special issue of *Science in Context* 2, no. 1 (1988), on scientific practice; Crosbie Smith and M. Norton Wise, *Energy and Empire: A Biographical Study of Lord Kelvin* (Cambridge, Eng., 1989); Nancy Cartwright, *How the Laws of Physics Lie* (Oxford, 1983); Ian Hacking, *Representing and Intervening: Introductory Topics in Philosophy of Natural Science* (Cambridge, Eng., 1983); H. M. Collins, *Changing Order: Replication and Induction in Scientific Practice* (London, 1985); Bruno Latour, *Science in Action: How to Follow Scientists and Engineers through Society* (Cambridge, Mass., 1987).

2. For the quotation and its place in Einstein's methodological development, see Gerald Holton, "Mach, Einstein, and the Search for Reality," in his *Thematic Origins of Scientific Thought: Kepler to Einstein* (Cambridge, Mass., 1973), pp. 219–59, on 234.

3. M. Norton Wise, "Pascual Jordan: Quantum mechanics, Psychology, National Socialism," in M. Walker and M. Renneberg, eds., *Science, Technology, and National Socialism* (Cambridge University Press, 1994), 224–54.

4. Barbara Maria Stafford, *Body Criticism: Imaging the Unseen in Enlightenment Art and Medicine* (Cambridge, Mass., 1991); Anson Rabinbach, *The Human Motor: Energy, Fatigue, and the Origins of Modernity* (Berkeley, 1990); Peter Galison, "Aufbau/Bauhaus: Logical Positivism and Architectural Modernism," *Critical Inquiry* 16 (1990):709–52.

Relativity not Relativism: Some Thoughts on the Histories of Science and Art, Having Reread Panofsky[1]

MARTIN KEMP

To grasp reality we have to detach ourselves from the present. Philosophy and mathematics do this by building systems in a medium which is by definition not subject to time. Natural science and the humanities do it by creating those spatio-temporal structures which I have called the "cosmos of nature" and the "cosmos of culture."[2]

The writings of Erwin Panofsky consistently explore a number of leitmotifs which carry profound implications for anyone who is concerned about the relationships between science and the humanities. The themes he has explored not only concern the historical analysis of particular episodes but also involve the underlying issues of cognition and interpretation. Considering Panofsky in the context of science, we may think most readily of his analyses of the conception and representation of space, first tackled in its own right in *Die Perspektive als 'symbolische Form'* in 1924–5, and subsequently re-worked in various contexts, including his books on the art of Dürer and the Early Netherlandish painters. But he also essayed ambitious theses on the role of artists and art theory in the reform of the natural sciences in the Renaissance, on the role of aesthetic factors in the formulation of scientific models, on the definition of the relative scopes of the sciences and humanities, on the intrusions of the observer and the relativity of the available means of measurement, and on the fundamentals of our understanding temporal processes in relation to events, place, monuments, and documents.

This range of concerns might not come as too much of a surprise to anyone acquainted with the astonishing span of Ernst Cassirer's ambition to forge Kantian philosophy anew into a universal explanatory framework in the light of twentieth-century discoveries in all the major intellectual disciplines, not least modern physics and mathematics. The need for a new kind of history to match the new ideas on space and time was felt keenly in Germany in the years when Panofsky's intellectual foundations were being established, no more so than by Edgar Wind in a series of unjustly neglected contributions to the philosophy of science. What is more surprising—certainly to me when I came to ask how Panofsky's ideas had been handled within the history of science—is how meagerly his ideas have actually been acknowledged and developed during those postwar years which saw the historical study of science increasingly becoming an institutionalized discipline in its own right. If I am right in thinking that his ideas have exercised relatively little leverage in the history of science—assuming that there is no significant Panofskian school of which I am unaware—the question arises as to why this should be so. One answer might be that his ideas cannot be used to obtain an effective purchase on the material of science. If I were intending to accept this explanation, this essay would struggle to proceed any further. Another reason might be that historians of science who would

have found Panofskian tools appealing and indeed useful were simply unaware of their existence and missed their potential. I will be arguing that this is to some extent the case, but that it does not suffice as an adequate explanation. Rather it seems to me that the history of science has itself undergone a historical development which has so far worked against a truly fruitful dialogue with Panofsky. In the earlier phases of the history of science, when the narrative was couched largely in terms of the great discoveries, Panofsky's emphasis upon the contextual nature of cultural symbols—as "symbolic forms"—seemed to have little to do with the goals of science. Subsequently, as new forms of relativism have made inroads into the study of science within social frameworks, the impetuses have come from very different and more recent sources in European anthropology and philosophy of history, such as Lévi-Strauss, Foucault, and Derrida. If, as certainly happens in the history of art, Panofsky is re-read in the light of these recent developments, he may be belatedly welcomed as providing prestigious succour, even if he did not play a directly formative role in the new ideas. However, I will be arguing that both the earlier neglect and the belatedly benign welcome miss the point of what may be gained from a re-examination of Panofsky's ideas on science in history.

It is only fair to declare my hand at the start and say that I come to the task as a confirmed non-Kantian, and that what I am identifying as unrealised potential in Panofsky is probably not being drawn out of his work according to underlying criteria of which Panofsky would have approved.[3] However, providing this partiality is frankly acknowledged, I think that the perspective that emerges will show some aspects of his thought in a freshly productive light. (At least Panofsky himself would have been able to recognize and give a philosophical gloss to what I am calling a different "perspective.") My study will be cast in three parts. Firstly I shall be looking briefly at two instances where his ideas *might* have born fruit but did not, and asking why.

Then I will look at two related dialogues that did develop to some degree, above all in relation to his essay on "Galileo as a Critic of the Arts." Finally, more expansively and speculatively, I will look at notions of space-time in science and in the writing of history, with particular reference to the historical impact of the theories of relativity on the "cultural cosmos."

For the purposes of this exercise, I will be dealing only with published sources—with the public dialogues as conducted in print. There is, of course, a personal and biographical dimension that remains to be explored, particularly through Panofsky's correspondence. And there is also the fascinating question of what might be called his direct paternity of science—in terms of the scientific careers of his sons, Hans and Wolfgang. For the third section of this paper, Wolfgang's distinguished career in high energy physics may prove to be especially germane.

Two Missed Opportunities, Amongst Others?

There is no puzzle as to why philosophers and historians of science who identify in some measure with Karl Popper's influential model of falsification should not feel inclined to defer or even to refer to Panofsky. Indeed, for historians so inclined, the writings of Gombrich provide the natural point of reference, given the mutual congeniality of Popper's and Gombrich's theories of cultural processes in science and art. However, it came as something of a surprise to find that two of the more prominently radical voices in the revision of ideas of scientific change, Thomas Kuhn and Paul Feyerabend, seem not to have been alert to what Panofsky might have had to offer for their theories, but rather cited the apparently less compatible ideas of Gombrich. The theory of paradigm-maintenance in Kuhn's *The Structure of Scientific Revolutions*, first published in 1962, which relies upon a sense of the conceptual inertia of groups of scientists who

share a common perspective, might seem to share much in common with Panofsky's notion of the common depiction of space in a particular culture as founded on the paradigm of the "conception of space" presupposed by that culture.[4] As in Kuhn's paradigm shifts, the underlying theory has to be broken down before a new perspective supplies the dominant perceptual frame. Panofsky's description of what happened when the classical concept of space was superseded by the medieval vision, is potentially compatible with Kuhn's scheme:

> Whenever work on particular artistic problems has advanced so far that—proceeding from the suppositions once held valid—further work in the same direction seems fruitless, there tend to occur those great "relapses," or better changes of direction. . . . And between antiquity and modern times there stand the Middle Ages, the greatest of these "relapses."[5]

There is some problem as to whether we are dealing with problems of representation, ways of seeing or more abstract concepts—or with the dependence of the first two on the third, as Panofsky generally maintains—but it seems to me that Kuhn's argument about modes of "seeing" through the selective spectacles of dominant paradigms works far better with Panofsky's notion of perspective as a symbolic form than with Gombrich's "making and matching" in pictorial representation as detailed in *Art and Illusion*.[6] But it is Gombrich whom Kuhn cites when he wishes to adduce a parallel from the world of art.[7] Part of the explanation may lie in Kuhn's ringing rejection of relativism, a rejection he shares with Gombrich, but I suspect that the truth is more prosaic, and that his use of Gombrich relies upon the happenstance of the accessibility of Gombrich's ideas to Kuhn in a particular place and at a particular time.[8] We all tend opportunistically to exploit what comes to hand in particular circumstances, and do not necessarily search extensively for a model that can be exploited in a less

cavalier fashion, particularly when looking outside our own "field."

If the non-relativist Kuhn missed whatever was relevant in Panofsky, what about the thoroughgoing relativist like Feyerabend? Even if we suspect that Panofsky would have found Feyerabend's anarchism repugnant on traditionally humanistic grounds, there is nevertheless much in Panofsky's notion of the way our vision is shaped by a set of beliefs which are dominant at a particular time that could be pressed into service in Feyerabend's *Against Method* (1972). In the section where the humane anarchist talks of a simple configuration of three lines meeting at a vertex being seen as an illusion only after the cognitive revolution of the 7th to 5th centuries B.C., he relates knowing to seeing in a thoroughly Panofskian manner.[9] Indeed, Cassirer's theory of the transmutation of myth into symbolic forms, which provided the inspiration for Panofsky's treatise on perspective, could be manipulated to support Feyerabend's idea that "science is much closer to myth than a scientific philosophy is prepared to admit," though he actually underlines Cassirer's "assumption that science and myth obey different principles of formation"—rather missing Cassirer's emphasis upon the dialogue between the two modes.[10] Again however, it is Gombrich who is cited, on no less than three occasions.[11] The solitary citation of John White on ancient perspective certainly does not make up for the absence of Panofsky himself.[12] As in the case of Kuhn, the explanation for the choice of Gombrich over Panofsky by a writer whose ideas are anything but Gombrichian probably lies in accessibility and in the incestuous nature of the process of citation. *Art and Illusion* was a ready point of reference in the 1960s and 1970s in a way that Panofsky's 1924–5 paper was not. The work of another radical in the 1980s, Bruno Latour, confirms that this situation continues to persist. Latour cites Ivins, Arnheim, and Alpers on questions of seeing and representing, but the closest Panofsky comes to a mention is in Latour's citing of Edgerton's somewhat Panofskian views on perspective.[13]

From Art to Science

The essay by Panofsky that gained most effective entry into the history of science was one that is little read by art historians, namely his *Galileo as a Critic of the Arts,* first published as a 41-page booklet in the Hague in 1954, "in a comparatively small edition and primarily addressed to historians of art and art criticism" (as the author confessed).[14] It entered the domain of the history of science chiefly through its publication in an abridged version in *Isis,* at the instigation of the editor of the official journal of the History of Science Society.[15] Already, in its 1956 form it showed signs of having stimulated a fruitful dialogue. As the result of a review of the original booklet by Alexandre Koyré in *Critique* under the title "Attitude esthétique et pensée scientifique" and following direct personal correspondence, Panofsky added the subtitle, "Aesthetic Attitude and Scientific Thought."[16] The gist of Panofsky's argument, as it related to the history of science, was that Galileo's dogged adherence to circular orbits in the face of Kepler's advocacy of the physical reality of elliptical paths for the planets was the result of aesthetic preference—a consequence of Galileo's classicizing and anti-mannerist taste, as reflected in his close relationship with the Florentine painter, Ludovico Cigoli. As it happened, the same issue of *Isis* that carried Panofsky's essay, also contained Edward Rosen's rather crabby review of the original version.[17] Rosen's reaction contains strong indications of why the history of science, particularly as then practised in America, was not well placed to react creatively to Panofsky's ideas. Rosen indicted Panofsky on a number of counts—to adopt the legal terminology of Panofsky's own sprightly and erudite reply[18]—but he did not really confront the argument that Galileo's stance in a scientific controversy of the utmost importance was essentially "aesthetic" in nature. The concluding words of Rosen's review—"I am convinced that it [Panofsky's book] will appeal so strongly to several different classes of readers

that he will soon have to prepare a second edition, in which he may wish to modify some of his present statements"—hardly encouraged readers of *Isis* to think that the author was bringing something both new and of value to their discipline. However, in retrospect, not only was Panofsky's sophisticated historical analysis of Galileo's visual predispositions a relatively early example of the opening up of internalist histories of science, but his ingenious analysis of the frontispiece of Galileo's *Dialogue on the Great World Systems* was also a precocious contribution to a branch of the iconography of science that is only now beginning to bear full fruit.[19]

Koyré had given Panofsky's thesis a more agile and sympathetic welcome, recognizing that it had introduced a new element into a debate that had become rather ritualized. Panofsky was himself to contribute a characteristically ingenious essay to a volume of *Mélanges* in honour of the great historian of science, pointing to an association between Lelio Orsi, the painter, and the Gregorian reform of the calendar.[20] However, Panofsky's "aesthetic" thesis proved to warrant no more than a solitary footnote in one of his two fundamental books on the revolution in astronomy.[21] The most creative reaction from within the history of science appears to come from Gerald Holton in his volume of essays, the *Thematic Origins of Scientific Thought,* in 1973.[22] Accepting Panofsky's basic argument, Holton points out that "Galileo's decision to stick to circles" may "*on the surface of it*" appear to be a typically disappointing result of such transfers from arts to the sciences. However, Holton subsequently argues (not wholly convincingly) that a transfer may later prove to exercise a creative impact at a deeper level—as when, 200 years later, "Fourier discovered the fact that any function of a variable can be expanded in a series of sines of multiples of the variable, thereby enabling us to subject Keplerian motion to Galilean physics."[23] Although Holton is here developing his own extension of Panofsky's case, his argument was well in keeping with Panofsky's own analysis of

what I would term "transfers of latent efficacy" from art to science. Indeed, the thesis had been framed by Panofsky in something like this form with respect to a more general aspect of the Galilean revolution, namely the envisaging of space.

Panofsky's contention that pictorial perspective as invented in the early fifteenth century precociously embodied the essence of the new concept of infinity as defined in science almost 200 years later is well known, and will be addressed within a different context in the last section of this essay. In a number of other places—most conspicuously in his essay on "Artist, Scientist, Genius: Notes on the Renaissance-Dämmerung," in his monograph on Dürer, and in his analysis of the Leonardesque Codex Huygens—he advocated the hypothesis that there were central facets in the Renaissance revolution in the visual arts that were to have a formative impact upon the rise of certain types of science.[24] The two key facets were the depiction of nature and the visual mathematics of Renaissance art. Panofsky explained that the new theoretical agendas of Renaissance art required that the artists needed to be informed of "how things are" and "how they may be reproduced." The first of these desiderata "falls clearly within the province of what we now know as the natural sciences; but since these were practically non-existent by the end of the Middle Ages, the theorists of art themselves had to become natural scientists." The second "was of a purely mathematical character; it resulted in that discipline which more than anything else deserves the title of a Renaissance phenomenon, perspective."[25] Stated baldly, the thesis of the scientific primacy of Renaissance art seems to ride roughshod over medieval science, and is in danger of retrospectively imputing motifs to artists in the light of later scientific developments. However, in Panofsky's hands, it is supported by a characteristic body of learning, subtle reference and suggestive outlines of an explanatory framework. One of the most important parts of this framework is his discussion of science in the ver-

nacular and the role of the artisanal tradition in the rise of early modern science—themes that have indeed proved fruitful. Another important suggestion, though not fully developed, is that the *via moderna* of the North—"that nominalistic philosophy which claimed that the quality of reality belongs exclusively to the particular things directly perceived through the senses and to the particular psychological states directly known through inner experience"—related specifically to the particularizing vision of the natural sciences as prefigured in Netherlandish naturalism, while the Platonizing inclinations of influential Italian philosophers nourished the idealizing and mathematical tendencies of Italian art and Galilean science.[26]

In his Dürer monograph, Panofsky teases out three stands in the mathematical impulse in Renaissance art and theory. The first is a "curious inward correspondence" between geometrical perspective and the *Weltanschauung* of the period, with its sense of historical distance and its giving of priority to the individual observer; the second is a general "craving for exactness of predictability" (though the nature and origins of this "craving" are not explained); and thirdly he notes the correspondence between the ordering of forms in geometrical systems of representation and the harmonic theory of beauty which was being developed on antique precedents.[27] The combined impulse does not come *from* the sciences. Indeed, he is at pains to emphasize that classical and medieval optical science was not "concerned with problems of artistic representation."[28] Rather, the alliance of mathematical theory and practical procedures leads *towards* the new sciences of Galileo and his fellow reformers.

The idea that the sciences were re-directed by the theory and practice of the visual arts has gained some adherents in the history of science, though sympathetic authors such as Alastair Crombie have seen the artistic and scientific revolutions as "exemplary products of the same intellectual culture" rather than characterizing art and science in terms of cause and effect.[29]

Wholehearted advocates of Panofsky's thesis appear to be limited to those who approach the Scientific Revolution primarily by way of representation in art, such as James Ackerman, Samuel Edgerton, and Kim Veltman.[30] Edgerton even speculates that "without linear perspective . . . Western man" would not "have been able to visualize and then construct the complex machinery that moved him out of the Newtonian paradigm into the new era of Einsteinian outer space—and outer time."[31] Although I do not subscribe to the view that perspective or other tools of artistic naturalism precipitated the new sciences, I am far from claiming that the riddle of Panofsky's "curious inward correspondence" can be dismissed, and it is still far from solved. The complex dialogues between vision, visualization, quantification, and representation in the Renaissance—dialogues that Panofsky did more than anyone to highlight—remain live issues of the utmost importance in our understanding of how the sciences of the earth and of the heavens were reshaped.

Space-time

Panofsky's *Die Perspektive als "symbolische Form"* is itself what would have been termed an "event" in time and space. Through the writings of Cassirer, he would have been conscious of their own work in the great historical succession of theories of cognition of space, involving such luminaries as Descartes, Bishop Berkeley, and Kant.[32] Cassirer himself consciously attempted to rescue Kant's sense of space as a pure intuition of the human mind from the collapse of the Euclidian parameters which Kant had taken as fundamental. It was this problem that Cassirer directly addressed in his *Zur Einsteinschen Relativätstheorie*, and it plays a significant role in his more famous *The Philosophy of Symbolic Forms*, particularly in the third volume.[33] In making a fundamental distinction between sensory or "physiological" space and the abstract conceptions of "metrical"

space which involve the non-sensory qualities of "continuity, infinity and uniformity," Cassirer laid the groundwork for the subsequent invasion of space as a purely "functional" concept by the Einsteinian theory of relativity.[34] Modern physics has "left definitively the realm of representation and representability in general for a more abstract realm." Cassirer not only cited Einstein directly, but also Arthur Eddington, who did so much to consolidate the theory of relativity in the scientific community, and Hermann Weyl, whom he quotes with particular enthusiasm:

> Intuitive space and time may not serve as the medium in which the physics of the external world is constructed, but are replaced by a four-dimensional continuum in the abstract, arithmetical sense. Whereas for Huyghens the colors were "really" vibrations of the ether, now they appear only as mathematical, functional processes of a periodic character: and in these functions four independent variables appear as representatives of the spatiotemporal medium related to coordinates. Thus what remains is ultimately a symbolic construction in the exact sense as that carried out by Hilbert in mathematics.[35]

Cassirer quoted Eddington specifically to the effect that in modern space-time "the world is represented no longer as a coexistence of thing unities but as an order of 'events.'"[36] Further referring to Whitehead, he emphasized that the "world is no longer taken as a world of constant 'things' whose attributes change in time; it has become a self-contained system of 'events,' each of which is determined by four equivalent coordinates which are 'indissolubly linked and are definable only in respect to one another.'"[37] If anything, quantum mechanics takes this process of conceptual abstraction a stage further: "in its most recent form it [quantum mechanics] seems to renounce all 'representation' of the processes within the atom, and all spatial images in general."[38] This further move is seen as "the first necessary step toward a new mode of formation

and conceptual unity." Cassirer's footnote refers the reader to Max Planck.[39] It is not hard to anticipate Cassirer's next strategy, which was to characterize relativity as a subject of the perceiving mind, not as a variable sensory perception but as "a genuine transcendental idea in the Kantian sense":

> The world view of the older physicists shows itself to be not absolutely valid but conceived from a particular standpoint of observers who are relatively at rest in relation to one another. If instead of this standpoint we introduce systems of reference that are in motion relative to one another, all the fixed "attribute concepts" that were valid for the classical view must undergo a shift, a variation. It is not only the so-called sensuous qualities that show this kind of dependency on the state of the perceiving subject; according to the special theory of relativity, the magnitude, form, mass, and energy content of the thing also change with the observer's state of motion.[40]

Thus the scientific content of the theory of relativity has to do with the relativity of object and subject, but—and this is the really important conclusion for Cassirer—on an epistemological level relativity represents the purest realization of Kant's philosophy.

Obviously in *Die Perspektive* Panofsky is not so directly concerned with the Einsteinian revolution, since he is looking at the antique-mediaeval-Renaissance steps towards the metrical kind of functional space that imputed the notion of infinity, but there are clear pointers to the genesis of his thesis at the very time when Cassirer and others were integrating the theories of relativity into a framework of Kantian philosophy. Following a passage in which Panofsky quotes at length from Cassirer, who was in turn quoting in part from Ernst Mach, Panofsky suggests that,

> The precise construction of perspective entails a fundamental abstraction from the structure of psycho-physiological space. It is not only the end result of perspective but also its purpose to realise that homogeneity and infinitude—which the immediate experience of space knows nothing about—in a representation, and simultaneously to transform the space of psycho-physiology into that of mathematics. It thus negates the difference between front and behind, right and left, bodies and intervening space ("free space"), in order to dissolve the totality of parts and contents of space into a single "quantum continuum."[41]

The phrase "quantum continuum" is an odd one—even self contradictory. I have not traced its source, and suspect that it may be of Panofsky's own contriving, to carry the implication that perspectival space is an abstraction which not only embodies Galilean infinity but can also be extended to embrace more modern concepts of space-time. His continued concern to bring his idea of spatial perception and representation into harmony with the latest ideas in science is reflected in *Early Netherlandish Painting,* where he cites a 1948 study by Luneburg to the effect that "binocular visual space is a finite piece of a 'hyperbolic Rimemannian space.'"[42] By now, however, he does not imply that linear perspective presents a kind of "quantum continuum" in a truly modern sense, but that we should look to cubism and its derivatives to arrive at a manifestation of relativity in the visual arts:

> It was only with Picasso and his more or less avowed followers, that an attempt was made to open up the fourth dimension of time so that the objects cease to be determinable by three coordinates alone and can present themselves in any number of aspects and in all states of either "becoming" or disintegrating.[43]

This potentially fascinating equation, dropped characteristically into a footnote, has been the subject of subsequent if inconclusive explora-

tions.[44] Given that Panofsky was based in the same Institute as Einstein by the time he wrote his suggestive note, I greatly regret that he does not seem to have explored it further—or perhaps it was the very presence of Einstein, and Panofsky's direct access to the very font of knowledge of what relativity actually meant that deterred further exploration of an idea that is difficult to develop beyond a facile level.

There is clearly further potential in the kind of juxtapositions of spatial representations, perceptions, intuitions, and theories that Panofsky attempted in *Die Perspektive*—even without accepting his own philosophical stance. Indeed, the potential may not unreasonably be described as infinite in its own right. But there is another area in which Panofsky brought scientific insights to bear upon "non-science" that seems not only to be rather neglected but also to have the potential to bring Panofsky's ideas into some kind of commensurability with more empiricist philosophies. This area concerns discussion of the nature of history itself as a method for organizing our view of the world.

At the center of the most fundamental statement of his principles as a historian—in "The History of Art as a Humanist Discipline"—is a sustained comparison of science and the humanities as ways of ordering each respective cosmos. He recognizes a fundamental difference between the temporal aspirations of natural science which "observes the time-bound processes of nature and tries to apprehend the timeless laws according to which they unfold" and those of the humanities, which "are not faced with the task of arresting what would otherwise slip away, but of enlivening what would otherwise remain dead."[45] But there are fundamental senses in which the ordering of one cosmos exhibits "some very striking analogies" with the ordering of the other.[46] Although the following list of Panofsky's analogies inevitably does some violence to the fluency of his presentation, I think it will help to clarify the nature of his shared processes and their relationship to Einsteinian relativity:

1) just as there is relativity in the data of science, so there is in the raw material of history. There is a class of historian who is interested in "events," and for whom all available records (assuming they are considered relevant) become "documents," while the cultural historian focuses on chosen "monuments" (say the writings of Petrarch) in relation to which someone else's "monument" becomes a "document" (say an illuminated manuscript of Petrarch's *Trionfi*);

2) "pre-selection" of what can be observed is dictated by the theory or concept to be explored and by the underlying assumptions of method in both fields;

3) the instruments with which the scientist observes are themselves subject to the laws of nature, just as the historian's documents are "themselves produced in the course of the process which he wants to investigate";

4) the processes of decoding and classification are common in their basic demands on the investigator's cognitive apparatus;

5) underlying all these endeavors in history are the relativities of time and space, which mean that "the year 1400 means something different in Venice from what it means in Florence" or elsewhere. "The very concept of simultaneity would be as meaningless in history as it would in physics" without a shared "frame of reference."

The aggregate result of these relativities is a process in which the beginning presupposes the end, and in which everything is calibrated in relation to other variable scales. As Panofsky confesses, "we are apparently faced with a hopeless vicious circle"—what I would regard as the vicious circle that is inherent in all relativism.[47] Yet, Panofsky argues, "this situation is by no means a permanent deadlock." I believe that his solution demonstrates his adherence to a theory of cultural relativity but not to a philosophy of relativism, and that it stands in an important relationship to the ideas of Edgar Wind, whom Cassirer rightly suspected of strong empiricist leanings. Let us first look at Panofsky's solution:

Every discovery of an unknown historical fact, and every new interpretation of a known one, will either "fit in" with the prevalent general conception, and thereby corroborate and enrich it, or else it will entail a subtle, or even a fundamental change in the prevalent general conception, and thereby throw light on all that has been known before. In both cases the "system that makes sense" operates as a consistent yet elastic organism, comparable to a living animal as opposed to its single limbs; and what is true of the relationship between monuments, documents and a general historical concept in the humanities is evidently equally true of the relationship between phenomena, instruments and theory in the natural sciences.[48]

Introducing this discussion, Panofsky refers the reader by way of footnote to Wind's little-studied but highly impressive *Habilitationsschrift* (1929) on the philosophy of science, *Das Experiment und die Metaphysik,* published in 1934, and to his more summary treatment of the same questions in "Some Points of Contact between History and Natural Science" in a volume of essays presented to Cassirer in 1936 (which also contains Panofsky's own "Et in Arcadia Ego").[49] I do not have the opportunity here to do justice to the central arguments of Wind's book, which re-examined the Kantian "Antinomies" in the light of relativity—with reference to many of the same sources used by Cassirer himself, including Eddington, Whitehead, and Poincaré. Suffice it to say that the notions I have extracted in outline from Panofsky's essay are all essentially present, though cast even more overtly in the terms of scientific relativity, particularly with respect to the analogy between "document" and "instrument," "the intrusion of the observer" and the act of interpretation as an "event." Wind's own solution to the potentially "vicious circle" owes something to the pragmatism of Charles Pierce and William James, and much to Alfred North Whitehead, Gauss, and Riemann.[50] For Wind, Cassirer's

"symbols" only assume final value in building up an organic body of internally consistent knowledge if they can be embodied in an *experimentum crucis* which generates outcomes that can be directly observed.[51] The indivisibility of the boundary between observer and observed, and their reactive interdependence, is not the basis for relativism but provides the grounds for ever more rigorous and self-aware experimental scrutinies. Experiment becomes a vehicle through which an understanding of "the self-transformation of man" may more accurately be characterized. Wind relies on the concept of "implicit determination ('*innere Grenzsetzung*') which defines the relation of 'part to whole' in such a way that any proposition concerning the structures of the 'whole' can be tested in terms of the behaviour of the parts. . . . Even propositions which refer to the *whole of the world* do imply an experimental meaning which can be exactly defined and tested."[52] A key piece of evidence for the experimental basis of relativity was the so-called "Michelson-Morely Experiment," which was widely interpreted as exercising a formative role on Einstein's theory, notwithstanding Einstein's own rather variable testimony on this point.[53]

It would be wrong—appealing though I might personally find it—to draw Panofsky too far along the path of Wind's experimentalism, but Panofsky's sense of the modification of the whole organism of knowledge to "fit in" new data regarding its parts shares much in common with Wind's radical re-writing of Kantian "Antinomies" in the light of new theories of space-time. And this re-writing is closer to what I take to be the stance of Einstein than Cassirer's exploiting of relativity in the service of symbolic forms. Panofsky's way out of the "vicious circle" also, dare I say, exhibits some characteristics which are commensurate with "making and matching" in the Popperian and Gombrichian sense—although Gombrich is of course justified in identifying something ultimately irreconcilable in Panofsky's and his own epistemologies.[54]

What I think can be recognized in the joint en-

deavours by Panofsky and Wind in the 1930s to re-define the nature of the science and humanities as non-circular pursuits in the light of the new kinds of physics is the establishing of a radical research program which has barely been recognized, let alone seriously commenced. The prospect, as yet distant, is of a historical and contemporary understanding of space-time in terms of successive and simultaneous perceptions over the ages—an understanding founded upon a self-conscious awareness of "the intrusion of the observer" be it in the person of the historian or the scientist or the artist. Recent reception theory has made some inroads into the question of the intrusive observer, but in a way that tends to work against a direct confrontation between the historian and (what I am prepared to characterise in a traditional way) the primary phenomenon. The intellectual demands of a new history of space-time are so daunting, even for a single period like the Renaissance, that it seems as if we need to await the advent of a scholar with Panofsky's levels of synoptic and analytical power.

Notes

1. I am grateful to Professor Kathleen Weil-Garris-Brandt, who read this article in draft and made valuable suggestions.

I think it will be helpful to give a working definition of relativism, as used in this essay. The 1982 *Supplement to the Oxford English Dictionary* provides a helpful if rather flat definition of "historical relativism" as "the view that there can be no objective standard of historical truth, as the interpretation of data must be affected by subjective factors characteristic either of the historian or the period in which he works"; and "cultural relativism" as "the theory that there can be no objective standards by which to evaluate a culture; that a culture cannot be understood except from the point of view of its own values and customs; the practice of studying a culture from such a viewpoint." To these I would wish to add a definition of "representational relativism" as "the theory that there can be no objective way of judging the relationship between a representation and what it purports to represent, since what is seen as reality in a given culture is definable only in terms of its specific modes of representation."

2. E. Panofsky, "The History of Art as a Humanistic Discipline," in *Meaning in the Visual Arts* (Harmondsworth, 1970), 24; originally in *The Meaning of the Humanities*, ed. T. Greene (Princeton, 1940), 89–118.

3. For my own stance, see "The Taking and Use of Evidence, with a Botticellian Case Study," *The Art Journal* 44 (1984):207–15; and review of M. Baxandall, *Patterns of Intention* in *Zeitschrift für Kunstgeschichte* 50 (1987):131–42.

4. E. Panofsky, *Early Netherlandish Painting. Its Origin and Character*, 2 vols. (New York 1971), I:5 (originally Cambridge, Mass., 1953). T. Kuhn, *The Structure of Scientific Revolutions*, 2nd ed. (Chicago, 1970 [1962]).

5. E. Panofsky, *Perspective as Symbolic Form*, trs. C. Wood (New York, 1991), 47 (originally "Perspektive als 'symbolische Form,'" *Vörtrage der Bibliothek Warburg*, 1924–5. [Leipzig and Berlin, 1927], 258–330). I have drawn upon the translation of Wood and more directly upon a translation completed earlier by Matthew Rampley during the course of his doctoral studies in St. Andrews.

6. For a use of Kuhn within a Panofskian framework, see S. Y. Edgerton Jr., *The Renaissance Rediscovery of Linear Perspective* (New York, 1975), 162–3.

7. *Scientific Revolutions*, 161, citing *Art and Illusion* as demonstrating the "inventions . . . that made possible successively more perfect representations of nature." Yet Kuhn (p. 127) is also happy to draw upon the work of Nelson Goodman, whose ideas of representation stand in sharp contradiction to Gombrich's.

8. For Kuhn's rejection of relativism, see "Reflections on my Critics," *Criticism and the Growth of Knowledge*, ed. I. Lakatos and A. Musgrave (Cambridge, 1970), 234.

9. P. Feyerabend, *Against Method. An Outline of an Anarchistic Theory of Knowledge* (London, 1978 [1972]), 261–2.

10. *Against Method*, 297.

11. *Against Method*, 132, 226, and 235.

12. *Against Method*, 268, citing J. White, *Perspective in Ancient Drawing and Painting* (London, 1965).

13. B. Latour, "Drawing Things Together," *Representation in Scientific Practice*, ed. M. Lynch and S. Woolgar (Cambridge, Mass., 1990), 28, citing S. Y. Edgerton, Jr., "The Renaissance Artist as Quantifier," in *The Perception of Pictures*, 2 vols., ed. M. Hagen (New York, 1980) I: 179–212. Edgerton's *Rediscovery* is also listed in Latour's bibliography, 65. The other citations are to W. Ivins, Jr., *Prints and Visual Communication* (Cambridge, Mass., 1953), and *On the Rationalization of Sight* (New York, 1973); R. Arnheim, *Visual Thinking* (Berkeley, 1969); and S. Alpers, *The Art of Describing* (Chicago, 1983).

14. E. Panofsky, *Galileo as a Critic of the Arts* (The Hague, 1954). There have been two Italian translations: *Galileo critico d'arte*, intro. R. Micheli and L. Tongiorgi Tomasi, *Dimensioni* 2 (1982); and *Galileo critico delle arti*, ed. M. Mazzi (Venice, 1985).

15. "Galileo as a Critic of the Arts. Aesthetic Attitude and

Scientific Thought," *Isis* 47 (1956):3–15, after illness had prevented its delivery at the History of Science Society in Washington in 1955.

16. A. Koyré, "Attitude esthétique et pensée scientifique," *Critique* 9, xiii, 100–101 (1955): 835–47. Koyré, like Rosen, recognized that Galileo's lack of direct discussion of Kepler's ideas poses problems for Panofsky's thesis.

17. E. Rosen, review of Panofsky's *Galileo* in *Isis* 47 (1956): 76–80.

18. E. Panofsky, "More on Galileo and the Arts," *Isis* 47 (1956):182–85.

19. See, for instance, I. Lavin "Bernini's Cosmic Eagle," in *Gianlorenzo Bernini. New Aspects of his Art and Thought. A Commemorative Volume* (University Park, 1985) 209–14; W. Ashworth, Jr., "Divine Reflections and Profane Refractions: Images of a Scientific Impasse in Seventeenth-Century Italy," *Gianlorenzo Bernini,* 179–95, and his forthcoming book, *Emblematic Imagery of the Scientific Revolution*; and G. Broberg, "Natural History Frontispieces and Ecology," *Natural Sciences and the Arts,* ed. A. Ellenius (Stockholm, 1985), 84–97. For other studies that variously draw upon Panofsky's "Galileo," see M. Chappell, "Cigoli, Gallileo and Invidia," *Art Bulletin* 57 (1975):91–98; S. Y. Edgerton, Jr., "The Geometrization of Astronomical Space: Galileo, Cigoli, Florentine *Disegno*," and "The Strange Spottedness of the Moon," in *The Heritage of Giotto's Geometry. Art and Science on the Eve of the Scientific Revolution* (Ithaca, 1991), 223–53; and M. Kemp, *The Science of Art. Optical Themes in Western Art from Brunelleschi to Seurat* (New Haven and London, 1992), 93–96.

20. E. Panofsky, "*Sol aequinoctalis fuit creatus.* Notes on a Composition by Lelio Orsi and its Possible Connection with the Gergorian Calendar Reform," *Mélanges Alexandre Koyré,* 2 vols. (Histoire de la pensée, XIII), II:360–80.

21. E. Koyré, *From the Closed World to the Infinite Universe* (New York, 1958); *The Astronomical Revolution: Copernicus, Kepler, Borelli,* trs. R. Maddison (Ithaca, 1973), 514 n.9, for the citing of Panofsky's study.

22. G. Holton, *Thematic Origins of Scientific Thought. Kepler to Einstein* (Cambridge, Mass., 1973).

23. *Thematic Origins,* 434.

24. E. Panofsky, "Artist, Scientist, Genius: Notes on the Renaissance-Dämmerung," *The Renaissance. A Symposium,* ed. W. Ferguson (New York, 1953), 77–93; *The Life and Art of Albrecht Dürer* (Princeton, 1955 [1943]), 242–73 (developing his own *Dürers Kunsttheorie, vornehmlich in ihren Verhältnis zur Kunsttheorie der Italienen* [Berlin, 1915]); and *The Codex Huygens and Leonardo da Vinci's Art Theory,* Studies of the Warburg Institute, XIII (London, 1940), 90–118.

25. *Dürer,* 244.

26. *Early Netherlandish Painting,* 8.

27. *Dürer,* 261.

28. *Dürer,* 249.

29. A. Crombie, "Science and the Arts in the Renaissance: The Search for Truth and Certainty, Old and New," *Science and the Arts in the Renaissance,* ed. J. Shirley and F. D. Hoeniger (Cranbury, N.J., 1985), 15–16.

30. J. Ackerman, "Artists in Renaissance Science," *Science and the Arts,* 94–129; Edgerton, *Rediscovery,* and *The Heritage of Giotto's Geometry*; K. Veltman, *Studies on Leonardo da Vinci I. Linear Perspective and the Visual Dimensions of Art and Science* (Berlin, 1986).

31. *Rediscovery,* 165.

32. For Panofsky and Cassirer, see M. Podro, *The Critical Historians of Art,* (New Haven and London, 1982), 181–92; M. A. Holly, *Erwin Panofsky and the Foundations of Art History* (Ithaca, 1984), 114–57; and S. Ferretti, *Cassirer, Panofsky, and Warburg. Symbol, Art and History,* trs. R. Pierce (New Haven and London, 1989), 142–236.

33. E. Cassirer, *Zur Einsteinschen Relativtätstheorie* (Berlin, 1921; trs. W. and M. Swabey in *Substance and Function,* Chicago, 1923); and *Philosophe der symbolischen Formen* (Berlin, 1923, 1925 and 1929; trs. R. Manheim, *The Philosophy of Symbolic Forms,* 3 vols. [New Haven and London, 1953, 1955 and 1957]). See also J. Krois, *Cassirer: Symbolic Forms and History* (New Haven and London, 1987).

34. *Symbolic Forms,* II:83f.

35. *Symbolic Forms,* III:467–68, Cassirer cites H. Weyl, "Philosophie der Mathematik und Naturwissenschaft," *Handbuch der Philosophie,* 80. See also D. Hilbert, *Neubegründung der Mathematik* (Leipzig and Berlin).

36. *Symbolic Forms,* III, 467, citing A. Eddington, *Space, Time and Gravitation* (Cambridge, Cambridge University Press), 12ff. and 184ff.

37. *Symbolic Forms,* III:472, citing A. N. Whitehead, *An Enquiry Concerning the Principles of Natural Knowledge* (Cambridge, 1925).

38. *Symbolic Forms,* III:475.

39. *Symbolic Forms,* III:475n.85, citing M. Planck, "Verhältnis der Theorien zeeinander," *Kultur der gegenwart* (Leipzig and Berlin, 1915).

40. *Symbolic Forms,* III:477.

41. *Perspective,* 31, citing Cassirer, *Symbolischen Formen,* II:107–8 (*Symbolic Forms,* II:83–84), in turn citing E. Mach, *Erkenntnis und Irrtum* (Leipzig, 1905), 334. The phrase "quantum continuum" also appears in *Perspective,* 44.

42. *Early Netherlandish Painting,* 12, citing Luneburg, "Metric Methods in Binocular Vision Perception," *Studies and Essays Presented to R. Courant on his 60th. Birthday,* (New York, 1958), 125.

43. *Early Netherlandish Painting,* 5n.1.

44. For the most sustained examination of this question, see L. D. Henderson, *The Fourth Dimension and Non-Euclidian Geometry in Modern Art* (Princeton, 1983). And for two contrasting approaches, see A. Keller, "Continuity and Discontinuity in Early Twentieth-Century Physics and Early Twentieth-Century Painting," and G. Mermoz, "On the Synchronism between Ar-

tistic and Scientific Ideas and Practices: an Exploration of Hypotheses, 1900–1930s," both in *Common Denominators in Art and Science*, ed. M. Pollock (Aberdeen, 1983), 97–106 and 134–44. See also the good discussion by A. Miller, "Aesthetics and Representation in Art and Science," *Languages of Design* 2 (1994): 13–37.

45. *Meaning*, 24.

46. *Meaning*, 6.

47. *Meaning*, 9.

48. *Meaning*, 9–10.

49. E. Wind, *Das Experiment und die Metaphysik* (Tübingen, 1934), and "Some Points of Contact between History and Natural Science," *Philosophy and History. Essays Presented to Ernst Cassirer*, ed. R. Klibansky and H. Paton (Oxford, 1936), 255–64. See also Wind's "Can the Antinomies be Restated?"

Psyche 14 (1934):177–8.

50. For an outline of Wind's philosophical development, see H. Lloyd-Jones' introduction to the collection of Wind's essays, *The Eloquence of Symbols*, ed. J. Anderson (Oxford, 1983), xii–xxvi; and B. Buschendorf, "Nachwort" to Wind's *Heidnische Mysterien in der Renaissance* (Frankfurt am Main, 1981), 396–415.

51. *Experiment*, 33.

52. *Psyche*, 177.

53. *Experiment*, 32. Compare Holton, *Thematic Origins*, 261–352.

54. See particularly, E. H. Gombrich, "*Idea* in the Theory of Art: Philosophy or Rhetoric," *Idea* VI Colloquio Internazionale, ed. M. Fattori and M. Bianchi (1989):411–20.

English Gardens in Berlin: Aesthetics, Technology, Power

M. NORTON WISE

With the defeat of Napoleon sealed in Paris in 1814, Prussia began to represent its victory to itself in a variety of cultural forms, stressing always its distance from "French" values and its intention to join Britain in the pursuit of industrial power. Landscape gardens provided fertile ground for such representations. Between 1815 and 1850 numerous gardens were constructed or reconstructed in the naturalistic "English" style in Berlin and Potsdam. The largest belonged to the Hohenzollern royal family. They were built by two famous architects in the departments of gardens and of buildings in the royal administration, the landscape architect Peter Josef Lenné and the building architect Karl Friedrich Schinkel. Designed for display on a massive scale, these immense works of art exist today as public parks, somewhat like Kensington Park or Regency Park in London but even more like the great estates at Windsor Castle or Stowe.

English gardens in Berlin, however, contain a striking anomaly in comparison with those in England: they all feature buildings that once housed steam engines. Focusing largely on these engine houses, I will give a highly abbreviated version of a larger story about the role of the gardens in the transfer of steam technology from England to Prussia. I will attempt to show how the gardens served aesthetically to integrate steam engines into Prussian culture by representing the engine in Prussian terms and by identifying engine power with Prussian power.

A sense of size is helpful at the outset. Looking East over the River Havel near Potsdam, a present-day visitor encounters a scene much like that painted in 1845 by August Haun. This natural-looking landscape of forested hills, however, is almost entirely artificial. It consists of two immense gardens (which continue to the left in the second half of the panorama, not shown). In the center sits the palace at *Glienicke*, designed by Schinkel for Prince Carl, the anglophile third son of King Friedrich Wilhelm III, who died in 1840. The tower rising to the left of the palace is the engine house of *Glienicke*. On the right, occupying the hill behind the Glienicke Bridge (of spy-trading fame during the cold war), is *Babelsberg*, where the new castle designed by Schinkel for the second son, Prince Wilhelm, sits on the hill. Its engine house appears just to the right of the small paddle steamer on the river. This striking black presence is the *Alexandra,* used by the royal family, under Friedrich Wilhelm IV from 1840, to travel from the palaces and gardens at *Sanssouci* in Potsdam (off to the right) to a third splendid garden on the *Pfaueninsel* (to the left), where yet another engine house marked the shoreline.[1] The tranquil vista is a product of steam, and it celebrates its generative force. The painting reiterates that celebration, as do numerous others from the same period.

This interpretive theme has already been expressed for *Glienicke* by a remarkable nineteenth-century witness, Helmut von Moltke. The later

Figure 1. Panorama of Glienicke from the West, A. C. Hahn, about 1845

Field Marshal and Count, famed for his role in the Austrian and Franco-Prussian wars, visited Prince Carl in 1841 and wrote the following account to his wife. "I wish I could escort you around in this exquisite park. For as far as the eye can see, the grass is of the freshest green; the hills are crowned with beautiful deciduous trees; and the stream and the lakes weave their blue ribbon through a landscape in which castles and villas, gardens and vineyards lie scattered. Certainly the *Glienicke* park is one of the most beautiful in Germany." Here the garden presents its face of peaceful beauty. But power lies beneath the romantic production and surges forth in the Count's exposition.

"It is unbelievable what art has known how to make out of this barren earth. A steam engine works from morning til night to lift the water out of the river Havel up to the sandy heights and to create lush meadows where without the engine only weeds of the heath [heather] would survive.

A powerful cascade roars over cliffs under the arch of a bridge [*Teufelsbrücke* or bridge of the devil], half washed away, seemingly from its violence, and abruptly rages fifty feet down to the Havel onto a terrain where prudent Mother Nature would not have thought to let a pail of water flow, because the parched sand would have immediately swallowed it. Trees forty feet high are planted where they would have had to stand forty years to achieve this mightiness. Scattered around lie enormous boulders, which one day geologists will give up guessing about if notice has not reached them that they wandered here from Westphalia through Bremen and Hamburg [i.e., by barge, over rivers and canals to Berlin]."[2]

Thus the steam engine brings forth "Nature." Its creation is unmistakably a work of technical art. But it is just the technological character of this masterwork, in its extravagance and perfection, that von Moltke appreciates. The engine makes beauty and power where the original of Mother

Figure 2. "Teufelsbrücke," A. Lompeck, 1852

Nature would not have allowed them to exist, any more than she would have brought boulders through several hundred miles of equally artificial canal-linked waterways, or would have installed mighty trees on a sandhill. If this world-creating engine is not directly viewed, its presence is nevertheless everywhere felt through the irony of naturalistic artificiality that it creates. Its house too, as will become apparent below, is designed for admiration, like the body of a powerful automobile.

Prince Carl had purchased *Glienicke* in 1824 following the death of its former owner, Prince Hardenberg, Prussian chancellor from 1810–1822 and the architect of a famous program of economic reform in that period. Hardenberg himself had rented *Glienicke* from 1811, but was able to purchase it only after his triumphal entry into Paris with Friedrich Wilhelm III in 1814, when he was raised to princely status. It was Hardenberg who commissioned the young Lenné in 1816 to help him turn the estate into a showpiece of naturalistic freedom in the English style and of simultaneous economic liberalism (coupled with political conservatism). Into his landscape he integrated a brick and tile manufactory employing over sixty workers. It was located not far from his pleasure garden, which he outfitted with a horse-powered irrigation and fountain system featuring the latest in experimental technology, including several hundred feet of cast zinc pipe (which corroded within three years and had to be replaced).[3] This combination of aesthetics, economics, and technological modernization characterized Hardenberg's policy for all of Prussia. It continued to develop (albeit with substantial opposition) under administrators who got their start in his government. Thirty years later this policy had produced the showpiece landscape depicted in the panorama above. In it we should recognize some of the cultural foundations for Prussia's industrial revolution, which entered its "takeoff" phase by the mid-forties. By then, Berlin's entrepreneurs and their ministerial promotors could see themselves as young challengers to the British industrial monopoly.

No doubt Hardenberg would have preferred a steam engine to power his garden, but not only were there no engine builders in Berlin in 1816, there were no engines either, or rather there was precisely one, at the Royal China Factory (KPM). English engines were prohibitively expensive to import and impossible to maintain, unless one brought over an English mechanic as well. The first Prussian steamboat, for example, was built in Berlin in 1816 by an imported Englishman named John Barnett Humphrey and was fitted with an imported English engine. For exorbitant fees, Humphrey carried passengers between Potsdam and Berlin, until 1824 when his Steamboat Travel Co. went bankrupt. The situation for manufacturing engines was equally grim. Hardenberg therefore devoted considerable energy to overcoming this economically debilitating deficiency in the technologies of iron and steam. His ministry invented numerous schemes for promoting engine building, engine use, and engine espionage. For example, they sent the promising young mechanic F. A. J. Egells to England on a study tour of machine works with the expectation that he would then establish his own works in Berlin, which he did by 1825.[4] Simultaneously, however, they were sending Lenné and Schinkel on tours of English gardens and buildings with similar modernizing intentions. Much of this activity was organized through the Ministry of Trade and Industry under Hans von Bülow, where they installed in 1819 an ambitious young administrative entrepreneur named Peter Beuth to head the Technical Division for Industry.

Among his numerous projects, P. C. W. Beuth established in 1821 a new school of trade and industry, the *Gewerbeschule* or Technical Institute, whose students spent part of their time apprenticed to newly established machine builders such as Egells before they went on to establish their own firms. Schinkel too maintained a considerable presence at the *Gewerbeschule*, both professionally and as a close friend of Beuth. His main duties, however, were at the *Bauakademie*, or School of Architecture, a sister institution of the *Gewerbeschule*. Thus there existed a modernizing

Figure 3. "The Aesthetic View from Pegasus," K. F. Schinkel

network of associations and friendships extending from some of the highest ministers to low but rising mechanics and across the middle administrative level from Lenné to Schinkel to Beuth, and including such prominent scientific figures as Alexander von Humboldt. A good indicator of this network is the membership of the *Verein zur Beförderung des Gewerbefleisses* (Union for the Advancement of Industry) organized by Beuth. By 1840 the *Verein* included all of the royal princes except Wilhelm, a variety of liberal ministers and advisors such as von Humboldt, industrially ori-

ented professors of science and technology who taught at both the university and practical schools, such as Gustav Magnus the teacher of Hermann Helmholtz, and a wide variety of trading and manufacturing people, including those in the new iron and machine industries like Egells and Borsig (below).

Aesthetics played a prominent role in both the *Verein* and the *Gewerbeschule*, and in the technological exhibitions that they mounted in 1822, 1827, and 1844. Schinkel set the standard but Beuth led the movement. He pursued inexhaust-

ibly the vision of an industrial culture integrated organically into the landscape of rural towns, avoiding the horrors of the British "Coketowns" while gaining the civility of a materially comfortable and spiritually refined citizenry. One of Beuth's assistants described their goal as "to integrate art with industry," and Schinkel painted him in 1837 as a Greek god riding Pegasus over a factory town.[5] The principle of the complementarity of utility and aesthetics was one that Lenné also sought to realize in his steam-powered gardens and in the institutions for gardening culture, set up to parallel Beuth's institutions for industrial culture: the *Verein zur Beförderung des Gartenbaues* (1822), in which Lenné played a leading role, and the *Gärtnerschule* (or *Königlichen Gärtner-Lehranstalt zu Schöneberg und Potsdam*, 1823), which he established and directed.[6]

When Prince Carl obtained *Glienicke* in 1824, the efforts of Hardenberg's government to modernize Prussian society were just beginning to pay off. Carl immediately set out to display his support for the newly emerging economic and aesthetic order: by commissioning Schinkel to rebuild his house and Lenné to extend his English garden; by attempting to acquire, through Humphrey's bankruptcy, an English steam engine to power the garden; and by sprinkling English phrases in his conversation and letters. Successful with house and garden, he failed initially with the engine, for unknown reasons.[7] By the midthirties, however, Egells had his Berlin engine works in full operation. The process of representing the power of Prussia to remake itself through the power of steam to remake nature accelerated rapidly.

At *Glienicke* in 1836–38, Schinkel's favored student and heir apparent Ludwig Persius housed the new 18 horsepower engine and its full-time mechanic in a lovely Italianesque structure on the bank descending to the Havel. The picture shows implicitly something that should be remarked more often about steam engines at this time. The working engine included not only its machinery proper, but also its house and its keeper. They

formed an integral system. An appropriate analogy might be a locomotive in motion, with engineer and stoker at their work. Thus building a house for a pumping engine was nothing like building a garage for a car. The structure of the house typically *was* the support structure for the engine, pumps, smokestack, piping, and a reservoir, as well as an apartment for the mechanic and his family, to keep him in constant attention. In figure 4 the machinery is at lower left. The tower contains the smokestack, and on successive floors: (1) coal storage, (2&3) the apartment of the attendant, (4) a belevedere looking out over the Havel, and (5) a water reservoir of 1800 ft^3. On the far right is the garden house, with an apartment for the full-time gardener.[8] To unite the technical requirements of this system with the aesthetic requirements of the estate was a demanding architectural task.

From this pumping system ran a network of cast iron pipes to feed the fountains, lakes, and streams of the garden, as well as its plants. In addition, one pipe filled a special reservoir on the hill to supply a torrent of water for the remarkable display at the *Teufelsbrücke* that von Moltke described. Prince Carl loved pageantry. On special occasions his "fleet," consisting of a three-masted schooner kept permanently anchored in front of the engine house and a variety of smaller boats, would parade in front of the estate bedecked with colorful flags. He enjoyed also assimilating his engine to the mythical powers of the German *Volk* and its warrior heroes, in what would look now like a Wagnerian *Gesamtkunstwerk*. One should imagine a group of favored guests arriving via steamboat on the Havel. As they approached, masses of water penned up in the special reservoir would be let loose down a gorge and over the cliff to crash fifty feet below on the shore directly in front of them, while the Prince's cannons boomed out a ten-gun salute.[9]

Such elaborate effects were no doubt exceptional. Carl's brothers, however, went to considerable lengths also to incorporate engines into

Figure 4. Engine house at Glienicke today

their visions of themselves and Prussia. The most romantic and politically conservative of these projections is *Babelsberg,* where Schinkel and Persius, after numerous frustrations with their employers, produced a version of a medieval castle for Prince Wilhelm (later Kaiser Wilhelm I) and Princess Augusta. Lenné initiated the large garden, although again not to the satisfaction of Wilhelm and Augusta, who preferred the Gothic designs of their friend Prince Hermann Pückler-Muskau. These politically reactionary aristocrats looked to the mythical German past for their symbols of power and directed their architects accordingly. Schinkel and Lenné, as avid modernizers, failed to appreciate their aesthetic taste.

After Schinkel's death in 1841, Persius received

the commission to build an engine house for Babelsberg in a compatible style. Completed in 1845, it supported a large pumping engine of forty horsepower from Egells. Among its functions, the engine filled a large reservoir high on the hill, from where the water descended with great pressure to drive a magnificent fountain, rising 130 feet from the River Havel in front of the castle.[10] (Wilhelm thereby bettered his brother King Friedrich Wilhelm IV in possessing the most powerful geyser in the family.)

In a more modern style, Schinkel remodeled a palace in the city for the youngest Prince Albrecht. Lenné designed the garden, for which Schinkel added a neo-classical engine house directly adjacent to the palace. Its elegant chimney

Figure 5. Engine house at Babelsberg, Carl Graeb, 1853

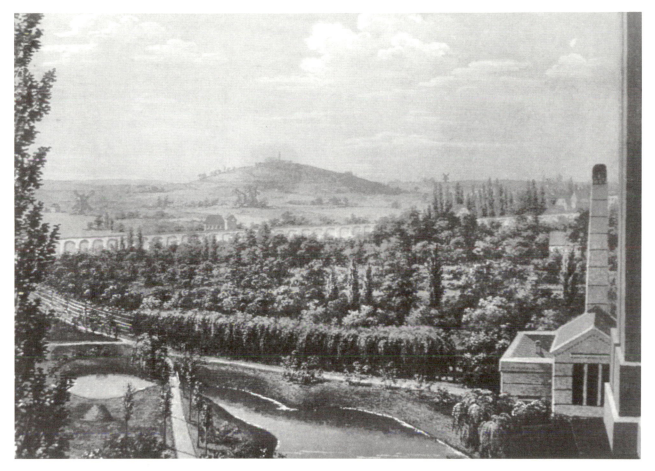

Figure 6. Prince Albrecht Palais, toward Kreuzberg, about 1835

stands sentinel over the water which the machinery moves and which fills the foreground.[11] In the background rises *Kreuzberg*, the hill south of the city on which stands a remarkable memorial to the war of independence against Napoleon.

Schinkel designed the memorial in 1818. It is actually the remnant of a grand cathedral which he had originally proposed to honor Prussia and its people in their great victory. The symbolic remnant preserves only one tower, and that one in iron rather than stone. On top stands the iron cross, a giant version of the famous medal that

Schinkel had designed for Friedrich Wilhelm III in 1813. The iron is important. It celebrated first of all the loyalty of the King's subjects in turning in their jewelry to support the war in return for cast iron rings and patriotic medals. But it celebrated also the coming economy of iron and steam, as it pushed the technological capacity of the Royal Foundry to its limits to cast the complex figures that stand in the niches around the monument in memory of twelve crucial battles. These heroic figures have faces modeled on those of the king, his family, and his generals.[12] Thinking of all this

from Prince Albrecht's palace in the city, one can imagine him looking out over his engine house and garden toward *Kreuzberg,* where he could almost see his family immortalized in iron beneath the iron cross, a picture simultaneously of Prussian independence, economic development, and military strength.

If these symbols are becoming too obvious, they may nevertheless merit one more look, in Schinkel's (and Lenné's) most exquisite production for the Hohenzollern princes and the earliest with an engine, this one for Crown Prince Friedrich Wilhelm IV, completed in 1827 with interior modifications through the 30s. Called *Charlottenhof,* it is a small house and garden near the enormous *Neue Palais* of Friedrich Wilhelm III at *Sanssouci.* Schinkel lavished his attention on every detail of this intimate retreat for his friends the Crown Prince and Princess, not only on the building but on its interior: chairs, sofas, tables, chandelier, desks, etc., perhaps in part because Friedrich Wilhelm IV was himself an architect of some talent. Deeply religious in their lives and their tastes, the royal couple covered the walls with reproductions of famous biblical scenes from the Italian Renaissance, especially by Raphael and Michelangelo. I want to call attention, however, to a particular element, also full of religious symbolism, that figures throughout the design: candelabra. Most dramatically, as the visual focus looking out from the house and terrace toward a large pond (far left in figure 8), Schinkel installed a stately candelabrum atop a broad pedestal. It constituted the smokestack on a low-lying house for a three horsepower engine.[13]

This unusual presentation established the eastern pole on the east-west axis of the design, the pole of the rising sun and of daylight, a theme reinforced in the light blue walls and ceiling of the portico on the eastern side of the house. Sitting in the portico, one would look out across the

Figure 7. The Kreuzberg monument today

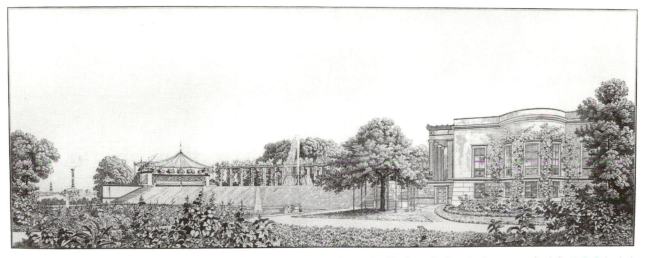

Figure 8. Charlottenhof, with chimney at far left, K. F. Schinkel

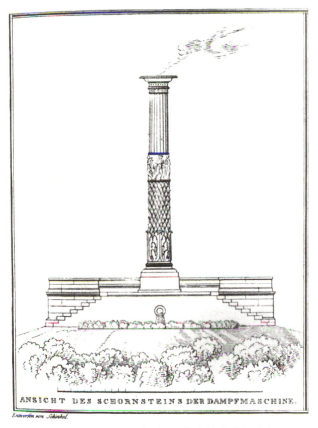

ANSICHT DES SCHORNSTEINS DER DAMPFMASCHINE.

Entworfen von Schinkel.

Figure 9. Engine house at Charlottenhof, K. F. Schinkel

formal terrace with large dish and fountain to the candelabrum of the engine, complete with decorative wisps of smoke trailing in the wind, at least in Schinkel's imagination. At the opposite pole is the entrance to the house, where he repeated these themes a bit later on a smaller scale.

In the entry hall one faces another large dish with fountain which nestles between dual stairways on either side. On the railings at the top, two tall, gold-gilt candelabra (1835) stand as the symbolic lights for this space of the setting sun and of nighttime, represented over the doorway in a dark blue window carrying a field of stars. Ascending the staircase and moving left, one comes to the Crown Prince's bedchamber, with figures of Christ, Elija, and Moses (after Raphael) above the headboard. Here Schinkel redid the candelabra as bedposts (1828), and with a new meaning. They now protected the Crown Prince's sleep and supported the Prussian eagle, symbol of monarchical power.[14]

Considered as a whole, then, the candelabra at *Charlottenhof* unite religious devotion with the powers of engines and the Prussian state in one of the most aesthetically pleasing of all Schinkel's

Figure 10. Bedroom of Friedrich Wilhelm IV at Charlottenhof today

designs. If the point needed reiteration that engine houses did not hide the engines, but instead naturalized and even celebrated their presence among cherished images of Prussian tradition, *Charlottenhof* would supply convincing evidence.

But the point goes further. Engine architecture for the gardens of the Hohenzollern princes not only legitimized the present in terms of the past, as it did for the latecomer Prince Wilhelm at *Babelsberg* in 1845, it projected a vision of the future in which iron and engines would support an aesthetically pleasing version of an industrial culture. When the Crown Prince and his brothers

Carl and Albrecht joined Beuth's Union for the Advancement of Industry they aligned themselves symbolically with the most liberal faction of the state administration. But when they integrated engines into their gardens between 1827 and 1837 they went beyond symbolism to put their personal financial resources behind the entrepreneurial spirit that Beuth was promoting. Schinkel and Lenné applied their creative energy to designing that spirit into the material reality of the landscape, to render the vision visible in interior and exterior space.

The most dramatic example of this reified sym-

Figure 11. The great fountain at Sanssouci, Johannes Rabe, 1845

bolism, however, was yet to come, not on the personal estates of the princes but in the most lavish garden of the state itself, namely *Sanssouci,* built originally by Frederick the Great in an attempt to rival Versaille. Lenné had begun its transformation from the formal French style, with broad straight avenues and geometrical symmetry, to the natural curves and textures of the English style soon after the War of Independence. And already in 1819 he and John Barnett Humphrey had tried to sell Friedrich Wilhelm III on an English engine to supply irrigation and a fountain rising 45 feet in the air. They argued for the unity of utility and aesthetics in such an installation, as well as for the economy of the engine. But Friedrich thought Humphrey's price of 11,500 taler a poor showing of economy. Besides, he noted, the engine would destroy the livelihood of the peasants who watered the garden with buckets.[15] *Sanssouci* had to wait for the Crown Prince to ascend the throne in 1840.

When Friedrich Wilhelm IV took up Lenné's plan for a complex system of fountains and waterworks for the buildings and gardens of *Sanssouci,* a master German machine builder of the second generation had come into the market. Educated partly in Beuth's *Gewerbeschule* in the early twenties and for ten years in Egells' shop, August Borsig set up independently in 1837 with two horses to power his iron works. But he was soon building heavy-duty machines and engines with an eye toward locomotive construction. A year later he had constructed a stunning 80 horsepower engine for *Sanssouci,* one of the largest and certainly the most elegant in Prussia. It drove fourteen pumps simultaneously to send water through two 10-inch diameter pipes at over 2 atmospheres pressure, part of it going directly to the gardens and fountains and part to a large reservoir high on a hill behind the palace (the *Ruinenberg,* which provided a vista of "ancient" ruins). Returning from this reservoir, the

water could be distributed throughout the gardens and fountains, but most spectacularly it drove a great spout 126 feet into the sky, reaching higher than the roof of the palace on the hill behind it.[16]

The symbol bespoke its origins. Behind this overwhelming geyser stood an engine for a new political economy. Its power had been doubled on the advice of Beuth, who never missed an opportunity to promote industry with art. Persius (on orders from Friedrich Wilhelm IV) housed it in a comparably imposing building, an exotic mosque with a minaret for a chimney. He intended the engine to be seen and honored inside its temple, where it sat beneath the dome in what would normally have been the central place of worship.[17]

Visitors entered through the front door to marvel at its grandeur. The ornate columns and arches of this space, which are also the main support members of the machine, exhibit its dynamic action against a background of Moorish decoration extending to the top of the dome. The elaborately transposed religious display inevitably suggests, however sacriligously, the presence of a new spiritual power. And indeed, the crowds of visitors who came to view its wonders were taught to see it in that light. A tourist guide of 1843 likened the idea of building the fountains and engine to "the spark of heavenly fire which Prometheus, son of a Titan, stole from the gods in order to animate his human model of clay and earth."[18]

Figure 12. Engine house at Sanssouci, Ferdinand Marohn, 1845

Figure 13. Borsig's engine at Sanssouci today, Manfred Hamm

Figure 14. The Prussian eagle as the governor of the engine at Sanssouci

symbolically present in the form of the Prussian eagle poised above the governor that regulated the giant machine.

Domestic industry had been able to construct the entire engine with only two colossal cranks imported from England. "We are justifiably delighted at this advance of German national industry, as one of the proofs of how Germany more and more emancipates itself from the British industrial monopoly that has prevailed until now." Even more specifically, German national industry appeared here in the shape of Borsig's machine works, which was expanding as fast as the railroads. In 1844 he produced his twenty-fourth locomotive, a new and widely admired design which won a first prize at the Berlin Industrial Exhibition. He named it "Beuth." By 1854, when he died of a stroke, his firm had built 500 locomotives.[20] Entrepreneurial capitalism was flourishing in Berlin. With it came a change in the steam-powered garden.

In 1847, just prior to the revolutions that briefly swept away the old order, Borsig moved much of his operation to Moabit, north of the city, where Schinkel and Lenné were laying out a new multi-use suburb and where some of the newly wealthy were establishing themselves. There, in the midst of his works, Borsig built his own villa on the banks of the Spree with the architectural assistance of another Schinkel student, Johann Heinrich Strack. Spreading before the house and down to the river was a garden designed by Lenné himself. Fairly small to be sure, it nevertheless contained an extensive *Wasserkunst*, including an impressive fountain shooting into the air, driven by one of the engines in the plant. In greenhouses constructed of glass and cast iron, also from the plant, and warmed by its drainage water, Borsig pursued his avocation of exotic plant culture, sharing his accomplishments with Lenné, Beuth, and other members of the Union for the Advancement of Horticulture, which he had joined in 1835. In 1852 he brought into bloom the first *Victoria Regia* in Berlin.[21]

The English garden in Borsig's hands repre-

To fully appreciate this godlike quality, visitors were advised to go and stand before the engine and gaze up at its ominously quiet operation, ensured by hardwood gear teeth meshing with iron. "The hushed quiet and uniform motion of the imposing masses and forces of this hydraulic steam engine arouse a stirring of amazement at the vast power of the human spirit, which itself knows how to put the elements to use, to accomplish truly titanic work without strain."[19] The human spirit is here specifically the German spirit,

Figure 15. "Das Borsigsche Etablissement," J. M. Kolb, 1854

sented something quite new. If earlier it had projected the symbols of British achievement into German culture through the medium of princely power, it announced here the attained economic power of entrepreneurs and engines in a transformed German state. No longer did the engine simply power the garden and project a new culture, it paid for the garden and powered the culture. The middle class had begun to imitate princes and to compete with them for possession of the symbols that had figured so importantly in their own rise to prominence, if not yet to political power.

Notes

1. August C. Hahn, after Wilhelm Schirmer. I thank the staff of the Plankammer of the Staatliche Schlösser und Gärten Berlins, Charlottenburg (hereafter SSGB), for their considerable assistance and for permission to reproduce this and other pictures below. Described by Michael Seiler, in the catalog of the 1987 exhibition, *Schloss Glienicke* (Berlin, 1987), p. 425, cat. no. 312.

2. Helmut von Moltke, *Gesammelte Schriften und Denkwürdigkeiten des General-Feldmarschalls Grafen Helmuth von Moltke*, vol. 6, *Briefe*, 3. Sammlung (Berlin, 1892), quoted in Klaus von Krosigk and Heinz Wiegand, *Glienicke* (Berlin, 1984), p. 47. Painting of the *Teufelsbrücke* by A. Lompeck,

1852, SSGB; described by Michael Seiler, *Schloss Glienicke*, 413, cat. no. 281.

3. Michael Seiler, "Entstehungsgeschichte des Landschaftsgartens Klein-Glienicke," in *Schloss Glienicke*, 109–156, p. 114.

4. Conrad Matschoss, *Die Entwicklung der Dampfmaschine: Eine Geschichte der ortsfesten Dampfmaschine und der Lokomobile, der Schiffsmaschine und Lokomotive*, 2 vols. (Berlin, 1908), 1:172f., 176f.

5. Eric Dorn Brose, *The Politics of Technological Change in Prussia: Out of the Shadow of Antiquity, 1809–1848* (Princeton, 1993), ch. 3, "The Aesthetic View from Pegasus," gives a most illuminating account of Beuth's activities; quotation, p. 115; Schinkel's painting, p. 99, from Conrad Matschoss, *Preussens Gewerbeförderung und ihre Grossen Männer* (Berlin, 1921), p. 72. On the significance of the Beuth network for the natural sciences in Berlin, see Robert M. Brain and M. Norton Wise, "Muscles and Engines: Indicator Diagrams and Helmholtz's Graphical Methods," in Lorenz Krüger, ed., *Universalgenie Helmholtz: Rückblick nach 100 Jahren* (Berlin, 1994), 124–45.

6. Gert Gröning, "Peter Joseph Lenné und der 'Verein zur Beförderung des Gartenbaues in den Königlich Preussischen Staaten'," and Hans Joachim Wefeld, "Peter Joseph Lenné und die erste Gärtnerschule," in Florian von Buttlar (ed.), catalog of the exhibition, *Peter Joseph Lenné, Volkspark und Arkadien* (Berlin, 1989), 82–90 and 91–97.

7. Seiler, "Entstehungsgeschichte," 138.

8. Tilo Eggeling, "Ludwig Persius als Architekt in Glienicke," in *Schloss Glienicke*, 63–79, pp. 66–71. Sabine Bohle-Heintzenberg and Manfred Hamm, *Ludwig Persius, Architekt des Königs* (Berlin, 1993), pp. 17–19.

9. Seiler, "Entstehungsgeschichte," 141, 149, citing *Journal über Glienicke*, entry of 1862.

10. Bohle-Heintzenberg and Hamm, *Persius*, 21, 79–80, 162. Painting by Carl Graeb, 1853, SSGB.

11. Unknown artist, about 1835, SSGB, Nachlass Sievers. Made originally with a camera obscura, the picture is reversed. Buttlar, *Lenné*, p. 208, cat. no. 93.

12. Michael Nungesser, *Das Denkmal auf dem Kreuzberg von Karl Friedrich Schinkel* (Berlin, 1987), 22–30.

13. Drawings from Karl Friedrich Schinkel, *Sammlung Architektonischer Entwürfe* (Berlin, 1866), plates 109–112. Details of interior furnishings in Hans Hoffmann, *Schloss Charlottenhof und die Römische Bäder*, 3rd ed., revised by Renate Möller (Potsdam, 1991), *passim*; engine, p. 7. On Friedrich Wilhelm IV as architect, see Bohle-Heintzenberg and Mann, *Persius*, 9–11, 51–65.

14. Picture from Hoffmann, *Schloss Charlottenhof*, p. 29. I am grateful to Elaine Wise for pointing out how Schinkel continued the candelabrum theme throughout his design.

15. Gerhard Hinz, *Peter Joseph Lenné und seine bedeutendsten Schöpfungen in Berlin und Potsdam* (Berlin, 1937), pp. 50–51.

16. Hinz, *Lenné*, 67. Matschoss, *Entwicklung*, 1: 185, 801. O. Wagenbreth and E. Wächtler, eds., *Dampfmaschinen: Die Kolbendampfmaschine als historische Erscheinung und technisches Denkmal* (Liepzig, 1986), pp. 215–217, 266; see pictures of engine on pp. 217, 272, 279, 304–5. Fountain etching by Johannes Rabe, 1845, for which I thank the Plankammer der Stiftung Schlösser und Gärten Potsdam-Sanssouci, Neue Palais (hereafter SSGPS), reproduced in Harri Günther and Sibylle Harksen, *Peter Joseph Lénné, Katalog der Zeichnungen* (Tübingen/Berlin, 1993), p. 47.

17. H. G. R. Belani (pseudonym for Karl Ludwig Häberlin), *Geschichte und Beschreibung der Fontainenanlagen in Sanssouci unter Friedrich dem Großen und Sr. Majestät dem Könige Friedrich Wilhelm IV* (Potsdam, 1843), p. 41. Bohle-Heintzenberg and Mann, *Persius*, 74–77. Painting by Ferdinand Marohn, 1845, SSGPS, Inv. Nr. 2115.

18. Belani, *Fontainenanlagen in Sanssouci*, 40. Photograph by Manfred Hamm, courtesy of SSGPS.

19. Belani, *Fontainenanlagen in Sanssouci*, 67.

20. Belani, *Fontainenanlagen in Sanssouci*, 68. Matschoss, *Entstehung*, 1: 801; see pictures on 802.

21. Ulla Galm, *August Borsig* (Berlin, 1987), 87–90. Colored etching by Josef Michael Kolb after a photograph by Johannes Rabe, 1854, from Ludwig Rellstab, *Berlin und seine nächsten Umgebungen* (Darmstadt, 1854), p. 238. I thank the Berlin Museum for a copy of their reproduction.

MUSIC AND FILM

Music and Iconology

ELLEN ROSAND

When considering the relevance of Erwin Panofsky's thought to music, the first thing that comes to mind is, of course, musical iconography. Indeed, not only is Panofsky's name invoked in the opening sentence of our most definitive dictionary article on that subject, in the *New Grove*, but his theoretical formulation of three stages in the process of studying a work of art shapes the entire subsequent discussion.[1] The very field of musical iconography, then, would seem literally to owe its definition to Panofsky. In fact, as currently conceived, musical iconography can hardly be called a field in its own right; it is, rather, a stepchild, a subcategory of the larger practice of iconography in general. Like its adoptive parent, it concerns itself with the description, analysis, and interpretation of subject matter, as opposed to form—a subject matter, however, that is exclusively musical. Indeed, as the same *New Grove* article explicitly admonishes, musical iconography is necessarily visual; it is emphatically not to be confused with the investigation of meaning in musical works. The rhetorical strategies of Dufay, the puzzles of Renaissance canons, numerology in the music of Bach, eighteenth-century *Affektenlehre,* for example, are not the proper objects of the musical iconographer's attention.[2]

Musical iconography, thus, is founded on a visual base. Its operations focus on depictions of music—of instruments, of performance, or of actual notation. Admittedly, musical iconography builds upon the discipline of organology, the historical study of musical instruments. Organology itself has been relegated by some musicologists to the lowest rung of Panofsky's famous synoptic table, the realm of "primary or natural subject matter," the object of "pre-iconographical description," a practice demanding no more than "practical experience (familiarity with objects . . .)."[3] In principle, then, and at its most naive level of practice, musical iconography assumes the evidentiary truth of painting. As Panofsky himself observed, everyone's "monument" is someone else's "document." But not all pictorial representations of music can be accepted as documents by the musicologist. Unsurprisingly, for example, the groupings and combinations of angelic concerts in fourteenth- and fifteenth-century paintings have not proved reliable guides to reconstructing contemporary performance practice.[4] *Musica mundana* and *musica humana* play to different aesthetics. Indeed, the very recognition of the distinction—significantly, between higher and lower values—returns us to the hierarchy of the hermeneutic ladder.

If the mere recognition of instruments may be said to correspond to the lowest, pre-iconographical level of Panofsky's synoptical table, the musical scholar may quickly ascend to the higher stages of true "iconographical analysis" and, perhaps, even of "iconological interpretation." Thus, for example, in the pastoral known as the *Concert champêtre* (fig. 1) musical instruments play a key role in articulating the values set in dialogic juxtaposition:[5] the lute of the urban visitor to this shady grove and the flute associated with the rustic shepherd evoke a traditional high-low alternative that lies at the heart of Western musical culture. The stringed instrument, associated with the lyre of Apollo himself, is the higher, for it accompanies the human voice; it is the instrument of enlightenment, of

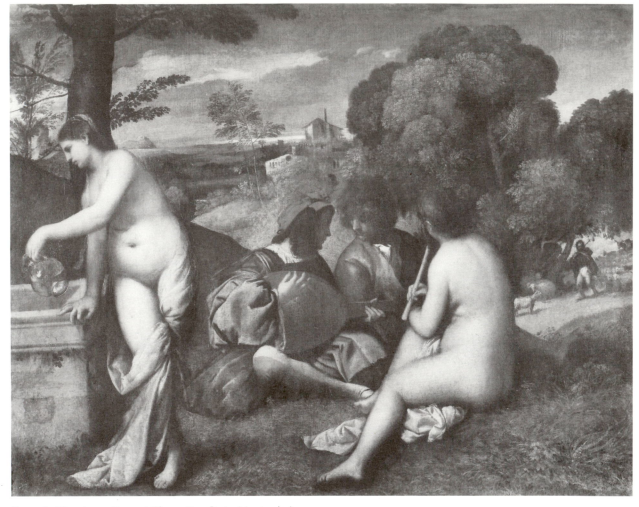

Figure 1. Giorgione, *Concert Champêtre*, Paris, Musée du Louvre

reason and the mind. The wind instrument—the rejected pipe of Minerva, the syrinx of Pan—is the instrument of passion and the senses, of unreason; performed as a more immediate and organic extension of the body, precluding vocal expression, it provides the accompaniment to the drunken train of Bacchus. And the competition between these two, the god of music and his mortal challenger, comes to stand for very basic alternatives in the cultural imagination of the West—nowhere more movingly than in Titian's late canvas (fig. 2) (which, interestingly, Panofsky rejected for its bloody narrative).[6] Pictorially, the contest between Apollo and Marsyas comes to stand as the very dramatization of the art of music, a *summa* of its etiological mythos and a figuration, as it were, of its hierarchic range between heaven and earth.

In such images, music functions as an aspect of a larger cultural complex. The instruments are

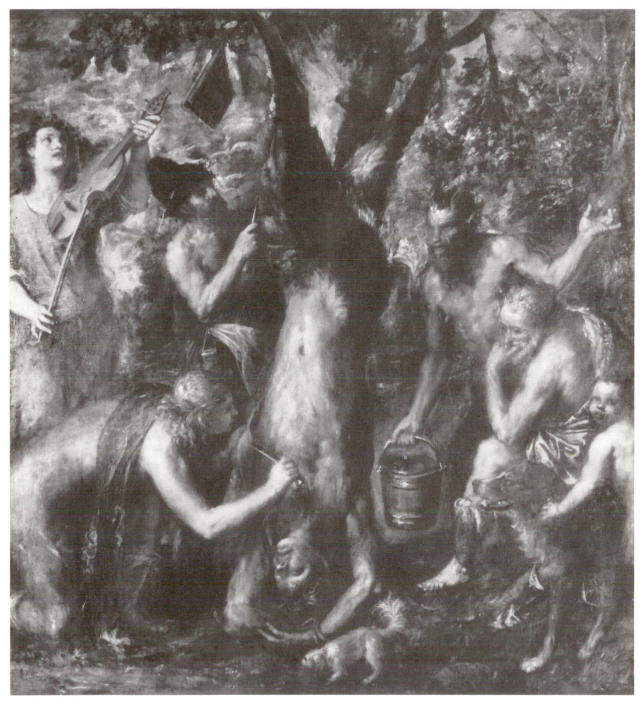

Figure 2. Titian, *The Flaying of Marsyas*, Kroměříž, Státnizánek

both the primary and secondary subject matter, objects of both recognition and analysis. Musical iconography here requires no specifically musical knowledge for interpretation. Indeed, on the second level the only "equipment" necessary for interpretation is that "knowledge of literary sources (familiarity with specific themes and concepts)" called for in Panofsky's table. It is when music itself, legibly notated, appears in painting that the particular expertise of the musician contributes uniquely to interpretation; it is here that we may want, finally, to consider the possibility of an iconography that is specifically musical.[7]

Aside from the general impact of his work on the shaping of the subdiscipline of musical iconography, Panofsky had a direct influence on (and interaction with) one musicologist in particular, Edward Lowinsky. Perhaps more than any other scholar in the field of Renaissance music, Lowinsky aspired to the kind of larger cultural vision exemplified in Panofsky's work. A fertile field of interaction between the art historian and the musicologist was afforded by Titian's *Bacchanal of the Andrians* (fig. 3). There they met to pursue in common the goal of interpretation, and the explorations of the one enhanced the interpretation of the other, creating an enriched and deeper understanding of the meaning(s) of the picture. This was not simply a case of someone's monument becoming someone else's document but seemed to promise an interpretive whole rendered greater than the sum of its parts. Although following with remarkable literalness an ekphrasis by Philostratus the Elder, the painting includes a crucial detail not to be found in the ancient text: a piece of music, legible to the actors in the picture and, if inverted, to the viewer (fig. 4). The text underlaid in the music reads: "Qui boyt et ne reboyt, il ne scet que boyre soit." Prominently central and demanding interpretation in several ways, this detail presents itself as a key to the picture.

In a footnote to his last (and posthumously published) book, *Problems in Titian: Mostly Iconographic,* Panofsky recalled observations on this

motif made by Lowinsky. "As I learn from my friend," Panofsky wrote, ". . . the canon in Titian's painting is revolutionary in that it moves from C to D, from D to E, from E to F♯, from F♯ to G♯, from G♯ to A♯, and then back to C. This, according to Professor Lowinsky, means that the canon applies the theory of Aristoxenus (discarded by the Middle Ages on the strength of objections raised by Boëthius but revived and defended in the Renaissance), according to which the octave can be divided into six whole tones or twelve semitones."[8] That recollection, in turn, prompted the musicologist to return to the problem in a more formal (and dauntingly overambitious) study.[9]

Interpreting the music in Titian's painting as a *canon per tonos,* Lowinsky realized its performance in a manner consonant with the meaning of the text, as a drinking round. This interpretation reads the music as giving voice to inebriation through the "irrational" chromatic rise of each successive statement of the canon; in performance this would lead to a literal thickening of the voices and loss of verbal articulateness—a perfect realization of Philostratus' description of the song of the Andrians: "They sing . . . that this river . . . is a draught drawn from Dionysus. . . . This is what you should imagine you hear and what some of them are really singing, though their voices are thick with wine" (*Imagines* 25). Thus, the music too participates in the renaissance of a lost pictorial invention from antiquity. The setting of "Qui boyt" has generally been attributed to Adrian Willaert, composer at the court of Alfonso d'Este, for whom Titian painted the *Andrians* as part of a pictorial cycle in the duke's *camerino.* The painter's dialogue with antiquity would seem to be matched by the composer's. Lowinsky's interpretation of the canon, so heartily welcomed by Panofsky, seemed appropriate confirmation of the concentration of artistic talents in Ferrara at this moment (the early 1520s); it seemed a worthy critical response to the inventiveness of both Titian and Willaert.

What had intrigued Panofsky in Lowinsky's ini-

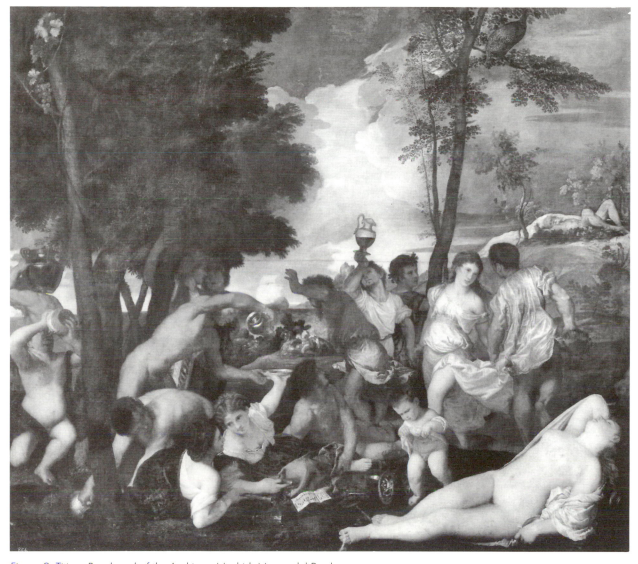

Figure 3. Titian, *Bacchanal of the Andrians*, Madrid, Museo del Prado

tial observations was less the fit of the music to the painting's immediate literary subject than its larger cultural implications. For the musicologist's reading led back to the music theory of classical antiquity, adding a significant dimension to our image of Renaissance culture, one that sustained Panofsky's own historical vision. Indeed, Low-

insky's published study expanded enormously from that inspiring bit of notation lying so casually along the painted banks of the wine-fed river of Andros: it became a study of "the origin and history of the *canon per tonos*," from Aristoxenus to Bach.

However convinced we may (or may not) be

Figure 4. Titian, *Bacchanal of the Andrians,* detail

by Lowinsky's realization of the canon (one must be a music historian to refute him—and several have)[10] and however reasonable (or welcome) we may find his more ambitious interpretation—his invocation of Aristoxenus and the musical and music-theoretical history he constructs—his reading, it must be admitted, does aspire to that "history of cultural symptoms or 'symbols' in general" that Panofsky affirmed as the interpretive principle of the highest rung on the hermeneutic scale: iconology. In searching for the larger meaning of the canon, Lowinsky was confident that he was indeed discovering "essential tendencies of the human mind"—at least, of the musical mind.

Is this, then, truly musical iconology, as opposed to musical iconography? Whether or not we are persuaded by Lowinsky's demonstration, his effort to transcend the pictorial object and seek a level of more purely musical meaning does suggest an important direction. Implicit in that effort is the recognition that musical iconography is not in fact analogous to iconography in the visual arts: dependent as it is upon the hospi-

tality of its pictorial host, it can hardly be concerned with the meaning of works of music as opposed to their form. Indeed, aside from text settings, it is notoriously difficult to distinguish *meaning* from *form* in works of music. In that case, then, iconography must seem an inappropriate notion for truly musical scholarship, which must rather seek to develop its own equivalent to iconography. Asserting its independence as a discipline, it must discover its proper goals and methods in its own musical material, in its own art. In other words, a new kind of musical iconology (if that word is still useful) needs to be defined, one that is not servant to visual representation—or, a still more complex issue, to literary representation. Surely it is possible for musical hermeneutics to study the "intrinsic meaning or content" of its art, to discover "essential tendencies of the human mind . . . expressed by [its own] specific themes and concepts."[11]

The proper musical response to Panofsky's search for meaning, then, is to discover in music meanings as psychologically, culturally, and historically rich as those that he sought to demonstrate in the visual arts.

Notes

1. Howard M. Brown, "Iconography of Music," *The New Grove Dictionary of Music and Musicians* (London, 1980), 6:11–18. Brown describes Panofsky's three stages as follows: "pre-iconographical description, the process of identifying the objects, the events, and the expressive qualities in the work, that is, their primary or natural meanings . . . ; iconographical analysis in the narrower sense, the process of connecting motifs and combinations of motifs with stories and allegories, that is, the secondary or conventional subject matter of the work of art; and iconographical interpretation in a deeper sense, the process whereby 'those underlying principles which reveal the basic attitude of a nation, a period, a class, a religious or philosophical persuasion' are revealed, that is, the intrinsic meaning or content of the work of art." In musical iconography, according to Brown, these stages would correspond to identifying the depicted instruments, analyzing and evaluating the subject matter as evidence, and investigating what the work of art can reveal then about cultural or intellectual history.

2. "The term 'musical iconography' does not describe the discipline that deals with the meaning or subject matter of music itself, even though studies like those dealing with 18th-century *Affektenlehre*, Schweitzer's interpretation of Bach's alleged numerological manipulations, Lowinsky's hypothesis concerning a secret chromatic art in the Netherlands motet and Elder's exposition of symbolism in the Flemish music of the Renaissance all deal with music in much the same way that iconography examines works of art" (Brown, "Iconography," 11).

3. For Panofsky's synoptical table, see the introductory chapter to *Studies in Iconology: Humanistic Themes in the Art of the Renaissance* (New York, 1939), 14–15, subsequently modified slightly in "Iconography and Iconology: An Introduction to the Study of Renaissance Art," in his *Meaning in the Visual Arts: Papers in and on Art History* (Garden City, N.Y., 1955), 40–41. James McKinnon, who has devoted considerable thought to the field of musical iconography in Panofskian terms, has attempted specifically to distinguish between iconography and iconology of music. See his "Iconography," in *Musicology in the 1980s: Methods, Goals, Opportunities*, ed. D. Kern Holoman and Claude V. Palisca (New York, 1982), 90; also idem, "Musical Iconography: A Definition," *RIDIM Newsletter* II, 2 (spring, 1977): 15–18.

4. Emanuel Winternitz, one of the first professional "musical iconographers," notes some of the most obvious kinds of unreliability in "On Angel Concerts in the 15th Century: A Critical Approach to Realism and Symbolism in Sacred Painting," *The Musical Quarterly* 49 (1963): 450–63, reprinted in his *Musical Instruments and Their Symbolism in Western Art: Studies in Musical Iconology* (New Haven and London, 1979), 137–49.

5. As Patricia Egan observed in "*Poesia* and the *Fête Champêtre*," *Art Bulletin* 41 (1959): 303–13.

6. Erwin Panofsky, *Problems in Titian, Mostly Iconographic* (New York, 1969), 171n.85. For the subsequent enthusiastic acceptance of the painting, see the exhibition catalogues for *The Genius of Venice 1500–1600* (London, 1983), no. 132, *Titian: Prince of Painters* (Venice and Washington, 1990), no. 76, and, most recently, *Le siècle de Titien* (Paris, 1993), no. 265.

7. James Haar's contribution to this volume makes this abundantly clear. Another scholar who has been deeply concerned with musical iconography is H. Colin Slim. See, among other articles, his "Paintings of Lady Concerts and the Transmission of 'Jouissance vous donneray,'" *Imago musicae* (1984): 51–73; "Musical Inscriptions in Paintings by Caravaggio and His Followers," in *Music and Context: Essays for John M. Ward* (Cambridge, Mass., 1985), 241–63; "An Iconographical Echo of the Unwritten Tradition in a Verdelot Madrigal," *Studi musicali* 17 (1988): 33–54; and "Dosso Dossi's Allegory at Florence about Music," *Journal of the American Musicological Society* 43 (1990): 43–98.

8. Panofsky, *Problems in Titian*, 101n.26.

9. See Edward Lowinsky, "Music in Titian's *Bacchanal of the Andrians*: Origins and History of the *Canon Per Tonos*," in *Tit-*

ian: His World and His Legacy, ed. David Rosand (New York, 1982), 191–282.

10. There is more than one serious inconsistency in Lowinsky's interpretation of the canon, which is based, to a certain extent, on an earlier, much more modest interpretation by Gertrude P. Smith, "The Canon in Titian's Bacchanal," *Renaissance News* 6 (1953): 52–56. In reading the canon as a *canon per tonos,* that is, as a four-voice piece that modulates upward by half-step with each successive vocal entry, and as one in which two of the voices, reading upside down, perform the music backwards, Lowinsky and Smith before him were forced to interpret what looks suspiciously like a breve rest at the end of the composition as a fragment of an F clef. This was Thurston Dart's primary objection to Smith's interpretation (*Renaissance News* 7 [1954]: 17). To be sure, Dalyne Shinneman's reading of the composition, which incorporates the rest, presents a much less interesting piece of music ("The Canon in Titian's *Andrians:* a Reinterpretation," in Philipp Fehl, "The Worship of Bacchus and Venus in Bellini's and Titian's Bacchanales for Alfonso d'Este," *National Gallery of Art Studies in the History of Art* 6 [1974]: Appendix IV, 93–95). Lowinsky's voyage of discovery through the entire *canon per tonos* literature, even if based on a misread map, does nevertheless provide us with an example of musical iconology. The path may not be entirely *vero,* but it is surely *ben trovato.*

11. This, of course, is one of the aspirations of Leo Treitler's contribution to this volume, as well as much of his other work and that of some other musicologists.

Music as Visual Language

JAMES HAAR

In Leonardo da Vinci's *Trattato della pittura* the artist finds music inferior to painting because it "disappears as it is born"; he admits, however, that in the opinion of some, music "becomes lasting when it is written down."[1] Thus, Leonardo, no friend to music in the context of a *paragone,* recognized something fundamental to the Western musical tradition, the desire for permanence through visual representation. Beginning in the Carolingian period, use of a notational system made possible the recording of musical activity on an unparalleled scale all the more remarkable for being without substantive precedent in classical antiquity.[2]

Music began to be notated as part of an effort to standardize the repertory of liturgical chant in the Frankish empire and to aid in its memorization.[3] Use of notation was at first exclusively, and then chiefly, connected with verbal text; but unlike ancient Greek notation the West did not settle on alphabetic symbols. Instead, European musical script emphasized by means of visual metaphor the movement of sound in space. Through a series of ingenious developments notation achieved by the twelfth century its first goal, exact representation of pitch levels.[4] Written record of other musical elements was slower to develop. Early markings suggesting such things as rhythm and tempo were stillborn, with almost complete reliance on oral tradition. During the High and later Middle Ages, notation of rhythmic values, essential for successful representation of polyphonic music, was achieved with increasing refinement until the intricate theoretical system and practical workings of mensural music were completely and almost unam-

biguously realized. Other elements of artistically controlled musical sound, such as tempo, dynamic level, and tone quality began in the seventeenth century to be described on the written page, using verbal annotation and an occasional mathematical symbol. These aspects of notation have remained at relatively primitive levels, partly because of their inherently subjective and mutable nature. Modern sound recordings "get it all," but necessarily and happily only for a single performance.

The history of notation as written language for music has of course been intensively studied and, at least for music before c. 1500, continues to be subject to scholarly inquiry. Most of this scholarship has naturally been devoted to explication of the meaning of written musical symbols; there has been comparatively little attention given to musical calligraphy as an art with aesthetic aims and values. But written music like written words is the result of activity in which utilitarian features are blended with elements of choice in representational design and style, and these elements have a history of their own, one still to be written.[5]

Liturgical chant, the most frequently copied body of music in the Middle Ages, reached stable visual form by the thirteenth century, and except for a few peripheral experiments remained unchanged through the Renaissance and beyond.[6] This "square" notation, which even today conjures up the liturgical milieu as well as the sound of Gregorian chant, was the basis for writing down secular music and for polyphony as well. New visual symbols, originally derived from the rhomboid-shaped notes used in an ancillary

way for chant, were added in the course of the thirteenth century, and in the *ars nova notandi* of the early fourteenth century use of stemmed notes, colored notes, and void or "white" notes gave striking variety to the notational picture. By mid-century manuscripts containing Italian or French polyphony presented distinctive appearances, in which utilitarian and aesthetic aspects are well blended.[7]

At the end of the fourteenth century, a period for which the term *ars subtilior* has been coined to describe the notational intricacy, chiefly rhythmic, of the written script and the music it records, aesthetic considerations moved to the foreground. Pieces were copied in decorative shapes—circles, crosses, hearts, and outlines of instruments—which were meant primarily to be looked at; performers presumably used copies of more sober design.[8] Some of the musical and textual calligraphy in these highly "visual" pieces is of exquisite workmanship; but all of it exemplifies a trend that was taking place in musical as well as verbal script, the increased use of cursive forms of writing. Chant notation represents for music a book or "print" hand, still the basis for nearly all musical notation through much of the fourteenth century. The new music of the end of the century was copied in new calligraphic style, careful but flowingly cursive.[9]

In the early fifteenth century the shift from black to white notation for polyphony is evidence of the triumph of cursive musical handwriting. Clear differences in the quality of musical script become evident as surviving sources are divided into utilitarian, even hasty copies and exquisitely crafted presentation volumes, in size and delicacy of execution similar to Books of Hours.[10] Individuality of style enables us to distinguish among scribal hands, and we get the impression—deceptive, since no fifteenth-century autographs are known to survive and everything we have is a copy, probably at several removes from the putative original—that musical handwriting is expressive of the act of composition.

At the turn of the fifteenth century, just as the printing of polyphonic music began, a number of magnificent manuscripts designed for princely collections or as presentation volumes were written; the work of Habsburg court scribes under the leadership of Petrus Alamire is especially notable.[11] These books are able to be sung from but were not primarily intended for performance; they record a repertory in permanent form but are also designed to be read, or at least leafed through like some sort of expensive Renaissance coffee-table books. They are sometimes elaborately decorated and illuminated; more to our point, the notation itself is visually beautiful.

Musical literacy was until the end of the Middle Ages restricted to professional clerical singers, a few aristocratic laymen, and scholarly theorists. In the sixteenth century this changed. Thanks in great part to the production and commercial dissemination of printed music, a larger and more varied body of musicians, amateur as well as professional, had access to a repertory of music, some of it a generation or more old but most of it new. The activity of reading music changed habits of composition and of performance in a lasting way; what music looked like on the page was now of greater importance than it had ever been.

Reading could and usually did mean performing from the written page. But music could and can be read silently, its imagined patterns of sound conveyed to an inner ear or even directly to a mind intent on extracting meaning from its visual symbols. Music intended to be read, whether in a context of real or simulated performance, could be used in peripheral ways, could appear in paintings or pieces of decorative art.

Representations of music as a liberal art and of music-making, celestial or mundane, in the visual arts have always been done chiefly through depiction of instruments, and of the act of singing or playing. The addition of notation to pictures centrally or peripherally concerned with music started slowly in the later fourteenth and early fif-

teenth centuries, becoming relatively frequent in the next century and almost commonplace from the mid-sixteenth century onward. This subject has been much studied by musicologists of an iconographic bent, and I have nothing of substance to contribute to it. What I propose to discuss is the use of notation in painting and decorative art in contexts not illustrative of musical performance, not even necessarily concerned with music as we ordinarily understand it. My argument is that reading this notation conveyed meaning to the musically literate viewer, that unheard music could be used as an important adjunct to iconographic schemes. For this I will use a series of examples, for the most part well known and much studied. My choice is not altogether arbitrary; the cases range from those in which the represented music is of mainly ornamental character to ones in which it is of central importance. In none of these cases do previous explications satisfy me, so I shall suggest alternate interpretations, not provable beyond doubt in what I find a very slippery field of study, but nevertheless advanced with as much confidence as I can muster.

The first example is an allegory of music. These are most often depictions of St. Cecilia; but I have chosen instead a painting (in the Museo Horne in Florence) by the Ferrarese artist Dosso Dossi, usually described as a general musical allegory but apparently concerned with the invention of music and aspects of its composition (fig. 1). This painting has been studied by a number of art historians and recently, with his customary thoroughness, by Colin Slim, at present the foremost musicologist in the field of Renaissance iconography.[12] In brief, Slim, drawing in part on earlier scholarly work, identifies the male figure as the biblical Jubal, perhaps conflated with his half-brother Tubalcain (a smith), depicted as inventing music (through use of proportionately weighted hammers striking an anvil to give off notes) and musical instruments (the viol at his feet), aided by knowledge given spiritually (the torch in the hand of the putto at the left). Notated music, here seen on two stone tablets, is in this view a further biblical invention, attributed to Tubalcain who gave permanence to the invention by inscribing music or musical laws on stone pillars.[13] Slim gives a full account of an iconographic tradition, extending back to the late fourteenth century, involving Tubalcain and the creation of music; further, he deciphered and transcribes the textless canon inscribed in circular form and identifies the triangle-shaped piece on the stone at the right of the picture as the famous mensuration canon from Josquin des Prez's *Missa L'homme armé super voces musicales.*[14]

This is certainly further than we have ever got before with this picture. It is not easy to add to Slim's explication of the work. And yet I am not really satisfied. First of all, the painting looks anything but biblical in theme. Slim admits that there may be some conflation of Jubal and Pythagoras, also identified with a musical hammer-and-anvil legend. But the male figure cannot literally be both; he does not at all suggest the venerable sage Pythagoras; and we might remember that in the Pythagorean anvil anecdote the philosopher did not wield the hammers himself but heard a smith doing so.[15]

Slim while rejecting the view that the women could depict, à la Titian, secular and sacred music, does not try to identify them. All three adults in the painting look to me like figures from classical myth; the male in particular suggests Vulcan as smith. What the latter might be doing in a musical allegory is not altogether clear, but some specifically Ferrarese connections of the god with music, including particular reference to Alfonso I d'Este, have been suggested.[16]

Vulcan, or more properly the Greek Hephaestus, was a smith and a maker of objects, aided by divine fire. He even created life-like statues of women, who served him at his forge on Olympus. Alfonso d'Este was also a smith and an artisan by avocation; when not preoccupied with his

Figure 1. Dosso Dossi, *Allegory of Music* (Florence, Museo Horne)

beloved artillery he made many sorts of things, including musical instruments; and he played the viol. Could we be looking at an idealized Ferrarese duke, the patron of Dosso, seen as Vulcan?[17]

At least one early description of the painting, a late seventeenth-century inventory of the Borghese collection in Rome, identifies it as "Vulcan with hammers and anvil, two women, one nude, one seated and one standing."[18] Rome in the 1690s is far from Ferrara c. 1530, when Dosso is thought to have painted the work; but we are further still. I am inclined to accept the evidence of the inventory.

Slim may well be right in identifying the smith as Jubal, but if so the women remain mysterious and the purpose of the music on the tablets they hold remains unexplained. Felton Gibbons, who thought the women represent biblical figures connected with Tubalcain, entertained a classical explanation as an alternative or conflated iconographic message:

Dosso's treatment simultaneously evokes the inspiration of classical antiquity. Tubalcain becomes Vulcan, Zillah and Naomah become profane and sacred Venuses, the former characterized by the more modest exposure of her body and her musical table with its circular canon, the latter by complete

nudity and a sacred, triangular (and thus trinitarian) musical canon inscribed "Trinitas in unum."[19]

I would suggest that Gibbons is essentially right but that a bit more could be said. The god-smith, aided by inspiration, uses his musically weighted hammers to create first the elements of music (the notes lying on the anvil), then musical instruments (the viol at his feet), and finally music itself, represented by secular and sacred canons, the canon being not only convenient for the artist since it contains much in little, but also a genre of almost marmoreal perfection, written here in the perfect shapes of circle and triangle, and protected by secular and sacred tutelary goddesses. The classical image is fundamental; the biblical tradition secondary. The music represented is that of Dosso's time, perhaps suggesting a new perfection of the art attained by modern cultivators, at any rate no more inappropriate for a classical than for a biblical scene. But, sad for a musicologist to say, this is a case in which precise identification of music in a painting does not by itself resolve its iconographic problems.

Notated music is sometimes used to depict an attribute of a figure in a painting. This would seem to be true of Carpaccio's *St. Augustine in his Study* (formerly thought to be St. Jerome) (fig. 2).[20] Here, amid a wealth of detail unusual even for Carpaccio, we see an oblong choirbook open to a four-voice polyphonic composition, and a single sheet containing a three-voice text-less piece.

Helen Roberts' 1959 article establishing the subject of this painting was accompanied by a brief study of the music by Edward Lowinsky.[21] In attempting to relate this music to the life of St. Augustine Lowinsky considered the piece in the bound volume to be a sacred composition (here he was aided by Roberts' later discovery that the first word of the work's otherwise illegible text is "Deus"); in transcribing it he became convinced that it is a polyphonic hymn and, possibly going

Carpaccio one better, he texted it with the first stanza of the Ambrosian hymn *Deus Creator Omnium,* Ambrose's hymn texts being particular favorites of Augustine. The single sheet he characterized as a secular piece (Roberts says Lowinsky "established it" as such), something to show the secular side of Augustine, his inordinate fondness for music.

The prominence given the music in Carpaccio's painting does suggest that some meaning was intended. Nonetheless Lowinsky's reading seems not only too precise and too schematic but at odds with the painting's tone of quiet spiritual rapture. If the objects in the room are all meant to refer to Augustine—rather than to portray the study of a humanistic Venetian churchman closer to Carpaccio's time[22]— they surely do not include mementos of the saint's sinful youth, placed in full view of the spiritual gaze, certain to be censorious, of St. Jerome as he appears (invisible to us) to the awestruck Augustine.[23]

I see no reason why the composition on the single sheet must be a secular piece. Gustave Reese's observation that both pieces might be devotional *laude* of the type printed by Ottaviano Petrucci in Venice in 1506–07 seems very much more to the point, an Augustinian one, that music occupies an honorable place in the religious practice of ordinary people.[24] If the contents of the textless music sheet in the painting are compared to a typical *lauda* from Petrucci's second book of 1507 (fig. 3), the similarity in style, especially the declamatory rhythms, is striking.

The painting was finished at nearly the same time these North Italian devotional pieces were published. What Carpaccio shows, however, is presumably a manuscript choirbook and a single sheet of paper. The latter, though "below" the bound book in Lowinsky's vertical reading of the painting, is actually in front of it spatially and is in a position of special prominence, getting a good deal of the supernatural light accompanying the offstage apparition of St. Jerome. One curious feature of the page, not commented on by any

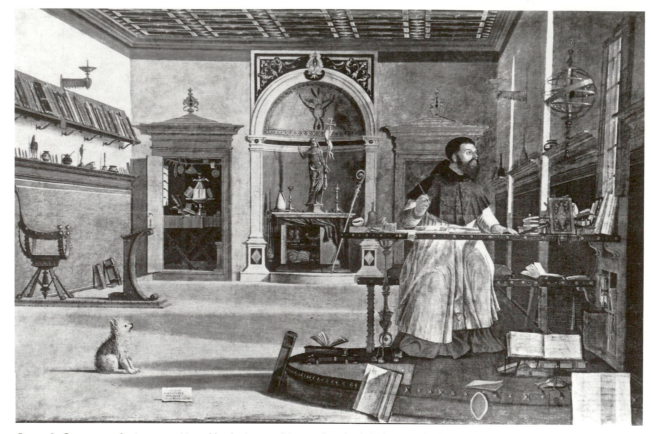

Figure 2. Carpaccio, *St. Augustine Visited by St. Jerome* (Venice, Scuola di S. Giorgio degli Schiavoni)

critic I have read, is that it has been folded, in precisely the way that individual pieces of music were folded in the sixteenth century when they were included in letters. The impression one gets is that the piece had recently reached Augustine as an enclosure in a letter, and was being propped up so that it should be noticed and studied when opportunity arose.

I stop here rather than suggesting that the folded sheet was in a letter from St. Jerome sent in advance of his miraculous apparition; it should be clear that I think Lowinsky over-interpreted the evidence. Both the bound volume and the single

sheet may refer in a general way to Augustine's interest in music, but like the rest of the contents of the room I think they are a record of what might have been seen in the study of a humanistic scholar of Carpaccio's time. The music may be real music, but I doubt that it is of iconic significance.

Renaissance portraits of musicians are now and then accompanied by indications of their profession, including notated music.[25] Here I come closest to Panofsky's work, for it was he who identified the subject of a portrait by Jan van

Carpaccio, St. Augustine Visited by St. Jerome (detail) [after Lowinsky, "The Music," p. 263]

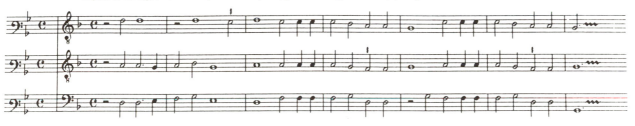

Petrucci, *Laude Libro Secondo* (Venice 1507), fol. 33v

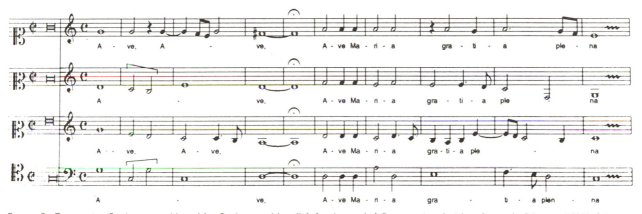

Figure 3. Carpaccio, *St. Augustine Visited by St. Jerome* (detail) [after Lowinsky] Petrucci, *Laude Libro Secondo* (Venice, 1507), fol. 33ᵛ
A-ve, A-ve, A-ve Ma-ri-a gra-ti-a ple-na

Eyck as that of the composer Gilles Binchois.[26] I will not enter into the controversy over this identification;[27] in fact I will avoid the subject of portraits of composers and will deal instead with a painting depicting a man not known to be a professional musician.

Hermann tom Ring's portrait of Johannes Münstermann (fig. 4) shows the sitter with a partbook, one of a set shown complete in four books.[28] I have written elsewhere about this painting and will not dwell on it at length.[29] In general it may be said to show the kind of blend of near-pedantic realism with unaccountable rearrangement of objects that makes this kind of study an exercise in frustration. The subject looks as if the painter interrupted him in the midst of singing; but the partbook under his hand is a Cantus (soprano) book (fig. 5), probably not appropriate for a mature male. He could be, almost surely is, reading silently. If he is pointing rather than simply marking his place his finger is at a phrase setting the words "se tanta crudeltà cangiar volete," which is unlikely to be an emblematic utterance but might well be a personal message.

There is no printed volume known with the title given in the painting; but there are two books, both entitled *Di Verdelotto tutti li madrigali del Primo, et Secondo libro a quatro voci,* issued by competing printers in 1540 and 1541.[30] The madrigals in the painting are in both; and Ring

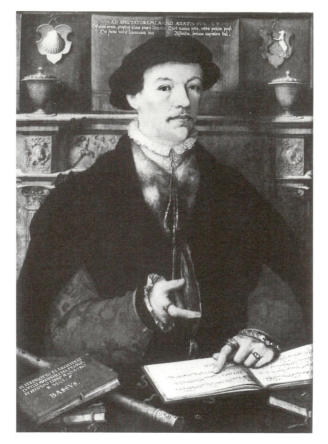

Figure 4. Hermann tom Ring, *Portrait of Johannes Münstermann* (Munster, Westfälisches Landesmuseum für Kunst und Kulturgeschichte)

has evidently copied them, with surprising fidelity to typography of text and music, from Girolamo Scotto's edition of 1540. The painter's pages are wider and shallower than the originals; more serious, the two madrigals depicted are not nos. xxii–xxiii in any surviving edition of the music prints.

What are we to make of all this? The sitter must have chosen the pieces, "Fuggi fuggi cor mio" and "Madonna per voi ardo." If the picture had a matchmaking purpose, as has been speculated,[31] the pieces may have conveyed a message—

as do the vast majority of early madrigal texts— from lover to beloved, to be read along with the verbal message, also presumably chosen by the sitter, at the top of the painting:

AD SPECTATOREM. ANNO AETATIS 25.
Effigiem cernis, quam pinxit Apelles
Hec forme reddit lineamenta meae.
Quod natura dedit, reddit pictura poesi
Assimilis, servans intextitura diu [dui?].

The interest in the two madrigals here included would then be that they make personal and specific what appears general in the message addressed "to the beholder." This may, in other words, be a painting intended as a gift, in which music adds a message to be read and pondered upon by the recipient.[32]

Musical instruments are favorite subjects in Renaissance intarsia. Less often depicted, but of great interest when they are found are examples of notated music.[33] I have chosen three examples relevant to my theme, the appearance of written music separate from any music-making activity. The first two are from the studiolo of Federigo da Montefeltro in Urbino; the third is found in the grotta of Isabella d'Este Gonzaga in Mantua.

The studiolo in the ducal castle in Urbino has an inscription with the date 1476, presumably that of its completion.[34] Under the portraits of the duke and his son and of twenty-eight *huomini illustri* (now dispersed), the walls of the little room are covered with tarsie executed by Baccio Pontelli on ideas and designs that have been variously attributed.[35] On two of the walls, open cabinet doors show volumes containing music. The west wall (fig. 6) has a book leaning against a covered goblet; the opening (fig. 7) is inscribed with a four-voice motet, for which no other source is known, in honor of Federigo as warrior and man of letters. Its text reads:

Bella gerit musasque colit
Federicus omnium maximus Italiorum
Dux foris atque domis.

Author and composer are unspecified.[36] The piece is complete and can be read without difficulty.[37] It is undistinguished in quality but is congruent with stylistic norms c. 1470. Its brevity suggests that it may have been composed for the purpose we see here; while it could and may have been performed—at, say, a celebration marking the completion of the studiolo—it may have had no existence separate from its appearance here. Its importance lies in the fact that music was chosen for the only object in the tarsia explicitly naming and praising Federigo.

On the north wall, in a cabinet containing closed books, military objects, and a cloth with the emblem of the Garter on it, is another open volume containing a musical composition (fig. 8). Musical instruments lie on a bench below the cabinet but have no apparent connection with the notated piece (fig. 9). The latter is a French chanson, *J'ay pris amours en ma devise*, a well-known rondeau found in several mid-century chansonniers.[38] Its text is not in any way remarkable; Federigo could have taken Love as his emblem, but so could many other people. At least

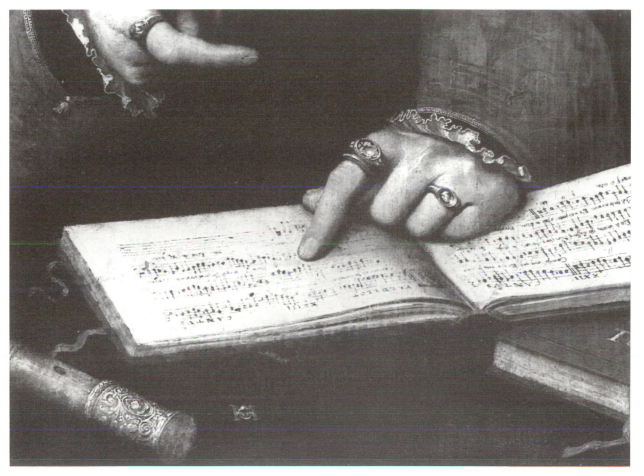

Figure 5. Ring, *Johannes Münstermann* (detail)

Figure 6. Studiolo of Federigo da Montefeltro (Urbino, Palazzo Ducale), west wall

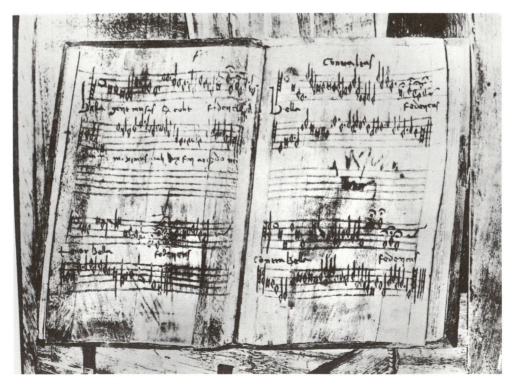

Figure 7. Studiolo of Federigo da Montefeltro, west wall (detail)

Figure 8. Studiolo of Federigo da Montefeltro, north wall

Figure 9. Detail of fig. 8

Figure 10. *J'ay pris amours en ma devise* (Paris, Bibl. nat., MS nouv. acq. fr. 4379, fols. 27ᵛ–28)

one of the surviving sources for the piece is Neapolitan, and Federigo had enough contacts with the court of Naples so that he, a lifelong lover of music, could have come across the chanson there.[39] *J'ay pris amours* as copied into one of these manuscripts (fig. 10) may be compared with Figure 9. They are close but not identical in the musical text, and the tarsia has only the refrain—and that in not very good shape—of the poem. The exemplar for the tarsia is probably not any of the surviving manuscript sources.

There is proof that Federigo had a special fondness for *J'ay pris amours.* In November 1474 a *rappresentazione* on the theme of "Amore al Tribunale della Pudicizia," apparently the work of

Raphael's father Giovanni Santi, was held in Urbino. The occasion was a visit from Naples of Prince Federigo of Aragon. At this event, in which the duke presided in the tribunal, there were costumed actors, singers, and dancers. One of the pieces performed was a lauda, *Laude e grazie in gentil core,* "intonata sul canto de Jam pris Amor."[40] If this was not Federigo da Montefeltro's personal choice he would nonetheless have recognized the piece, and would have remembered the event as the work of furnishing his studiolo went on in the following two years. In 1474 Federigo was made duke; he received the Order of the Ermine from the king of Naples and the Garter from Edward IV of England. This year

has been called the culmination of his career, and there is every reason to think that he wanted it commemorated in the decoration of his study. A chanson celebrating *Amore* as emblem sanctified by *Pudicizia* played its role here, along with a motet glorifying the duke's military and humanistic prowess. That the verbal texts of these pieces were insufficient, that the music should appear as well, shows what importance the written language of music had acquired.

Federigo's castle at Gubbio also contained a studiolo, completed c. 1479–82, and perhaps planned and executed by the same artists and craftsmen who had worked in Urbino.[41] Nothing of this remains in situ, and of Justus of Ghent's painting of the Liberal Arts, done for this room, only two survive; but the intarsia which as in Urbino covered the lower walls has been preserved and is now in The Metropolitan Museum. It contains a number of the same trophies and emblems of the duke's career as are found in Urbino. In a report on the room by Preston Remington we read that on the lower shelf of a cabinet there is "an open volume, its pages now blank. Not many years ago the pages of this book were inscribed with the music of a song entitled 'Rosa Bella.'"[42]

Remington does not say how he knows this, nor how the music could have disappeared from the intarsia.[43] But he does add that "a manuscript of this song, formerly in the ducal library at Urbino, is now preserved in the Vatican Library." Indeed there is a mid-fifteenth-century chansonnier, MS Urbinate latini 1411, which came into papal possession upon the dispersal of the ducal library in Urbino in the mid-seventeenth century. It is an upright volume of a size generous for chansonniers and so just possibly the object represented in the Gubbio intarsia.[44] And it contains two settings, ascribed to Johannes Ciconia and John Dunstable respectively, of the celebrated ballata text *O rosa bella*, often attributed to Leonardo Giustinian.[45]

The manuscript has an inscription of extraordinary interest: "Questo libro de Musicha fu donato a Piero da Archangelo de li bonaventuri da Urbino dal Mag^co Piero di Chosimo de Medici di Fiorenza" (fol. 1^v). On the page following this is a large heraldic device showing the arms of Federigo da Montefeltro, topped by a crowned eagle, quartered with the Medici *palle*. This would appear to be an instance of bogus heraldry; but Federigo did have contacts with Piero de' Medici, notably in 1468 when both served as godfathers to a son of Francesco Filelfo.[46]

The manuscript would seem to have been part of Federigo's library, prized perhaps because of its exalted donor.[47] Whether *O rosa bella* meant something special to the duke I don't know;[48] the manuscript itself is what may be depicted in the intarsia. As for whether the latter ever showed one of the settings of *O rosa bella*, the answer can be a cautious yes. During the later nineteenth century the Gubbio intarsia panels, wherever they had been after leaving the Montefeltro castle, belonged to the Roman Lancellotti family.[49] They were seen in the Lancellotti villa at Frascati by the English musicologist W. Barclay Squire, who photographed the panel containing, as it then did, *O rosa bella*. Where these photographs might be now I do not know, nor was E. C. Stainer, the scholar to whom Squire showed them, able to make much sense of them; but my guess from what Stainer gives is that it was Ciconia's setting that once appeared on the walls of the studiolo in Gubbio.[50]

The inspiration for Federigo da Montefeltro's studiolo may have come from Ferrara, where Leonello and then his brother Borso d'Este had a study at Belfiore with panels of intarsia.[51] This was destroyed in 1483, before Isabella d'Este, precocious as she doubtless was, could have taken a firm impression of it. The models for her studiolo and grotta in the Castello San Giorgio in Mantua were surely Federigo's cabinets in Urbino and Gubbio, where she visited as the guest of her sister-in-law Elizabetta Gonzaga in March of 1494.[52] The cityscapes in the intarsia panels of Isabella's grotta are reminiscent of those she saw in the ducal palace in Urbino.[53] More important for our purposes was the use of *J'ay pris amours*

Figure 11. Studiolo of Isabella d'Este (Mantua, Palazzo Ducale), intarsia panel

en ma devise in the Urbino studiolo as a model for Isabella's choice of the Ockeghem canon *Prenez sur moi,* inscribed as a *banda* beneath an idealized Mantuan cityscape in the grotta, one of the chambers private to her use decorated in the first decade of the sixteenth century.

Isabella knew what she wanted but could not always get it, and she had special difficulty obtaining the paintings she planned for her studiolo.[54] There would seem on the other hand to have been no special problems connected with the intarsia panels, which were executed by Antonio and Paolo della Mola in 1506–08.[55] The Ockeghem canon is at the bottom of one of the ideal cityscapes forming part of the grotta's dec-

oration (fig. 11); whether it has anything to do with the scene above it may be doubted, but it is interesting that the canon was *not* placed below the musical instruments figuring in the adjacent panel. It would seem thus to have emblematic rather than overtly musical significance.

Although Ockeghem's canon circulated in manuscript chansonniers in the third quarter of the fifteenth century it may not have been known in Italy before its publication by Petrucci as the final piece in his *Canti C* of 1504.[56] The intarsitore followed Petrucci's version of the canon fairly closely (fig. 12), but he simplified the puzzling flat-sharp signature at its opening and made a few other minor changes. He Italianized the title

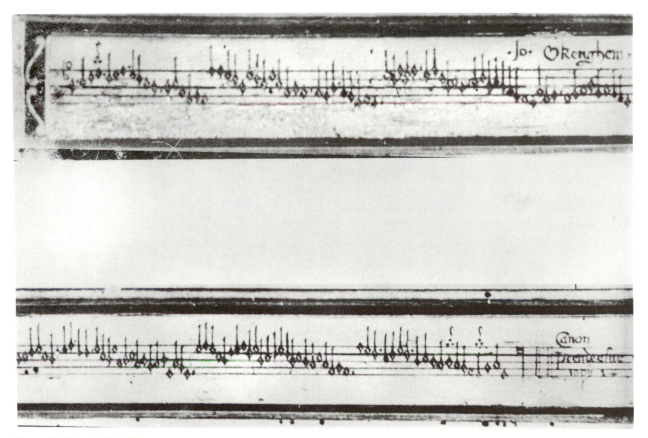

Figure 12. Detail of fig. 11

and altogether omitted the text, of which Petrucci has given only the incipit. Whether the text, which survives in other sources of the piece, was known in Mantua probably cannot be determined; it is a rondeau dealing with the fickleness of love, beginning with the line "Prenez sur moi vostre exemple amoureux" (the text refers to the puzzle canon which is its musical setting).[57]

The text as a whole is irrelevant here; what is important is its opening phrase, which suggests not just a motto in general but a clear borrowing from Federigo da Montefeltro's use of J'ay pris amour en ma devise. Ockeghem's piece, famous throughout the sixteenth century, was no doubt discussed by musical literati at Isabella's court. Her various personal emblems, on which more will be said in a moment, appear to have been her own inventions, even if learned explications for them were supplied by others.[58] It is tempting to think that in choosing Prenez sur moi she was allying herself with her late kinsman by marriage, the most celebrated humanist and patron of the arts in her aristocratic world.

In Prenez sur moi there is no text; the music itself carries the emblematic message. Another emblem of Isabella's devising, also musical in nature, carries the notion of music as language even further (fig. 13); it has clef, mensuration

Figure 13. Grotta of Isabella d'Este (Mantua, Palazzo Ducale), ceiling

signs, and a repeat sign, but only a series of rests rather than notes, and thus a soundless as well as wordless musical message. This device, which some scholars have termed, appropriately but not helpfully, the Emblem of Silence,[59] was a favorite of Isabella's. It is found in the ceiling of the grotta; she had it embroidered into clothing, wore a signet ring with its design, and included it among her emblems and those of her husband in a majolica service (fig. 14).[60]

Various outré explanations of this emblem's meaning have been advanced, including neo-Platonic theories of vital ebb and flow, the principle of *multum in unum,* and reference to another composition by Ockeghem, the *Missa Prolatio-num.*[61] None of these are I think even remotely plausible. The device was surely meant simply to be read, then interpreted, as with all Renaissance emblems. How might a musically literate person of the time have read it? The staff and clef may be taken as givens. The four mensuration signs mean, literally the range of possibilities in measured musical time; figuratively, the range of human circumstances. The repeat sign indicates just what it says, start again; or, there is no limit to whatever the message might be. The rests, arranged symmetrically from large to small and back, are at first merely a pleasing design; next,

Figure 14. Nicolo da Urbino, plate depicting Perseus and Andromeda, c. 1525 (Boston, Museum of Fine Arts)

they indicate the fullest extent of musical—or human—activity. Most important, and I think the reason rests were chosen rather than notes, is that in the notational system used in the sixteenth century rests are perfect, subject neither to imperfection nor to alteration, and hence immutable, in perfect as well as imperfect time (the range of circumstances in human life). The message, redeemed from immodesty through its simplicity of presentation, is clear: the maker of the emblem is a rock of steadfast incorruptibility.

Isabella's other mottos, including XXVII, a numerical pun meaning *vinte sette*, the seven who conquered against all odds, *nec spe nec metu* meaning steadfast in good and bad times, are consistent with this reading. A plucky lady, one might say; but only to the musically literate is her full message understandable.

Notes

1. Jean Paul Richter, *The Literary Works of Leonardo da Vinci*, 3rd ed., 2 vols. (London, 1970), 1: 79 (*Trattato* 31b): "Adonque la musica, che va consumando mentre ch'ella nasce, è men degna che la pittura . . . e se tu dicessi la musica s'eterna con lo scrivela, il medesimo facciamo noi qui con le lettere."

2. The Greeks did have a notational system; in fact they had two, one for vocal music and one for instruments. Forty-one musical fragments of varying length, dating from the third

century B.C. to the fourth century A.D., are known to survive. See Egert Pöhlmann, *Denkmäler altgriechischer Musik* (Nuremberg, 1970); see also Thomas J. Mathiesen, "New Fragments of Ancient Greek Music," *Acta musicologica* 53 (1981): 14–32. There would seem to be no direct connection between ancient Greek notation and the Western system, of which the earliest written record comes from the ninth century.

3. There are various theories about the origin, date, and character of the earliest Western notation. See Kenneth Levy, "Charlemagne's Archetype of Gregorian Chant," *Journal of the American Musicological Society* 40 (1987): 1–30; David G. Hughes, "Evidence for the Traditional View of the Transmission of Gregorian Chant," ibid.: 377–404, and the bibliographies appended to both articles.

4. Exact, that is, in a relative sense, since pitch was not then (or now) fixed in the absolute sense of correspondence with frequency of vibration.

5. For a succinct and well-organized survey of the history of Western notation, see Richard Rastall, *The Notation of Western Music. An Introduction* (New York, 1982). In this and other general histories of notation calligraphic features are noted in passing but are not studied for their own sake.

6. A good survey of the development of chant notation, with some reference to writing techniques, is given by David Hiley in *The New Grove Dictionary of Music and Musicians,* ed. Stanley Sadie, 20 vols. (London, 1980), 13: 344–54.

7. For an attractive pictorial history of the notation of polyphony, see Peter Gülke and Heinrich Besseler, *Schriftbild der mehrstimmiger Musik. Geschichte der Musik in Bildern III, 5* (Leipzig, 1973).

8. See Ursula Günther, "Das Ende der ars nova," *Die Musik-forschung* XVI (1963): 105–20. For a study of a piece presented in the visual shape of a harp, see Reinhard Strohm, "'La Harpe de mélodie' oder das Kunstwerk als Akt der Zueignung," *Festschrift Carl Dahlhaus zum 60. Geburtstag,* ed. H. Danuser et al. (Laaber, 1988), 305–16.

9. In this and the next two paragraphs I am indebted to the work of Graeme Boone, whose stimulating paper, "The Origins of White Notation," read in preliminary form at the national meeting of the American Musicological Society in November 1984, is soon to be published.

10. Among the most beautiful of these chansonniers is the MS Copenhagen, Kong. Bibl. Thott 291, 8°, probably copied at the Burgundian court in Dijon in the 1470s; it measures 17 × 12 cm. See Knud Jeppesen, ed., *Der Kopenhagener Chansonnier* (Copenhagen, 1927).

11. See Herbert Kellman, "Alamire," *New Grove Dictionary,* 1: 192–93. One of the most sumptuous of these manuscripts has been published in facsimile (black-and-white but with six color plates); see *Renaissance Music in Facsimile,* vol. 22: *Vatican City, Biblioteca Apostolica Vaticana, MS Chigi C VIII 234* (New York, 1987).

12. H. Colin Slim, "Dosso Dossi's Allegory at Florence about Music," *Journal of the American Musicological Society* 43 (1990): 43–98. Citing (p. 49) a number of scholars who have commented on the painting, Slim gives a full bibliography, including the studies of Amalia Mezzetti, *Il Dosso e Battista Ferraresi* (Milan, 1965) and Felton Gibbons, *Dosso and Battista Dossi, Court Painters at Ferrara* (Princeton, 1968).

13. Slim suggests (pp. 66–68) that the tablets in Dosso's painting are "late metamorphoses" of stone or marble pillars inscribed by Tubalcain with the laws of music, an anecdote of Josephus elaborated on in the popular twelfth-century *Historia scholastica* of Petrus Comestor and picked up by fifteenth- and early sixteenth-century writers, including music theorists. This strikes me as unlikely, for if the tablets really illustrated Comestor they should contain the laws of harmonics (depicted in the painting by means of the "musical" hammers), not pieces of notated music.

14. For another representation of this piece (probably earlier than Dosso's painting), in an intarsia panel in the church of San Sisto in Piacenza, see Jaap van Benthem, "Einige Musikintarsien des frühen 16. Jahrhunderts in Piacenza und Josquins Proportionskanon *Agnus Dei,*" *Tijdschrift van de Vereniging voor nederlandse Muziekgeschiedenis* 24 (1974): 97–111. The canon in the Piacenza panel is untexted but has a classicizing Latin epigram placed under it, reading "Artibus haec cunctis ortum dedit inclita virtus / Totus et aeterno concendo jubilat orbis."

15. The anecdote was best known through its transmission by Boethius, *De Institutione Musica* I, x. See Calvin M. Bower, trans., *Anicius Manlius Severinus Boethius. Fundamentals of Music* (New Haven, 1989), 17–20.

16. See Franca Trinchieri Camiz, "Due quadri 'musicali' del Dosso," in *Frescobaldi e il suo tempo nel quarto centenario della nascita* (Venice, 1983), 85–91, especially 86–87, for citations of contemporaries, including Paolo Giovio, who in writing about Alfonso testify not only to his love of music but to his abilities, Vulcan-like, to make all sorts of objects, including musical instruments, in "sua stanza segreta, fatta da lui a modo di bottega, e di fabbrica" (Giovio, *Vita di Alfonso d'Este* [1553], 15). Camiz's article is cited by Slim (p. 83) as having come to his attention "too late to consider"; but he clearly does not accept her argument that Dosso's painting is a classical, not a biblical scene.

17. All the portraits of Alfonso I d'Este known to me show him full face and with a full beard, making difficult any effort at seeing him beardless and in profile in Dosso's painting.

18. See Paolo della Pergola, "L'inventario Borghese del 1693," *Arte antica e moderna* 28 (1964): 459. Mezzetti, *Il Dosso,* 85, cites a description of a painting by Dosso in the Aldobrandini inventory of 1682 (also published by Pergola in *Arte antica e moderna* 22 [1963]: 73), which she believes to be the *Allegory of Music.* But there are a number of discrepancies in this description, whereas that in the Borghese inventory is exact as far as it goes. There may have been two "Vulcan" paintings by Dosso, only one of which, the Horne *Allegory of Music,* survives; see Camiz, "Due quadri," 85, 91. On Dosso's indebtedness to Mantegna's *Mars and Venus,* especially in the figure of Vulcan in the latter painting, see

Sylvie Béguin et al., *Le Studiolo d'Isabelle d'Este* (Paris, 1975), 36.

19. Gibbons, *Dosso and Battista Dossi*, 97.

20. The painting is still in the Scuola di San Giorgio degli Schiavoni in Venice, for which it was commissioned. See Jan Lauts, *Carpaccio. Paintings and Drawings. Complete Edition* (London, 1962), 33, 37, and pls. 103–105. For the identification of the subject, see Helen I. Roberts, "St. Augustine in 'St. Jerome's Study': Carpaccio's Painting and its Legendary Source," *The Art Bulletin* 41 (1959): 283–97.

21. Edward E. Lowinsky, "Epilogue: The Music in St. Jerome's Study," *The Art Bulletin* 41 (1959): 298–301; repr. in Lowinsky, *Music in the Culture of the Renaissance and Other Essays*, ed. Bonnie J. Blackburn, 2 vols. (Chicago, 1989), 1: 262–66. See also Volker Scherliess, *Musikalische Noten auf Kunstwerken der italienischen Renaissance bis zum Anfang des 17. Jahrhunderts* (Hamburg, 1972), 25–26, 87–91.

22. Cf. Guido Perocco, *Carpaccio nella scuola di S. Giorgio degli Schiavoni* (Venice, 1954), 134, where the figure of St. Augustine is said to be a possible likeness of Cardinal Johannes Bessarion (d. 1472), whose library was presented to the Venetian Senate at his death. Later (p. 140) Perocco adds "siamo in uno studio che ricorda quella del Duca d'Urbino."

23. For the legend of St. Jerome's miraculous appearances to St. Augustine, see Roberts, "St. Augustine."

24. Gustave Reese, *Music in the Renaissance* (New York, 1954), 167.

25. An example is Giuseppe Belli's portrait of Gaspar de Albertis (Bergamo, Accademia Carrara). See Scherliess, *Musikalische Noten*, 41, 84–85; Knud Jeppesen, "A Forgotten Master of the Early Sixteenth Century: Gaspar de Albertis," *The Musical Quarterly* 44 (1958): 311–28.

26. Erwin Panofsky, "Who is Jan van Eyck's 'Tymotheus'?," *Journal of the Warburg and Courtauld Institutes* 12 (1949): 80–90.

27. In support of Panofsky's hypothesis are Edward E. Lowinsky, "Jan van Eyck's *Tymotheos*: Sculptor or Musician? With an Investigation of the Autobiographic Strain in French Poetry from Rutebeuf to Villon," *Music in the Culture of the Renaissance*, 1: 351–88, and Tillman Seebass, "Prospettive dell' iconografia musicale—considerazioni di un medievalista," *Rivista italiana di musicologia* 18 (1983): 67–86, esp. 82–86. Opposing it are Wendy Wood, "A New Identification of the Sitter in Jan van Eyck's *Tymotheos* Portrait," *The Art Bulletin* 60 (1978): 650–54, and Stephanie S. Dickey, "Letter to the Editor," ibid. 62 (1980): 183.

28. For Ring, see Paul Pieper in *Kindlers Malerei Lexikon*, 16 vols. (Zurich, 1964–71), 5: 82–85.

29. Iain Fenlon and James Haar, *The Italian Madrigal in the Early Sixteenth Century: Sources and Interpretation* (Cambridge, 1988), 325–26.

30. Fenlon and Haar, *The Italian Madrigal*, 310–12.

31. See Hildegard Westhoff-Krummacher, "Ein Brautwerbungs-porträt von Hermann tom Ring," *Westfalen. Hefte für Geschichte, Kunst und Volkskunde* 45 (1967): 250–55. In this article there are references to earlier studies identifying the subject of the painting. I would prefer to characterize the painting as a betrothal gift, although I cannot adduce proof, certainly cannot name a single woman as recipient.

32. The madrigal texts (as given in the prints) are as follows: "Fuggi, fuggi cor mio L'ingrat', e crud' amore, Che tropp', e grand' errore Fars' un cieco fanciul si alt' iddio, Connosce'l tempo perso Per una finta se colma d'inganni, Esci di servitu, esci d'affanni, Non istar piu sommerso in gelosia, Sospetti, sdegn', e pianti, Che fin de ciec' amanti E'n van pentirs', e finir in dolore, Per esser tropp' errore Fars' un cieco fanciul si alt' iddio."

"Madonna per voi ardo / & voi non me'l credete / perche non pia quanto bella sete / ogn' hora mir' et guardo / se tanta crudelta cangiar volete / donna non v'accorgete / che per voi mor' et ardo / & per mirar vostra belta infinita / & voi sola servir bramo la vita."

33. Scherliess, *Musikalische Noten*, is devoted to the subject. See also Gustave Reese, "Musical Compositions in Renaissance Intarsia," *Medieval and Renaissance Studies*, ed. John L. Lievsay (Durham, NC, 1968), 74–97.

34. Pasquale Rotondi, *Il Palazzo ducale di Urbino*, 2 vols. (Urbino, 1950), 1: 344; Cecil H. Clough, "Federigo da Montefeltro's Private Study in his Ducal Palace of Gubbio," *Apollo* 86, 68 (1967): 278–87; see p. 286. A recent general study of the studiolo is Luciano Cheles, *The Studiolo of Urbino. An Iconographic Investigation* (University Park, PA, 1986). A new and detailed account of musical imagery in the studiolo is that of Nicoletta Guidobaldi, "Court Music and Universal Harmony in Federico da Montefeltro's Studiolo in Urbino," *Musikalische Ikonographie* (1994): 111–20.

35. See Rotondi, *Il Palazzo ducale*, I: 351ff.

36. Among the writers of Latin poems on Federico, such as Porcellio Pandoni, author of *Feltria*, or Gian Maria Filelfo who wrote a *Martias* extolling the duke's military virtues, any could have written this text. See Giovanni Santi, *La Vita e le gesta di Federico di Montefeltro duca d'Urbino. Poema in terza rima* (*Codice Vat. Ottob. lat. 1305*), ed. Luigi Michelini Tocci, 2 vols. (Città del Vaticano, 1985), I: xxviii. What looks like an "F" above the music in fig. 7 could possibly be part of a composer's name, but from photographs this is impossible to determine. Although Federigo was said by his biographer Vespasiano di Bicci to have had a great love of music and to have maintained "una degna Cappella di Musica, dove eran musici intendentissimi e aveva parecchi giovani che facevano canto e tenore," little is known about musicians at this court. See Bramadante Ligi, "La Cappella musicale del Duomo d'Urbino," *Note d'Archivio per la storia musicale* 2 (1925): 1–368, esp. 8–9.

37. The reproduction in Ligi, "La Cappella musicale," is of poor quality and is given upside-down. Better is that in Scherliess, *Musikalische Noten*, Abb. 68. Scherliess' transcription of the motet has a few errors but is basically correct.

38. A number of related contrapuntal settings of this chanson text survive; see Howard Mayer Brown, *Music in the*

French Secular Theater, 1400–1550 (Cambridge, MA, 1963), 234–35. The version in the Urbino panel may be found in several fifteenth-century poetic anthologies and in two musical manuscripts; see Edward L. Kottick, "The Chansonnier Cordiforme," *Journal of the American Musicological Society* 20 (1967). 10–27; see p. 23. Kottick's rather general information about *Jay pris amours* is made more specific in Geneviève Thibault and David Fallows, eds., *Chansonnier de Jean de Montchenu* (B. n. Rothschild 2973 [I.5.13]) (Paris, 1991), xciii.

39. Paris, Bibl. nat. MS nouv. acq. fr. 4379 is thought to have been copied in Naples. See *Census-Catalogue of Manuscript Sources of Polyphonic Music 1400–1550,* 5 vols. (American Institute of Musicology 1979–88), 4: 29–30. Federico was in Naples in 1474, to receive the Order of the Ermine. See Santi, *La Vita e le gesta,* II: 429ff.

40. See Santi, *La Vita e le gesta,* 1: xxii–xxv; Wolfgang Osthoff, *Theatergesang und darstellende Musik in der italienischen Renaissance,* 2 vols. (Tutzing, 1969), 1: 33–38; 2: 11–18, 34–37.

41. See Clough, "Federigo da Montefeltro's Private Study," 286; cf. Marcin Fabianski, "Federigo da Montefeltro's Studiolo in Gubbio Reconsidered; its Decoration and its Iconographic Program," *Artibus et Historiae 11,* 21 (1990): 199–214.

42. Preston Remington, "A Renaissance Room from the Ducal Palace at Gubbio," *Bulletin of the Metropolitan Museum of Art* 36, 1 (January 1941): 3–13; see pp. 7–8.

43. Clough, "Federigo da Montefeltro's Private Study," 279, suggests that the panels were subjected to rather drastic cleaning.

44. See the description in *Census Catalogue,* 4: 68, where the size of the manuscript is given as 215 × 142mm.

45. On this text and its settings, see Nino Pirrotta, "*Ricercare* and Variations on *O Rosa Bella,*" *Music and Culture in Italy from the Middle Ages to the Baroque. A Collection of Essays* (Cambridge, MA, 1984), 145–58 (originally published in Italian in *Studi musicali* 1 [1972]). See also David Fallows, "Dunstable, Bedyngham and *O rosa bella,*" *Journal of Musicology* 12 (1994): 287–305.

46. Cecil H. Clough, "Federigo da Montefeltro's Patronage of the Arts, 1468–1482," *Journal of the Warburg and Courtauld Institutes* 36 (1973): 129–44; see p. 135. Henrietta Schavran, "The Manuscript Pavia, Bibl. Univ. Cod. Aldini 362: A Study of Song Tradition in Italy ca. 1440–1480," Ph.D. diss., New York, University, 1978, 61, states that the heraldic device in Vat. Urb. lat. 1411 must have been entered before 1465, since the Medici *palle* in it lack the *fleur-de-lis* granted by Louis XI in that year; but the device is rather crudely executed, and could have been done at any time, even after Federigo's death. Clough, "Federigo da Montefeltro's Private Study," 284, mentions one Pietro Angelo as a knight in Federigo's

ducal entourage.

47. Vat. Urb. lat. 1411 now contains only twenty-five folios; perhaps it was originally larger. It is mentioned in a Medici inventory of 1456; see Francis Ames-Lewis, *The Library and Manuscripts of Piero di Cosimo de' Medici* (New York, 1984), 124, 373, 503. For a rather negative view of this manuscript's quality (and doubts as to its Florentine origin) see David Fallows, "Polyphonic Song in the Florence of Lorenzo's Youth ossia: The Provenance of the MS Berlin 78.C.28: Naples or Florence?," *La Musica a Firenze al tempo di Lorenzo il Magnifico,* ed. Piero Gargiulo (Florence, 1993), 48–49.

48. For evidence that *O rosa bella* was still popular in the 1470s see Pirrotta, "*Ricercare* and Variations," 156.

49. Clough "Federigo da Montefeltro's Private Study," 278–79.

50. E. C. Stainer, "Dunstable and the Various Settings of O Rosa Bella," *Sammelbände der internationalen Musikgesellschaft* 2 (1900–1901): 1–15, esp. 5–7.

51. Cecil H. Clough. "Federigo da Montefeltro's Artistic Patronage," *Journal of the Royal Society of Arts* 126 (1978): 718–34; see pp. 727–28.

52. See Julia Cartwright, *Isabella d'Este,* 2 vols. (London 1907), 1: 108–10.

53. See illustrations 411–418 in vol. 2 of Rotondi, *Il Palazzo ducale.*

54. Egon Verheyen, *The Paintings in the Studiolo of Isabella d'Este at Mantua* (New York, 1971), esp. ch. 2.

55. Antonio Bertolotti, *Arti minori alla corte di Mantova nei secoli xv, xvi, e xvii* (Milan, 1889; repr. 1974), 171–72.

56. *Prenez sur moi* is found in the Copenhagen Chansonnier (see above, n. 10) and was the opening piece (now lost) of another Burgundian chansonnier, Dijon, Bibl. mun. MS 517. The text is preserved in the Rohan chansonnier (Berlin, Staatl. Mus. der Stiftung preuss. Kulturbesitz, Kupferstichkab. MS 78.B.17).

57. For the text see the modern edition in Ockeghem, *Collected Works,* vol. III, ed. Richard Wexler with Dragan Plamenac (American Musicological Society, 1992), lxxxviii, 80. The English translation given in Reese, "Musical Compositions," 83, is rather misleading.

58. Isabella prided herself on having thought up her emblems herself; but she expressed surprise at the complexity of Mario Equicola's *Nec spe nec metu* (Mantua, 1513), a twenty-seven chapter treatise on that verbal emblem. See Béguin, *Le Studiolo,* 8–9.

59. Béguin, *Le Studiolo,* 8.

60. Béguin, *Le Studiolo,* 8, 36.

61. See Volkmar Scherliess, "Notizien zur musikalischen Ikonographie (II). Die Musik-Impresa der Isabella d'Este," *Analecta Musicologica* 15 (1975): 21–28.

What Obstacles Must Be Overcome, Just in Case We Wish to Speak of Meaning in the Musical Arts?

LEO TREITLER

The challenge to contemporary musical studies that I read in Panofsky's writings is in this central conception: The "real objects" of the Humanities are the meanings that are embodied in the works that are its material objects. But the apprehension of a work's meaning begins in its demand "to be experienced aesthetically," as "when we just look at it (or listen to it) without relating it, intellectually or emotionally, to anything outside of itself."[1]

The problem of meaning in music is in large part a problem of language and its uses. That is the part I mean to address here, with two emphases: the standards for language-meaning that we carry to music when we speak of *its* meaning, and the ways in which we use language to describe the linkages between music and other aspects of our experience. Both are sources of obstacles to our addressing the challenge of meaning in music.

I believe the situation we are in with respect to these matters is ultimately a heritage from that around 1800, when a radical new musical production, which must have been bewildering and intoxicating in ways that we cannot imagine, posed anew the challenge of meaning to musicians, critics, and theorists. The conceptions entailed in their answers had evolved to such a state by 1940, when Panofsky first gave expression to his precept,[2] that a question about the meaning of

a musical work would either have been answered in terms of historical significance—in the narrow sense of style history—or it would have been rejected as meaningless on the grounds that music can mean nothing other than itself. For a range of reasons, whose pursuit would require a separate study, those answers are not now regarded as sufficient in the scholarly musical profession, and the question of meaning has again been opened. In addressing it there will be value in looking backward, to the opinions of that earlier moment, as well as to opinions we may formulate.

While thinking about the problem I read in a recent issue of *The New Yorker* magazine a story by Gabriel Garcia Marquez, and was stopped by this sentence:

> Inside the lights burned in the middle of the day and the string quartet was playing a piece by Mozart, full of foreboding.[3]

My mind fantasized a clothing advertisement in the same magazine. In a crisp black-and-white photograph by Helmut Newton, Marquez is reading the story aloud and has just come to that sentence. A squad of young men and women rush up to him, outfitted in black leather boots, britches, and vests. Their hair is close-cropped or slicked back. Their leader is handing Marquez a summons. I will pick up this story again later on.

This cartoon, from an earlier issue of *The New*

"*What's it all about, Alfie?*"

• •

Figure 1.

Yorker (fig. 1), touches virtually all aspects of my subject. A bewildering musical situation is depicted. What is the "it" of the caption—the music that is being played? the situation as a whole? life?[4] Who wants to know? Who or what is that figure at the keyboard? What are they all doing there? There are hints of the atmosphere in which some of the most influential answers to the question about musical meaning have been given: mystery, enigma, other-worldliness. I would identify that atmosphere as transcendentalist. In its arctic setting it embodies the essence of at least one line of thinking about these questions, and perhaps the leading one in recent traditions of theorizing and critical practice about music. I identify that line as formalist. Think if the question posed in this cartoon were posed in the torrid setting of a Marquez novel. Would it be harder to keep the work's demand to be experienced aesthetically under control? Which setting would Panofsky have preferred?

Alfie could have followed the advice of Robert Schumann in thinking about an answer: "The best way to talk about music is to be quiet about it!"[5] But what did Schumann mean in saying that? Is it music's "ineffability," as it was often put, or is it the vagueness of language?

Why is Alfie not shown at an easel or at a writing desk? If the cartoonist meant to convey the general belief that the question of meaning poses a greater mystery for music than for the other arts, then I want to suggest that this has been something of an exaggeration.

An exception is usually made for abstract art. This cartoon (fig. 2), drawn some three decades earlier puts the proposition that abstract painting has affective power, and at once ridicules it in ways that would now be unacceptable: the woman's hat, the man's scowl.

In the closing remark of his essay "Titian's *Allegory of Prudence:* A Postscript,"[6] Panofsky seems to have been on the woman's side: "In a work of

Figure 2.

art 'form' cannot be divorced from 'content.' The distribution of color and lines, light and shade, volumes and planes, however delightful as a visual spectacle, must also be understood as carrying a more-than-visual meaning." I read this conjointly with his one-sentence dismissal of formalist attitudes:

> The pseudo-impressionistic theory according to which 'form and color tell us about form and color, that is all,' is simply not true.[7]

Panofsky had the support of older authorities, e.g., in the far sharper formulation of John Ruskin, writing in 1857:

> Affection and discord, fretfulness and quietness, feebleness and firmness, luxury and purity, pride and modesty, and all other such habits, and every conceivable modification and mingling of these, may be illustrated, with mathematical exactness, by conditions of line and color.[8]

There is support for a similar claim for music in a letter of 1780 under the title "Über die musikalische Malerey" by J. J. Engel, a prominent critic and theater director in Berlin. Feelings, he wrote, may be "painted" through control of the minutest musical details—the character of intervals and of melodic line, rhythmic quality, harmonic color, tempo, etc.: such painting he called "expression." This is like Beethoven's famous notation in the sketches for the "Pastorale" Symphony that it was to be "mehr Ausdruck der Empfindung als Mahlerey" ("more an expression of feeling than painting")—more expressive than picturesque.[9] But how can music be either expressive or picturesque?

Schumann's radical declaration that "the best way to talk about music is to be quiet about it" is one way to evade the question. It seems to express thoughts that Lydia Goehr in a forthcoming paper identifies as "the romantic-modern aesthetics of silence," which regards "music as the transcendental language of the inexpressible relatively positioned in its difference from ordinary languages of the expressible." As Wagner put it: "The essence of higher instrumental music consists in uttering in tones a thing unspeakable in words."[10] It will be helpful to summarize the philosophical context and main source of Goehr's paper, Arthur Schopenhauer.

For Schopenhauer, writes Goehr, "music stands apart from all other fine arts insofar as, in music 'we do not recognize the copy, the repetition, of any ideas of the inner nature of the world. . . . We must attribute to music a far more serious and profound significance that refers to the innermost being of the world and of our own self.' When, however, Schopenhauer tries to describe this interior relation between music and the world and self, he realizes straightaway that he can proceed only by analogy. The relationship is 'abstract' and 'very obscure' and 'essentially impossible to demonstrate' . . . Music . . . has nothing to do with communicating knowledge about ideas or about the phenomenal or represented world at all. There is 'no [literal] resemblance between [music's] production and the world as representation.' But since we do not have a language which can 'unmask' or 'reveal' information about the will directly, other than music itself, we can proceed only by drawing analogies to things we can talk about.

'We must never forget . . . [that] when referring to all these analogies . . . music has no direct relation to them but only an indirect one: for [music] never expresses the phenomenon, but only the inner nature, the in-itself of every phenomenon, the will itself.'" This core idea makes abundantly clear why the problem of meaning in music is so much a problem of language. In referring to a "romantic-*modern* aesthetic" Goehr assimilates the aesthetics of composers as different as Arnold Schoenberg and John Cage. Schoenberg, for example, quotes with approval this dictum of Schopenhauer: "The composer reveals the inmost essence of the world and utters the most profound wisdom in a language which his reason does not understand," but faults Schopenhauer for losing himself "when he tries to translate details of this language . . . into our terms," for in the process "the *essential* . . . is lost" [my emphasis].[11] It is not difficult to recognize here the germ of Schoenberg's austere and uncompromising duality of "style and idea," an opposition between music's essential interiority and its contingent surface. In the same essay Schoenberg wrote: "When . . . Wassily Kandinsky and Oskar Kokoschka paint pictures the objective theme of which is hardly more than an excuse to improvise in colours and forms and to express themselves as only the musician expressed himself until now, these are symptoms of a gradually expanding knowledge of the true nature of art" (143–44).

But in the early 19th century this basic conception was unfolded in two directions that came to differ greatly, especially over the sources of musical beauty and the relations among the arts; both—the transcendentalist and formalist directions—are visible in the utterances of Schoenberg. For the transcendentalist, the beautiful in music is spiritual and metaphysical. For the formalist, it lies in the structural coherence of the notes themselves. For the formalist, therefore, music is necessarily sui generis, while transcendentalism posits a domain that transcends the boundaries separating the arts—an idea that is apparent in Schoenberg's remark about Kandinsky and Kokoschka. The dif-

ferences here, of course, lead to different vocabularies being admitted into critical discourse about music from each vantage-point, however, an aesthetic theory was founded that asserted the difficulty of the match between music and language about music, theories that would impede the development of a conception of meaning having the breadth of Panofsky's "iconology."

Schumann did not follow his own advice to remain silent. The critical essay in which it occurs is signed "Florestan," one of his alter-egos. The essay continues in Schumann's own voice: "If things were ordered according to that lunatic Florestan, one could call the above a review—and let it stand as an obituary for this periodical."

But Schumann was not totally at odds with his lunatic. He went on to say: "We, ourselves, may regard our silence as the ultimate homage . . . , due partly to the hesitancy one feels when confronted with a phenomenon one would prefer to approach through the senses." The ambivalence is a Romantic characteristic. People liked talking about the difficulty or impossibility of talking about music as much as they liked talking about music.

Felix Mendelssohn, in a famous letter of 1842, turned things around in an intriguing way, reminding us that attitudes were by no means uniform in their day. In a reply to Marc André Souchay, who had asked him about the meanings of some of his "Songs Without Words," he wrote:

There is so much talk about music, and so little is said. I believe that words are not at all up to it, and if I should find that they were adequate I would stop making music altogether. People usually complain that music is so ambiguous, and what they are supposed to think when they hear it is so unclear, while words are understood by everyone. But for me it is exactly the opposite—and not just with entire discourses, but also with individual words; these, too, seem to be so ambiguous, so indefinite, in comparison with good music,

which fills one's soul with a thousand better things than words. What the music I love expresses to me are thoughts not too *indefinite* for words, but rather too *definite*.

Thus, I find in all attempts to put these thoughts into words something correct, but also always something insufficient, something not universal; and this is also how I feel about your suggestions. This is not your fault, but rather the fault of the words, which simply cannot do any better. So if you ask me what I was thinking of, I will say: just the song as it stands there. And if I happen to have had a specific word or specific words in mind for one or another of these songs, I can never divulge them to anyone, because the same word means one thing to one person and something else to another, because only the song can say the same thing, can arouse the same feelings in one person as in another—a feeling which is not, however, expressed by the same words.

Resignation, melancholy, praise of God, a *par-force* hunt: one person does not think of these in the same way as someone else. What for one person is resignation is melancholy for another; to a third person, neither suggests anything truly vivid. Indeed, if one were by nature an enthusiastic hunter, for him the *par-force* hunt and the praise of God could come down pretty much to the same thing, and for the latter the sound of horns would truly be the proper way to praise God. We [on the other hand] would hear nothing but the *par-force* hunt, and if we were to debate with him about it we would get absolutely nowhere. The words remain ambiguous, but we both understand the music properly.

Will you accept this as my answer to your question? It is at any rate the only one I know how to give—though these, too, are nothing but ambiguous words. . . .

 Felix Mendelssohn Bartholdy

Berlin, 15 October, 1842[12]

The letter is often cited for its assertion about the preciseness of music's expression, but it is for its far more radical assertion about the opposite effect of language that I cite it here. It is not music's ineffability that makes for the difficulty of talking about musical meaning, says Mendelssohn, but the ambiguities, vagueness, and inconsistencies that are inherent in the normal practice of language communication. Consider, for example, the remark of Daniel Gottlob Türk, that "certain subtleties of expression cannot really be described; they must be heard."[13] This has been cited as a formulation about "the illusive nature of notions of expression,"[14] or it might be taken as a formulation about music's ineffable nature. But if one takes Türk at his word, he is saying that those subtleties can be heard, but they cannot be described. The implication is that the fault lies in the tools of description more than in the vagueness of the object described.

What Mendelssohn anticipated is the growing lack of faith through the course of this century, and from a number of vantage-points, in a tacit theory of language that I will call "The Literal Meaning Theory."[15] The theory posits that expressions in conventional and ordinary language normally refer in one-to-one correspondences to an objective reality that has an invariant existence independent of any human understanding. Literal expressions are therefore expected to have a precise reference, and to be consistent in their meanings from one speaker to another, and from one utterance of the same speaker to another.

A consequence of the problem that Mendelssohn identified is that theories of musical meaning that assume a rigorous use of language according to this literal meaning theory are suspect and, in my view, always break down. The best we can do is continuously make formulations that are sketches of our understanding, through which we try to show one another what we mean, without expecting finality from these sketches. In view of these difficulties it behooves us to look to those skilled in the imaginative use

of language, as well as to those who are skilled in theorizing. I turn first to one of the latter, Agawu, in *Playing with Signs,* which is perhaps the most explicit and detailed theory of musical meaning that has been published in recent years—at least by a music theorist. This is in order to dramatize a number of problems with our use of language as a tool for the interpretation of music, problems that are most apparent in the hands of those who are least mindful of them.[16]

I have culled from this study a basic vocabulary of some of the predicates through which the author seeks to clarify the modalities of musical meaning: denoting, embodying, expressing, representing, symbolizing. My purpose is to direct attention to two immediately striking characteristics of the uses of these terms: first, they do not yield a clear sense of what is to be understood by them—especially in differentiating one from the other, and second, they are used to hold music at arms' length from the meanings that are attributed to it, that is, they are asked to identify not music's attributes but abstractions of some sort that music signifies.

Here are some examples (with emphasis added throughout): "Measures 72–76 present a concentrated passage of descending fifths, *symbolizing* one high point of the learned style" (107). But "The *alla breve denotes* learned style" (90). "Symbolizing" and "denoting" are treated as synonyms, both pointedly circumventing the identification of those passages as *being in that style.* The next passage takes this distancing a step further: "*Sturm und Drang* [modern designation for an agitated, minor-mode symphonic style of the 1760's and 70's] *denotes* instability" (87). Now we usually say that "instability"—say the instability of a series of diminished seventh chords or a syncopated passage—is a property of such passages that is capable of being directly experienced or felt. To say that it is "denoted" is special in several ways: it is to deny that our cognition of it comes through our own experience of or response to features of the music, to deny in fact that music can have inherently unstable features, and to affirm instead that in identifying instability we simply acknowledge that the music has met certain conventional conditions for such identification to take place, conditions that may be quite arbitrary. This is to say something very special indeed about the experience of music. It is understandable from the vantage-point of a post-modern attitude toward music as an indifferent play of signs and criticism as a word game, an attitude that is having a very considerable influence in recent talk about musical meaning.

It is to me something like the recent experience of seeing a young woman walking up Fifth Avenue in New York, bundled in the tattered layers of a bag-lady. I reacted at first with that numbing feeling of sadness and guilt that is part of every New Yorker's affect, but then I noticed the confident, sashaying stride, the clumpish but pristine boots, and the well-cared-for look from the neck upwards. She must have gotten the outfit from some fashionable couturier, to wear as her radical statement of solidarity with the homeless.

A step still further: "Introversive semiosis [e.g., quoting a first-movement theme in the last movement of the same work] *denotes* internal, intramusical reference . . . while extroversive semiosis [e.g., a fanfare] denotes external, extramusical, referential connection" (132). Two things are puzzling about this use of the term "denote": first, how are the roles of subject and object in each pair determined (would the meaning change if they were reversed?) and second, would the puzzle not simply vanish if "denote" were replaced by "is" or "entails"? It would, but then it would be a different attitude about the nature and experience of music, and the function of language in describing it. The extreme indirectness of the language is itself a sign of the insistent attitude about music as a play of signs. Ontology gives way to epistemology.

This is driven home by the use of the word "represents": "Measure 32 *represents* some sort of beginning" (106). As "beginnings, middles, and endings" are also said to be "symbolized" (118), then "representing" joins the synonyms "symbolizing-

denoting". There is talk of "representations that Beethoven makes toward sonata form" (118) and of "representations toward the tonic" (124). But "beginnings," "middles," "ends," "sonata form," and "tonics" are properties about which we usually say "this is what it is," not "this is a representation of it."

The furthest extreme is reached in the uses of the word "express." Dictionary definitions usually begin with the idea of bringing out, stating, showing, giving manifest form to, attitudes, feelings, characteristics, or beliefs that are held or embodied, before moving to the very different sense of signifying something by certain characters or figures (as in "mathematical expression"). In ordinary usage the term would seem to be resistant to exploitation for any such distancing function as the other terms undergo. But "expression" is straight-away defined by the author as "extroversive semiosis" (i.e. signification of external, extra-musical objects). It is converted to a term of reference in preparation for the exposition of a theory of musical expression that depends entirely on codes for external reference.[17]

With the conversion of "expression" to a term of reference there remains no real differentiation among these terms; they are basically all interchangeable; they all come down to "signify." And behind it is the doctrine that music has nothing to express (let us say in the sense of Beethoven's "espressione," a word he wrote in one form or another in performance directions for eight of the thirty-two piano sonatas, for example) other than its constituent material elements—hence "meaning" can come only through external reference. Behind that is the assumption that the purely material elements can be isolated, on one side, and the standards of the literal meaning theory of language, on the other. Music cannot literally have any of the expressive meanings that may be attributed to it—it cannot literally be "mournful," to cite Beethoven's marking for the slow movement of his Piano Sonata opus 10 no. 3 (*Largo e mesto*)—it can have them only through such signifying negotiations as I have been describing. The concept

with which such negotiations most commonly have been associated is that of metaphor.

The question about how music can be "picturesque" or "expressive" (e.g., "mournful") is often answered by saying that it is so in a metaphorical sense. According to most accounts of metaphor, music would be neither picturesque nor expressive in the literal sense, but rather we transfer temporarily the property of being expressive or picturesque from something that *really* has it to music. What that something might be, how the transfer is accomplished, what we (or Beethoven) might think is gained by such a move, and what is to be gained nowadays by such "metaphor-labelling," as I shall call it, are all questions that have not been satisfactorily answered. By metaphor-labelling I mean the speech-act of characterizing musical meaning as "metaphorical," a widespread practice whose history and virtually obligatory status can be traced at least as far back as the famous treatise of Eduard Hanslick, *On the Musically Beautiful* (1854), where we read that "all the fanciful portrayals, characterizations, circumscriptions of a musical work are either figurative or perverse. What in every other art is still description is in music already metaphor."[18] I do not mean, by metaphor-labeling, "speaking metaphorically about music."

Newcomb (in the essay cited in note 17) cites Nelson Goodman's theory of expression in art as "metaphorical exemplification" for its advantages over theories of denotation.[19] In Goodman's account a work of art expresses properties it possesses by exemplifying them. It can possess them intrinsically, that is, literally, as a painting might exemplify the color yellow; or it can possess them through acquisition or borrowing, in which case the expression is metaphorical. Goodman's example is the expression of sadness in a painting—a counterpart of Beethoven's mournful Sonata movement. However conspicuously that work wears its mournfulness, it wears it as an acquired property. If it is worth explaining such a masquerade as metaphor at all, it is only if it sparks a cognitive jolt by joining irreconcilable

domains that exhibit attraction and repulsion vis-a-vis one another and that bring new and unexpected meaning which is precise and unforgettable. After all we are not conducting elementary exercises in the classification of figures of speech. Goodman offered a better account of metaphor when he both described and exemplified this effect with a metaphor of his own invention: "A metaphor is an affair between a predicate with a past and an object that yields while protesting." I do not experience the expression of Beethoven's Sonata movement or its characterization as mournful through that sort of jolt. I shall, however, shortly show that such jolts are possible and common in music.

Goodman's theoretical account assumes a standard of "literal meaning," and that commitment leads him into two moves that seem to me transparently erroneous—one historiographic, the other syntactical. First, he writes "a picture literally exemplifies only pictorial properties and metaphorically exemplifies only properties that are constant relative to pictorial properties." (He posits this evidently in order to exclude such predicates as "this picture is a gold-mine.") But this entails a characteristic disregard of history. What Mozart-lover of today would not be surprised at Robert Schumann's characterization of Mozart's g-minor Symphony as "this soaring—if somewhat pale—Grecian grace" (he was disputing a contemporary's characterization of g minor as a key of discontentment)?[20] Attributed properties change with the attitudes and situations of the attributors, no matter that intrinsic properties remain constant. But what is the ground of Goodman's assurance that he can always distinguish between the two? The syntactical error is his explanation that when we apply the label "sad" to a painting, it is a case of metaphorical transfer, because paintings are "insentient." But that fact is quite irrelevant, for in applying that label we do not predicate of the painting that it experiences feelings of sadness. That raises the question from what source has the property of "sadness" been borrowed? Strictly speaking, it

can only be from some person who feels sad—not from a poem or a film or a tragedy or a dirge, all of which are equally insentient. When I experience Beethoven's Sonata movement as "mournful" I am not anthropomorphizing any more than I do when I experience the day on which I write this as being gloomy. In neither instance do I find it difficult to analyze the predicated property into it constituent causal factors, in case I should find its necessary or desirable to do so: in the first instance the tempo, the dark register and voicing, the tendency to move to the subdominant harmony, the insistent reiteration of the chromatic dyad c#-d within d-c#-d and f-c#-d;[21] (fig. 3) in the second, the gray sky, the mist and rain, the grotesque bare trees with only the lifeless brown leaves of oaks hanging on. I do not find it necessary because I experience the mournfulness and the gloom directly, as much so as the more "intrinsic" properties into which I can analyze them. Should someone offer the correction that they make *me* feel mournful or gloomy, I would resist because if I am feeling blue and walk into a bright yellow kitchen I can comment on how cheerful it is without being cheered up by it. To insist that the labels "mournful" and "gloomy" are metaphorical is to insist that the experience of the music or the day as such is necessarily mediated by thoughts of objects that are literally mournful or gloomy—and that is what I doubt.

I said "dark register and voicing." I must have meant "low and dense." But there cannot be anything intrinsically low or dense about a musical sound, either. "High" and "low" are acquired properties of music that we treat as intrinsic properties. I believe they were acquired with the invention of musical notation in Western Europe in the ninth century. And when we speak of dark musical sounds, we mean the experience of darkness as a musical property, not necessarily mediated by thoughts of things that are *really* dark, like Rembrandt's "Night Watch" prior to its cleaning. But we may still find in the two kinds of darkness a shared affective quality.

Figure 3.

The musical analogue of the duality of metaphorical and literal meaning is the duality of the musical and the extra-musical that is implicit in the conception of music as a play of signs in general, and in metaphor-labelling in particular. Such duality would be implicit, for example, in any adaptation to music of Goodman's distinction between intrinsic and acquired properties. But just as the boundary between metaphorical and literal meaning in language cannot be drawn, so the boundary in the duality of the musical and the extra-musical cannot be located. A consequence, whether intended or not, is the tendency to regard virtually all descriptive language about music as metaphorical. That is the burden of Hanslick's remark, and it becomes explicit in Agawu's book. The words "style," "grammar," "syntax," and "language," are all identified as metaphors when applied to music, since they have their origins in the domain of language (9). If we think historically about the first of those terms, "style" originated as a word for a writing instrument, then was adapted for manners of writing, then for rhetorical styles, and finally for description and classification in all domains. It no doubt delivered a metaphorical kick each time it entered service in a new domain, but that is no reason to identify it forever as a metaphor in each of those domains. Its history provides a fine illustration of the way that language is, through its history, fundamentally metaphorical, not exceptionally so. But to insist on pronouncing, four centuries after the currency of *stile concitato*, that "style" functions today as a descriptive category only through the figure of metaphor—that music cannot "literally" embody style—is to question what, if any, literal, non-metaphoric descriptive language is left to music and how one is to recognize the boundary between the "musical" and the "extra-musical."

This forces the question "What is music?" Panofsky began his answer to the parallel question, "what is a work of art?," with the observation that a work of art "always has aesthetic significance," not by separating art from some extra-artistic domain. (He did that as well, but not in answer to this question of definition) The question took him straight to the dictum of Poussin, "La fin de l'art e la delection." We meet art's "demand to be experienced aesthetically . . . when we just look at it (or listen to it) without relating it . . . to anything outside of itself."[22]

Grammar and syntax have been regarded as properties of music at least since the beginning of theoretical and pedagogical writing about music in medieval Europe—longer ago than the entry of style as a descriptive concept for music —and the conception of music as a language may be found in writings at least as early as the seventeenth century.[23]

The following descriptive phrases are characterized as metaphoric: "movement to and from points of metric stability" (117) and "the shift from instability to stability and back again" (130).

The words "movement," "shift," and "stability" and its opposite "instability" could be found as well in descriptions of poems and sculptures, where I do not believe the trouble would be taken to identify them as metaphorical.

It seems odd in any case to insist on this identification, more than 1100 years after the music pedgogue Aurelian of Rome displayed a melodic conception with movement at its center. But, strictly speaking, "musical movement" is in the same category of predicates about music as is Marquez's predicate about the Mozart string quartet, "full of foreboding." Neither is literally, objectively, confirmably predicable of music. In my fantasy, Marquez demands of the magistrate "Tell me, then, what it is that I may safely say about the Mozart Quartet," and the magistrate, finding himself unable to provide a clear answer, is obliged to release him.

Another writer's identification of a "fanfare" in Beethoven's String Quartet opus 127 is called metaphorical (32), and that is as inconsequential as all other such identifications. On the other hand the *occurrence* of a "fanfare" in Mozart's String Quartet K 593 is considered a metaphor within the work itself (75). The suggestion that there is a figure entirely within the domain of music that corresponds to metaphor in language is, I think, highly interesting, and I will shortly suggest a strong example.

Sometimes we get a glimpse of the metaphorical power of an expression whose zest has been sublimated and allowed us an insight into the metaphorical foundation of descriptive language about music, as a norm, not an exception to "literal" description. In his *Essays on the Intellectual Power of Man,* the 18th-century English writer Thomas Reid wrote:

> In harmony, the very names of concord and discord are metaphorical, and suppose some analogy between the relations of sound, to which they are figuratively applied, and the relations of minds and affections, which they originally and properly signify. [He is moving right back to the ety-

mological root, which itself entails a metaphor, heart for mind, that survives in our expression to know something "by heart"; layer upon layer of metaphor.][24]

The loan of "concord" and "discord" was repaid by music with "consonance" and "dissonance," which "originally and properly" conveyed something about the "relations of sounds" and may be "figuratively applied" to the "relations of minds and affections."

If there is non-metaphorical descriptive language for music, it would refer to the domain of the "musical," set apart from the domain of the "extra-musical," as the domain of essentially uninterpreted tones and tone complexes or patterns— "Music itself," as Heinrich Schenker put it early in this century, in which "tones mean nothing but themselves."[25]

I have tried to offer glimpses of the difficulty of defining such a domain and of differentiating it from the domain of the extra-musical. But if we are to clear the way for the consideration of musical meaning, it is more important to be aware of that duality as an element in a certain history in which it met a certain need, rather than worry about whether we can operate with it. The idea of a musical domain so narrowly and exclusively defined as Schenker's belongs to the dualistic conception from the beginning. In fact it should be considered to have given rise to the duality in the first place; the duality of the musical and the extra-musical was a creature of efforts to redefine music in the radical new circumstances of its emancipation from language, from its former social, moral, and mimetic functions, and from the institutions of church and state authority around 1800, a situation that has been abundantly described in recent literature. Music became emancipated from non-music.

Schenker's conception of "music itself" is already apparent in writings of the early decades of the nineteenth century. Edward Lippman writes in his recent *History of Western Musical Aesthetics* that "the first significant proponent of formalism in nineteenth century aesthetics is Johann Fried-

rich Herbart," who, in 1813 articulated the position that has come to be associated with Hanslick, that: "In music . . . the elements are tones, or really relations of tones, and the objectively beautiful arises from their combination."[26]

Herbart was quite explicit about the attitude that underlies twentieth-century habits of musical analysis: "In strict composition . . . the tones only need to be read, and yet they please."[27]

Metaphor-labelling as I have been describing it points back to the formalist conception of music that originated it, and rarely plays any other role than to reassert that conception and thereby to question the value of non-formalist interpretations of musical meaning, explicitly or otherwise.

This prompts me to indicate briefly what I think the alternative must be: to take a remark like Marquez's at face value, accepting "foreboding" as a property that music can have and that we can experience in an unmediated way, analyzing it then in terms of the details of the music. This would be, as I understand it, the counterpart for music of what Panofsky called "recreative aesthetic synthesis."[28]

On the other hand, if "foreboding" is a transferred property, what would it be transferred from—painting? poetry? film? tragedy?—and why would they have it intrinsically whereas music cannot?

As for Marquez, his aperçu is intuitive. He is one of those "talented laymen" of whom Erwin Panofsky wrote, in whom the faculty of synthetic intuition may be better developed than in erudite scholars.[29]

The most gifted of such laymen, as far as music is concerned, was surely Marcel Proust. I introduce here a few passages from *Swann's Way* that seem to me to represent in an extraordinarily sensitive way the registers through which music is presented to us and through which we re-present it, in order to display how this virtuoso of language moves us from directly perceived qualities, through conscious interaction with impressions, feelings, and outward associations, to reflection—even musical analysis—synthesis, and recollection.

The year before . . . he had heard a piece of music played on the piano and violin. (294) . . . Perhaps it was owing to his ignorance of music that he had received so confused an impression, one of those that are none the less the only purely musical impressions, limited in their extent, entirely original, and irreducible to any other kind. (294–5) . . . And it had been a source of keen pleasure when, below the delicate line of the violin-part, slender but robust, compact and commanding, he had suddenly become aware of the mass of the piano part beginning to emerge *in a sort of* liquid rippling of sound, multiform but indivisible, smooth yet restless, *like* the deep blue tumult of the sea, silvered and charmed into a minor key by the moonlight. But then . . . suddenly enraptured, he had tried to grasp the phrase or the harmony . . . that has just been played and that had opened and expanded his soul, as the fragrance of certain roses, wafted upon the moist air of evening, has the power of dilating one's nostrils. (294) . . . Doubtless the notes which we hear at such moments tend, according to their pitch and volume, to spread out before our eyes over surfaces of varying dimensions, to trace arabesques, to give us the sense of breadth or tenuity, stability or caprice. But the notes themselves have vanished before these sensations have developed sufficiently to escape submersion under those which the succeeding or even simultaneous notes have already begun to awaken in us . . . Scarcely had the exquisite sensation which Swann had experienced died away, before his memory had furnished him with a transcript, sketchy, it is true, and provisional, which he had been able to glance at while the piece continued, so that, when the same impression suddenly returned, it was no longer impossible to grasp. He could picture to himself its extent, its symmetrical arrangement, its notation, its expressive value; he had before him some-

thing that was no longer pure music, but rather design, architecture, thought, and which allowed the actual music to be recalled. (295–6) . . . Swann listened to all the scattered themes which would enter into the composition of the phrase, as the premisses enter into the inevitable conclusion of a syllogism; he was assisting at the mystery of its birth (p. 499) . . . Swann had regarded musical motives as actual ideas. . . . He had observed that it was to the closeness of the intervals between the five notes which composed [the motive] and to the constant repetition of two of them that was due that impression of a frigid and withdrawn sweetness (495).[30]

Should we simply regard such writing as belonging in another world, irrelevant to our theoretical discussions of musical meaning and expression? Should we cover our embarassment over it by cataloging it, in the words of the title of a recently published essay, among "metaphorical modes in nineteenth-century music criticism"?[31] I believe we would do better to accept its authority and learn from it the multiplicity of ways in which we must approach the interpretation of music if we are to approximate our experience of it, even if that cannot yield the formulations of a consistent theory.[32]

Metaphor is prized, not only for its ability to impart meaning in a particularly telling way, but even more—at its best, at least—for the instantaneousness with which its incongruities impact on the intellect (Schopenhauer's metaphor for syllogism as a mousetrap) and the emotions (Shakespeare's line "How sweet the moonlight sleeps upon the bank" [*The Merchant of Venice*]). Goodman's metaphor is sly, to be savored slowly. Proust's metaphor—"the liquid rippling of the piano sound . . . silvered and charmed into a minor key by the moonlight"—is itself enrapturing, with its crescendo of brilliant incongruities. Metaphor inhabits a realm where imagination, not logic, rules. Donald Davidson begins his essay

"What Metaphors Mean" with the aphorism "metaphor is the dreamwork of language."[33]

Music is capable of such effect, complete within its own idiom. The long second movement of Franz Schubert's Trio in E-flat major, opus 100, Andante con moto, begins with a morose, introverted theme in c minor, accompanied by a trudging figure that, even though played a touch too fast (we learn why only in the finale), register as the tattoo of a funeral march—repeated chords, accent on the fourth beat followed by dotted rhythm, and occasionally drum-roll-like trills, all standard signs that could be heard throughout the nineteenth century. That theme, which can only be repeated, alternates with a soaring E-flat major theme that undergoes a vigorous, affirmative development; it seems as though it might be capable of lifting the movement out of the hopelessness of the c-minor music, but in the end always slumps back into it. (fig. 4)

The whole movement is like circular, obsessive thinking over a grim subject. The finale, Allegro moderato, is one of those endless rondos of Schubert's that seem to modulate through more keys than there are, this one going on in an endless patter of mindless energy. (fig. 5)

Toward the middle of the movement the piano's right hand converts its simple triplets to a hemiola rhythm, the violin in pizzicato chords and the left hand of the piano take up the tattoo from the second movement, and, as if out of the depths of the unconscious, the cello steps forward to play the morose theme *sotto voce*. Suddenly it is as though this is what all that patter had been intended to suppress. (fig. 6)

The reason for the faster-than-funeral-march tempo of the second movement is that the cello must be able to bring back the theme in the finale at something approaching its original tempo. It is as powerful a metaphor as any that I can think of in language. But music often brings together recognizably disjunct or even incompatible realms, and in this way is often metaphoric. Metaphor is as normal a source of meaning for music in its own domain, as it is in language in its domain.

Figure 4.

Music inhabits a realm in which metaphor communicates.

Schubert brings the c-minor theme back a second time near the end of the finale, in fact he makes an end to the piece through that return. By the simple move of opening the third phase of the theme—which until now had always looped back to the beginning—into the major mode, he emancipates the piece from the sense of entrapment with which the second movement had closed (fig. 7)—a sense that is reinforced by a single failed attempt at escape near the end (fig. 8) —and from which the Scherzo and Finale had seemed simply to walk—or skip—away.

I am responding here to the narrative dimension in the piece, in the face of serious questions that have been raised lately about the interpretation of music as narrative. Some have to do with the identification of a narrative voice—rarely heard in music.[34] Music does not usually narrate, it is said, and when claims are made about musical narrative it may be that they are really claims about musical enactment, or it may be that it is really the critic who is narrating. There is confusion, also, it is said, about the characters of narrative, which may be a mix of musical elements such as keys and themes, and persons, such as the listener who moves through the piece and the composer as he or she composes. A further question is how one can consider music to narrate when it does not have a past tense.

These objections are on target and are quite

Figure 5.

sufficient to block any claim that music can narrate, in the literal sense in which a written or spoken language sequence can narrate. And that literalism makes the objections as inconsequential as the metaphor-labelling that I have been talking about.

Creative writers, we have seen, whistle past the disputes of theorists about the contents of music. And so, often, do composers. Bèla Bartók's *Mikrokosmos* comprises 153 "Progressive Piano Pieces" in six volumes. They are published with titles in Hungarian, French, German, and English. Bartók provided only the Hungarian titles, the translations were made by his friend Tibor Serly. Bartók named No. 142 in volume 6 *"Mese a Kis Legyről"* ("A Story About a Little

Fly"). The published French title is *"Ce que la mouche raconte"* ("What the fly recounts"). Note the difference: Bartók's title presents the piece (or the score or the performance) as a story. Who is the narrator? Perhaps Bartók, perhaps the performer, perhaps the listener. In the French, the fly may be the narrator, but it may be that what we hear is the contents of the fly's story with Bartók as the ghost writer. Perhaps the present tense—"raconte"—favors the fly as narrator. The published German and English titles seem to nail that down: *"Aus dem Tagebuch einer Fliege"* and "From the Diary of a Fly." As the fly tells it. None of the titles presents the piece as an enactment, e.g., "A day in the Life of a Fly," although that might be a more precise way of characteriz

Figure 6.

ing one's experience of it. But it would not be entirely satisfactory either, for there is no element in the music that is clearly identifiable as the fly, to whom it all happens, nor are the musical events clearly identifiable as imitations of the fly's actions. Perhaps we could think of it as something like a film in which the camera is the eye of the character.

There are some relevant signs in the published score. At a certain point there is an increase in tempo, indicated by a metronome marking and the word *Agitato* above the system. Between the two staves at that point are the words *molto agitato e lamentoso*. The listener would have no trouble recognizing the moment. Also above the system at that point are the Hungarian words, *"Jaj, pokhalo!!"* with two exclamation points, in quotation marks. *"Pokhalo"* is a spider web. The words in Italian are the composer's, those in Hungarian are spoken by the fly, directly or as quoted by someone (I am being very careful here). Ten measures later, above the system, are the words *con gioia, leggero*. Now *Lamentoso* and *con gioia* belong to that category of composers' instructions, half prescription, half description or commentary, like Beethoven's *Largo e mesto*. In Bartók's case, those words seem to suggest commentary by the composer as narrator.

In any case, in presenting the piece as a story rather than an enactment, Bartók was committing no greater impropriety than that committed by painters and art critics or historians who speak of "narrative painting." The problem is in that impreciseness of language that Mendelssohn put

Figure 7.

Figure 8.

his finger on. The right word would be between "narrative" and "enactment." But just how important is it to find the right word? Will those black-leathered critics turn from Marquez to Bartók and hand him a summons as well, for falsely representing a piece of music as a story?

Hayden White writes in his commentary at the conclusion of *Music and Text* of the "cognitive contents" of musical works. Reacting to the way the harmonic progress of the first movement of Beethoven's Seventh Symphony is prefigured in its introduction—as a "prolepsis" (recall Marquez's "foreboding"!), he calls that a "narrational" relationship. The awareness of such categories, he suggests—others are "actions," "events," "conflicts," "development over time," "crisis," "climax," "denouement"—is a kind of tacit pre-knowledge, like the knowledge of a mother tongue. The point of the comparison is that a mother tongue is the language we speak and understand most directly, in the least mediated way, because we begin to learn it from the beginning of our consciousness. And that is when we begin to learn those categories of experience, which are to us intrinsic qualities.[35] We know them in a non-discursive, as well as in a discursive way.

Art, writes Maynard Solomon in an unpublished paper, can "symbolize vast realms of experience and feeling. . . . Such experiences are the rhythms of life, organic, emotional, and mental . . . , which are not simply periodic, but endlessly complex, and sensitive to every sort of influence. . . . The referentiality of musical form may extend far beyond pictorial, topical, narrative, or mythic dispositions. . . . For literary forms and mythic rituals also derive from—and in turn represent—'earlier,' perhaps more fundamental patterns of experience. . . . By universal processes of symbolic perception and without conscious intention the formal structure of a musical composition may project imagery capable of evoking archaic and psychologically pregnant models of human experience. . . . Musical composition is an act of creation analogous to the

creation of life, and . . . musical form is capable of symbolizing the process by which creativity resists the natural tendency of all things to go out of existence. Music keeps itself alive by the constant introduction of instabilities, tensions, and disequilibriums that cause postponements even as they ultimately require resolutions, by constantly posing questions—harmonic, rhetorical, structural—that require answers, by inconclusive or deceptive cadences, overlapping phrases, and by disturbances of symmetry that are imperative signals for prolongation."[36]

Israel Knox, characterizing Arthur Schopenhauer's view of music, writes, "Music peals forth the metaphysics of our own being, the crescendo, the climax, the crisis, the resolutions of our own striving, impetuosity, peace, and the retardations and accelerations, the surging and passivity, the power and silence of things."[37]

The belief that this shares with Solomon is that underlying the material surface of the musical work is an idea, an image, a configuration, a sense, that bonds with our own consciousness, with the forms in which we register our experience. It is the engagement with that sense of self that allows us to accept Bartók's piece about the fly as a narrative.

Mikrokosmos no. 144 is entitled "Minor Seconds, Major Sevenths." Nevertheless I experience that, just as much as the "Fly" piece, which might have been called "Overlapping Whole-Tone Segments," in terms of the same sorts of "narrativizing" categories, but not at the expense of ignoring the minor seconds and major sevenths, which are controlled in a quite beautiful way.

Neither the narrative nor the formalist title alone reveals what either piece is all about. There are other titles in the *Mikrokosmos* that suggest sonorities ("Bagpipe"), genres ("Peasant Dance"), styles ("From the Island of Bali"), actions ("Wrestling"), affects ("Merry Andrew"); different emphases, but none tells what the piece is all about, and none excludes the other categories. One could associate a different aesthetic or histo-

riographic theory with almost every category. But the lesson I draw from *Mikrokosmos* is that these aspects do not compete but rather coexist in music, and they ought not to compete in its interpretation. That is the sense of the title. Music is protean and its meanings are many-dimensioned.

Notes

1. This idea is developed in Erwin Panofsky, "The History of Art as a Humanistic Discipline," in *Meaning in the Visual Arts* (Chicago: University of Chicago Press 1955), 11, 14–22.

2. The essay was originally published under the same title in T. M. Greene, ed., *The Meaning of the Humanities* (Princeton: Princeton University Press, 1940), 89–118.

3. "Bon Voyage, Mr. President," in *The New Yorker* (September 13, 1993): 100–111.

4. The caption has reference to the last line of the 1965 film *Alfie* by Lewis Gilbert (based on a play by Bill Naughton). The title character is a sort of Cockney Don Giovanni who addresses the audience in a running commentary as he dashes through delightful, bewildering, and finally disturbing engagements with women. In the end he looks at the viewer and asks "What's it all about?" This is taken up in the song "Alfie" by Burt Bacharach with words by Hal David. The first lines are "What's it all about, Alfie? Is it just for the moment we live? What's it all about when you sort it out, Alfie?" Perhaps the penguins are all singing this song. I am much obliged to Mr. Steve Lindeman of the Rutgers University Department of Music for directing me to the film and song.

5. "Chopin's Piano Concertos" (1836). *The Musical World of Robert Schumann*, translated, edited, and annotated by Henry Pleasants (New York: St. Martin's Press, 1965), 112–13.

6. Panofsky, *Meaning in the Visual Arts*, 146–68.

7. Panofsky, "The History of Art as a Humanistic Discipline," 16.

8. John Ruskin, *The Elements of Drawing. The Works of John Ruskin.* Vol. 15, ed. E. T. Cook and Alexander Wedderburn (London: George Allen, 1904), 118.

9. Engel's letter is published in his *Gesammelte Schriften* (Berlin, 1807). Excerpts will be published in Oliver Strunk, *Source Readings in Music History*, ed. Leo Treitler (New York: W. W. Norton, forthcoming). Beethoven's note is reported in *L. van Beethoven: Letters, Journals and Conversations*, ed. M. Hamburger (New York, 1951), 68. There is a temptation to fold both Engel and Beethoven on this subject into a standard historical narrative of aesthetic theories, in which the theory of imitation gives way about the middle of the eighteenth century to a theory of expression. The trouble with such accounts is that the remarks of both Engel and Beethoven were meant to interpret music that is still with us and still challenges us to come to terms with the question of its meaning—especially the Pastoral Symphony. "Imitation" and "expression" were both available to both of them despite the fact that they both wrote after 1750, and they both need to be available today. Such autonomous accounts have their own interest, but they must not regulate our efforts at interpretation.

10. "Schopenhauer and the Musicians: An Inquiry into the Sounds of Silence and the Limits of Philosophizing about Music," in Dale Jacquette, ed., *Schopenhauer: Philosophy and the Arts* (Cambridge: Cambridge University Press, forthcoming). I am grateful to professor Goehr for providing me with a pre-publication copy of this paper.

11. Schoenberg, "The Relationship to the Text," in *Style and Idea* (Berkeley: University of California Press, 1984), 142.

12. Strunk, *Source Readings*.

13. *School of Clavier Playing.* Translated from the German of 1789 by Raymond Haggh (Lincoln: University of Nebraska Press, 1982), 337.

14. V. Kofi Agawu, *Playing With Signs: A Semiotic Interpretation of Classic Music* (Princeton: Princeton University Press, 1991), 27.

15. The language philosophy of Ludwig Wittgenstein, the semiotic theories of Umberto Eco, George Lakoff's cognitive theory of metaphor. I have borrowed the label "Literal Meaning Theory" from George Lakoff and Mark Turner, *More than Cool Reason: A Field Guide to Poetic Metaphor* (Chicago: the University of Chicago Press, 1989), especially pp. 114–19. For detailed citations of literature and a promising theory of musical metaphor, see Robert Hatten, "Metaphor in Music: Musical Signification," *Proceedings of the Second International Congress on Musical Signification, University of Helsinki 1988*, ed. Eero Tarasti (The Hague: Mouton, forthcoming).

16. See note 14.

17. I have been discussing this book here in pursuit of my primary purpose in this paper, which is to highlight problems posed by language use in the interpretation of music, not in order to criticize the theory it conveys. But I must indicate briefly in this note what most troubles me about Agawu's theory. I can best do so by quoting from Anthony Newcomb's paper "Sound and Feeling," *Critical Inquiry* 10 (June 1984): 614–43: "It is probably more true of music than of any other art that the sign (if we conceive it as such) is not transparent—that is, the sign does not disappear in favor of its function as pointing to the signified." Agawu has arrayed his semiotic vocabulary to have all signs pointing to—and presumably all eyes on—the signified, which is either altogether extramusical, and if musical, outside the bounds of the particular work, or if within the work, conceptual (as in the case of "instability," for example). But the sign itself seems to disappear once it has done its work of signifying, and the signified remains isolated. There is no consideration of the kinds of pro-

cesses that are set in motion through the introduction of instabilities, tensions, and disequilibriums, and the consequences that these have, and no consideration of the relations that such processes have to human experience. Newcomb's observation is profound, for the error that it reveals casts its shadow on much current theorizing about the interpretation of music—from the vantage-points of semiotics, hermeneutics, and those political positions from which there has been an overzealous trashing of all strong conceptions of music (such as the idea of absolute music or of the autonomous work, or of the concept of the aesthetic).

18. Hanslick, *Vom Musikalisch-Schönen: ein Beitrag zur Revision der Ästhetik der Tonkunst,* trans. Geoffrey Payzant as *On the Musically Beautiful: A Contribution towards the Revision of the Aesthetics of Music* (Indianapolis: Hackett Publishing Company, 1986), 30.

19. *Languages of Art,* 2nd ed. (Indianapolis: Hackett, 1981), part II.

20. Schumann was differing with Christian Friedrich Daniel Schubart, *Ideen zu einer Astetik der Tonkunst* (Vienna, 1806); Schumann, *Gesammelte Schriften,* I: 105. I am grateful to my colleague Professor Rufus Hallmark for locating the passage for me.

21. See my "Contributions on Beethoven, Pianoforte Sonata, op. 10 no. 3: Largo e Mesto," in the round-table discussion "Style Analysis," *International Musicological Musicological Society: Report of the Eleventh Congress Copenhagen 1972,* ed. Henrik Glahn, Soren Sorensen, and Peter Ryom (Copenhagen: Wilhelm Hansen, 1975), 80–82.

22. Panofsky, "Art History as a Humanistic Discipline" 11.

23. See Fritz Reckow, "Tonsprache," in *Handwöterbuch der musikalischen Terminologie* (Wiesbaden, 1979) and "*Sprachähnlichkeit*" *der Musik als terminologisches Problem: Zur Geschichte des Topos Tonsprache.* Habilitationsschrift Freiburg i. Br. 1977. Also Reckow's essay "Zwischen Metapher und Terminus: die Tonsprache," *Veröffentlichungen der Walcker-Stiftung für musikwissenschaftliche Forschung* V (Stuttgart 1974).

24. Published in Peter Kivy, *Music Alone: Philosophical Reflections on the Purely Musical Experience* (Ithaca: Cornell University Press, 1990), 46–47.

25. *Counterpoint: A Translation of Kontrapunkt,* trans. John Rothgeb and Jürgen Thym (New York: Schirmer Books, 1987), 16.

26. Lincoln: University of Nebraska Press, 1992, 293–94.

27. Lippman, *Western Musical Aesthetics* 296.

28. Panofsky, "Art History as a Humanistic Discipline," 14–22.

29. "Iconography and Iconology: An Introduction to the Study of Renaissance Art," in *Meaning in the Visual Arts,* 38.

30. *In Search of Lost Time,* Volume I: *Swann's Way,* trans. C. K. Scott Moncrieff and Terence Kilmartin, Rev. D. J. Enright (New York: The Modern Library, 1992).

31. "Thomas Grey, Metaphorical Modes in Nineteenth-Century Music Criticism: Image, Narrative, and Idea," in *Music and Text: Critical Inquiries,* ed. Steven Paul Scher (Cambridge: Cambridge University Press, 1992), 93–117.

32. Samuel Beckett wrote that "A book could be written on the significance of music in the work of Proust" (*Proust, 1931*) and Jean-Jacques Nattiez has done it (*Proust as Musician*). But in my reading of it the book is too single-mindedly devoted to extracting just such a consistent theory from Proust.

33. *Inquiries into Truth and Interpretation* (Oxford: Clarendon Press; New York: Oxford University Press, 1984).

34. Carolyn Abbate has been able to identify moments in music where a strong sense of a narrative voice can be felt. See *Unsung Voices* (Princeton: Princeton University Press, 1991). But such moments are rare, and she discredits all other narrative interpretation.

35. *Music and Text,* 293–95.

36. "The Image in Form," unpublished paper presented at a conference on "The Interpretation of Mozart's Instrumental Music," Stanford University, May 1992, quoted with the kind permission of the author.

37. Israel Knox, "Schopenhauer's Aesthetic Theory," Michael Fox, ed., *Schopenhauer: His Philosophical Achievement.* (Totowa, N.J.: Barnes & Noble, 1980), 144.

Ventriloquism

CAROLYN ABBATE

When asked to contemplate Panofsky, author of an essay on meaning in the *visual* arts, I wondered once again about the gulf between painting and music, between the visible and the audible: one full of color and light yet silent, one invisible and marvellously noisy. There is, seemingly, no means of expression, no modality shared by the two. Yet although I have no gift for the interpretation of visible things, investigating the metaphysics of music—and questions of how music can be said to speak—has brought me to an obsession with an art whose effect came to depend precisely on a bizarre disjunction between something seen and something heard. The path from Rousseau or Hegel, through the highest intellectual culture of modern Europe, to a world of ventriloquists' handbooks and horror movies may seem torturous or merely eccentric, yet reveals how paradoxes in the Romantic conception of musical meaning might be understood in terms of an uncanny model, the thrown voice and the puppet who traps it. In ventriloquism, a disembodied voice is detached from any visible source, for the body of the actual ventriloquist must seem not to produce it. The garish puppet that becomes the ventriloquist's stock prop is on the other hand all too concrete: made of plaster, paint, and cloth. Yet his mouth is (in reality) mute. A marriage of immaterial voice and inanimate body thus pins the voice down to a body, gives animation to the body by means of voice.

This marriage also gives the free-floating voice a terrible authority; my argument is that the terms of this authority within classic fantasies about ventriloquism correspond to claims for a transcendent force ascribed to music in the nineteenth century. At the turn of the nineteenth century, continental poets and philosophers celebrated a new insight: that music, far from constituting an imperfect mimetic art, was instead more lofty than painting or words—freed from the imperfections of representational forms precisely because it had no capacity to symbolize the material world. Schiller's famous couplet, "when the soul begins to speak, then, ah, the soul has ceased to speak" can be taken as summary of this fantasy on music's transcendence; Friedrich Kittler has argued that the meaningless "ah" that breaks into the poem is the music of the inarticulate soul evoked by the couplet: a quintessentially Romantic conceit.[1] Yet as soon as that soul uses language ("begins to speak"), it no longer "speaks" true: music, in becoming a language, sheds it transcendent aura.

It hardly seems necessary to belabor here the debates that such Romantic suspicions of language (and concomitant deifications of music) have provoked in modern literary-philosophical circles.[2] Yet it may be salutary to realize that the image of music as a sound beyond imperfection, whose meaning was indecipherable yet palpable, was one that generated a great though covert uneasiness at the turn of the nineteenth century. This uneasiness took one form in writings on music, as a terror of *performers* and meditations on their role as vessels for some disembodied voice. In a different realm entirely, a similar disquiet greeted three newly popular and newly frightening figures: the ventriloquist's doll, the castrato, and the musical automaton. All three figures have one thing in common; they embody an apparent misalliance between sound

and the body that one assumes to produce it. Commonplace in earlier centuries, castrati were by 1820 rare monsters, male figure from whom a female (soprano) voice emerges; the automaton was a dear creation of Enlightenment fascination with machines that mimic God's creations, lifeless metal that nonetheless sings, flutes, or fiddles.[3]

Ventriloquism was an ancient art that mutated at the turn of the nineteenth century into a new form. This transformation revolved around the puppet, and is affirmed in the differences between Charles Brockden Brown's *Wieland* in 1778 and Kenneth Allott's *The Ventriloquist's Doll* in 1944, reflected in the painstaking archival chronicles published in *Houdini's History of Magic*, in "Valentine Vox"'s history of ventriloquism, *I Can See Your Lips Moving*.[4] Ventriloquists of the eighteenth and early nineteenth centuries performed their magic alone on stage: their voices were thrown into far corners of the room, beneath the earth; they imitated animals and foreign accents. In magician's handbooks, this trick is called the capacity to produce "the distant voice" or "distant ventriloquism." Mr. Nichols, who appeared in Boston in 1827 held a "colloquy with a person in the chimney and another person under the floor, the voice of the chimney passing into that of another, and from the cellar to different parts of the house . . . will represent himself and two servants in the kitchen below, together with a singing old lady under the floor and the crying of two children" (Houdini, p. 16). Such voices are the ancient equivalent of a modern cinematic device, what Michel Chion calls the "acousmatic voice"—referring to the filmic phenomena of sound which may seem to inhabit the world represented by the film, but that cannot be ascribed to any visible body on the screen: it is *left over*.[5] And like Pythagoras behind his curtain, such a voice speaks with immensely greater authority than any visibly embodied sound.[6]

By mid-century, however, magicians' handbooks urge the novice ventriloquist to supply himself with a puppet whose mouth, eyes, eyebrows, cheeks, teeth, and other parts must be moveable. Such new fashions were seen as a short-cut, strengthening the illusion of a second person by giving that illusion a visible focus, but coarsening the old and subtle art of throwing the voice, creating a motley crowd of invisible bodies.[7] This new mode of puppet ventriloquism attained its most notorious literary embodiment in Huysmans' *Against the Grain* (*A rebours*), whose central sexual episode concerns the hero's obsession with a nameless female vaudevillian:

> Above them all stood out the woman whose monstrous gift had for months given him such contentment. To the amazement of a crowded audience who were half-frightened at what they heard, she would give voices . . . to a half dozen dolls of graduated sizes, seated on chairs like a row of Pan-pipes . . . one night, he had a miniature sphinx brought [into his bedroom], [one] carved in black marble . . . together with a chimaera, in colored earthenware, flourishing a bristling mane . . . he placed these two monsters, one at each end of the room, put out the lamps, leaving only the red embers glowing on the hearth, to throw a vague and uncertain illumination about the chamber that exaggerated the sizes of the objects half lost in the darkness . . . with weird intonations . . . she gave life and voice to the two monsters without so much as moving her lips, without even a glance in their direction. In the half-light, he seemed to see them move, languorously, towards his throat. (Dover repr., 100–101).

This ventriloquist's puppets are inanimate simulacra of human forms, ranging from the dolls arranged in pan-pipe order to the monstrous chimaera; it is sufficient that they have mouths that can objectively seem to catch the thrown voice, and the very fact that the statues talk is enough to suggest their animation. Des Esseintes puts his mistress to work en-voicing monsters, and refers to her gift as "monstrous" sharing with us a sense of being eye- and ear-witnesses to reality gone badly awry.

Why is the ventriloquist's puppet such a mon-

strous figure? By the time cinema takes up the image in the twentieth century, this monstrosity is well-established. *Dead of Night* (1947, perhaps the most famous ventriloquism movie), or the 1978 film *Magic,* set up this penumbra of fearfulness in different ways, yet the fear attaching itself to ventriloquism derives not from any of its trappings, but from the fact that we see and hear the originating speaker when his words also resonate from a second site. That second site becomes the focus of our uneasiness. The trappings of the carnival—the tawdry costumes, the stage and spotlight, not least the fixed stare, reddened lips, and mobile, prothagnous jaw of the dummy —are sets and costumes. They both mask and give expression, in gaudy form, to an anxiety that does not *originate* in such Gothic trappings, but springs rather from ventriloquism's disruptive ability to split a single voice into two apparent subjects, and to suggest that the second, visually more sinister body, houses the *dominant* sound.

For, as all fictions about ventriloquism will tell us, that second voice has a power that the first, real, and human voice—the voice securely located in the ventriloquist's body—is unable to maintain. Jaunty Victorian how-to manuals tell us that the thrown voice(s) should be saucy, free, or somehow all-knowing—that is, to speak home truths or possess fabulous power. In Brockden Brown's *Wieland,* disembodied voices in a mansion housing a doomed family are assumed to come from God; their murderous instructions are carried out faithfully, because the voice that issues them carries a divine timbre. Later in the nineteenth century, once the puppet is introduced, this authority is concentrated by being localized in the *visible* body, and simultaneously we first encounter the terrible fantasy that a puppet might actually be an animate being. The puppet's impossible autonomy becomes, of course, the stock device in tales of ventriloquistic horrors. How this intimated abomination is defeated, however, is most instructive.

In *Magic,* the dummy Fats says what Corky the ventriloquist (played by Anthony Hopkins) would "really *like to say,*" urges Corky to murders he

would, as "himself," never "dare to commit." The film never uses special effects or trick photography to create the illusion that the dummy is actually animate. But until the final moment, superb scenes of ventriloquism have their effect: Fats *seems* his own voice, his own person, independent of Corky and wholly alive. The final scene, however, offers a clear statement of the matter's truth, by revealing how entirely the dummy's voice *is* Corky's. Corky has stabbed himself, rather than be forced "by Fats" to murder his girlfriend. The scene depicts the "double" death of ventriloquist and dummy (fig. 1). As he dies, Corky reproaches Fats by saying "they never loved me. It was always us." The dummy, whose voice is also dying, finally says "Schmucko. 'Us' was you."

This "'us' was you" represents an extraordinary node. At this instant, the film articulates a truth—that the dummy's voice *is* the ventriloquist's. But its means of assuring that we understand this statement *as truth* is to exploit the uncanny authority of that dummy-voice, here, speaking in the act of denying its own existence. The moment of double negation became a necessary *topos* in virtually all fantasies of ventriloquism (already in *Wieland* the mysterious voices reveal in the end that the family's house guest is a ventriloquist, and that they do not have life, do not exist). Yet though our uneasiness is assuaged, the moment allows no real resolution: for why have we believed that the abomination is not real? Trapped in a devil's circle, we oscillate between accepting the puppet's declaration of nonexistence, and realizing that our very belief reconjures that voice, with all its proud authority, into new life.

Michael Bolton's *Dead of Night* was produced in 1947. In the film, five separate episodes— stories told by guests at an English country house—were directed by four different men; the ventriloquism tale, narrated by a psychiatrist named Dr. van Stratten as "one of my most interesting cases" was done by Cavalcanti. Partly through Cavalcanti's touch, it remains the most unnerving of all ventriloquism fantasies. Yet it is

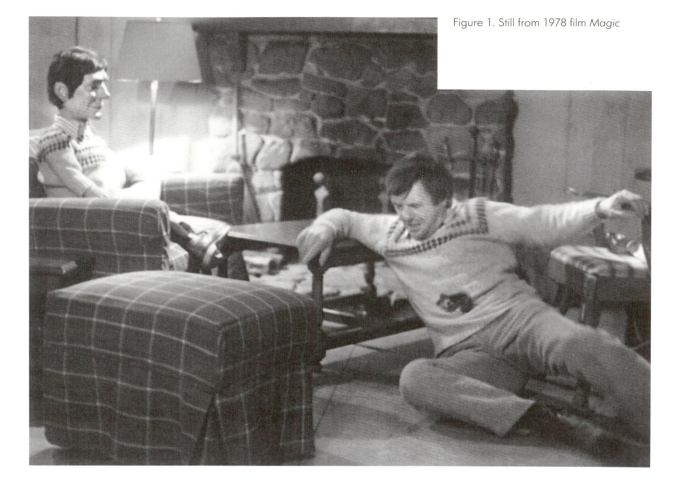

Figure 1. Still from 1978 film *Magic*

unnerving also because the *topos obligé,* where the free-floating voice denies its existence, is interrupted before its expected consumation.

Dr. van Stratten tells how he became involved with the case of Maxwell Frere (Michael Redgrave). Frere has been arrested for the shooting of another ventriloquist, Sebastian Kee, and the psychiatrist is introduced to the case through reading Kee's police deposition, which mutates cinematically into three flashbacks to encounters between Frere and his rival. They first meet backstage at a Paris nightclub, and Frere's dummy, "Hugo," torments his owner by flirting with Kee and refusing to be silenced. Their next meeting is in the bar of a London hotel, where Frere is drunk; Hugo makes obscene remarks to two women in the bar and, after Frere becomes embroiled in a brawl, Kee escorts him to his room and puts him (and Hugo) to bed. In a final, disastrous meeting that same night, Frere bursts into Kee's room claiming that his rival has stolen Hugo; to Kee's horror, the dummy is found lying on this bed, and Frere shoots Kee in a jealous rage.

Frere is jailed to await trial for his crime, but refuses to explain his actions. Dr. van Stratten suggests that Hugo be returned to him, and observes their conversation to learn the "truth," especially, how Hugo could have gotten from Frere's room to Kee's bed (here, of course, is the

suggestion of the puppet's impossible autonomy). When Hugo is first brought in and laid on Frere's cot, the ventriloquist jumps up, turns his face to the wall, and gasps, as if sight of the puppet is too much for him to bear. Frere quickly recovers, picks up Hugo and—clearing his throat and moving his lips experimentally—assumes his familiar ventriloquist's position. The conversation between the two eerily recalls the stock farewells and recriminations of human lovers, "I knew you wouldn't leave me, Hugo. I knew you'd come back." "Not for long, my boy, not for long. You're going to stop in jail for years and years and years and years. That wouldn't suit me." Hugo goads Frere by suggestively praising Sebastian Kee, "such a charming fellow; they tell me he's recovering . . . I have my career to think of." When Frere panics and shouts "you wouldn't run out on me now, I don't believe it. You wouldn't do that," Hugo's face is shown, for the first time, alone, as if even the camera has begun to believe in his autonomy, "Oh, wouldn't I? Wouldn't I? Wouldn't I?" From this point on, as the scene accelerates, the camera shifts between closeups of Hugo, Frere, and the watching psychiatrist. When Hugo finally turns and says "try to stop me Maxwell. You're finished," Frere ceases to speak. He gasps once, and smothers Hugo with a pillow. In the murder scene, all the ventriloquist's greatest tricks are laid before us: Hugo's voice becomes muffled in the pillow, reduced to cries of "Maxwell, Maxwell, Maxwell," and finally to screams whose origins are truly acoustically occult (it is impossible to tell whether they are Hugo's or Frere's). The camera suddenly jumps outside the jail cell, to Dr. van Stratten, who watches something we cannot see (though we hear a series of dull thuds and grunts) and who himself begins to panic, shouting for the key, desperately rattling the door. He finally bursts in, to find Frere, gasping rhythmically, kicking Hugo's head into powder.

Why does Dr. van Stratten panic when he sees Frere about to destroy the dummy? He suggests later (and disingenuously) that he feared for Frere's sanity should the dummy be "murdered."

But his terror mirrors our realization that the Hugo body will be "killed" before the trapped voice can make the ritual gesture of denying its own existence; here, there can be no "us was you," no erasure of the second voice. Rather than being caught in the circle, this voice escapes to hover, unchained, in our world. In the final scene, that voice takes up residence elsewhere, in revenge: in the body of Max Frere.

I have lingered on my magician's manuals and horror flicks to underscore my historical puzzle: why should the ventriloquist's doll attain demonization in the nineteenth century, and why does this parallel in odd ways the *elevation* of music as transcendent voice? For the Devil's circle that is set in motion by ventriloquism is replicated in philosophical writings that strip music of mimetic force, the better to exalt its imprecision and muteness into overwhelming authority. Rousseau stands as a central figure in this regard. In a passage from the *Essay on the Origins of Language*, he writes:

> Even if one spent a thousand years calculating the relations of sounds and the laws of harmony, how would one ever make of that art an imitative art? Where is the principle of this supposed imitation? Of what is harmony the sign? And what do chords have in common with our passions? When the same question is applied to melody, the reply is the same: *it is the mind of the reader beforehand* [c'est l'ésprit du lecteur en avant]. By imitating the inflections of the voice, melody expresses pity, cries of sorrow and joy, threats and groans. All the vocal signs of passion are within its domain. (chapter 14: English trans., 57)

Rousseau's treatise, lying historically at a period of the decline of mimetic doctrines, in general oscillates between claiming music as a *sign* for visible objects or images (mimesis), and as the ineffable sound of preverbal thought, as in this passage from chapter 14. Such later notions as Schopenhauer's "pure" music as phenomenal

trace of the will is prefigured by Rousseau's no-
tion of "the mind of the reader beforehand"; in
this phrase, the doctrine of imitation, of music as
a *sign* for the phenomenal world, crumbles for an
instant. And Rousseau's vision of music as a pre-
lapsarian sound, as perfect expression predating
language, anticipates those nineteenth-century
philosophies of music and language, which set
up a series of binary oppositions in which music
is invariably the privileged term. Here, however,
the phrase "it is the mind of the reader before-
hand," like the metaphysics it anticipates, is a
moment of ventriloquism. Here music, reified, be-
comes the puppet and his unassailable voice. By
making music discursively meaningless (in effect,
music declares that it cannot speak) but the
bearer of a greater Truth, the ventriloquistic circle
of oscillating authority is set in motion.[8] Music
has a force that no other art can equal, but to be
so endowed, it must *bespeak* its own muteness.
Us (music that speaks, tells us what it is, and the
human mind to whom it is speaking) is you (the
human mind, listening to meaningless sound,
alone).

This particular metaphysics of music, of course,
remains with us today. A recent trend in philo-
sophical writings (including those of Derrida and
George Steiner), apostrophizes music as the
comforting, maternal bosom that is our refuge
from thought. I am not greatly exercised by the
gender images in all this: that music is female,
preverbal, dumb. (George Steiner dedicates *Real
Presences* to a woman identified as "the sound of
music" in a bleak, linguistic world.) This, if re-
grettable, seems no more than a tedious re-
creation of outmoded notions of the feminine.
But this unanswerable need for a sweeter alter-
native to language, and the move that seizes
upon music as a panacea, a short circuit to truth,
is oddly antique. *Real Presences,* which is largely
a meditation upon "whether anything meaningful
can be *said* (or written) about the nature and
sense of music" embodies in pungent forms both
the metaphysical assumption and the particular
tone (the word is significant) of this position. Thus
Steiner cites with approval "Lévi-Strauss's rhap-

sodies about music as the "supreme mystery of
man," and mourns that "when it speaks of mu-
sic, language is lame," that "attempts to verbal-
ize [music] produce impotent metaphors," and
that "almost cruelly, we can contrast the com-
municative wealth of the musical with the waste
motions of the verbal. The singular concision of
complex moods in Chopin defies discourse."[9]

We must not forget that Steiner is summarizing
and re-asserting a metaphysics of music that
was historically limited (though his truism—that
criticism about Beethoven's Ninth does not have
the same punch as Beethoven's Ninth—seems
eternal). But the strategy that declares music a
supreme and "linguistically pure" form of expres-
sion is predicated on a secret debasement and
silencing of music: the ventriloquistic Devil's cir-
cle.

Missing in Steiner is a necessary *uneasiness,*
an insight granted to early nineteenth-century
music theorists and writers, that the Romantic im-
age of music's transcendence also led to de-
monic or uncanny endings. Such are the endings
of Hegel's chapters on music in the *Lectures on
Aesthetics,* of Kleist's *Die heilige Cäcilie: oder die
Gewalt der Musik.* Hegel, in rhapsodizing about
performers as genial channels for a composer's
thought, pulls back as if appalled by his direc-
tion. He asks at last whether this model of a ves-
sel *through whom* the composer speaks means
that the vessel (performer) also commands the
music. Do the performer's artistry and passion
engender a sense that he is creating the music
he plays? Naturally, the performer must be more
than a machine; naturally he must have some au-
tonomy in matters of interpretation, tempo, emo-
tional expression. In certain respects his voice is
louder than that of the creator who looms behind
him, since he alone can give life and body to
thoughts that emanate from elsewhere. Yet that
performer, for Hegel, must continually declare,
with every note, that he is merely the handmaiden
of genius, that he is an automaton.[10]

Having raised his performer from inanimation,
Hegel puts the monster to rest by having his
performance-voice state that it does not exist (it

is dumb before the master). Kleist's fable, on the other hand, allows ventriloquism and music to collide openly. In his story, a mass played in the Cologne cathedral by an orchestra of nuns strikes three rampaging Protestants into immobility; St. Caecilia has performed a miracle by speaking through music. Yet the three blasphemers are condemned every midnight to re-sing the music that felled them. They bolt upright like marionettes whose strings are suddenly pulled; they scream like leopards. Replication of the mass's original performance, of musical performance *itself,* in this sinister miniature gives us three ventriloquist's dolls within a parable that perverts any benign Romantic musings on the "power of music." Performers, genial ventriloquist's puppets, and music itself, ventriloquistic art, would come in the nineteenth century to haunt the landscapes they were meant to transfigure.

Notes

1. See Friedrich Kittler, *Aufschreibesysteme 1800/1900* (Munich: Wilhelm Fink Verlag, 1987), 46.

2. The most notorious *locus classicus* in deconstructive analysis of music is Jacques Derrida's essay on Rousseau in *Of Grammatology,* trans. Gayatri Chakravorty Spivak (Baltimore: Johns Hopkins University Press, 1976), 165–268, and Paul de Man's response in *Blindness and Insight,* 2nd. ed. (Minneapolis: University of Minnesota Press, 1983), 102–41.

3. These phenomena are explored in my forthcoming book, *The Uncanny Voice of Music.*

4. H. J. Moulton, *Houdini's History of Magic in Boston 1792–1915,* repr. (Glenwood: Meyerbooks, 1983); Valentine Vox, *I Can See Your Lips Moving: the History and Art of Ventriloquism* (Hollywood: Celebrity Books, 1991).

5. Michel Chion, *La voix au cinéma* (Paris: Editions de l'Etoile, 1982), 116–23; and Slavoj Zizek, *Looking Awry* (Cambridge: MIT Press, 1991), 126–30.

6. On theories of "acousmatic sound" see Jean-Jacques Nattiez, *Music and Discourse,* trans. Carolyn Abbate (Princeton: Princeton University Press, 1990), 68–74.

7. Vox, *I Can See Your Lips Moving,* 71–90.

8. This effect of double negation in musical-metaphysical writings has been invoked by Susan Bernstein, who writes "for indeed, even when music, as an organon of truth, is most subordinated to the logos, its thematic treatment (and, implicitly, the critical use of musical tropes) attributes to it the ability to say more than language can say—precisely because it does not, strictly speaking, 'mean' anything," Review of Béatrice Didier, *La Musique des lumières,* in *MLN* 101 (September 1986): 960.

9. George Steiner, *Real Presences* (Chicago: University of Chicago Press, 1989), 18, 19, 20.

10. See *Aesthetik* volume 2, ed. Friedrich Bassenge (Berlin: Verlag das Deutsche Buch, 1985), "Die künstlerische Exekution," 323–26.

Iconology at the Movies: Panofsky's Film Theory

THOMAS Y. LEVIN

In the New York Herald Tribune of November 16, 1936, below the involuntarily ironic headline "FILMS ARE TREATED AS REAL ART BY LECTURER AT METROPOLITAN," one could read at some length about how "for the first time in the history of the Metropolitan Museum of Art the motion picture was considered as an art during a lecture there yesterday afternoon by Dr. Erwin Patofsky [sic], member of the Institute for Advanced Study at Princeton University [sic]." What made this event so newsworthy, besides the incongruous union of the plebeian medium of the movies with such an austere institution and famous art historian, was the seemingly unprecedented and rather astonishing cultural legitimation of the cinema that it implied. While the study of film continues to this day to struggle for a modicum of institutional legitimacy within the academy, in 1936 the notion of any scholar lecturing anywhere on film (much less this particular scholar speaking at that particular museum) was nothing short of remarkable.[1] What could possibly have motivated the recently immigrated, renowned art historian and theorist Panofsky to undertake such an excursion into the domain of popular culture?

The canonical account is that Panofsky was approached in 1934 by Iris Barry, who was in the process of gathering support for a new Film Department at the Museum of Modern Art of which she would later become the founding curator. For alongside architecture, which was already being established as a department at MOMA following a highly successful 1931–32 exhibition, the mu-

seum's young director Alfred H. Barr—who himself published articles on cinema in the late 1920s and early 1930s—had announced in July 1932 the plan to establish a "new field" at the museum that would deal with what he felt was the "most important twentieth-century art": "motion picture films."[2] When, with the help of a $120,000 grant from the Rockefeller Foundation, the Film Department of MOMA officially opened in June 1935 (initially housed in the old CBS building on Madison Avenue in a room piled high with films and books), it was also thanks to the engagement of Panofsky, who had agreed to lend his voice to promote what was then considered, as he himself put it, "a rather queer project by most people."[3] This solidarity first manifested itself in the form of an informal lecture, "On Movies," presented in 1934 to the faculty and students of the Art & Archaeology Department at Princeton University and subsequently published in the Departmental Bulletin in June 1936.[4] "And so," Robert Gessner notes in his obituary, emphasizing the legitimation function that Panofsky's text was meant to serve, "the respectability of the front door was opened." Merely by speaking on film at Princeton and, subsequently, in contexts explicitly associated with the fledgling film library,[5] Panofsky gave an intellectual (art historical) and cultural (continental) imprimatur to MOMA's pioneering move to establish a serious archival and scholarly center for the study, preservation, and dissemination of the history of cinema. Indeed, once the film department was

founded, Panofsky was named as one of the six members of its advisory committee in March 1936, a position he held well into the 1950s.[6]

Panofsky's scholarly interest in cinema was, however, not nearly as punctual and radically exceptional as it is usually claimed to be. In fact, he continued to present his ideas on film in public lectures and in print long after the MOMA film library had become a firmly established part of the New York cultural landscape. In 1937 a slightly revised version of "On Movies" appeared under the new title "Style and Medium in the Moving Pictures" in one of the leading organs of the international avant-garde, Eugene Jolas' Paris-based English-language journal *Transition*.[7] The "final" version of the film essay, now entitled "Style and Medium in the Motion Pictures," was not published until 1947 in the short-lived New York art journal *Critique,* whose editors had prompted Panofsky to substantially rework and expand upon his earlier text.[8] This significant rewriting of the essay—the one later widely reprinted and translated—also occasioned a new round of public presentations. According to one eyewitness account, "Panofsky took such delight in the movies that in 1946–1947 he traveled to various places in and around Princeton, to give his talk as a *tema con variazioni*. He would end by showing one of his favorite silent films, such as Buster Keaton's *The Navigator,* which he would accompany with an extremely funny running commentary."[9] Furthermore, Panofsky's engagement with the cinema extended well beyond the immediate context of the various versions of film essay and included, for example, his discussion of "the 'cinematographic' drawings of the Codex Huygens,"[10] his inaugural address at the first meeting of The Society of Cinematologists in 1960, and his not infrequent discussions of films well into the 1960s.[11]

The various manifestations of Panofsky's cinephilic passion are generally explained as just that, simply a function of his long-standing love of a medium almost exactly as old as he. Indeed, in a rather autobiographical passage from "On Movies" which was subsequently dropped in later versions of the text, Panofsky says as much himself, admitting to the reader that

> I for one am a constant movie-goer since 1905 (which is my only justification for this screed), when there was only one small and dingy cinema in the whole city of Berlin. . . . I think, however, that few persons are so inveterate addicts as I.[12]

Seemingly taking its cue from such lines, Panofsky scholarship has cast the work on film as one of his charming "intellectual hobbies and idiosyncrasies" similar in its uniquely anecdotal significance to Panofsky's fabled distaste for children (Heckscher) or as an index of the intellectual freedom afforded the recent immigrant by the much-less-stuffy art historical discipline in the US (Michels).[13] Motivated at worst by an unreflected high cultural contempt for the cinema, there has thus been—until only very recently—a virtually complete lack of serious scholarly work on Panofsky's film essay in the art historical secondary literature.[14] While this is perhaps to some degree a function of art history's longstanding resistance to the cinema, the failure to engage an analysis of cinema from well within the art historical ranks is curious indeed.[15] It is particularly puzzling given that the "epochal"[16] film essay supposedly "has been reprinted more often than any of his other works" and only recently has even been characterized by an authority in the field as "by far Panofsky's most popular work, perhaps the most popular essay in contemporary art history."[17]

The seeming incongruity between the film essay's ostensible popularity and its consistent scholarly neglect is not only highly symptomatic but, as I shall suggest, is in fact *necessary*: Panofsky's remarks in film can *only* maintain their harmless renown *as long as* they remain unread. According to a classically Morellian logic, however, careful attention to this seemingly marginal and inconsequential moment in Panofsky's

oeuvre might well serve—precisely thanks to its incidental and informal character—to expose the epistemic limits of his project more readily than the more carefully elaborated works. As will become clearer below, Panofsky's interest in cinema is anything but accidental. Rather, the response to the "movies" betrays unambiguously the centrality of a certain model of experience, a privileging of the representational, of the thematic, and of continuity, all of which are vital to Panofsky's critical, historical corpus even as they demarcate its theoretical limits. The cinema essay thus turns out to be of great methodological significance not where one might expect it (i.e., in the context of film studies) but rather in current art historical debates about the aesthetic-politics of the iconographic project.

The reception of Panofsky's film essay within the context of film theory is no less curious than that accorded it by art history. On the one hand, despite its anthological "popularity" in collections of film theory and criticism, Panofsky's essay is almost completely absent from the canonical historiography of film theory.[18] On the other hand, the essay has not suffered quite the same critical neglect in cinema scholarship as it has in art history, although the very few sustained responses to the text—discussed below—are far outnumbered by passing references to it in the form of isolated citations.[19] This is no accident, since Panofsky's wonderfully cinephilic meditation on film is less a sustained argument than a paratactic series of sometimes more and sometimes less elaborated reflections. While some of these are very insightful, the essay as a whole is largely derivative, an eloquent restatement of positions familiar from French and German film theory of the 1920s. Possibly as a result (and certainly overdetermined by disciplinary myopia), cinema studies has largely failed to take up other of Panofsky's essays which, while not explicitly concerned with the cinema, are nevertheless of great methodological and philosophical relevance to contemporary discussions in the field. Indeed, in a chiasmus as formally elegant as it is

true, just as art history has much to learn from Panofsky's texts on cinema, film studies would do well to attend to some of Panofsky's work in art history and theory, in particular his early discussion of mechanical reproducibility and the recently translated study of "Perspective as Symbolic Form."[20]

In terms of the history of film theory, Panofsky's film essay manifests many of the hallmarks of the first generation of theoretical writings on the cinema which are, by and large, the product of the silent cinema era. Primarily concerned with legitimating the new medium by establishing that it too was "art," so-called "classical" film theory—as represented, for example, by the work of Rudolf Arnheim, Hans Richter, or Béla Balázs—often invoked the Laocöonian rhetoric of aesthetic specificity to articulate the differences between film and more traditional media such as theater or opera, in order subsequently to establish, in an often prescriptive and normative fashion, the medium's distinctive aesthetic provinces (at the level of both form and content). Panofsky's film essay, although chronologically later than the bulk of "classical film theory" from which it borrows quite liberally,[21] clearly adopts that paradigm's central rhetorical strategy, as evidenced in its repeated attempts to establish the medium's "unique," "specific," "exclusive," and, above all, "legitimate" aesthetic capacities.[22] However, having established at the start that the specificity of the medium must be a function of its technology, the essay struggles with the conflicting ramifications of the genealogy, vacillating between the two antinomial fields of the film theory landscape, i.e., the position that holds that cinema's technology lies first and foremost in its "fantastic," transformative capacities (cut, dissolve, superimposition, slow motion, etc.) versus the position that regards cinematic technology as first and foremost photographic. Indeed, the drama both within Panofsky's essay and across its various versions resides in its symptomatic negotiation of the tension between what one could loosely call the "constructivist" and the "realist"

accounts of the motion picture "medium" and the consequences of each for its "style."

The most explicit—and consequently often cited—of Panofsky's specificity arguments is the claim that cinema's "unique and specific possibilities can be defined as *dynamization of space* and, accordingly, *spatialization of time.*"[23] While the second half of this definition, an important topos of early film theory,[24] is left completely undeveloped, Panofsky does articulate at some length how, in contrast to the space of the theater which is (more or less) static, film space is utterly dynamic. Although the movie spectator is physically immobile, Panofsky insists that

> aesthetically, he is in permanent motion as his eye identifies itself with the lens of the camera, which permanently shifts in distance and direction. And as movable as the spectator is, as movable is, for the same reason, the space presented to him. Not only bodies move in space, but space itself does, approaching, receding, turning, dissolving and recrystallizing as it appears through the controlled locomotion and focusing of the camera and through the cutting and editing of various shots—not to mention such special effects as visions, transformations, disappearances, slow-motion and fast-motion shots, reversals and trick films. This opens up a world of possibilities of which the stage can never dream.[25]

What defines the cinema over and against other media, Panofsky claims, is the unique capacity afforded it by its range of technical features to *construct* space through or *in* time. From the start, then, the aesthetic significance of the technological apparatus seems tied to cinema's formally *transformative* potential.

Of course, the full range of these cinematically specific possibilities were only taken up slowly, the history of early cinema being effectively the testing ground for the new syntactic devices made possible by the technology—through cutting, editing, and other capacities of the apparatus—and often referred to as film lan-

guage. According to Panofsky, the formal development of the cinema "offers the fascinating spectacle of a new artistic medium gradually becoming conscious of *its legitimate, that is, exclusive possibilities* and limitations."[26] Elaborating this teleology of specificity, Panofsky compares cinema's halting development from early attempts at self-legitimation (through the imitation of established artforms such as painting and theater, effectively denying its own specificity, to the later articulation of its increasingly film-specific formal arsenal) with the evolution of the mosaic (first simply a practical means of making illusionistic genre paintings more durable and later leading to "the hieratic supernaturalism of Ravenna") and to line engraving (first a cheap and easy substitute for precious book illuminations, later leading to Dürer's purely "graphic" style). Explicitly invoking the linguistic metaphor that would become the cornerstone of semiotic film theory decades later, Panofsky writes that

> the silent movies developed a definite style of their own, adapted to the specific conditions of the medium. A hitherto unknown language was forced upon a public not yet capable of reading it, and the more proficient the public became the more refinement could develop in the language.

Rehearsing a claim about the historicity of perceptual skills in their relation to reigning modes of representation, Panofsky is here arguing (as did other theorists such as Dziga Vertov and Walter Benjamin, albeit with radically different conclusions) that cinema not only stages a new visual episteme, but simultaneously schools a new mode of vision. As documented amply by the early history of cinema, with its accounts of horrified misreadings of close-ups as dismemberment, generalized confusion regarding temporal and spatial continuity across cuts, the use of live film narrators to "tell" the story along with the images, etc., it took some time before people began to master the rather extensive repertoire of formal cinematic devices—p.o.v. shot, parallel action, shot-reverse-shot, etc.[27]—which consti-

tutes the seemingly automatic (because habitu-alized) "cinematic literacy" of the contemporary moviegoer.

At this point, however, Panofsky's essay takes a dramatic turn. Given that cinema's formal lexicon effectively constitutes a new representational space, one that both extends the spatial illusion of perspectival depth across time and also creates new spatio-temporal folds and voids, one could expect at this point an analysis of the socio-epistemic *stakes* of this new representational regime along the lines articulated in Panofsky's perspective essay of 1924/25. Indeed the explicit filiations between cinema and perspective —the cinematic photograms based qua photographs on the optics that gave rise to perspectival space—call out for such a synchronic analysis that would map cinema onto 20th-century theories of substantiality, materiality, spatiality and being, models of the subject, etc. And in fact, Panofsky himself commented on the relationship between single-point perspective and the new representational technologies. Accounting for the fact that none less than Kepler recognized that a comet moving in an objectively straight path is perceived as moving in a curve, Panofsky writes:

> What is most interesting is that Kepler fully recognized that he had originally overlooked or even denied these illusory curves only because he had been schooled in linear perspective. . . . And indeed, if even today only a very few of us have perceived these curvatures, that too is surely in part due to our habituation—*further reinforced by looking at photographs*—to linear perspectival construction.[28]

Just as in the essay on perspective Panofsky showed how "perspectival achievement is nothing other than a concrete expression of a contemporary advance in epistemology or natural philosophy,"[29] just as there he describes how the actual painted surface is present in the mode of denial, repressed in favor of an imaginary, *projected* space—this structure of disavowal being a central film theoretical topos—so too one could

imagine a reading of film language that articulated the epistemic correlates of *cinema* as symbolic form, showing how it too, as Panofsky said of perspective, is "a construction that is itself comprehensible only for a quite specific, indeed specifically modern, sense of space, or if you will, sense of the world."[30] Having raised the question of cinema's specificity and its relationship to film language and a transformation of perception, Panofsky has set the stage, as it were, for an iconological reading of cinematic form as sedimented content (Adorno), the term understood as Panofsky defined it in opposition to the content-based analysis that is the province of the iconographic interpretation.

Instead of an iconological reading of cinema as symbolic form, however, such as is undertaken in various ways in Benjamin's 1935/36 essay on the "Artwork in the Age of its Technological Reproducibility," Heidegger's "The Age of the World Picture," Jean-Louis Baudry's "Ideological Aspects of the Basic Cinematic Apparatus," or in Deleuze's *The Time-Image* and *The Movement-Image*, to name just a few,[31] Panofsky's essay takes a crucial methodological swerve in another direction. Instead of engaging film form as such—as Balázs does, for example, when he suggests that "the camera has a number of purely optical techniques for transforming the concrete materiality of a motif into a subjective vision. . . . These transformations, however, reveal our psychic apparatus. If you could superimpose, distort, insert without using any particular image, if you could let these techniques have a dry run, as it were, then this technique as such would represent the spirit [*Geist*]"[32]—Panofsky instead focuses on the intelligibility of the *content* of the images. Comparing the initial unintelligibility of early cinema with similar difficulties at other points in the history of art, Panofsky writes:

> For a Saxon peasant of around 800 it was not easy to understand the meaning of a picture showing a man as he pours water over the head of another man, and even later many people found it difficult to grasp

the significance of two ladies standing behind the throne of the emperor. For the public of around 1910 it was no less difficult to understand the meaning of the speechless action in a moving picture.[33]

Having reduced the question of specificity to the fact that early cinema was silent—thereby effectively bracketing the question of film language[34]—Panofsky focuses on the means employed by early cinema to help render these mute images intelligible. Besides the use of cinematic intertitles (which Panofsky compares to medieval *tituli* and scrolls), another technique used to foster comprehension was the employment of easily recognizable types and actions:

> Another, less obtrusive method of explanation was the introduction of a *fixed iconography* which from the outset informed the spectator about the basic facts and characters, much as the two ladies behind the emperor, when carrying a sword and a cross respectively, were uniquely determined as Fortitude and Faith.[35]

In order to ensure that the meaning of its sequences would be grasped, early cinema made use of a wide range of types (the Vamp, the Villain, etc.) and genres (Westerns, melodramas, etc.), which—conveniently—are ideal material for iconographic analysis. So, for example, Panofsky reads the Vamp and Straight Girl as modern equivalents of the medieval personifications of the Vices and Virtues. But of course there is *nothing film specific* about these types or genres. Indeed, their very function as aids to deciphering the cryptic new film language *require* that their readability depend on pre- or extra-cinematic knowledge. This shift of focus serves to justify the iconographic excursions on early cinema types and genres, acting styles, etc., which occupy Panofsky for much of the remainder of the essay, allowing him to display his often magisterial command of film history and genre filiations. Remaining resolutely at the representational level

of the photographic image, these readings of genres must even remain blind to the more subtle genre iconographics of the complex cinematic syntagm (which would *require* an attention to cinematic language even within a strictly iconographic project). As a result, in order to invoke his iconographic method, Panofsky, the theorist of cinematic specificity, must reduce film to precisely that aspect which, according to his own definition, is *not* specific to cinema.

Unless of course—as turns out to be the case—Panofsky has introduced a new, rather debatable criterion of the medium's specificity, namely the photographic. Once one realizes to what extent Panofsky, as Jan Bialostocki once perceptively remarked, "thought of film as an extremely 'iconographic' art, the heir of the tradition of symbolism and of the old meanings connected with image,"[36] then many of the otherwise puzzling moves in the film essay begin to make sense. The utterly uncritical commitment to, and exclusive concern with, Hollywood narrative cinema, the micrological analysis of differences in acting styles in silent and sound film, the excursi on certain favorite film stars (Garbo, Asta Nielsen), indeed, in general, a focus on content that almost completely disregards questions of cinematic form—all of these stem from the imperatives of a motion picture iconography. Such a project depends, however, on a complete shift in Panofsky's conception of cinematic specificity. Abandoning the focus on film language implied in the "dynamization of space" argument, Panofsky has now located the specificity of the medium in that aspect of its technology that guarantees the survival of depicted content, namely its photographic foundation. As already indicated in the shift in the essay's title away from the dynamics of "movies" to the emphasis on moving or motion *pictures*, the later versions of the film essay will focus increasingly on the photographics—instead of the cinematics—of film.[37] This explains both Panofsky's insistence that the cinema is first and foremost a moving picture—using historical precedence (films had images before they had

spoken sound) to make claims of ontological priority (film *is* first and foremost visual)—and the resulting, aesthetically rather reductive "principle of co-expressibility" (first added in 1947) which argues that sound must be subservient to the image. Compared to Adorno and Eisler's much richer and exactly contemporaneous argument for what they called "contrapuntal" sound-image relations, which emphasizes the autonomy of both the acoustic and the visual and their reciprocal enrichment through a logic of montage, Panofsky's position clearly wants to maintain the priority of the (photographically) represented space over a more cinematic, poly-semiotic sound-image construct.[38]

Nowhere is the iconographic emphasis on content over form more strikingly evident than in the extensive new concluding argument of the final version of the film essay. Panofsky argues here that, unlike other representational arts that work "top down"—i.e., from an idea that serves to shape inert matter—film works from the bottom up. Unlike the "idealistic" media of painting, sculpture, drama, and literature, all of which, no matter how "realistic," construct their "worlds" on the basis of ideas, film draws upon that world itself:

> The medium of the movies is physical reality as such: the physical reality of eighteenth-century Versailles—no matter whether it be the original or a Hollywood facsimile indistinguishable therefrom for all aesthetic intents and purposes—or a suburban home in Westchester. . . . All these objects and persons must be organized into a work of art. They can be arranged in all sorts of ways ("arrangement" comprising, of course, such things as make-up, lighting, and camera work); but there is no running away from them.[39]

For Panofsky, cinema's elective affinity with the physical world is what assures its status as an iconographic "good object" and, as such, the legitimate heir to the traditional pictorial arts. Un-

like Kracauer, for whom film's photographic basis became an argument for its privileged relation to the quotidian and the marginal; unlike Aragon, for whom the same iconico-indexicality enabled film to capture and reveal the unseen, hidden meanings of everyday objects (a Surrealist aesthetic program rearticulated in Benjamin's notion of the "optical unconscious"); unlike Béla Balázs' "physiognomic" theory, which saw in film the capacity to give a face to inanimate objects; unlike André Bazin, for whom film's grounding in the photographic served as an argument against montage and in favor of a long take that supposedly respects rather than violates the profilmic, ostensibly allowing the viewer's gaze to roam freely through the deep-focus field; unlike Lukács, who argued (as early as 1911) that it was precisely cinema's *combination* of a photographic realism with the anti- or super-naturalism of the cut that afforded it what he called a "fantastic realism," Panofsky's insistence on the importance of cinema's relation to "physical reality" is something else entirely. What Panofsky does here is to ground an aesthetics of cinema in the imperatives of its photographic basis, in order, almost as a corollary, to justify the continued relevance of the content-based methodology of the iconographic project. He is thus understandably allergic to any cinematic practices (such as expressionism) that subject the pro-filmic to processes of abstraction: "To prestylize reality prior to tackling it amounts to dodging the problem. The problem is to manipulate and shoot unstylized reality in such a way that the result has style. This is a proposition no less legitimate and no less difficult than any proposition in the older arts."[40] As a result, "The Cabinet of Dr. Caligari," praised as an "expressionistic masterpiece" in the first version of the essay, is reduced to "no more than an interesting experiment" in the final version ten years later.

The most articulate formulation of Panofsky's theory of cinema's photographic specificity is, however, not contained in any of the versions of the film essay. It can be found, rather, in the con-

text of his correspondence with Siegfried Kracauer, who, upon the recommendation of Rudolf Arnheim, sought out Panofsky shortly after his arrival in the U.S. in 1941. While the majority of the letters between the two exiled scholars—sometimes in German, sometimes in English—deal with the pragmatics of intellectual networking (letters of recommendation, scheduling of meetings, organizing of contacts), these are punctuated every so often by more substantive epistolary responses to each other's works. Just as Kracauer was struck by the methodological elective affinity between his own micrological approach and Panofsky's *Dürer*, Panofsky was also very enthusiastic in his response to many of Kracauer's writings, recommending that Princeton University Press publish *From Caligari to Hitler* and even suggesting jokingly that Kracauer write a sequel study to be called "From Shirley Temple to Truman."[41] While Kracauer's relentlessly complimentary remarks on the first two versions of Panofsky's film essay seem a bit (strategically) exaggerated in light of the text's negligible presence in his published work,[42] the concluding argument about film's relation to "physical reality" which first appears in the final version of Panofsky's film essay (published the same year as Kracauer's *Caligari*) may well have been a significant impulse. Indeed, Panofsky's observation that "it is the movies, and only the movies, that do justice to that materialistic interpretation of the universe which, whether we like it or not, pervades contemporary civilization"[43] is the only passage marked "important" in Kracauer's copy of *Critique*,[44] and may well have played a role in the development of the argument in Kracauer's next book. For when it finally appeared in print over 10 years later, Kracauer's *Theory of Film* carried a subtitle with a decidedly Panofskian resonance: "The Redemption of Physical Reality." And it is a preliminary outline of this very book, which he had been asked to review for Oxford University Press shortly after the publication of the *Critique* essay, that provokes Panofsky to articulate in unprecedented detail the role of the photographic in his conception of cinema's specificity. As he explains to Mr. Philip Vaudrin at OUP, in a letter dated October 17, 1949:

> The outline of Mr. Kracauer's book interested me so much that I could not withstand the temptation to read it right through in spite of my being somewhat busy these days, and that is perhaps the best testimonial I can give in its favor. So far as anyone can judge from a mere outline, Mr. Kracauer's book promises to be a really exciting and fundamentally important work, and his main thesis—the intrinsic conflict between cinematic structure and "story," endlessness and finiteness, episodic atomization and plot logic, strikes me as being both original and fundamentally correct.
>
> I only wonder whether the argument may not be carried even further in saying that this conflict is *inherent* in the technique of photography itself. Mr. Kracauer interprets, if I understand him rightly, photography as one pole of the antinomy, saying that the snapshot "tends to remove subjective frames of reference, laying bare visible complexes for their own sake" and that the narrative furnishes the other pole. I wonder whether this conflict is not inherent in the photographic medium itself. There has been a long discussion as to whether photography (not cinematic photography but just ordinary photography) is or can ever become an "art." This question, I think, has to be answered in the affirmative, because, while the "soulless camera" relieves the artist of many phases of the imitative processes normally associated with the idea of art yet leaves him free to determine much of the composition and, first and foremost, the choice of subject. We find, therefore, even in snapshots not only an interest in "fragments of reality for their own sake" but also an enormous amount of emotional coloring, as in most snapshots of babies, dogs, and other

vessels of sentimentality. This, I think, accounts for the very early appearance of sentimental or sanguinary narratives in films as well, a phenomenon which Mr. Kracauer seems to underestimate, directly opposing as he does the purely factual incunabula of the film to the purely fantastic productions of Méliès. The addition of motion and, later on, sound, transfers this inherent tension to the plane of coherent, and possibly significant, narratives; but I think that it may be inherent in the photographic medium as such—a proposition which is by no means an objection to Mr. Kracauer's theory but would rather invest it with a still more general validity.[45]

Leaving aside the fascinating issue of Panofsky's reading of Kracauer and the latter's response to Panofsky's criticisms, which must be explored elsewhere, what is crucial for the present context is Panofsky's remarks on the aesthetics of photography. Elaborating on comments made almost two decades earlier on the freedom of the photographer to concentrate on the choice of subject matter[46] Panofsky here suggests that this license afforded by the photograph results in the privileging of subject matter with overdetermined emotional markings, the provenance of which it is the task of an iconographic analysis to reveal. This, in turn, grounds the necessity of an iconographic practice in the specificity of the photographic medium itself, and then, by extension, in that of narrative cinema. One is now in a position to understand what is at stake when, in response to a letter in which Kracauer expresses his tremendous enthusiasm upon reading the *Dürer* book, Panofsky writes:

> You are the first person by whom I feel that I have been, like Palma Kankel, "understood profoundly," and I cannot thank you enough for that. I was particularly pleased by your interest in such a detail as *the internal relationship between technology and content*, which the 19th century in its peculiar blindness overlooked in *both* the ostensibly extra-

"artistic" technological domain as well as the ostensibly equally extra-"artistic" material domain. This stems from the fact that we have both learned something from the movies![47]

If Panofsky insists that cinema is an "art originating from and always intrinsically connected with technical devices"[48] the invocation of that technological foundation allows him to solidify what one could now call, rephrasing the title of his essay, the relationship between *content* and medium in the motion pictures. This, in turn, makes iconography indispensable to the study of the cinema.

Panofsky's insistence on content in the cinema is, as Regine Prange has recently demonstrated very convincingly, highly overdetermined.[49] The essays on cinema were written at a time when iconography's methodological relevance was being threatened by the increasing abstraction of modern art. Panofsky's seemingly progressive endorsement of film's mass appeal, of its "communicability," may well have as its hidden agenda an attack on modernism and modern art, a resistance to abstraction that can be traced quite consistently from the early 1930s (at which point Panofsky felt that he could still integrate Cézanne and Marc into his universal iconological model) through the mid-1940s.[50] Film's photographic basis, its "materialism," thus marks the welcome return of the signified, of content, as an alternative to an insistence on the signifier—this too a sort of materialism, albeit in a different sense—in abstraction. Panofsky uses cinema, as Prange rightly points out, to rehabilitate as an artistic norm the world of "nature" which contemporary art has abandoned. Film, to the extent that it can be argued to be essentially photographic, and narrative cinema, to the extent that it too maintains the emphasis on the signified (unlike the reflexive involution of avant-garde film), restores the legitimacy of the iconographic method, and the model of immediate experience and transparent perception upon which it de-

pends. In so doing, however, it serves further to confirm various methodological critiques of iconography that have been voiced in recent art theory. Just as an encounter with modern art, with its problematization of the supposed immediacy of perception, might have forced a reflection on the theory of experience upon which iconography depends, so too an engagement with avant-garde film might have thrown into question some of the assumptions left unexamined by the ready intelligibility of narrative cinema. Similarly, the decidedly anti-modernist stance evident in the film essay's exclusive focus on narrative cinema and the resulting privileging of genre and types only further buttresses the claim that iconology has an elective affinity with thematic continuity and is therefore structurally blind to radical shifts in the development of representational and perceptual practices. This in turn limits the analytic scope of the iconographic project, as Oskar Bätschmann has astutely pointed out.

> The only certain contribution of Panofsky's model seems to be the history of types, i.e. the understanding of how specific themes and ideas are expressed by objects and events under changing historical conditions. . . . Because the possibility of a history of types is tied to thematic continuity, it is incapable of grasping not only ruptures in tradition, as Kubler established, but also relatively simple and frequent transformations of formal schemata. This is why the contribution of a history of types to a history of art can only be of limited value.[51]

However controversial Bätschmann's remarks may be for debates in art historical methodology, they are undoubtedly correct as a description of the circumscribed validity of Panofsky's remarks for the study of film.

To the extent that it has been received at all, Panofsky's film essay has enjoyed its most serious and productive response within that province of film studies concerned with the history of cinematic types, stereotype-formation, and genre theory. The project of a cinematic iconography has been taken up in a variety of ways which range from the highly cinephilic but methodologically pious essay by French film critic Jean-Loup Bourget[52] to feminist film theorists such as Clair Johnston for whom "Panofsky's detection of the primitive stereotyping which characterised the early cinema could prove useful for discerning the way myths of women have operated in the cinema."[53] Panofsky's bracketing of film form in favor of content also explains the sustained response to his text by another theorist—Stanley Cavell—who shares his fascination with film as a medium of the "real." Indeed in his study *The World Viewed: Reflections on the Ontology of Film* Cavell calls Panofsky one of "two continuously intelligent, interesting, and to me useful theorists I have read on the subject" [of what is film?].[54] The other theorist is, symptomatically, André Bazin, the high priest of realist film theory. It was these two figures, so Cavell explains in a postface to the second, "enlarged" edition of his book, that prompted him to explore the question of film's relation to reality: "I felt that, whatever my discomfort with their unabashed appeals to nature and to reality, the richness and accuracy of their remarks about particular films and particular genres and figures of film, and about the particular significance of film as such, could not, or ought not, be dissociated from their conviction that film bears a relation to reality unprecedented in the other arts."[55] While sympathetic to Panofsky's position in general, Cavell's homage to the film essay takes the form of a relentless, careful critique which discerns even more precisely than the text's own author, some of the key issues at play in Panofsky's reflections. Indeed, Cavell not only pushes Panofsky at times towards an iconology of cinema which the essay fails to deliver,[56] he even goes so far as to defend Panofsky against himself, challenging his claim that once film literacy had developed sufficiently, the genre and type cues originally invoked to help the viewer navigate cinema's complex formal in-

novations became superfluous. "Devices like these," Panofsky had argued, "became gradually less necessary as the public grew accustomed to interpret the action by itself and were virtually abolished by the invention of the talking film."[57] If the principle contribution of Panofsky's work on film consists in this iconographic analysis of types and genres, and if the employment of such conventions was indeed abandoned or at best reduced as film literacy became widespread, then, so Cavell, if Panofsky is right he has proven that his own project is either superfluous, or at best relevant exclusively to silent film. But, writes Cavell, pointing to the continued existence of the western gangster and other film genres, Panofsky is simply mistaken here: while it is true that the particulars of the iconography accorded the villain-type change with time, what does survive is the iconographic specificity of such a type. Indeed, Cavell argues in rather Panofskian fashion that the continued dependence upon film types and genres is "accounted for by the actualities of the film medium itself: types are exactly what carry the forms movies have relied upon. These media created new types, or combinations and ironic reversals of types; but there they were, and stayed."[58] What Cavell has effectively done here—for better or for worse—is argued for the continuing validity of a Panofskian iconographic program for the study of film. And in fact Cavell's second book on film, *Pursuits of Happiness: The Hollywood Comedy of Remarriage*[59] is nothing less than just such an iconographic study of a specific film genre which Cavell has articulated for the first time. Indeed one could certainly claim that this book—and to a lesser extent perhaps the very domain of film studies that focuses on genre and types, on the meaning of gesture and scenes, etc.—is, in its iconographic dimensions, indebted to and in some sense a continuation of the program proposed by Panofsky—but of course not only by him—in his essay on film.

It is, however, not in film studies, but in the context of a politicized re-reading of Warburg and Panofsky in contemporary German art history

that the photographic specificity of Panofsky's film essay, as well as its epistemic overdeterminations, are of greatest significance today. According to the historiographic map sketched by Johann Konrad Eberlein, one must distinguish between two phases of iconology, the first of which—iconology in the narrower sense—had Panofsky as its main protagonist, and concentrated primarily on the Renaissance and humanism. Criticized by a younger generation for what was perceived as a too-mechanistic relation to sources taken from a too-narrow spectrum, and for a denigration of the image in order to simply illustrate these sources, a second iconological episteme then developed in the late 1980s which focused more on questions of style, reception, and sociological issues. Whether one marks the onset of this new paradigm, as Eberlein does, by the appearance of Horst Bredekamp's 1986 essay "Götterdämmerung des Neoplatonismus" ("Twilight of the Gods of Neo-Platonism")[60] or dates it back to Martin Warnke's session on "Das Kunstwerk zwischen Wissenschaft und Weltanschauung" ("The Artwork between Science and World View") at the 12th German Art History Congress in Cologne in 1970,[61] in both cases the good object of this second phase of iconology was, of course, Aby Warburg. Both Panofsky and Warburg, so this story goes, began their careers with a complex, Riegelian method that, as Benjamin once put it, undertook "an analysis of artworks which considers them as a complete expression of the religious, metaphysical, political and economic tendencies of an epoch and which, as such, cannot be limited to a particular discipline."[62] But in contrast to Warburg's approach to iconology (which was decidedly "kulturgeschichtlich"), Panofsky's work came to be seen as increasingly "geistesgeschichtlich," more traditionally art historical in its almost exclusive focus on questions of interpretation and content, on the depicted rather than on the very conditions and cultural stakes of depiction. It was thus Warburg who became the patron of a new critical art history, an attempt to confront iconology

with the social theory of the Frankfurt School in order to recast art history as an historical science, integrated into a larger inter-disciplinary cultural science which would analyze the constantly shifting functions of all images including those of "low," trivial, and popular culture.

Perhaps feeling the need to prove that Panofsky too could be marshalled for such a project, scholars such as Volker Breidecker have recently turned to the film essay as a seemingly obvious example of such a Warburgian sensibility in Panofsky's corpus. Arguing that it demonstrates Panofsky's interest in a popular and even "low" art form and that it is explicitly sociological in orientation, this line of argument points to statements such as Panofsky's claim that narrative film is not only art

> but also, besides architecture, cartooning and "commercial design," the only visual art entirely alive. The "movies" have reestablished that dynamic contact between art production and art consumption which, for reasons too complex to be considered here, is sorely attenuated, if not entirely interrupted, in many other fields of artistic endeavor.[63]

Leaving aside the profoundly anti-modernist cultural politics of such a seemingly progressive aesthetic populism, the attempt to rehabilitate Panofsky as a theorist of popular culture calls attention instead to his ingenious (and oft-cited) response to the charge that cinema is simply "commercial":

> If commercial art be defined as all art not primarily produced in order to gratify the creative urge of its maker but primarily intended to meet the requirements of a patron or a buying public, it must be said that noncommercial art is the exception rather than the rule, and a fairly recent and not always felicitous exception at that. While it is true that commercial art is always in danger of ending up as a prostitute, it is equally true that noncommercial art is always in danger of ending up as an old maid.[64]

Despite its dubious sexual politics, this rejection of the classical model of aesthetic autonomy—all art being exposed as somehow contaminated by cinema's oft-maligned commercialism—is an important variation on Benjamin's elaboration of Paul Valery's suggestion that cinema, rather than being an art, will transform the very notion of the aesthetic. As Brecht once put it in the early 1930s: "It is not true that film needs art, unless of course one develops a new understanding of art."[65] However, despite this insistence on the irreducibly commercial, corporate—which is to say political—dimension of the medium, even a cursory reading of Panofsky's film essay will confirm that the sociological component of the argument remains superficial at best. This is not to say that Panofsky was blind to the political dimension of the cinema, as indicated by his fascinating comment in 1942, in response to Kracauer's study of Nazi propaganda films, that "there is no such thing as an *authentic* 'documentary film,' and that our so-called *documentaries* are also propaganda films only—thank God—usually for a better cause and—alas—usually not as well made."[66] However, due to a constellation of overdeterminations, some of which have been sketched above, his sensitivity to that dimension of cinema remains strikingly undeveloped in the film essay. Taken as a whole, and despite its extended and sympathetic discussion of film's folk-art genealogy, despite its discussion of film spectatorship and exhibition practices, and despite its meditation on the relation of the actor to the apparatus,[67] the film essay simply will not serve to overturn the critique that Panofsky's later work privileges the "content" of works over their formal or stylistic characteristics, the iconographic at the cost of the political, or that his approach was largely "geistesgeschichtlich," ignoring material and technical conditions and social effects of the works. The film essay's astonishing silence on questions of ideology, alienation, profit, monopoly structures, corporate capital, etc., its romanticization of the spectatorship "community," its endorsement of viewer "identification" with the camera —almost point-for-point the exact

antithesis to Adorno and Horkheimer's contemporaneous "culture industry critique"—would if anything actually buttress such objections.

Panofsky's bracketing of almost all questions dealing with film language, with cinema as symbolic form and thus with the issue of cinema's socio-political imbrications, is, Prange argues, a symptomatic myopia of *Stilgeschichte*. And despite admirable attempts to redeploy its iconographic project as a proto-semiotics—as in Peter Wollen's important study which both echoes unmistakably the syntax of Panofsky's essay in its title: *Signs and Meaning in the Cinema*, and also provides a triptych of film stills that effectively illustrate Panofsky's examples (fig. 1)[68]—the film essay remains anything but Warburgian. Rather than marshalling it as an index of Panofsky's supposed sensitivity to mass-culture, one would do better to study it as an important document that *in its very unselfconsciousness* can teach art history (perhaps more readily than many of Panofsky's other writings) about the methodological pitfalls and elective affinities of the iconographic program. By the same token, the film scholar interested in discovering relatively unexplored resources in the archaeology of film theory would do better to look at Panofsky's study of perspective than the essay on film. For while the numer-

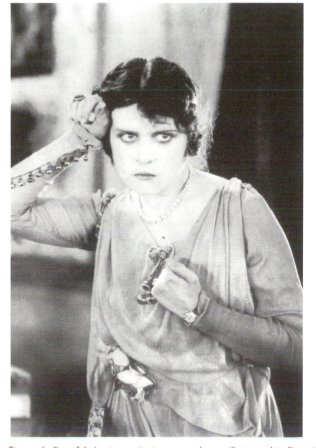

(Opposite) the vamp, Theda Bara; (above) the straight girl, Mary Pickford; (top) Sam Taylor's *My Best Girl*, with Mary Pickford and Buddy Rogers— checkered tablecloth and breakfast coffee

Figure 1. Panofsky's cinematic iconography as illustrated in Peter Wollen's *Signs and Meaning in the Cinema* (Bloomington & London: Indiana University Press, 1969/1972)

ous film-theoretical insights in "Perspective as Symbolic Form" remain for the most part in embryonic form, it nevertheless gives an inkling of what such an—iconological—Panofskian reading of cinema might look like. Indeed, the perspective essay has given us *more* than an inkling, for it is precisely also as a reading of this text than one can understand another work exactly contemporaneous with Panofsky's film essay—Benjamin's "The Artwork in the Age of its Technological Reproducibility"—which is perhaps the prototype of a Panofskian "cinema as symbolic form." One can describe it as such not because it is known that as Benjamin was preparing to defend this text in the form of theses in front of the Schutzenverband Deutscher Schriftsteller in Paris on the 20th and 26th of June, 1936, one of the texts he turned to was Panofsky's "Perspective as Symbolic Form,"[69] nor because this essay became one of the key texts in the so-called "Warburg Renaissance."[70] Rather, what justifies considering Benjamin's difficult and often misread essay as an attempt to read "cinema as symbolic form" is the fact that the questions he asks there—how cinema corresponds to a new order, structure, tempo of experience, how it has transformed perception, revolutionizes the status of the artwork, how it relates to earlier technologies of iteration, to fascism and to class struggle, in short, how it stages a certain cultural episteme—are the very matter one might expect to find in what would effectively be a reading of "Cinema as Symbolic Form." To understand to what extent Benjamin on cinema is Panofskian, and why Panofsky's essay on cinema is, in an important sense, *not*—this is the challenge posed by "Style and Medium in the Motion Pictures."

Notes

Among the many people whose generous temporal, institutional, and critical engagements were of great help in the genesis of this study, I would like especially to thank Irving Lavin (Institute for Advanced Study, Princeton), whose welcome invitation to undertake a sustained analysis of Panofsky's film essay gave rise to this reading, and Gerda Panofsky, who graciously allowed me to quote from Panofsky's correspondence with Siegfried Kracauer, as well as Horst Bredekamp (Berlin), Volker Breidecker (Berlin), Ingrid Grueninger (Deutsches Literaturarchiv, Marbach), Evonne Levy (San Diego/Princeton), Wolfgang Liebermann (Berlin), Regine Prange (Tuebingen), Rohna Roob (Museum of Modern Art Archive, NYC), P. Adams Sitney (Princeton), and Tim Wardell (Princeton University Press).

1. To get a sense of the symbolic capital that Panofsky's lecture on film represented, one must recall that, despite the fact that the first film library in the US was established as early as 1922 at the Denver Art Museum by its director, George William Eggers, cinema did not begin to be recognized as a subject worthy of being taught at the university level in any form in the US until the later 1930s. Indeed, in 1937, when New York University began a pioneer film appreciation course and Columbia University offered a new class in the "History, Aesthetic and Technique of the Motion Pictures" (taught by the MOMA film librarians Iris Barry and John Abbott together with Paul Rotha), this was a curricular innovation of such importance that *Time Magazine* ran a story on the birth of college-level courses on film ("'Fine Arts Em1-Em2,'" *Time Magazine* vol. 30:15 [October 11, 1937]: 36). As an index of the unabated intensity of the resistance to academic study of cinema to this day, consider the following vitriolic remarks by Hilton Kramer:

> About the first, the study of the arts and the humanities in the colleges and universities, I want to begin with a modest but radical proposal: that we get the movies out of the liberal arts classroom. We've simply got to throw them out. There is no good reason for the movies to be there, and there is every reason to get rid of them. They not only take up too much time, but the very process of according them serious attention sullies the pedagogical goals they are ostensibly employed to serve. The students are in class to read, write, learn, and think, and the movies are an impediment to that process. Students are going to go to the movies anyway, and to bring them into the classroom—either as objects of study or as aids to study—is to blur and destroy precisely the kind of distinction—the distinction between high and low culture—that is now one of the functions of a sound liberal education to give our students. (Hilton Kramer, "Studying the Arts and the Humanities: What can be done?," *The New Criterion* [February 1989]: 4)

For an example of the counter-argument, see Colin MacCabe, *On the Eloquence of the Vulgar. A Justification of the Study of Film and Television* (London: British Film Institute, 1993), a lecture held in October 1992 to inaugurate a new M.A. course in media studies.

2. Barr's writings on cinema include: "The Researches of

Eisenstein," *Drawing and Design* 4:24 (June 1928): 155–156; "S.M. Eisenstein," *The Arts* 14:6 (December 1928): 316–321; and "Notes on the Film: Nationalism in German Films," *The Hound & Horn* 7:2 (January/March 1934): 278–283. The first public announcement of Barr's plan to establish a "new field" at the museum that would deal with "motion picture films" was in a high production-value publicity pamphlet entitled "The Public as Artist" and dated July 1932. The justification for this unprecedented move and the planned scope of the new department's activities were articulated as follows:

> The art of the motion picture is the only great art peculiar to the twentieth century. It is practically unknown as such to the American public. People who are well acquainted with modern painting and literature and drama are almost entirely ignorant of the work of such great directors as Gance, Stiller, Clair, Dupont, Pudovkin, Feyder, Chaplin and Eisenstein.
>
> The Film Department of the Museum, when organized, will show in its auditorium films which have not been seen publicly, commercial films of quality, amateur and "avantgarde" films, and films of the past thirty years which are worth reviving either because of their artistic quality or because of their importance in the development of the art. Gradually a collection of films of great historic and artistic value will be accumulated. (MOMA scrapbook #31 [1934])

3. Panofsky in a letter to the editors of *Filmkritik* which is cited in the introductory remarks to the first German translation of the film essay, "Stil und Stoff im Film," trans. by Helmut Färber, *Filmkritik* 11 (1967): 343. Another account of the genesis of Panofsky's film essay can be found in an obituary written by Robert Gessner, professor of cinema at New York University: Robert Gessner, "Erwin Panofsky 1892–1968," *Film Comment* 4:4 (Summer 1988): 3.

4. Erwin Panofsky, "On Movies," *Bulletin of the Department of Art and Archaeology of Princeton University* (June 1936): 5–15 [hereafter referred to as EP1936]. There are conflicting accounts as to when the text was actually written: the widely available reprint (of the 1947 version of the essay) in Gerald Mast, Marshall Cohen, and Leo Braudy, eds., *Film Theory and Criticism* (New York: Oxford University Press, 4th ed. 1992) incorrectly dates the first publication of the text as 1934, a mistake which can be traced to the editorial note accompanying the 1947 version of the essay in *Critique* (see n. 8 below). A 1941 reprint of the second version of the essay claims that it was written in 1935 (see Durling, et al., eds., *A Preface to our Day*, n. 7 below, p. 570).

5. One such event organized by MOMA's Princeton Membership Committee at the Present Day Club on January 10, 1936 featured a screening of "A Fool There Was" from the MOMA film library collection after which, according to the invitation, "Dr. Erwin Panofsky will give a short introductory talk on Moving Pictures." (Invitation to Mr. and Mrs. [John] Abbott, MOMA Film Library Press Clippings Scrapbook #2,

p. 35; the reference to Panofsky's talk was written by hand on the invitation).

6. The other members of the committee, which was chaired by Will H. Hays (the president of the Motion Picture Producers and Distributors of America, Inc.), were David H. Stevens (Director of Humanities, Rockefeller Foundation), Stanton Griffis (Chairman of the Finance Committee, and Trustee of Cornell University, Chairman of the Executive Board of Paramount Pictures, Inc.), Jules Brulatour (Pres. of J.E. Brulatour, Inc.) and J. Robert Rubin (Vice-President of MGM). For more details on the founding and early activities of the Film Library, see the MOMA *Bulletin* 3:2 (November 1935) entitled "The Film Library" and 4:4 (Jan. 1937) entitled "Work and Progress of the Film Library," and also John Abbott, "Organization and Work of the Film Library at the Museum of Modern Art," *Journal of the Society of Motion Picture Engineers* (March 1937): 294–303.

7. Behind the title pages by Duchamp, Léger, Miró and others, the remarkable *Transition* (published in Paris from 1927–1938 and reissued in facsimile by Kraus Reprint in 1967) featured work by writers such as Artaud, Beckett, Breton, Kafka, Moholy Nagy, and Joyce, including various installments of his work in progress that would later become *Finnegan's Wake*. It was in the penultimate issue of this journal—alongside texts by Joyce, Hans Arp, James Agee, Paul Eluard and Raymond Queneau, and images by Kandinsky, De Chirico, Miró and Man Ray—that the second version of Panofsky's film essay appeared in February 1937: "Style and Medium in the Moving Pictures," *Transition* 26 (1937): 121–133 [hereafter referred to as EP1937]; rpt. in Dwight L. Durling, et al., eds., *A Preface to our Day. Thought and Expression in Prose* (New York: The Dryden Press, 1940): 570–582. Panofsky's essay was the last in a series of texts on photography and cinema in *Transition* which included Antonin Artaud's scenario "The Shell and the Clergyman" and S. M. Eisenstein's "The Cinematographic Principle and Japanese Culture" (*Transition* 19–20 [June 1930]), Paul Clavel's "Poetry and the Cinema" (*Transition* 18 [November 1929]), L. Moholy-Nagy's "The Future of the Photographic Process" and Jean-George Auriol's "Whither the French Cinema" (*Transition* 15 [February 1929]), Elliot Paul and Robert Sage's "Artistic Improvements of the Cinema" (*Transition* 10 [January 1928]) and the surrealist anti-Chaplin manifesto "Hands off Love" (*Transition* 6 [September 1927]).

8. Erwin Panofsky, "Style and Medium in the Motion Pictures," *Critique* (New York) I:3 (January–February 1947): 5–28 [hereafter referred to as EP1947; pagination according to the widely available reprint in Mast, Cohen, and Braudy, *Film Theory and Criticism*]. In an explanatory footnote we read (p. 5): "At the request of the Editors of *Critique* [. . .] Prof. Panofsky consented to revise and bring up to date the original version, first published in 1934 [sic] [. . .] For *Critique*, Prof. Panofsky has rewritten it extensively, expanding both length and scope."

9. William S. Heckscher, "Erwin Panofsky: A Curriculum Vi-

tae," *Record of the Art Museum, Princeton University* 28:1 [1969]: 18.

10. Erwin Panofsky, *The Codex Huygens and Leonardo Da Vinci's Art Theory* (1940; rpt. Nendeln: Kraus Reprint, 1968): 122ff. The "subterranean" afterlife of Panofsky's early essay on film in this study was first pointed out by Horst Bredekamp in his "Augenmensch mit Kopf. Zum hundertsten Geburtstag des Kunsthistorikers Erwin Panofsky," *Die Zeit* (27 March 1992).

11. As Robert Gessner recalls: "When the Learned Society of Cinema was founded in 1960 Erwin Panofsky was appropriately elected the first honorary member; it was my delightful duty to confront him in his Princeton Pantheon, then presided over by his dear friend, J. Robert Oppenheimer, and induce Panofsky to address the opening session of The Society of Cinematologists. His rare mixture of wit and scholarship will always be remembered and cherished by the members privileged to be present at the NYU Faculty Club on Washington Square" (Gessner, "Erwin Panofsky": 3). In a letter dated April 9, 1956 to Siegfried Kracauer, commenting on an article of his entitled "The Found Story and the Episode" (*Film Culture* 2:1/7 [1956]: 1–5), Panofsky writes:

> I read it, as you can imagine, with great interest, and I am quite convinced that you are right. I must confess, though, that it made me realize how much I have lost contact with the movies in later years; only a fraction of the instances you cite is known to me by direct experience, which is in part due to the fact that good moving pictures very rarely reach this town and that, with advancing years, I am simply too lazy to undertake a trip to New York to keep up-to-date. I am all the more touched that you still refer to that old article of mine, which is now more than twenty years old. (Kracauer papers, Deutsches Literaturachiv [hereafter DLA] Marbach)

However, Panofsky obviously did see contemporary films on occasion, as evidenced by the following account of his remarks on the formally complex film by Alain Resnais just two years before his death, as recounted by William Heckscher:

> It was strangely touching to hear Panofsky discuss (on February 2, 1966) the enigmatic film [based on a screen-play written] by Alain Robbe-Grillet, "L'Année dernière à Marienbad," which in 1961 had been filmed not there but at Nymphenburg and Schleissheim. As those who have seen the film will remember, the heroine, Delphine Seyrig, remains ambiguously uncertain whether or not she remembers what can only have been a love affair "last year at Marienbad." Panofsky said he was immediately reminded of Goethe, who at the age of seventy-four (Panofsky's own age at that point) had fallen in love with Ulrike von Levetzow, a girl in her late teens, whom he saw during three successive summers at Marienbad. The elements of Love, Death and Oblivion in Goethe's

commemorative poem, the "Marienbader Elegie," seemed to Panofsky to anticipate the leitmotifs of the film. He noted the opening word of the elegy ("Was soll ich nun vom Wiedersehen hoffen . . . ?") and pointed out how the elements of clouded remembrance and erotic uncertainty were shared by both the poem and the film. He added that the director, Alain Resnais, had a way of leaving his actors uncommonly free to chart their own parts. Miss Seyrig might well have been familiar with Goethe's poem and its ambiguous message. Was she not, after all, the daughter of a famous and learned father, Henri Seyrig, archaeologist, former Directeur Général des Musées de France, and on repeated occasions a member of the Institute for Advanced Study at Princeton? (Heckscher, "Erwin Panofsky": 18)

12. EP1936:5–6.

13. Heckscher, "Erwin Panofsky": 18; Karen Michels, "Die Emigration deutschsprachiger Kunstwissenschaftler nach 1933," in Bredekamp et al., eds., *Aby Warburg. Akten des internationalen Symposions Hamburg 1990* (Weinheim: Vch Verlagsgesellschaft, 1991): 296.

14. To my knowledge, the present essay is the first sustained examination of Panofsky's film essay in the English-language secondary literature on Panofsky. The quite consistent neglect of the film text—even where, as in Michael Ann Holly's *Panofsky and the Foundations of Art History* (Ithaca/ London: Cornell University Press, 1984), to take just one representative example, there is an intelligent discussion of the early essay on "Perspective as Symbolic Form" in the context of contemporary debates on the representational politics of photographic culture—is itself, as I will suggest below, quite symptomatic. In German, besides Irving Lavin's introduction to the German reprint of the film essay and the study of the Rolls-Royce radiator ("Panofskys Humor," in Erwin Panofsky, *Die Ideologischen Vorläufer des Rolls-Royce-Kühlers & Stil und Medium im Film* [Frankfurt/M./New York: Campus Verlag, 1993]: 7–15), Regine Prange has recently published what is effectively the first close reading of the film essay in the context of Panofsky's oeuvre—"Stil und Medium. Panofsky 'On Movies,'" in: Bruno Reudenbach, ed., *Erwin Panofsky. Beiträge des Symposions Hamburg 1992* (Berlin: Akademie Verlag, 1994): 171–190. According to Prange, the occasional references to Panofsky's film essay in the German art historical literature arise in discussions of the proto-cinematic structure of antique and medieval image sequences; cf. Georg Kauffmann, *Die Macht des Bildes—Über die Ursachen der Bilderflut in der modernen Welt* (Opladen 1987): 31f., and Karl Clausberg, "Wiener Schule—Russischer Formalismus—Prager Strukturalismus. Ein komparatistisches Kapitel Kunstwissenschaft," *Idea* 2 (1983): 151 & 176f.

15. A telling index of the methodological threat which cinema poses for the history of art can be found in Martin Warnke's mapping of the "Gegenstandsbereiche der Kunst-

geschichte" [provinces of art history] in the very popular introduction to the discipline edited by Hans Belting and others: *Kunstgeschichte. Eine Einführung* (Berlin: Reimer, 1985; rpt. 1988):

> If one considers the media as part of a visual culture which can be subject to scholarly analysis, then this widens the field of inquiry of concern to the history of art, making not only so-called *trivial art* (such as the production of comics, magazines, posters or department-store paintings) but also the entire domain of the *new media* into objects of art-historical research. Research on the history of *photography* has in fact taken on some momentum within art history during the last few years (in America it has long been an accepted practice). By contrast, the study of film (not to mention television) has not yet found scholarly footing within art history; they are currently becoming the province of a *media science* now in the process of being established. *One wonders whether the discipline of art history is capable of surviving if it fails to take account of this formative medium of visual experience;* but one can also have one's doubts as to whether the discipline has the methodological and personnel resources needed to expand its scholarly enterprise into the field of the mass media, and whether in order to do so it might not have to sacrifice essential presuppositions and goals. Art history has experienced a comparable extension of its field of inquiry only once, when, in the second half of the 19th century, arts and crafts museums were established everywhere. The discipline mastered the demands made upon it then very well: indeed, the collections of the arts and crafts museums contain photographs, posters, and advertisements which provide a point of departure for the new perspectives oriented around media-studies. Even the inclusion of design within the art historian's field of inquiry is easily reconciled with longstanding tasks of the arts and crafts museums. To some extent, therefore, the new expansionist tendencies are breaking down doors that have long been open. *This is not true, however, of the media of film and television.* The fact that these domains of inquiry will not be touched upon here is not meant to be a statement against these new expansionist proposals. One can already predict, however, that the discipline will not be able to avoid these media completely if only because films about artists are already among the primary sources of the history of art and also because since the 1960s artists themselves have been making use of videos, either for documentary or for creative purposes. (21–22; emphasis added; this and all subsequent translations are, unless otherwise noted, my own)

While, indicatively, the bibliography at the back of the volume does not contain one single reference to the film theory literature, in a section entitled "Beispiele grenzenüberschreitender

Untersuchungen aus der Kunstgeschichte" [Examples of Art Historical Studies that go beyond the Confines of the Discipline] there is exactly one essay listed that deals with film: Panofsky's.

16. Karen Michels, "Versprengte Europaeer: Lotte Jacobi photographiert Erwin Panofsky," *IDEA. Jahrbuch der Hamburger Kunsthalle* 10 (1991): 13, note 9. This reading of a photograph of Panofsky is one of the rare texts that broaches the question of his position on technological reproducibility.

17. Heckscher, "Erwin Panofsky,": 18; Lavin, "Panofskys Humor": 10. The surprising number of reprints of the 1947 essay can be divided more or less into two groups. An initial wave of reprints occurred in the 1950s (and again in the 1970s) in anthologies on theater, the contemporary arts and aesthetics—examples include volumes such as Eric Bentley, ed., *The Play* (New York: Prentice-Hall, 1951), T. C. Pollock, ed., *Explorations* (Englewood Cliffs, N.J.: Prentice-Hall, 1956), Morris Weitz, ed., *Problems in Aesthetics* (New York: Macmillan, 1959) and then, over a decade later, James B. Hall and Barry Ulanov, eds., *Modern Culture and the Arts* (New York: McGraw-Hill, 2nd ed. 1972), Harold Spencer, ed., *Readings in Art History* (New York: Charles Scribner's Sons, 1976) and Richard Searles, ed., *The Humanities through the Arts* (New York: McGraw-Hill, 1978). A second wave of reprints within the context of film studies was initiated by Daniel Talbot's *Film: An Anthology* (New York: Simon and Schuster, 1959) following which the essay reappeared in Charles Thomas Samuels, ed., *A Casebook on Film* (New York: Van Nostrand- Reinhold Co., 1970), T. J. Ross, ed., *Film and the Liberal Arts* (New York: Holt, Rinehart and Winston, 1970— here misleadingly with the 1936 title "On Movies"), John Stuart Katz, compl., *Perspectives on the Study of Film* (Boston: Little Brown, 1971), Douglas Brode, compl., *Crossroads to the Cinema* (Boston: Holbrook Press, Inc, 1974), Gerald Mast and Marshall Cohen, eds., *Film Theory and Criticism* (NY/London/Toronto: OUP, 1974; 2nd ed. 1979; 4th ed. 1992) and David Denby, ed., *Vintage Reader of American Film Criticism* (New York: Random House, 1976).

The vast majority of the translations (always based on the 1947 version of the text) also appeared in journals or volumes devoted to mass media: in German—"Stil und Stoff im Film," trans. Helmut Färber, *Filmkritik* XI (1967): 343–355, rpt. with slight modifications in Erwin Panofsky, *Die Ideologischen Vorläufer des Rolls-Royce-Kühlers & Stil und Medium im Film* (Frankfurt/M./New York: Campus Verlag, 1993): 17–51; compare also the translation by Meggy Busse-Steffens, "Stilarten und das Medium des Films," in Alphons Silbermann, ed. *Mediensoziologie. Band I: Film* (Düsseldorf/Vienna: Econ Verlag, 1973): 106–122—French—"Style et matériau au cinema," trans. Dominique Noguez, *Revue d'Esthétique* 26, 2-3-4 (Special Film Theory Issue, 1973): 47–60—Danish (in: Lars Aagaard-Mogensen, ed., *Billedkunst & billed tolkning* [Copenhagen: Nyt Nordisk Forlag Arnold Busck, 1983]: 152–167; 206f.)—Hebrew (in: H. Keller, ed., *An Anthology of the*

Cinema [Tel Aviv: Am Oved Publishers, 1974]: 12–27)—Polish ("Styl i tworzywo zo filmie," in Erwin Panofsky, *Studia z Historii Sztuki*, ed. and tran. Jan Bialostocki [Warsaw: Painstwowy Instytut Wydawniczy, 1971]: 362–377)—and Spanish (in: Jorge Urrutia, *Contribuciones al Analisis Semiologico del Film* [Valencia: Fernando Torres, 1976]: 147–170).

18. Although a thorough history of film theory still remains to be written, it is nevertheless worth noting that there is barely even a reference to Panofsky in either of the two works which currently serve temporarily to bridge that gap: Guido Aristarco's *Storia delle Teoriche del Film* (Torino; Einaudi, 1951/rev. 1963) and J. Dudley Andrew's *The Major Film Theories* (New York/London: Oxford University Press, 1976). An intelligent exegetical summary and citation cento of Panofsky's essay does appear, interestingly enough, in a more recent East German overview of the history of film theory: see Peter Wuss, *Kunstwert des Films und Massencharakter des Mediums. Konspekte zur Geschichte des Spielfilms* (Berlin: Henschel Verlag, 1990: 248–54).

19. In *Visionary Film* (New York: Oxford University Press, 1980), for example, P. Adams Sitney invokes Panofsky's critique of films that "pre-stylize" their objects (as in the expressionist cinema) in a discussion of ritual and nature in the films of Maya Deren, without, however, further engaging the essay. (p. 25) In his study *Film and Fiction. The Dynamics of Exchange* (New Haven/London: Yale University Press, 1979) Keith Cohen also cites a number of passages from Panofsky's film essay in various contexts, without however examining the essay as such.

20. Erwin Panofsky, "Original und Faksimilereproduktion" *Der Kreis* 7 (1930), rpt. in *Idea* 5 (1986): 11–123, and "Die Perspektive als 'Symbolische Form'" (1924/25), rpt. in: Panofsky, *Aufsätze zu Grundfragen der Kunstwissenschaft* (Berlin: Wissenschaftsverlag Volker Spiess, 1985): 99–167; translated by Christopher Wood as *Perspective as Symbolic Form* (New York: Zone Books, 1991) [hereafter referred to as PERSPECTIVE]. While art historians have already located their readings of this text within current debates on perception directly relevant to film theory (see, for example, Michael Ann Holly, *Panofsky and the Foundations of Art History*: 130–157), it is virtually unknown in film studies. One of the rare exceptions is Gabriele Jutz and Gottfried Schlemmer's "Zur Geschichtlichkeit des Blicks," in: Christa Blümlinger, ed., *Sprung im Spiegel. Filmisches Wahrnehmen zwischen Fiktion und Wirklichkeit* (Wien: Sonderzahl, 1990): 15–32.

21. Although it is beyond the scope of this essay to trace these filiations, one can get a sense of Panofsky's sizable debt to the establshed film theoretical discourse if one reads the film essay against the backdrop of Arnheim's 1932 *Film als Kunst* (Berlin: Ernst Rowohlt Verlag, 1932) and other of his feuilleton essays from the late 1920s and early 1930s. Particularly striking are the parallels with Arnheim's 1931 "Zum ersten Mal!," rpt. in Rudolf Arnheim, *Kritiken und Aufsätze zum Film*. hrsg. von Helmut H. Diederichs (München/Wien: Carl Hanser Verlag, 1977): 19–21.

22. Indeed, according to the editorial remarks introducing a later reprinting of the text, this specificity argument forms the article's core: like Aristotle's *Poetics* "the heart of the essay is in the statement of essential differences between stage and screen [. . . in order] to define the potentialities and limitations of the moving picture as a medium and its special artistic province." (D. L. Durling, et al., eds., *A Preface to our Day*: 570). Other republications in anthologies of film theory also invariably group the text with others focused on "the medium" (as, for example, in Mast and Cohen, eds., *Film Theory and Criticism*).

23. EP1947:235. In Kracauer's *From Caligari to Hitler. A Psychological History of the German Film* (Princeton: Princeton University Press, 1947), for example, a book whose publication by Princeton UP had been decisively mediated by Panofsky, the only citation from Panofsky's essay in the entire book is a reference to this argument which, indicatively, leaves out the undeveloped discussion of the "spatialization of time" (p. 6).

24. For a recent discussion, see Anthony Vidler, "The Explosion of Space: Architecture and the Filmic Imaginary," *Assemblage* 21 (1993): 45–59. Vidler cites Elie Fauer's 1922 essay on "cinéplastics" (a term he coined in 1922 under the influence of Leger to capture film's particular synthesis of space and time) where he states: "The cinema incorporates time to space. Better, time, through this, really becomes a dimension of space" (Elie Faure, "De la cinéplastique," *L'Arbre d'Éden* [Paris: Editions Cros, 1922], rpt. in Marcel L'Herbier, *L'Intelligence du cinématographe* [Paris: Editions Coréa, 1946]: 275f). The space of cinema, Faure suggests, is a *new* space similar to that *imaginary space* "within the walls of the brain" (an issue taken up in recent work on "narrative space") in which Faure sees "the notion of duration entering as a constitutive element into the notion of space [. . .]."

25. EP1947:236.

26. EP1947:240; emphasis added.

27. As an example of an even more difficult visual convention, consider the visual technique used to mark two episodes shown in sequence as having taken place simultaneously. The original Batman televison series developed a rather striking *visual* means to convey such temporal simultaneity, a spinning of the last image of the first sequence in its own plane around its visual center, perhaps readable as the visual equivalent of a fast rewind, which effectively signified "meanwhile back in"

28. PERSPECTIVE: 34; emphasis added.

29. PERSPECTIVE: 65.

30. PERSPECTIVE: 34.

31. Walter Benjamin, *Das Kunstwerk im Zeitalter seiner technischen Reproduzierbarkeit* (Frankfurt/M.: Suhrkamp, 1963), trans. Harry Zohn as "The Work of Art in the Age of Mechanical Reproduction," in Hannah Arendt, ed., *Illuminations* (New York: Schocken Books, 1969); Martin Heidegger, "Die Zeit

des Weltbildes," *Holzwege* (Frankfurt/M.: Klostermann, 1950), trans. William Lovitt as "The Age of the World Picture," in *The Question Concerning Technology* (San Francisco: Harper and Row, 1977), 115–54; Jean-Louis Baudry, *Effets idéologiques produits par l'appareil de base* (Paris: Albatros, 1978), 13–26, trans. Alan Williams as "Ideological Aspects of the Basic Cinematic Apparatus," in Phil Rosen, ed., *Narrative, Apparatus, Ideology. A Film Theory Reader* (New York: Columbia University Press, 1986), 286–98; Gilles Deleuze, *L'image-mouvement* (Paris: Editions de Minuit, 1983), trans. Hugh Tomlinson and Barbara Habberjam as *Cinema 1: The Movement-Image* (London: Athlone, 1986) and *L'image-temps* (Paris: Editions de Minuit, 1985), trans. Hugh Tomlinson and Robert Galeta as *Cinema 2: The Time-Image* (London: Athlone, 1989).

32. Bela Balázs, *Schriften zum Film*, vol. 2, ed. Helmut Diederichs, et. al. (Berlin/Budapest: Hanser: 1984): 135.

33. EP1947:240.

34. The analogy with the Saxon peasant is revealing in that the cultural intelligibility or unintelligibility of this gesture of pouring is here not a question of the form or mode of its representation (which would be the appropriate analogon to cinematic language): the Saxon peasant, one can assume, recognizes *what* is depicted, but has difficulty knowing what it means. It is the meaning of that configuration, and not the intelligibility of the representation as such, which is at issue here. The question, in other words, is one of content, not form.

35. EP1947:240; emphasis added.

36. Jan Bialostocki, "Erwin Panofsky. Thinker, Historian, Human Being," *Simiolus* 4 (1970): 82.

37. For a discussion of some of the implications of the changes in the essay's titles, see Irving Lavin, "Panofskys Humor."

38. Hans Eisler [and Theodor Adorno], *Composing for the Films* (New York: Oxford University Press, 1947). For a discussion of the aesthetic politics of contrapuntal sound, see my "The Acoustic Dimension: Notes on Cinema Sound," *Screen* (London) 25:3 (May–June 1984): 55–68.

39. EP1947:247–48.

40. EP1947:248.

41. In a letter to Kracauer dated April 29, 1947, Panofsky apologizes for not yet having had time to properly read Kracauer's "Hitler-Caligari" but makes the following comment: "Aber schon jetzt bin ich *sehr* begeistert und überzeugt von der fundamentalen Richtigkeit Ihrer These. Natürlich mischt sich für einer, der -im Gegensatz zu den meisten Amerikanern- alle, oder doch die meisten, dieser deutschen Filme von 1919–1932 gesehen hat—oft in speziellen und unwillkürlich mit dem Film assoziierten Situationen, ein merkwürdiges Gefühl von persönlicher Erinnerung mit ein, das es einem schwerer macht, die Dinge ganz rein analytisch zu nehmen (als ob man sozusagen ein Zeitgenosse des Jan van Eyck wäre, dem plötzlich Jan van Eyck's Bilder "erklärt"

werden). Aber dieses merkwürdige Gefühl—"nostalgisch" ist zu viel, "retrospektiv" zu wenig—erhöht die Freude an der Lektüre nur noch mehr." Kracauer's grateful response, dated May 2, 1947, is equally fascinating: "Wie sehr ich es verstehe, dass Sie das Rencontre von objektiven Analysen und persönlichen Erinnerungen merkwürdig berührt. Ich selber war hin und her gezerrt zwischen Fremdheit und Nähe, wunderte mich manchmal, dass ich etwas von aussen beobachtetes so gut von innen kannte—wie wenn man heute deutsch sprechen hört und zugleich hinter und vor der Sprachwand ist—, und war glücklich wenn sich bei Gelegenheit mein damaliges Urteil und meine heutige Erkenntnis als eins erwiesen. Im Schreiben kam ich mir wie ein Arzt vor, der eine Autopsie vornimmt und dabei auch ein Stück eigener, jetzt endgültig toter Vergangenheit seziert. Aber natürlich, einiges lebt, wie immer verwandelt, fort. Es ist ein tightrope walking zwischen und über dem Gestern und Heute." (Kracauer Papers, DLA) For a discussion of the relationship between Panofsky and Kracauer, see Volker Breidecker, "Kracauer und Panofsky. Ein *Rencontre* im Exil," *Jahrbuch der Hamburger Kunsthalle* Neue Folge 1 (forthcoming 1994), and the preview by Henning Ritter, "Kracauer trifft Panofsky: Eine Autopsie," *Frankfurter allgemeine Zeitung* 85 (April 13, 1994): N5. For a sketch of Kracauer's contemporaneous relationship with another major figure in the New York art-historical community, see Mark M. Anderson, "Siegfried Kracauer and Meyer Schapiro: A Friendship" *New German Critique* 54 (Fall 1991): 19–29.

42. Kracauer repeatedly professes his admiration for the film essay, as early as his second letter to Panofsky on October 1, 1941 in which he writes: "Let me add that I really admire your essay 'Style and Medium in the Moving Pictures'; I am so glad about the fact that my own thoughts on film which I hope to develop now finally in form of a book, take almost the same direction" (Kracauer Papers, DLA). But the slight reserve evident in the qualification 'almost' in the final phrase manifests itself subsequently in Kracauer's published work: in *Caligari*, for example, there is only one passing reference to Panofsky's essay (see note 23 above), which is striking given the nearly two dozen citations of other contemporary writers on film such as Harry Potamkin or Paul Rotha. Even the final version of the essay, about which Kracauer was also enthusiastic—claiming in a letter to Panofsky on November 6, 1949 that "Das rote Heftchen der 'Critique' mit Ihrer Abhandlung—a true classic—habe ich immer bei der Hand" [I always have the red 'Critique' pamphlet with your essay—a true classic—within arms reach]—is only cited in passing on four occasions in Kracauer's *Theory of Film*. (Kracauer Papers, DLA)

43. EP1947:247.

44. Kracauer's copy of *Critique*, which Panofsky had sent him, carries the following dedication: "To Dr. S.K. with best wishes, E.P. An old, old story with a few new trimmings" (Kracauer Papers, DLA Marbach).

45. Kracauer Papers, DLA.

46. In the 1930 essay on "Original und Faksimilereproduktion" Panofsky had already noted that a photograph is a "durchaau persönliche Schöpfung [. .] bei der der Photograph [. . .] in Bezug auf Ausschnitt, Distanz, Aufnahmerichtung, Schärfe und Beleuchtung nicht sehr viel weniger 'friei ist als ein Maler" [thoroughly personal creation [. . .] in the production of which the photographer [. . .] is not much less 'free' than the painter in terms of framing, distance, orientation, sharpness of focus and lighting] (Cited in Michels "Versprengte Europäer": 12).

47. Handwritten letter from Panofsky to Kracauer dated December 23, 1943 (DLA; emphasis added): "Aber Sie sind der erste, von dem ich mich, wie Palma Kankel, "tief verstanden" fühle, und dafür kann ich Ihnen garnicht dankbar genug sein. Besonderen Spaß hat es mir gemacht, daß Sie gerade eine Einzelheit wie die innere Beziehung zwischen Technik und Inhalt, die das 19.Jahrhundert in seiner sonderbaren Blindheit *sowohl* für das angeblich außer-"künstlerisch" Technische als für das angeblich ebenfalls außer-"künstlerisch" Gegenständliche übersehen hatte, interessant fanden. Das kommt daher, daß wir beide etwas von den Movies gelernt haben!"

48. EP1937:133.

49. Prange, "Stil und Medium."

50. Cf. Adolf Max Vogt, "Panofsky's Hut. Ein Kommentar zur Bild-Wort-Debatte" in Calpeter Braegger, hrsg., *Architektur und Sprache* (Munich 1982): 279–296. Compare also Regine Prange, "Die erzwungene Unmittelbarkeit. Panofsky und der Expressionismus," *IDEA* 10 (1991): 221–251. On Panofsky's infamous quarrel with Barnett Newman in the early 1960s, cf. Beat Wyss' hilariously typo-ridden essay, "Ein Druckfehler," in Reudenbach, ed., *Erwin Panofsky:* 191–199.

51. Oskar Bätschmann, "Logos in der Geschichte. Erwin Panofskys Ikonologie," in: Lorenz Dittman, ed., *Kategorien und Methoden der Deutschen Kunstgeschichte 1900–1930* (Stuttgart: Franz Steiner Verlag, 1985): 98–99. Kubler's critique of iconography, which Bätschmann discusses at some length, can be found in *The Shape of Time. Remarks on the History of Things* (New Haven/London: Yale University Press, 1962): 127.

52. In his richly illustrated essay "En relisant Panofsky" (*Positif* 259 [Sept. 1982]: 38–43), Bourget takes up Panofsky's tri-partite model and argues that, since most film criticism jumps all too hastily from the pre-iconographic to the iconological, the urgent task facing film criticism is to develop a proper cinematic iconography. To this end Bourget expands upon a number of Panofsky's examples, providing a list of at least ten films in which—to cite only one example—one finds a checkered table cloth and coffee on the breakfast table as a sign of domestic happiness.

53. Clair Johnston, "Women's Cinema as Counter-Cinema" (1973), rpt. in Bill Nichols, ed., *Movies and Methods* (Berkeley/Los Angeles: Univ. of California Press, 1976): 209.

54. Stanley Cavell, *The World Veiwed: Refections on the Ontology of Film* (Cambridge, Mass.: Harvard University Press, 1971; [enlarged edition] 1979); citation p. 16.

55. Cavel, *The World Viewed:* 166. Citing Panofsky's line that "The medium of the movies is physical reality as such" Cavell earlier points out that " 'Physical reality as such,' taken literally, is not correct: that phrase better fits the specialized pleasures of *tableaux vivants*, of formal gardens, or Minimal Art." Rather, as he explains, what Panofsky means is that film is fundamentally photographic, and "a photograph is of reality or nature." This, however, raises the question: What happens to reality when it is projected and screened? (p. 16).

56. Comenting on the fact that films allow us to see the world without ourselves being seen, i.e. that films afford us the power of invisibility, Cavell writes: "In viewing films, the sense of invisibility is an expression of modern privacy or anonymity. It is as though the world's projection explains our forms of unknownness and of our inability to know. The explanation is not so much that the world is passing us by, as that we are displaced from our natural habitation within it, placed at a distance from it. The screen overcomes our fixed distance; it makes displacement appear as our natural condition" (*The World Viewed:* 40–41).

57. EP1947:241.

58. Cavell, *The World Viewed:* 33.

59. Stanley Cavell, *Pursuits of Happinness: The Hollywood Comedy of Remarriage* (Cambridge, Mass: Harvard University Press, 1981).

60. Horst Bredekamp, "Götterdämmerung des Neoplatonismus," *Kritische Berichte* 14/4 (1986): 39–48; rpt. in Andreas Beyer, ed., *Die Lesbarkeit der Kunst. Zur Geistes-gegenwart der Ikonologie* (Berlin: Verlag Klaus Wagenbach, 1992): 75–83. This text, which attempted to undertake an ideological reading of iconology as a project, argued—as the title already indicates—that its central philosopheme was a neoplatonism that functioned as a symptomatic escape from the threatening rise of nationalism in the 1920's. It functioned not as an attack but as a defence of iconology, and especially of Warburg.

61. Michael Diers, "Von der Ideologie- zur Ikonologiekritik. Die Warburg-Renaissancen" in: *Frankfurter Schule und Kunstgeschichte* (Berlin: Reimer, 1992): 27. The papers from this session were published as Martin Warnke, ed., *Das Kunstwerk zwischen Wissenschaft und Weltanschauung* (Gütersloh: Bertelsmann Kunstverlag, 1979).

62. Walter Benjamin, "Drei Lebensläufe," in *Zur Aktualität Walter Benjamins*, Siegfried Unseld, ed. (Frankfurt a.M.: Suhrkamp Verlag, 1972): 46.

63. EP1947:234.

64. EP1947:244.

65. "Es ist nicht richtig, daß der Film die Kunst braucht, es sei denn, man schafft eine neue Vorstellung von Kunst" (Bert Brecht, "Der Driegroschenprozeß," *Versuche* 8–10, vol. 3 [Berlin 1931]: 301).

66. The full passage, in response to Kracauer's *Propaganda and the Nazi War Film* (New York: Museum of Modern Art, 1942) shortly after its publication, reads: "Inzwischen habe ich Ihre Schrift mit der grössten Bewunderung gelesen und finde, dass Sie nicht nur das spezielle Problem glänzend gelöst haben, sondern auch einen höchst wichtigen allgemeinen Beitrag zur Struktur des 'Documentary Film' geliefert haben. Ich galube nämlich—sagen Sie das nicht weiter—dass es einen *echten* 'Documentary Film' überhaupt nicht gibt, und das unsere sogenannten *Documentaries* auch Propaganda-Films sind, nurr Gott sei Dank, meistens für eine bessere Sache, und, leider Gottes, meistens nicht so geschickt gemacht. Ich hoffe zu Gott, dass wir von Ihren Erkenntnissen Nutzen ziehen werden und das Nazi-Pferd vor anstatt hinter unsern Wagen spannen." (Kracauer papers, DLA Marbach)

67. Reversing the traditional argument that contrasts the "authenticity" of the theatrical performance (resulting from the shared spatio-temporal space of actor and audience and the resulting "I-Thou" intensity) with the alienated (because technologically mediated, discontinuous) performance for the camera, Panofsky argues—in quite dialectical fashion—that this very discontinuity *requires* a massive identification on the part of the actor with his/her role in order for the coherence of the fictitious role to be maintained across the multiple interruptions and alienations. While this is charming as a thought, it is, of course, quite naive, in that it (again) fails to take into account the extent to which the work of the apparatus—not least, the capacity to repeat a scene 100 times until it is "right"—compensate for much of the intensity "lost" in the mediation.

68. Peter Wollen, *Signs and Meaning in the Cinema* (Bloomington and London: Indiana University Press, 1969; "new and enlarged edition" 1972).

69. See Walter Benjamin, *Gesammelte Schriften* (Frankfurt/M.: Suhrkamp Verlag: 1974): 1/3: 1049f., and 7/2: 679. In his 1933 essay "Strenge Kunstwissenschaft," Benjamin cites the Warburg Institute as an example of the new type of art history at home in the margins: "Rather, the most rigorous challenge to the new spirit of research is the ability to feel at home in marginal domains. It is this ability which guarantees the collaborators of the new yearbook their place in the movement which—ranging from [Konrad] Burdach's work in German studies to the investigation of the history of religion being done at the Warburg Library—is filling the margins of the study of history with new life" (Walter Benjamin, "The Rigorous Study of Art,' trans. Thomas Y. Levin, *October* 47 (Winter 1988): 84–90). See also my "Walter Benjamin and the Theory of Art History: An Introduction to 'Rigorous Study of Art,'" *October* 47 (Winter 1988): 77–83 and Wolfgang Kemp, "Walter Benjamin und die Kunstwissenschaft. Teil 2: Walter Benjamin und Aby Warburg," ibid. 1:3 (1975): 5–25.

70. See, for example, Franz-Joachim Verspohl, "'Optische' und 'taktile' Funktion von Kunst. Der Wandel des Kunstbegriffs im Zeitalter der massenhaften Rezeption," *Kritische Berichte* 3:1 (1975): 25–43. On Benjamin's relation to the Warburg Institute, cf. Momme Brodersen, "'Wenn Ihnen die Arbeit des Interesses wert erscheint . . .' Walter Benjamin und das Warburg-Institut: einige Dokumente," in Bredekamp et al., eds., *Aby Warburg. Akten des internationalen Symposions Hamburg 1990* (Weinheim: VCH Verlagsgesellschaft, 1991): 87–94.

The Mummy's Return:
A Kleinian Film Scenario

ANNETTE MICHELSON

I

My movies are made by God; I'm just the medium for them.
—Harry Smith

In offering elements for a textual analysis of Harry Smith's epic collage film, *The Magic Feature*,[1] I pay tribute to the men responsible for its preservation and dissemination. To them, as well, we owe the first important critical assessment of a work whose visual splendor is grounded in that artisanal mode of production that has sustained the American cinema of independent persuasion. Jonas Mekas and P. Adams Sitney, in their passionate dedication to that cinema in general and to the work of Harry Smith in particular (a dedication resistant to public indifference and to the very caprices of the author himself) have retrieved this work for the corpus of the New American Cinema.

It is, moreover, Sitney's assiduous investigation of the sources of Smith's iconography that continues to provide the basis for any reading of this text. And we are further indebted to him for something of comparable value: his ability to draw from Smith, in conversation, the phantasmatic construction of a life history. I stress the importance of this latter element in so far as these extravagant musings demand, in my view, acknowledgment as constitutive, together with Smith's film practice, of a field that must be studied as such. Text and film-text, then, are to be considered for the purpose of an iconological project as reciprocally illuminating within a unified field.

My reading, its method, lead me, however, to differ with those of Sitney in many important respects. For Sitney, whose pioneering account of the cinema of the American avant-garde, published twenty years ago as *Visionary Film*, remains a major text within its field of study, *The Magic Feature* is the narrative of a spiritual quest, sharing with the mythopoeic cinema of Brakhage, Anger, and Markopoulos, "the theme of the divided being or splintered consciousness which must be reintegrated."[2]

Now this first intuition may appear sound, but only on condition that we examine the ground and nature of that division and splintering. They cannot, I believe, be understood as yet other elements of Romanticism's legacy within which a drama of spiritual salvation and transcendence is enacted; they must be explicated in terms that are more concrete and more fully explanatory.

Noel Carroll, the other prime exegete of this film-text, has offered a reading wholly antithetical to that of Sitney and equally subject to question. He sees it as an articulation of the epistemology of British empiricism, literalizing Locke's image of the mind as "cabinet or closet, full of simple impressions of perception, and of Hume's notion of the mind as a heap or collection of different perceptions tied together by certain relationships."[3] If, however, one is to understand this film as a whole, in the full range of its imagery, its pace and rhythm, its parametric construction, its serial repetition, and permutational structure, if one is to account for its constantly postponed resolution of action, one requires an approach that is, again, more fully explanatory. One wants, as

well, to consider its material aspect as collage animation. And one must confront the manner in which this form, this work offers the incessant fragmentation and restoration of the body, of a woman's body, in particular. Moreover, the performance of these assaults and of all other operations, are of a magical character, the work of a man of singularly small stature and hyper-agility. A homunculus is, in fact, the central, dominant, omnipotent protagonist of the action articulated through apparitions, transformations, vanishing acts effected by the constant invention, supply, and deployment of magical instruments and weapons. As Smith himself remarked, "First I collected the pieces out of old catalogues and books and whatever; then made up file cards of all possible combinations of them; then, I spent maybe a few months trying to sort the cards into logical order."[4] All the permutations possible were built up: say, there's a hammer in it, and there's a vase, and there's a woman and there's a dog. Various things could then be done—hammer hits dog; woman its dog; dog jumps into vase; and so forth. It was possible to build up an enormous number of cross references.[5]

If I am led to differ with Sitney's reading of *The Magic Feature,* that is because it accepts Smith's discourse, epitomized in my epigraph as scripture, so to speak. If it be such, one is bound to further persevere in one's hermeneutic efforts. Both readings heretofore offered confuse, as it were, the order of those principles of exegetical tradition which, deriving from Origen, read scripture through the Platonic topos of body/soul/spirit, passing from the literal to allegorical, and thence to the analogical register of faith. It is the median term of allegory—that of the soul which we now term the psyche—that I shall claim as the ground of a coherent reading.

Smith, talking to a group of students in 1971, advised them to look at films as discrete systems of signs, bearing in mind their character as such as against the reality effect of the motion picture. One recognizes the stress upon the acknowledgment of persistence of vision characteristic of a

generation of American modernists, and salient in the work and theoretical production of Frampton, Sharits, Snow, Gehr, among others. Smith, however, presses on: "You shouldn't be looking at this as a continuity. Film frames," he declares, "are hieroglyphs, even when they look like actuality. You should think of the film frame always as a glyph, and then you'll understand what cinema is about."[6]

From the time of their insertion into European discourse, hieroglyphs were known, as in Florio's definition (1598), as "secret mystical or enigmatical letters," a view that persisted into the nineteenth century, when they were characterized as sacred writing. And certainly Smith, in his role as divine instrument, as bearer of a gnosis, enjoins upon us the attentive reverence owed to the hieroglyphic inscription of that gnosis. However, we now possess the key to the hieroglyphic script of the Rosetta stone. And *The Magic Feature,* presumably dictated by God, presents itself as a mixture of pictures, visual puns, conventional signs, that is to say, as a rebus for our deciphering. Following Carlyle's advice, as offered in *Sartor Resartus,* I shall consequently not "proceed to receive as literally authentic what was but hieroglyphically so." It is by now most surely evident that I shall take my cue from the prime interpreter of the rebus, that my approach, though the median term of the psyche, is to be psychoanalytic.

Now, recent film theory has not, in its highly developed psychoanalytic register, been most extensively concerned with the analysis of the film text itself, but rather with the positioning of the spectator within cinematic construction. Its work has been grounded largely in the paper, published in 1927, in which the position of the fetishist is described as one of disavowal. "To put it plainly," Freud writes, "the fetish is a substitute for the woman's phallus which the little boy once believed in and does not wish to forego; we know why, for if mother has lost hers, he, too, is subject to that threat of castration."[7] The child retains his belief—in the woman originally endowed with a phallus—but he also gives it up;

Figures 1–2. Stills from Harry Smith, *Heaven and Earth Magic* (*The Magic Feature*), 1961

Figures 3–4. Stills from Harry Smith, *Heaven and Earth Magic* (*The Magic Feature*), 1961

Figures 5–6. Stills from Harry Smith, *Heaven and Earth Magic* (*The Magic Feature*), 1961

during the conflict between the dead weight of the unwelcome perception and the force of the opposite wish, a compromise is constructed such as is only possible in the realm of unconscious thought—by the primary processes. He knows, but all the same . . .[8]

Such then, as claimed by a dominant trend in contemporary film theory, will be the position of the film viewer in relation to the reality effect of cinematic representation.

In the exercise of decipherment to follow, I shall want to shift the psychoanalytic method of inquiry, back to the film text. In so doing, I shall take as my structural model, a quotation, not from Freud's essay on fetishism, but rather from an earlier paper of 1919, entitled *Psychoanalysis and Religious Origins* that I have found helpful and suggestive when confronted with the hermeneutic task posed by singularly complex and enigmatic works:

A little reflection was bound to show that it would be impossible to restrict to the provinces of dreams and nervous disorders a view such as this of the life of the human mind. If that view has hit upon a truth, it must apply equally to normal mental events, and even the highest achievements of the human spirit must bear a demonstrable relation to the factors found in pathology—to repression, the efforts at mastering the unconscious and to the possibilities of satisfying the primitive instincts. There was thus an irresistible temptation and, indeed, a scientific duty, to apply the research methods of psychoanalysis, in regions far remote from its native soil, to the various mental sciences. And indeed psychoanalytic work upon patients pointed persistently in the direction of this new task, for it was obvious that the forms assumed by the different neuroses echoed the most highly admired productions of our culture. Thus, hysterics are undoubtedly imaginative artists, even if they express their phantasies mimetically in the main and

without considering their intelligibility to other people; the ceremonials and prohibitions of obsessional neurotics drive us to suppose that they have created a private religion of their own, and the delusions of paranoiacs have an unpalatable external similarity and internal kinship to the systems of our philosophers. It is impossible to escape the conclusion that these patients are, in an asocial fashion, making the very attempts at solving their conflicts and appeasing their pressing needs which, when they are carried out in a fashion that has binding force for the majority, go by the names of poetry, religion, and philosophy."[9]

In following the Freudian model I shall draw as well upon the theory of object relations, formulated and documented for us by Melanie Klein in the psychoanalysis of young children. Klein, stressing the importance of the psyche's developments with the very earliest period of life, radically revised our view of early infancy and its consequences for later development. Given the relative neglect of Kleinian theory within the recent literature of cinema studies, I shall allow myself to retrace its account of the human subject's formation in those aspects that I judge to be pertinent for my project.[10]

The relational aspect of a primordial dyad is fundamental to her analysis of successive positions as the ground of the formation of infantile psychoses. Like D. W. Winnecott, Klein tended to believe that not babies, but babies-with-mothers formed the proper object of analysis. Moreover, Klein, in strong opposition to the dominant psychoanalytic thought extended the trajectory of the human subject into the earliest stages of existence, laying stress upon anxieties, defenses, and relations as constituting, from earliest infancy on, the crucial factors in the development of two successive infantile positions. The first of these, known as the paranoid-schizoid position, is operative within the first three to five months of the infant's life. The infant, at this earliest stage of de-

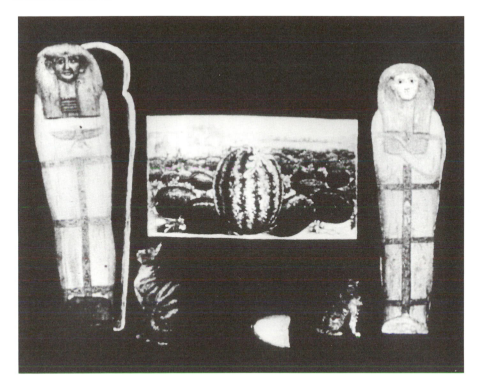

Figure 7. Still from Harry Smith, *Heaven and Earth Magic* (*The Magic Feature*), 1961

velopment relates to external reality not as a group of "whole objects" (Mother, Father), but rather as "part objects"—first and foremost the Mother's breast. This part-object, when present to satisfy the infant's hunger, functions as a "good breast," nourishing and satisfying. When absent during hunger, it acts as a "bad breast," frustrating and denying. It is consequently experienced as dual and persecutory: bent on the annihilation of the infant.

The dynamics of this relatively simple schema are nonetheless complex: the mechanism of "projective identification" is that which allows the object to become a representative of the developing ego—the identification of an object with the hated parts of the self, endowed with qualities of independence. At the same time, the infant introjects the object and its associated qualities, creating within its own psyche an internalized good breast or bad breast. The internal

objects, as idealized constructs, become the prototypes of all helpful and gratifying objects, or—as in the case of the bad breast—the prototype of all external, persecutory objects. Such a process of introjection and holding of internal objects corresponds, on Kleinian thought, to the beginning of the formation of the superego. Interestingly enough, however, the splitting of the object necessarily involves concurrent splitting of the ego, as the infant attempts to separate its good and bad objects.

The bad breast comes to possess the oral-sadistic impulses deriving from the infant's own feeling of envy. Destructive phantasies of biting, devouring, and annihilating the breast and the mother's body are prevalent when the infant is in a state of such paranoid anxiety. Later psychosexual stages will bring phantasies constructed about the infant's urethral and anal-sadistic impulses. Throughout, however, consistent defense

mechanisms continue to operate—splitting projection/introjection, a hallucinatory phantasy of control over the object (phantasies of omnipotence), and complete denial of the object, expressed by phantasies of annihilation.

I began this schematic exposition of Kleinian theory by remarking that its insistence upon extending the subject's psychoanalytic history back into the very earliest months of infancy met with great resistance, and I now want to stress the extreme hostility elicited, and which continues to this day. This we must understand as generated by the extreme violence of the infantile psyche's psychotic states as described in the theory of object relations. Both precocity and violence were, as we know, derived from and confirmed by Klein's extensive work over several decades in the as yet undeveloped field of the psychoanalysis of children, now shaped, nonetheless, by her pioneering efforts. In that process, she delivered to us a scenario of infantile development whose complex violence does indeed require a considerable adjustment of perspective, even from those already disabused, by Freudian theory, of the idealization of childhood so deeply embedded in our culture.[11]

I now return to the account of infantile development and its analysis of the second, crucial stage: that of the depressive position. Those physiological changes that extend the child's perceptual faculties now render it capable of establishing connections among the part-objects of breast, hands, voice, gaze, so as to perceive the Mother as a unified whole. The separating of good from bad which produces splitting is reduced, and the infant accedes to the depressive position through a growing awareness that the mother, embodying good and bad, is source of both love and hate, of satisfaction and frustration. It is then that the child comes to believe that it can, through projection of aggressive and destructive phantasies onto the mother, destroy and consequently lose the mother. The depressive anxieties thus generated produce a sense of loss of the good external object, a sense that the infant has, in its destructive phantasies, caused that loss. Good and bad breasts are now seen as the same object. It is this realization, and its consequent anxiety, that generates, in turn, an impulse toward reparation. The infant defends itself against those feelings of loss partly through manic defenses. For, Klein tells us, in describing the mourning that occurs during the depressive state, the ego is driven by depressive anxiety to build up omnipotent and violent phantasies, partly for the purpose of controlling and mastering the bad and dangerous objects, partly in order to save and restore the loved ones. Omnipotence, denial, and idealization, closely bound up with ambivalence, enable the early ego to assert itself to a certain degree against its internal persecutor and against a perilous dependence upon its loved objects, and thus to make further advances in its relation with its loved objects.

Together with these defenses and in place of these, Klein tells us, the child cultivates what she holds as the primordially significant aspect of the depressive position—reparative tendencies, in which the subject actively seeks to repair the damage (the loss inflicted on the good object), thereby successfully working through the depressive position." Reparation is, however, a complex process, for it involves impulses of control and fantasies of omnipotence, and therefore is closely aligned with sadistic impulses leading to reintroduction of manic defenses. It is only through *repetition* of reparative tendencies, through reinforcement and successful introjection of strong internal good objects that the child comes to trust its own constructive bent, and its capacity for love. And this, finally, is of especial importance, for to Klein and to her followers the reparative impulse is the ground of creative action. Confidence in one's reparative powers appears to be important, fundamentally so, for development in general, but is, more particularly, the generative source of artistic production.

II

Allegory dwells in a palace of transparency.
—Lemierre

It is by now surely evident, after this long expository interlude, that what is proposed is a reading of *The Magic Feature* as the representation of an elaborate working through, in the form of a prodigally generous form of reparation offered by artistic practice, of the spectrum of infantile development through paranoid-schizoid and depressive positions. And our first step toward that reading will entail an account of the initial image of the film which I note, with more than casual interest and amusement, neither of the exegetes cited above troubled to include in his own reading: that of the Homunculus who sets in motion this epic of repeated slaughter and resurrection by introducing (literally carrying on to the screen or scene) the other member of the primordial dyad, whose name we read, as in a rebus: "Mummy." She is dead, embalmed, encased Egyptian-style, imprisoned in her coffin. It is from that initial point on that one is impelled to read *The Magic Feature* as an elaborate articulation by an artist of what has come to be known as The Kleinian Scenario of Infantile Development. It is, of course, the scenario of a Horror Feature, and the longest running one known to us. For it presents the narrative of the ever-recommencing struggle of the little man, endowed in phantasy with magic powers (of aggression, insemination, destruction, and restoration), constantly engaged in the repetition compulsion of murderous assault upon and fragmentation of Mummy's body and the restoration of its integrity in an act of reparation. To cite Smith:

Then there's a graveyard scene, when the dead are all raised again. What actually happens at the end of the film is everybody's put in a teacup, because all kinds of horrible monsters came out of the graveyard, like animals that folded into one another. The heroine gets thrown in a teacup, which is made out of a head and stirred up. This is the Trip to Heaven and the Return, then the Noah's Ark, then the Raising of the Dead."[12]

Sitney offers the following account of the little man, his actions and his role.

Although Smith has described him as having the same function as the prop-mover in traditional Japanese theater, his continual manipulations in the alchemical context . . . with his almost absolute resistance to change when everything else, including the heroine, is under constant metamorphosis elevates him to the status of a magus. According to the argument of the film, he injects her with a magical potion while she sits in a diabolical dentist's chair. She rises to heaven and becomes fragmented. The "elaborate exposition of the heavenly land" occurs while the magus attempts a series of operations to put her back together. He does not succeed until after they are eaten by the giant head of a man (Max Muller), and they are descending to earth in an elevator. Their arrival coincides with an obscure celebration, seen in scatological imagery (the Great Sewer, to which Smith has referred in his musings) and in which a climactic recapitulation of the journey blends into an ending which is the exact reversal of the opening shots."[11]

The reference to the "alchemical context" is clarified by reference to the phantasmatic autobiography elicited by Sitney in the interview of Smith previously cited. Additionally and most importantly, that text foregrounds an etiology of infantile aggression and fantasies of omnipotence.

Like I say, my father gave me a blacksmith shop when I was maybe twelve; he told me I should convert lead into gold. He had me build all these things like models of the first Bell telephone, the original electric light bulb,

and perform all sorts of historical experiments. I once discovered in the attic of our house all those illuminated documents with hands with eyes in them, all kinds of Masonic deals that belonged to my grandfather. My father said I shouldn't have seen them, and he burned them up immediately. That was the background for my interest in metaphysics.[14]

I mostly lived with my mother. I performed what might be considered sexual acts with her until I was eighteen or nineteen maybe. No actual insertion or anything, but I would always get up in the morning and get in bed with her because she had a long story she would tell me about someone named Eaky-Peaky. She was a really good story teller. My posture is derived from trying to be exactly her height; for she was shorter.[15]

She would leave me in a theater. I saw some good films there, which I wish it were possible to locate again. I saw one, for example, which was pretty good in which bad children put caps into the spaghetti at a fancy Italian dinner. (That was one of the first sound films that I ever saw.) When the people chewed their spaghetti there was a BAAAKH; that was about all that was on the soundtrack. The mouth would fly open, and false teeth would go across the dinner table, and so forth.

I saw all those Fu Manchu movies; they were some of my favorites. There was also some serial that had a great big spider about the size of this room, which would be chasing Pearl White down through tunnels. That thing scared the shit out of me, but I probably had erections during it, it was so terrifying. I was very interested in spiders at about the age of five.[16]

Klein, in characterizing infantile sexuality between the ages of three and five, tells us that it is in this phase that we can locate the origin of the unconscious equation of breast, penis, faeces,

child. The infant's phantasies at the polymorphous stage of instinctual development, when excitations form all bodily zones and libidinal and destructive aims rival one another, produce the theory of parental intercourse as a feeding or excretory act, of conception through the mouth and birth through the anus: in them are superimposed oral excretory and procreative urges and phantasies. And, indeed, the film's little man alternates his destructive acts with a spectrum of actions of insemination of the maternal figure. Adolescence normally shows the re-emergence of early infantile sexuality. When the adolescent in horror turns away from his impulses, it is not only because he discovers his incestuous object choice, the wish to sleep with his mother, but because he becomes aware that he is attracted and excited by perverse and cruel phantasies.

Textual analysis of *The Magic Feature* requires, however, the unveiling, as it were, of the scenario's third leading actor, for the Baby/Mummy dyad is, of course, extended into a trio, completed by Daddy. Our scenario's Baby, is, of course a homunculus, or little man, formed in Daddy's very image, and wielding that same powerful instrument of Daddy's, the secret of his power over both Mummy and Baby, and over all things in general. Represented by syringe or by hammer, it is the instrument of destruction, vivification, transformation; it is magical, the source of the homunculus' omnipotence.

But the homunculus of *The Magic Feature*, this protagonist of the Kleinian Scenario, is not just any anonymous little man; he is a very particular one. Mummy's chic and dainty avatars have been culled from the nineteenth-century fashion plates of *Godey's Lady's Book*, cut, dismembered, placed on pedestals, encased, entombed, revived, framed, and elevated. But the homunculus is taken from the illustrations for the volume, *Kallipaedie or Education to Beauty through Natural and Symmetrical Promotion of Normal Body Growth*[17] by Dr. Daniel Gottlieb Moritz Schreber. This celebrated German pedagogue of the last century, has now receded into the past,

eclipsed by the celebrity of his son, Daniel Paul Schreber (1842–1911), the presiding judge of the Court of Appeals in Saxony, whose *Memoirs of a Mental Patient,* first published in Leipzig in 1903, narrated in great detail his life in various mental institutions, but also the excruciating periods of disturbance that preceded them.[18] These crises were described with a candor that led the Schreber family to buy up and destroy the book after publication. The few copies that remained attracted, as we know, considerable and enduring interest in psychiatric circles. One of these copies came into Freud's possession in Vienna, in 1910, the eventual result was Freud's penetrating analysis of the case, published in 1911, the only major one undertaken and published by Freud without direct contact with the patient, on the basis of this admittedly abundant documentary evidence.[19] Generally considered a seminal text, and the forerunner of numerous related studies in the area of paranoia, Freud's analysis has, within the last twenty years, been subject to a widespread renewal of interest and to intensive revision of approach to the case. I shall in what follows draw upon the pioneering work of William B. Niederland, whose investigation extends to an analysis of Schreber's family history and research into the father's history.[20]

Schreber's long phantasmatic narrative presents all the density and obsession with detail, the "invented logic" that characterize the discourse of the paranoiac. Schreber invents special terminology which he calls *Grundsprache* (ground language or root language) and which he attributes to God or a divine ray emanating from God. These were the means of communication between himself and the Divine source of his mission.

His delusional system, as revealed in the *Memoirs* has been summarized *briefly* as follows:

1. He felt he had a mission to redeem the world and restore it to its lost state of bliss.

2. This mission must be preceded by the destruction of the world and by his personal transformation into a woman.

3. Transformed into a female, he, Judge Schreber—now a woman—would become God's mate, and from this union a better and healthier race of men would emerge.

Schreber, whose sleep depended "totally on the celestial constellations" claimed: "A force of attraction emanates from my single human body over enormous distances . . . this may appear quite absurd. Nevertheless, the action of the force of attraction is a fact that for me is absolutely unquestionable."

He, Schreber, was awakened by rays to a new heavenly life, a state of bliss. For God only pure human nerves were usable, because they were destined to become attached to God himself and finally to turn into parts of God as "forecourts of heaven," as he termed them.

A male state of bliss occupied an even higher level than the female state of bliss; the latter seems to have consisted (Schreber speaking) of an uninterrupted sensation that it was the ultimate goal of all souls, merged with other souls, to coalesce into higher entities and to feel themselves parts of God ("forecourts of heaven").

Schreber's discourse on the omniscience and omnipresence of God stresses, as well, the importance of the connection, pre-established, in his view, more than a century before, of the connection between the names of Flechsig, his doctor, and Schreber—a connection that was not, as we shall see, limited to himself as a merely individual member of these families.

The undergoing, at the hands of the doctor, of a "soul murder" is woven into the narrative of Schreber's feminization, a process involving unutterable pain and issuing in ecstatic surrender. Schreber eventually developed the delusion that he actually was a woman, declaring that he had the breasts of a woman and experienced the "soul voluptuousness" of a female being. He was, in fact, the last real person left, whereas others, including Professor Flechsig, attendants, other patients were merely "miracled-up, cursorily sketched, many-headed little men."

We know that Freud was particularly interested

in the psychopathological process that led or ascended from Dr. Flechsig, his persecutory physician to the figure of God. A partial family tree shows the various steps in the production of the delusional system that culminates in the Flechsig-father-God identification. The diagram shows the patient's delusional use of the presence of Gott (God) in his father's names and of Theo (the Greek root meaning God) in his physician's name. It presents, we are told, the linguistic basis for the deification of the ancestors and, via the psychotic transference, of Flechsig. It also illustrates Schreber's statement: "I have parts of their souls in my body." Freud analyzed the patient's psychotic thought process as an "attempt at restitution." One of the characteristic manifestations of this attempt consists of an effort to regain lost libidinal objects by reinforcing the cathexis of the verbal representations standing for the lost objects. The outstanding libidinal object in Schreber's case was the father. The verbal representation of his father—his given name, Daniel Gottlieb—is recathected and it will be noted that in all the variations of the delusional names the word "God" occurs in one or another of them.[21] *Furchtegott* (fear God) is of especial interest, revealing the patient's ambivalence, his fear of God as well as the threat he addresses to God. The patient, as we see, shared the name of Daniel with his father and the name of Paul with his physician.

Considering the photographic portrait of Dr. Flechsig installed behind his office desk, with the contextual confirmation of his professional capacity and status, the huge map of his domain of sovereignty, the brain, one wonders, indeed, how his patient could not take him for that omniscient, omnipotent object of veneration and of fear? Benefitting from the research offering a more precise identification of the father-figure in the case, we learn that Dr. Daniel Gottlieb Moritz Schreber was a celebrated social, medical, and educational reformer, who taught in the medical school of the University of Leipzig. He wrote and published close to twenty books on health and

pediatric care. He was described in his obituary as "physician, teacher, nutritionist, anthropologist, therapeutic gymnast and athlete, and above all as man of action, of tremendous enthusiasm and endurance." Among the twenty books mentioned was the *Kallipaedeia,* the popular guidebook for parents and educators, known as *Education to Beauty Through Natural and Symmetrical Promotion of Normal Body Growth* and reprinted after his death as *Erziehungslehre* or *Educational Doctrination* [sic]. "And it was an especial and important point of pride with Dr. Schreber that his methods, theoretically derived, were, nevertheless, actively and personally applied in the rearing of his own children."[22] His educational system, as set forth to his readership of parents and educators, was based on the application of firm discipline, control, pressure, in the expectation that an early discipline will establish, in the malleable years of childhood, a moral discipline and a physical, muscular control that will ensure bodily health and mental soundness. He invented for this system, a set of exercises and physical controls that were to be applied to children, and *were* certainly applied to his own children, including young Daniel Paul. He seems to have been particularly concerned about the

Figure 8. Paul Schreber's delusional use of presence of God, "I have parts of their souls in my body"

Figure 12 / Dr. Paul Theodor Flechsig in his office.

Figure 9. Dr. Paul Theodor Flechsig in his office

Figure 3 / *Geradehalter*, a device designed to ensure rigidly erect sitting posture.

Figure 10. Dr. Schreber: Geradehalter—to ensure rigid sitting posture

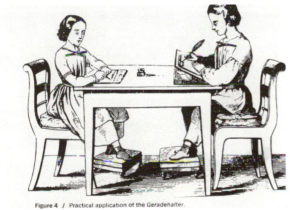

Figure 4 / Practical application of the *Geradehalter*.

Figure 11. Dr. Schreber: practical application of Geradehalter

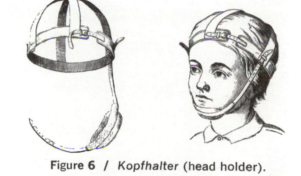

Figure 6 / *Kopfhalter* (head holder).

Figure 12. Dr. Schreber: Kopfhalter (head holder)

development of upright, straight posture. In this he was not alone, certainly, in Germany, but he was singular in his construction of varied and elaborate apparatus for the training in question, as illustrated by his recommendations for application of the following elements of his orthopedic apparatus:

Geradehalter: designed to ensure rigidly erect sitting posture.

Kopfhalter or head belt.

Kopfhalter and *Geradehalter* demonstrated in combine use.

Braces designed to prevent or correct deformity of bowed legs.

Apparatus for maintenance of child's perfect posture in sleep.

Head brace used as part of foregoing.

Exercise: The Bridge.

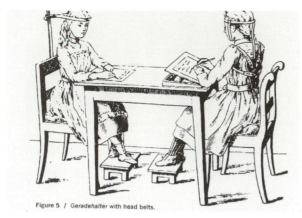

Figure 5 / Geradehalter with head belts.

Figure 13. Dr. Schreber: Geradehalter with head belts

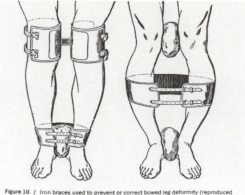

Figure 10 / Iron braces used to prevent or correct bowed leg deformity (reproduced from Dr. Schreber's printed works).

Figure 14. Dr. Schreber: Iron braces—to prevent or correct bowed legs

Figure 1 / Apparatus constructed for the purpose of maintaining perfect posture the sleeping child.

Figure 15. Dr. Schreber: Apparatus for maintaining perfect posture in sleep

Figure 2 / Same apparatus in use.

Figure 16. Dr. Schreber: Apparatus used in sleep

The pedagogue's *Pangymnastikon*[23] offered an entire gymnastic system condensed into one apparatus, the construction and application of which are described in his book of the same name. This device, ensuring that all gymnastic exercises were brought within the compass of a single piece of equipment, was viewed as the simplest means for achieving the fullest development of muscular strength and endurance.

It is from this set of illustrations, no doubt, that Schreber derived his own images of "curiosily sketched little men with multiple heads." And indeed, Schreber's entire delusional system can be seen as the projection of the system of constraints imposed upon the body of the psyche of the child of this extraordinary, totally controlling, God-like father. As Schreber put it, "a miracle directs the movements of my eyes. I have not men-

Figure 7 / Physical exercise, *Die Brücke* (the bridge).

54

Figure 11 / "Little men" having "multiple heads" (reproduced from Dr. Schreber's *Pangymnastikon*).

Figure 17. Dr. Schreber: Die Brücke (the bridge)—exercize

Figure 18. Dr. Schreber: "little men with multiple heads" from *Pangymnastikon*

tioned this miracle before, but it has been regularly enacted for years. Rays (father), after all, want constantly to see what pleases them. . . . My eye muscles are therefore influenced to move in that direction toward which my glance must fall on things just created or else on a female being."

Although an iconological study of *The Magic Feature* hardly requires that we situate the operation of the family triad more exactly within its text, we will want, however, to recall that Smith received, at the age of puberty, the command from his own father, of a task impossible to fulfill. "You must perform that magic feat which no one in the history of the world has yet performed: the conversion of lead into gold." (And Smith, in a spontaneous articulation of the accepted relation between gold and stool, speaks of his works as "excreta."[24]) Smith has offered us, in the visual splendor of his magic feature, the reparative offering in which the grief and anger of infantile psychosis are rehearsed and resolved. Out of the existing body of nineteenth-century illustration he cut, tore, then restored by collage and montage the turbulent saga of a passage from schizoid paranoia to depression. Smith's claims that his films were made by a force speaking

through him has only to be translated from the rhetoric of transcendence to that of immanence. It was the force of the little man, the homunculus, acting through him that converted that grief, that anger, those leaden directives of fashion and of pedagogic control into the reparative gold of *The Magic Feature*.

Notes

1. The alternate title of this work is *Heaven and Earth Magic*.

2. For a comprehensive survey and interpretation of Smith's oeuvre, see P. Adams Sitney, *Visionary Film: The American Avant-Garde* (New York: Oxford University Press, 1974). *The Magic Feature* is described on pp. 287–99.

3. Noel Carroll, "Mind, Medium and Metaphor in Harry Smith's *Heaven and Earth Magic*," *Film Quarterly* (winter, 1977–78): pp. 37–44.

4. P. Adams Sitney, "Harry Smith Interview," *Film Culture* 37 (summer 1965), cited in *Visionary Film*, p. 287.

5. Ibid., p. 294.

6. From a lecture in 1971 cited in Sitney, *Visionary Film*, p. 299.

7. Sigmund Freud, "Fetishism," in *Collected Papers*, vol. 5, ed. James Strachey (New York: Basic Books, 1959), p. 199.

8. Ibid., p. 200.

9. See Freud, *Collected Papers*, pp. 92–96. For a demonstration of its explanatory power in the construction of the se-

miotics of the oeuvre of Marcel Duchamp, see Annette Michelson, "Anemic Cinema: An Emblematic Work," *Artforum* (September, 1973): pp. 64–69.

10. For the following exposition of Kleinian theory I have drawn upon Melanie Klein, *Contributions to Psycho-Analysis, 1921–1945* (New York: McGraw-Hill Book Company, 1964) and Melanie Klein, *Envy and Gratitude and Other Works, 1946–1963* (New York: Delta Books, 1977), passim.

11. A very recent example would be the extraordinary statement of Sally Mann, the remarkable photographer of children whose work has been the subject of much critical debate: "I think childhood sexuality is an oxymoron." Cited in Richard B. Woodward, "The Disturbing Photography of Sally Mann," *The New York Times Magazine,* 27 September 1992, p. 52.

12. For this description and that of the larger conception and realization of *The Magic Feature,* see P. Adams Sitney, "Harry Smith Interview," in P. Adams Sitney, ed., *The Film Culture Reader* (New York: Praeger Publishers, 1970), pp. 260–77.

13. Sitney, *Visionary Film,* p. 292.

14. "Harry Smith Interview," p. 263.

15. Ibid., p. 264.

16. Ibid., p. 265.

17. Dr. Daniel Gottlieb Moritz Schreber, *Kallipaedie oder Erziehung zur Schonheit durch naturgetreue und gleichmassige Forderung normaler Korperbildung* (Leipzig, 1858).

18. Daniel Paul Schreber, *Denkwurdigkeiten eines Nervenkranken* (Leipzig: Fleischer, 1903).

19. See "Psychoanalytic Notes upon an Autobiographical Case of Parnoia (Dementia Paranoides)," in Sigmund Freud, *Three Case Histories,* ed. and intro. Philip Rieff (New York: Collier Books, 1966), pp. 103–186.

20. William G. Niederland, *The Schreber Case: Psychoanalytic Profile of a Paranoid Personality* (New York: Quadrangle/The New York Times Book Co., 1974). For quotations from the Schreber text I have drawn upon citations in Niederland. For English translation of the text, see Daniel Paul Schreber, *Memoirs of My Nervous Illness,* trans. I. Macalpine and R. Hunter (London: Dawson, 1955).

21. The table is published in Niederlander, p. 46.

22. Niederlander, p. 50.

23. D.G.M. Schreber, *Das Pangymnastikon oder das Ganze Turnsystem an einem Einzigen Gerate* (Leipzig: Fleischer, 1862). Three editions of the English language translation of this work were published that same year by Ticknor and Fields in Boston.

24. Cited in "Harry Smith Interview" p. 271. The reference to "my cinematic excreta" opens Smith's detailed description of his films prepared for the catalogue of the Film-Makers Cooperative.

COMMENTARY

Thoughts on Erwin Panofsky's First Years in Princeton*

CRAIG HUGH SMYTH

The invitation to be dinner-speaker came to me, I gather, because of happening to have been one of Erwin Panofsky's students long ago in Princeton and, years later, chair of his department when he became Morse Professor at his old institute in New York, after retiring here. This means —as I reassured myself when saying "yes" to Irving Lavin—that a dinner talk from me could be anecdotal, especially about Pan's later years in New York. But then I began to think about his first years in Princeton, upon moving from Germany, and about what they may have meant to his work.

Erwin Panofsky came to live in Princeton in 1934, dividing his time that year between teaching at New York University and Princeton University.[1] In 1935 he was invited to join the Institute for Advanced Study—while continuing to teach part-time at Princeton and New York. Nineteen thirty-four/five was my freshman year at Princeton. The two Panofsky sons were in the same class, and we became acquainted—both of them interested in everything, looking delighted, never seen studying, always having the highest possible marks. Charles Rufus Morey, my undergraduate interdepartmental thesis adviser, sent me (classics major, writing on Vergil illustration in the Italian Renaissance) to Erwin Panofsky, to be guided to sources such as he worked with when

writing on the medieval separation and Renaissance reintegration of classical form and classical subject matter.[2] Visiting Pan was immediately a mind-opening experience—"mind-boggling" we didn't say then—the first of memorable visits. In graduate school came his seminars for my generation, chiefly on the fourteenth century in Northern Europe. We had his lectures on iconology and on Dürer, and also, never published, the history of fifteenth-century German Painting—a mainstream art historical course on a subject rarely heard of at the time in this country.

After Irving's invitation, I began to think about what Pan found at Princeton in the 1930s. There was something new going on at the University when he arrived, and he connected with it. A new interdisciplinary program in the humanities was being formed. Plans for it had begun in 1932,[3] two years before his arrival. He was soon in touch with at least two key figures involved in the thinking behind it. In 1936 the program began operating—with teachers and students from various departments. Named the Special Program in the Humanities, SPH for short, it had many alumni in nearly thirty years of existence, including Neil Rudenstine, now Harvard's president. In 1937, just after SPH began, Panofsky took part (with three other scholars) in a lecture series on the humanities chaired by the originator of the program: Theodore Mayer Greene—T. M. Greene. These were the Spencer Trask Lectures, for which Panofsky wrote "The History of Art as a

*The somewhat informal tone of this paper reflects its origin as the after-dinner speech at the symposium banquet.

Humanistic Discipline," first published in the book of Trask Lectures—entitled, *The Meaning of the Humanities* and edited, with a long introduction, by T. M. Greene, Princeton University Press and Oxford University Press, 1938.[4] Panofsky's lecture was the one he republished in his *Meaning in the Visual Arts,* 1955, where it became famous.[5]

Michael Ann Holly's volume on Erwin Panofsky has done much to point out Pan's concerns before he came to the United States:[6] his focus as an art historian on meaning and interpretation, on the significance of cultural context for both meaning and interpretation, for understanding the work of art and its larger cultural significance —thus demonstrating in the process the interdisciplinary study involved. Yet Holly observed that, although Panofsky had "posited the iconological approach" in his *Hercules am Scheidewege* of 1930 and in his article on method of 1932, "as a method it lacked coherent systematization until 1939"[7]—in other words, until the publication of *Studies in Iconology* in 1939,"[8] after Panofsky's arrival in Princeton. If this is the case, the Trask lecture of 1937 on principles and method should be relevant as well.

My thoughts about Pan's first years in Princeton emerged as questions. What effect may he have had on what was going on here in the humanities, and how may that development have been fruitful for him?

Princeton's thinking about the humanities in the 1930s emanated from the circle of Paul Elmer More. This is not a name one hears now, though there is an entry on him in the Encyclopaedia Britannica. He was an independent scholar, born in 1864, living in his later years at Princeton on Battle Road, the street where Pan soon built his own house.

William Lyon Phelps of Yale—also once well known—wrote, in an obituary for the American Academy of Arts and Letters,[9] that More was "one of the most learned men in the world, a scholar in Sanskrit and some other Oriental lan-

guages," and "a first-class scholar in Greek and Latin" (he wrote books on Platonism, Hellenistic philosophies, and Christianity); that he was "of course at home in the principal modern European tongues"; and that he was "familiar with the history of human thought from the dawn of philosophy to the latest contemporary conjecture," loving learning for its own sake and for the sake of humanity. In addition, in Phelps' words, "More's long series of volumes called the *Shelburne Essays* were penetrating and brilliant illustrations of literary criticism at its best."[10] In More's circle at Princeton were Christian Gauss, future dean of the college, Robert K. Root, future dean of the faculty, and younger faculty members, among them: T. M. Greene in philosophy, Asher Hinds (A. E. Hinds), English, Albert M. Friend, Jr., history of art, Whitney Oates, classics, and Francis Godolphin, classics, later also to be dean of the college. Friend, the art historian in this list, became an outstanding medievalist of the day, with great influence at Dumbarton Oaks in its formative years.[11]

As undergraduates we saw most of these people, in various combinations, every day at a table in "the Balt" (the Baltimore Dairy Lunch) on Nassau Street, talking over coffee, P. E. More sometimes with them. There in the Balt, in 1932, Greene first proposed the special interdisciplinary humanities program. The story of this initiative has at last been put in print in an article of 1987 by Wallace Irwin, Jr., entitled "The Legacy of SPH: How a Small Program in the Humanities Changed Princeton's Entire Curriculum."[12]

What was the creed of this group? First of all, in Irwin's words, "a belief in the supreme value, and the interconnectedness, of all studies relating to the human condition."[13] Interdisciplinary study was assumed.[14] Above all, study of the humanities—the arts, literary and visual, very much included—"enhanced one's capacity to make responsible choices."[15] Here More was the cornerstone: "freedom," "purpose" and "responsibility" were central to his concept of man —of humankind, he would say now.[16]

In the Introduction to the Trask Lectures Greene called "freedom of thought and responsible action . . . the very condition of human dignity."[17] Whitney Oates insisted that "questions of good and evil, inherent in human freedom, lie beyond the reach of science and are the province of the humanities."[18] Freshman year, 1934/35, we heard Oates in Latin class, speaking again and again of "values," values that form a sense of responsibility. Responsibility was the key word for More and for his circle. Something of the kind emerged in all classes taught by members of the circle and its adherents. Albert Friend gave an undergraduate course on "Northern Renaissance Art" in which there was one paper, to be written in ten days at mid-term. In my year—and I think every year—the subject was the "Dignity of Man," followed by a long meeting of each student individually with Friend to discuss the paper and its relevance to life.

Very important was the circle's conviction that mere history was not enough. Friend wrote: "If a student studying his period of history in his own field and in two cognate subjects discovers the same trends and patterns, he may conclude that it is the period itself that controls man" [a post-structuralist sound?]. The student's work, Friend wrote, "is to discover what patterns have been and are."[19] In his Introduction to the Trask Lectures, Greene termed this "a cultural or historico-philosophical synthesis" and characterized it as "the highest of all humanistic thought and action."[20]

Erwin Panofsky's Trask lecture for Greene in 1937 fitted into Greene's and Friend's world. In its opening paragraphs Pan spoke of *humanitas* as a value, of humanism as "an attitude defined" as "the conviction of the dignity of man," with two postulates, one Responsibility, the other Tolerance.[21] In concluding, he said the aim of the humanities was "something like wisdom," words consonant with More's thinking (and with T. S. Eliot's contemporary estimate of More).[22] The lecture for Greene was framed, as it were, in agreement with the More circle's creed. But to Responsibility Pan added Tolerance. Princeton surely meant Tolerance to him after Nazi Germany. As for the main body of the lecture, it is fascinating to compare its similarities and differences to a major work by Greene, a comparison I shall return to in a moment. The lecture comes to seem in part like a Princeton native.

But, first, a word on Friend's course in the Northern Renaissance as a further clue to what Pan found at Princeton. In twenty-four typewritten lectures—one of which he handed out at the beginning of each class, then read aloud and commented on—Friend gave an account of Western religious and philosophical thought: from the early Greeks to Augustine, Erigena, and Dionysius the Areopagite, to scholasticism, mysticism, and Renaissance natural philosophy, Neoplatonism, and magic. The purpose he gave? To provide background for understanding what the later Middle Ages thought was "real." [I think of Pan; I can think of some of today's prominent views.] Accompanying the lectures, but purposely kept quite separate from them and always, so to say, ahead of them, were weekly preceptorials, given by Friend himself, on the art of the Rhine countries, France, and Spain. The preceptorials were not devoted to enumerating facts, contrary to what is said of American art history, but (as he explained explicitly in the last lecture) to an investigation of the "real" in the plastic arts and, concurrently, to an investigation of artistic expression, of the experience of the work of art as material and representation, of aesthetic experience and of spiritual experience, of the beholder's levels of consciousness, and of the evidence art gives, consciously and unconsciously, about thought, feeling, and life—of thinkers, yes, and also of people who make a civilization.[23] We can say that for Friend the visual arts were embedded in social discourse. It was mostly left to the student to put the lectures and preceptorials together by himself (no women in Princeton then) through observation and intuition—the two words central to More's definition of experience.[24]

Would Pan have known Friend's course? He had an office not far from Friend's in the art history department's McCormick Hall. Pan encouraged Friend to write on Dürer.[25] If he heard of the course from no one else, very likely Friend told him. As a graduate student, I listened to Mr. Friend in the quiet of the McCormick Hall library one Sunday morning, out of sight in the distance, telling someone, at length and profoundly, about Michelangelo. When they emerged, the person he had been telling was Charles de Tolnay. (Years later I told Tolnay how impressed I was by his quiet and politeness. "What, me—polite?" he answered, almost shouting. I have no doubt Tolnay was attentive because of what he heard.)

As for Charles Rufus Morey—loved by Pan—head of the art department since 1924, his short book *Christian Art* of 1935, to take one example, presented the art of each epoch as part of ideology, in present-day terms.[26] For him the concept of *mimesis* did not rule. Pan wrote superbly about Morey in an obituary for the American Philosophical Society.[27] They understood each other. It was Morey who suggested Pan for the Institute for Advanced Study.[28]

Hugo Buchthal is said to have observed that Panofsky's interest in the meaning of the visual arts made him "suspect to the establishment" in Germany.[29] In Princeton of the 1930s, he found, surely, the opposite, a setting that encouraged his interests.

Princeton's humanities of the 1930s produced at least one major publication besides the Trask Lectures: T. M. Greene's, *The Arts and the Art of Criticism*, published by Princeton University Press in 1940.[30] Greene, the philosopher, wrote —as he stated in the preface—in collaboration with colleagues from other disciplines. Of these he singled out three first of all: Asher Hinds and Albert Friend (both from the original More circle) and Roy Welsh of the Music Department, newer to Princeton, but by now of the same mind. The book is, so to say, an examination, articulation, and systematization of the More circle's beliefs as developed in their continual discussions.

Friend "contributed much of the critical analysis of the plastic arts."[31] The "classification of artistic categories was initiated by conversations with A. E. Hinds" and their "specific application —to literature—made under his expert guidance."[32] At the opening of the book's section IV, Greene recorded that he was "especially indebted to A. E. Hinds for the following analysis of artistic and literary criticism."[33] Section IV is, in fact, the heart of the book, entitled "Principles of Criticism." (In the text "critical response to art" is the terminology as well.) Credited with taking part as collaborators, too, though to a lesser extent, were Whitney Oates, classics, Donald Stauffer and C. W. Kennedy, English, and D. D. Egbert, history of art and architecture.[34]

Not least, Greene cited three others who, in Greene's words, "helped greatly in the analysis of various problems."[35] One of these was Erwin Panofsky. The other two were Francis Godolphin, classics, and George Forsyth, Jr., art and architecture, later of Sinai fame. Greene had begun work for this book by 1932.[36] It was probably well under way when he turned to Panofsky for help. Greene worked on the problems concerned almost until the book went to press.

It is a misfortune, owing to those times, that the book is not well known. Its message had long been permeating much of Princeton through Greene's annual lecture course, which consisted of the text as it was being written and revised. Transcripts of the lectures were available and tended to circulate. But by the time the book was published in 1940, war overseas had stopped the flow of books to Europe,and this country was at war the next year, taking all attention. The few reviews hardly grasped the book's message or the passion it represented.[37] Greene's writing lacked dash; George Boas called it High Church.[38] There were few footnotes. (Pan used to say: "We stand on our footnotes."[39]) Greene was a Kant scholar,[40] concerned with processes of knowing. Scholars with historical concerns may have

wanted more references to the history of thought on the subjects addressed.

As the book's Preface says, it studies "the work of art as an object of delight, a vehicle of communication, and, at least potentially, a record of significant insight"[41]—meaning, for Greene, insight of human import for the artist's time and times thereafter. Concluding the volume is the analysis of critical response. Greene's work is philosophy applied to the arts and humanities in collaboration with humanists of deep conviction who gave from their several disciplines to his. By no means least, it is systematic.

Eugene Kleinbauer's *Modern Perspectives on Western Art History*, published in 1971, cites the book—uses it—for its terminology and for its systematic classifications.[42] Greene's classifications are accompanied by a hallmark of Greene's systematic thinking: charts. At the end, there are four charts within one large one. The four are headed, (1) "Basic Artistic Categories"; (2) "The Abstract Arts: Music, Dance, Architecture"; (3) "The Representational Arts: Sculpture, Painting"; (4) "Symbolic Art: Literature." Under each of these are subdivisions: Matter, Form, Content. And under these: basic aspects of each, with attention to relations and terminology.

The book, too, is in four parts: First, "The Matter of Art," concerning media and the raw materials of subject matter (raw subject matter in sculpture and painting, for example, is classified as "representational," "emotive-conative," "symbolism," and "social function"). Next comes "Artistic Form," then "Artistic Content," and last, "Principles of Criticism."

Long before the book's publication in 1940, Greene's concerns were in the Princeton air. In the autumn of 1938 I had to make a report on scale in architecture, for my first graduate seminar. At a certain point, I automatically headed for T. M. Greene. Though I'd not taken Greene's course, I knew about his systematizing and care with terms, as most anyone in the humanities did, from other teachers, students, and the lecture transcripts. I wanted to be sure of thinking sys-

tematically, and that I had chosen sensible terminology. Greene liked this problem of scale, immediately entered it, and gave it and me hours of time, for several days—always ending up with charts.

For Erwin Panofsky, T. M. Greene's efforts were not just in the Princeton air; he knew them at first hand, working with Greene on Greene's book. This, as we know, was the time when Pan, in Princeton, produced the two writings referred to most often in this conference. In the first, "The History of Art as a Humanistic Discipline"—for Greene's Trask series of 1937, published in 1938—he specifically cited Greene for suggesting one item of his terminology: "organic situation" for the vicious circle in the normal processes of investigation.[43] The second, Panofsky's book *Studies in Iconology*, published in 1939, Greene cited in *his* book of the following year, quoting a long passage with evident approval.[44] Doubtless Greene would have approved as well the way Panofsky systematized and charted the exposition of iconological method in his Introduction to *Studies in Iconology*[45]—in keeping with Greene's own practice, but deriving from the systematic scheme and chart of the article on method Panofsky had published in 1932,[46] developed now for the book of 1939.[47]

Greene the Kant scholar, Panofsky devoted to Cassirer:[48] they had much to talk about and views to exchange. I think especially of elements common to their publications from Princeton at the end of the 'thirties: their conviction that art is an expressive vehicle; their common concern with the analysis of the work of art and its reception and interpretation; the stress each put on the importance to interpretation of the contexts of creation and reception; the recognition both gave to form in shared understanding that the form of the work of art is not an end in itself;[49] their rather analogous views on style;[50] the emphasis that Greene's book and Panofsky's Trask lecture both placed on aesthetic experience in apprehending art's content;[51] and, of much inter-

est, the dedication of both Greene and Panofsky to discerning and defining the aspects and goals of critical response—plus the cultural equipment needed. Here Greene's book and Panofsky's lecture shared the concept of "re-creation"—the concept and the term.

For Greene, critical response has "three aspects: the historical, the recreative, and the judicial."[52] He called these "mutually conditioning factors of a single organic process,"[53] and wrote about each factor. In the Trask lecture Panofsky gives re-creation an essential role and within an analogous formula: "intuitive aesthetic re-creation and archaeological research are interconnected so as to form . . . an "organic situation" (the term already credited to Greene).[54] As best I know, before the Trask lecture for Greene "re-creation" does not occur in Panofsky's exposition of method for apprehending art and its content.[55] "Recreation" is fundamental to Greene's analysis of criticism. This analysis he credited especially to A. E. Hinds, as we saw. Was Hinds the main source? Was Greene? Friend? Panofsky? Did they all come upon the concept together? In any case, they agreed.

I suggest comparison of Panofsky and Greene for agreements and differences, and also consideration of Greene's volume both for itself and as part of our history. For many of us in those times it was basic.

We have been talking context—one aspect of Panofsky's Princeton context in the 1930s. If there were competing groups and rival theories in Princeton then, they do not stand out in memory. There was remarkably civil discourse—a sharing of insights. It is worth considering this context more deeply than here at the dinner table. And, as I say, it is worth looking into Greene's book on its own account.[56]

I am sorry not to have left time for anecdotes.

Notes

1. For Panofsky's move from Germany to Princeton and the dates, as well as his description of teaching in New York as a visitor from Germany starting three years before the move, see his essay, "Three Decades of Art History in the United States: Impressions of a Transplanted European," in *Meaning in the Visual Arts, Papers in and on Art History* (Garden City, N.Y., 1955), 321–46.

2. E. Panofsky and F. Saxl, "Classical Mythology in Medieval Art," *Metropolitan Museum Studies* 4, 2 (1933): 228ff. (It was a side-effect of Princeton's Special Program in the Humanities [begun in 1936 with the class of 1940, as described below] that art history was joined, at Morey's suggestion, to a classics major for a thesis not written in the program.)

3. For this and other facts about the program and its formation, see below and the citation in note 12.

4. E. Panofsky, "The History of Art as a Humanistic Discipline," in T. M. Greene, ed., *The Meaning of the Humanities* (Princeton and Oxford, 1938), 89–118.

5. E. Panofsky, "The History of Art as a Humanistic Discipline," in Panofsky, *Meaning*, 125.

6. M. A. Holly, *Panofsky and the Foundations of Art History* (Ithaca and London, 1984). For Panofsky's critical concerns before his move to the United States, see also M. Podro, *The Critical Historians of Art* (New Haven and London, 1982), 178–208 (the book makes the year 1927 its approximate limit [ibid., xv]).

7. Ibid., 159. For the article of 1932, see note 46 below. (There is a bit more on Holly's observation in note 47.)

8. E. Panofsky, *Studies in Iconology: Humanistic Themes in the Art of the Renaissance* (New York, 1939).

9. W. L. Phelps, "Paul Elmer More," in *Commemorative Tributes of the American Academy of Arts and Letters 1905–1941* (New York, 1942), 346–50. (I am most grateful to Ann Gilkerson for putting up with several interruptions in her own work to find or check some references for me, including this one.)

10. Ibid., 347. For another eulogy, as well as critique, of More's achievements, see T. S. Eliot, "Paul Elmer More," *Princeton Alumni Weekly* (February 5, 1937):373–74. See A. H. Dakin, *Paul Elmer Moore* (Princeton, 1960) for More's life, publications, and thought, and for other estimates (among them Eliot's of July 1937, following More's death in March, including the words: "The critic who [like More] is, so to speak, a better critic than his age deserves, is isolated . . . for he remains in his own time ineffective . . . More was a better critic than Pater" [from T. S. Eliot, "Commentary," *The Criterion* 16, 65 (1937), 666–69]).

11. E. Kleinbauer, *Modern Perspectives on Western Art History* (New York, 1971), 59–60. A *Festschrift* was written for Friend: K. Weitzmann, ed., with the Assistance of S. Der Ner-

sessian, G. H. Forsyth, Jr., E. H. Kantorowicz, and T. E. Mommsen, *Late Classical and Medieval Studies in Honor of Albert Mathais Friend, Jr.* (Princeton, 1955).

12. W. Irwin, Jr., "The Legacy of SPH: How a Small Program in the Humanities Changed Princeton's Entire Curriculum," *Princeton Alumni Weekly* (January 14, 1987), 12–19.

As an undergraduate, Class of 1940, Irwin was enrolled in the program in 1936, at its start, and after graduation was a member of the program's advisory council from the time of the council's first meeting in May 1942. A photograph of that first council meeting is on page 13 of the article, showing Greene, Friend, Hinds, and Oates among others.

13. Ibid., 15.

14. The program began in the freshman year with courses in seven fields and culminated in the senior year with a synthesis of two or more fields (Irwin, *SPH* 14). The program regularly included several series of meetings in which all the SPH faculty, from its various disciplines, and all the students took part. Irwin reports that the first series consisted of long meetings on the topic "Facts and Interpretation," in order "to illustrate a favorite concept of Greene's, the historical and philosophical dimensions that determine the humanist's approach to any subject" (ibid., 15). (We can sample Greene on the "mutually dependent" historical and systematic aspects of interpretation in his Introduction to Greene, ed., *Meaning*, xxx–xxxviii, referred to again, in a related connection, in note 20 below.)

15. Irwin, *SPH*, 16 and 19.

16. As expressed in a book by More published by the Princeton University Press just when SPH was taking shape: P. E. More, *The Sceptical Approach to Religion*, New Shelburne Essays, 2 (Princeton, 1934), esp. 4ff.

17. See Greene's Introduction, in Greene, ed., *Meaning*, xiv.

18. Irwin, *SPH*, 16.

19. Ibid., 18.

20. Greene's *Introduction to Greene*, ed., *Meaning*, xviii, and xxxiii–xxxviii, on the need of the humanities to make reality intelligible and of historians and philosophers together to "return again and again to the task of relating an ever-changing present to an ever-extending past" (ibid. xxxvii).

21. Panofsky, "The History of Art as a Humanistic Discipline," in Panofsky, *Meaning*, 2.

22. Ibid., 25. Cf. Paul Elmer More on "critical memory" and wisdom, in the essay entitled "Criticism," *Selected Shelburne Essays* (New York, 1935), 1–24, esp. 22–24, a publication dating from the year after Panofsky's arrival in Princeton. (The essay, first published in 1910, can also be found in P. E. More, *Shelburne Essays, Seventh Series* [New York, 1967 (1910)], 213–43, esp. 241–43.) In the article on More that T. S. Eliot published in Princeton early in the year of Panofsky's Trask lecture, Eliot concluded that More and Irving Babbitt were "the two *wisest* men" he had known—the italics Eliot's (Eliot,

More, 374, as cited in note 10 above).

23. It was said in my time that the typed lectures had been the same for years, while the weekly preceptorials concerning the history of art—given by Friend to each of the groups of students into which his course was divided for preceptorials —might be subject to changes.

24. More, *The Sceptical Approach to Religion*, 6–7.

(The paragraph above, on Friend's course, repeats with some differences a passage of mine in C. H. Smyth and P. Lukehart, eds., *The Early Years of Art History in the United States: Notes on Departments, Teaching, and Scholars*, [Princeton, 1994], 40.)

Friend comes to mind in connection with present-day convictions that painting as sign interacts with the world, in constant touch with signifying forces outside painting (I think of Bryson). For Friend as for SPH the history of art was not isolated from the other humanities, in theory or in practice (just as for Greene and his collaborators, including Friend, there was not a gap between philosophy and the arts, as we see in what follows).

25. A. M. Friend, Jr., "Dürer and the Hercules Borghese Piccolomini," *Art Bulletin* 25 (1943): 49, where there is a grateful acknowledgement to Panofsky in the final footnote.

26. C. R. Morey, *Christian Art* (London, New York, Toronto, 1935).

27. E. Panofsky, "Charles Rufus Morey (1877–1955)," *Yearbook of the American Philosophical Society* (Philadelphia, 1956), 482–91.

28. As reported in an unpublished manuscript on the history of the Institute for Advanced Study, in the Institute's archives. When preparing an essay on Morey, for the volume cited in note 24 above, I consulted this manuscript in 1986, with the kind permission of Harry Wolf, then director, and on the advice of Irving Lavin, who had discovered there Morey's role in advising Abraham Flexner, the Institute's first director, about the first appointments to the School of Humanistic Studies (now the School of Historical Studies).

29. H. van de Waal, "In Memoriam Erwin Panofsky, March 30, 1892–March 14, 1968," *Mededelingen der Koninklijke Nederlandste Akademie van Wetenschappen*, AFD. Letterkunde, Nieuwe Reeks—Deel 35—No. 6 (Amsterdam/London, 1972), 231.

30. T. M. Greene, *The Arts and the Art of Criticism* (Princeton, 1940).

31. Ibid., ix. To my knowledge, Albert Friend did not write about criticism himself—or as a critic, except in so far as criticism was incorporated in contributions he made as archaeological, so to say, art historian and in his teaching, as in the preceptorials of his own course on the Northern Renaissance or in those of the department's course on modern painting, for instance. Art historian and critic were not separate in either case.

32. Ibid., viii–ix.

33. Ibid., 369 no. 1.

Sad to say, Asher Hinds died suddenly in 1943 (Irwin, *SPH*, 13) without having completed the book on literary criticism that Greene cites here as in preparation. For many among Princeton's students and faculty, Hinds' critical mind was a lasting inspiration.

34. Greene, *Arts and Criticism*, ix.

35. Ibid.

36. Ibid., xii and Irwin, *SPH*, 14, quoting a letter from Hinds.

37. Of chief interest is the review by the prominent philosopher I. Edman, *Art Bulletin* 22 (1940): 274–76—understanding and appreciative, but without conveying a sense of Greene's and his collaborators' deep devotion to a cause. It seems mainly for this reason that the review elicited a quiet explanation from Greene (ibid. 23 [1941]: 80–81). (Edman also wrote a review for philosophers in *The Journal of Philosophy* 37 [1940]: 449–59, approving especially the uniqueness, as he said, of the book's categories of criticism. Appearing here, it was far from the sight of most historians, theorists, and critics of the book's six arts. The philosopher S. C. Pepper, in *Journal of Aesthetics* I, nos. 2 and 3 (1941): 124–26 approved. For a perfunctory review by an art historian/philosopher, see A. P. McMahon, *Parnassus* 12 (1940): 45–46.

38. As I remember, George Boas told me this either in 1941 or 1946. Yet he specifically approved (in G. Boas, *Wingless Pegasus: A Handbook for Critics* [Baltimore, 1950], 89 n. 4) the essay at the end of the book contributed by one of Greene's collaborators, entitled: "Supplementary Essay. A Discussion of the Expressed Content of Beethoven's Third Symphony, by Roy Dickinson Welch" (Greene, *Arts and Criticism*, 485–506).

39. David Allan Robertson, Jr., good and constant friend since Princeton in the 1930s, reminded me of this Panofsky aphorism. I am grateful to Irving Lavin for the exact wording.

40. Greene was well known as such, having been assigned the book on Kant in the Philosophy Series of the Modern Student's Library under the general editorship of Ralph Barton Perry, Professor of Philosophy, Harvard: T. M. Greene, *Kant Selections* (New York, Chicago, Boston, 1929), with Greene's substantial Introduction, xvii–lxxi.

41. Greene, *Arts and Criticism*, vii.

42. Kleinbauer, *Modern Perspectives on Western Art History*, 4–7, 10.

43. Panofsky, *Meaning*, 9.

44. Greene, *Arts and Criticism*, 301–2.

45. Panofsky, *Iconology*, 3–31 (republished as "Iconography and Iconology: an Introduction to the Study of Renaissance Art," in Panofsky, *Meaning*, 26–54).

46. E. Panofsky, "Inhaltsdeutung von Werken der bildenden Kunst," *Logos* 21 (1932): 103–119. (I have gone back to this article and refer to it now thanks to David Summers' concentration, in his paper at the conference, on Panofsky's thinking before moving to the United States.)

47. The "coherent systematization" that Holly found lacking in Panofsky's exposition of method until 1939 (as mentioned above and cited in note 7) she evidently saw as coming into view in the Introduction to *Studies in Iconology* of that year (Panofsky, *Iconology* 3–31, republished in Panofsky, *Meaning*, 26–54). On the other hand, the article of 1932 on method (cited above in note 46) is also systematic, though lean in comparison to the Introduction of 1939, its successor. Meanwhile, the Trask lecture of 1937 on "The History of Art as a Humanistic Discipline," concerning principles and method (as published in 1938 in Greene, ed., *Meaning*, 89–118, republished in Panofsky, *Meaning*, 1–25) is richer still, with more analogies to Princeton thinking in the humanities especially as represented by Greene (see also below)—thinking in which Panofsky shared during his first Princeton years. The lecture does come to seem in part like a Princeton native, as observed above and suggested further in what follows.

48. For views on Panofsky and Cassirer, see Holly, *Panofsky and Foundations*, 114ff. together with footnotes on those pages. (From time to time, reading there, one can think of Greene.)

49. Compare in particular Panofsky, "The History of Art as a Humanistic Discipline," in Panofsky, *Meaning*, 16, and Greene, *Arts and Criticism*, 123 (pages 123–219 constitute the book's Part II, "Artistic Form"). Formalism? No, not here in either.

50. Cf. Greene, *Arts and Criticism*, esp. 231, 374, 375, 377 ff., 383, and 386; and Panofsky's Trask lecture (Panofsky, *Meaning*, 16, 20, and 21 (with the implication, as I read him, that subject matter, form, and content constitute style, as in Greene).

51. See Greene's concentration on the share of aesthetic experience in apprehending the work of art and its content (Greene, *Arts and Criticism*, 3–25, for instance) and Panofsky's comparable emphasis on aesthetic experience in the Trask lecture, where even his definition of the work of art is its demand to be experienced aesthetically (Panofsky, *Meaning*, 11, 14, and 16 especially). In contrast, aesthetic experience has no part in the Introduction to *Studies in Iconology* of 1939 or in the article of 1932, from which the Introduction of 1939 was developed (see notes 46 and 47 above), any more than does "re-creation" (see below).

52. Greene, *Arts and Criticism*, 369–70. For Greene's characterization of "re-creation," see esp. 9 ff., 370 ff., 269 ff., and 350 ff. (Greene's three aspects of critical response are cited and incorporated in the account of western art history by Kleinbauer, *Modern Perspectives in Western Art History*, 4–7).

For a sense of Paul Elmer More's concept of criticism, doubtless well known to Greene and other members of the More circle when they were developing their own views, one might turn, not only to his essay "Criticism" of 1910, republished in 1935 in his *Selected Shelburne Essays* as cited above in note 22, but to an essay he published in the mid-thirties, "How to Read *Lycidas*," in P. E. More, *On Being Human*, New

Shelburne Essays, 3 (Princeton/London, 1936), esp. 195–202—as well as to many another of his earlier critical essays, such as those on Hazlitt, Pater, or Sainte-Beuve, all locatable from the Index in Shelburne Essays, volume 11, as cited in note 22.

53. Greene, Arts and Criticism, 370.

54. Panofsky, Meaning, 16. For Panofsky's understanding and use of "re-creation" in this lecture, see pp. 14–22. I think I see an analogous sense of this "organic situation" in Michael Podro's The Critical Historians of Art. On the one hand, there are his words at the book's close: "Insofar as we really engage with a past work we must re-make it for ourselves" (Critical Historians, 215); ". . . our modern sensibility is in there from the start. The painting is constituted for us by exercise of our sensibility and there is no way in which the painting for us can be freed from our present situation unless we turn it into a mere archaeological object, disengaged from any but scholastic concerns" (ibid., 214). On the other hand, as he writes in the Introduction, ". . . we try to see the work in the light of the conditions and intentions with which it was made" (ibid., xvi), that is to say, "to provide answers to diverse matters of fact, on sources, patronage, techniques, contemporaneous responses and ideals—the kind of question we can broadly describe as archaeological" (ibid., xviii). Organic reciprocity between archaeological search for historical facts and remaking the work of art for oneself does seem to be implicit and not inconsonant with views expressed by Greene and Panofsky in Princeton.

Unlike Greene, Panofsky does not include "the judicial" as a third, distinct aspect of critical response in addition to re-creation and "archaeological research" (Greene's "historical" aspect). But he does include "appraisal of quality" in "intuitive aesthetic re-creation" (ibid., pp. 14–15); and in a footnote (ibid., 18) he goes on to address critical appraisal briefly again, as well as the issue of greatness. (One can imagine this note as a short conversation with Greene, for whom greatness is a final concern, as it was for Panofsky in the article of 1932 [Panofsky, "Inhaltsdeutung," p 116].)

55. However, in the last footnote of his article of 1932 on method (Panofsky, "Inhaltsdeutung," 118), Panofsky takes note of a kind of response to the work of art that is not among the responses the article presents as necessary to apprehending works of art and their content. Citing it by way of an addendum, but excluding it because it is not historically controlled, he refers to it as "freischöpferische Rekonstruktion": "nicht mehr 'Interpretation,' sondern freischöpferische 'Rekonstruktion,' d.h. ihr Wert oder Unwert bestimmt sich nicht mehr nach dem Masstab geschichtlicher Wahrheit, sondern nach dem Masstab systematischer Originalität und Folgerichtigkeit. Sie ist so lange ungreifbar, als sie sich ihrer überhistorischen oder besser ausserhistorischen Zielsetzung bewusst bleibt, wird aber in dem Augenblick bekämpft werden mussen, in dem sie die Historie durch einem anders

gearteten Ausproch in Notwehr versetzt." In terminology and concept, "freischöpferische Rekonstruktion" is thus tantalizingly near "re-creation," as characterized by Greene (see the references in note 52 above). It is not a constituent of Panofsky's own approach in the article of 1932, but its mention as an addendum in the footnote tells what Panofsky could bring to discussions with Princetonians. It is again not a constituent of his approach in the Introduction to Studies in Iconology, of 1939, deriving from the article of 1932; there is not even a footnote now on "Rekonstruktion"—and no mention of "re-creation." (Panofsky's "synthetic intuition," required for apprehending content here [and standing in for "Weltanschauliches Urverhalten" of 1932], is not what "re-creation" is for Greene and for Panofsky in the Trask lecture, but more like Greene's "synthesis" [as mentioned above and cited in note 20].)

Whether European or American critical theory had previously formulated either Panofsky's "freischöpferische Rekonstruktion" or "re-creation" as used by Greene and Panofsky in their Princeton publications, I am not aware. For "re-creation" in Panofsky Holly has suggested a "point of contact with Dilthey's epistemology" (Holly, Panofsky and Foundations 37–38). I should expect that the concept of "re-creation"—with its emphasis on apprehension of the work of art through, in Greene's book, an "artistic experience" involving imagination and feeling and, in Panofsky's essay, "intuitive aesthetic" experience—has its roots in the theory of empathy ("Einfühlung," and its accompanying "Zufühlung" and "Nachfühlung") as enunciated originally by Robert Vischer and in its subsequent permutations. (On the theory of empathy see now Empathy, Form, and Space: Problems in German Aesthetics 1873–1893, Introduction and Translation by H. F. Mallgrave and E. Ikonomou [Santa Monica, 1994], esp. 17–29, 89–123, but also, earlier, Podro, The Critical Historians of Art, 100 ff. Neither Panofsky nor Greene cite anyone else or each other. There is a tiny possibility, I suppose, that Princeton views on " re-creation," if already in existence, were not unknown to Panofsky before the article of 1932 went to press, perhaps prompting the footnote's addendum. In 1931 Panofsky had started teaching at New York University as a visitor from Germany, when C. R. Morey was teaching there regularly from Princeton. It would have been natural enough for Panofsky to have made contact through Morey with other scholars in Princeton, then much respected in Europe as a center of art historical research [see Panofsky, "Three Decades," in Panofsky, Meaning, 325–26].)

56. For instance, into the then soon to be controversial chapter on artistic truth (beginning one's exploration first, I should say, with the observations in Greene, Arts and Criticism, 435–37, for comparison with current views). (Edman for one, otherwise generally approving, did not agree with Greene on artistic truth, in his review in The Journal of Philosophy, cited in note 37 above.)

Words, Images, Ellipses

HORST BREDEKAMP

Panofsky between Lévi-Strauss and Barthes

"Some people wish to ridicule the study of art by describing it as the writing of books about little pictures. But what are our discussions and writings if not descriptions of the little pictures in the retina of our eyes or false little pictures in our head?"[1] These words by Georg Christoph Lichtenberg are a commentary of unsurpassed irony on the conflict between the lingual and visual media. This controversy—its extreme positions marked by representatives of the thesis of "world as text" grouped on one side and radical constructivists on the other—is no longer a matter of a *paragone* between the verbal and graphic arts, but has come down to the theoretical problem of predominance of language over image or of image over language. Although the suggestion to end these claims and counterclaims to hegemony is repeatedly put forth, the dispute is likely to continue for as long as man has the faculty to see and speak.

Shortly after the Panofsky *Symposium* at Princeton, Lévi-Strauss' work *Regarder Ecouter Lire* (Observe Listen Read), the anthropologist's legacy of critical writings in literature, music, and art history, was published. Surprised by its tone and content, some reviewers characterized the work as a return to old-European pretensions.[2] Lévi-Strauss' homage to art and its interpretation is astonishing not only because it creates an eloquent bridge between New World and European art, but also because its polemic, either openly stated or palpable between the lines, outlines in sharp contour the rift between the iconic and the lingual.

In his discussion of the three Graces in Botticelli's work "Primavera," Lévi-Strauss emphasizes the "principal significance of Panofsky's iconographic and iconologic analyses," and rejects, in the same breath, any kind of analysis of art that is purely concerned with form.[3] His appreciation of iconology is not new. In a similar argument in his work *Anthropologie structurale deux*, published in 1973, he had invoked Panofsky as a star witness to efforts that would hold in check tendencies of arbitrary, whimsical interpretation. As a representative of a historically testable hermeneutic Panofsky was characterized as a "great structuralist" because he was a "great historian" whose standards of interpretation derived from history.[4] The art historian thus becomes the anthropologist's guarantor for the defense of the object and its objective interpretation.

As he had done in *Regarder Ecouter Lire*, where he eloquently elided from the picture structuralist, post-structuralist, and postmodern philosophers, Lévi-Strauss, in *Anthropologie structurale deux*, did not deign mention his adversary by name, that is, Roland Barthes and the semiology that, in the 1960s, he brought to the prominence it holds to this day. It has been suggested, and rightfully so, that Lévi-Strauss was, in effect, pitting Panofsky's iconology against Barthes' assumption that only the polyvalence, not the contents, of symbols is knowable[5] since all substantive interpretation will be buried under layers of lingual forms of thought and communication. Stretching Ferdinand de Saussure's dictum that linguistics could become "the paradigm and chief form of representation of the entire field of semiology,"[6] Barthes saw semiology as a subdivision of linguistics rather than linguistics as part of semiology.[7]

Ironically, it was this expansion of definition that led to Barthes' expulsion from the temple of strict linguistics. And, in a twist of double irony, his opponents Lévi Strauss and Panofsky were banished at the same time. Georges Mounins, who led the attack in 1970, significantly carried out the purge, however, in a nuanced manner. His criticism of Lévi-Strauss can be read as a tribute, whereas Panofsky was more or less casually dismissed.[8] It was Barthes who had to bear the brunt of the exorcism. He was expelled from the circle of traditional linguists because he had attempted to blur the demarcation between linear language, which unfolds in time, and simultaneous body language, which acts within the confines of space.[9] True to this propensity, Barthes had already in 1967 declared that Saussure's method was inapplicable to graphic art and that it had to be overcome.[10]

Barthes' fame was, as is well known, founded precisely on these attempts at crossing boundaries, adumbrated by the "plaisir de l'image."[11] Possibly in reaction to his expulsion from the temple, but also under the influence of Japanese and Chinese pictography, Barthes, in 1970, intensified his efforts to apply linguistic categories to the realm of the visual. Shortly after he had proclaimed his famous dictum of language as "fascist" in nature because it forces human beings ineluctably to make decisions,[12] he crowned his admiration for Cy Twombly's calligraphic art with the remark that it does not seek to "vanquish those who confront it."[13]

As much as one senses in Barthes a desire to apply the analytic tools of linguistics to visual objects, his analyses of form remain fixated on lingual theoretical considerations. For example, he read in Giuseppe Arcimboldo's painting "Vertumnus," in which the pictorial and the tangible are brilliantly combined, the quite poetic imagination of the "ouvrier de la langue" (sic!), a "language worker."[14] However, his assumption that a plum was planted in the eye of the countenance of autumn because the French word "prunelle" has the double meaning of plum and

apple of the eye ignores that this double meaning exists neither in Italian nor in Latin. Barthes' categorizations of the motive of an Italian painter in terms of the peculiarities of the French language exemplifies that very linguistically monochromatic arbitrariness that Lévi-Strauss, without explicitly discussing Barthes,[15] has characterized as a "ventriloquistic" short-cut strategy that transposes the work of art into the arbitrary openendedness of a hermeneutic understood as a purely lingual act.[16] For Lévi-Strauss, the transposition of all forms of symbols to the level of language was a surrender of the historic and material substance of a work of art.

In contrast to Barthes, who lucidly dissolved the world in language, Lévi-Strauss searched for the traces of language in the world. Apparently aware that structural linguists had trimmed Saussure's roots in intellectual history,[17] Lévi-Strauss pointed to the "double paradox" that the kind of pairing of conceptual frameworks which was central to Saussure's work had already been developed in the eighteenth century: not so much with regard to language, but more pronounced for music.[18] Since a work of art was for him, in an almost pictorially magic way, the concrete embodiment of meaning,[19] he turned to Panofsky as the historically rooted guarantor of that meaning.

Lévi-Strauss' position has been strengthened by similar impressions,[20] that even the most elaborate contemporary paradigms in semiologic theory are unable to dispel the suspicion that art historical methods, if fully developed, would have yielded the same results, especially since in each case it was not a matter of developing a new method but merely of applying a new vocabulary.[21]

All this can be cited in support of the central theme of Lévi-Strauss' *Regarder Ecouter Lire*. Yet, doubts remain. Even those art historians for whom semiology is a perduring method of orderly thinking, even while smothering the historical vitality of pictorial forms under the flour dust of theoretical agreement, will not be able to achieve that unclouded peace of mind that comes from certainty.

However, even if the way linguistic semiology was transposed into art history was wrong, from the standpoint of methodology, semiology, as a field, has achieved seismographic results by illuminating the development of mass media.[22] Above all, it is the desire to conduct activities on a theoretically sound basis that leads to the rejection of "business as usual"[23] and to the search for an appropriate foundation for the visual that does justice to an open sign theory as well, without becoming ensnared in the pitfalls of its shortcomings.

Early Alternatives

Scholars have repeatedly been urged to desist from assertions of hegemony of either the pictorial or the scriptoral and to permit a truly egalitarian interaction between the two positions.[24] Understandable as the motives for such forays are, a mere act of will cannot bring this about, if for no other reason than the difference between neural impulses that underlie iconic and verbal faculties.[25]

A way out of the dilemma may be a return to the starting point, to the point from which the linguistic paradigm had risen.[26] The current renascence of Heinrich Wölfflin's conceptualizations may be an indication of just such a trend. Although such a revival carries with it the danger of resuscitating long obsolete conclusions, the application of visual categories that originated in the period when the linguistic paradigm was first formulated would, nevertheless, be more than a mere return to a pure formalism.[27]

For such a reconstruction of earlier alternatives, which could also be profitably applied to a rejuvenated semiology, Panofsky's Hamburg background offers rich material. The conceptual framework that was developed at the Warburg Library for the Study of Cultural Science could serve as a visual counterweight to an absolute linguistic model. This reminder of a yet unsalvaged treasure is not meant as a moment in the heroic epic of cultural history, rather it derives from a desire to rethink the entire problem from the bottom up, for a fresh grasp of its historical development.

The same approach is also applicable, to name one example, to Aby Warburg's "Mnemosyne" pictorial atlas which has gained recent recognition as a psychomotoric history of pictorial representation, from prints of antiquity to postage stamps and modern advertising logos.[28] Warburg concurred with linguistic theories such as those of Hermann Orthoff, and believed that the effect of verbs and adjectives could be enormously augmented if they were supplemented with formal, foreign ingredients. This process, which seemed to correspond to the method of implanting antique forms into non-antique pictorial forms, was, however, not the basis for his "pathos formula." Rather it confirmed Warburg's thoughts on the emotive layering of artistic forms. Beyond a desire for exploring language, he was guided by the very psycho-historical processes that are affected by "the magical perception of the normal human eye."[29]

A reappraisal of Warburg's work would be of great value for one reason alone. He tied together considerations that were of vital interest to areas of inquiry far beyond the general Hamburg investigative framework.[30] Warburg's "Pictorial Language of Gestures,"[31] for example, has a close affinity to the research of the French historian Marc Bloch, who had an equal interest in the meaning of images and gestures.[32] Even Marcel Duchamp could be regarded as spiritually close to Warburg. The similarities of technique applied in the collage work of avant-garde artists is quite evident.[33] Another comparable enterprise is Walter Benjamin's *Passagen Werk*, in which the pictures of urban life should likewise have been permitted to speak for themselves.[34] The fact that these projects were left unfinished and that their achievements made before 1933 have been more or less forgotten is due to Nazi rule in Germany, the repercussions of which are felt to this day.

The development of semiology may well have taken a different direction had Warburg's work been better known. Any authentic knowledge of his work by English-speaking or French philosophers and art historians has so far been confined to a small circle of aficionados—even at the Princeton Symposium, Aby Warburg was the "great unknown."[35] By the same token, Panofsky's iconology would hardly have been characterized as language-fixated.[36] Any evaluation of Panofsky that presents him as the "Saussure of art history"[37] overlooks the fact that iconology is not the application of Saussure's methods by different means. It would be much more accurate to view it as an alternative approach that was conceptualized simultaneously with Saussure's. In line with the second stage of Panofsky's model, the iconographic, the only texts that should be consulted are those that have a direct bearing on the work that is being studied at a particular moment. This does not mean—and this is a point that is notoriously misunderstood—that the lingual should supersede the pictorial form. Rather it is a step toward the third iconologic phase in which the unconscious historicity of the visual is transcended and its independence is realized. The third level of "meaning in the visual arts" uses language as a counterpart to the network of visual meaning rather than as a "superior self" as is suggested by the theory of "image-as-text" which follows the "world-as-text" metaphor.[38] Instead of placing his trust in linguistically transmitted idioms (topoi), Panofsky, in this phase of his work, traced the associative, unconscious acts that give rise to it—"which give meaning even to formal arrangements and technical procedures."[39] Panofsky's keen sense for both visual representations and language enabled him to formulate a broader interpretive paradigm for the world of images than critics and false apologists of iconology are generally willing to concede.

Critics of iconology, among them the present writer, have frequently decried this discipline for attempting to tame and intellectualize the vital, subversive forms of works of art.[40] On the other hand, the "synthetic intuition" within which the iconologic meaning reveals itself testifies to a reflective, even playful, instability that runs counter to hastily construed, orderly thought processes.[41] The crucial aspect of iconology is its tendency to recognize pictorial forms not only as carriers of linguistically transmitted meaning, but also, and above all, as factors that disturb it. Therefore, any iconology worth its name will encompass areas of irony, of inversion, which not only lend an air of excitement to the image as product of creative fantasy, but also point up the need for an iconology of form besides that of motivation.[42] Following this tradition, to which the Hamburg project "Political Iconography" seeks to establish a link,[43] it remains to discover an iconology for a wide variety of fields, such as medicine, anthropology, neurology, and cognitive psychology. All of these are areas in which "image" has become, through a peculiar set of coincidences, the guiding, principal theme.[44]

Ellipses

The research work at the Warburg Library for the Study of Cultural Science stood under the form of the ellipse. Its invention may itself deserve no more than a footnote, but its history puts into exemplary relief the very principle it commends as a subject for contemplation. It touches on the boundaries of a rational, and that includes linguistic, approach to the visual.[45]

Warburg saw Kepler's transposition of the circular orbits around Mars into ellipses as a milestone in the process of the emancipation of human thought from pictorial, magical thinking. Furthermore, as he penetrated deeper into Kepler's problematic, he recognized the symbolic meaning of transcendence for his own, protracted, spiritual crisis. As a symbol of the circle enclosed between the elliptic poles of magical

thinking and of the Enlightenment, the ellipse gave form and content to the motto imprinted in the cupola of the reading room at the Warburg Library: "Per monstra ad sphaeram."[46]

Warburg's preoccupation with ellipses is also attested to by an episode that took place in September 1928. During a visit with Albert Einstein at the seaside resort of Scharbeutz, Warburg tried, with the aid of his pictorial atlas "to grant [Einstein] a glimpse of the soil in which his cosmologic mathematics had originated." In a letter to Fritz Saxl, Warburg wrote later: "[Einstein] followed my pictures like a schoolboy at the movies and tested the soundness of my conclusions by following up with merciless questioning. Only on Kepler and the ellipse, I believe, I did not get a passing grade. Otherwise he was satisfied with me."[47] It may be surmised that Einstein was not only discomforted by Warburg's identification with Kepler but also by his portrayal of Kepler as wrestling with astrology and magic. In a thank-you note to Warburg, Einstein touched once more on the subject with the intent of absolving Kepler, "who had to earn his keep by playing such an unsophisticated game"—meaning astrological practices.[48]

Einstein was, nevertheless, painfully aware of the fact that around the year 1600 rational thinking was by no means a common practice in all things. His displeasure, however, was not so much directed at Kepler as at Galileo. Einstein was, and always remained, puzzled by Galileo's rejection of Kepler's calculations of the ellipse. He treated this problem explicitly in his introduction to the English translation of Galileo's *Dialogue*, which was published in 1953. Here Einstein states: "That this decisive progress should have left no trace anywhere in Galileo's work is a grotesque illustration that creative human beings frequently lack a receptive frame of mind."[49]

Einstein's remark inspired Panofsky to examine Galileo's motive for rejecting Kepler's *Nova Astronomia* and to bridge, as it were, the gap between the histories of physics and art.[50] Panofsky

thus saw Galileo's failure as having been motivated, not by considerations of physics, but by powerful, subconsciously active, visual imprints on his mind. These were conjured up by the elliptical, as opposed to the circular, shapes of Kepler's orbits. To Galileo's sense of harmony, inextricably wedded to the movement of circles, Kepler's conclusions were as unpalatable as was Torquato Tasso's poetry or the artistic collections established in *Kunstkammers*. The reasons were aesthetic and this created an insurmountable barrier in his mind with regard to poetry and *Kunstkammers*, which ultimately extended to the mechanics of the heavens. Galileo's visually oriented preconception not only ran counter to certain forms of images and texts, it manipulated his understanding of formulae.

Although Panofsky's analysis was taken up and broadened the following year by the prominent historian of science Alexandre Koyré, it must have been a great disappointment for Panofsky that Einstein, possibly motivated by the same impulse as Galileo, ignored his work completely. Although Einstein discussed the problem again in his last interview, in 1955, he took no account of Panofsky's conclusions.[51]

Lévi-Strauss, to come back to our starting point, too searched for "meaning" in translingual forms. Anthropology may have a different set of goals, but Lévi-Strauss' conclusions call to mind Warburg's attempt to illuminate the psychomotoric aspects of the European Renaissance in the mirror of the snake rituals practiced among Pueblo Indians in New Mexico.[52] His retrospective, *Regarder Écouter Lire*, ends with a confession that only works of art, from the European Renaissance to the artistic expressions of the indigenous peoples of the New World, bear testimony that something of substance has taken place between human beings in the course of time.[53] It may be more than a mere symptom that at a time when the end of the subject, of authorship, and of the link between form and content is being contemplated in formalized linguistics, an anthropologist should ex-

hort scholars to call on iconology to testify to the ultimate meaning of human existence.

Panofsky's ironic vision of his own epitaph ends with a profession of love for "a few adults, all dogs, and for words." These words are the fulfillment of Georg Lichtenberg's sardonic aphorism concerning the visual character of language cited at the beginning of this essay. However, Panofsky saw his epitaph in a dream, in that hieroglyphic realm of the pictorial atlas of the unconscious in which, according to Sigmund Freud, all words appear as pictures.[54]

(Translated from the German by Brigitte M. Goldstein)

Notes

1. Georg Christoph Lichtenberg, *Aphorismen*, ed. Albert Leitzmann, 5 vols. (Berlin, 1902–1908), vol. 2, 1904, p. 168, no. 448.

2. Henning Ritter, "Das Exotische, ein vergeblicher Traum," *Frankfurter Allgemeine Zeitung* (22 November 1993), *Bilder und Zeiten*.

3. "Far be from me the idea to underestimate, in the manner of the formalists, the great importance of Panofsky's iconographic and iconologic analyses." Claude Lévi-Strauss, *Regarder Ecouter Lire* (Pairs, 1993), p. 68.

4. "To convince one's self of this, one need only consult, in the field of art criticism, a work as simply and completely structuralist as that of Erwin Panofsky. For if this author is a great structuralist, it is above all because he is a great historian. History offers him both an invaluable source of information and an interdisciplinary (combinatoire) field in which the accuracy of interpretations could be tested in a thousand different ways." Claude Lévi-Strauss, *Anthropologie structurale deux* (Paris, 1973), p. 324f.

5. S. Radnóti, "Die wilde Rezeption. Eine kritische Würdigung Erwin Panofskys von einem kunstphilosophischen Standpunkt aus," in *Acta Hist. Art. Hung.*, vol. 29 (1983), pp. 117–153; here p. 134. "She will not interpret the symbols but only their polyvalence; in a word, the object will no longer be the plain meanings of the work, but on the contrary, the empty meaning which supports them all." Roland Barthes, *Critique et Vérité* (Paris, 1966), p. 57f.

6. Ferdinand de Saussure, *Cours de linguistique générale*, 5th ed. (Paris, 1955), p. 101; English translation: *Course in General Linguistics*, ed. C. Bally et al. (New York, Toronto, and London, 1966), p. 68. The best analysis from an art history standpoint is David Summers, "Conditions and conventions: On the Disanalogy of Art and Language," in *The Language of Art History*, ed. Salim Kemal and Ivan Gaskell (Cambridge, 1991), pp. 181–212 (p. 185ff.).

7. "Man is condemned to articulate language and no semiologic enterprise can ignore this. It is, however, necessary to reverse Saussure's formula and to affirm that semiology is a part of linguistics: the essential function of this task is to suggest that, in a society such as ours, in which myths and rituals take the form of reason, that is, in definitive speech, the human language is not only a model of meaning, but also its foundation." Roland Barthes, *Système de la mode* (Paris, 1967), p. 9.

8. Georges Monin, "Lévi-Strauss et la linguistique," in *Introduction à la sémiologie* (Paris, 1970). To Lévi-Strauss, pp. 199–214; to Panofsky, p. 9. "Because for an responsible semiology the time of encyclopedism is no doubt already passed."

9. Georges Monin, "La sémiologie de Roland Barthes," in ibid., p. 191.

10. Roland Barthes, "La peinture, est-elle un language?," in *L'obvie et l'obtus. Essais critiques III* (Paris, 1982), pp, 139–141 [1969].

11. Roland Barthes, "Interview with Radio France-Culture, February 23, 1978," as cited in Louis-Jean Calvet, *Roland Barthes, 1915–1980* (Paris, 1990), p. 263.

12. Roland Barthes, *Leçon/Lektion* (Frankfurt am Main, 1980), p. 18.

13. Roland Barthes, "The Wisdom of Art," in Cy Twombly, *Paintings and Drawings*, exh. cat. (New York, 1979), pp. 9–22. "Twombly's art . . . does not grasp at anything" (p. 22).

14. Roland Barthes, "Arcimboldo ou rhétorique et magicien," in *L'obvie et l'obtus* (see note 10), p. 123.

15. He expressed his aversion to Barthes' paradigms openly in another context. See Claude Lévi-Strauss and Didier Eribon, *De près et de loin* (Paris, 1988), p. 107.

16. "A faithful observer or the animator unconscious of a piece of which he makes himself the center, and of which the audience can always ask itself whether the text is emitted by a person of flesh and blood or whether that which he invented is attributed to the puppets through clever ventriloquy." Lévi-Strauss, *Regarder Ecouter Lire* (see note 3), pp. 95–101.

17. Compare the fundamental, historical scientific critique of formal linguistics by Ludwig Jäger, "Die Internationalisierung der Linguistik und der strukturalistische Purismus der Sprache: Ein Plädoyer für eine hermeneutisch-semiologische Erneuerung der Sprachwissenschaft," in *Methoden- und Theoriediskussion in den Literaturwissenschaften als internationaler Prozess (1950–1990)*, ed. Harmut Böhme et al. (Stuttgart, 1996).

18. Lévi-Strauss, *Regarder Ecouter Lire* (see note 3), pp. 95–101.

19. James A. Boon, in the present volume.

20. Martin Jay, *Downcast Eyes: The Denigration of Vision in*

Twentieth Century French Thought (Berkeley and Los Angeles, 1993).

21. A example of this is Mike Bal and Norman Bryson, "Semiotics and Art History," *The Art Bulletin* 73, 2 (1991): 174–208. Compare the discussion with Francis Dowley and Reva Wolf in *The Art Bulletin* 74 (1992): 522–528, and the pointed rejection by Marie Czach, *The Art Bulletin* 75 (1993): 338–340. As an example of an earlier critique, compare Werner Oechslin, "Kunstgeschichte und der Anspruch des Strukturalismus," *Orbis scientiarum*, vol. 2, 1 (1971), pp. 60–72.

22. Klaus Bartels, "Kybernetik als Metapher. Der Beitrag des französischen Strukturalismus zu einer Philosophie der Information und der Massenmedien," in *Kultur. Bestimmungen im 20. Jahrhundert,* ed. Helmut Brackert and Fritz Wefelmeyer (Frankfurt am Main, 1990), pp. 441–474.

23. Rosalind Krauss, "Using language to do business as usual," in *Visual Theory. Painting and Interpretation,* ed. Norman Bryson, Michael Ann Holy, and Keith Moxey (New York, 1991), pp. 79–94.

24. See also W. J. T. Mitchell's "What is Visual Culture?" in the present volume. An overview is present by Oskar Bätschmann, "Bild—Text: Problematische Beziehungen," in *Kunstgeschichte aber wie?,* Fachschaft Kunstgeschichte München (Berlin, 1989), pp. 27–46.

25. *Kunstforum,* vol. 124 (1993), especially p. 130f. (Wolf Singer); p. 139 (Ernst Pöppel); pp. 143 and 147 (Ingo Rentschler). Compare also Ingo Rentschler, Terry Caelli, and Lamberto Maffei, "Focusing in on Art," in *Beauty and the Brain,* ed. Ingo Rentschler, Barbara Herzberger, and David Epstein (Basel, Boston, and Berlin, 1988), pp. 181–216.

26. See note 17.

27. Wölfflin's concepts of artistic style, of the linear, the open, and the closed, are complex, bipolar structures. See Martin Warnke, "On Heinrich Wölfflin," in *Representations,* vol. 27 (1989): 172–187; also Warnke, "Warburg und Wölfflin," in *Aby Warburg. Akten des internationalen Symposiums Hamburg 1990,* ed. Horst Bredekamp, Michael Diers, and Charlotte Schoell-Glass (Weinheim, 1991), pp. 79–86. Panofsky himself had greater regard for it than the scholars' dispute between Hamburg and Munich art history is willing to concede. See Horst Bredekamp, "Ex nihilo. Panofskys Habilitation," in *Polyanthea. Essays on Art and Architecture in Honor of William S. Heckscher,* ed. Karl-Ludwig Selig (Den Haag, 1993), pp. 1–19. And yet, because of their abstract exaggerations, both sides underestimate the historical contradictions of the history of artistic forms. Compare Anna Wessely, "Transporting 'Style' from the History of Art to the History of Science," *Science in Context,* vol. 4 (1991), no. 2, pp. 265–278. A historical outline of the use and problematic of the concept of style was recently offered by Robert Suckale, *Die Hofkunst Kaiser Ludwigs des Bayern* (Munich, 1993), pp. 48–51.

28. Martin Warnke, "Der Leidschatz der Menschheit wird humaner Besitz," in Werner Hofmann, Georg Syamken, and Martin Warnke, *Die Menschenrechte des Auges. Über Aby Warburg* (Frankfurt am Main, 1980), pp. 180–186. Compare the most recent work by Isebill Barta Fliedl, "Vom Triumph zum Seelendrama. Suchen und Finden oder Die Abenteuer eines Denklustigen. Anmerkungen zu den gebärdensprachlichen Bilderreihen Aby Warburgs," in *Die Beredsamkeit des Leibes. Zur Körpersprache in der Kunst,* ed. Isebill Barta Fliedl and Christoph Geissmar (Wien, 1992), pp. 165–170; also Werner Rappl, "Mnemosyne:: Ein Sturmlauf an die Grenze," in *Aby M. Warburg. Bildersammlung zur Geschichte von Sternglauben* and *Sternkunde im Hamburger Planetarium,* ed. Uwe Fleckner et al. (Hamburg, 1993), pp. 363–398.

29. Aby Warburg, "Einleitung zum Mnemosyne-Atlas (1929)," in *Beredsamkeit* (see note 28), pp. 171–173. Compare Ernst H. Gombrich, *Aby Warburg: An Intellectual Biography* (London, 1970), p. 178f. Hermann Osthoff, *Vom Suppletivwesen der indogermanischen Sprachen* (Heidelberg, 1899).

30. An example of a precursor represents *Iconographie photographique de la Salpêtrière (1876–1918)* by the Paris neurologist Jean-Martin Charcot. Although the photography of the body language phase of hysterical fits has a cinematographic side, as a sort of photo museum of nervous diseases, it has a static, physiognomy-oriented aspect which transforms the disease into a disease picture. After initial interest in diagnosing these disease pictures, Sigmund Freud changed his focus from photographs of disease to its verbal replication. Warburg's project which was designed to encompass process also stands in diametrical opposition to Charcot's "iconographie." As an enterprise that is based on a systematic as well as associative structure and retains an interpretive, distancing, and clarifying language while preserving the specific characteristics of iconic representations, the visual aim of Warburg's project too had an objective that was different from Charcot's whose project was informed by the inventory method of the eighteenth century. See also Sigrid Schade who, in her cultural/historical comparative study of Charcot's and Warburg's pictorial atlases, is more inclined to emphasize what the two men have in common. "Charcot und das Schauspiel des hysterischen Körpers. Die 'Pathosformel' als ästhetische Inszenierung des psychiatrischen Diskurses—ein blinder Fleck in der Warburg-Rezeption," in *Denkräume zwischen Kunst und Wissenschaft.* 5th Conference of Women Art Historians in Hamburg, ed. Silvia Baumgart et al. (Berlin, 1993), pp. 461–484.

31. Warburg, *Einleitung* (see note 29), p. 173.

32. Ulrich Raulff, "Parallel gelesen: Die Schriften von Aby Warburg und Marc Bloch," in *Warburg* (see note 27), pp. 167–178.

33. William S. Heckscher, "The Genesis of Iconology," in *Stil und Überlieferung in der Kunst des Abendlandes.* Records of the Thirty First International Congress of Art History in Bonn 1964, vol. 3 (Berlin, 1967), pp. 239–262 (245); see also Werner

Hofmann "Die Menschenrechte des Auges," in *Menschenrechte* (see note 28), pp. 85–111 (102ff.).

34. Wolfgang Kemp, "Fernbilder. Benjamin und Aby Warburg," in *Kritische Berichte*, vol. 3, no. 1: (1975) 5–25 (10ff.). The most recent analysis of Benjamin's *Passagen Werk* is by Susan Buck-Morss, *The Dialectics of Seeing. Walter Benjamin and the Arcades Project* (Cambridge, Mass., 1989). The author is, however, unfamiliar with Aby Warburg's project even though she arranges her own pictorial " mnemosyne" at the end of the book.

35. Willibald Sauerländer, "Panofsky in Jurassic Park. Meaning in the Visual Arts: Views from the Outside," *Kunstchronik*, vol. 46, 12 (1993): 709–718 (715).

36. Oskar Bätschmann, "Logos in der Geschichte: Erwin Panofskys Ikonologie," in Lorenz Dittmann, ed., *Kategorien und Methoden der deutschen Kunstgeschichte, 1900–1930* (Stuttgart, 1985), pp. 89–112. Illuminating also is Karen Michel's analysis of Panofsky's language "Bemerkungen zu Panofskys Sprache," in *Panofsky* (see note 27), pp. 59–69.

37. Giulio C. Argan, "La storia dell' arte," *Storia dell' Arte*, no. 1/2 (1969): 5–36 (25). Concerning this question compare Christine Hasenmueller, "Panofsky, Iconography, and Semiotics," *Journal of Aesthetics and Art Criticism*, vol. 36 (1978): 268–301; Michael Ann Holly. *Panofsky and the Foundations of Art History* (Ithaca, NY, and London, 1984), p. 42ff.; Andreas Beyer. "Postmoderne versus Ikonologie?" in *L'Art et les révolutions*. XXVIIᵉ Congrès international d'histoire de l'art (Strasburg, 17 September 1989), vol. 5 (1992), pp. 197–207 (201) where Panofsky's relationship to Charles Sanders Peirce is discussed.

38. Felix Thürlemann defines the specific character of the pictorial form, in the tradition of Saussure and Algirdas Julien Greismas, by endowing it with "the status of a text." See "Geschichtsdarstellung als Geschichtsdeutung," in *Der Text des Bildes. Möglichkeiten und Mittel eigenständiger Bilderzählung*, ed. Wolfgang Kemp (Munich, 1989), pp. 89–115 (90). Compare *Die Welt als Text*, ed. Detlef Garz (Frankfurt am Main, 1994).

39. Erwin Panofsky, "Iconography and Iconology," in *Meaning in the Visual Arts* (Garden City, N.Y., 1955), p. 38.

40. Kurt W. Forster, "Critical History of Art or Transfigurations of Values?," *New Literary History*, vol. 3 (1972): 459–470 (467). Colin Eisler, "Panofsky and his Peers in a Warburgian Psyche Glass," *Notes in the History of Art*, 4, nos. 2/3: (1985) 85–88. Horst Bredekamp, "Götterdämmerung des Neuplatonismus," in *Die Lesbarkeit der Kunst. Zur Geistes-Gegenwart der Ikonologie*, ed. Andreas Beyer (Berlin, 1992), pp. 75–83. A summary of other critical analyses of iconology from Otto Pächt to Svetlana Alpers and Wolfgang Kemp by Peter Schmidt can be found in his work *Aby M. Warburg und die Ikonologie* (Bamberg, 1989), p. 41ff.

41. Anthony Grafton in the present volume. Compare Hasenmueller, *Panofsky* (see note 37), p. 296f. Panofsky

makes this point in his posthumously published work *Problems in Titian: Mostly Iconographic* (London, 1969). He shows here, with brittle frankness, that the barriers to adequate linguistic understanding of a work of art can never be completely overcome.

42. Irving Lavin, "Ikonographie als geisteswissenschaftliche Disziplin," in *Lesbarkeit der Kunst* (see note 40), pp. 11–22 (19ff.). Compare Gottfried Boehm, "Was heißt: Interpretation?" in ibid., pp. 13–26. Also for an attempt to reconstruct, within the paradigm of textual pictorial structures, "the text distance of the pictorial text" in the "narrative of medieval stained glass windows" around 1200, see Wolfgang Kemp, *Sermo Corporeus. Die Erzählung der mittelalterlichen Glasfenster* (Munich, 1987), p. 119f.

43. *Bildindex zur politischen Ikonographie*, with an introduction by Martin Warnke (Hamburg, 1993).

44. Barbara Maria Stafford, "Present image, past text, post word: Educating the late modern citizen," *Semiotica* 91, nos. 3/4 (1992): 195–198. Horst Bredekamp, *Antikensehnsucht und Maschinenglauben. Die Geschichte der Kunstkammer und die Zukunft der Kunstgeschichte* (Berlin, 1993), pp. 99–102.

45. See Rudolf Preimesberger, "Zu Jan van Eycks Diptychon der Sammlung Thyssen-Bornemisza," in *Zeitschrift für Kunstgeschichte* 60, 4 (1991): 459–489 (465).

46. Aby Warburg as cited in Martin Jesinghausen-Lauster, *Die Suche nach der symbolischen Form. Der Kreis um die kulturwissenschaftliche Bibliothek Warburg* (Baden-Baden, 1985), p. 216. Compare the more pragmatic view of Tilmann von Stockhausen in his work *Die kulturwissenschaftliche Bibliothek Warburg. Architektur, Einrichtung und Organisation* (Hamburg, 1992), p. 37ff.

47. Aby Warburg to Fritz Saxl, letter of 5 September 1928, in Warburgs Korrespondezarchiv.

48. Albert Einstein to Aby Warburg, letter of 10 September 1928, in Warburgs Korrespondenzarchiv. The letters were made available through the courtesy of Claudia Naber.

49. Albert Einstein, intro. to *Galileo Galilei. Dialogue Concerning the Two Chief World Systems*, trans Stillman Drake (Berkeley, 1953), p. xvi.

50. Erwin Panofsky, *Galileo as a Critic of the Arts* (Den Haag, 1954), p. 23f. See also Martin Kemp in the present volume.

51. Alexandre Koyré, "Attitudes esthétiques et pensée scientique," *Critique*, nos. 100/101: (1955) 835–847, reprinted with Panofsky's text in Erwin Panofsky, *Galilée Critique d'Art*, (ed. and trans. Nathalie Heinich (Leuven, 1983), pp. 81–97. Bernard Cohen, "An Interview with Einstein," *Scientific American*, vol. 93 (July 1955): 69–73 (69). See also Albrecht Fölsing, *Albert Einstein. Eine Biographie* (Frankfurt am Main, 1993), p. 243.

52. Aby M. Warburg, *Schlangenritual. Ein Reisebericht* (Berlin, 1988). In the afterword to this edition Ulrich Raulff discusses Warburg's concept of "structural" thinking, which

however should not be regarded as a direct precursor to Lévi-Strauss' terminology. See ibid., pp. 61–94 (86). See also Salvatore Settis, "Kunstgeschichte als vergleichende Kulturwissenschaft: Aby Warburg, die Pueblo Indianer und das Nachleben der Antike," in *Künstlerischer Austausch. Artistic Exchange*. Records of the Twenty-Eighth International Congress for Art History Berlin, 15 to 20 July 1992, ed. Thomas W. Gaethgens (Berlin 1993) vol. 1, pp. 139–158.

53. Lévi-Strauss, *Regarder Ecouter Lire* (see note 3), p. 176.

54. Sigmund Freud, *Vorlesungen zur Einführung in die Psychoanalyse. Der Traum,* ed. Alexander Mitscherlich, Angela Richards, and James Strachey, vol. 1 (Frankfurt am Main, 1969), pp. 101–241 (182ff.; 232ff.).

The Panofsky Conference:
A Window on Academic
Culture in the Humanities

CARL E. SCHORSKE

My running orders from Irving Lavin were clear: I was to be a roving reporter, responding to the games as they unfolded with critical or synoptic commentary. The organization of the events by discipline, I thought, provided a clear frame for ordering both observation and reflection. Each team would show how its practitioners explore and exploit the visual arts for the kind of meaning its discipline seeks—or makes—today.

Only to a very limited extent was that expectation realized. As the conference progressed, it became clear that a taxonomy of learning based on traditional disciplines, with their relative unity of purpose and procedure, was not adequate to the contemporary situation of our academic culture. For the self-definitions of the disciplines, their ego-structures, the senses of identity that had governed their work and enabled them to control their gates were giving way before intellectual concerns that had created new, trans-disciplinary communities of interest. The presence of the latter in every field suggested an alternative taxonomy, one based on intellectual perspectives and/or ideological-cultural commitments.

As the divisions of outlook became manifest, I began to wonder whether the symposium should have been organized not by discipline but by perspectival categories; e.g., classical-historical, multi-cultural, ludic/hedonistic, critical-theoretical. One could imagine four or five multi-disciplinary panels, each devoted to one philosophy of culture or methodological approach, construing the

visual arts in its way as it applied to literature, film studies, anthropology, music, etc. Yet, these several approaches are hard to circumscribe firmly; they are almost as permeable to each other and as subject to blurring as the disciplines themselves.

My own response to the conference as it unfolded was thus an increasing awareness, on the one hand, of the ubiquity of pluralization—often of polarity—of scholarly missions and methods across the disciplines; and, on the other, of the differences in the degree to which the several disciplines could maintain cohesion in the face of the conceptual fragmentation to which all are now subject. In short, I began to see the symposium, with due allowance for the smallness of its sample, as providing a remarkable window on the state of academic culture in the humanities. What was needed to grasp its complexity was not simply a new organization by sub-cultures of ideology and method, but rather a dual perceptual grid, one that could reflect in its coordinates both the disciplinary-institutional perspective and the trans-disciplinary-conceptual allegiances by which scholarly identity is constituted. All readers of this volume will recognize that no grid can do justice to the intellectual variety and individuality of the contributions. I have tried here to pursue a middle course between taxonomic abstraction and particularity by limiting my discussion to three of the six disciplines represented. Within them, the individual papers could still serve as vehicles for

documenting trans-disciplinary intellectual currents without reducing them to a mere statistical existence. The selection of only three disciplines is again motivated by the desire to keep some concreteness while pursuing a structural-analytic aim. The three specific fields chosen—anthropology, literature and history—while all affected by contemporary trans-disciplinary currents, have responded to them in quite different ways that are at least partly represented in their symposium contributions.

Of the three disciplines, cultural anthropology seemed to have the strongest ego, the greatest consensuality. Its representatives at the symposium seemed to have adapted the traditions of their field most readily to the new ideological currents. Literature stood at the opposite end of the spectrum of cohesion. Polarized between tradition and several kinds of trans-temporal modernism, their group-ego fractured, the literary scholars offered the conference the widest array of intellectual positions with general significance for humanistic study. History, represented at the colloquium only by intellectual historians of the Renaissance, showed a greater degree of unity of outlook than is characteristic of the discipline as a whole, but between traditionalists and two kinds of modernists important differences emerged. An examination of the other fields represented would enrich the yield with variations arising from their special concern with the nature of the medium, as in musicology or cinema studies, but it would not much alter the general taxonomy. I shall draw where possible on the papers in each of the three disciplines addressed specifically to Panofsky and his significance. These too reveal in striking variety the ways in which contemporary scholars define themselves even as they honor—or question—the aims and achievements of an illustrious forbear.

The four anthropologists displayed in their papers both the persistent cohesion of their discipline and the vigorous advent of intellectual perspectives that enrich even as they fragment current scholarly practice. Committed by intellectual tradition to the respectful exploration of cultures as "other," anthropologists have rolled easily with the problems of ethnocentricity and multi-culturalism that have produced deep divisions in other humanistic and social scientific disciplines since the 1960s. They have also been immunized by their tradition against another critical issue in the humanities: the relation and comparative value of high and popular culture. Yet as they pursued the problem of meaning in visual culture, even the anthropologists manifested the effects of transdisciplinary ideological and critical currents.

The problems of multi-culturalism in society and the academy that have led other disciplines to question their own European-American ethnocentricity have, paradoxically, fueled in anthropology a drive in the opposite direction. For the first time, the profession devoted to establishing the dignity and identity of extra-European cultures developing an "anthropology of us." Shelley Errington represents this interest in a paper on contemporary American culture, sharpening the normally *acceptant* anthropological vision with a critical, sociological perspective. She treats her subject, Disney World, as a kind of play-within-a-play of American consumerist culture. Two major myths of America—progress in material well-being and consumer choice—are shown to be harnessed to corporate power in the utopia-oriented theme park. At once an aesthetic analyst of style and a sociological critic of power, Errington shows how the sponsors and creators of Disney's "world" use aesthetic illusion ("optical realism") to reenforce cultural illusions that keep Americans personally striving and publicly passive. In her oral presentation Errington contrasted the art of Disney World, which is used to limit the spectator's imagination, with a Singapore theme park in which artistic representation is used to release it. Thus she employed the visual artifices of another culture's theme park to heighten our sense of our own ethnic difference—but in a socially critical mode. Yet essentially

her framework and method are as American as her subject. She translates for our era of multi-cultural consciousness the same analytic of visual forms—architecture, spatial layout, painting—that anthropologists have used for understanding other cultural systems into intellectual instruments for criticizing our own.

As it has resisted ethnocentricity, so anthropology has by tradition self-consciously opposed the idea of the autonomy of art so prevalent in the very definition of "culture" in the humanistic disciplines of the West. Once again, as in the case of multi-culturalism, the anthropologist's traditional disciplinary perspective paradoxically functions as avant-garde outlook in the contemporary context of humanistic scholarship, challenging with its functional-symbolic analysis the separateness of the intellectual-aesthetic from the vernacular domain.

Fred Myers, in "Re/Writing the Primitive," makes of Australian Aboriginal painting the center of a dynamic analysis of bi-cultural interaction. Myers too is engaged in the new anthropologist's quest for an "anthropology of us," but in an explicitly transactional perspective. Examining the re/definition of the Aboriginal symbolic artifact in the international art market, he constructs a field of discourse in which modern social mechanisms of evaluation and value-formation are shown to be constitutive of the material object. While he exposes our culture through its ingestion and interpretation of the "other's" product, he shows how the very production of Aboriginal art is altered by that society's experience of the reception of their art in the West. The author thus provides a kind of stereoptic vision of cultural interaction. The traditional anthropological view of culture-as-system reveals the social complexity of meaning-making in the arts in the West. At the same time the staticism often characteristic of anthropology yields in its treatment of traditional cultures to the more dynamic, historical view of culture that belongs to western humanism. Thus anthropology, in expanding its field of concern to "us," liberates "us" by means of its associative construc-

tion of and sensitivity to "difference"; but "we" in turn, with our traditional socio-political categories for addressing problems of change, nourish a new dynamic anthropology. The multi-cultural universe in which we live here initiates a reciprocal enlargement and loosening up of both anthropology and art-historical scholarship. When one party's avant-garde is the other's traditionalism, as Errington and Myers show in their separate ways, the quest for new meanings in the visual arts is advanced.

Shelley Errington is adapting the anthropologist's distant vision of cultural otherness to examine an instance of our own culture. Even in her social criticism, she works within what the *philosophes* used to call the *esprit de système,* using visual material to illuminate the educational functioning of corporate capitalism in the very structures of the popular theme park. Myers shows how in the west's commodification of Aboriginal symbolic products, the meaning and function of the art in both cultures changes; Myers' transactional analysis erodes the fixity of the system. He works now, as the *philosophes* would say, not in the *esprit de système* but in the looser, more empirical *esprit systématique.*

Margaret Conkey, in reinterpreting Ice Age imagery, attacks the very categories with which, both in art history and in archeological anthropology, "cave painting" has been viewed. She breaks up the autonomy of art and the transcendent universalism which western thought has imposed on the objects of early man in favor of a pluralized, localized approach. Paleolithic imagery is no longer seen as the "origin" of our art, but as an autonomous instance of material culture-making. In the absence of ethnographic information, the quest for meaning centers on the process, technical and social, by which the images come into being in a given local setting. The investigation displays a deeply skeptical interpretive reserve in the face of the object, and privileges the perception of ambiguities and puzzles over the construction of consistencies. The joy of association so characteristic of Panofsky

and his iconology yields to a cool, critical affirmation of the isolation of the objects that makes them, until much more evidence is found, resistant to any comprehensive cultural meaning.

James Boon carries the dismantling of the closed systemic vision of his discipline's tradition from the cultural object to the cultural subject; i.e., the scholar-investigator. Pairing Panofsky with Lévy-Strauss, Boon admires them not for their structural work, their systems of meaning-making, but for transcending these, especially in their later years. He celebrates them as heroes of sleuthing, voyager-guides who lead their readers to surprise convergences, then decode in penetrating insights the chaos of clues observed on the picaresque journey through the strange forests of art and culture. Boon sees the two scholars as at their best in their exploitation of the marginal and accidental phenomena of their fields. He rests his case for the analogy between the mental styles of the two scholars on a virtually serendipitous crossing of interests—in Goethe, Dürer, etc. In turn, his own antic style, replete with turns and returns, embodies the virtues of perception and invention he lauds in his subjects. The paradoxes of self-reflexivity become the mirrors of the self in the other. This is equidistant from the objectivizing, synthesizing approach to culture evident in Shelley Errington, the transformational comparativism of Myers, and the material-object concentration of Conkey.

The matter and the manner of Boon's paper together mark him as a *homo ludens* of postmodern scholarly culture. His riddling play, his ironic criticisms suggest the court jester and his role: Like the traditional jester, he wears the patch-work garment that expresses the fragmented, colorful reality that resists the illusions of oneness cherished by kings and poets alike. But he does not press his bold and penetrating critique of the system to the point of *lèse majesté,* of defiance of cultural authority.

Such seems to be Boon's relation to anthropology, inclusive of Lévy-Strauss. He subverts charivari-like the construction of stable "patterns of culture" by proferring the delights of an ephemeral, thought-provoking culture of patterns. Here Boon attaches himself to the ethos of adventurous ethnographic field work, exalting observant perception over reflective construction. The kaleidoscope replaces the bi-cultural stereoscope of Fred Myers. Boon legitimates his critical, deconstructionist vision by attaching to one side of the outlook of the culture-heroes Panofsky and Lévy-Strauss, even as he lets their other, structural side fall of its own weight with his silences.

The disciplinary heritage of understanding man through contrasting cultural otherness persists in Boon as in the other anthropologists of the panel. But he confines it, at least here, to academic culture. Art and cultural myth are driven by the same urge: the desire to possess the object through creative illusion, the will to power through (re)presentation. Panofsky and Lévy-Strauss, as part of the culture of "us" scholars, are driven, Boon suggests, by a similar urge at a second remove. They desire to master the crafted illusions of the artist and myth-maker with the more remote but intellectually comprehensive illusions of the scholarly interpreter. *Geistegeschichte:* Is it a story of ghosts? The jester's dissociative, comic vision disrupts the last refuge of the *esprit de système,* the scholarly culture itself.

The anthropologists at the symposium displayed an easy substantive catholicity, doubtless achieved on the basis of the adaptability of two traditional dispositions of their field: affirmation of cultural "otherness" and the ethos of the fieldworker, ever open to the unexpectedly emergent. Their differences of approach exist on a common spectrum. The literary scholars, by contrast, presented a spectacle of extreme division, and one fundamental polarization. At one pole Marc Fumaroli represented a severely traditional historical humanism; at the other extreme, W. J. T. Mitchell proposed a new approach to visual culture based on multi-cultural and other premises derived from and for contemporary society. He offered an intellectual and institutional strategy

for the creation of a new discipline appropriate to the post-modern culture he envisions. Wendy Steiner exemplified another aspect of present-day culture in her analysis of a single, concrete case: the sexual problematic of Mapplethorpe's photography and its reception. Philip Fisher developed a new aesthetic of wonder to account for the very modern experience of the unpredictable, the instantaneous, the delight in the new that is also central to James Boon's ludic vision.

The gently emendatory spirit prevailing among the reforming anthropologists at the conference thus yields in literary studies to a more highly charged atmosphere. There academic method and mission have become strongly linked to divisions on the future of culture which challenge the evaluation of its past.

Both Marc Fumaroli and Wendy Steiner introduce their essays with rhetorical plaques that, read in juxtaposition, dramatize both their differences and the cultural stakes they share. Each uses a modern artist and a rationalist philosopher to show forth humanity's situation today: Fumaroli draws on Apollinaire and Descartes; Steiner, on Mapplethorpe (through his Cincinnati museum curator) and Kant.

"Avant tout," Apollinaire proclaimed, "les artistes sont des hommes qui veulent devenir inhumains. . . . " Fumaroli links this "sublime and compelling utterance," whose horrendous association with the terrors of modern political experience we should now recognize, to the anti-traditional rationalism of Descartes. The modernity of both consists for Fumaroli in the destruction of cultural memory and the rhetorical tradition which preserves our sense of human commonality and community. Modern, autonomous art and modern rationalism: *voilà les ennemis!*

Steiner opens with an anecdote about Kant recounted by Panofsky. It shows the philosopher, even in the face of death, proudly maintaining the forms of conventional courtesy that expressed, he said, his "sense of humanity." "Such civility, hard to imagine now," Panofsky observed. Steiner recognizes—and respects—Panofsky's

(and Fumaroli's?) fear of a "satanocracy" should civility decay. Is Robert Mapplethorpe, the artist whose work she discusses with sympathetic understanding, part of the process? Does Mapplethorpe comport with Apollinaire's definition of the modern artist as one whose truths "are to be found nowhere in nature?" Steiner acknowledges that she herself is open to the charge of complicitiy with "satanocracy" for her exploration of a moment when the traditional culture of civility, through its secular arm in the law courts, brings new art to judgment for its tabooed sexual content. For her no less than for Fumaroli, what is at stake in the search for "meaning in the visual arts" is the larger question of the crisis of contemporary culture. Fumaroli works from the point of view of a betrayed past, Steiner from that of a problematic but liberating present. Yet both, when they speak of art, in fact address the question of the state of the culture. They use a multi-dimensional approach; their thinking is cast in terms at once moral, political, aesthetic and philosophical. No "anthropology of us" is in evidence here, no ludic irony. We are in the thick of renewed battle between ancients and moderns, albeit in a radically transmuted form.

Alone among the participants in the symposium, Fumaroli espouses a pure classical position, with Ciceronian rhetoric as a central point of reference. His historical outlook, substantially indebted to Vico, enables him to attack modernism at its roots (in Cartesian rationalism and positivism), yet modernism is not all of modernity. He casts a bridge to modernity through those who, like Panofsky, Ernst Robert Curtius and, in the arts, James Joyce, explore and exploit the Viconian *ricorso*, the adaptive reappropriation of the ancient *Kulturgut*. Recurrence and continuity (through memory) are at one here, sustaining a morally legitimated *sensus communis* in the midst of a modern world suffering from rational scientism and instinct unleashed.

Against Fumaroli's priority of continuity, against the authority of the past, the other three literary scholars of the conference all posit and affirm

modernity as their point of departure, exploring as some of its major features: discontinuity; the power and worth of the new; the pleasure principle; the pluralized and incoherent nature of reality. Steiner explores these concerns thru a single episode where contemporary artistic and social practice reveal their ambiguities. The Mapplethorpe case is a powerful condenser of the confusion of aims and norms for producing and receiving art in our historical moment. Aesthetic standards of past and present, the nature and status of photography as both art and recording machine, community civility and sexual freedom: all are now in reciprocal interaction, now in gridlock in Mapplethorpe's transgressive art. For Steiner, the ethical heritage is not a point of committed reference, as with Fumaroli. Nor, on the aesthetic side, does she validate the ethical indifferentism lodged in the claims of art's autonomous formal values that modernist art critics used in defense of Mapplethorpe. Like Fred Myers in his transactional analysis of Australian Aboriginal art, Steiner unfolds the polysemic cultural content of the episode—but with a stress on its conflictual character as a cultural impasse, hence also an intellectual one. Like Margaret Conkey with her cave images, Steiner insists on the problematic, the unresolvable, the ultimately unknown nature of the cultural relations contained in the object. But where Conkey makes us feel acutely that too little is known to build a satisfying interpretation, Steiner makes us feel that, paralyzed by the weight of our information and the multiplicity of our attitudes and concepts, we know too much. The forces or elements which intersect to constitute the Mapplethorpian moment are arrested in contradiction. Steiner suggests the need of an "aesthetic of content" to break the gridlock. But the critical stance of her postmodernism, with its continuing, equalizing employment of concepts acknowledgedly derived from the culture of hierarchy she rejects, seems to inhibit the kind of theoretical creation she calls for. Kant's civility and Apollinaire's verité seem to have equal rights in Steiner's emblem of our pre-

sent cultural situation, where critical vision is strong enough to expose the illusions of the past but too locked in the spectacle of paradox to construct a meaning for it or a condition beyond it.

It will have been noticed that, in dealing with the crisis in culture that is their common concern, both Fumaroli and Steiner employ a rhetoric of shock. Apollinaire's proclamation of the artist's inhumanity, Mapplethorpe's homoerotic sadomasochism in photography: these constitute bold and violent threats of disruption to the civil order. The return of the repressed, both erotic and thanatal, and with it the modern cultural phenomenon of de-sublimation: these constitute the disjunctive shock of the new in both Fumaroli's and Steiner's readings of culture.

Philip Fisher explores the flip side of the phenomenon of shock: Wonder. Not fright but delight is the affect accompanying the experience of wonder. It too is anchored in the pleasure principle so crucial in the table of values of contemporary western culture. But other characteristics mark Wonder even more strongly as modern, as the experience *par excellence* of post-Baudelairean urban man. Wonder arises in the face of the *new*. It is unexpected in time, extra-ordinary in space. It is instantaneous, disjoined from the regularity of experience, cut off, in its effect on the feelings, from any tie to past or future. Wonder is radically independent of memory, prized as the source of our humanity by Fumaroli. Not *ricorso* that brings renewal from the source of culture is the focus of desire, but the ever new. The world is affirmed not for its perduring structure and value, but for its openness and its richness in surprise, that can provide us the child's delight in seeing its expectations disrupted by the sudden appearance of the new.

Steiner and Fisher, the one in photography, the other in aesthetics, though their focus is confined to limited subjects, are involved in the common enterprise of defining characteristic features of modern culture. Both center their analyses on the experience of instantaneity, of shock, of disjunc-

tion from the ordinary and from continuity. The legitimacy they accord to the discrete, extra-systematic moment as a focus of cultural inquiry itself removes them from Fumaroli's "theater of memory." It brings them close to the commitment to the value of the unexpectedly emergent and convergent prized by Boon in Lévy-Straus and Panofsky.

W. J. T. Mitchell returns the encounter with the modern from the challenging special cases of Steiner and Fisher to a more general level in his paper, "What is Visual Culture?" The question is centrally addressed in the form of a proposal for the construction of an educational program in visual studies at the University of Chicago. Like any *paideia*, the proposal reveals with particular clarity the table of values and intellectual procedures with which a sub-culture, through institutionalization, seeks to shape a new generation. Despite a commitment to openness, the Mitchell program rests on post-modern ideological premises quite as well-defined as Fumaroli's traditional ones. Politically, they include multi-culturalism and cultural democratizion, elimination of any a priori distinction in value between elite art and other popular or commercial symbolic goods. These premises demand the development of a discourse capable of transgressing and transcending the limits imposed by previous disciplinary structures and methods that were developed to sustain substantive claims to autonomy and difference; e.g., art history vs. media studies; literary studies vs. philosophy. The breadth of the field of "visual studies" resulting from the elimination of traditional classes of imaging (and imaging by classes) produces a breath-taking openness. All the cultural subjects and objects that the eye can behold lie scattered randomly over a vast field. "Video ergo sum": one must begin with radical doubt to reconstruct the world of understanding of visual objects. As Descartes separated *res* and *verbum*, so Mitchell aspires to dissociate *imago* from *verbum*, but in relation to an idea of culture. The several relevant disciplines of the academy are invited to bring their

intellectual tools to the task of constructing the new meta-discipline out of the myriad materials lying on the field. Reminiscent of the constructivist-realist collages of Rodchenko and the films of Vertov in shattered post-war, revolutionary Russia, the new discipline for a new world is to be made out of the pieces of the old with the compository power of the conceptual imagination. Even more than in Fisher's Wonder or the unexampled raw physicality of Steiner's Mapplethorpe, Mitchell's critical constructivism in visual study rests on an insistent presentism as its cultural referent. To make the world new, new language must be forged and tempered. (One recalls Locke's language theory, or the Pont Royal linguistics that accompanied the religious/cultural revolutions of the seventeenth century.) A new education, free of the shackles of tradition, (once again Locke comes to mind) enlists the young and prepares them for the task ahead. Mitchell harnesses the students imaginatively, asking them, for example, to participate in the creation of a discourse on the visual through the construction of a glossary. The pedagogy is as fresh as the new discipline to be created. It bonds the learners through a partly self-created in-group language with a universal potential—always an effective motor force in group identity-formation and collective empowerment.

The intellectual substance of Mitchell's proposed education is an extension to the sphere of the visual of language-centered critical culture theory generated by literary scholars. The first section of his Chicago curriculum is devoted to "Signs," and approaches the visual from the linguistic and taxonomic problems arising in the culture of the word. Previous historical efforts at theorizing about the visual find little place here. The subjects in which the newly-won theoretical tools will be tested and refined are those prioritized in contemporary "advanced" post-industrial culture. A semester is devoted to the body, including violence, sexuality and gender; another to the institutionalization of visual culture and its hegemonic import. Like "signs," these subjects

are more richly variegated in the program than this reduction to thematic content can convey. But all are designed as intellectual laboratories in which to develop a multi-cultural alternative to Euro-centric culture and the scholarly analytic developed to sustain it. That the theoretical armamentarium with which the new meta-discipline is to be produced is also of European-American origin is not addressed in Mitchell's program. It is part of the post-modern ironical predicament from which a universalist culture of difference will hopefully provide release.

The historians at the colloquium offered a spectrum of approaches to the problem of meaning in the visual arts less strongly differentiated than those of the anthropologists and literary scholars. The fact that all were intellectual historians—and specialists in the Renaissance at that—gave them, despite all differences, a common sense of direct affiliation to the European high-cultural tradition and to Panofsky. Had the panel included historians of nineteenth and twentieth century culture, whether elite or popular, European or non-European, more striking differences of perspective would surely have emerged. Yet even within the homogeneity arising out of a shared specialty, distinctions in outlook revealed a fracturing of cultural assumptions and intellectual style related to the stronger divisions in the panels of anthropology and literature.

In all the historians' papers Panofsky was a central referent. Two historians affirmed attachment to him without any expressed critical reservation: Donald Kelly in his theoretical appreciation; Kristin Zapalac, through her exemplification of his method in a problem in Reformation imaging. In their respective domains of historiography and historical practice, both scholars affirm Panofsky's reciprocal illumination of idea and image in the matrix of culture; both embrace synchronic integration and the diachronic culture-shifts that are so central to the European tradition as Panofsky refined it. This form of traditionalism in scholarly conceptualization comports well with the substantive humanism of Fumaroli, but neither Zapalac

nor Kelly share the self-conscious and embattled spirit with which he articulates it as a cultural value system. Their traditionalism seems both open and confident, fortified by a gently emendatory, empiricistic professional ethos against both the systematic defenders and the militant critics of the European culture that is the object of their study. "Meaning in the visual arts" remains for them a profitable pursuit, for which Panovsky provided an invaluable intellectual model.

Against the background of these voices of grateful affirmation, Randolph Starn sounded a strong dissenting note. He challenged the very question which the colloquium had been summoned to address. "Meaning in the Visual Arts" for him is a *question mal posée*. "*Pleasure* in the Visual Arts": that would be the proper pursuit of a life-enhancing art-historical scholarship. The *esprit sérieux* of the German tradition, he charged, has diverted us from the proper quest for an understanding that enhances gratification. German tradition, with Panofsky as its most influential prophet *in partibus infidelium* (i.e., the U.S.A.), intellectualized the experience of art by subjecting it to the rational grid of philosophy, draining it of the potential for releasing the sensory satisfaction proper to art's nature.

Starn's call for the return of the repressed in art history recalls the aim of John Ruskin in art criticism: "to restore the sense of sight." For both critics, the foes to fight are the dismal philosophers: the English utilitarians for Ruskin, the German idealists for Starn. But where Ruskin sought social liberation by means of the redeeming joy of art in work, Starn seeks psychological liberation through the joy of sensuous feelings that art conveys. Art history, a discipline that should have charted the delights of art, focused instead on conceptual and intellectual understanding of its historical and philosophical relations.

Of course it is with the contemporary cultural currents that challenge sublimation, rather than with Ruskin, that Starn's championship of the senses and the pleasure principle has its strongest affinity. Here he joins company with those

concerned with the workings of desire in other areas. Wendy Steiner's exploration of Mapplethorpe's communication of sexual experience in photography and its implications for the idea of art is grounded, like Starn's theoretical statement, in the privileging of desire in cultural evaluation. Although W. J. T. Mitchell, in his quest for an egalitarian and multi-cultural analysis of visual culture effectively espouses a return of the socially repressed that Starn avoids, both critics unleash their batteries against the Apollonian vision, the identification of art with intellectual refinement. For Mitchell as for Starn, Panofsky must be rejected as participant and spokesman of elitist culture. Panofsky's conceptions of art-history stand for Mitchell in the path of a new universalist understanding of visual culture, as for Starn they block the liberation of the senses from the trammels of Teutonic philosophic and puritanical constraints.

In his summons to a *gaia scienza*, Starn approaches in theory what we have encountered in James Boon's critical practice in anthropology. Boon and Starn equally prize *homo ludens* as a cultural ideal and as a scientific attitude. Both recognize in Erwin Panofsky a strong ludic streak, but they evaluate it differently. For Boon, Panofsky's play is in games of hunt-the-treasure and in the perception of puzzles requiring decoding; from these issue the associations of verbal and visual ideas that empower his cultural vision. For Starn, Panofsky's ludic impulse is misdirected into iconological puzzles at the expense of the sensory pleasure which should be the art historian's object. In Starn's felicific calculus, even *intellectual* play with texts, symbols and ideas must be reckoned in the debit column, as part of the mechanism of repression of sensory pleasure that the German school of art history has imposed.

Anthony Grafton's paper, "Panofsky, Alberti and the Ancient World," catches and refracts as in a prism many of the conflicting intellectual-cultural lights of the conference. With Fumaroli, Grafton shares a central concern and subject matter: the continuity of Europe's classical tra-

dition and its transformation. With his fellow historians, Kelly and Zapalac, as well as with Fumaroli, he also shares a commitment to texts and to the philological method as crucial to making historical meaning of art. In these respects Grafton may be classed with the humanistic traditionalists of the colloquium. Yet in his brilliantly ironic rhetoric—it rises to the stature of a deconstructive analytic—Grafton shows kinship with one of the most radical critics at the colloquium, anthropologist James Boon. If neither Grafton nor Boon espouses commitment to the pleasure principle in its a-rational, sensory aspect as championed by Starn, both are of the postmodern species *homo ludens* in their scholarship. Theirs is a gay science whose offensive weapon, *charivari*, is deployed against the *esprit de système*, the holistic or totalizing unitary conception of culture (or, for the historian, of a cultural era). Pride of place in scholarship is the pursuit of the separate artifacts of which a culture is composed and their transformative appropriation by it. Such a pursuit both corrects the picture of a culture and at the same time reveals the limits of any stable, integral vision of it.

Grafton introduces the split he sees between the holistic-coherent and the fragmented-transformational views of cultural study through mock-heroic, paired images of Alberti and Panofsky. The first, Alberti, is the many-faceted prototype of modern universal man as projected by Burckhardt. The second is Panofsky as scholarly universal man, as seen by Grafton and his generation in the 1970s. For them, Panofsky's prodigies in the many-sided field of interdisciplinary scholarship were almost as imposing for their range and reach as Alberti's in his accomplishments. In his dazzling scholarship Panofsky seemed to combine "the panoramic vision of the parachutist with the microscopic vision of the truffle hunter." When the social and quantitative historians in the 1970's threatened the field of intellectual history, Panofsky's masterful integration of empirical concreteness and synoptic vision of culture inspired its threatened votaries.

Grafton then, no less than Donald Kelly in his appreciation of Panofsky today, admired the sweep with which Panofsky defined a "real" Renaissance and its sense of a coherent classical culture.

Grafton's essay has an autobiographical center: his own loss of innocence concerning the validity of Panofsky's synoptic vision. He corrects the mock-heroic images of both Alberti and Panofsky by applying the techniques of philology to Alberti's texts. He discovers not only a more complex Alberti, with a playful and sovereign relationship to antiquity and its masters, but also a flawed Panofsky. In the reexamined Panofsky, the disparate talents of parachutist and truffle-hunter so prized by Grafton and his cohort in their youth proved to be working not in reciprocal reenforcement but at cross-purposes. The parachutist's comprehensive vision of the cultural terrain below distorts the reality on the ground. With his new Alberti, Grafton argues his point: Panofsky used Alberti as "a key witness to the existence of a real Renaissance." But, on Grafton's close reading of his work, Alberti did not "fit Panofsky's splendid model." While Alberti conceived of a historically coherent classical culture different from his own, his relation to the works of antiquity was freely critical, often aggressively exploitative. Grafton's Alberti seems a post-modern man *avant la lettre*, appropriating the cultural remnants of the past—now with respect, now with sardonic playfullness, always with a critical sense of distance—to the free construction of his own multifaceted world. In a carnavalesque historical inversion, Alberti suddenly seems in Grafton's account more modern than Panofsky in his relation to antiquity and its heritage.

If Grafton put aside the innocent faith of his youth in Panofsky's synoptic illusions, so too, he argues, did Panofsky himself. Through the experience of exile and his exposure to America's more empirical scholarly climate, Panofsky lost his belief in his Germanic parachute. "He moved from asserting the rigid purity of humanistic scholarship to following its playful arbitrary quali-

ties. . . . " The traditional philological method, always at his command, became central to his free exploration, even though its findings could "undermine . . . the symbolic forms that [he] pursued them to support." This second Panofsky redeems the first, and makes it possible, as Alberti did [and as Grafton clearly intends to do] to make classical texts and ideas live in what he recognized, quite happily, as a "non-classical world." A modern *gaia scienza*, abjuring claims of holistic cultural understanding in favor of the open, broken field of contemporary culture, can preserve the ancient legacy by a combination of traditional philological craftsmanship, historical understanding and constructive wit.

Of the many contributors of evaluatory characterizations of Panofsky at the conference, only Anthony Grafton related the changing lineaments of his portrait subject to a change in his own scholarly outlook. All portraits, however, necessarily reflect the values of the scholarly portraitist. Hence in the other images of Panofsky too, however incompletely, the academic cultural spectrum is refracted once more.

Most striking is the contrast between the Panofskys of Fumaroli and Mitchell, those two polaric militants who, as perhaps no others at the conference, related their scholarly positions clearly to the great contemporary battle for the future of culture. For Fumaroli, Panofsky is rightly cherished as a perpetuator of classical culture and its rhetorical tradition against the rationalist levelling of modernism. But Fumaroli associates him with the more rigid conservative humanism of the literary scholar Ernst Robert Curtius, a connection which, as Willibald Sauerländer has observed, overlooks both Panofsky's express reservations on Curtius and his far more complex and discontinuous conception of the process of cultural transformation. W. J. T. Mitchell is as committed to creating a scholarship in service of the democratic multiculture of the future as Fumaroli is devoted to a learning that can preserve the hierarchical classical culture of the past. Mitchell

has to combat Panofsky for all that Fumaroli cherishes: his outmoded form of humanism, his Kantian aesthetic and his privileging—despite occasional appreciation of popular or non-European objects—of European high art objects as the norm for the study of visual culture. While Mitchell appreciates Panofsky's pioneering of interdisciplinarity in scholarship and his philosophical reflectiveness (though not his Cassirerian idealism), he nonetheless sees his status in the art historical profession as ultimately serving its anti-theoretical, culturally confining forces of darkness.

We have already observed how Randolph Starn, in calling for an art history focused on sensory experience, condemned Panofsky for crushing the pleasures of art under the weight of philosophy. So stern is Starn's defense of the pleasure principle in relation to art that he confines it to the realm of the senses. Thus he denies Panofsky his one possibility of recognition as pleasure-loving *homo ludens*; namely, verbal and intellectual play.

Of the six commentators on Panofsky in the three disciplines here considered, two acknowledge Panofsky without reservation as a master-contributor to the culture they hold dear: Fumaroli and, in his less totalistic, professionally defined way, Donald Kelly. Two reject him out of a perspective profoundly critical of traditional European intellectual culture: Mitchell as a multicultural and critical theorist; Starn as a participant in the modern movement for the liberation and cultural rec-ognition of desire. Between these two pairs, one embracing, one rejecting the master in relation to their aims for contemporary culture, stands a third pair: Boon and Grafton. For them—as for Thomas Levin in his paper on Panofsky and the Movies—there are two Panofskys. They reject (in Boon's case, pass over) the first Panofsky, architect of larger cultural constructs, while they honor his exploratory style, his perceptual acuity and the associative imagination that enabled him to conjoin the seemingly disparate phenomena of culture without locking them into a system. Both of the species *homo ludens* in its post-modern variation, Boon and Grafton maintain an active balance on the high wire that affords a distant vision of our pluralized culture while the all-too-serious, sometimes dangerous *Kulturkämpfe* go on below.

The variety of assessments of Panofsky, so dependent on the position of the scholar amid the issues that inform and divide contemporary culture and their representatives at the symposium, suggests that we scholars too may be in need of an "anthropology of us," perhaps enhanced by a sociology of knowledge. With such a foundation for our self-consciousness, we might find a means to a less exclusivist perspective, and a freer, transactional relationship to the multiform, extra-academic culture in which we have our being and perform our functions. It was the highest tribute to Panofsky that so polymorphously representative a symposium could be assembled in his name.

Struggling with
a Deconstructed Panofsky

WILLIBALD SAUERLÄNDER

"Das Hinscheiden von Erwin Panofsky wirkte wie ein Erdbeben, das Ordnungen, in denen man heimisch war, zerbrach und auseinanderriß"[1]— "The passing away of Erwin Panofsky was like an earthquake shattering and tearing to pieces an order in which one was at home." Such were the concluding remarks of the obituary written by Hans Kauffmann after Erwin Panofsky's death a quarter of a century ago. It may well be that the somewhat queer pathos of these words could only flow from a Germanic pen. But Kauffmann's sentence expressed nevertheless quite well the feeling of loss that befell the art-historical community at the moment of the decease of its greatest master. More than any other scholar of his generation Panofsky had shaped the methods and the interests of the field, had enlarged the perspectives of the discipline and raised art history to a new respected status among the humanities. So his colleagues had reason to be thankful and there remains reason for thankfulness until today.

And yet, after a quarter of a century, Kauffmann's twisted sentence with its apprehensive metaphors of "earthquake" and "broken orders" sounds today curiously prophetic. During the seventies and eighties Panofsky remained certainly present on the art-historical scene, but soon he became to be regarded as the burdensome father figure from a bygone period of humanistic scholarship. The admiration for his unsurpassed erudition, his brilliance, and his wit gave way to a vehement reaction against his approach to the problems of interpretation, a re-action taking sometimes a vociferous violence which has been rightly denounced as "Panofsky-bashing."

The reason for this reaction are complex. It was probably unavoidable that a wave of uncritical imitations, which "disguised symbolism" set free during the fifties and sixties, drew the attention of sceptical young scholars to the inherent weaknesses of the iconological system Panofsky had developed with such dashing success from 1930 to 1953, from "Herkules am Scheidewege" to "Early Netherlandish Painting." Certain arguments which were raised against Panofsky's iconology were by no means new. When Daniel Arasse wrote in 1983 about the "Studies in Iconology": "L'analyse du contenu se fait en dehors de la mise en oeuvre des thèmes, de leur forme," he repeated only what Otto Pächt had insisted upon as early as 1964 or even 1955.[2] The same is true of James Marrow's critical discussion of Panofsky's disguised symbolism in 1986.[3] This, however, was a conventional discussion of Panofsky's scholarly legacy taking place on the traditional ground of the art historical discipline. The epicenter of the "earthquake" which was to shatter and to break up Panofsky's whole system of interpretation, and many of the values going along with it, lay elsewhere.

The epicenter was situated, as everyone is aware, in the field of literary criticism. It was the massive impact of structuralist and poststructuralist theories—semiotics, deconstructivism, reception—which since about 1980 began to put into question the very foundations of Erwin Panofsky's

concept of the "History of Art as a Humanistic Discipline."[4] Panofsky who saw himself as a humanist surviving in a period of rising barbarism believed pathetically in the universal validity of western cultural tradition.[5] Panofsky the iconologist took it for granted that the cultural symbols of the past had and continue to have an unequivocal meaning which may be temporarily forgotten or obscured but could at any moment be again revealed by the right or adequate interpretation. Now these beliefs have been shaken by the intellectual, social, and ideological developments in the quarter of a century that separates us from Panofsky's death. New theories have radicalized the scholar's awareness of the hermeneutic circle in which he finds himself inescapably enclosed. The mere possibility of an objective interpretation of a work of art seems now more or les elusive. "Since readers and viewers bring to the images their own cultural baggage, there can be no such thing as a fixed, predetermined, or unified meaning" we read in 1991.[6] But the dissolution of traditional methods—of the "status quo" as we are told—goes further. In the footsteps of de Man and Derrida interpretation is understood as an open game, never ending and proceeding with numberless exchangeable alternatives. "No interpretation can be privileged over any other."[7] "The goal of art history is to produce as many interpretations as possible, which are original, suggestive and plausible" writes candidly one of the less cautious spokesmen for the new theory.[8] In the light of such postmodern destructions Panofsky's Platonic idea of iconology with its unquestioned faith in the possibility of philological correctness and symbolic insight must no doubt look charmingly naive and utterly outdated. As Michael Ann Holly puts it, describing the position of "the late 20th-century historian, the post-Panofskian iconologist": "Reading the past is plausible, re-experiencing it, in Panofsky's terms, forever impossible."[9]

It can remain open if such statements do full justice to the complexity and the contradiction of Panofsky's thinking. In any case such seems to be the state of the Panofsky discussion around 1990. But we must go one step farther. The deconstruction of objectivity in interpretation has a social and political dimension that cannot be passed over silently, as it has characteristically affected the discussion of at least one of Panofsky's most emphatic interpretations. If we read in an excellent text, which I have cited here already several times, "interpretive behavior . . . is socially framed, and any semiotic view that is to be socially relevant will have to deal with this framing," it sounds like a perfectly rational argument.[10] Still it is boring to imagine that from now on any interpretation of a painting, a poem, or a piece of music should primarily be regarded and evaluated as dependent on or conditioned by the "social framing" of its author. But two sentences later we read in a tenor that strongly recalls Foucault: "There is no way around considerations of power inside and outside the academy."[11] Here we have definitively left the ground of innocence and entered a terrain where the denial of objectivity leads fatally to all sorts of suspicions. This becomes painfully evident if we turn to the text of another author who analyses—not to say denounces—Panofsky's interpretation of Dürer in his monograph of 1943 as "socially framed" by the author's background as an upper class Jewish refugee from Nazi-Germany.[12] Now that may be so. But with such a statement the deconstruction of objectivity has ended in a sleuthing "political connectness" one had hoped not to see adapted in any free country to the judgment of liberal scholarship. Certainly, every approach has its dangers and its price, but confronted with such a result of deconstruction I find it difficult not to feel an anachronistic nostalgia for Panofsky's un-deconstructed faith in the universal validity of "the History of Art as a humanistic discipline."

So in the moment of the centenary of his birthday in 1992 Panofsky remained certainly very present in the discourse of the discipline, but he was no longer the generally admired great master. After the theoretical "earthquake" he had become a disputed and controversial figure from an unrecoverable past. Any scholarly celebration

of his one hundredth birthday had therefore to struggle with the problems and controversies surrounding a deconstructed Panofsky. At two places such celebrations took place. One of them was Hamburg where Panofsky had taught from the fall of 1920 until he was expelled in the spring of 1933 by the racial paranoia that had befallen Germany, including its universities and academics.[13] At Hamburg only one historian of medieval literature and one sociologist had been invited.[14] The results of their talks were surprisingly elusive and seemed to prove that at least in Germany the influence of Panofsky on fields outside art history has remained slim. All the other lectures of the Hamburg symposium—13 altogether—were given by art historians. As it was only natural, a number of talks were devoted to Panofsky's years in Hamburg and to general problems of cultural emigration.[15] They tried hard to reconstruct a forlorn past and did so in that mood of loss, regret, and guilt which is unavoidable in all German studies on the great intellectual exodus during the thirties. Other papers examined different aspects of Panofsky's scholarly approach and achievement.[16] Some were cautiously critical but their argumentation—bound to specific German traditions of learned discourse—sounded somewhat parochial and neglected totally the semiotic discussion of Panofsky, which has been going on since 1980 in the United States. Only one paper, on "Panofsky on movies," came close to ideas put forward during the second—later and bigger—Panofsky conference, which took place in Princeton in the fall of 1993.[17]

The symposium at Hamburg had been an art historical event. For the Centennial Commemoration at the Institute for Advanced Study, Irving Lavin had invented a quite different, very innovative, one might even say adventurous program. One observer even spoke with amused admiration of Irving's "extravaganza."[18] Given the astonishing visualization that has taken place in many neighbouring fields of art history and in our culture in general during the last three decades, Irving Lavin raised the question: What may have

been the catalysing role of Erwin Panofsky in bringing forth this explosion. "When I started my carreer in the early 1950s the history of art was an elite subject of no more than dilettantic interest to 'serious' historians in other fields, whereas by now no humanist or social scientist can seem serious if he does not consider visual culture . . . I believe the change is partly due to the enormous influence of Panofsky, . . . to his . . . method of explicating works of art by reference to other domains, such as philosophy, literature, theology etc.; in this way he showed that works of art are in turn relevant to those fields, as well."[19] Therefore, the speakers in Princeton could by definition not be insiders—i.e., art historians—but curious neighbours. In the sequence of the five sessions of the symposium they were anthropologists and historians, then historians of literature, science, film and music. So the colloquium was interdisciplinary in the widest sense. The task that Irving Lavin had set out for the participants was not to praise or to criticize once more Panofsky's stupendous scholarly achievement. He wanted them to test the stimulating effect Panofsky's ideas and cross-cultural explorations beyond the borders of art history might continue to exercise on the humanities and the social sciences at large. So the Princeton commemorial was anything but a retrospective. Its adventurous topic was Panofsky's "Meaning in the Visual Arts" in 1993.

Even if not so intended this program could be read as a kind of cautious answer to the recent wave of Panofsky criticism mentioned above. It drew attention to the undeniable fact that it had after all been Panofsky who had taught art history in America how to grasp not only the aesthetic appearance but also the cultural significance of the work of art. Even those who contradict him today remain dependent on the hermeneutic procedures he had introduced and systematically elaborated. But so much having been said, two qualifications are necessary.

First: it should not be forgotten that the postulate to understand works of art in a broader cultural and even anthropological context had first

been raised by Aby Warburg before World War I when Panofsky was still a student. It was Warburg who in his famous lecture in 1912 on the frescoes in the Palazzo Schifanoja at Ferrara had asked his art historical colleagues to overcome their "grenzpolizeiliche Befangenheit," "order-police preoccupations" by a comprehensive iconological analysis.[20] For someone coming from the German tradition, Warburg was the great absent ghost during the conference at Princeton.

The second qualification is more important but also more delicate to formulate. If one wanted to make Panofsky one of the main catalysts of the visualization taking place since the sixties in many fields outside art history, one would have to reverse the direction of his main methodological efforts and quite a part of his humanistic beliefs. The author of the "Studies in Iconology" and of "Meaning in the Visual Arts" tried to make images readable by explaining their content in the light of texts. The great philologist Leo Spitzer is said to have joked: the title of "Meaning in the Visual Arts" should have been "Philology in the Visual Arts." For Panofsky words made the images meaningful. Nowadays it is the reverse. Texts are expected to be illuminated in the mirror of images. In the age of the media "Mnemosyne" is more and more replaced by "Video," the book by the screen. This is a very complex and fascinating process which may have far reaching consequences for the future of art history.[21] The role of any single scholar in this great and revolutionizing process, which affects our culture as a whole, remains difficult to evaluate. If one wants to involve Panofsky in this process one has to reverse the lessons he taught and much of the values he believed in. So it was not the least interesting aspect of the Princeton commemoration that it revealed the profound difference between Panofsky, the humanist from a forlorn past, and the unfocused, postmodern scene of scholarship today. In such a situation it would make little sense to discuss session by session, one lecture after the other, as if we had to deal with a normal academic conference where

specialists come together to discuss specialists' problems. The uncoherent character of this commemoriation can better be described by shining flash-lights on some of the ideas and suggestions that emerged during the sessions—reflecting the perspectives of different fields and diverse "philosophies."

It is not by chance that the only European contributor—Marc Fumaroli from the Collège de France—faces us with the most conservative view of Panofsky's legacy. Fumaroli who knows better than anyone else the tradition of rhetoric and its importance for European literature until the end of the eighteenth century, sees Panofsky —and also Warburg—in this rhetorical perspective. He compares the themes of iconology to the "topoi" in literature, the dominating role of which has been magisterially demonstrated by Ernst Robert Curtius.[22] Iconological themes and literary "topoi" are seen as the guarantors of tradition and continuity. This argument has a sharp anti-modernist bias which will not surprise the reader of Fumaroli's "Etat culturel."[23] But it remains true that the close connections between Curtius, Panofsky, and the Warburg Library are well known and it would be foolish to deny their common interest in the survival of the classical tradition. Panofsky's distance from modernity can also not be overlooked. "Barbarus ad portas" he had rhymed in 1962.[24] And yet, the comparison between Curtius and Panofsky, "topos" and "meaning," does not go without difficulties. In conversations Panofsky used to say: "Curtius sieht nicht, daβ 'Topoi' umfunktionieren"—"Curtius doesn't see that topoi are transmuted." One has only to compare the pages by Curtius on the "locus amoenus" with those by Panofsky on "blind Cupid" in order to understand what the author of the "Studies in Iconology" had in mind.[25] Curtius was interested in the diachronic stability of the "topoi," Panofsky in the changes of meaning, which one and the same iconographic motif might undergo in the course of history—in "the traffic accidents of tradition" as he used to joke. Among the contributors to this

volume, Fumaroli stands nobly apart. He doesn't deconstruct Panofsky's iconological scheme; he petrifies it. He celebrates iconology as a palladium against the blanks of radical modernity. This is a view not unfashionable since 1989.

Of all the other contributions in this volume it is probably Anthony Grafton's essay on "Panofsky, Alberti and the Ancient World" that can most fruitfully be compared to Fumaroli's evaluation of Panofsky's iconology in the light of the rhetorical tradition. But Grafton develops a playful and witty description of Panofsky's humanism, which reads like an inversion or, one might even say, a destruction of Fumaroli's solid palladium. He sees Panofsky—and especially the late, the "second" Panofsky—as a kind of Alberti "redivivus" who, knowing the classical tradition as well as anyone, makes it the material for his own wit, allusions, and inventions. Grafton leaves little doubt that his sympathies are with this "second" playful Panofsky. "A carnival funhouse replaces the stately hall of symbolic forms that perfectly reflect each Zeitgeist. Historical accident and personal taste dictate the fates and functions of classical motifs. . . . Above all, as in textual criticism, error, not accuracy . . . becomes the determinative element." And finally: "The second Panofsky's philological work, with its cheerful admission of the shaping power of accident and the distorting pressure of personal taste, remain exemplary." This view of Panofsky's legacy is fundamentally different from Fumaroli's. It is fascinating to observe how in 1993 an intellectual historian is able to reveal deconstructive potentials in Panofsky's iconological games that thirty years ago remained hidden from Panofsky's admirers as well as his critics. "Meaning" appears now as an open, no longer as a closed concept. In Grafton's interpretation, Panofsky's humanistic legacy expands and grows. But it was the late Panofsky himself who had stepped at least on the threshold of such a deconstructive expansion. When he wrote that charming little paper entitled "On the Mouse which Michelangelo Failed to Carve" he mused: "Now I can only write an arti-

cle on the iconology of a non-existing work of art."[26] "Meaning in the Visual Arts" had become surrealistic, the iconologist himself inventing the program, which he then deciphers. Grafton's sensitive argument elegantly disarms quite a number of recent Panofsky critics by presenting us with a trans-philological Panofsky.

Grafton's distinction between a "first" and a "second" Panofsky implies the difference between the European, the German scholar of the years 1914 to 1933 and the "transplanted European" who wrote and taught in the United States from 1933 to 1968. As Grafton puts it: "He (Panofsky) had learned, presumably in the years of interaction with Cassirer, to see the central forms of cultures as coherent sets of symbols. He had discovered in America that he could describe these to a large and unrefined public because he was released from the tolls of his Begriff-stricken mother tongue." This is certainly true but the liberation that Panofsky experienced when he escaped from the Old into the New World was more than just a change of tone. In his paper "Meaning in the Visual Arts as a Humanistic Discipline" David Summers recalls very convincingly and in great detail that the "first Panofsky can only be understood in the context of the discourse on interpretation and 'Auslegung,' which was going on in Germany from Dilthey to Husserl, from Cassirer until Heidegger in 1930. In the center of this debate stood the tantalizing problem of objectivity and its imprisonment in the interior of that vicious circle from which no interpretation can escape. Regarding recent Panofsky criticism it is essential to bear in mind that in 1930 the author of "Meaning in the Visual Arts" was himself conscious of the fact that any interpretation is framed by the interpreter's position. Between Cassirer and Heidegger Panofsky struggled to propose a way towards relative objectivity.[27] Perhaps this hermeneutic dimension of the "first" Panofsky has been somewhat forgotten as once in America he himself felt liberated from these twisted German debates. In 1937 he still wrote "we are appar-

ently faced with a hopeless vicious circle" but understandably he no longer cites Heidegger, no longer enters the hermeneutic discourse but—following a suggestion by Theodor Meyer Greene—he appeases: "Actually it is what the philosophers call an organic situation."[28] In the introduction to "Studies in Iconology" the problem of the vicious circle is no longer mentioned. It was in the course of this process of liberation from the burden of his German past that Panofsky formulated his program of "The History of Art as a Humanistic Discipline." He did so in the threatening political climate of the thirties, with the undertones of which we can grasp Craig Hugh Smyth's "Thoughts on Panofsky's First Years in Princeton." Iconology became the self-sufficient method we now know, a sophisticated technique of exegesis, the astonishing game of the "second" Panofsky who unraveled with his magic wand the riddles of "disguised symbolism." The effect was dazzling and art history was enormously enriched by the playfulness of Panofsky's later work. But the system of iconology was now based on a kind of unquestioned philological pragmatism. The Panofsky who declared "The discussion of methods spoils their application" had for good or bad definitively escaped from the vicious circle. It is this late Panofsky who became in the last decades the victim of harsh and, at least in part, understandable criticism. It is welcome that David Summers reminds us that any balanced critic should discuss the whole Panofsky. He was much more aware of the "framing" of interpretations than the brilliance and playfulness of his late work lets us suppose and than his recent critics are ready to admit.

The rise of iconological studies has from its beginnings been accompanied by the accusation that such a unilateral approach over-intellectualized the sensuous and formal qualities of the work of art. Already in the twenties such a witty connoisseur as Max Friedlaender opposed sarcastically "Körpergeschichte" to "Geistesgeschichte" in a conversation with no one other than Panofsky.[29] After World War II it was Ernst Gombrich who first voiced his scepticism in 1948 in his memorable study "Icones Symbolicae. Philosophies of Symbolism and their Bearing on Art" and later in 1972 in a quite outspoken way under the telling title "Aims and Limits of Iconology." He wrote: "We should always ask the iconologist to return to base from every one of his individual flights, and to tell us whether the programs he has enjoyed reconstructing can be documented from primary sources or only from the works of fellow iconologists. Otherwise we are in danger of building up a mythical mode of symbolism much as the Renaissance built up a fictitious science of hieroglyphs that was based on a fundamental misconception of the nature of Egyptian script."[30]

Gombrich's warnings against fashionable iconology and easy symbolism had been a recall to reason in the style of critical rationalism. With the change and expansion of the visual scene during the sixties and seventies and with a new awareness of the sheer sensual, corporal presence of images, iconological symbolism in the style of Panofsky began to be denounced as a spiritualizing deformation of the body of art. Carlo Ginzburg's criticism of Panofsky's "philosophical" interpretation of Titian's erotic paintings is a telling, if somewhat crude, case in point.[31] "Die Götterdämmerung des Neuplatonismus," "The Nightfall of Neoplatonism," which Horst Bredekamp announced in 1986, sounded like an obituary for Panofsky's concept of meaning and symbolism.[32]

That this is a complex debate with undertones of postmodern sensualism becomes clear in reading Randolph Starn's brilliantly polemical paper "Pleasure in the Visual Arts." Starn writes: "The many pages on Venus, Cupid and winsome demigods in the 'Studies in Iconology' are quite blank on the pleasures of viewing" and he finds harsh words for what he castigates as "art historical anhedonia." At the symposium the audience protested with indignation and recalled Panofsky's sensitive reactions to the lines on Dürer's woodcuts and other works of art. Such an

indignation was certainly sympathetic, but besides the point. I don't think that Professor Starn would deny that there is more than one passage in Panofsky's writings that reveals the author's visual pleasure. Randolph Starn tries to demonstrate in a much more general way that the separation of art history "German style" from aesthetics—the cleaning of the new serious academic discipline from the remnants of mere aesthetic judgments—had lead to a regrettable, even disastrous loss of sensual pleasure in the appreciation of art. And he seems to recognize in Panofsky's conception of the work of art as a symbolic form, with all its neoplatonic ingredients, the acme of this anti-sensual and anti-aesthetic line of thought. It is evident that this argument fits well into the new cultural climate that first began to take birth in the sixties. In a chapter entitled "Fin de la transcendance" Baudrillard wrote in 1970: "Il n'y a plus d'âme, d'ombre, de double, d'image au sens spéculaire."[33] But this naturally does not exclude that Starn is—at least up to a certain degree—convincing in calling for a more rhetorical and less philosophical appreciation of the visual arts and for the return to pleasure. I think he has a point. But in the end it is a question of balance. We may complain that art history "German Style" over-intellectualized the work of art, forgot Dionysos in sacrificing all too eagerly to Apollo. But we should also be aware that indulging in mere visual pleasure may easily deprive works of art of those metaphorical qualities that formed the nucleus of Panofsky's concept of meaning and the humanist's *intellectual* pleasure. This would be an impoverishment no less regrettable than the suppression of pleasure. "Aut prodesse aut delectare volunt poetae." I think neither of these alternatives should be neglected if we want to do art history in the full sense.

Towards the end of his life Aby Warburg began to compose his legendary picture atlas, "Mnemosyne."[34] He put side by side series of images —by no means exclusively works of art—in order to demonstrate visually the diachronic persis-tence of certain beliefs, superstitions, facial expressions, and gestures. It was an enterprise that could not be enshrined in any academic disciplines as they existed in the late twenties. Warburg was an "historical anthropologist" *avant la lettre*.[35] Panofsky learned from Warburg during his years in Hamburg the use of different levels of visual material but did so as an art historian. He certainly did not become an anthropologist. If he included in the "Studies in Iconology" a modest woodcut from a blockbook, this was the means to another end, a step towards the understanding of the great work of art.[36] I have already indicated that this very peculiar relation of Panofsky to Warburg—Warburg reduced and foreshortened for the needs of art history—created a problem for the Princeton commemoration. If W.J.T. Mitchell asks "what is visual culture?" and refers for comparison to Panofsky's interdisciplinary approach, he raises a question that could have been addressed with greater justification to Warburg. But there remain more fundamental questions in regard to Mitchell's paper. He tries to be fair to Panofsky's thought and to read his paper on "The History of Art as a Humanistic Discipline"—at least in some of its basic assumptions—as "most up to date." I am afraid that this is a confusion that does justice neither to Panofsky nor to the visual culture of 1994. If Panofsky speaks of an "organic situation" he wants to remind his reader only that there cannot be such a thing as an absolute, final interpretation. He relativizes the art historians' hermeneutic potentials. But this doesn't mean in the least that he relativizes the canon of tradition, which remains for him the unshakable basis of art history. The unfocused visual culture of today, however, as Mitchell describes it so impressively, can only function because it has totally emancipated itself from any hierarchical canon. It can not even be compared to the series of images in Warburg's picture atlas because Warburg believed to see in these "pin-ups" the reflection of mankind's long struggle against superstition and the demons, a process of enlightenment. "Athens must always

be reconquered from Alexandria" as he used to say.[37] The open visual culture of today where "the boundaries have eroded between the aesthetic and the non aesthetic" no longer charges images with such fateful meanings. We are much farther away from Panofsky than Mitchell seems to think. Another problem is where to look for the location of art in this new lunapark of visual culture. But this is a modern question which may be raised more in reference to Adorno than to Panofsky or Warburg.

Reading some of the papers from the session on anthropology it is instructive to see how far the concept of meaning here has moved away from Panofsky's "Platonic" and hierarchical ideas towards a material, "handicraft," and social understanding of the physical object. This is what one learns from Margaret W. Conkey's contribution "Making Things Meaningful: Approaches to the Interpretation of the Ice Age Imagery of Europe." "Intention," she writes, "cannot be grasped apart from the practical conditions within which image-making and image-using go on. To understand intentions is to think about visual culture as a practice." Is this just another variant of the "Götterdämmerung des Neuplatonismus," which art historians have proclaimed? Maybe so, but there remain differences. Not only is the anthropologist's text in a most agreeable way free from those polemic undertones that make some of the critical statements of art historians sound so unnecessarily excited. Moreover, the exploration of meaning and intention is described as a process of tense interconnection between empiricism and conceptualism. This pragmatic interconnection seems to suspend the never-ending discussion of the "vicious circle" and of "social framing." One is somewhat surprised to find the late Heidegger, a notoriously ontological thinker, cited in this "Aristotelian" context. It may well be that the moment will come when art historians have to examine their ideas and methods in the light of recent procedures used in anthropology. Such an examination would be an eccentricity probably not even imaginable in Panofsky's days. The hierarchy of fields would be reversed.

Fred Myers' paper: "Re/Writing the Primitive: Art Criticism and the Circulation of Aboriginal Painting" gives rise to similar reflections. The problem, we learn, is no longer the enlargement and revision of the Western canon of taste by the aesthetic integration of primitive, non-Western art. In such a past perspective even Panofsky, the humanist, had occasionally mentioned African art with benevolent condescension. Myers is too cautious and argues in a too subtle way to demand simply a reversal of this traditional Western view in looking at non-Western art. He asks for a "broader critical discourse that will constitute the history and context for Aboriginal painting in the West." He observes "slowly there is a shift in Zeitgeist, so Aboriginal painting is not seen only as failed authenticity or failed Western art. It develops its own critical discourse, its own sensibilities." The reception of "Aboriginal painting" in the Western art scene—and more still the exploitation of the Aboriginal painting by the Western Art market—is a pathetic and painful example of the conflict between the traditional submission of Non-Western art to Western standards of judgment and the new demand to create independent discursive spaces for a sensitive evaluation of Non-Western art. This is a delicate and ambivalent situation. The enlightened demand for the sensitive exploration of a new plurality in meanings can all too easily degenerate into the intolerant call for political correctness. We can only hope for the insight that any recognition of plurality in meaning is possible only on the basis of some universal values. And how did Panofsky write in the frightening years before 1939? "The ideal . . . of the humanities would be something like wisdom."[38]

Horst Bredekamp cites in his thoughtful contribution "Words, Images, Ellipses" Lévi-Strauss, who called the work of Erwin Panofsky "pleinement et totalement structuraliste."[39] The decoding of meaning is, we may assume, the analogous goal of iconology as elaborated by Panofsky

and the "anthropologie structurale" as built up by Lévi-Strauss. Lévi-Strauss' reference to Panofsky belongs to the relatively late but very intense and interesting reaction to the work of the author of "Studies in Iconology" by French structuralism during the sixties and seventies. Perhaps this Parisian reception remains the strongest crossfertilizing effect Panofsky's thoughts on iconology and perspective have exercised anywhere. So James A. Boon's essay "Panofsky and Lévi-Strauss" raises high expectations. Boon has carefully avoided treating his evasive topic too systematically, he evokes the vague affinities between "iconology" and the "mythologiques" by associations and echos. He admits: Panofsky shows rarely if ever an interest in anthropology. He insists: Although both Panofsky and Lévi-Strauss escaped from Nazi Germany or Nazi-occupied Europe to New York, they never met. He seems even to underestimate Lévi-Strauss' evaluation of Panofsky's iconological system as a model analogous to his own. Needless to remind the reader, that Lévi-Straus discovered Panofsky only after he had already erected his own building of "Anthropologie structurale." It looks as if Lévi-Strauss had been impressed by the hierarchical lucidity of iconological interpretation that Panofsky had proposed. Interesting enough, this seems not to be the aspect of the Panofsky-Lévi-Strauss connection that fascinated James Boon most. Certainly he compares "Panofsky's formulation of Dürer's mathematical classifications" with the ambition of intelligibility for all senses and semiological registers that Lévi-Strauss called "structuralist." He suggests that Lévi-Strauss' frequent digressions "into unexpected resemblances across cultures and times . . . resembles Panofsky's similar habit as in his digression on sun-gods." I am not sure if this comparison is totally justified because comparing in Renaissance representations of Christ and Apollo Panofsky does *not* digress across cultures and times but sticks, on the contrary, to the value-charged context of Western cultural tradition. But this is not the main point I want to make. Speaking of Pa-

nofsky's paper "Et in Arcadia Ego. Poussin and the Elegiac Tradition," Boon says rightly: "Panofsky's sleuthings illuminate just why uncertainty has remained assured in the meanings of 'Et in Arcadia Ego,' among other meanings. Such an outcome may, indeed, be the beauty of Panofsky's iconography, and of Lévi-Strauss' structuralism, alike." So at the end it is the playful Panofsky, sleuthing meanings among other meanings, who is compared to the structuralist "bricoleur" Lévi-Strauss. Such a digression seems to echo Grafton's praise of the "second"—the witty, Erasmian-Panofsky who has left behind him all philological pedantry. It was a fascinating postmodern spectacle: Whenever one listened to one of the lectures of the 1993 commemoriation the shell of unified meaning seemed to break and polyvalence to rise.

During the last twenty years art history has begun to build myths of its own "archéologie du savoir." Books and articles on the great art historians of the past—the "fathers of the discipline"—are published in great numbers. This literature is very diverse, but more than once such texts reveal a woeful feeling of loss and nostalgia. In recent German art history Aby Warburg has become a legendary figure—the forgotten bearer of an unachieved promise—whose memory and legacy must be saved from a ruined past. The recent discovery of the close relation between Erwin Panofsky and Siegfried Krakauer seems surrounded by a similar aura of astonishment and loss. The case is in fact memorable. In Weimar Germany Panofsky and Krakauer seem never to have met. The intellectual distance between Hamburg and Frankfurt—the circle of the "Kulturwissenschaftliche Bibliothek Warburg" and the people around the "Frankfurter Zeitung" and the futural "Institut für Sozialforschung"—was a long one.[41] So it was only as Jewish refugees from Nazi Germany in North America that Panofsky and Krakauer came in contact. Their common ground was their interest in film. Panofsky had been a passionate movie-goer—an addict of films—since the day before World War I. But the

chaired professor for Art History in Hamburg had never written a line on cinema. It was only the "second" Panofsky who—liberated from the fetters of German academic respectability—felt free to publish his famous paper on "Style and Medium in the Moving Pictures."

In his paper "Iconology at the Movies: Panofsky's Film Theory" Thomas Y. Levin recalls in great detail the circumstances that were at the origin of the iconologist's digression on film. The voice of Panofsky, the renowned art historian and distinguished member of the recently founded "Institute for Advanced Study" was expected to be of help in gaining respectability for the new film department of "Moma." Now this is a telling story. As much as "Pan" may have liked films, the humanist's excursion into the cinema in the form of an official lecture was widely regarded as a descending or amusing extravagancy. Panofsky's interest in film was seen at the best as a by-road, another example for the author's playfulness. The canon of great art and tradition had to remain undisturbed by it.

In the light of Levin's lecture it seems no longer possible to maintain such appeasing assumptions. Panofsky the movie-goer and Panofsky the iconologist were one and the same person. One might even argue that Panofsky was a movie-goer before he became an iconologist and that he read the "Early History of Man" by Piero di Cosimo as he was habituated to look on figures and narratives in films. If so, the question: who came first, the iconologist or the movie-goer would follow that of the chicken and the egg. There is no difference between Panofsky the addict of films, Panofsky the passionate reader of Balzac, Simenon, and other detective stories, and Panofsky the iconologist. Always his fascination and his fun were the same: watching types and plots. So Levin is right to stress the crucial importance of Panofsky's essay on film. But I would like to insist: this text reveals Panofsky's strengths as well as it points to his limitations. It shows that Panofsky's obsession with content was much less philological than it was visual. More even than in

symbolism he was interested in the staging of stories and characters. Beneath all his stupendous learning lived his naive joy to be visually entertained by the figurations of all sorts of events—myths, legends, fairy tales—by types and their chameleon-like transformations over the course of history. In this sense his essay on film, far from being a digression, is emblematic. It seems to me a matter of fairness—and of good humour—to stress these positive aspects of Panofsky's gifts and achievements as they are revealed by his interest in film and his paper on the "Moving Pictures."

It is much more difficult to analyse the limitations that this same text lays open. Levin has intelligently and convincingly discussed these limitations in the light of film theory which he seems to know admirably. But I am afraid there remain problems of a more general kind. The relation of Panofsky to modernity is more complex than some of his critics have admitted. He used to joke that he admired Picasso, but he immediately added: "He was the last artist of the 19th century. Nowadays artists express only themselves." What Panofsky never could swallow was the modern separation of form and expression from content, content in the most traditional, iconographic sense. Levin has described the problems this incapacity creates for the film essay. In the same manner Panofsky has always remained speechless in front of abstract art. The expression of feeling and passion by the blanks of empty forms hurt him, worse it made him afraid and there is a chance that he regarded it as barbarian. For Panofsky, the humanist—and humanist not only in an academic, Ciceronian sense—forms and expressions had to be tamed and civilized by connection with some kind of content. The scream had to be transformed into language. Now, one may have greater sympathies for the open-mindedness of an art historian like Meyer Schapiro who analyzed Romanesque art in the light of abstract painting with fascinating results, which after fifty years seem also questionable. But it is all too easy to denounce

the myopia of Panofsky's position in the name of conventional modernism. At the end of the twentieth century such a partisan critic begins to look obsolete. Modernism itself being deconstructed, we begin to see that the different reactions against the avant gardes were an integrated part of the ambivalent history of modernity. And one should never forget: With the burning of books, degenerate art exhibitions, with Ortega y Gasset and more still with Sedlmayr there were far more intolerant reactions against contemporary art than the charmingly naive humanism of Erwin Panofsky who quarrelled with a modern painter on the right ending of a latin word—and lost. In reading this story one is reminded of Swift's "Battle of the Books."[41] It seems as if Panofsky really assumed that abstractionism in painting could not go together with a correct knowledge of Latin. In 1994, when abstract painting seems to be behind us and when a mastery of Latin is rare even among academics, this slightly grotesque "Querelle des Anciens et Modernes" between Princeton and Manhatten in 1961 shows once more how far we have come from Panofsky's idea of humanism.

Notes

Abbreviations

Bal/Bryson: Mieke Bal and Norman Bryson, "Semiotics and Art History." *The Art Bulletin* 73 (1991): pp. 174–208.

Künstlerischer Austausch: Künstlerischer Austausch. Artistic Exchange. Akten des XXVIII. Internationalen Kongresses für Kunstgeschichte, Berlin 15.–10.Juli 1992. Ed. Thomas W. Gaehtgens, vols. 1, 2, 3. Berlin 1993.

Symposion: Erwin Panofsky. Beiträge des Symposions Hamburg 1992. Ed. Bruno Reudenbach (Schriften des Warburg-Archivs im Kunstgeschichtlichen Seminar der Universität Hamburg, Vol.3). Berlin 1994.

1. Hans Kauffmann, "Erwin Panofsky (1892–1968)." *Kunstchronik* 21 (1968): pp. 260–66, especially p. 266.

2. Daniel Arasse, "Aprés Panofsky: Piero di Cosimo, peintre." In *Pour un temps/Erwin Panofsky.* Centre Georges Pompidou 1983, pp. 135–48.
The two texts by Otto Pächt are: "Panofsky's Early

Netherlandish Painting I and II." *Burlington Magazine* 98 (1956): pp. 110–16 and 267–79.
"Künstlerische Originalität und ikonographische Erneuerung." In *Stil und Übelieferung.* Akten des 21. Internationalen Kongresses für Kunstgeschichte, Bonn 1964, vol. 3, Berlin 1967, pp. 262–71.
Arguments similar to those of Arrasse can be found in Oskar Bätschmann, "Logos in der Geschichte. Erwin Panofskys Ikonologie." In Lorenz Dittmann, ed., *Kategorien der deutschen Kunstgeschichte,* Stuttgart 1985, pp. 89–111.

3. James H. Marrow, "Symbol and Meaning in Northern European Renaissance." *Simiolus* 16 (1986): pp. 150–69.

4. For a balanced and precise analysis of the interrelations between Semiotics and art-historical interpretation see Bal/Bryson. Panofsky is here only briefly mentioned.

5. See Willibald Sauerländer, "'Barbarus ad portas.' Panofsky in den fünfziger Jahren." Symposion, pp. 123–27. And in the same sense Oskar Bätschmann, "Pan deus Arcadiae venit." *Panofsky and Poussin,* Symposion pp. 71–82.

6. Bal/Bryson, p. 207.

7. Bal/Bryson, p. 207 referring to Derrida.

8. David Carrier, "Circa 1640." *New Literary History* 21, 3 (1990): pp. 649–70.

9. Michael Ann Holly, "Witnessing an Annuniciation." *Künstlerischer Austausch,* vol. 2, pp. 713–25.

10. Bal/Bryson, pp. 207/208.

11. Bal/Bryson, p. 208.

12. Keith Moxey, "Panofsky's Melancolia," *Künstlerischer Austausch,* vol. 2, pp. 681–92.

13. For Panofsky's beginnings in Hamburg, see Horst Bredekamp, "Ex nihilo: Panofskys Habilitation," Symposion, pp. 31–51.

14. Hartmut Kugler spoke about: "Perspektive als symbolische Form in der mittelalterlichen Dichtung. Panofsky und die germanistische Mediävistik," Symposion, pp. 201–11. Hinz Abels gave a talk with the title: "Die Zeit wieder in Gang bringen." Soziologische Anmerkungen zu einer unterstellten Wirkungsgeschichte der Ikonologie von Erwin Panofsky, pp. 213–228.

15. These were: Heinrich Dilly, "Das Kunsthistorische Seminar der Hamburgischen Universität," Symposion, pp. 1–14. Ulrike Wendland, "Arkadien in Hamburg. Studierende und Lehrende am Kunsthistorischen Seminar der Hamburgischen Universität," pp. 15–29. The lecture by Horst Bredekamp cited in note 13. Martin Warnke, "Panofsky—Die Hamburger Vorlesungen," pp. 53–58. Volker Breidecker, "Einige Fragmente einer intellektuellen Kolletivbiographie der Kulturwissenschaftlichen Emigration," pp. 83–108.

16. These were: Bruno Reudenbach, "Panofsky und Suger von St. Denis," Symposion, pp. 109–22. Konrad Hoffmann, "Panofskys 'Renaissance,'" pp. 139–44. Klaus Herding, "Panofsky und das Problem der Psycho-Ikonologie," pp. 145–70, Beat Wyss, "Ein Druckfehler," pp. 191–99.

17. Regine Prange, "Stil und Medium. Panofsky 'On Movies,'" Symposion, pp. 171–90. The arguments are partially similar to these of the talk by Thomas Y. Levin (in this volume).

18. James D. Wolfensohn cited by Milton Esterow in Art News, December 1993, p. 155.

19. Irving Lavin in a circular letter to the participants of the commemoriation. For the program of the commemoration Prof. Lavin has slightly changed this text.

20. Aby Warburg, "Italienische Kunst und internationale Astrologie im Palazzo Schifanoja zu Ferrara." Now in Aby M. Warburg, *Ausgewählte Schriften und Würdigungen*, ed. Dieter Wuttke, Baden-Baden 1980, pp. 173–98.

21. See Horst Bredekamp, *Antikensehnsucht und Maschinenglauben. Die Geschichte der Kunstkammer und die Zukunft der Kunstgeschichte*, Berlin 1993.

22. Ernst Robert Curtius, *Lateinische Literatur und Europäisches Mittelalter*, Bern 1948.

23. Marc Fumaroli, *L'Etat culturel*, Paris 1991.

24. Cited by Herbert von Einem, "Erwin Panofsky zum Gedächtnis," *Wallraf-Richartz-Jahrbuch* 30 (1968): p. 11.

25. Curtius as in note 22, pp. 202–6. Panofsky, *Studies in Iconology*, pp. 95–129.

26. Erwin Panofsky, "The Mouse which Michelangelo Failed to Carve." In *Essays in Memory of Karl Lehmann*, New York 1964, pp. 242–51.

27. Erwin Panofsky, "Zum Problem der Beschreibung und Inhaltsdeutung von Werken der bildenden Kunst," Logos 21 (1932): pp. 103–19. Reprinted in Erwin Panofsky, *Aufsätze zu Grundfragen der Kunstwissenschaft*, ed. Hariolf Oberer and Egon Verheyen, Berlin 1964, pp. 85–99.

28. Erwin Panofsky, "The History of Art as a Humanistic Discipline." In *The Meaning in the Humanities*, ed. T. M. Greene, Princeton 1940, pp. 89–118. Reprinted in Erwin Panofsky, *Meaning in the Visual Arts*, Princeton 1955, pp. 1–25.

29. Erwin Panofsky, "Glückwunsch an einen großen Kunsthistoriker." In *Max J. Friedlaender. Ter ere van zijn negentigste verjaardag 5. Juni 1957* (1957), pp. 11–18, especially p. 17.

30. Ernst Gombrich, "Icones symbolicae. Philosophies of Symbolism and their Bearing on Art," *Journal of the Warburg and Courtauld Institutes* 8 (1945): pp. 7–60. Reprinted in *Symbolic Images. Studies in the Art of the Renaissance*, London 1973, pp. 123–95. "Aims and Limits of Iconology," ibid. pp. 1–22.

31. Carlo Ginzburg, "Tiziano, Ovidio e i Codici della figurazione erotica nel 1500." In *Tiziano e Venezia*, Vicenza 1980, pp. 125–35.

32. Horst Bredekamp, "Götterdämmerung des Neuplatonismus," *Kritische Berichte* 14 (1986): pp. 39–48.

33. Jean Baudrillard, *La société de consommation* (1970), p. 308.

34. See Ernst Gombrich, *Aby Warburg. An Intellectual Biography*, London 1970, pp. 283–306.

35. Peter Burke, "Warburg as Historical Anthropologist." In *Aby Warburg. Akten des Internationalen Symposions*, Hamburg 1990. Ed. Horst Bredekamp et al. Weinheim 1991, pp. 39–44.

36. For the difference between Warburg and Panofsky, see Michael Podro, *The Critical Historians of Art*, New Haven/London 1982, p. 205.

37. See Gombrich as note 34, p. 215.

38. Panofsky, *Meaning* as note 28, p. 25.

39. H. Bredekamp (in this volume). German manuscript p. 16, after Claude Lévi-Straus, *Anthropologie structurale deux*, Paris 1973, p. 324.

40. See for an example Wolfgang Kemp, "Walter Benjamin und die Kunstwissenschaft" (Teil 2), *Kritische Berichte* 3 (1975): pp. 5–25.

41. See: Beat Wyss, "Ein Druckfehler," Symposion, pp. 191–99.

Notes on Contributors

Carolyn Abbate is professor in the Department of Music at Princeton University.

James A. Boon is Professor of Anthropology at Princeton University; he also teaches European Cultural Studies. An Indonesianist and specialist in Balinese culture, his books address the history of colonialist representations, diverse schools of ethnography, plus critical theory and the coincidence of arts (verbal, musical, visual . . .). He is currently composing essays on "Extra-Vagance" in ritual practices, interpretive styles, and inter-disciplinary modes of reading.

Horst Bredekamp is professor in the Kunst-geschichtliches Institut of the Humboldt-Universität zu Berlin.

Margaret W. Conkey is Professor of Anthropology and Director of the Archaeological Research Facility at the University of California, Berkeley. She has published numerous articles on issues of interpretation in the imagery and material culture of the European Upper Paleolithic, has co-edited a book on *The Uses of Style in Archaeology* (1990), and continues to be a contributor to the archaeological literature on gender and feminist approaches. She is currently carrying out field research in the Midi-Pyrénées of France that is inquiring into the cultural landscapes and social geography of the Upper Paleolithic image-makers.

Shelly Errington is Professor of Anthropology at the University of California at Santa Cruz. A specialist on island Southeast Asia, she has published on the area's traditional political forms, literature, and gender symbolism. More recently she has written about the arts, the international art market, global flows of images and information, and the politics of culture. Her book *The Death of Authenticity . . . and Other Tales of Progress* is forthcoming in 1996.

Philip Fisher is professor in the Department of English at Harvard University.

Marc Fumaroli is a member of the Académie Française and Professor of Rethoric and European Civilization (XVIth–XVIIIth centuries) at the Collège de France, Paris. He is one of the leading scholars in the interdisciplinary field of European culture from the Renaissance to neo-classicism. In the last twenty years his interests in the visual arts have produced extensive articles and essays on diverse topics: from the iconography of Constantine in the diplomatic relations between Rome and Paris in the XVIIth century to the iconography of Saint John the Baptist in Italian painting of the XVIth and XVIIth centuries. His latest contributions have engaged religion and erudition in the works of Nicolas Poussin, and the literary and artistic background of Antoine Watteau. The 1989 Louvre exhibition catalogue, *L'inspiration du Poète de Poussin,* and the *Ecole du Silence,* a book of collected essays in the history of art (1994) are among his most recent publications.

Anthony Grafton, Dodge professor of history at Princeton University, has published numerous studies in the history of the classical tradition in western Europe. These include an intellectual biography of the sixteenth-century classical scholar *Joseph Scaliger* (1983), an essay on the interaction between *Forgers and Critics* (1990) and a study of the role played by classical texts and traditions in Europeans' interpretation of the

great discoveries of the sixteenth and seventeenth centuries: *New Worlds, Ancient Texts* (1992).

James Haar, W. R. Kenan Jr. Professor of Music at the University of North Carolina at Chapel Hill, has published on various aspects of Renaissance music with particular attention to the Italian madrigal. His most recent book (with Iain Fenlon) is *The Italian Madrigal in the Early Sixteenth Century. Sources and Interpretation* (1988). He is currently beginning work on a book dealing with Romantic attitudes toward early music.

Donald R. Kelley, James Westfall Thompson Professor of History at Rutgers University and Executive Editor of the *Journal of the History of Ideas,* has published many articles and books on modern European history, including *The Human Measure* (1990), *Renaissance Humanism* (1991), and *Versions of History from Antiquity to the Enlightenment* (1991).

Martin Kemp is British Academy Wolfson Research Professor at the University of St. Andrews. In October 1995 he takes up the Professorship in the History of Art at the University of Oxford. He studied Natural Sciences and Art History at Cambridge and at the Courtauld Institute of Art, London. He is author of *Leonardo da Vinci, The Marvellous Works of Nature and Man* (1981, winner of the Mitchell Prize), and *The Science of Art, Optical Themes in Western Art from Brunelleschi to Seurat* (1990). He is currently researching issues in scientific representation and writing a book on anatomical, physiognomic, and natural themes in art from the Renaissance to the nineteenth century.

Irving Lavin is Professor of Art History in the School of Historical Studies at the Institute for Advanced Study. Best known for his work on Gianlorenzo Bernini, he has published widely on subjects ranging from late antique to modern art. His latest book is *Past-Present. Essays on Historicism in Art from Donatello to Picasso* (1993).

Thomas Y. Levin is assistant professor in the German Department at Princeton University, where he holds the Charles G. Osgood Preceptorship. A former fellow at the J. Paul Getty Center for the History of Art and the Humanities and at the Institute for Advanced Study/Collegium Budapest, Levin is a cultural and media theorist whose work on the Frankfurt School has appeared in *New German Critique, October,* and *Critical Inquiry.* His most recent publication is a volume of Weimar essays by Siegfried Kracauer entitled *The Mass Ornament,* which he translated, edited, and introduced (1995).

Annette Michelson is professor in the Department of Cinema Studies at New York University.

W.J.T. Mitchell is Gaylord Donnelley Distinguished Service Professor of English and Art History at the University of Chicago, and editor of *Critical Inquiry.* His recent books include *Iconology* (1986) and *Picture Theory* (1994), and his essay in this volume is part of a book in progress entitled *A Critique of Visual Culture.*

Fred R. Myers is Professor of Anthropology at New York University. A specialist in the ethnography of Aboriginal Australia and the author of *Pintupi Country, Pintupi Self: Sentiment, Place, and Politics among Western Desert Aborigines* (1986), he has turned his attention to the ways in which indigenous peoples' identities are mediated through the arts and material culture. A co-edited volume of essays on critical ethnography and art, *The Traffic in Culture: Refiguring Art and Anthropology* (with George Marcus), is in press and a monograph on the circulation of Aboriginal acrylic paintings is in preparation.

Ellen Rosand, Professor and Chairman of the Department of Music at Yale University and past-president of the American Musicological Society, has written extensively on Italian topics, particularly opera and the music of Venice. Her book *Opera in Seventeenth-Century Venice: The Creation of a Genre* was published in 1991.

Willibald Sauerländer is director emeritus of the Zentralinstitut für Kunstgeschichte in Munich.

Carl E. Schorske is Professor of History, emeritus, at Princeton University, where he directed the program in European Cultural Studies. His works include *German Social Democracy* (1955) and the Pulitzer Prize-winning *Fin-de-siècle Vienna, Politics and Culture* (1980). He has served as historical consultant to the Musée de l'art moderne, the Metropolitan Museum of Art, and other museums.

Craig Hugh Smyth is professor emeritus of Harvard University, former director of The Institute of Fine Arts at New York University, and former director of the Harvard University Center for Italian Renaissance Studies (I Tatti) in Florence.

Randolph Starn is Professor of History at the University of California, Berkeley. Among his many publications on Italian Renaissance culture and art his most recent book is *Ambrogio Lorenzetti: The Palazzo Pubblico* (1994). He is currently working on theories and practices of authenticating historical documents and artifacts.

Wendy Steiner is the Richard L. Fisher Professor of English at the University of Pennsylvania. Among her writings on literature-painting connections are *Pictures of Romance* (1988) and *The Colors of Rhetoric* (1982). She is an active cultural critic, and her book, *The Scandal of Pleasure: Art in an Age of Fundamentalism* appears in the fall of 1995.

David Summers is professor in the Department of Art at the University of Virginia.

Leo Treitler is Distinguished Professor of Music at the Graduate School and University Center of the City University of New York. He has made a specialty of musical tradition in the early European Middle Ages, and has long pursued interests in the historiography and philosophy of music. His book of critical and theoretical essays, *Music and the Historical Imagination,* was published in 1989.

M. Norton Wise is Professor of History at Princeton University. He is co-author with Crosbie Smith of *Energy and Empire: A Biographical Study of Lord Kelvin* (1989). His articles on the history of physics include a series on British natural philosophy and political economy. He is presently preparing a book on the mediating technologies that in particular cultural "moments" have grounded scientific explanation.

Kristin Eldyss Sorensen Zapalac, Assistant Professor of History at Washington University in St. Louis, lectures and publishes on the cultural history of early modern Europe. Her book *"In His Image and Likeness": Political Iconography and Religious Change in Regensburg, 1500–1600* (1990), was completed during her tenure in the Harvard Society of Fellows. She is currently immersed in two monographic projects: the first is entitled "Defining Differences: Constructing Identity out of Difference in Early Modern Europe"; the second—from which the essay in the present volume is taken—explores the relation between *signum* and *res* in the religious thought and art of the fifteenth and sixteenth centuries.